THE BACKYARD ASTRONOMER'S GUIDE

■ CAMDEN HOUSE ■

THE BACKYARD ASTRONOMER'S GUIDE

All Astronomical Photographs by Amateur Astronomers

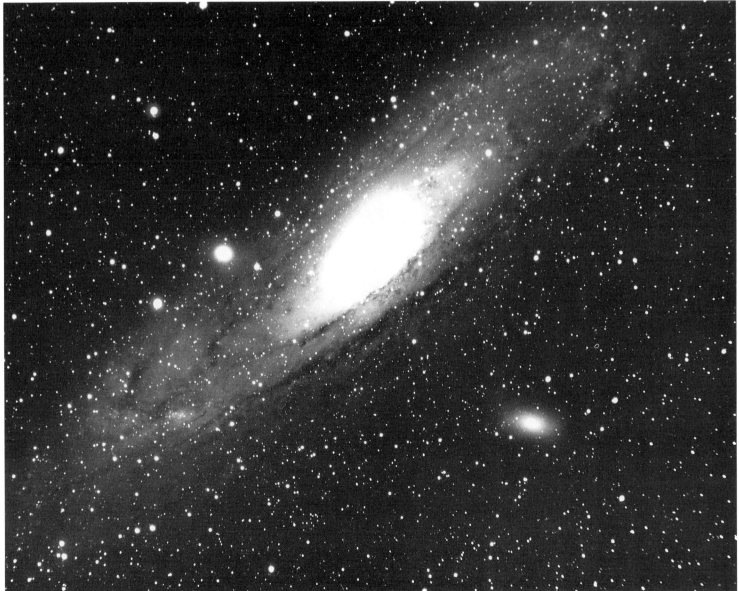

■ TERENCE DICKINSON & ALAN DYER ■

Second printing 1992 (revised)

Canadian Cataloguing in Publication Data

Dickinson, Terence
 The backyard astronomer's guide

Includes index.
ISBN 0-921820-11-9

1. Astronomy - Amateurs' manuals. I. Dyer, Alan, 1953- . II. Title.

QB64.D53 1991 522 C91-094361-3

Trade distribution by
Firefly Books
250 Sparks Avenue
Willowdale, Ontario
Canada M2H 2S4

Printed and bound in Canada by
D.W. Friesen & Sons Ltd.
Altona, Manitoba, for
Camden House Publishing
(a division of Telemedia Publishing Inc.)
7 Queen Victoria Road
Camden East, Ontario
K0K 1J0

Front Cover: The brightest sector of the Milky Way, near the constellation Sagittarius. Two-photograph composite by Terence Dickinson; both with 50mm f/1.7 lens.

Title Page: The Andromeda Galaxy. Photograph by Rajiv Gupta, using a 5-inch f/6 refractor.

Back Cover: Star-rich region of the constellation Scorpius by Michael Watson; 8-inch f/1.5 Schmidt camera. Foreground of backyard astronomers by Terence Dickinson.

Design by
Linda J. Menyes

Technical illustrations by
Margo Stahl

Colour separations by
Hadwen Graphics
Ottawa, Ontario

Printed on acid-free paper

■ ACKNOWLEDGMENTS

Many friends, and many more strangers, contributed to this book through their questions, comments and opinions about backyard astronomy. In fact, the content was largely dictated by the concerns expressed by fellow amateur astronomers during conversations by telephone and at meetings, conventions and star parties. We became convinced that the primary focus of *The Backyard Astronomer's Guide* should be the topics being actively discussed by today's backyard astronomers.

But just having an idea for a book means little unless it can be nurtured and brought to fruition by a team of competent professionals. Topping the list is designer Linda Menyes, who worked an extraordinary number of extra hours to produce a beautiful yet functional book that exceeds our most optimistic expectations. Equally hardworking was our production manager, Susan Dickinson, whose attention to detail amazes all who know her—including her husband, who wrote many of the words she so carefully copy-edited. Editors Tracy C. Read and Barry Estabrook made many useful suggestions.

Thanks also to copy editor Laura Elston; proofreaders Catherine DeLury, Christine Kulyk, Mary Patton, Lois Casselman and Charlotte DuChene; typesetters Patricia Denard-Hinch, Eileen Whitney and Johanna Troyer. Richard Talcott, Russ Sampson, Seth DuChene, Kathryn MacDonald and Laurel Aziz read the entire manuscript and made helpful comments. We also appreciate contributions by Roy Bishop, Perry Remaklus and Ralph Lindenblatt.

To Susan, who helps in so many ways.

—*T.D.*

For all the friends I've met under the stars.

—*A.D.*

■ CONTENTS

■ INTRODUCTION ■

A New Stargazer's Guidebook

There is something deeply compelling about the night sky. Those fragile, flickering points of light in the blackness beckon to the inquisitive mind. So it was in antiquity, and so it remains today. But only in the past decade have large numbers of people decided to delve into stargazing—recreational astronomy—as a leisure activity. Today, more than half a million people in North America call themselves amateur astronomers.

Not surprisingly, manufacturers have kept pace with the growth of the hobby, and there is now a bewildering array of telescopes and accessories to meet the needs of the hundreds of thousands of backyard astronomers. This development has produced a gap in the reference material available to stargazers, a gap that this book attempts to bridge.

■ WHAT THIS BOOK IS ABOUT

In our work as astronomy authors and communicators, we have encountered thousands of enthusiasts seeking tips on how to be backyard astronomers—specifically, how to select the appropriate equipment, how to use it, how to avoid buying unnecessary gadgets and, most important, how to feel comfortable that they are using the equipment they have as well as they can.

The truth is, one can become a competent amateur astronomer with hardware no more sophisticated than binoculars combined with the appropriate reference material: this book, one or two star

atlases, an annual astronomical almanac and a subscription to *Astronomy* or *Sky & Telescope* magazines. But most enthusiasts yearn to graduate to a telescope. Our main task in the following pages is to act as your guides as you select and use the proper equipment and accessories for many enjoyable nights under the stars—in essence, this is a detailed *practical* guide to getting the most out of the experience of night-sky watching.

In many respects, this book is a sequel to coauthor Dickinson's *NightWatch: An Equinox Guide to Viewing the Universe*, which emphasizes preliminary material for the absolute beginner. *NightWatch* assumed no previous experience on the part of the reader. Here, we provide extensive reference material for enthusiasts who have decided that amateur astronomy is an activity worth pursuing, even though they may not yet own a telescope.

■ FOCUS ON PRACTICAL INFORMATION

The best plan with any leisure activity is to become knowledgeable about the equipment before buying it. We provide that information with specific references to brands and items available on today's market. It is easy to be romanced by the technology and by glitzy high-tech advertising; we flag the unnecessary and the frivolous.

No single book, obviously, can do it all, and this one is no exception. However, before we started to

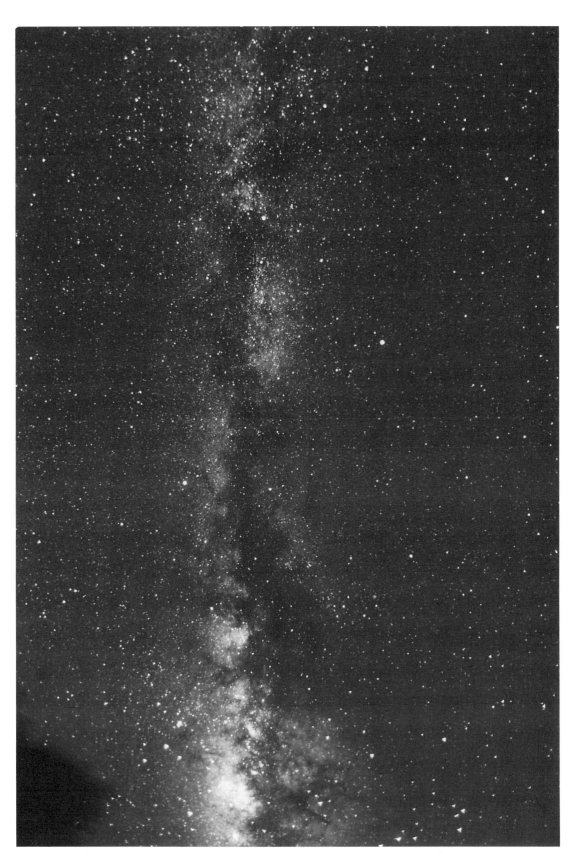

■ *The backbone of the night, the Milky Way marks the centreline of the vast wheel-shaped system of stars in which our sun resides. We are viewing the galaxy from the inside; the centre is the bright bulge near the lower edge. Photograph by Jerry Lodriguss. Like all the other astronomical photographs in this book, this picture was taken by an amateur astronomer capturing the splendour of a memorable night under the stars.*

9

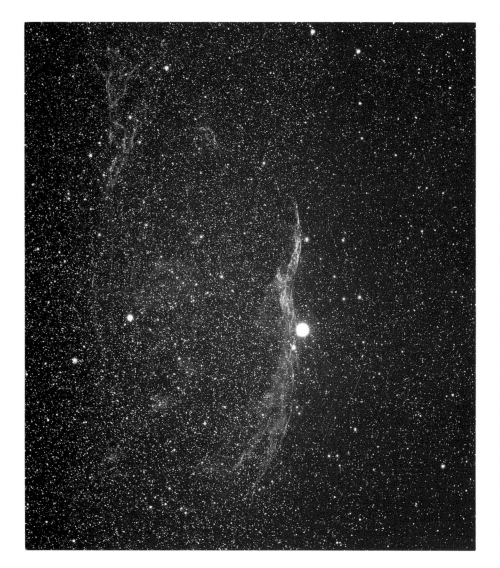

tended to serve as rough guides only. Prices in Canadian dollars are 25 to 40 percent higher, depending on current exchange rates and sales taxes.

With this book, we also wanted to dispel the misperception that one must be a computer whiz with a degree in astrophysics to use a telescope properly or to appreciate fully the wonders of the universe. Physics and computers are unnecessary baggage for personal exploration of the cosmos, and we have deliberately avoided extensive discussions of any such subjects. However, we do offer suggestions and Appendixes for anyone interested in topics that we chose not to include, such as telescope making.

Finally, a few words about the illustrations. All the celestial photographs reproduced in this book were taken by amateur astronomers. Most of the images have never been published before. Some of the photographs rival those taken with much larger telescopes at professional observatories, attesting to the skill and dedication of modern amateur astrophotographers. But beyond the technical achievements is the astonishing beauty that modern cameras, films and telescopes can capture. Many readers undoubtedly will be stirred by these pictures to attempt celestial photography for themselves. We devote three chapters to astrophotography, the major sub-hobby within recreational astronomy. We specifically attempted to display new pictures of familiar objects as well as state-of-the-art astrophotography. Other illustrations are intended to complement the main text. In most instances, the caption material is not contained within the main text and should be considered supplementary information.

■ THE LURE OF ASTRONOMY

For many enthusiasts, the canopy of stars is almost tranquillizing. One member of a husband-and-wife team described it thus: "Astronomy is one of the few hobbies that lets you get completely away from it all. It opens your mind, everyday problems fade, and you don't even notice the time—or the cold. One night, we tape-recorded our viewing session, then replayed it the next day and heard ourselves saying over and over, 'Oh, wow! Look at that,' as we took turns at the telescope. It was really beautiful."

Whatever their passion, all amateur astronomers agree that a major threshold in the hobby is the magical night when the sky ceases to be a trackless maze of glittering points and begins to transform itself in the mind of the observer into the real universe of planets, stars, galaxies and nebulas with names, distances, dimensions and a powerful aura of mystery. Once that happens, there is no turning back. The night sky becomes an infinite wonderland waiting to be explored.

Terence Dickinson and Alan Dyer, July 1991

■ *Above: Once considered to be an extremely difficult target for telescope viewing, the Veil Nebula, in the constellation Cygnus, is now routinely observed in detail with small telescopes using special filters —one of many recent advances in amateur-astronomy equipment. Photograph by Jim Riffle.*
■ *Right: Emerging unexpectedly, the dancing curtains of an aurora (northern lights) can light up a dark night sky with a unique pulsating radiance. This exceptionally intense display, seen on the night of March 12-13, 1989, was visible as far south as Guatemala. Photograph by Terence Dickinson.*

work on this project, we took a close look at the amateur-astronomy guidebooks already available. We saw certain subjects covered over and over again (the same constellation-by-constellation observing lists, for example), while some aspects of the hobby were consistently overlooked. With this in mind, we have concentrated on the areas we feel have been traditionally neglected or have only lately emerged as topics of interest.

In recent years, for instance, the Schmidt-Cassegrain telescope has become the most popular type of instrument for amateur astronomy, yet many references offer only one or two pages on the subject. In this book, we devote half of one chapter and parts of others to the Schmidt-Cassegrain. We detected a need for candour in discussions of commercial astronomy equipment, so we have tried to be as specific as possible about brand names, reporting what we do and don't like and why.

Prices of telescopes and other equipment quoted throughout are in 1991 U.S. dollars and are in-

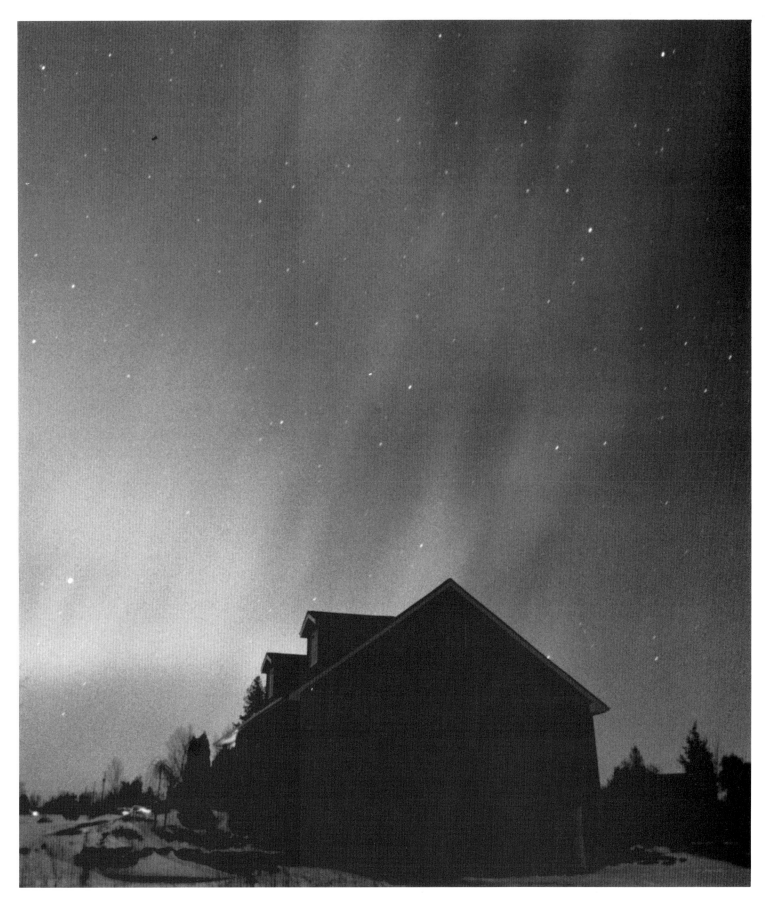

Amateur Astronomy Comes of Age

American poet and essayist Ralph Waldo Emerson once wrote: "The man on the street does not know a star in the sky." His observation stood the test of a century and a half. But in recent years, and during the past decade in particular, a growing number of people *want* to become acquainted with the stars. More astronomy books were published and sold in the 1980s than in any previous decade. More telescopes were manufactured and sold in the 1980s than in any previous decade. More people enrolled in the astronomy courses of colleges, universities and planetariums than in any previous decade.

The 1980s also saw the emergence of astronomers and astrophysicists as media and publishing superstars—Carl Sagan and Stephen Hawking, for example. There is no mistaking the signals: Astronomy has come of age as a mainstream interest and a recreational activity.

■ NATURALISTS OF THE NIGHT

Not coincidentally, the growth of interest in astronomy during recent years has parallelled the rise in our awareness of the environment. The realization that we live on a planet with finite resources and dwindling access to wilderness areas corresponds with a sharp increase in activities which involve observing and appreciating nature—birding, nature walks, hiking, scenic drives, camping and nature photography. Recreational astronomy is in this category too. Amateur astronomers are naturalists of

the night, captivated by the mystique of the vast universe that is accessible only under a dark sky.

In recent decades, the darkness that astronomy enthusiasts seek has been beaten back by the evergrowing domes of artificial light over cities and towns and by the increased use of security lighting everywhere. In many places, the lustre of the Milky Way arching across a star-studded sky has been obliterated forever. Yet amateur astronomy flourishes as never before. Why? Perhaps it is an example of that well-known human tendency to ignore historic or acclaimed sites in one's own neighbourhood while attempting to see everything when travelling to distant lands. Most people now perceive a starry sky as foreign and enchanting rather than as something that can be seen from any sidewalk, as it was when our grandparents were young.

That is certainly part of the equation, but consider how amateur astronomy has changed in two generations. The typical 1950s amateur astronomer was usually male and a loner, with strong interests in physics, mathematics and optics. In high school, he spent his weekends grinding a 6-inch f/8 Newtonian telescope mirror from a kit sold by Edmund Scientific, in accordance with the instructions presented in *Scientific American* telescope-making books. The four-foot-long telescope was mounted on what was affectionately called a "plumber's nightmare"—an equatorial mount made of pipe fittings. In some cases, it was necessary to keep the telescope out of

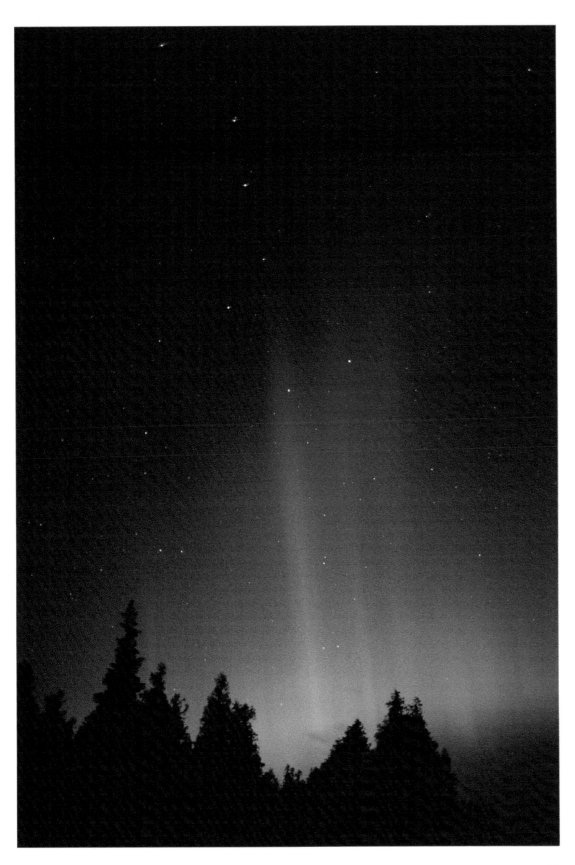

A wedge of aurora briefly paints the night sky below the Big Dipper on June 10, 1991. Of all the sky's stellar configurations, none is more familiar or more useful as a guidepost. Photograph by Terence Dickinson.

13

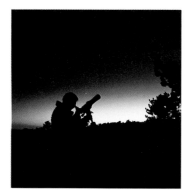

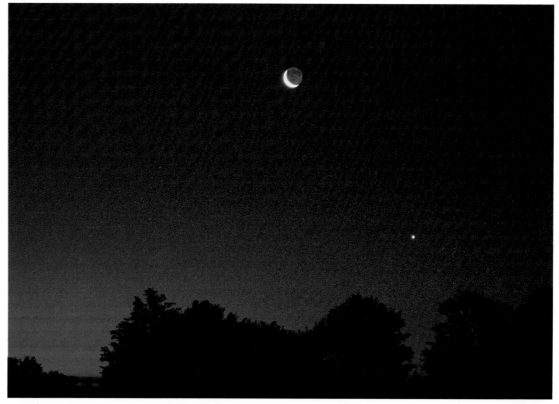

■ *Above: Awaiting the onset of darkness, a solitary amateur astronomer readies his equipment for a night of celestial exploration. Using a telescope small enough to carry under one arm, he can examine changes in the cloud belts of Jupiter, 45 light-minutes from Earth, or peer across millions of light-years of space to see a galaxy of 100 billion stars. The lure of astronomy as a leisure pursuit is in the satisfaction of personally exploring the cosmos—knowing where to look and how to select and use the proper equipment. Photograph by Terence Dickinson.*

■ *Top right: An early-morning twilight scene decorated by the crescent moon and Venus, the two brightest objects in the night sky. Photograph by Garry Woodcock.*

■ *Right: The Earth's rotation twirls the stars along concentric trails in this five-hour time exposure. Polaris, the North Star, is the stubby trail at centre. During the exposure, a bright meteor left its signature on the sky just left of Polaris. Photograph by Jerry Lodriguss.*

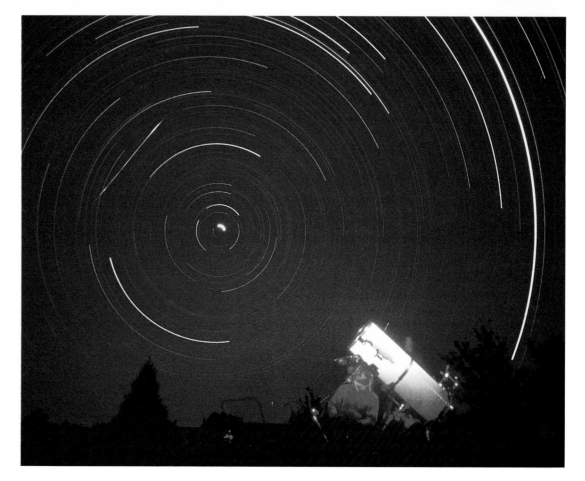

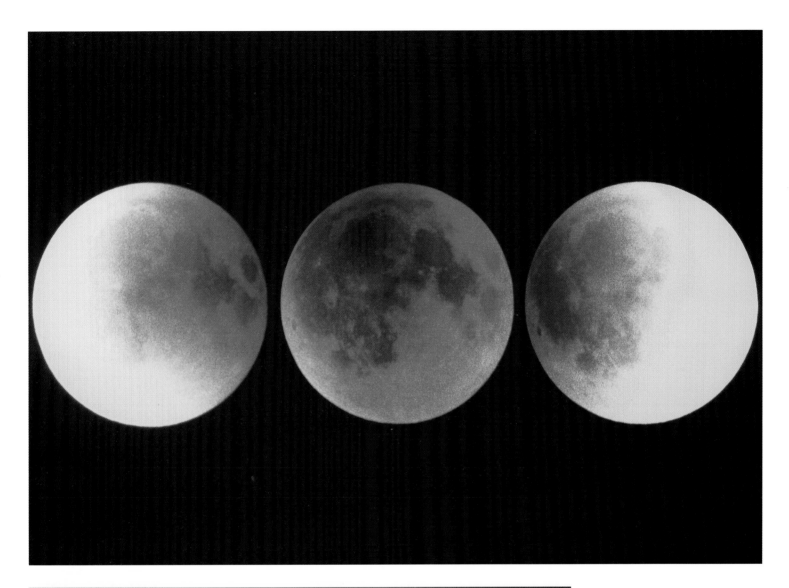

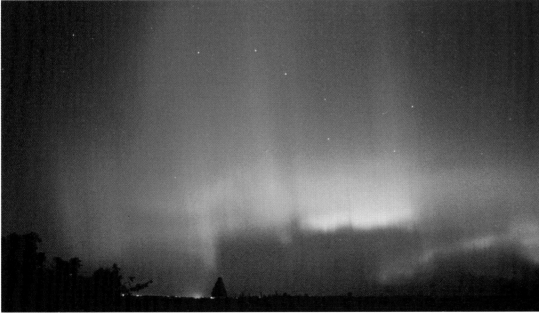

■ Above: One of the best lunar eclipses of the 20th century for North American observers occurred the night of August 16, 1989. The dimensions of the Earth's shadow, almost three times the size of the moon, are apparent in this composite of three photographs taken over a period of 2½ hours by James Rouse.
■ Left: This dazzling red auroral display lit up the sky over Canada and the northern United States on the night of September 3, 1989. Photograph by Rolf Meier.

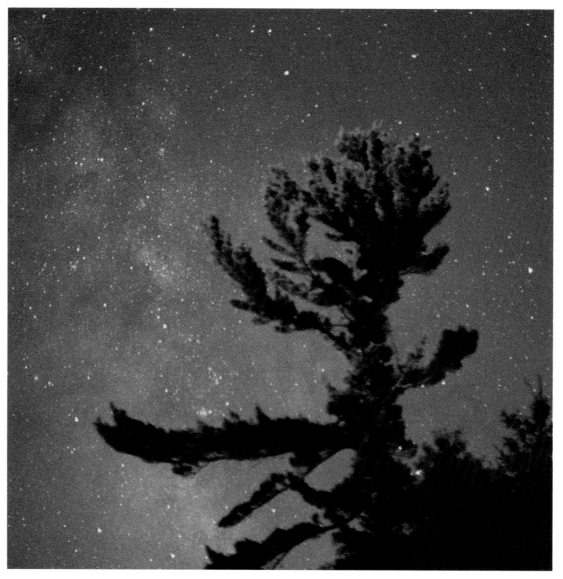

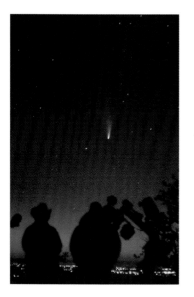

Above: If you are lucky, like the observers pictured here, you may have an opportunity to see a brilliant comet. From March 7 to 12, 1976, Comet West was at its best, adorning the eastern morning sky like a giant ghostly feather. Many backyard astronomers missed Comet West at its best because of cloudy weather over much of North America. Photograph by Richard Keen.

Right: Stargazing is an appreciation of nature on the grandest scale. From our observing platform here on Earth, we receive starlight from the Milky Way that began its journey when glaciers still covered the ground that now supports a century-old pine. Backyard astronomers soar through galactic corridors with eye and mind in the silence of the night. Photograph by Terence Dickinson.

sight to be used only under cover of darkness to avoid derisive commentary from neighbours.

Practical reference material was almost nonexistent during the 1950s. Most of what there was came from England, and virtually all of that was written by one man, Patrick Moore. Amateur astronomy was like a secret religion—so secret that it was almost unknown.

Thankfully, that is all history. Current astronomy hobbyists represent a complete cross section of society, encompassing men and women of all ages, occupations and levels of education. Amateur astronomy has finally come into its own as a legitimate mainstream recreational activity, not the pastime of perceived misfits and oddballs. But more than that, it has recently emerged as a leisure activity with a certain prestige, because, unlike some other hobbies, it is not possible to buy your way into astronomy. The only road to success as an amateur as-

tronomer is through knowledge and experience. But be forewarned: once you gain that knowledge and experience, astronomy can be addictive.

■ AMATEUR ASTRONOMY TODAY

Amateur astronomy has become incredibly diversified—no individual can master the field entirely. It is simply too large; it has too many activities and too many specialties, and there are too many types of instrumentation available. In general, though, amateur astronomers divide fairly easily into three groups: the observers, the telescope makers and the armchair astronomers. The last category refers to people who pursue the hobby mainly vicariously —through books, through lectures or computer networks or through discussions with other aficionados. Armchair astronomers can be experts on nonobservational aspects of the subject, such as cosmology or astronomical history.

The telescope makers' category includes all do-it-yourself activities and technological innovations related to amateur equipment. It involves crafting optics and telescope components and adapting electronics and computers to astronomy and is an important sector of amateur activity. With the vast array of commercial equipment available today, however, it is smaller than it once was.

With these loose definitions out of the way, we can say that this book is written primarily for the observer—one whose dominant interest in astronomy is to explore the visible universe with eye and telescope. We are not in any way apologetic about this. Observing, we believe, is what it is all about. The exhilaration of exploring the sky, of seeing for yourself the remote stars, planets, galaxies, clusters and nebulas—real objects of enormous dimensions at immense distances—is the essence of backyard astronomy.

■ GETTING IN DEEPER

Amateur astronomy can range from an occasional pleasant diversion to a full-time obsession. Some amateur astronomers spend more time and intensity on the hobby than do all but the most dedicated research astronomers at mountaintop observatories. Such "professional amateurs" are the rare exception, but they are indeed the true amateur astronomers—that is, they have selected an area which professional astronomers, either by choice or through lack of human resources, have neglected. They are, in the purest sense, amateurs: unpaid astronomers.

In the past, such dedicated individuals were often independently wealthy and able to devote much time and effort to a single-minded pursuit. This is almost never the case anymore. For instance, Australian Robert Evans is a pastor of three churches, has a family with four daughters and is by no means a man of wealth or leisure. Yet he has spent almost every clear night since 1980 searching for supernovas in galaxies up to 100 million light-years away. He discovered 18 within a decade—more than were found during the same period by a team of university researchers using equipment designed exclusively for that purpose.

Similarly, most bright comets are found by committed amateur astronomers. The world leader in *visual* discoveries is William Bradfield, another Australian, who was an aerospace engineer by day until his retirement in 1987. But by night, two decades of tireless searching with a 6-inch refractor telescope he constructed from an old large-format portrait-camera lens resulted in the discovery of 14 comets. Bradfield made one exceptional find on the morning of December 17, 1980. With dawn approaching, he had already packed up his telescope but decided to take one last look at the sky with his

7 x 35 binoculars. "There it was," he recalls, "with a nice tail, just waiting for me."

In North America, where the competition from amateur and professional astronomers is much stiffer, David Levy of Tucson, Arizona, has seven visual discoveries (as of mid-1991) and is the continent's comet champion among active visual searchers. Levy uses 8- and 16-inch reflector telescopes and observes from his backyard. His prowess at the eyepiece resulted in a part-time assignment to assist in asteroid and comet searches at Palomar Observatory, a rare instance of an amateur engaging in both amateur and professional astronomy.

Dedicated individuals such as Levy, Bradfield and Evans represent a tiny fraction of those who call themselves amateur astronomers. The rest are more accurately described as recreational or backyard astronomers. Although neither term has gained wide usage, both more precisely describe what most amateur astronomers do. They are out there enjoying themselves under the stars, engaging in personal exploration that, 99.9 percent of the time, has no scientific benefit. But so what? It is challenging and fun. Backyard astronomy was summed up neatly a few years ago in *Astro Notes*, the newsletter of the Ottawa Centre of the Royal Astronomical Society of Canada: "The objective is to explore strange new phenomena, to seek out new celestial objects and new nebulosities, to boldly look where no human has looked before . . . and mainly to have fun."

■ IT'S ONLY A HOBBY

Tom Williams, a chemist and astronomy hobbyist from Houston, Texas, has been researching the his-

■ *Only a true naturalist of the night knows the special feeling of anticipation that builds as dusk ushers in the pristine darkness. Then, under starry black-velvet skies, the exploration begins. Photograph by Alan Dyer.*

The distinction between amateur astronomers and people who say they are "just interested in astronomy" is somewhat fuzzy, but it seems to be directly related to their ability to identify celestial objects. Enthusiasts who can locate the Andromeda Galaxy and who know that the Pleiades star cluster is not the Little Dipper would likely regard themselves as amateur astronomers. Perhaps naturalists of the night is the most appropriate of all the terms used to describe those who savour the splendours of the night sky. Photograph by Terence Dickinson.

tory of amateur astronomy. He has taken an interest in the distinction between the vast majority of casual stargazers and the handful of scientific amateurs. Williams points out some parallels with ornithology:

"There are 11 million bird watchers in North America, but they call themselves birders, not amateur ornithologists. The real amateur ornithologists are the few thousand people involved in nesting studies, migration analyses, and so on." Similarly, notes Williams, "of the 500,000 astronomy hobbyists, the same small percentage are real amateur astronomers who contribute to science. The rest are recreational astronomers. The majority are in these activities for pure enjoyment, nothing more."

Somewhere in the history of amateur astronomy, there emerged an unwritten understanding that enthusiasts who do not spend their nights engaged in such active scientific pursuits as estimating the brightness of variable stars or doing central meridian timings of markings in Jupiter's atmosphere are

wasting their time. This notion, which is pure rubbish, is fortunately on the wane. Backyard astronomy is a pastime, a *recreational* activity. Its usefulness is measured by the enjoyment and inspiration it brings to its devotees.

That is not to say there is no place for systematic and potentially scientifically valuable observing, but it is not every backyard astronomer's duty. Some choose to take a more rigorous approach to the hobby; most do not. Our book is dedicated to the latter group.

REACHING FOR THE STARS

Some of the activities of astronomy buffs totally baffle those not afflicted with the bug. Take the arrival of Comet West, for instance, the brightest comet visible from midnorthern latitudes in the past 30 years. Comet West was at its best in early March 1976, but the weather over much of North America was terrible. Astronomy addicts were having severe withdrawal symptoms as they stared at the

clouds each night, knowing that the comet was out there, beyond reach. In Vancouver, a group of young enthusiasts decided that they had had enough. "The comet was peaking in brightness. We had to do something," recalls Ken Hewitt-White, now programme director of Vancouver's MacMillan Planetarium and the mastermind of the Great Comet Chase.

They rented a van and began driving inland over the mountains, which the forecast predicted would be clear of cloud cover by 4:30 a.m., the time when the comet was to be in view. The outlook for Vancouver was continued rain. "There were five of us with our telescopes, cameras and binoculars all packed in the van," says Hewitt-White. "A sixth member of our group had to get up early for work and reluctantly stayed behind.

"It was a nightmare from the start—a blinding snowstorm. 'It's *got* to clear up,' we told each other. We drove 200 miles, and it was still snowing. After a few close calls on the treacherous road, we finally turned back. Then, as we crossed the high point in the Coast Mountains, the sky miraculously began to clear. It was exactly 4:30. We pulled over and immediately got stuck. But we had not gone far enough: a mountain peak blocked the view.

"Five comet-crazed guys in running shoes started scrambling up the snowdrifts on the nearest cliff to gain altitude. By the time we reached a point where the comet should have been in view, twilight was too bright for us to see it. Half frozen and dripping wet with snow, we pushed the van out and headed back to Vancouver. Within minutes, we drove out of the storm area and saw cloudless blue sky over the city. When we got home, we heard the worst: the guy who stayed behind had seen the comet from a park bench one block from his home."

The eclipse chasers, another subgroup of amateur astronomers, spend countless evenings planning every detail of an eclipse expedition—a trip, sometimes to remote sectors of the globe, for the express purpose of standing in the moon's shadow to watch a total eclipse of the sun. Given the vagaries of the weather and the inevitable glitches in foreign countries, probably half of these pilgrimages are partial or complete failures. Ventures have been foiled by dust storms, lost luggage, broken-down rental cars and balky camera equipment.

Regardless of the outcome, as soon as they get home, the eclipse stalkers whip out maps and start planning next year's expedition. For anyone who has not seen a total solar eclipse, the behaviour may seem somewhat inexplicable. But for veteran eclipse hunter Robert May of Scarborough, Ontario, it is "the greatest of all natural spectacles, a truly awesome phenomenon. I want to see every one I can while I am still physically able to do so." May says

that for him, eclipse chasing has added a new dimension and a real purpose to foreign travel.

Some astronomy enthusiasts never feel the need for a varied observing programme or a large telescope and are satisfied to remain casual skywatchers for decades. Alex Saunders, who lives in a suburb of Toronto, has used the same 60mm refractor for more than 40 years. "I bought it secondhand for $25 in 1950," he says proudly. He vividly recalls his first views with the small telescope: "Never will I forget my first look at the moon and how amazed I was at the sharpness and clarity of the craters and mountain ranges. Saturn was magnificent, truly breathtaking, its golden rings starkly visible. I watched it for most of the evening, almost hypnotized."

Saunders, now in his seventies, has used that little telescope summer and winter for decades. Countless times, he says, he has stood entranced at the eyepiece and on each occasion has enjoyed a renewed experience with the moon, Saturn or some other celestial sight. For him, astronomy has been

■ *What is unusual in this scene? Only a backyard astronomer would know that the pale smudge near top centre does not belong. In May 1983, Comet IRAS-Iraki-Alcock swept through the Earth's vicinity. At 17 times the distance to the moon, this comet came closer to Earth than any comet since 1770. Typically, a naked-eye comet is 5 to 50 times more remote. Comets are named for their discoverers—in this case, a scientific satellite and two amateur astronomers. Photograph by Terence Dickinson.*

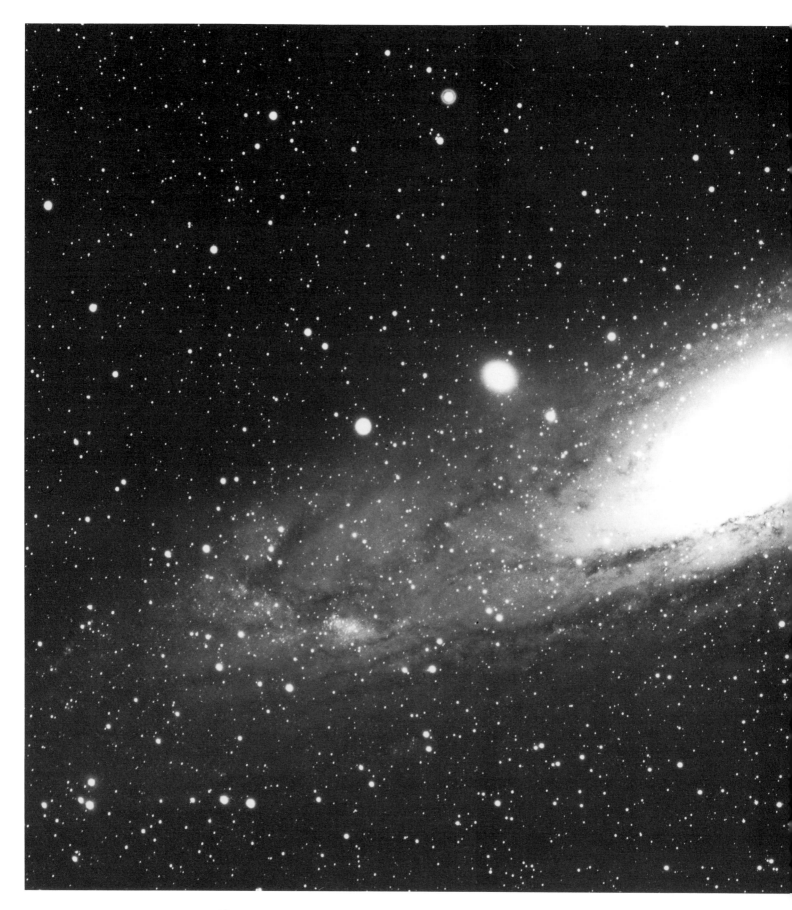

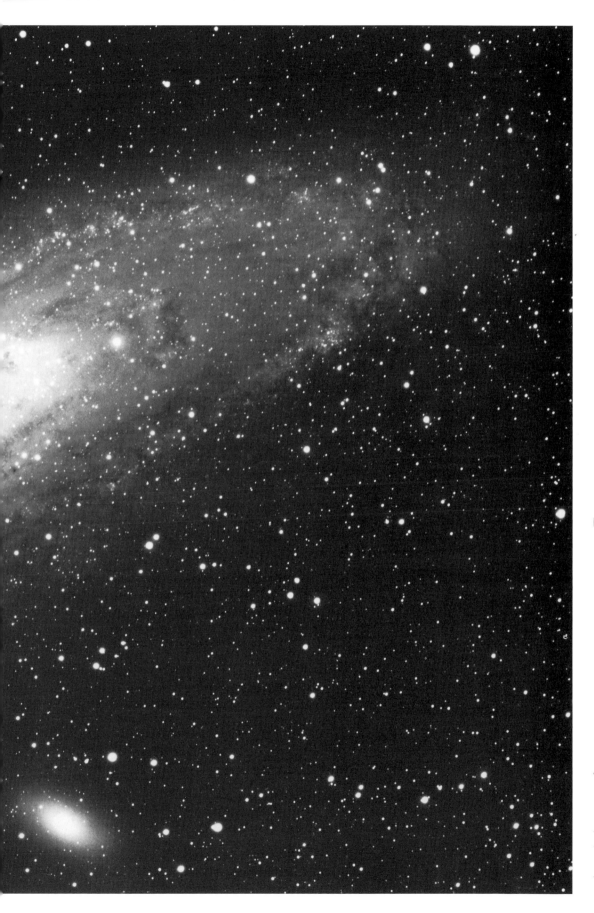

The Andromeda Galaxy, 2.3 million light-years away, is the remotest object visible to the unaided eye. On dark autumn nights, it appears as a dim oval smudge near overhead for northern-hemisphere observers. Yet that smudge is the combined light of 500 billion stars held together by their mutual gravity in a colossal wheel-shaped star city similar to our own Milky Way. Some of the brightest stars of the Andromeda Galaxy are resolved in this remarkable photograph—one of the finest ever taken by amateur astronomers. Foreground stars in our own galaxy (most less than 3,000 light-years away) are also scattered across the scene. Photograph by Tony Hallas and Daphne Mount, using a 5-inch f/8 Astro-Physics refractor.

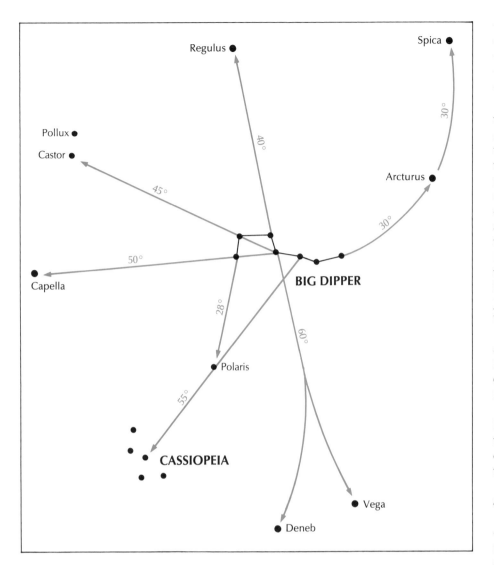

Regulus ●

Spica ●

Pollux ●

Castor ●

Arcturus ●

40°

45°

30°

50°

30°

BIG DIPPER

Capella ●

28°

Polaris ●

60°

55°

CASSIOPEIA

Vega ●

Deneb ●

■ *The Big Dipper is the night sky's premier guidepost. Visible throughout the year from midnorthern latitudes, it points the way to key stars and constellations. To gauge the distances indicated in degrees, keep in mind that the Big Dipper is 25 degrees long— about the distance from the tip of the thumb to the end of the little finger of an outstretched hand at arm's length. Of all the diagrams available to backyard astronomers, none is more useful to memorize than this.*

that could be seen through the city glow, heads would swing in synchrony, everyone listening intently. Those nights were impromptu stargazing parties that Kemp enjoyed as much as did the guests who never knew his name.

Among the many backyard astronomers willing to share their infatuation with the cosmos, Martyn McConnell and a few fellow enthusiasts set up their telescopes each summer in a provincial park near the Thousand Islands in Ontario. "As many as 500 people have lined up to look through the telescopes," he reports. "We show them Saturn, the Hercules cluster, the Ring Nebula. The sky conditions are excellent. Some people stay until midnight, after the lines are gone, waiting to see whether we will look at something else. One person drove 150 miles to camp in the park just because he knew we would be there." McConnell says that he gets as much enjoyment displaying the cosmos and talking about the hobby as he does observing on his own.

Similar telescope-viewing opportunities are available across North America, many of them coordinated with International Astronomy Day, the Saturday in April nearest the first quarter moon. When Halley's Comet was visible during the winter of 1985-86, thousands of people turned out for publicly announced viewing sessions. In several cities, the police had to untangle traffic jams created by cars converging on parks and schoolyards where telescopes were set up. In Toronto, more than 10,000 residents braved the bitter January cold for a telescopic peek at the famous celestial visitor.

As anyone who saw Halley's Comet knows, much of the attention was media-generated. The comet itself was interesting, but visually, it was only moderately impressive. It was the familiar name that drew the crowds, all of whom wanted to see a renowned comet. The Halley affair, more than anything else, vividly demonstrated the crucial psychological aspect of a first look through a telescope: the view means little if the person at the eyepiece knows nothing about the object under observation. Getting a peek at Halley's Comet was, for many people, like seeing a famous movie star. This was true for astronomy buffs as well. The pervasive difference— and it is an important one—is that through continued observation of the night sky, backyard astronomers become familiar with hundreds of other objects, many of which reach at least the status of Halley's Comet as fascinating subjects of scrutiny.

a lifelong interest sustained by the little telescope and by the avid reading of astronomy books and magazines. He has never joined a club and seldom attends lectures or planetarium shows, but he quite rightly regards himself as an amateur astronomer. And so he is.

■ SHARING THE UNIVERSE

A telescope always draws a crowd. The late James Kemp, an astronomy enthusiast, spent mild summer evenings with his Questar telescope in a city park near his apartment in downtown Toronto. We often wondered whether some night he would emerge from the park without his telescope, its having been scooped up by someone nasty. It never happened. Instead, a small crowd inevitably joined him, each person waiting patiently for a look.

An articulate man with a gift for exposition, Kemp would entrance the crowd with constellation mythology, explanations of black holes and spacecraft-exploration results. As he pointed to the few stars

■ ARE YOU READY?

As we said previously, astronomy is not an instant-gratification hobby. It takes time and effort to become good at it and to realize the rush of satisfaction that comes from discovering for yourself, bit by bit, the wonders of the night sky. Any backyard as-

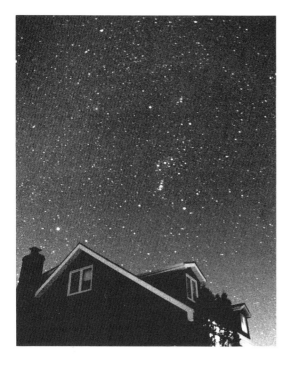

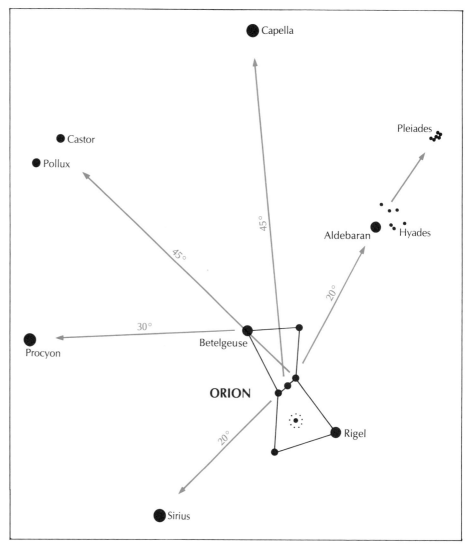

tronomer knows how enjoyable it is to hear the "oohs" and "aahs" from people who are looking through a telescope for the first time. It is even better to be uttering the oohs and aahs yourself. With this in mind, we offer the backyard astronomer's Aah Factor, a one-to-ten scale of celestial exclamation.

Factor one on the scale is a detectable smile, a mild ripple of satisfaction or contentment. Factor ten is speechless rapture, an overwhelming rush of awe and astonishment. Here are a few examples to aid in developing your own list.

☐ One: Any routine celestial view through binoculars or a telescope; a faint meteor; a good astronomy book.

☐ Two: Finding the planet Mercury; sunspots; the moon's surface through a telescope; discovering how clear things look through binoculars mounted on a tripod; cloud belts on Jupiter.

☐ Three: Saturn or the Orion Nebula through a telescope, even if you have seen them umpteen times before; the starry dome on a clear, dark night in the country; Jupiter's Red Spot; a coloured double star.

☐ Four: A beautiful sunset or sunrise; seeing a bright Earth satellite for the first time; a partial eclipse of the moon; a close conjunction of two planets or of the moon and Venus; Earthshine in binoculars; finding the Andromeda Galaxy for the first time.

☐ Five: Identifying Jupiter's moons through binoculars for the first time; a moderately bright comet in binoculars; telescopic detail on Mars.

☐ Six: Recognizing your first constellation; a bright meteor; a good telescopic view of a galaxy or a globular cluster; the shadow of one of Jupiter's moons slowly crawling across the planet's face;

your initial look at your first successful astrophoto.

☐ Seven: A first view of the moon through a telescope; a first view of the Milky Way with binoculars; a total eclipse of the moon.

☐ Eight: A rare all-sky multicoloured auroral display; the moment you begin to realize how immense the universe is.

☐ Nine: A bright comet; a first view of Saturn's rings through a telescope; a bolide or a fireball.

☐ Ten: A perfect view of a total eclipse of the sun; discovering a comet or a nova.

It is nice to log a two or a three on the scale each night. Soon, you will be climbing the scale of celestial aahs. It is captivating and addictive. One rabid enthusiast made himself ill while attending a concert with his wife and friends because he had noticed a spectacular aurora brewing when they were parking the car. He felt tortured by not seeing it but did not want to spoil the evening for the others. Such is the power of the night sky. How far you are taken by its spell depends on you.

■ *Orion the hunter, visible throughout the world in the evening sky from late November to early April, is the most easily recognized of all the traditional constellations. It is also the most important guide to the night sky after the Big Dipper. Orion's three-star belt is the constellation's distinctive feature. From top to bottom (Betelgeuse to Rigel), Orion spans almost 20 degrees—twice the width of your fist held at arm's length.*

Binoculars for the Beginner and the Serious Observer

On the evening of April 29, 1986, the 26 members of the evening astronomy class at St. Lawrence College, Kingston, Ontario, set out in a car convoy for a prearranged observing session in the country. This was no ordinary outing. It was the last good chance to view Halley's Comet, and conditions were perfect. The site selected—the instructor's backyard—was in deep twilight when the group arrived.

Soon, darkness enfolded the gathering and revealed the comet as a dim naked-eye smudge near the constellation Corvus. But with binoculars, it was a different story. The famous celestial visitor was a delicate veil of cosmic mist, the tail extending at least five degrees to the left from the oval cometary head. An anonymous gasp of delight drifted through the night air, followed by another and another until the whole group was chattering excitedly.

That night provided the happy troop with an unforgettable experience. The backyard telescopes gave nice views of the comet's head but not of the whole comet at once. Only binoculars could do the job, to the surprise of everyone there.

■ THE BINOCULAR ADVANTAGE

Of all the equipment that an amateur astronomer uses, binoculars are the most versatile and the most essential. Yet the attributes of good binoculars are often underrated by backyard astronomers, especially beginners.

No doubt about it, binoculars are not nearly as ex-

otic as a telescope. Binoculars can be found in almost any home. But many people ignore them when they think of celestial observing. They purchase a telescope without ever turning their binoculars to the night sky, thinking that only a telescope can truly reveal the universe. But veteran backyard astronomers always have binoculars within easy reach. Why? Binoculars are midway between unaided eyes and telescopes in power, field of view and convenience. Consider this list of a few of the celestial objects that binoculars will show:

☐ In a dark, moonless sky, standard 7 x 50 binoculars can pick up more than 150,000 stars, compared with the 3,000 or so visible to the unaided eye. The hazy band of the Milky Way breaks up into countless thousands of stars—one of the great treats in amateur astronomy.

☐ Star colours are more evident with binoculars than without and range from blue to yellow to rusty orange.

☐ Two to four of the large moons of Jupiter can be seen close beside the brilliant planet.

☐ The planets Uranus and Neptune, which are difficult to impossible to see with unaided eyes, are easy targets when you know where to look.

☐ The Andromeda Galaxy, a huge city of stars larger than our entire Milky Way Galaxy, is plainly visible as an oval smudge near overhead in autumn and early winter for northern-hemisphere observers.

☐ Star clusters of exquisite beauty, such as the

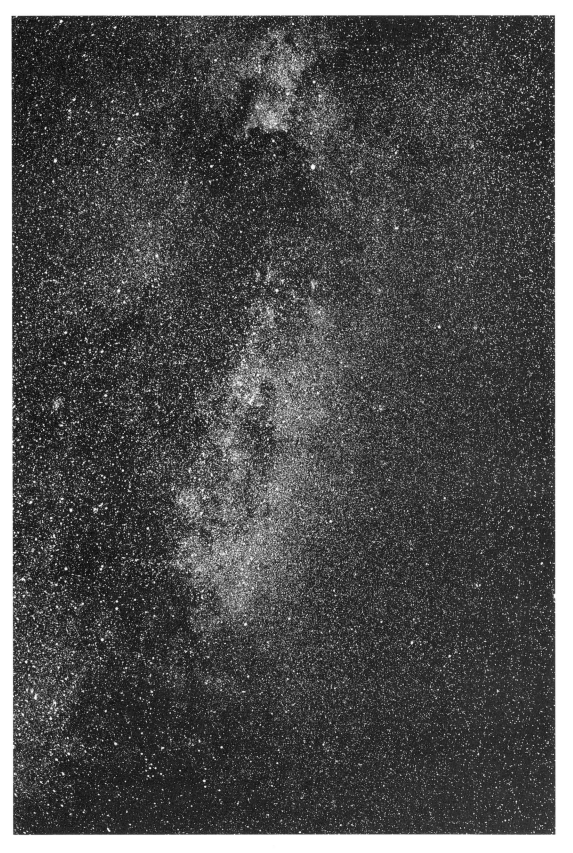

■ Binoculars transform the Milky Way from the misty glow seen by the naked eye into a glittering tapestry of thousands of individual stars. No instrument is better suited to panoramic exploration of our own galaxy than humble binoculars. This view of the constellation Cygnus simulates a binocular view under ideal conditions. The North America Nebula is at top centre near the bright star Deneb; star cluster NGC 6940 is at left centre. Photograph by Alfred Lilge.

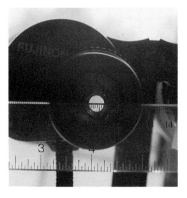

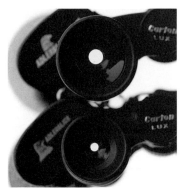

Pleiades and Hyades, are seen in their entirety in binoculars, whereas most telescopes (because of their smaller fields of view) can show only portions of them.

□ On the moon, at least 100 craters and mountain ranges, as well as subtle shadings on the flat plains that 17th-century astronomers thought were seas, are all evident.

The utility of binoculars goes far beyond this list. Planets hidden in twilight glow are often most easily detected by sweeping with binoculars. Earthshine on the moon (the faint illumination of the moon's nightside) is greatly enhanced by binoculars. There is no better instrument for watching a lunar eclipse, for monitoring a planet's motion through a constellation over weeks or months or for observing a bright comet. In short, nearly every celestial object visible to the eyes alone will be improved by binoculars.

Moreover, binoculars can reveal a multitude of objects completely invisible to the naked eye: nebulas (star-forming regions), wispy remnants of ancient supernovas and star clusters ranging from bright stellar splashes to dim patches of starlight. Most challenging are the galaxies, great islands of stars like our Milky Way Galaxy that dot the void of deep space. With practice, you can detect several dozen galaxies up to 30 million light-years from Earth. They are not easy to find, but just seeing them

with humble binoculars is astonishing: for 30 million years, the galaxy's light has been on its way to Earth, ending its journey by entering the eyes of a curious observer. Not bad for binoculars.

Easier quarry for beginners are star clusters in the Milky Way. These range from naked-eye collections of stars like the Pleiades to such glittering jewels as the Double Cluster, in Perseus, or M7, in Scorpius. Hundreds of celestial sights are available to observers with binoculars, enough to keep a backyard astronomer busy for years. Far from being a substitute for a small telescope, binoculars are indispensable partners in the exploration of the universe.

One further advantage: Using two eyes for celestial viewing allows you to see a greater amount. Your body is more comfortable, and the brain is at ease receiving messages from both eyes. If observed with two eyes, objects at the threshold of vision register as real, whereas one-eyed detection produces fleeting and uncertain cerebral messages. How much more can be seen? Most experts estimate 40 percent above single-eye viewing.

■ SELECTING BINOCULARS

Binoculars are, in essence, miniature telescopes —a pair of prismatic spotting scopes reduced in size and linked together for viewing with two eyes. The prism system has a threefold purpose: reducing the length of the optical system by folding the light path;

■ *Top: The exit-pupil diameter is an important characteristic of binoculars. The calculation is simple: divide the aperture in millimetres by the magnification. These 10 x 70 binoculars offer a 7mm exit pupil, which is the maximum size of the eye's pupil. Binoculars that yield exit pupils from 5mm to 7mm are ideal for astronomy because they combine low power, wide field of view and maximum light delivery.*

■ *Above: Comparison of 7 x 50 binoculars (top) yielding a 7mm exit pupil and 10 x 42s with a comparatively small 4mm exit pupil. For daytime viewing, both are effective instruments, but at night, when the eye's pupil dilates to 6mm or 7mm, binoculars should offer a 5mm-to-7mm exit pupil for optimum views of dim celestial objects.*

■ THE CELESTIAL SHOWCASE

Naked Eye	Binoculars	Telescope
constellations*	star clouds of Milky Way*	hundreds of double and multiple stars*
meteors*	planetary motion*	hundreds of variable stars*
auroras*	bright comets*	hundreds of galaxies*
Earth satellites*	lunar eclipses*	hundreds of star clusters*
solar and lunar haloes*	details of constellations*	dozens of nebulas*
a few double stars	moons of Jupiter	planetary detail*
five planets	dozens of lunar craters	planetary satellites*
planetary motion	dozens of variable stars	thousands of lunar features*
bright comets	dozens of double stars	sunspots and solar detail*
a few star clusters	dozens of star clusters	solar eclipses
three galaxies	several galaxies	comets
a few nebulas	several nebulas	lunar eclipses
a few variable stars	seven planets	planetary motion
solar eclipses	solar eclipses	lunar occultations
lunar eclipses	sunspots	asteroids
sunspots	bright asteroids	
Milky Way		

A telescope is not necessary for examining many celestial objects, and sometimes, binoculars or even the unaided eyes can provide a better view. This inventory shows the versatility of humble equipment —or no equipment at all. *Asterisked items in each column indicate the viewing targets most easily seen.

reducing the overall weight; and finally, producing a right-side-up image for convenient terrestrial viewing. Binoculars come in a bewildering array of sizes, magnifications, models and prices. Virtually useless toy binoculars with plastic lenses can be had for a few dollars; at the other end of the scale, the colossal Fujinon 6-inch refractor binoculars (25 x 150) cost as much as a new Honda Civic. In between, there is something for everybody.

The vast majority of quality binoculars are manufactured by a handful of factories in Germany and Japan. These countries have monopolized the binocular market for decades. A small number of binoculars (the very inexpensive and the *very* expensive specialized instruments) are manufactured in other countries.

There is a lot to be considered when selecting binoculars for astronomy. The chief factors are optical quality, weight, price, magnification and objective-lens size. Any size and type of binoculars will get you started, but the precise optics in higher-quality models show faint stars and nebulas better than less expensive models of the same size. There is usually a good reason why one binocular is three times the price of another, even though they look the same on the outside.

Reasonable-quality binoculars can be purchased for about $100. First-class glasses are $300 and up. Price is a major guide in this competitive market. Familiar brand names mean little except at the very high end. We have tested superb binoculars marketed with labels like Adlerblick and Optolyth that we had never heard of before. Also, we found no zoom binoculars of acceptable quality.

Overall weight is important too. Binoculars in the popular 7 x 50 size can range from 1½ to 3 pounds. In astronomy, binoculars are held above horizontal, a more tiring position than horizontal or lower, as in most terrestrial viewing. Every ounce counts; in general, we recommend forgoing ruggedness for light weight.

◼ FOCUS AND FUNCTION

Most binoculars focus with a knob on the central bar of the instrument. Turning the knob focuses both lenses by the same amount. However, each of your eyes has a slightly different focus. To accommodate this, the right eyepiece usually has a separate focusing capability with a scale and a zero point. The zero point is a rough guide to the point of equal focus. So-called perma-focus binoculars are just a gimmick and are especially unsuited to astronomy. You need the precise focus offered by conventional models.

Certain binoculars are better performers on astronomical targets. Binoculars that are ideal for some terrestrial purposes may show flaws when turned to the sky. Since you probably already own at least one

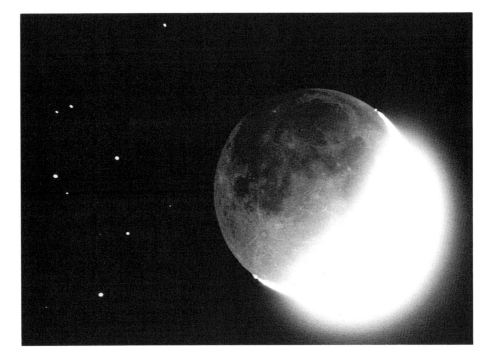

pair of binoculars, you should know how they stack up against what is available as well as where they stand in the spectrum of binocular applications to astronomy. First, some binocular facts.

There are two basic types of prism binoculars: porro prism and roof prism. Roof prism binoculars have straight tubes and are generally smaller and more expensive than porro prism models. They are available with main objectives up to 63mm in diameter, but one of the advantages of the design—compactness—is defeated in sizes above 42mm. Roof prism binoculars have been raised to a high art by the German firms of Zeiss and Leitz. Porro prism binoculars have the familiar humped, N-shaped light-path design and are available in all sizes.

Binoculars have two numbers engraved near the eyepiece end, such as 7 x 50. The first number is the magnification, and the second number is the diameter of the front lenses in millimetres. Thus 7 x 50 means 7 power and 50mm objectives (main lenses). There are dozens of combinations, from 6 x 16 to 25 x 150. There are, of course, advocates of virtually every combination of size and magnification. The optimum magnification for astronomical binoculars is determined by the exit pupil—an important principle that also applies to telescopes.

◼ EXIT PUPIL

For maximum efficiency under typical low-light astronomical conditions, the light cone exiting the binocular (or telescope) eyepiece should be no larger than the dilated pupil of the eye. All the light from the instrument should enter the pupil rather than some light falling uselessly on the surrounding

◼ *Binoculars are the best optical aid to use for celestial objects or phenomena that encompass two to five degrees of the sky. The crescent moon passing over the Pleiades star cluster on April 8, 1989, was just such an event. Both the cluster and Earthshine on the moon were enhanced by binoculars. Photograph by Terence Dickinson.*

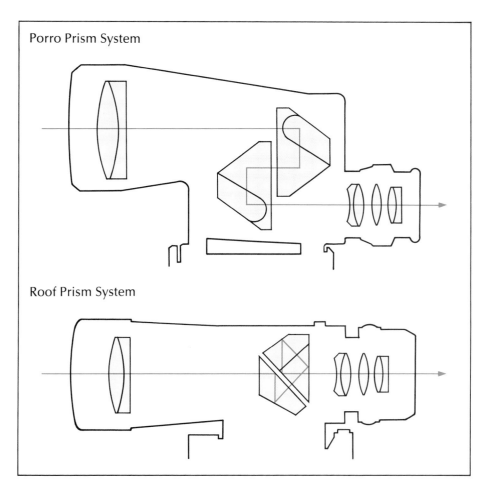

Porro Prism System

Roof Prism System

■ *Binoculars come in two designs based on the arrangement of prisms that fold the light path. Roof prism binoculars are the more compact of the two, but porro prism models generally cost less and offer equivalent performance in the sizes best suited to astronomy.*

iris (the coloured part of the eye). When the eye is fully dark-adapted, the pupil's diameter is five to seven millimetres. Binoculars such as 7 x 42s produce an ideal eyepiece-exiting light cone, or exit pupil, of six millimetres. The exit-pupil calculation is simple: diameter in millimetres divided by magnification. For 7 x 42s, it is $42 \div 7 = 6$.

Most people under the age of 30 have pupil diameters of seven to eight millimetres in dark conditions. After 30, everyone generally loses one millimetre every 10 to 15 years throughout life as the eye muscles become less flexible. In addition, the outer edges of the eye's cornea and lens have some aberrations of their own, so an exit pupil about one millimetre smaller than the eye's entrance pupil is preferred for astronomy.

An exit pupil larger than the eye's pupil means that some of the instrument's light-collecting power is wasted. At night, this should be avoided. You need as much light as you can get. In daytime situations, it is of little concern because there is plenty of light anyway. Moreover, the eye's entrance pupil shrinks to two or three millimetres in daylight. But five to seven millimetres of exit pupil works to advantage in such situations because it is easier to get the eye's pupil inside a larger exit pupil.

In telescopes, exit pupils down to 0.5mm are normal. For example, a 125mm telescope at 175 power (175x) has a 0.7mm exit pupil. Higher magnification means a smaller exit pupil whether we are referring to telescopes or binoculars. Small exit pupils are fine when you are seeking high-resolution detail with an instrument that is large enough to provide the necessary resolving power, like a telescope. But with small fixed-magnification instruments like binoculars, the optimum power for the application must be selected. In any case, the optical quality of the instrument at higher powers must be proportionately better to produce good imagery. For instance, if 10 x 50 binoculars are to provide images as sharp as 7 x 50s, the optical tolerances must be twice as strict. Stated another way, it is easier to make good-quality 7 x 50s than 10 x 50s. But suppose we could get superbly crafted and optically perfect 16 x 50 or 20 x 60 binoculars. Why not go for the power? They are too difficult to hold steady, for one thing, and the field of view in 20 x 60s is restricted.

■ THE IDEAL BINOCULARS FOR ASTRONOMY

At the front end of the binoculars, the objective lenses should be as large as possible for astronomical viewing: collecting the maximum amount of light produces a brighter image. However, there is a practical limit, which is determined by the weight of the instrument. Fifty-millimetre binoculars tend to be the largest size that is convenient to hold for any length of time.

To place what we have discussed so far in concise form, here is a checklist of some of the key factors involved in selecting binoculars.

☐ Larger objective lenses mean brighter images, but a 50mm lens is a practical limit for hand-held binoculars. Go larger only if a tripod will be used regularly.

☐ A 7mm exit pupil provides the maximum input of light that the eye can accept. However, for most people, 5mm is just under the maximum diameter of the dark-adapted eye and provides optimum use of the incoming light. Therefore, binoculars with a magnification one-fifth the objective diameter in millimetres are often preferred.

☐ Higher magnification means better resolution, but it also means more stringent optical-quality standards to produce good images.

☐ Higher magnification results in amplified jiggling during hand-held operation. This factor alone limits binocular magnification to 10x.

When we put all of this together, it is clear that there are certain favoured sizes of binoculars for amateur astronomers, and they are relatively limited. The most popular are 7 x 50 and 10 x 50. Also good are 7 x 42 and 8 x 40 for those who prefer

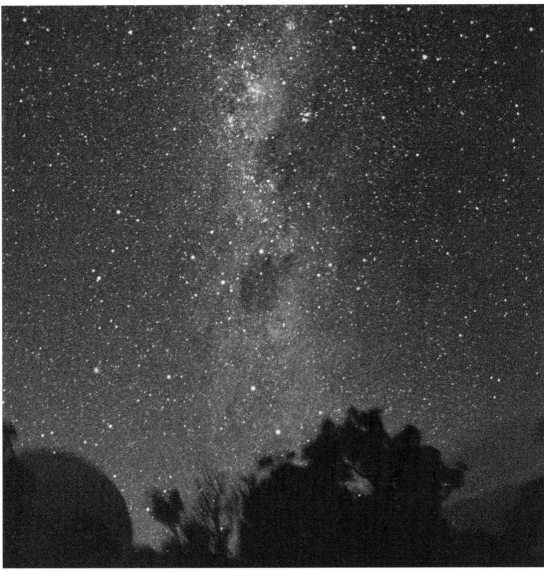

■ *Top left: Star clusters that hover on the threshold of naked-eye visibility are wonderful targets for binocular users. One of the best is the Double Cluster, in Perseus, which resolves into two nests of stellar jewels. For a guide map showing the cluster's location, see the Sky Region Appendix. Photograph by Terence Dickinson.*

■ *Top right: The total eclipse of the moon on the night of August 16, 1989, was almost certainly witnessed by more people in North America than any previous celestial phenomenon. Binoculars provided exquisite views as the full moon plunged into the Earth's deep rusty-hued shadow and dropped to 1/100,000 of its normal brightness. Photograph by Terence Dickinson.*

■ *Left: The southern sector of the Milky Way Galaxy rides high in the sky over Australia and other southern latitudes but is never well seen from the northern hemisphere. Yet here lie some of the night sky's finest binocular treasures. The dark blob at centre is the Coal Sack, the most obvious of many dark nebulas along the Milky Way. Immediately to the Coal Sack's upper left is the Southern Cross. Below it, above the trees, are Alpha and Beta Centauri. The spectacular Eta Carinae Nebula, flanked by three clusters, is at top. Photograph by Terence Dickinson.*

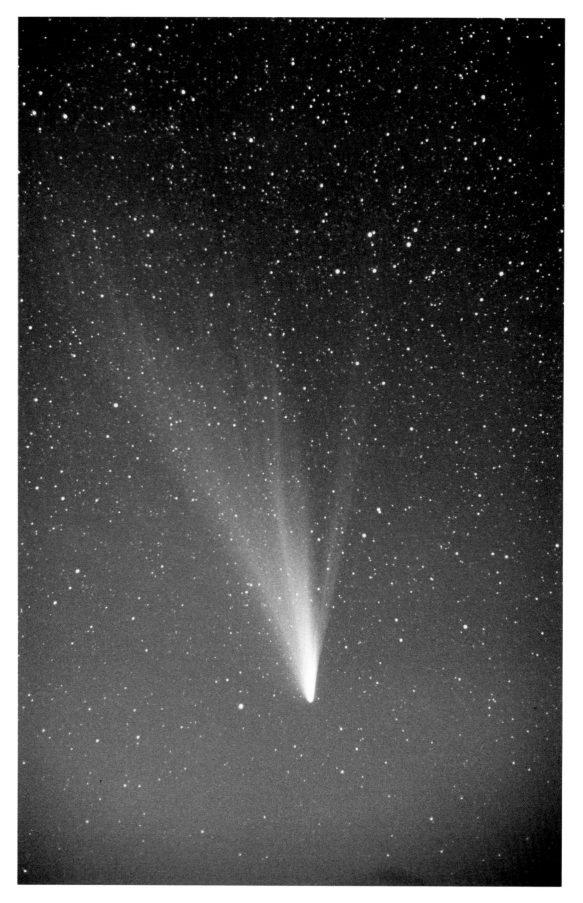

■ *Comet West, one of the great comets of the 20th century, decorated the early-morning sky in March 1976. Binocular observers had the best view of the comet's sweeping 10-degree-long dust tail and pale blue gas tail. The combination of low power and wide field makes binoculars the instrument of choice for examining the delicate structure of brighter comets. Photograph by Dennis di Cicco.*

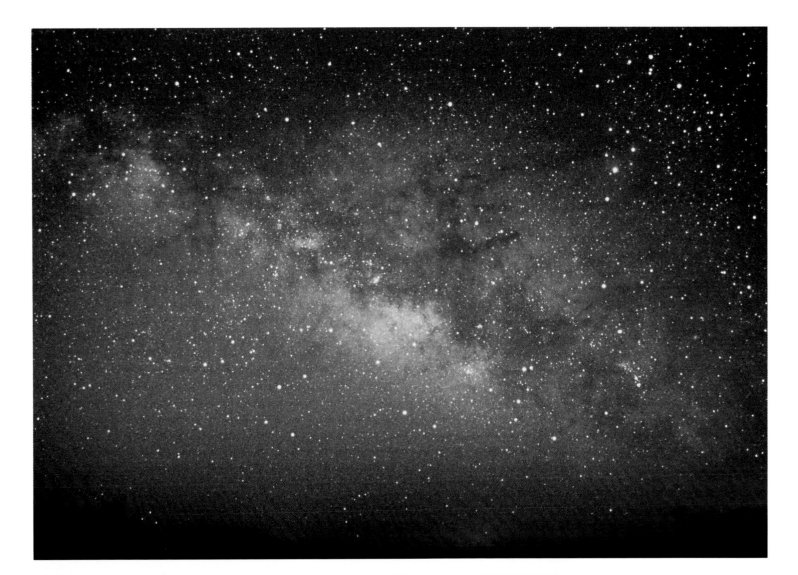

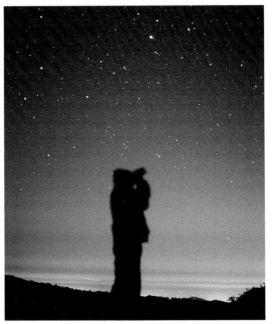

■ Above: The sector of the Milky Way running through Sagittarius and Scorpius is the night sky's richest hunting ground for a backyard astronomer armed with binoculars or a telescope.

■ Far left: Silhouetted against the dome of light over San Diego, 65 kilometres away, a sky observer turns binoculars to the darkness overhead.

■ Left: Sirius, the brightest star in the night sky, provides an unmistakable guiding light to M41, a pretty star cluster visible in binoculars. All photographs on this page by Terence Dickinson.

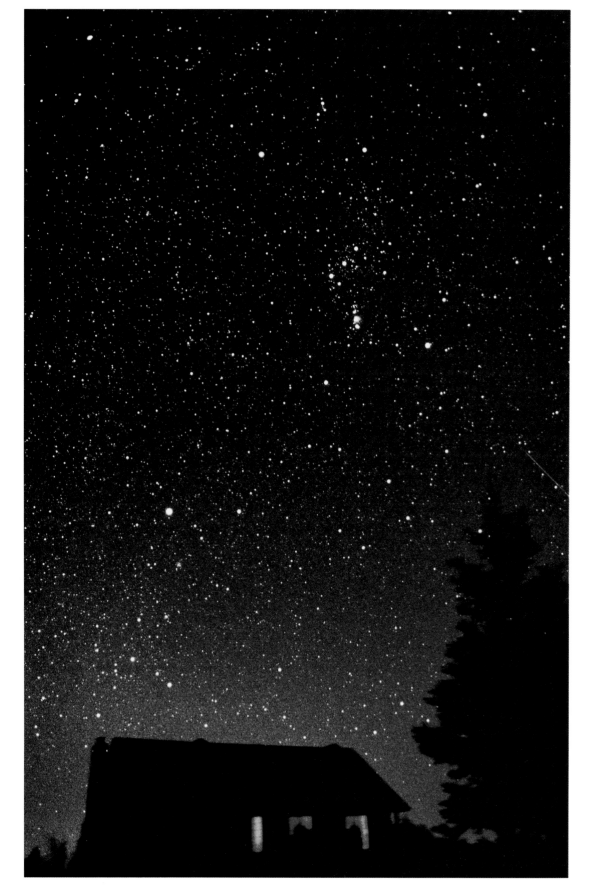

■ *Scenes like this are becoming rare as light pollution creeps ever farther over the countryside. Dark night skies may not be essential for backyard astronomy, but they offer conditions that make veteran observers smile. The constellation Orion rides high above the house, and Sirius, the brightest star, is unmistakable. Just below Sirius is M41, pictured on the previous page. Photograph by Terence Dickinson.*

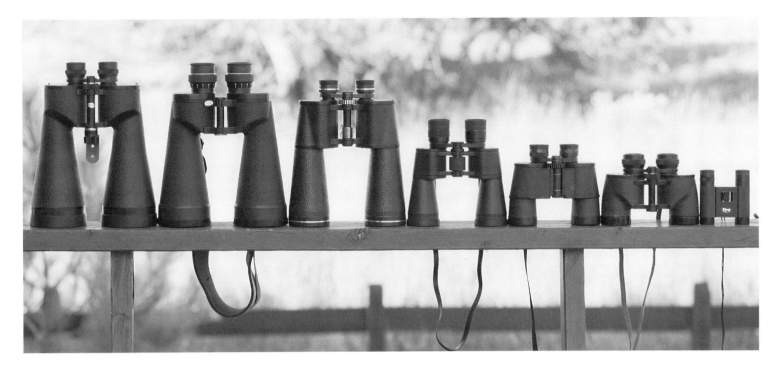

somewhat smaller and lighter glasses. We recommend either 7 x 50 or 10 x 50, although there is a significant difference between the two. Typically, 7 x 50s have a seven- or eight-degree field of view, one to two degrees wider than 10 x 50s. This is good. But bright star and planet images often look spiked or flared in 7 x 50s, even at the centre of the field, because of aberrations in the outer edge of the eye. This is a disadvantage, although only a minor one. The chief difference is that a top-quality 10 x 50 glass will yield more stars and more resolution than 7 x 50s. More detail makes sense because of the higher power, but why are there more stars apparent if the aperture is the same 50mm? The reason is that the smaller exit pupil partly avoids the edge-of-eye aberrations (producing sharper stars) and the higher magnification makes the sky background darker. This occurs because in 10 x 50s, there is less sky per unit area viewed. With the sky background more spread out, contrast is enhanced and fainter objects are visible.

Compare 7 x 50 and 10 x 50 binoculars of similar quality. The difference should be obvious on any night, regardless of the sky conditions. A lot comes down to personal preference. Given equivalent quality, higher magnification reveals greater detail on the moon, makes Jupiter's moons easier to spot, shows individual stars in clusters more readily and resolves closer double stars. There is less obvious difference in faint, extended objects such as nebulas and in larger galaxies like M31 and M33, where the objective is to see the extent of the target rather than detail in the object.

In extensive tests with dozens of binoculars, we have found 7 x 50s give the best results on Milky Way fields, the Andromeda Galaxy, the North America Nebula and a few other extended objects. For all other targets, 10 x 50s have the edge. Overall, we feel that 10 x 50s are the binoculars of choice. However, if you already own 7 x 50s, the difference is not significant enough to replace them (unless the 7 x 50s are of poor quality).

Nowhere in our discussion have we referred to Twilight Factor, Relative Brightness Index or some of the other specifications often included in the manufacturers' binocular brochures. These factors are all derived from magnification, exit pupil and aperture, and for astronomy, they provide no additional information about performance beyond what we have outlined.

■ FIELD OF VIEW

The diameter of the circle that can be seen through binoculars is called the field of view. This is often expressed in the number of feet that span the field when viewed from a distance of 1,000 yards (or metres at 1,000 metres), although many binoculars now use the more convenient angular diameter in degrees. One degree is equivalent to 51 feet at 1,000 yards or 17 metres at 1,000 metres. Most 7 x 50 binoculars have 7- or 8-degree fields; 10 x 50s show 5 to 6½ degrees. Some models offer a wider field of view, which is nice, but it often comes at the expense of optical quality. Binoculars that are designated wide-angle or ultrawide-angle can have 8-to-12-degree fields of view. Invariably, though, these models have severe optical distortions around the edge of the field. While not objection-

■ *Binoculars on parade. Except for the smallest model, all are porro prism. From right to left: 8 x 20 roof prism, 7 x 35, 8 x 40, 7 x 50 (Carton Adlerblick), 20 x 60, 10 x 70, 11 x 80 (with tripod adapter). Note the substantial leap in bulk from 50mm to 60mm and larger binoculars. That is why 50mm binoculars offer the optimum size-weight-performance compromise.*

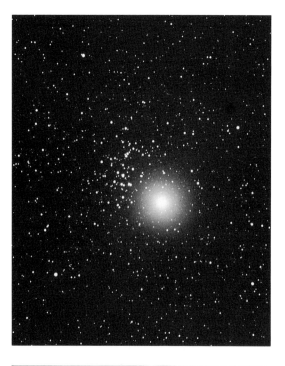

oversize rubber eyecups that, when folded down, provide the extra distance for eyeglass users. When up, they act as a guide for placing the eyes in correct position when the user is not wearing glasses. Achieving the high eyepoint requires sophisticated eyepieces with more glass in them, so these binoculars are usually expensive, although we have seen acceptable 10 x 50s for slightly more than $100.

■ BINOCULAR TESTS

As a quick check for both viewing comfort and optical quality, follow points one through six outlined below. Point seven is a more rigorous test.

□ 1. Weight: How heavy are the binoculars? Eliminate all glasses built to withstand jungle warfare. You should not need Arnold Schwarzenegger arms and shoulders to hold them up for a reasonable length of time. For hand-held glasses, light weight—less than 32 ounces (907 grams)—is essential.

□ 2. Prisms: In full daylight or indoors, hold the binoculars a few inches in front of your eyes, and look in the eyepieces. Aim the glasses at the sky or a window to provide bright illumination. The optical path should be completely round and evenly illuminated. Most inexpensive binoculars, and sometimes more expensive but poorly designed glasses, will have a squarish rather than a circular appearance inside at the prisms. This is because of improperly positioned prisms or, more likely, inexpensive, undersize prisms that impinge on the light path. BAK-4 prisms are regarded as the best quality, but it is often impossible to determine what type of prism is in a specific binocular.

□ 3. Craftsmanship: Check all the moving parts. Moderate but even pressure should be required to adjust focus and interpupillary distance. There should be no evidence of grease or lubricants seeping out at any point. Look for smudges on the optics. No respectable firm will allow blemished optics to leave the factory.

□ 4. Optics Check: Examine the in-focus image of the binoculars very carefully, both in daylight and at night. The central area of the field of view should be pin-sharp with no evidence of fuzziness, false colour or double imaging. This test can be conducted in a store if you can look at something that provides a high level of light-to-dark contrast and fine detail. Many glasses with perfectly acceptable image sharpness in the central region of the field quickly lose their definition toward the edge. We generally rate binoculars unacceptable if the image grows fuzzy less than 50 percent of the way from the centre to the edge. This capability can be tested during the daytime by looking at sharp detail, such as the leaves or branches of a distant tree or the distinct features of a building against the bright sky. Such testing will also reveal other potential problems. In

able in everyday terrestrial use, in astronomy, when all the stars in the outer field resemble comets or sea gulls, there is no advantage.

■ EYEGLASSES AND BINOCULARS

Binocular users who must wear glasses for correction of astigmatism or who prefer to keep their glasses on while observing will benefit from so-called high-eyepoint binoculars, designed to push the exit pupil 20mm to 28mm from the surface of the eyepiece lens, compared with 10mm to 15mm for normal binoculars. This allows room for the lens of the glasses to fit between the exit-pupil point and the eyepiece.

High-eyepoint binoculars usually come with

high-contrast situations, a blue or green colour fringe—called a chromatic aberration—may appear around the edge of objects, which is a sign of poor-quality optics. One problem you do not have to worry about is distortion, the bending of straight lines as they are moved through the field. In astronomical viewing, distortion is hardly noticeable.

□ 5. Coatings Check: Light transmission is increased and flare and ghosting from internal reflections are reduced by coatings. The best binoculars are multicoated on all optical surfaces, including the prisms. It may be printed on the binoculars themselves or in the literature provided with them that the glasses are coated or multicoated. Multicoated lenses usually give off a deep green or purple sheen when held under bright light. Coated lenses (meaning single-layer coatings) are generally pale blue. Coating increases light transmission at each optical surface to about 97 percent, compared with 93 percent for no coating. Multicoating lets about 99 percent of the light through. The problem is determining whether *all* of the optical surfaces are coated—often, they are not. To find out, shine a bright light into the binoculars from the objective (large lens) end. Looking down into the glasses, tilt them slowly back and forth, and watch for the multiple reflections from the coated-lens surfaces. All should be subdued blue, green or purple, depending on the coatings used. Noticeably brighter white reflections are a sign of uncoated elements.

□ 6. Collimation: If, after using the binoculars for a few minutes, you feel eye strain and for some reason have to "force" the images to merge, the binoculars are probably out of collimation, which means that the two optical systems are not precisely parallel. This is the main item to watch for in the purchase of used binoculars. All it takes is one accidental dropping of the binoculars from about eye height to the ground, and collimation can be knocked out. It requires professional attention to repair.

□ 7. Astronomical Testing: Optical perfection is a never-ending quest among amateur astronomers, and all but the very finest binoculars will usually yield evidence of some optical imperfections when used to observe the stars. Viewing brilliant point sources on a black background is the most rigorous test of optics. In the centre of the field, a bright star should show near-pointlike imagery with small, irregular spikes emerging from the bright central point. The fewer spikes seen the better, but the important thing is that they must be symmetrically arrayed around the point with no obvious flaring in any direction. If you find there is flaring and you normally wear glasses, put them on and see whether the asymmetry disappears. If it is still there, the binoculars are likely at fault and should be rejected. Move the bright star toward the edge of the field. It

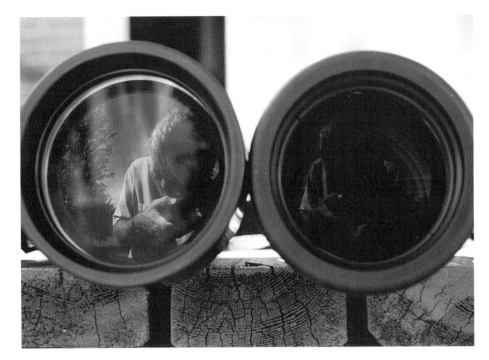

will begin to grow wings, usually parallel to the edge of the field. This indicates astigmatism in the eyepieces, which is nearly always present to some degree because it is a very difficult defect to eliminate in short-focal-length systems such as those of binoculars. Compare carefully, because there are great differences among binoculars in the amount of astigmatism present.

■ WHICH IS BEST?

We have tested dozens of binoculars from several manufacturers. Some models are superb performers but cost as much as a telescope. Most backyard astronomers will not spend more than $400 for 50mm or smaller binoculars. We have examined many nice glasses in the $200 to $400 range. We particularly like both the 7 x 50 and 10 x 50 Adlerblick binoculars from Carton Optics of Japan. They are extremely lightweight, well-made glasses of excellent optical quality. The 10 x 50s weigh only 1½ pounds; the 7 x 50s are just three ounces heavier and are high-eyepoint models. The Celestron Ultima binoculars are similar in design and also provide very good performance.

Several models of the Celestron Pro series and Swift Instruments' Dolphin line in the $100 to $200 price range are good values. Other recommendations in this price range are the Bausch & Lomb Legacy, Orion Explorer and Minolta Standard, all 7 x 50s. We found that many models of the best-known brand names were not as impressive as similarly priced models by less familiar manufacturers. For this reason, we urge anyone in the market for new binoculars to compare as many brands and

■ Top: Binocular lens-coating comparison shows how magnesium-fluoride coating on the left lens reduces reflections, while multicoating on the right lens comes close to eliminating them completely. By reducing the reflection of light, more light passes through the lens. Binoculars with multicoatings on all air-to-glass surfaces have 97 percent throughput; magnesium fluoride on all surfaces, 85 percent; no coatings, 55 percent.
■ Above: Well-made binoculars have prisms that do not reduce the system's light path.

■ Scenes which show star-crowded sectors of the Milky Way create the impression that the stars are almost on top of one another—a feeling you will get with binocular views as well. This illusion arises because of the depth of the scene, rather than the density of the stars. You are peering through thousands of light-years of almost empty space at stars typically many light-years apart. Sometimes, a dark cloud of gas and cosmic dust—a nebula—intervenes, blocking starlight from behind, as does the Caterpillar Nebula (Barnard 168) here as it reaches out from the small, bright Cocoon Nebula. The Caterpillar Nebula is visible in binoculars as a two-degree-long dark finger in the Milky Way 10 degrees east of the star Deneb. Photograph by Tony Hallas and Daphne Mount, using a 5-inch f/8 Astro-Physics refractor.

defects. The purchase price of the inexpensive binoculars can then be written off to experience, and you will be much better prepared to make a decision about the binoculars that will be used for a lifetime of observing.

For the purist, the Nikon 7 x 50 SP-HP Prostar (about $600) has the best optics we have seen in any binoculars at any price by any manufacturer. The images are astonishingly crisp and bright. But the Nikons are heavy brutes, almost twice the weight of the average 7 x 50 binoculars, and too heavy to hold for a reasonable length of time. They score an A+ for optics but an F for weight and really must be tripod-mounted for proper viewing, which substantially reduces their attractiveness.

In the same price range but a bit lighter and optically a very close contender is the Fujinon FMT-SX 7 x 50. Other superb glasses in the high-price class are the Leitz Trinovid and Optolyth 7 x 42 roof prism binoculars. At 1½ pounds, these excellent performers are in the preferred weight category for hand-held astronomical viewing.

■ GIANT BINOCULARS

In the past decade, a class of giant-aperture binoculars has become popular for recreational astronomy. When tripod-mounted, these instruments are awesome performers. Sizes widely used in backyard astronomy are 10 x 70, 14 x 70, 11 x 80, 15 x 80 and 14 x 100. Binoculars in these sizes range from $400 to $8,000. Models with magnifications higher than 16x are less versatile because of their comparatively narrow fields of view. Finding celestial objects with tripod-mounted binoculars is tougher when the field of view gets down to around three degrees. Furthermore, many telescopes offer similarly wide fields at their lowest magnification.

A few giant binoculars have 45- or 90-degree eyepieces that make viewing close to the zenith much easier on the neck. Also available are counterweighted holders for cantilevering the binoculars away from the tripod head so that the observer can get underneath them.

Giant binoculars are ideally suited to examination of the largest galaxies, such as Andromeda, M33, NGC 253 and the Magellanic Clouds. Their relatively wide fields are perfect for framing star clusters and large nebulas against the starry backdrop. A large-binocular view deep into the Milky Way clouds in Cygnus, Sagittarius or Carina offers unparalleled vistas of the star-spangled galaxy we inhabit. From a dark location, several hours spent touring the Milky Way with giant binoculars can pass by in what seems like minutes. It is one of the great treats in astronomy. Another giant-binocular specialty is that rare bright comet which reaches fifth magnitude or brighter and sports a tail two degrees

■ *Above: Large 80mm binoculars are too heavy to hold for an extended period. A standard camera tripod is the usual answer, but there are more versatile possibilities. A counterweighted cantilever, shown here, allows the binoculars to be positioned at any angle or height above the ground.*
■ *Right: a pivoting car seat covered with waterproof material is augmented with a counterweighted holder for the binoculars. There are many other possible homemade solutions.*

models as possible. Check out at least five manufacturers, and expect to spend a minimum of $100.

A perfectly acceptable alternative is to buy an inexpensive pair of 8 x 40s or 7 x 50s for about $60 and use them as "training wheels," fully expecting to buy better binoculars in a year or two after you have become used to astronomical observing and have discovered all of the less expensive model's

or longer. The wide field, great light grasp and comfortable binocular vision afforded by large glasses make the comet seem to float in the abyss.

· Are giant binoculars an essential step up from regular binoculars? Standard binoculars are mandatory equipment for any backyard astronomer, whether beginner or veteran. Their extreme portability and wider field of view compared with those of telescopes put them in a class of their own. Regardless of what other equipment you have, 40mm-to-50mm binoculars are indispensable in astronomy. We do not rank giant binoculars in the same category. They are the obvious step up from standard-sized binoculars, and they fit nicely between regular binoculars and a telescope. Our experience, though, is that the big binoculars are nice to have around, but you can do without them. Your order of priorities should be standard-sized binoculars first, telescope second and the giant binoculars third, if you feel the need for an intermediate piece of hardware. An exception is if you live someplace with a scenic daytime vista where regular binoculars are inadequate to bring in distant detail. Such a dual terrestrial-celestial application would make the big glasses a top priority.

Our specific recommendations for big glasses start with the Fujinon FMT-SX 10 x 70s (about $700). They are instruments of outstanding quality with high-eyepoint eyepieces, excellent optics, a 5¼-degree field and superb multicoatings on every optical surface. However, the most popular giant

binoculars by far are the 11 x 80s marketed by virtually every optics company: Meade, Celestron, Swift, Unitron, Bushnell, University, Orion and many others. There is very little difference in price or performance among the 11 x 80s on the market. They represent good value in astronomy equipment in their price range ($300 to $500), and their 4½-degree fields make them versatile performers. Less popular but worth considering are 15 x 80s. Their higher power and 5mm exit pupil offer a nice combination.

Avoid the 20 x 80 giant binoculars for astronomical applications—they have too much power and too little exit pupil to reveal galaxies and nebulas at their best. Most spotting scopes are similarly overpowered for optimum observation of fainter targets, and they are usually equipped for only straight-through viewing.

■ *Clockwise from far left bottom: Sailing the celestial seas is best done in a boat— on land. Try using a small inflatable child's boat (about $20) to scan the overhead sky in complete comfort. Head, legs and shoulders are supported more effectively than in the standard lawn chair, shown for comparison. Head can be raised or lowered by varying leg pressure. (Boat idea suggested by Jim Zeleny of Thunder Bay, Ontario.) Tripod-mounted binoculars offer jiggle-free viewing and pointing. But one drawback with most tripod-mounted arrangements is the neck wrenching required for overhead gazing. Supergiant 25 x 105 binoculars, used by England's comet and nova discoverer George Alcock, have 45-degree eyepiece prisms to prevent waking up the next morning with "astronomer's neck." Photograph courtesy George Alcock.*

Telescopes for Recreational Astronomy

A generation ago, many backyard astronomers built their telescopes from scratch. Today, 90 percent of amateur astronomers purchase commercially manufactured equipment. With the increasing popularity of the hobby, telescope companies have evolved from basement operations to major concerns with annual sales in the millions of dollars. Competition in the field is intense, and the leading manufacturers conduct lavish advertising campaigns in the key astronomy magazines. All too often, such advertisements are the only information a potential customer has to evaluate what is on the market. We therefore have included not only general information on telescope designs but also our personal opinions on many of the telescopes and accessories on the market at the publication date of this book. As a result, we hope that it will be easier to make a choice among the many options in a very complicated marketplace. In fact, a backyard astronomer now has an unprecedented number of telescope models from which to select—as of 1991, there were about 175 models available in North America from more than two dozen companies.

Why are there so many types of telescopes? The reason, in part, is because there are so many kinds of celestial objects. The telescope which provides superb images of the planets is not necessarily the same one that offers stunning deep-sky views. There have always been specialized telescopes for specialized purposes. However, in the past, one type of telescope, indeed one particular brand, has usually predominated, making the choice of which instrument to buy a relatively simple task—each customer bought what everyone else was buying. Observing tastes tended to follow the same pattern. Whatever type of observing the telescope in vogue excelled at, that is what most people concentrated on.

By contrast, today's backyard astronomers are interested in a wide range of celestial targets, from the moon to the most distant clusters of galaxies. Couple the size of the current market with the eclectic tastes of modern amateur astronomers, and the result is that for the first time in the history of amateur astronomy, the three main classes of telescopes—refractor, Newtonian and catadioptric—are equally popular.

■ TELESCOPE EVOLUTION ▬▬▬▬▬

The fact that there are now three main types of telescopes vying for market preeminence leads to the perennial question: Which telescope is best? It is an endless debate. If you listen to the conversation of any group of recreational astronomers, you will hear the merits of this, that or the other telescope.

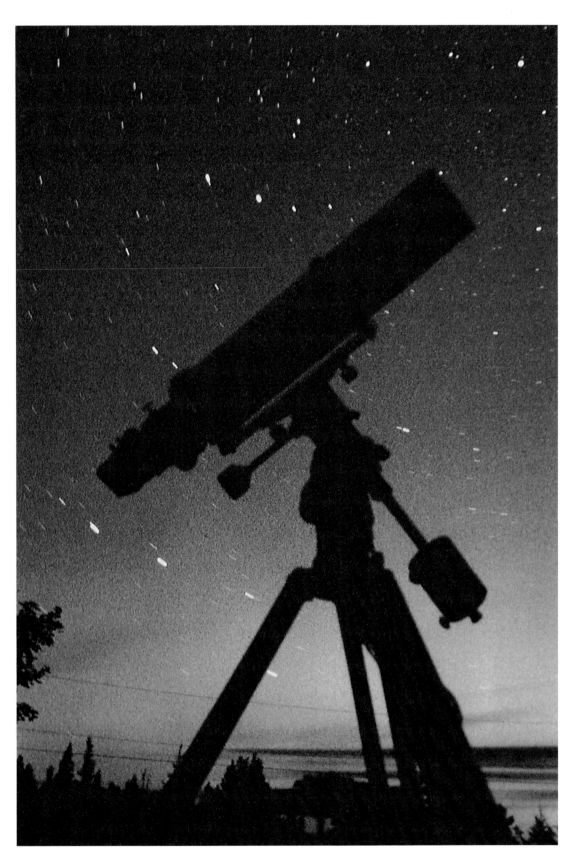

■ *A telescope sits ready for use, silhouetted by a modest aurora that brightens the northern horizon. In classic backyard-astronomy fashion, this 4-inch refractor is kept fully assembled in a ground-level room, where it can simply be carried outside to the favourite observing spot. When the instrument is taken to a remote site, such portability allows it to be quickly loaded and unloaded from the car. Photograph by Terence Dickinson.*

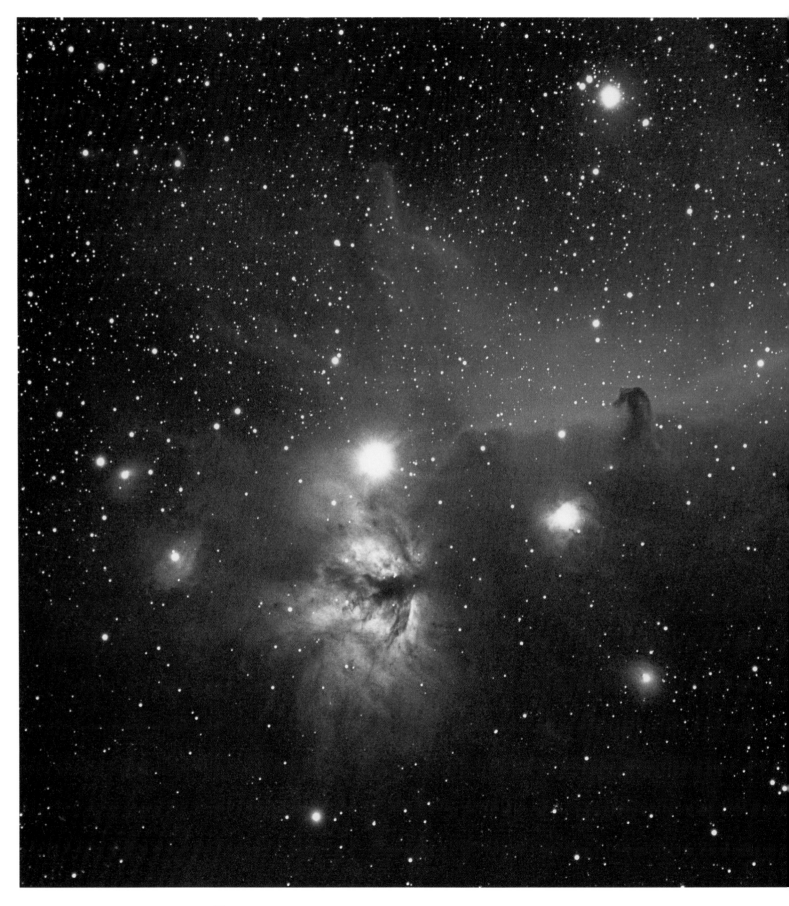

■ Telescopes in action. The essence of backyard astronomy is observing—personal exploration of the cosmos. The attraction (some say addiction) is that the more you know about what you are seeing, the more beautiful and meaningful it becomes. Centre photograph by Terence Dickinson; above and left by Alan Dyer.

■ Far left: The Horsehead Nebula, in Orion, is a challenge for both visual observation and astrophotography. Just seeing it is the visual challenge; capturing the subtle details in a painstaking time exposure is the astrophotographer's task. Photograph by Tony Hallas and Daphne Mount.

Top: Aperture fever, 19th-century style, reached its climax in 1845 with the completion of the 72-inch reflector built by William Parsons, a wealthy Irish aristocrat. With it, Parsons (also known as Lord Rosse) discovered the spiral nature of galaxies and made a number of other important finds, although not as many as he might have because the telescope's cumbersome mount required several operators at all times. Nor is the weather in Ireland known to be kind to astronomers. Parsons was the last amateur astronomer to build and operate the world's largest telescope.

Right: A modern backyard astronomer surrounded by his instruments. Australian Gregg Thompson, an expert deep-sky observer, uses an 18-inch Sky Designs Dobsonian-style Newtonian (to his right) and a 16-inch Newtonian on a German equatorial mount. The two telescopes are housed in a spacious observatory on the roof of his house.

Facing page: Lunar and planetary observing by backyard astronomers reached its zenith in the 1950s and early 1960s, partly because these bodies had been largely ignored for decades by research astronomers. Another factor was that long-focus refractors and Newtonians, instruments well-suited to moon and planet watching, were in vogue at the time. Saturn by Charles Giffen, using a 15.5-inch refractor; other drawings by Alika Herring, using a 12.5-inch Newtonian.

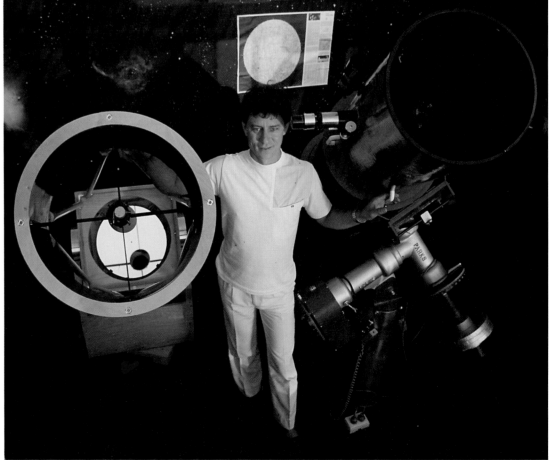

But it is even clearer today than it was in the past that there is no such thing as a perfect telescope. Perfection will always be an elusive dream. Even so, there have been long intervals in which one type of telescope was the most popular and set the agenda for the prevailing style of observing. This fundamental concept—how equipment drives observing interests—is seldom discussed in amateur astronomy. But it is our opinion that the history of amateur astronomy can be largely divided into periods during which a single type of telescope held dominion over the backyard observer's universe.

■ BEFORE 1950:
THE SMALL-REFRACTOR ERA

Until the 1950s, a typical backyard telescope was a 2.5- or 3-inch brass-fitted refractor that looked good in a study beside an oak bookcase. Larger telescopes were available, but at a very high price. Commercial telescopes were expensive relative to the wages of the average working person. They were made for the upper class, the genteel astronomers of wealth and leisure. The observing activities of such amateur astronomers consisted of casual views of the planets, scanning a handful of clusters and nebulas and measuring the positions and brightnesses of hundreds of double and variable stars—tasks well suited to a small refractor.

■ 1950 TO 1970:
THE NEWTONIAN ERA

The post-World War II period saw the introduction of reasonably priced binoculars and telescopes of decent quality and design. Commercial telescope companies began to offer equatorially mounted Newtonian reflectors with relatively large apertures of 6 to 12 inches. The Newtonian quickly became the most popular instrument of the day.

Other reflector types, such as Cassegrains and tilted-mirror designs, were as uncommon then as they are today. The second most popular telescope was a commercial 3- or 4-inch refractor, usually f/15. Refractors that were more than 4 inches in aperture were relatively rare for amateur astronomers. They were simply too expensive for the average backyard observer. The somewhat outdated statement still made in many astronomy guidebooks that "the best beginner's telescope is either a 3-inch refractor or a 6-inch reflector" dates from this era.

The Newtonians of the 1950s and 1960s were medium- or long-focal-length telescopes (f/7 to f/10). They were big and awkward; however, long-focus Newtonians were, and remain today, excellent for high-resolution planetary observing. As a result, we entered the golden era of planetary study by amateurs. It was a time when the journal of the Association of Lunar and Planetary Observ-

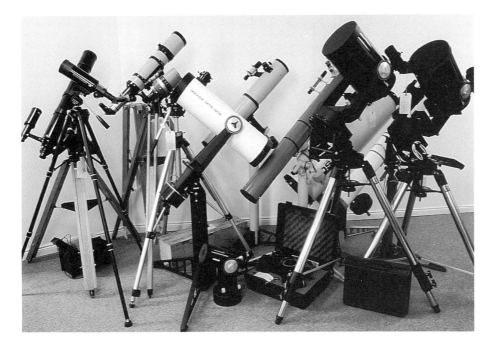

TELESCOPE TYPES

Refractor

Newtonian Reflector

Schmidt-Cassegrain

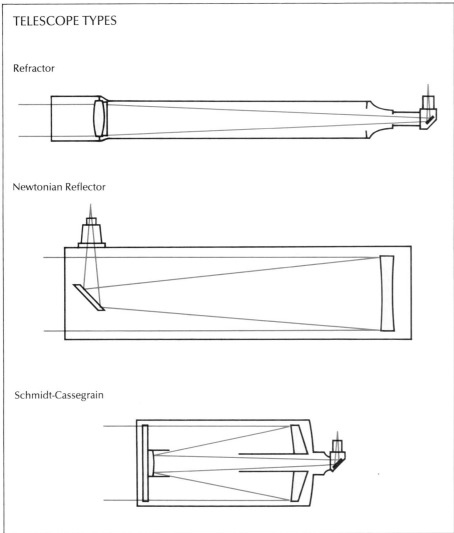

ers was filled with wonderful drawings of Mars, Jupiter, Saturn and Venus.

The larger Newtonians sparked an initial interest in observing deep-sky objects such as nebulas and galaxies, but it remained a minor sideline for most observers. The books of the day bear this out: *Norton's Star Atlas*, the observer's bible of the 1950s and 1960s, lists only 75 deep-sky objects in the descriptive tables of the 1959 edition, yet thousands of deep-sky objects are and were within reach of a good 6-inch telescope. J.B. Sidgwick's classic *Observational Astronomy for Amateurs*, first published in 1957, devoted 270 of the 310 pages to solar system objects; the deep-sky realm of nebulas and galaxies was all but ignored.

Although telescopes were becoming larger and better able to reveal faint deep-sky objects, something else occurred to change the observer's focus. In 1965, near the end of the Newtonian era, Mariner 4 became the first interplanetary probe to return close-up images of Mars, revealing a cratered surface unlike anything telescopic observers had imagined. It was the start of two decades of intense exploration of the planets by space probes.

The images from the planetary probes deeply influenced amateur astronomy. Their first effect was to swing the emphasis of "serious" backyard astronomy away from the now-explored planets. The space probe voyages and manned moon landings effectively removed the moon and the planets as targets of opportunity for amateur astronomers. Planetary observing plummeted.

On the other hand, the unprecedented media exposure of the continuing string of space missions beginning in the late 1960s—Apollo, Mariner, Viking, Pioneer, Venera and Voyager—heightened public interest in astronomy and space. The hobby turned from a fringe pursuit into a mainstream pastime, setting the stage for the next era.

■ 1970 TO 1980: THE SCHMIDT-CASSEGRAIN BREAKTHROUGH

The many converts to astronomy during the late 1960s and into the 1970s increased telescope sales to the extent that companies could introduce mass-production techniques for serious amateur telescopes. The real breakthrough was Celestron's 8-inch Schmidt-Cassegrain, a type of catadioptric telescope. It combined lenses and mirrors in an innovative design with a wide array of photographic accessories, easy portability and attractive pricing, and it was effectively marketed by the first modern advertising in the field. In many ways, the hobby as we know it today began with this instrument.

Schmidt-Cassegrains are at their best when used for deep-sky observing and astrophotography. Their portability enabled amateur astronomers,

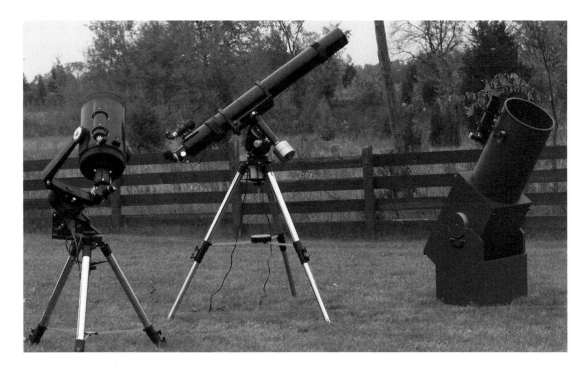

many for the first time, to transport the instruments to dark-sky sites, and observing and photographing deep-sky objects began to soar in popularity.

The peak of the Schmidt-Cassegrain era marked the virtual disappearance of the refractor as serious amateur equipment and a reduction in the number of cumbersome Newtonian reflectors that had so dominated the hobby only a decade earlier.

This era also precipitated a decline in home telescope making because of the increasing affordability of equipment during the 1970s (through lower costs and higher levels of disposable income). The trend has largely continued, and today, only a few amateurs grind their own mirrors or lenses—thus the absence of such topics here. Telescope making has enjoyed a resurgence over the past few years, but just to the extent of the home manufacture of simple tube assemblies and plywood mounts to house commercially produced optics. The design that inspired the latest homemade models—the Dobsonian—emerged during the early 1980s.

■ 1980 TO 1985: THE NEWTONIAN IS REBORN

There was a major swing back to Newtonians during the 1980s. Prior to that, the Newtonian was usually carried on a massive German equatorial mount, which allowed the telescope to track the sky automatically—at a price. Equatorial mounts for large telescopes are huge and very heavy. A mount for a 10-inch instrument could easily weigh 75 pounds, making the typical Newtonian an unwieldy behemoth to move to a distant observing site. When light pollution started to become a serious problem in the 1970s and telescopes had to be transported to dark-sky areas, colossal mounts would not suffice. The compact Schmidt-Cassegrains of the 1970s partly solved the problem but still had a portability limit. Schmidt-Cassegrains that were 10 inches or more in aperture were hefty instruments. How could amateurs move to even bigger telescopes yet retain portability?

The solution: sacrifice automatic tracking by using simple, squat altazimuth mounts supporting Newtonians with thin, lightweight primary mirrors. Popularized by California amateur astronomer John Dobson, these telescopes are now universally called Dobsonians. Beginning in 1980, companies such as Coulter Optical offered thin-mirror Dobsonians for as little as $500 for a 13-inch model. Aperture fever swept the land.

Once again, the instrumentation had led observers into new territory. The big "light buckets," as large Newtonians are irreverently called, are unsurpassed at revealing faint deep-sky targets. Objects that are barely perceptible smudges in an 8-inch Newtonian or Schmidt-Cassegrain become impressive spectacles in a 20-inch Dobsonian. Armed with giant Dobsonians, observers can pursue deep-sky targets previously thought impossible.

However, low-cost aperture still comes at a price. What Dobsonian fans often sacrifice for economical big mirrors is optical quality. To provide the sharpest images, large optics should be just as good in quality as smaller optics. The optician's labour for an excellent 20-inch mirror costs at least $2,000 to $3,000. Add the cost of materials and labour for the rest of the telescope, and the result is a huge expense

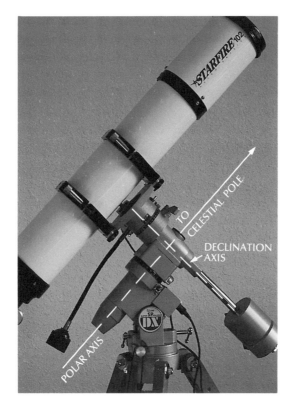

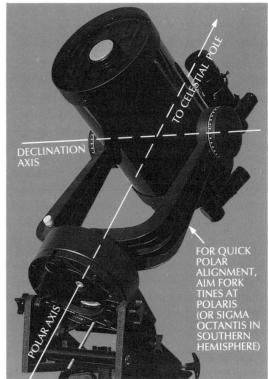

for a big, truly first-class instrument. Toward the end of the 1980s, such premium Dobsonians began to appear on the market.

■ 1985 TO 1990: THE REFRACTOR RETURNS

Refractors were all but extinct by the 1980s. People considered them to be too small in aperture, and those models which did have sufficient aperture were plagued by colour fringes around bright objects (chromatic aberration) and were too massive and too expensive.

If the situation had remained constant, the refractor story would have ended here and we would be noting that "the 3-inch refractor is suitable for beginners, but for most backyard-astronomy applications, the other types of telescopes are preferred." However, in the mid-1980s, things changed.

The first development was the introduction of a new type of glass (actually an artificially grown crystal known as calcium fluorite) to replace one of the glass elements in the standard two-element front lens of the refractor. The new combination effectively eliminated chromatic aberration, even in fast-focal-ratio telescopes, whose colour fringing is the most difficult to eliminate. A 4-inch f/8 fluorite refractor is less than three feet long and outperforms any achromatic 4-inch f/15 refractor.

The term achromatic can be defined as "nearly free of extraneous colours." It is what can be expected from small refractors with standard two-

element lenses. In the mid-1980s, the buzzword became apochromatic, which means "completely free of extraneous colours" or, more precisely, that the colour is reduced below the eye's threshold of detection. The latter is the level of performance achieved by two-element fluorites and new three- and four-element refractors.

Modern fluorite lenses work and, contrary to popular opinion, do not deteriorate. We have yet to see evidence that fluorites degrade over time, but the idea persists, perpetuated by the manufacturers of nonfluorite telescopes. Fluorites are just as moisture- and shock-resistant as conventional glass lenses. However, full-aperture lenses of this type are costly. Optical wizards asked whether there might be other ways of making apochromatic refractors in large apertures at less-than-astronomical prices. In the 1980s, two telescope designers, working independently and approaching the traditional refractor's quirks from different directions, revolutionized the equipment for recreational astronomy.

Al Nagler, a military optics expert and amateur astronomer, began developing ways to reduce the focal ratio without increasing chromatic aberration. His Tele Vue Renaissance and Genesis 4-inch models (both four-element systems) were instrumental in reestablishing the refractor as a serious tool for astronomy.

Aerospace engineer and amateur astronomer Roland Christen also attacked chromatic aberration. In the mid-1980s, Christen's firm, Astro-Physics,

■ Equatorial mounts are available on commercial telescopes in two basic designs: German, left, and fork. Their advantage over simpler mounts, such as that pictured on facing page, is that they will track a celestial object with a single-axis motion as Earth rotates. To function properly, the polar axis must be pointed toward the celestial pole. (Except for astrophotography work, a quick visual alignment toward the pole is fine.) As the sky rotates, the telescope will follow the stars either by itself, if it has a clock drive, or with the turn of a single knob.

marketed the first triplet apochromatic refractors priced for amateur astronomers. Christen's telescopes have a three-element objective lens—each element is made from a different type of glass, and together, they produce virtually colour-free images. His design breakthrough allowed reasonably priced 4-, 5-, 6- and even 7-inch apochromatic refractors.

The introduction of affordable apochromatic refractors in the 1980s coincided with increasing disenchantment with the bright but fuzzy views offered by the low-quality optics in many Dobsonians and in a spate of poorly made Schmidt-Cassegrains. The race for bigger telescopes that had driven amateur astronomy since the 1950s gave way to the desire for better telescopes. Planetary observing, which requires first-class optics, saw a resurgence with the return of the refractor.

■ THE 1990s: QUALITY FIRST

In the 1990s, the doors are wide open to every type of observing interest and choice of equipment. The only common factor that today's backyard observers seem to be demanding is quality. Regardless of the size and design of a telescope, amateurs are looking for top-grade optics on solid mounts; manufacturers are being forced to deliver that quality.

The equal popularity of the refractor, reflector and Schmidt-Cassegrain means that for the first time, instruments suitable for every category of observational activity—solar, lunar, planetary, deep-sky, comet hunting and astrophotography—are available in a wide range of sizes. Backyard observing in the 1990s is not driven by any single brand or type

of telescope that happens to be in vogue. The availability of three classes of fine telescopes, each with formidable strengths, has ushered in a new era, perhaps a new maturity, in amateur astronomy. The swinging pendulum of fashion that has characterized the hobby since World War II has apparently come to rest—at least for a while.

■ CHOOSING A TELESCOPE

Since no single telescope dominates the market anymore, the choices facing the prospective buyer can be daunting. Time and again, we are asked: What is the best telescope? or Which telescope would you buy? The answer is frustrating to many first-time buyers: There is no best telescope. Furthermore, a telescope we would choose may not be the one best suited to your needs.

Some enthusiasts hop from one telescope model to another, enticed by glossy advertisements and convincing salespeople. A few years ago, telescope hopping was a rarity. A backyard astronomer bought one telescope and liked it. Now, the profusion of models sets some amateurs on a quest for the Holy Grail of astronomy: the perfect telescope. Thousands of dollars and several telescopes later, they realize *there is no telescope that will do everything well.* Refractor, reflector, catadioptric—each has its advantages and disadvantages. Many veterans who recognize the strengths of each type own

more than one telescope. That is the real answer to finding telescope paradise.

■ THE MAGNIFICATION SCAM

Some amateur astronomers and telescope dealers insist that the most important characteristic of an instrument is its aperture. They are right, up to a point. Larger telescopes do generally provide brighter, sharper images.

But what about magnification? We have ignored it, and so should you. The magnification of a telescope is a meaningless specification. With the right eyepiece, any telescope can magnify hundreds of times. The question is, How does the image look at, say, 450x? Probably either very faint or blurry. Why? There are two reasons:

□ Not Enough Light: The telescope simply is not collecting enough light to allow the image to be magnified to that extent. When an image is enlarged, it is spread out over a greater area and be-

■ *The authors recommend an 80mm refractor, like this Celestron Firstscope 80, as a minimum beginner's telescope. (Meade's Model 312 is similar.) The mount is a simple altazimuth design with left-right and up-down axes. Once a celestial object is centred, it immediately begins moving out of the field due to the Earth's rotation, but the slow-motion controls on flexible cables make continuous recentring easy at low powers and not too difficult up to 120x. Nevertheless, many observers favour the tracking convenience of equatorial mounts despite the higher cost and greater weight.*

When shopping for a telescope, you will encounter the following terms. They represent the most important specifications of any telescope.

■APERTURE AND LIGHT-GATHERING POWER

Telescopes are rated by their aperture. A 4-inch instrument has a lens or mirror four inches in diameter. The larger the telescope's lens or mirror, the more light it collects. Large-aperture telescopes present brighter images and reveal fainter stars than do small telescopes. The light-gathering power of a telescope is proportional to the surface area of the lens or mirror, not to its diameter. Thus an 8-inch telescope has four times the light-gathering power of a 4-inch model, making its images four times brighter. In the world of amateur astronomy, small telescopes have apertures of 2.4 to 5 inches; moderate-sized instruments have 6-to-12-inch apertures; and large models have 14-to-25-inch apertures.

■RESOLUTION

How well a telescope resolves fine detail and close double stars depends on the aperture and on the quality of the optics. In theory, an 8-inch telescope has twice the resolving power of a 4-inch instrument, and so on. The resolving power of a telescope can be estimated with a simple formula: Resolving Power (in arc seconds) = 4.56 ÷ Aperture of Telescope (inches); or 116 ÷ Aperture of Telescope (mm). This is Dawes' limit. Nineteenth-century amateur astronomer William Dawes devised the calculation to estimate how far apart two stars of approximately equal brightness must be before they could be resolved as two separate stars. Dawes used a small refractor to establish the relationship. The formula does not necessarily translate to other kinds and sizes of telescopes, and it has inappropriately come to be used as a definitive test of telescope optics. Quality instruments can sometimes outperform the resultant figures. However, because of the atmosphere, it is not possible to reach Dawes' limit on most nights. Often, a resolution of one arc second is the best any telescope can do.

■FOCAL LENGTH

The length of the light path from the main mirror or lens to the focal point (the location of the eyepiece) is called the focal length. Many telescopes have the focal length marked somewhere on the tube. For most instruments, the lengths range from 500mm to 3,000mm. The optical focal length of refractors and Newtonians often approximates the length of the tube, since the lens or mirror is at one end of the tube and the eyepiece is at the other. With Maksutovs and Schmidt-Cassegrains, the optical path is folded back upon itself, making the tube much shorter than the focal length. On such telescopes, the focal length is sometimes marked on the tube as E.F.L. = 2,000mm, meaning that the effective focal length is 2,000mm. The longer the focal length, the higher the power the telescope will produce with any given eyepiece.

■FOCAL RATIO

Like camera lenses, telescopes are given a speed rating, the focal ratio, which is the focal length divided by the aperture. For example, a 6-inch (150mm) telescope with a focal length of 1,200mm has a speed rating of 1,200 ÷ 150 = 8, or f/8. A 6-inch telescope with a focal length of 750mm is an f/5 system (750 ÷ 150 = 5). The formula can also be turned around. If the aperture and focal ratio are known, they can be multiplied to give the focal length.

With any given eyepiece, faster f/4 to f/6 systems offer lower powers and wider fields of view than slow f/8 to f/15 systems. For photography, faster systems yield shorter exposure times. But faster systems do not, by themselves, produce brighter images. The brightness of any image seen in the eyepiece is dependent solely upon the aperture.

■MAGNIFICATION

The magnification that a telescope provides can be varied merely by changing the eyepiece. To determine how much power a particular eyepiece provides on a telescope, divide the focal length of the instrument by the focal length of the eyepiece (using the same units of measurement for both).

The focal length of most eyepieces is marked on the top or side. All but vintage types have focal lengths measured in millimetres. They range from 55mm (low power) to 4mm (high power). For example, a 25mm eyepiece on a 2,000mm telescope yields a magnification of 2,000 ÷ 25 = 80x. A 12mm on the same telescope produces 2,000 ÷ 12 = 166x.

How much can a telescope magnify? The general magnification limit is 50 times the aperture in inches, or 2 times the aperture in millimetres. For example, the maximum usable power for a 60mm telescope is only 120x. Claims that such a telescope can magnify 400x are misleading. At more than the 50-power-per-inch limit, the image in any instrument will be too fuzzy for useful observing.

Any telescope advertising that trumpets high magnification—especially on inexpensive instruments—should be regarded as a "buyer beware" signal. This type of emphasis is aimed strictly at the uninformed consumer. Magnification limits are imposed by the nature of light and optics—perfect optics.

Can a big telescope, say, a 16-inch, magnify 50 times per inch to its theoretical maximum of 800x? Almost never. Because of the ever turbulent atmosphere, the maximum worthwhile power even for larger instruments is about 300x. Only on rare occasions when the atmosphere is very steady can a large telescope be profitably pushed further. People do not build or buy giant instruments in order to obtain highly magnified images but, rather, to get brighter, sharper images and to see fainter objects.

■ WAVEFRONT ERROR

Telescope optics are often advertised as 1/8 wave or 1/20 wave. This is a measure, in wavelengths of green light, of how far the actual optical surface deviates from an ideal surface. However, the important characteristic is not how good the individual optics are but how small the error is in the final wavefront of light emerging from the complete telescope. The light reflected off a mirror with a surface accuracy of 1/16 wave has a wavefront error of 1/8 wave. A telescope made with two mirrors, each of which produces a wavefront error of 1/8 wave, has an accumulated final error of 1/4 wave, usually considered the minimum for perfect star images. This calculation is called the Rayleigh criterion, or diffraction-limited optics.

However, manufacturers almost never specify system wavefront error, and to complicate matters further, there is no agreed-upon standard for measuring optical-surface accuracy (one company's 1/20 wave is another's 1/10 wave). The telescope industry is working toward uniform standards, so perhaps the picture will change, but for now, seeing is believing.

comes too faint to be useful. The telescope has been pushed beyond its limits. The only recourse is to move to a bigger telescope. The brighter images in larger telescopes will allow higher powers, theoretically. Because of the following, however, it does not always work that way in practice.

☐ Blurry Atmosphere: The Earth's atmosphere is always in motion, distorting the view through the telescope. Some nights are worse than others. At low power, the effect is usually not noticeable. But at high power, it can blur the image badly. Increasing the magnification only makes things worse; it becomes impossible to see any more detail. Instead, the image becomes fuzzier and fainter. Since big telescopes have to look through a larger column of air than do small telescopes, they are often more affected by atmospheric turbulence (astronomers call the condition "poor seeing").

Most amateur astronomers find that about 300x is the practical upper limit for any size telescope, despite advertising claims to the contrary. In fact, a telescope touted solely on the basis of its magnification is surely a lemon advertised by a company that does not know what constitutes a good instrument.

■ AVOIDING APERTURE FEVER

Now that the magnification myth is dispelled, you know you need as much aperture as you can afford. Or do you? If you are not careful, you may catch aperture fever. The first signs of it are longer and longer perusals of the telescope advertisements in *Sky & Telescope* and *Astronomy* magazines, accompanied by imagining the spectacular views to be had with the Colossal SuperScope.

However, be warned. Big telescopes do not always foster contentment among astronomers. Quite a few of our colleagues observe happily with their 14-to-25-inch instruments, and so might you. But without a convenient, dark, permanent site to house such a brute, think very carefully about what you want. The biggest telescope is not always the best.

A 12-inch-aperture telescope will outperform a 6-inch one, all else being equal. That is the catch. All things are rarely equal. Price, for instance. Big telescopes can be expensive. If you lose interest in the hobby, you will have a sizable investment tied up in a telescope that may be tough to sell. Lose interest? Never, you say. Well, lots of people do. The reasons can often be traced right back to big telescopes, which can be awkward to set up and require effort to carry to the backyard or out into the country. For the sin of being too heavy, big telescopes end up collecting dust in closets and basements.

Another problem is the shakes. A large-aperture telescope needs, without exception, a heavy-duty mount. A lightly mounted large-aperture telescope might be more portable, but the images will dance

■ *Top: Although a large telescope like this 16-inch Newtonian can provide wonderful views of deep-sky targets, there are certain disadvantages with an instrument that requires three people to set it up. Photograph by Steve Dodson.*

■ *Above: In the 1950s, when astronomy was virtually unknown as a leisure activity, just a few relatively costly commercial instruments were available. Backyard astronomers usually built their own—typically, a 6-inch Newtonian on a simple pipe-fitting stand.*

about with every puff of wind and every touch of a hand. An instrument with a flimsy stand is soon banished to the basement.

Big telescopes, especially the less expensive models—those most likely to lure the enthusiast with aperture fever—are often saddled with poor or second-rate optics that prevent them from realizing their full potential. In our experience, well-crafted telescopes in the 4-to-8-inch range can outperform mediocre instruments of much larger aperture. This is partly because the big telescopes are more sensitive to poor seeing, which degrades image detail, particularly on the moon and planets.

Finally, one simple and often-overlooked fact is that large telescopes do not fit into small cars. It is surprising how many amateur astronomers

■ COMPARING TELESCOPES

	Refractors	Reflectors	Catadioptrics
Optical Advantages	☐ Because of the unobstructed design, refractors have, theoretically, the least aberrations of any optical system. ☐ It is easier to manufacture a high-quality surface on a lens than it is on a mirror. Therefore, the intrinsic optical quality is usually superior to that of the other designs.	☐ Optical system is completely free of chromatic aberration. ☐ Easier to make in large apertures. ☐ Good light-gathering power in 6-inch and larger models. ☐ Wide field of view in fast (f/4 to f/6) models.	☐ Excellent suppression of chromatic aberration and other optical aberrations. If well made, they can be excellent performers. ☐ Good light-gathering power in 6-inch and larger models. ☐ Most models focus very close for use as telephoto lenses and spotting scopes.
Optical Disadvantages	☐ All refractors have a certain degree of chromatic aberration, producing a blue or purple aura around brighter objects. New apochromatic designs have reduced this aberration to insignificant levels. ☐ Narrow field of view in slow (f/12 to f/15) models. ☐ Limited light-gathering power in small apertures.	☐ In fast focal ratios (f/5 or faster), images toward the edge of the field appear out of focus (like tiny comets) because of coma, an optical aberration inherent in reflectors. ☐ Light loss from multiple reflections is worse than light loss in refractors. ☐ Obstruction from secondary mirror and supports creates diffraction and loss of contrast.	☐ More system light loss than other types due to multiple reflections and corrector-lens absorption and reflection. Enhanced coatings reduce this light loss. ☐ Largest central obstruction of all types of telescopes—usually one-third the aperture's diameter—causes loss of contrast.
Mechanical Advantages	☐ Eyepiece location at rear of telescope facilitates attachment of cameras.	☐ Eyepiece location at the upper end of the tube means the mounts can be supported by compact tripods or can be inexpensive Dobsonian designs.	☐ Eyepiece location at rear of telescope facilitates attachment of cameras. ☐ Wide range of focus accommodates many accessories.
Mechanical Disadvantages	☐ Counterweights on German equatorial mounts add weight and bulk. ☐ Long tubes of large models sway in the wind if mounts are poor.	☐ Counterweights on German equatorial mounts add weight and bulk. ☐ Long tubes sway in the wind if mounts are poor.	☐ Fork mounts can be difficult to balance with heavy accessories.
Ease-of-Use Advantages	☐ Extremely portable in new 4-inch apochromatic designs. ☐ Easy to aim.	☐ The eyepiece is at a comfortable observing level in the 6-to-12-inch-aperture categories most often used by amateur astronomers.	☐ Compact fork mounts, three-foot tripods and short tubes result in the greatest portability per inch of aperture.
Ease-of-Use Disadvantages	☐ Since the eyepiece is at the bottom of the tube, a four-to-six-foot tripod is necessary for observing at a comfortable level with 5-inch or larger refractors. Smaller models can operate on stubbier, generally less massive tripods, but the eyepiece can be very low and awkward to reach.	☐ With larger apertures, a stool or stepladder is needed to reach the eyepiece when the telescope points overhead. ☐ On equatorially mounted Newtonians with nonrotating tubes, the eyepiece can achieve extremely awkward positions. ☐ Difficult to aim.	☐ None.

buy or make a huge instrument without considering how to transport it.

Our advice is that the beginner should resist the temptation to buy a first telescope larger than 8 inches in aperture. Performance is much more than simply getting the brightest image affordable. *The best telescope for you is the telescope that you will use most often.* Of course, affordability is a limiting factor, but even more important is ease of operation. A well-made instrument that is convenient to use will provide a lifetime of enjoyment.

■ MATCHING THE TELESCOPE TO THE SITE

An important consideration when picking the best telescope is the observing site. Can observing be

	Refractors	Reflectors	Catadioptrics
Maintenance Advantages	☐ The closed tube prevents dust, moisture and foreign objects from entering the tube. ☐ Lenses are capable of withstanding more hard use than other types. Very rarely, if ever, require collimation.	☐ Since they are shielded by the tube, the mirror surfaces are less susceptible to being coated by dew or frost.	☐ Closed tube prevents dust, moisture and foreign objects from entering the tube.
Maintenance Disadvantages	☐ Exposed main lens attracts dew.	☐ The primary and/or diagonal mirror often requires collimation. ☐ Open-ended tube (or completely open tube in some designs) means dust and foreign objects can enter the optical system. ☐ Mirror surfaces deteriorate over time and require re-aluminizing every few years.	☐ Secondary mirror in Schmidt-Cassegrains sometimes requires collimation adjustment. ☐ Exposed corrector plate readily attracts dew.
Price Advantage	☐ None.	☐ Lowest price of all types per inch of aperture; the most aperture for dollar invested.	☐ Intense competition and popularity of these models often result in bargains, sales and low-cost used instruments.
Price Disadvantage	☐ Most expensive per inch of aperture (with the exception of the Questar-brand Maksutov-Cassegrain).	☐ None.	☐ More expensive than Newtonians of equal aperture but less expensive per inch of aperture than refractors.
Other Advantages	☐ Smaller models (4 inches and less) are less susceptible to thermal currents and other cool-down effects.	☐ Longer focal ratios (f/6 or longer) can be superb high-resolution instruments if optics are high quality. ☐ The elegance and simplicity of the design allows very large-aperture instruments (up to 30 inches) for amateur use.	☐ Best range of accessories, especially for astrophotography.
Other Disadvantages	☐ Long focal ratio of achromatic refractors makes them unwieldy in apertures over 4 inches. ☐ Massive lenses in largest models can require long cool-down time.	☐ Newtonians f/5 or faster must be very precisely collimated to function up to their potential—especially inconvenient as travel to dark sites becomes more necessary. ☐ Optics in large models often require long cool-down time. ☐ Optical path is most vulnerable to thermal effects from the ground, the observer and internal currents.	☐ In f/10 to f/14 versions, even the lowest power may not provide an adequate field of view for some types of observing. ☐ Closed tube often requires long cool-down time.

For dark-sky views, it will likely be necessary to drive far from the city. Some of our colleagues argue that if they have to drive for an hour or more to a dark site, they want equipment that will show the smallest, faintest deep-sky objects possible—a 10-inch or larger telescope. Such rationalization works for some people, but we have found that telescopes requiring more than 10 or 15 minutes to load into a vehicle or to set up suffer a steady decline in use after the first year of ownership. You soon find yourself saying, "I'll go observing some other time—it looks as if it's going to cloud up," or "It's too windy tonight," or any number of other excuses, all of them cover-ups for the real reason: it is too much trouble to set up the telescope. Instead of enjoying it, you feel guilty for not using it. And a year or two later, you will probably sell it.

On the other hand, if your backyard is protected from streetlights or yard lights, you almost certainly can do some profitable observing, even if you cannot see the Milky Way. If it is visible, even a hint of it, then consider doing the majority of your observing from home. Some of the advantages of the pristine skies of the countryside are lost, but the convenience of being in your own yard for routine observing or just for quick peeks is wonderful. Travelling to an observing site with your equipment inevitably becomes a tedious affair which is soon restricted to free weekend nights that look as if they may be perfect—a rare combination.

We may be belabouring our point about portability and convenience. But we feel that instead of choosing among refractor, reflector and catadioptric telescopes and then deciding on additional accessories and electronic gadgetry, you should base your decision on the specific observing situation. The best telescope in the world will not be any good if it sits unused because it is too awkward to set up or is not suited to the local sky conditions. Do not delude yourself by thinking, "Oh, that won't happen to me. I want the biggest telescope I can possibly get." That is aperture fever.

■*A view down the tube of a Schmidt-Cassegrain reveals the primary mirror at the bottom with a tubular baffle surrounding a central hole. A small secondary mirror is attached to the inside of the corrector plate at the front. The Schmidt-Cassegrain is the most compact of all telescope designs offered commercially. The Maksutov-Cassegrain is a similar design. Both are catadioptrics, the general term for telescopes that use a combination of mirrors and lenses in the main optical system.*

done from your home? If so, are the skies dark, or are they heavily light-polluted? Are views restricted by trees, houses and streetlights? How far will the telescope have to be carried?

Avoid fast f/4 and f/5 telescopes of any size if you are plagued by bright skies. They perform optimally under dark rural skies for wide-field sweeps along the Milky Way. From light-polluted sites, f/6 to f/15 systems are best—in general, they have better optical quality than ultrafast telescopes have and yield higher powers with a given set of eyepieces. Both characteristics will provide more pleasing images of the moon and the planets.

If there is little possibility that your telescope will be used at home, then focus your decision on portability and ease of transportation. A 4-to-8-inch Schmidt-Cassegrain or a 3-to-5-inch refractor on a fairly lightweight equatorial mount will probably be used far more than a bulkier instrument.

■REVIEWING THE TELESCOPE MARKET

Among the hundreds of telescopes on the market today, a few dozen models stand out for their wide availability and popularity. No one can offer a completely objective review of equipment, and our bias toward portable, high-quality telescopes may show, but we have tried to be fair to all models.

■ACHROMATIC REFRACTORS
(60mm to 4-inch)

A 60mm refractor (about $150 to $750) is usually considered to be the standard beginner's telescope.

Some excellent models have been available in the past, such as the legendary instruments from Unitron. In recent years, however, there have been few 60mm refractors, especially under $250, that we could recommend. In particular, avoid any model with a built-in finderscope that peers out through the main tube. The separate finderscope supplied with a low-cost instrument is often bad enough, but the through-the-lens variety is even worse.

Our answer to people who enquire about the wisdom of buying a low-cost 60mm telescope is: Spend

more to buy a 3-inch or 80mm refractor or a 4-inch reflector, or save money by purchasing binoculars.

With the 3-inch or 80mm size, the quality of the refractor improves greatly. Most f/9 to f/15 80mm refractors, including those from mass-market firms such as Tasco and Jason Empire, are worthy beginner's telescopes and, in our opinion, represent the very minimum to be considered. Colour correction of the crown/flint doublet lens is excellent, even by modern standards, and the telescope is portable, durable and virtually maintenance-free for decades. A few very short-focus f/5 or f/6 80mm refractors are now on the market. Some are plastic junk. Others are well made but specialized low-power instruments. We do not recommend them as general-purpose beginner's telescopes.

Two models that stand out in the 80mm class are the Celestron Firstscope 80 and the Meade Model 312, both Japanese imports priced at about $500. These f/11.4 units each come with one high-grade eyepiece. It is nice to see one good eyepiece offered

with a beginner's telescope rather than two or three of dubious optical quality. Other eyepieces are available as accessories.

Their altazimuth mounts make the package price approximately one-third lower than that of the equatorially mounted versions of the same 80mm telescopes, but there are attendant sacrifices. Chief among them is that the telescope cannot be pointed straight overhead because the mount gets in the way. Second, both slow-motion controls must be used constantly to keep the target object in view. The design of the altitude axis (the up-and-down motion) on both the Meade and the Celestron is rather crude, simply a bolt that, when tightened, applies pressure to the joint. It can be difficult to adjust. Nevertheless, these telescopes are deliberate attempts to offer 3-inch refractors at prices that make them available to a wide spectrum of observers, and they are good value for the money.

For about $700 to $900, the same 80mm tube assemblies are offered on equatorial mounts. It is an

■ SELECTING A TELESCOPE ■

The choice of which telescope to buy depends not only on the quality of the telescope but also on personal factors such as how important portability is, local sky conditions, observing interest, budget, storage space and aptitude for handling and maintaining complex hardware.

FACTORS	Ach. Refractor 60mm to 4-inch f/10 to f/15	Apo. Refractor 4-inch to 7-inch f/5 to f/9	Eq. Newtonian 4-inch to 18-inch f/5 to f/8	Dobsonian 8-inch to 25-inch f/4 to f/5	Schmidt-Cass. 4-inch to 11-inch f/6 to f/10
Sky Conditions					
urban (poor)	excellent	good	good	poor	excellent
suburban (fair)	excellent	excellent	excellent	fair	excellent
rural (good)	good	excellent	excellent	excellent	excellent
Observing Interest					
lunar and planetary	good	excellent	good to excellent	poor to fair	good
faint deep-sky	poor	poor to fair	good	excellent	good
wide-field deep-sky	poor to fair	good to excellent	good	good to excellent	fair to good
general observing	good	good	excellent	fair	excellent
astrophotography	poor	good to excellent	good	poor	excellent
daytime nature study	excellent	excellent (4-inch)	poor	poor	good
Other					
optical quality	fair to good	excellent	good to excellent	fair to good	fair to good
mechanical quality	poor to good	excellent	fair to good	fair to good	good
light-gathering power	poor	fair	good to excellent	excellent	fair to good
portability	excellent	good	poor to good	fair	good to excellent
ease of assembly	fair to good	fair to good	poor to good	good to excellent	excellent
ease of use	good	good	fair	good	excellent
ease of maintenance	excellent	excellent	fair	fair	good
storage space required	small	average to large	average to large	large	average
delivery time	excellent	poor to good	good	poor to fair	excellent
Cost					
$$ per inch of aperture	average	high	average	low	average
resale value	fair	excellent	good	fair	good

The unit of measure for finding your way around the sky is the degree. A complete circle is 360 degrees. From horizon to overhead—one-quarter of a circle—is 90 degrees. Apparent distances between stars can be measured in degrees. For example, the Big Dipper's pointer stars (to Polaris) are five degrees apart. Each degree (abbreviated °) is divided into 60 minutes (') of arc; one minute of arc contains 60 seconds (") of arc.

Celestial Objects	Apparent Size
Andromeda Galaxy	3°
sun and full moon	0.5° or 30' of arc
typical galaxies	1' to 20' of arc
large sunspot	1' of arc
Jupiter's disc	35" to 45" of arc
width of Saturn's rings	35" to 45" of arc
many planetary nebulas	10" to 100" of arc
separation of close double stars	0.5" to 2" of arc

The field of view of most 6x-to-9x finderscopes is about 5°. The field of view of most telescopes at their lowest power is 1° to 2°. The smallest angle that typical backyard telescopes can resolve is about 0.5" to 1" of arc. Binoculars can reveal double stars more than about 20" apart. Without optical aid, people with excellent vision can resolve doubles 3' apart.

upgrade we recommend. Not only does it allow much easier tracking and adaptability to a motor drive, but the tripod and mount are sturdier.

Celestron offers the 80mm f/11.4 and an excellent 4-inch f/9.8 achromatic refractor on the Super Polaris mount made by Vixen of Japan, one of the most popular equatorial mounts on the market today. With or without the optional battery-powered pulse-motor drive ($200), it is an ideal portable equatorial mount for 3-to-4-inch refractors.

In our opinion, two-element achromatic refractors of more than 4-inch aperture suffer unacceptably from noticeable chromatic aberration, which gets worse with each increase in size if the focal ratio remains the same. For large refractors, we prefer the apochromatic designs.

■ APOCHROMATIC REFRACTORS
(4-inch to 7-inch)

In less than a decade, apochromatic refractors have swept from obscurity to mainstream equipment because of the increased availability of fluorite and, more recently, ED (extra-low dispersion) glass. Both types permit far superior correction of chromatic aberration than standard optical glass.

Fluorite refractors were introduced by Takahashi in 1974. Although of outstanding quality, the Takahashi instruments remain very expensive. The 4-inch f/8 model, for example, with fully equipped equatorial mount, is about $5,000. More modestly priced is the Celestron 4-inch f/9 SP-C102F fluorite made by Vixen of Japan. It comes with the Vixen Super Polaris equatorial mount for $2,500.

The Takahashi and Vixen fluorite doublet designs use normal optical glass as the objective's front lens element with the fluorite right behind it. Tele Vue's four-element 4-inch f/5 Genesis refractor is different. It has a standard doublet objective lens; the fluorite element is part of a small doublet lens near the focuser. The result is less efficient reduction of chromatic aberration but with the wide-field and astrophotographic advantages of an f/5 focal ratio. This is a good general-purpose telescope and one of the finest portable deep-sky instruments ever manufactured. (Price without mount: $1,700.)

ED doublet apochromatic refractors have the same basic optical arrangement as fluorite doublets and yield similar image quality at a lower price, especially in apertures above 4 inches. Meade offers f/9 ED doublet refractors from 4- to 7-inch aperture (tube-assembly prices: $1,100 to $3,000). Astro-Physics makes competitively priced 5-inch f/8 and 6-inch f/9 Super ED doublet refractors. (Apparently, there are two grades of ED glass, regular and super.)

In 1992, Astro-Physics introduced an ED triplet design (using a three-element objective with Super ED in the middle) that eliminates the final traces of chromatic aberration still present in other refractor designs. These telescopes are particularly suited to planetary observing and astrophotography. The 4-inch f/6 (tube assembly: $1,800) is exquisitely portable. Other models are 5-inch f/8 ($2,500), 6-inch f/9 ($3,200) and 7-inch f/9 ($4,600).

■ THE DOBSONIAN REFLECTOR
(8-inch to 25-inch)

The name Coulter is synonymous with Dobsonian telescopes. Since 1980, Coulter Optical has specialized in Dobsonians that offer the observer the most aperture for the dollar ($600 for the 13-inch, $1,200 for the 17.5-inch). The telescopes are of bare-bones Dobsonian simplicity with f/4.5 thin-mirror Newtonian optics and one Kellner eyepiece.

We would describe the Coulter Dobsonians' optics as fair to good. But realistically, at these prices, precision optics are out of the question. You get what you pay for—in this case, lots of telescope for little money. We have enjoyed outstanding views

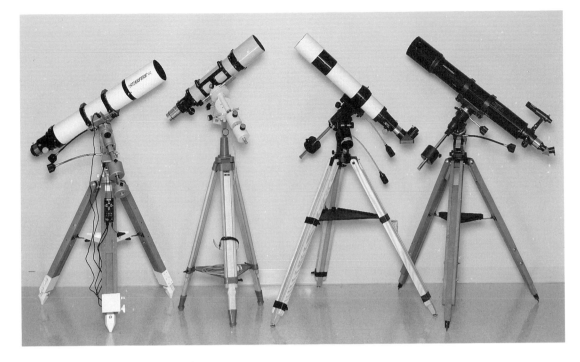

of galaxies, nebulas and star clusters in Coulter 13- and 17.5-inch telescopes, yet the same objects were insignificant fuzzballs in 3- and 4-inch refractors of comparable cost. These are brute-force telescopes intended to be used at low power, typically 5x to 10x per inch of aperture. In this range, they perform admirably as gateways to the deep sky for an aperture-hungry backyard astronomer on a budget.

Other companies offering giant Dobsonians with 14-to-25-inch apertures are the Jupiter Telescope Company, Obsession Telescopes, Safari Telescopes, Sky Designs and Tectron. All are small companies, some run by dedicated amateurs as part-time businesses. The new-generation Dobsonians feature first-rate optics and lightweight mounts that break apart into transportable components. For example, the Obsession telescopes are beautifully hand-crafted and snap together in five minutes. The 20-inch sells for $4,500, while the 25-inch is double the price.

If the thought of a 25-inch telescope in your backyard is appealing, think again—the tube is more than 10 feet long. Observing over most of the sky means balancing on a tall ladder. It is fun to look through such an instrument, but do you really want to own one? A 14-inch Dobsonian is, in our opinion, a comfortable size for personal use. It avoids ladders and the need to transport heavy pieces of equipment but is large enough to propel you deep into the galaxies.

■ EQUATORIAL NEWTONIANS (4-inch to 18-inch)

The standard instruments of the 1960s, the 6-inch f/8 or 8-inch f/7 equatorially mounted Newtonian,

are seldom seen anymore. Attracted to the more compact Schmidt-Cassegrain or lured by aperture fever to the Dobsonian, most people bypass the mid-sized Newtonian. Yet these forgotten telescopes can be excellent all-round performers, unworthy of such a fate. A good 6-inch Newtonian is a highly portable instrument that can reveal the universe at a bargain price. It can be used at both low and high magnifications and has enough aperture to bring in a wide range of deep-sky objects as well as crisp planetary views. Celestron, Meade and Parks Optical offer medium-aperture Newtonians in the $500 to $1,200 price range.

In larger-aperture models, Meade has 10- and 16-inch f/4.5 Newtonians on equatorial mounts ($700 and $2,000, respectively), which are significantly bulkier than similar-aperture Dobsonians. Their optical and mechanical quality is fair to good. Parks markets 10- and 12.5-inch Newtonians on massive German equatorial mounts. Often called research-grade or observatory mounts, these monsters are what gave Newtonians a bad name, but for use at a permanent site, they can be a solid choice.

The finest big-aperture Newtonian on an equatorial mount is an unusual design by Jim's Mobile Industries. Its NGT (next-generation telescope) is available in transportable, carefully engineered 18- and 25-inch models. However, at $8,000 and up, such telescopes are for the well-heeled serious enthusiast.

At the other end of the spectrum, tens of thousands of amateur astronomers and a few professionals started their astronomical activities with a Tasco 4.5-inch Newtonian, Model 11TR ($400).

■ *A lineup of apochromatic refractors on equatorial mounts. From left to right: Astro-Physics 4-inch f/8 Starfire on Super Polaris DX mount; Brandon 94mm f/7 on Jena mount; Tele Vue 4-inch Genesis on Tele Vue mount; Celestron SP-C102F 4-inch fluorite on Super Polaris mount. These complete telescopes are priced in the $2,000 to $3,000 range. By reducing the classic achromatic refractor's tube length by half and reducing the chromatic aberration as well, the 4-inch apochromatic refractor has become a favourite among backyard astronomers who want portability and maximum performance per inch of aperture. (Update: The Brandon telescope is no longer available, and the Astro-Physics model is now f/6.) Photograph courtesy* Astronomy *magazine.*

Erect View

Inverted View

Mirror Reverse View

Tasco is the McDonald's of optics—telescopes, binoculars and microscopes—volume selling at low prices. Its products are seen everywhere. The 4.5-inch Newtonian is one of the company's most ubiquitous telescopes. The same model is available from Jason Empire and Swift Instruments and as a house-brand item from many telescope and camera stores. It has several deficiencies: a small finderscope, poor 0.965-inch eyepieces, a spherical mirror and a barely acceptable mount, to name a few. Orion Telescope Center offers a version of the Tasco 4.5

with one improvement: a 6 x 30 finderscope instead of the inadequate 5 x 24 that is usually standard. While we have our reservations about it, the Tasco 4.5-inch Newtonian is, in one form or another, a highly successful telescope that has given pleasure to many aspiring astronomers.

Another popular beginner's instrument is the Edmund Astroscan (about $350), a 4.1-inch f/4.3 Newtonian in a teardrop-shaped housing that forms the ball for an ingenious ball-and-socket mount arrangement. Introduced in 1977, the telescope is rugged, highly portable and easy to use and has launched thousands of budding astronomers.

■ SCHMIDT-NEWTONIANS (4-inch to 8-inch)

More properly classed as a catadioptric telescope, the Schmidt-Newtonian will be mentioned here as a footnote to standard Newtonians. Like the latter, the Schmidt-Newtonian has a concave primary mirror and a flat secondary mirror, but unlike conventional Newtonians, it also uses a full-aperture corrector plate to reduce optical aberrations. Although this design boasts a wider field of view and theoretically lower aberrations than a regular Newtonian, the optical and mechanical performance of the Schmidt-Newtonians we have seen has been disappointing. In particular, Japanese-import models (usually 4.5- or 5-inch) sold by mass-merchandisers have exhibited poor optics, and some have also been crippled by dreadful built-in finderscopes.

Perhaps their status will change in the 1990s, but for now, Schmidt-Newtonians have been less than successful commercially and have had little impact on amateur astronomy.

■ THE MAKSUTOV-CASSEGRAIN (3.5-inch to 7-inch)

The only Maksutov astronomical telescope currently on the market is the Questar. (Celestron's C90 Maksutov is a spotting scope; we do not recommend it as an astronomical telescope.) The Questar was introduced in 1954 as a top-of-the-line compact telescope. Nearly four decades later, it still is. Everything viewed through a Questar is wonderfully crisp and totally free of any aberrations. It has been rumoured that the Questar can do things no normal 3.5-inch telescope can do, such as separating close double stars, revealing astounding detail on Jupiter and other feats far beyond the theoretical limit for its aperture. One night, we set up a 3.5-inch Questar beside a Carton 3-inch f/12 refractor and an Astro-Physics 4-inch f/6.5 refractor. The results: The 4-inch beat the 3.5, and the 3.5 beat the 3-inch—exactly as would be expected for three excellent optical systems. The images in the 4-inch refractor were distinctly brighter than those in the Questar and re-

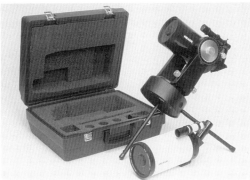

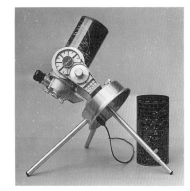

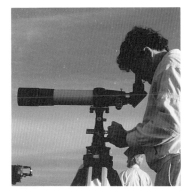

bination of generous aperture, portability, adaptability to astrophotography and all-round good performance has made it the telescope of choice for backyard astronomers. Despite competition from Dobsonians and apochromatics, the Schmidt-Cassegrain remains one of the most versatile telescopes ever produced.

Today's commercial Schmidt-Cassegrains made by the two largest telescope companies, Celestron International and Meade Instruments, have their roots in the amateur-telescope-making heyday of the 1960s. At that time, Californian Tom Johnson was one of the pioneering telescope makers. Lured by the theoretically near-perfect star images that the Schmidt-Cassegrain could produce across a wide field, Johnson built a 19-inch unit himself. This prototype was the forerunner of all Celestrons. In 1964, Johnson renamed his electronics company Celestron Pacific and began making optics—specifically, an economical Schmidt-Cassegrain.

Initially, Celestron's telescopes were intended for educational institutions and wealthy amateurs. In the late 1960s, large 22-, 16-, 12- and 10-inch telescopes were the company's specialty. In 1970, Celestron introduced an affordable 8-inch f/10, the C8. The retail price for the basic telescope, without tripod, was $795. Considering that standard 8-inch Newtonians cost $600 at that time, the C8 was expensive. But because of its compact size and ease of use, many amateurs flocked to the C8.

Celestron first saw serious competition in 1980, when Meade introduced its Model 2040 4-inch f/10 and Model 2080 8-inch f/10 Schmidt-Cassegrains. Meade had started out in the early 1970s selling telescope accessories and good-quality Newtonians, but it soon realized that the future belonged to the Schmidt-Cassegrains. The two companies began selling nearly identical products, and competition for the market was fierce. Throughout the 1980s, Meade and Celestron battled with advertising wars, price cutting and, then, feature wars.

In August 1983, Celestron made some significant changes to its basic 8-inch model by introducing the Super C8. The price was higher, but the Super C8 had several major improvements: a worm-gear drive built by the renowned firm E.R. Byers replaced the inaccurate spur-gear drive that many astrophotographers hated, an 8 x 50 finderscope superseded the often-criticized 6 x 30, and a new wedge allowed easier latitude adjustments.

One month later, advertisements appeared for Meade's answer to the Super C8: the LX (long-exposure) series. These telescopes also boasted a worm-gear drive to aid guided deep-sky photography. Since then, the LX feature has become standard.

After that, the competitors' gloves came off. It seemed that models changed by the month. What-

vealed more planetary and nebular detail and fainter stars. The Questar similarly outperformed the Carton. There are no magic telescopes.

Nonetheless, the Questar is a superb 3.5-inch instrument. Complete with mount, drive, leather case and tabletop tripod, it costs more than $3,000. Is it worth it? Judging by the thousands of owners and its nearly 40 years on the market, it is the right telescope for a large segment of the buying public. Questar also makes a 7-inch model—a scaled-up 3.5-inch that lacks the unmatched portability of the smaller telescope. The $15,000 price tag for the Questar 7 makes it strictly a tool for the affluent.

■ THE REMARKABLE 8-INCH SCHMIDT-CASSEGRAIN

Since 1970, the 8-inch Schmidt-Cassegrain has been the top-selling recreational telescope. A com-

■ *At less than two feet long, all these instruments are ideal for recreational astronomers who need a decent telescope in the smallest possible package. Top right, Questar 3.5-inch f/16 Maksutov-Cassegrain, a beautifully crafted instrument; $3,000 with fitted leather carrying case. Bottom left, Meade Model 2045D 4-inch f/10 Schmidt-Cassegrain, shown in fork-equatorial version with carrying case; $600. (Alongside is the spotting-scope version.) Top left, the Astroscan, Edmund Scientific's 4-inch f/4.3 Newtonian, housed in a distinctive ball-and-socket mount; $350. Above, Tele Vue 3-inch f/7 Oracle refractor; $800 with case but without mount. First three photographs, in the order described, are courtesy Questar, Astronomy magazine and Edmund Scientific.*

ever one company did, the other quickly copied or bettered. Many of these models surface on today's used-telescope market, so here is a quick rundown on some of the older instruments:

☐ Celestron, 1984: Super C8 Plus

This telescope was the same as the Super C8 but had an illuminated-reticle finderscope, a mirror star diagonal instead of a prism type and better adjustment mechanisms on the wedge to aid in polar alignment. It has since been discontinued.

☐ Celestron, 1984: Super Polaris C8

A low-cost ($800 in 1984) entry-level telescope, it has the same tube assembly as other C8s, but the mount is the popular lightweight Super Polaris German equatorial unit made in Japan by Vixen. The Super Polaris C8 is still available, although when it comes to Schmidt-Cassegrains, we generally prefer the fork-mounted models.

☐ Meade, 1985: LX3

A replacement for the standard LX, the LX3 was a fork-mounted high-end model with quartz-oscillator-controlled DC motors, a plug-in control box, reticle output, an 8 x 50 illuminated finderscope and improved wedge adjustments. This telescope set a new standard for features. It originally sold for $1,800, but the price was eventually slashed before it was discontinued.

☐ Meade, 1986: GEM

Meade's short-lived answer to the Super Polaris models was the German equatorially mounted (GEM) telescope. Although still offered in Japan, it

has been discontinued in North America because fork mounts have always been more popular here.

☐ Celestron, 1986: Powerstar

Celestron's $1,700 response to the LX3 featured a DC pulse motor with a separate hand controller. It is still available in a greatly updated version and is a good buy, with most of its extra features being worthwhile improvements over basic models.

☐ Celestron, 1987: Compustar

The ultimate in observing toys, this marvel comes with a computerized data base of thousands of celestial objects and has fast slewing motors that allow it to zip around the sky from target to target automatically. As of 1991, the $3,500 Compustar is still available, but it needs a software upgrade.

☐ Meade, 1987: LX5

The LX4, Meade's response to the Compustar, never appeared. Instead, Meade introduced the $1,800 LX5. It featured an improved control panel with outlets for electric-focus and declination motors, a direction switch for operation in the northern and southern hemispheres, two-times-normal guiding and eight-times-normal scanning speeds, a 9 x 60 finderscope and a 2-inch star diagonal. Both the LX3 and the LX5 were replaced by the Premier series.

☐ Meade, 1987: Modular Telescope

The Modular Telescope series was an entry-level replacement for the ill-fated GEM series. These instruments were no-frills models with fork mounts that were upgradable with various options and sold

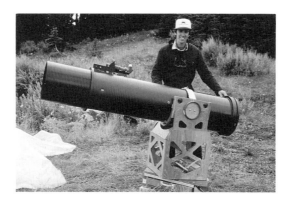

for a base price of $1,000 to $1,300 with mount and drive. They have since been discontinued.

□ Meade, 1988: LX6

The LX6 represented the first major change in the Schmidt-Cassegrain optical design. All previous models had been f/10 focal-ratio telescopes. The LX6 had a faster f/6.3 focal ratio, giving shorter exposures in deep-sky photography and a wider field of view.

□ Meade, 1990: Premier

Meade consolidated its somewhat confusing LX lineup into the Premier series, which retained the f/10 and f/6.3 versions of the telescopes but divided each into three models differing only by the number of accessories included.

■ CURRENT SCHMIDT-CASSEGRAIN MODELS

In addition to the Powerstar and Super Polaris models that have survived the telescope wars and are still offered, Celestron also has new low- and high-end instruments:

□ Celestron, 1988: Classic 8

After concentrating on German equatorially mounted telescopes for its low-end models, Celestron decided that the best entry-level telescope was the one it started with. So the old C8 was brought back and called the Classic 8. It has the same features (or lack of them) as the original 1970s model at essentially the mid-1970s price, making it a bargain in the modern telescope world.

□ Meade, 1988: 2080 Basic

Meade quickly fought back with its own "classic" model by reintroducing the original Model 2080, complete with LX worm-gear drive and tripod, for $1,000 — less than its selling price when it was discontinued in 1984.

□ Celestron, 1988: Ultima 8

In answer to suggestions from practising astrophotographers and major telescope dealers, Celestron introduced the Ultima 8. It features a beefed-up fork mount to reduce shake and vibration, a built-in power supply to minimize tangled cords and now has a microchip that can record manual drive corrections and automatically play them back, reducing tracking error from irregularities in the drive gears. (Celestron calls it the PEC, or periodic error correction.) It is a good telescope for someone keen on astrophotography.

□ Meade, 1992: LX100 and LX200

Dumping its Premier designation after only two years, Meade has returned to the LX insignia. But there are significant changes this time. Responding to requests for more rigid mounts, Meade has introduced beefier fork arms on the new LX models. Periodic error correction (Meade calls it Smart Drive) is standard as well. The LX200 has a new, sophisti-

cated computerized drive that automatically slews to celestial objects on command. The computer also allows the telescopes to track celestial objects in altazimuth mode (i.e., *without* the equatorial wedge), a first in backyard telescopes. Both LX100 and LX200 are available in f/10 and f/6.3 versions.

With two focal ratios available from Meade, a common question is, Which should I buy? The f/6.3 optics suffer from increased curvature of field. The faster optics also come at the expense of a slightly larger secondary mirror, which in any reflector system degrades image contrast to a small degree. Some astronomers argue that the difference is not noticeable. We disagree. For planetary observing, we recommend telescopes with as small a secondary obstruction as possible. However, for photography, such degradation is insignificant and is outweighed by the shorter exposure times that the f/6.3 optics provide. Nevertheless, we prefer the f/10 Schmidt-Cassegrains. If you need extra speed for photography, we suggest adding Celestron's f/6.3 reducer/corrector lens accessory.

■ WHICH IS BETTER, MEADE OR CELESTRON?

A constant question in the minds of buyers is whether Meade or Celestron is better. We have examined images in dozens of Meades and Celestrons, in current versions and in telescopes that date back to their first years of production, and have seen good and bad instruments from both companies. In particular, 1986 to 1989 were not good years for either. Celestron and Meade admit their quality control suffered then, in part because of the aftermath of cranking out units for observing Comet Halley. Hundreds of telescopes that arrived in the marketplace were unable to form clean star images. The word spread, magazines did reviews, and the reputation of the Schmidt-Cassegrain took a beating. Consumer confidence declined and, with it, telescope sales. As a result, Celestron and Meade attempted a merger in 1990. Since the products of these two companies represent about three-quarters of the sales of serious amateur telescopes in North America, the merger application was turned down by the U.S. Federal Trade Commission.

In the end, the answer to the devastation of basic performance in late-1980s models was that both companies instituted sweeping new quality-control standards. The result for the 1990s should be markedly improved telescopes showing little consistent difference in optical or mechanical quality between companies. If Celestron and Meade are vigilant on the production line, the 8-inch Schmidt-Cassegrain will once again become the best choice for an all-purpose telescope.

Whether they are the basic no-nonsense models

■ The NGT (next-generation telescope) from Jim's Mobile Industries features a low-profile split-ring equatorial mount that, considering the 18-inch telescope it is carrying, is very portable. The entire instrument disassembles into several pieces that fit into the rear storage deck of a compact car. The NGT is a top-of-the-line instrument ($9,000) that combines the aperture of Dobsonians with the tracking ability of traditional equatorial Newtonians and is great for astrophotography fans. Other breakdown telescopes at various levels of sophistication and price are now offered by several companies. Photograph courtesy Astronomy magazine.

or the top-of-the-line computerized marvels, today's 8-inch Schmidt-Cassegrains represent a good buy for many backyard astronomers. We have both owned Schmidt-Cassegrains and have derived years of observing pleasure from them.

■ LARGER AND SMALLER SCHMIDT-CASSEGRAINS

While the 8-inch models are the most popular, both Meade and Celestron manufacture other sizes. Celestron offered a 5-inch model until the mid-1980s. Meade still makes its 4-inch Model 2045D, a very compact and versatile unit that features a battery-powered DC motor drive to enhance its go-anywhere functionality.

At the other end of the scale, Meade has 10-inch f/10 and f/6.3 instruments. The price for the f/10 with

minimal accessories is about $2,000. The small price difference between the 8- and 10-inch models lures many buyers to the larger telescope. But don't forget portability and convenience. The 10-inch instrument is about 50 percent bigger and heavier than the 8-inch telescope. Our advice to most people is to stay with the smaller version.

Celestron's C11, now called the Ultima 11, is an 11-inch f/11 Schmidt-Cassegrain (about $3,500) that makes a nice observatory telescope but is nearing the limit of a one-person portable unit. Its tripod is also undersized for a telescope of this weight.

Takahashi has a 9-inch f/12 Schmidt-Cassegrain, and in typical Takahashi style, it is a beauty. Great optics and a solidly engineered German equatorial mount—the EM-200—combine to produce a first-class instrument. But the price is about $6,500, considerably more than similar-sized Meades or Celestrons.

The Celestron C14 is an observatory instrument ($10,000) for the advanced amateur. It has a large aperture but a poor drive; many astrophotographers have had to replace the drive with a custom-built unit. In order to compete with the C14, Meade announced plans for a 16-inch version, but as of mid-1991, the instrument had yet to appear.

Because of the inherent benefits of catadioptric telescopes (aperture and portability), other manufacturers may enter the market in the next few years, perhaps signalling a rise in popularity for Schmidt-Cassegrains. We have seen prototypes of some instruments that, if brought to production, will add yet more choices to an already wide selection. In a volatile market, our best advice is to watch the magazines each month for advertisements and reviews of the latest models.

■ WHERE AND HOW TO BUY A TELESCOPE ■

Now, the final hurdle. After making a selection, or at least narrowing down the choices, the question is, Where do I buy the telescope?

■ DIRECT PURCHASE FROM THE MANUFACTURER

Direct purchase may or may not be a good idea, depending on the manufacturer. Large companies with extensive dealer networks, such as Celestron and Meade, discourage direct sales by charging higher prices at the factory than those offered by dealers. Conversely, some small manufacturers prefer to sell directly to the public and thus avoid a dealer markup. Other telescopes are available at the same price from both dealers and manufacturers.

If there is no dealer network or if no local dealer sells the equipment you are interested in, there

may be no other option than to order directly from the manufacturer. Many smaller producers construct the telescope only after the order is received, rather than store instruments in the warehouse for months or years. Such operations usually require a payment of one-third of the total cost of the instrument when the order is placed. The balance is due when the equipment is ready to be shipped.

Ninety-nine percent of the time, there is no risk in this procedure. But as in any field of manufacturing, companies can go out of business. If this happens while a company has your money, you may be out of luck. To guard against such a contingency, seek recommendations about companies from knowledgeable amateur astronomers.

One indication that a business is in trouble is if its delivery times are far beyond the time quoted when

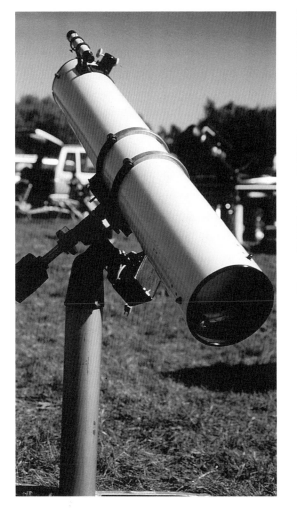

■ Left: Long out of production, the Criterion RV-6 clock-driven equatorial 6-inch f/8 Newtonian was one of the best inexpensive telescopes of all time. Similar classic equatorial Newtonians are still available from Celestron (6-inch f/5), Meade (6-inch f/8 and 8-inch f/6) and Parks Optical (6-inch f/6 and f/8; 8-inch f/6), all on equatorial mounts for $500 to $1,200. They offer good all-round performance in an ideal compromise between smaller-aperture refractors and larger-aperture nonequatorial Dobsonians.

■ Right: The telescope advertising war between Meade and Celestron during the 1980s focused on almost monthly advancements in electronics. Besides giving the instruments a high-tech appeal, most of the new gadgets proved to be practical. The chief advance was the conversion from AC to DC motors, which permit more varied speeds for guiding and slewing and allow the telescope to be powered directly by small batteries. Some models have built-in batteries. Outlets for additional accessories and readouts for digital setting circles are included in many models.

■ TELESCOPE PERFORMANCE LIMITS

Aperture (inches)	Aperture (mm)	Faintest Stellar Magnitude	Best* Resolution (arc sec.)	Highest* Usable Power
2.4	60	11.6	2.00	120x
3.1	80	12.2	1.50	160x
4	100	12.7	1.20	200x
5	125	13.2	0.95	250x
6	150	13.6	0.80	300x
8	200	14.2	0.65	400x
10	250	14.7	0.50	500x
12.5	320	15.2	0.40	600x
14	355	15.4	0.34	600x
16	400	15.7	0.30	600x
17.5	445	15.9	0.27	600x
20	500	16.2	0.24	600x

*Even large telescopes under good atmospheric conditions will not be able to use magnifications more than 600x or resolve better than 0.4 to 0.5 arc second.

More typically, 300x and 1.0 arc second are the practical limits. See Chapter 8 for more information about observing conditions.

■ ABERRANT BEHAVIOUR ■

■ *Right: Evidence that many people share an interest in telescopes and astronomy is provided by throngs like this at dozens of conventions each year across North America. Overall attendance more than tripled during the 1980s.*

■ *Above: A 1950s teenager demonstrates a 60mm refractor, a classic junk telescope similar to the ones sold today that usually have bold lettering on the box that blares: "250-power Astronomical Telescope." But it sells. These trashy telescopes are still bought by the thousands by novices or by well-intentioned parents and spouses. Are these instruments better than nothing? We think the money is more wisely spent on good-quality 7 x 50 or 10 x 50 binoculars with a camera-tripod adapter. Do not be an uninformed consumer when purchasing your first telescope.*

Every optical system exhibits aberrations—distortions that blur the image to some extent. Each telescope design is a compromise; reducing one aberration often increases another. Today's telescope designs are a balance of these five main optical aberrations.

Chromatic: All colours do not focus at the same point, producing coloured haloes around bright objects. Worse in fast refractor telescopes. Once the bane of refractors, this defect has been largely overcome in modern apochromatic refractors.

Spherical: Light rays from the edge of the mirror or lens do not focus at the same point as light rays from the centre, producing star images that never snap into sharp focus and hazy planet images.

Coma: Stars at the edge of the field distort into cometlike blobs pointed away from the centre of the field. Stars in the centre, however, are sharp. Worse in fast optical systems.

Curvature of Field: Stars at the edge of the field do not focus at the same point as stars in the centre. The plane of best focus is not flat but curved, a particular problem in astrophotography.

Astigmatism: Occurs when mirrors or lenses are not made or mounted symmetrically around the central axis. As a result, stars appear as elongated ellipses; especially noticeable in out-of-focus star images, as the direction of elongation flips 90 degrees when you rack from inside of focus to outside of focus.

Optical Aberration	Achromatic Refractors	Apochromatic Refractors	Newtonian Reflectors	Schmidt-Cassegrains
chromatic	yes	low	none	none
spherical*	low	low	low	low
coma	low	low	yes	low
curvature of field	low	low	low	yes
astigmatism*	low	low	low	low

*In well-made optics, spherical aberration and astigmatism are reduced to low levels. While many telescopes exhibit some spherical aberration, the amount is objectionable only in inexpensive or defective optics. Astigmatism is a common trait of optics with an error in manufacture or mounting.

64

the order was received. If possible, find out whether the company has shipped one of its products recently. If someone you know has been waiting for more than six months past the stated delivery date, then exercise caution. However, if the reports reveal that three- or six-month delivery dates have been adhered to, it is probably safe to proceed. One of us waited 20 months for a telescope, but it arrived only a few weeks past the originally stated deadline. Long waits are not in themselves cause for alarm, but repeated broken promises are.

■ MAIL ORDER FROM A DEALER

The major astronomy magazines have dozens of advertisements from dealers selling nationally by mail order. Some, such as Orion Telescope Center and Astronomics, market only telescopes and accessories. Other outlets, such as Adorama and Focus Camera, are deep-discount warehouses that retail mostly cameras, VCRs and other consumer goods but also sell telescopes, often at appealing prices. The mail-order savings may be attractive, but carefully read the fine print about shipping costs, so-called crating charges and other hidden extra fees. Before proceeding, evaluate the differences in personal service and guarantees between local and mail-order dealers. Think of the difficulties that can arise when a defective piece of equipment or an item that needs to be repaired must be shipped back to the originating mail-order dealer or the manufacturer in a distant city.

However, if the price differential makes a mail-order dealer your choice, telephone to determine the shipping charges and any extra costs. If it is still a good deal, do not order immediately. Call your credit-card company, explain that you are purchasing something by mail, and request that the funds not be released until the item is shipped. Most credit-card companies will honour such a request. Then order the equipment, and tell the dealer that the payment will be made only upon shipment. If this is unacceptable, it is a good indication that you should take your business elsewhere. Most mail-order dealers that advertise in the major astronomy magazines are extremely reputable and are interested in volume sales. If the item you request is in stock, it will likely be shipped within 48 hours.

■ PURCHASE FROM A LOCAL DEALER

The safest and usually the most convenient method of buying a telescope is from a local dealer, because you can see what you are getting before you pay and can load the goods into the car and drive away. If the telescope subsequently does not perform as advertised, it can be returned to the store where it was purchased. However, do

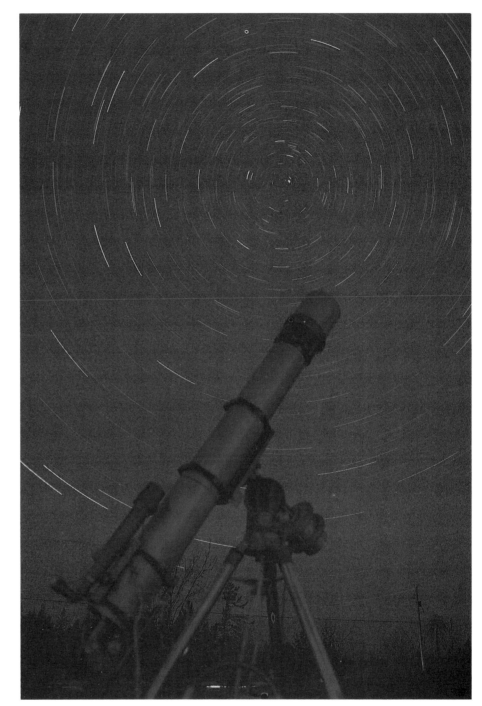

your homework beforehand. If you want something the dealer does not stock, do not accept a substitute without being convinced that it is an equivalent or superior purchase. Exceptions are the generic house-brand eyepieces and binoculars offered by some dealers, which are often identical to name brands but are sold at lower prices.

By thoroughly reviewing the information on equipment we have compiled for this book, you should be well prepared when you walk into any telescope store.

■ *Rather than let this refractor sit idle during a midnight coffee break, Terence Dickinson used a 24mm lens at f/2.8 to make a half-hour exposure of the stars wheeling around the north celestial pole near Polaris, a motion caused by the Earth's rotation.*

Eyepieces and Filters

During the past two decades, both of us have taught introductory courses for recreational astronomers. We soon learned that one thing was predictable: at least one class member would come forward after the first or second session to ask why he or she was having trouble using a telescope that had been received as a Christmas or birthday present. The telescope would be brought to the next class. Invariably, the instrument was a standard department-store beginner's telescope — the same type we unwittingly purchased as our first telescopes.

Apart from the problems of jiggly mounts and worthless instruction manuals, these telescopes are notorious for their poor-quality eyepieces and filters. Usually only one eyepiece of the two or three included — the one offering the lowest magnification — is usable. Our suggestion to the disappointed owner would be to toss the other eyepieces in the trash where they belong, use the low-power eyepiece and forget the filters. These items were added simply to give the appearance of fancy accessories when in fact a single higher-quality eyepiece would make the telescope easier to use.

Many things have changed in amateur-astronomy equipment over the years, but the same almost useless eyepieces and filters are still supplied with telescopes intended for novices or well-intentioned gift buyers. Thankfully, we can report that the situation is the complete opposite with eyepieces available for the more serious telescopes described in the previous chapter. One of the major revolutions in amateur-astronomy equipment that took place during the 1980s was the development of dramatically improved eyepieces and filters. The good news continues in the 1990s: eyepieces and filters are much better than they were a generation ago.

■ EYEPIECES ■

High-quality eyepieces are as essential to observing as a good primary mirror or objective lens. The telescope's main mirror or lens gathers the light and forms the image. The eyepiece magnifies the image. Poor optics at either end of the telescope result in less-than-optimum performance.

On every astronomical telescope, the eyepieces are interchangeable in order to vary the instrument's magnification. Only spotting scopes and binoculars have permanently mounted eyepieces. Most commercially produced telescopes are routinely equipped with only one or two eyepieces to keep the initial purchase price low. Formerly called oculars, eyepieces are the first accessory a telescope owner acquires.

To cut through the jargon, you must understand

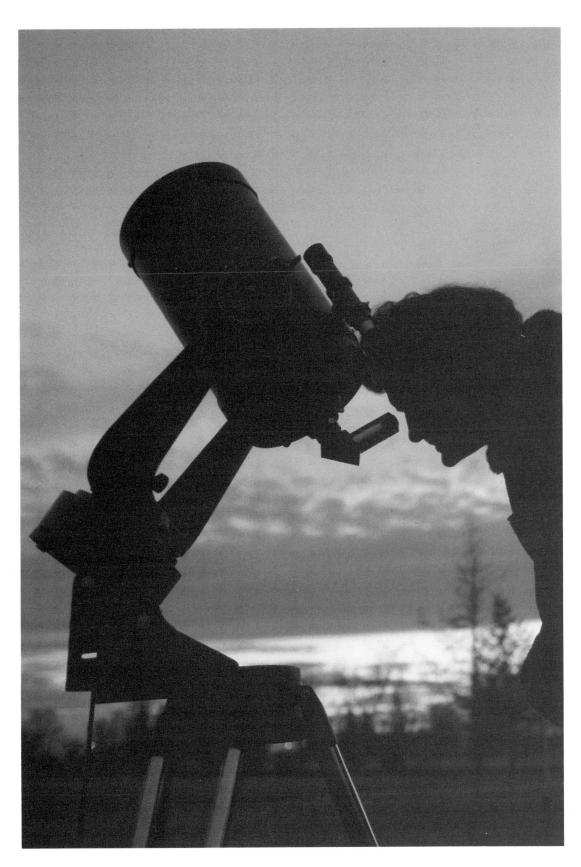

■ *Twilight frames an observer testing a new eyepiece on an 8-inch Schmidt-Cassegrain. Photograph by Alan Dyer.*

■ *Above: A variety of eye-pieces and other accessories. Clockwise from right corner: 1¼-inch star diagonal and hybrid star diagonal (0.965-inch to 1¼-inch); a Barlow and three eyepieces, all 0.965-inch; 0.965-inch eyepiece solar filter; standard and heavy-duty binocular tripod adapters; 1¼-inch nebula filter; 1¼-inch Barlow; dual red-and-white-light flashlight; eight 1¼-inch eyepieces; 16mm Nagler; 32mm Erfle for 2-inch focuser.*
■ *Right: A complete set of Tele Vue Plössl eyepieces from 7.5mm to 40mm focal length. Although each of these top-quality eyepieces has its use, backyard astronomers should avoid the impulse to buy a whole set, regardless of the brand or type. Three or four eyepieces and a good Barlow will satisfy most observing requirements for years.*

the difference between type and brand of eyepiece. The types are based on the design and arrangement of the lenses that constitute the eyepiece; those commonly encountered are Kellner, Orthoscopic, Plössl, Erfle, König and Nagler. Major brands include Meade, Tele Vue, Celestron, University, Orion, Parks, Tuthill and others. Manufacturers occasionally refer to eyepieces by their own trade names, such as Super Wide or Ultrascopic, descriptions that leave the prospective buyer wondering what type of eyepieces they really are. We will try to clarify as much as possible.

■ EYEPIECE SPECIFICATIONS

Like any lens or mirror, an eyepiece has a *focal length* specification, usually indicated in millimetres and marked on the top or side of the unit. A long focal length (55mm to 28mm) provides low power and a wide field of view. A medium focal length (26mm to 13mm) offers medium power and a medium-sized field. A short focal length (12mm to

4mm) produces high power and a small field. To determine a given eyepiece's magnification, divide the telescope's focal length in millimetres by the eyepiece's focal length. For example, a 26mm eyepiece on a 2,000mm telescope yields 77x.

How much sky is seen through the eyepiece depends on the magnification and on its *apparent field of view*. The apparent field of view depends on the eyepiece type as well as the specific design of different manufacturers. If you hold an eyepiece up to the light and look through it, you will see a circle of light. The apparent diameter of that circle (measured in degrees) is the eyepiece's apparent field of view, which is usually given in the manufacturer's specifications. Standard eyepieces, such as Orthoscopics and Plössls, have apparent fields of view of 45 to 55 degrees. Wide-angle eyepieces, like Erfles and Königs, have 60-to-70-degree fields. Extreme wide-angle eyepieces, such as Naglers and Meade's Ultra Wide (Nagler-type), have 82-to-84-degree fields. To find the *actual field of view* in degrees that an eyepiece gives on your telescope, divide the apparent field by the eyepiece's magnification. Taking the example in the previous paragraph, the 26mm eyepiece is a Plössl with a 50-degree apparent field. At 77x, its actual field is about two-thirds of a degree (50 ÷ 77 = 0.65).

Wider fields are generally preferred for deep-sky observing because a larger area of the sky can be viewed. However, because of an aberration in the eyepiece optics called astigmatism, the star images seen toward the edge of wide-angle-lens fields are often distorted. Although wide fields can provide exciting close-up views of the moon, they are not needed for planetary observing. Good views of the planets require freedom from ghost images and internal reflections, often present in multi-element wide-angle eyepieces.

■ EYE RELIEF

The distance the eye must be from the eyepiece in order to view the whole field is called the eyepiece's *eye relief*, an amount that depends on the eyepiece design. With all eyepieces, the higher the power, the shorter (or worse) the eye relief. Most high-power 4mm-to-6mm eyepieces are difficult to look through. For comfort's sake, a longer eye relief is usually desirable, although some 30mm-to-55mm eyepieces have an eye relief so large that it is difficult to position the eye for a proper view. Long eye relief allows the observer to wear glasses when viewing; however, only people with significant astigmatism need to wear glasses while observing. A quick refocus corrects for other vision variables.

Observers who need their glasses, or prefer to keep them on, should select eyepieces with at least 15mm of eye relief, which will permit all or most of

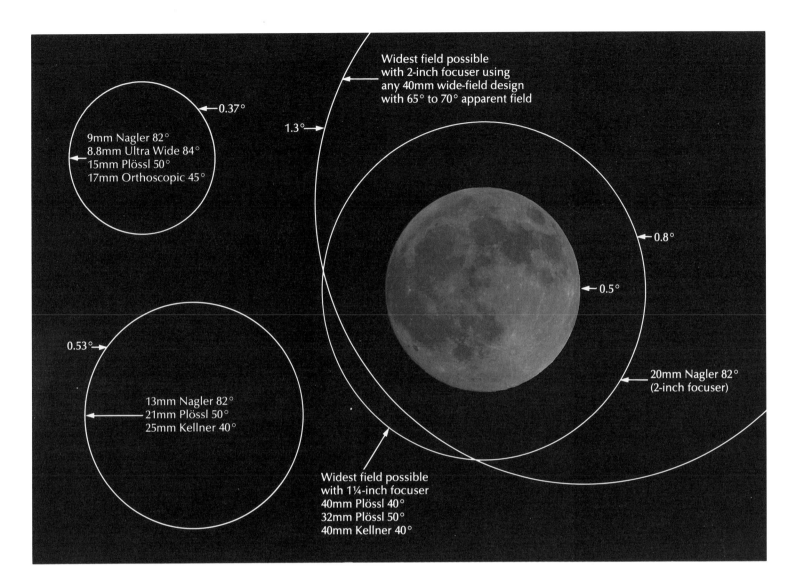

Widest field possible
with 2-inch focuser using
any 40mm wide-field design
with 65° to 70° apparent field

0.37°

9mm Nagler 82°
8.8mm Ultra Wide 84°
15mm Plössl 50°
17mm Orthoscopic 45°

1.3°

0.8°

0.5°

0.53°

20mm Nagler 82°
(2-inch focuser)

13mm Nagler 82°
21mm Plössl 50°
25mm Kellner 40°

Widest field possible
with 1¼-inch focuser
40mm Plössl 40°
32mm Plössl 50°
40mm Kellner 40°

the apparent field to be seen. The glasses may occasionally lightly touch the eyepiece housing; such contact is unavoidable in the dark and works as an aid to gauging proper eye position.

Eyepieces in the 15mm-to-20mm eye-relief range that work well both with and without glasses include most 25mm-to-32mm Plössls, the 21mm Edmund RKE, Tele Vue's 40mm Wide-Field and 13mm Nagler and Meade's 40mm Super Wide and 14mm Ultra Wide. For higher power, try the 21mm RKE or a 25mm Plössl and a 2.5x or 3x Barlow for the equivalent of 11mm-to-7mm eyepieces. Eye relief is increased with a Barlow lens that amplifies the magnification by 1.8x to 3x, making many eyepieces more comfortable for use with glasses. One veteran observer who has astigmatism and must use glasses constantly at the eyepiece employs a 26mm Plössl and one of three Barlows (1.8x, 2.5x and 3x) with an 8-inch Schmidt-Cassegrain (2,000mm focal length) to achieve 77x, 138x, 192x and 230x.

Placing a Barlow *ahead* of a 1¼-inch diagonal

adds approximately 50 percent to the magnification factor. A 1.8x Barlow becomes a 2.7x, a 3x becomes a 4.5x, and so on, an arrangement that is very effective with refractors in the 500mm-to-1,200mm focal-length range. For example, a 1,000mm focal-length refractor can be used at 40x, 100x, 120x, 150x and 180x with one 25mm eyepiece and a 2.5x and 3x Barlow.

An eye relief greater than 20mm is too large for people who do not wear glasses, as they must constantly manoeuvre into the position that offers the eyepiece's full apparent field of view, about an inch from the eye lens. More than 20mm eye relief is found in the 28mm RKE, most Orthoscopics larger than 24mm, Kellners of more than 30mm and Plössls greater than 35mm. However, the distance is measured from the eyepiece's lens surface and can be reduced by extending the eyepiece housing or by adding a rubber eyecup. The latter solution is applied to some Tele Vue eyepieces and to Edmund's 28mm RKE.

■ *An eyepiece's true field of view depends on its magnification with a particular telescope and on its apparent field of view. Examples of several eyepieces' true fields are compared with the moon's diameter (about half a degree) as seen through a telescope of 2,000mm focal length. Note that with eyepieces of the same focal length, the wider the apparent field, the wider the true field.*

69

■ *Top left: Telescope eyepieces are available in three standard sizes rated by the diameter of the part that fits in the telescope focuser: 2-inch, 1¼-inch and 0.965-inch. The 0.965-inch size should be avoided because of the limited selection and availability of good-quality eyepieces.*

■ *Bottom left: A star diagonal in either a 1¼-inch or 2-inch format is a mandatory accessory for refractors and catadioptrics. On some telescopes, the focuser will accept only the 1¼-inch format. In numerous tests, the authors found that a 1¼-inch prism diagonal is just as good optically as a 2-inch mirror diagonal. The advantage of the 2-inch is the potential of a wider field of view.*

■ *Right: Two formats, 1¼-inch and 2-inch, for eyepieces with the same 40mm focal length are shown in side view, top, and from below, bottom. These two eyepieces are designed to give the widest field of view possible in each format. The limiting factor is not the eyepiece focal length but the size of the tube wall where the light from the telescope enters the eyepiece. The 40mm eyepiece in the 2-inch format offers a field of view (both apparent and true) 1.6 times wider than the 40mm 1¼-inch version.*

Eye-relief information is seldom supplied by the manufacturer, but it should be, because it is an important viewer-comfort index. In general, eyepieces of all types in the 12mm-to-26mm focal-length range have excellent eye relief. In shorter focal lengths, the Tele Vue 9mm Nagler and the Meade 8.8mm Ultra Wide have superb eye relief that no other designs can match.

■ THREE BARREL DIAMETERS

The lenses that constitute an eyepiece are mounted in a barrel which slips into the focuser or into the star diagonal of the telescope. There are currently three standard eyepiece barrel diameters: 0.965 inch, 1¼ inch and 2 inch. The 1¼-inch size is by far the most common. All American-made telescopes, as well as an increasing number of imported models, have standard 1¼-inch focusers and eyepieces. Low-cost Japanese-import telescopes use the 0.965-inch standard. The selection and quality of eyepieces available in this smaller diameter are very poor. Anyone with such a telescope should consider switching to the larger 1¼-inch standard. For a refractor, this can be done in two ways. A step-up adapter tube that accepts 1¼-inch eyepieces can be inserted into the eyepiece holder, or attach a hybrid star diagonal prism that fits a 0.965-inch eyepiece holder at one end and accepts a 1¼-inch eyepiece at the other.

The hybrid star diagonal method will not work for a Newtonian with a 0.965-inch focuser. Also, an adapter tube may not be effective, since the eyepiece will be so far removed from the tube that it will not focus. Instead, the whole eyepiece holder and focuser on the side of the tube must be replaced with one that accepts 1¼-inch eyepieces. Check with local telescope dealers for the appropriate adapters and advice, or preferably, avoid buying an instrument with a 0.965-inch eyepiece in the first place, since it is definitely a liability.

The other barrel diameter that is becoming standard is 2 inches. It does not replace the 1¼-inch size because both can still be used. Two-inch eyepieces offer extremely wide fields and low power. Many top-of-the-line telescopes are routinely equipped with focusers for 2-inch eyepieces.

■ EYEPIECE COATINGS

Like camera lenses, all modern eyepiece lenses are coated to improve light transmission and to reduce flare and ghost images. The minimum coating is a single layer of magnesium fluoride that is applied to the eyepiece's two air-to-glass surfaces, giving them a bluish tint. Top-quality eyepieces are now multicoated, a complex process in which several layers of coating material are applied to the lenses to improve light transmission and contrast still fur-

ther. Multicoated lenses, critical for eyepieces with five or more elements, appear greenish, although some have a purple hue. Each air-to-glass surface should be treated. Check the advertisement to see whether multicoating is specified. If it is not, ask the dealer or distributor.

■ MECHANICAL FEATURES

Eyepiece barrels should be internally threaded for filters. Most 1¼- and 2-inch eyepieces have a standard thread that allows many kinds of filters to be screwed into the barrel. A few older eyepiece brands still available secondhand have no threads. Vernonscope uses a nonstandard thread on its Brandon eyepieces; they are good eyepieces and have an extensive line of custom filters, but Brandons cannot be used with any standard-thread filters.

Some eyepiece brands are parfocal, which means that every eyepiece in the series focuses at the same point. Switching eyepieces does not require refocusing. The feature is handy but not essential.

Most eyepiece manufacturers use chrome-plated aluminum for the barrel material. Some eyepieces have chrome-plated brass barrels, making them feel more solid but providing no major advantage over aluminum. Ideally, the inside fittings should be black-anodized as a precaution against lens flares from bright objects outside the field.

A few eyepieces have rubber eyecups, which are good for blocking stray light and for keeping the eye centred properly. In addition, all eyepieces should come with dust caps for both ends.

■ BASIC EYEPIECE DESIGNS

An eyepiece design utilizes a particular combination of lenses of a specific shape. The design determines the field of view and eye relief. With a few exceptions, manufacturers do not have exclusive licence to a design (for example, Plössl eyepieces are sold by several manufacturers). Most eyepiece designs are named for the 19th- or early-20th-century optical experts who invented them.

□ Kellner ($30 to $55)

This has been the workhorse eyepiece design for decades. The eyepiece that comes as standard equipment on most telescopes is a Kellner or a variation of one. It is an economical three-element type that produces average images in a fairly narrow field of view by today's standards—typically, 40 degrees. It works best on long-focal-length (f/10 or longer) telescopes and suffers from some chromatic aberration. Meade has a variation called the Modified Achromat, or MA. Edmund Scientific has a version called the RKE, in which the lens elements are reversed from the standard arrangement, giving it a wider 45-degree field. The RKE is not a true Kellner but is an improvement on the old design. We

recommend the RKE line for its combination of quality and low price ($45).

□ Orthoscopic ($40 to $100)

In 1880, Ernst Abbe, a Zeiss optical designer, invented a four-element eyepiece with a 45-degree apparent field and less chromatic aberration and ghost imaging than a Kellner. The Orthoscopic is still considered by many amateur astronomers to be the best eyepiece for planetary observing. Most manufacturers carry a line of Orthoscopics.

□ Plössl ($50 to $100)

This design has been around for decades and is now enjoying a resurgence as the result of intensive advertising by several manufacturers stressing the advantages of the Plössl. A true Plössl is a four-element design consisting of two nearly identical pairs of lenses (the internal lens elements are slightly altered) and is sometimes called a Symmetrical. The Plössl has a slightly wider field than the Orthoscopic, about 50 degrees, and a shorter eye relief. The best are excellent for all observing tasks, particularly planetary viewing, although eye relief is poor in 10mm and shorter versions. Some manufacturers are marketing eyepieces called five-element Plössls (such as the Meade Super Plössl), which are closer in optical configuration to Erfles but which perform much like the traditional Plössls. The Plössl design produces superb results in focal lengths between 30mm and 15mm with perfect eye relief and aberrations at a minimum.

□ Erfle ($45 to $160)

Invented during World War II, the Erfle is a five-element wide-angle design with 60 degrees of apparent field. Common in longer focal lengths, it is an excellent low-power, deep-sky eyepiece. Ghost images from internal reflections make most models unsuitable for critical planetary observing. All variations on the design suffer more from astigmatism (the aberration that makes stars near the edge of the field look like lines or arcs) than do other types. Some manufacturers have introduced upgraded variations on the original design, generally called Wide-Fields.

□ Nagler ($160 to $350)

This is an amazing eyepiece design that boasts an enormous 82-degree field of view. Unlike in wide-angle designs such as the Erfle, the star images in Naglers are nearly pinpoint at the extreme edge of the field. Once you have looked through a Nagler, you will not want anything else, which is unfortunate because these eyepieces are very expensive.

□ Designs to Avoid

Older amateur-astronomy handbooks regale the reader with references to many other eyepiece variations. Some, such as the Hastings, Monocentric and Tolles, are praised by planetary observers but are so rare that few amateurs will ever encounter

Type	Remarks	Optical Arrangement
Huygenian	A centuries-old design with no redeeming features. Often supplied with so-called beginner's telescopes sold in camera and department stores.	
Ramsden	Another primitive design of little value. A third lens element is added in a design called Achromatic Ramsden, which is somewhat better.	
Kellner	An inexpensive basic eyepiece that works well with f/10 or slower telescopes. Edmund RKE eyepiece is an improvement on the Kellner design.	
Plössl	The most popular modern eyepiece design. Excellent performance, especially in focal lengths from 15mm to 30mm.	
Erfle	Developed during World War II to give a wider field of view than other eyepieces, it later became popular among amateur astronomers.	
Orthoscopic	Once regarded as the best eyepiece available, the Orthoscopic is an optically excellent design but has a narrower field than other modern designs.	
Modern Wide-Field	A modern upgrade of the Erfle design that has less edge-of-field aberrations; excellent low-power eyepiece.	
Nagler	Introduced in the 1980s, this design offers a wider field of view than all other types with excellent suppression of aberrations; Meade Ultra Wide is very similar in design and performance.	

them. Others, like the Huygenian and Ramsden, are so poor, they deserve mention so that they can be avoided.

The Huygenian is familiar to many novices because it is the type fitted to department-store refractors and small reflectors. Marked with an "H," it is a two-element design and one of the first to be invented in the 17th century. Its poor performance (plus the inferior lenses) makes it one of the worst drawbacks of imported beginner's telescopes. Replace it with a set of 0.965-inch Kellners or Orthoscopics at the very least, and use the Huygenians for dust caps or for solar projection.

The Ramsden is another primitive two-element design of little value. A variation adds a third element to produce an Achromatic Ramsden. These are purported to be the same design as Kellner eyepieces (a Kellner is an improved Ramsden), but for a decent, inexpensive eyepiece, stick with name-brand Kellners and the Edmund RKE line.

☐ Zoom Eyepieces

Why buy three or four eyepieces if one zoom eyepiece will do it all? That is the temptation. Unfortunately, even the most costly zoom eyepiece will not replace a good set of individual eyepieces. In our tests, no zoom eyepiece could match the quality of a fixed-focal-length eyepiece, and all are haunted with ghost images.

☐ War-Surplus Eyepieces

Some discount houses sell Erfle eyepieces that have been salvaged from military equipment. They can also be picked up at swap meets and conventions for very low prices. Their major disadvantage is that they do not have standard barrel sizes and will need to be custom-machined. Often, the coatings are poor or nonexistent. Another problem is that some of the old coatings are mildly radioactive.

■ MODERN WIDE-FIELD DESIGNS

In yet another innovation during the 1980s, Tele Vue introduced its Wide-Field line in 40mm, 32mm, 24mm, 19mm and 15mm focal lengths (from $135 to $300). The six-element design of the eyepieces bears a family resemblance to the Erfle. Both Erfles and Tele Vue Wide-Fields have 65-degree apparent fields, but the Tele Vue design produces less ghosting and better imagery across the entire field.

After Tele Vue's success with its Wide-Field, Meade came out with the Super Wide and tried to outmanoeuvre Tele Vue by claiming a 67-degree apparent field. We have tested both brands and find virtually no difference between them in any category, except that some of the Meade eyepieces, especially the 40mm, are a bit lighter. Focal lengths offered by Meade are 40mm, 32mm, 24.5mm, 18mm and 13.8mm (from $120 to $300).

Another eyepiece design similar to the Tele Vue Wide-Field and the Meade Super Wide is the University Optics König—from $75 to $235. (König is a design, not a brand.) The eyepiece is available in 40mm, 32mm, 24mm, 16mm, 12mm and 8mm focal lengths. The 40mm has a 2-inch barrel, the 32mm either a 2-inch or a 1¼-inch barrel. In the 1970s, these eyepieces were considered to be the best. Today, they represent outstanding value. The 16mm, 32mm and a new seven-element version of the 40mm are stellar performers.

The 40mm Tele Vue Wide-Field, Meade Super Wide and University Optics König all offer the maximum possible field of view for the 2-inch format. Advertising claims to the contrary, eyepieces with greater focal length do not provide wider fields of view than these three 40mm designs. An eyepiece's field of view is determined by the aperture that receives the telescope light cone, not by the focal length. If the field aperture is as wide as the inside of the 2-inch barrel, as it is with these 40mm eyepieces, the apparent field will be maximum as well.

■ NAGLER-TYPE EYEPIECES

Al Nagler of Tele Vue caused a sensation when he introduced the 13mm Nagler in 1982. The eyepieces were an instant hit despite costing two to four times as much as high-quality traditional eyepieces of similar focal length. The Naglers' success can be attributed to two important innovations: an extremely wide apparent field of 82 degrees with outstanding sharpness and exceptionally comfortable eye relief for eyepieces of very short focal length.

What Nagler did to produce his revolutionary design was to take an exotic, extremely wide-angle eyepiece design and place a Barlow lens in front of it, something that is more difficult than it sounds. Anybody can combine a 2x Barlow with a 16mm eyepiece to get an 8mm eyepiece with comfortable eye relief, but the result is not a Nagler. He designed his melding of eyepiece and Barlow to operate as a single unit; that is, the aberrations of one cancel out the aberrations of the other, producing exquisitely sharp images edge to edge over an un-

■ *Left: A 2-inch focuser accommodates a 2-inch diagonal that in turn can hold either a 1¼-inch eyepiece (shown here) or a 2-inch eyepiece. This is the most versatile combination.*
■ *Above: The colossal Nagler 20mm, the world's most massive eyepiece, is a wonderful performer, but its weight can unbalance some telescope tubes. It is compared here with a typical 1¼-inch eyepiece. Almost all of the eyepieces sold on today's market, even the most expensive, are made in Japan or Taiwan. Eyepieces may be designed in the United States, but they are still manufactured offshore, sometimes to outstanding levels of quality.*

The kidney-bean aberration is not apparent in other Naglers. In 1987, Tele Vue brought out a series of eight-element Type 2 Naglers that eliminate the kidney-bean effect, making it possible to use them in the daytime. However, Nagler 2s (available in 20mm, 16mm and 12mm focal lengths) have less eye relief than the original Nagler series (13mm, 11mm, 9mm, 7mm and 4.8mm focal lengths).

Although Nagler 2s are relatively comfortable to use, they do not match the superb characteristics of the original 9mm, 11mm (discontinued) and 13mm Naglers or the Meade 8.8mm and 14mm Ultra Wides. Experienced observers will notice that Nagler 2s are not as sharp at the edge of the field as the original Naglers. The 20mm Nagler 2 has two distinctions that may deter backyard astronomers: it is the heaviest (two pounds) and the most expensive ($350) commercially available eyepiece ever produced. (Referring to its mass, one observer calls it "the grenade.") However, in its focal length, it is in a class by itself.

■ THE WORLD OF 2-INCH EYEPIECES

To achieve both long focal length and wide field in an eyepiece, the barrel diameter must be expanded, hence the 2-inch eyepiece. The jumbo size is generally reserved for 32mm-to-55mm eyepieces, although a few premium types, like Naglers, also use 2-inch barrels for shorter focal lengths. For example, a 2-inch eyepiece, such as a 55mm Plössl or a 40mm Wide-Field, on an 8-inch Schmidt-Cassegrain would yield an actual field of view of slightly less than 1.4 degrees. With 1¼-inch eyepieces, the widest field possible would be about 0.8 degree.

When buying a telescope, if you have the option of equipping it with a 2-inch focuser, do so. To move up to the 2-inch world on your present instrument, you must replace the focuser. This is difficult to do with most refractors, and it can be a chore with Newtonian reflectors, but it is easy with Schmidt-Cassegrains. A Schmidt-Cassegrain needs only a 2-inch star diagonal equipped with a lock ring that screws onto the back of the instrument in place of the standard 1¼-inch visual back. These accessories are manufactured by both Meade and Celestron, and they are also available from suppliers such as University Optics. A 1¼-inch adapter allows additional use of smaller eyepieces.

A 2-inch focuser for a Newtonian reflector can be purchased from Meade and from many specialty suppliers of Newtonian telescope parts (Kenneth F. Novak, for example, offers a variety of focusers). Since most 2-inch eyepieces are fairly long, they need to be racked out farther to reach focus. To accommodate this, many 2-inch focusers are tall, often too tall for 1¼-inch eyepieces to rack in far enough to focus. Because every Newtonian

■ *The authors consider a high-quality Barlow a top-priority accessory for any backyard astronomer's telescope. A Barlow is simply a concave lens at the bottom of a tube. Depending on its specifications, the Barlow amplifies the magnification of an eyepiece two to three times. The eyepiece fits in the top of the Barlow, and the combination then slips into the telescope's 1¼-inch focuser. Many amateur astronomers are unaware that two Barlows can be stacked for higher-power applications if no other arrangement can achieve the desired magnification. Also little known is the fact that a Barlow positioned at the forward end of a star diagonal, rather than the eyepiece end, will yield approximately 50 percent more magnification.*

precedentedly wide field of view. Nagler's background of optical-systems design for visual flight simulators and his interest in amateur astronomy created the perfect match for this breakthrough. (Although the Nagler is a specific eyepiece design, the name is used exclusively by Tele Vue.)

Other manufacturers were as impressed as the amateur astronomers using Nagler's new oculars. By 1985, Meade had introduced its competitive line, the eight-element Ultra Wide series in 14mm, 8.8mm, 6.7mm and 4.7mm sizes. With equally high price tags, they are virtual clones of the Tele Vue Naglers. Performance characteristics of the Ultra Wides and the Naglers are very similar. The Meades generally have slightly less eye relief but are lighter because they have aluminum barrels rather than brass. Meade advertises an 84-degree apparent field, compared with the Nagler's 82-degree field, but such small differences are meaningless in practical observing situations. The disadvantage of this class of eyepiece, besides price, is the weight. At about 1½ pounds each, the 13mm Nagler and the 14mm Ultra Wide are heavy.

The original 13mm Nagler also has an unusual idiosyncrasy called the "kidney-bean effect." If the eye is not properly centred over the eyepiece and if the sky is not dark, an elliptical shadow appears at the edge of the field and moves as the eye moves.

Type	Apparent Field	Advantages	Disadvantages	Price
Kellner	35° to 45°	Low cost. Good for long-focal-length telescopes.	Narrow field. Chromatic aberration.	$30 to $55
Orthoscopic	40° to 50°	Good eye relief. Freedom from most aberrations and ghost images.	Narrow field for deep-sky viewing.	$40 to $100
Plössl[1]	45° to 55°	Excellent contrast and sharpness. Best Plössls are better-made than most Orthoscopics, with wider field.	Less eye relief and more costly than Orthoscopics. Slight astigmatism at edge of field.	$60 to $150
Erfle & König[2]	60° to 70°	Wide field of view.	Ghost images in less expensive models. Astigmatism at edge of field in all models.	$50 to $300
Nagler[3]	82° to 84°	Extreme field of view with minor edge aberrations.	Very expensive. Some models are heavy and very large.	$160 to $350

[1]Also Meade's Super Plössls, Orion's Ultrascopics and Celestron's Ultima.
[2]Also Tele Vue's Wide-Fields, Meade's Super Wide and Orion's MegaVista and UltraScan.
[3]Also Meade's Ultra Wide.

is different, it is difficult to recommend any one model of focuser.

Incidentally, the focus point's distance from the side of the tube of a Newtonian can be measured. Aim the telescope at the moon, remove the eyepiece, and hold a white card up to the focuser. When a sharp image of the moon is projected onto the card, the card is at the focus point. Now, figure out whether an eyepiece in the new focuser would be significantly closer to or farther from the measured focus point. When an eyepiece is in focus, its "field stop" aligns with the focus point. On Orthoscopics, Plössls and Erfles, the field stop is the metal ring just inside the bottom of the eyepiece in front of the first lens. On Naglers, the field stop is inside the first lens near the bottom.

■ BARLOW LENS

Barlow lenses are "negative" lenses that increase the effective focal length of a telescope and double or triple the power of any eyepiece. (Meade Instruments calls Barlows Telenegative Amplifiers.) They are available in 1.8x, 2x, 2.5x, 2.8x or 3x magnifications. Combined with a 2x Barlow, a 20mm eyepiece effectively becomes a 10mm one. Barlows can double your eyepiece set if you plan carefully to avoid duplication of powers.

The advantage of Barlows is that they produce high power with longer-focal-length eyepieces, which are easier to look through because they provide better eye relief compared with eye-straining 6mm or 4mm eyepieces. For owners of fast telescopes such as f/4 and f/5 reflectors, Barlows are the only way to achieve high powers. Their disadvantage is that they put more optics into the light path and potentially more aberrations and ghost images. Some people swear by them; purists swear at them. Our tests show that the best multicoated Barlows introduce no detectable aberrations.

Barlows have a wide price range. The most inexpensive are better doorstops than they are lenses. The Barlows included with the less expensive import telescopes fall into this category. We recommend the top-end Barlows offered by Meade, Tele Vue, Celestron, Edmund and Vernonscope, which all sell for $75 to $100. Avoid those with variable magnification, which is accomplished by a lens that slides up and down the barrel; all Barlow lenses are designed to work best at one specific amplification.

In the past few years, some manufacturers have introduced 2-inch Barlows that double the power of 2-inch eyepieces, such as a 40mm Wide-Field or a 55mm Plössl. However, since 2-inch eyepieces are designed to yield low power, they are the ones

■ In 1991, Tele Vue introduced the Panoptic eyepiece, too late to be included in the main text or the table on this page. After testing this eyepiece, we feel that it ranks as an important new development in backyard-astronomy optics. Available in 35mm and 22mm focal lengths, the Panoptic is a low-power, wide-field design—the best yet, in our opinion. The 35mm ($350) is for 2-inch focusers; the 22mm ($275) works with either 2-inch or 1¼-inch; apparent field of both is 68°. What distinguishes the Panoptic is its superior correction of aberrations over the entire field. Seagull- and comet-shaped stars seen at the periphery of all other eyepieces over 20mm focal length are greatly reduced. Tele Vue also offers a special lens to permit use of the Panoptics with Tele Vue's 2-inch Barlow. We do not recommend this. There is no need for all this extra glass. For equivalent performance at higher power, use a shorter-focal-length highly corrected eyepiece, such as a Nagler or Meade Ultra Wide. But before you spend hundreds of dollars on any eyepiece, remember that the more economical Plössls, Orthoscopics, RKEs and others are just as sharp at the centre of the field as the more exotic designs.

■ *Far right: Schmidt-Cassegrains can be equipped with 1¼-inch visual backs, shown here, or 2-inch. A 1¼-inch system and eyepieces are less costly.*

■ *Top and bottom: The 9mm Nagler, one of the finest and most versatile eyepieces you can own, can be used in either 1¼- or 2-inch-format diagonals and focusers. A nearly identical eyepiece of equivalent quality is the Meade 8.8mm Ultra Wide. These eyepieces offer sharp imagery over an incredibly wide field with excellent eye relief, far superior to any other design in a comparable focal length. Of course, all this comes at a price—about $200.*

you are least likely to want to amplify. Giant Barlows are thus of limited visual utility, although they are excellent photographic accessories.

■ EYEPIECE AND BARLOW PERFORMANCE

The purpose of a telescope is to collect light from a celestial object and bring it into focus at the eyepiece or camera lens, depending on the application. In effect, the parallel rays from the celestial source are forced into a converging cone by the main lens or mirror of the telescope. The greater the focal ratio, the longer and skinnier the cone. An f/15 system has a long, narrow cone; the rays at the edge are angled two degrees from those at the centre. In an f/10 system, the edge rays are angled three degrees from the central rays, and in an f/5 system, they are angled six degrees. It is much easier for an eyepiece to accommodate rays at a two- or three-degree angle from the central axis than at a six-degree angle.

Try a typical eyepiece, say, a 26mm Plössl, on an f/15 refractor. The star field is perfectly sharp from edge to edge. Now, use the same eyepiece on an f/5 telescope (regardless of the type); the stars toward the edge of the field are no longer perfect pinpoints but resemble sea gulls or arcs, depending on the inherent aberrations of the telescope and/or eyepiece.

The steeper the light cone, the more difficult it is

to design an eyepiece to suppress aberrations. At f/4, it is impossible. Even at f/5, the best eyepieces still display astigmatism in the field's periphery. It is here that a good Barlow can improve eyepiece performance. The negative lens increases the effective focal ratio by reducing the steepness of the light cone entering the eyepiece. A 2x Barlow reduces the cone's angle by half, so an f/5 telescope becomes, in effect, an f/10—a situation in which any eyepiece would show much improved performance.

■ RECOMMENDED EYEPIECE SETS

Eyepieces are easy to collect. Once you buy one of a series, you may want to own the whole set. In truth, five, six or seven eyepieces are not needed. A set of four will do well, as will two or three to begin with. Brand loyalties sell a lot of eyepieces, but good eyepieces, no matter who makes them, will enhance the performance of any telescope. Here are a few recommendations.

For telescopes that accept only 1¼-inch eyepieces, the ideal low-power eyepiece is a 30mm-to-35mm Plössl. Maximum possible field of view (for a 1¼-inch system) combined with excellent performance make this eyepiece a standout. Our second choice is the 28mm Edmund RKE or a 25mm Plössl or Orthoscopic.

For the lowest-power eyepiece on a 2-inch system, we like the Meade 40mm Super Wide or the University Optics 40mm seven-element König. If a 40mm eyepiece yields more than a 7mm exit pupil on your telescope, then opt for a 32mm such as the University König or the Tele Vue Wide-Field.

In the lower mid-power range (15mm to 22mm), one of our favourites is the outstanding Meade 18mm Super Wide. Alternatively, at least five manufacturers offer 15mm-to-22mm Plössls, any one of which makes an excellent addition to an eyepiece collection. Eyepieces in this class are the ones most often used with a Barlow.

For the upper mid-power range (7mm to 14mm), the Meade 14mm, 8.8mm and 6.7mm Ultra Wides and the Tele Vue 13mm, 9mm and 7mm Naglers are highly rated and outclass the competition—but

at a price. At $200 to $300 each, they are more than double the cost of less exotic glass in the 7mm-to-12mm range. Observers on a more constrained budget could select the Edmund 12mm RKE, Celestron's 12.5mm Ultima (Plössl variation), Tele Vue's 13mm or 10.7mm Plössl or Meade's 12.4mm or 9.7mm Plössl. All are less than $85. Another entry in this category is Orion Telescope Center's 10.5mm Mega-Vista ($110), a good eye-relief wide-angle design.

For high power, we always use a good Barlow rather than a 4mm-to-6mm eyepiece. Eye relief is *much* better, and performance is not compromised. Three thoughtfully selected eyepieces and a Barlow make a versatile collection that will offer a magnification for every observing situation.

Whether your telescope is small or large, refractor, Newtonian or Schmidt-Cassegrain, these recommendations are valid. The only guidelines are the natural limitations of optics which confine the choice to eyepieces that yield a power more than four times the telescope's aperture in inches (to keep the exit pupil below 7mm) or less than 60 times the aperture (the maximum useful power). In practice, the most-used eyepieces are in the magnification range of 7 to 25 times the aperture.

■ COMA CORRECTORS

While aberrations can be reduced to near zero in modern eyepieces, they are still present in the main optics. A Nagler eyepiece on a conventional fast Newtonian still shows some edge-of-field aberrations that make stars resemble tiny comets, the result of coma inherent in the parabolic primary mirror itself. Therefore, the next logical step is to optimize the eyepiece design to cancel out the flaws of the main optics, producing an entire telescope system that is aberration-free. This means a very specialized product "tuned" to a certain telescope type and focal ratio. Enter the "coma killers."

The Pretoria is such an eyepiece. It cancels out the coma in f/4 to f/5 Newtonians but is not for use on other types of telescopes. The stars are clean nearly to the edge of its 50-degree apparent field. A 28mm model is marketed by University Optics.

A coma-corrector lens can be inserted into the optical path of a Newtonian in the manner of a Barlow, allowing for the addition of any eyepiece. Intended for photography, such devices can be used for visual astronomy, although only at low power on f/4 to f/5 Newtonians. At more than $250, however, a coma corrector is a costly way to eliminate off-axis aberrations. Because a corrector must be designed for a specific Newtonian-eyepiece combination, there is no guarantee that it will work at its best on your telescope with your eyepieces. Coma correctors are offered by Celestron, Lumicon and Tele Vue (Paracorr). Although these products work, their main application is in astrophotography.

■ FILTERS

The best accessory for a telescope is a set of first-class eyepieces. The best accessory for the eyepieces is a set of good filters. The difference they make is sometimes dramatic but more often subtle, requiring a trained eye to appreciate.

There are three types of filters for amateur astronomy: solar, planetary and lunar, and deep-sky. Each is very different in construction, but each has the same purpose: to reduce the amount of light reaching the eye. Considering that the goal of every telescope owner seems to be to increase light-gathering power, this may sound strange.

It is easy to understand why a filter is required for observing the sun, and because solar filters are integral to that task, they are dealt with separately in Chapter 9. But the planets? In larger telescopes, planets such as Venus, Jupiter and Mars can sometimes be too bright; a filter cuts down glare without decreasing resolution. A filter can also highlight planetary features by improving the contrast between regions of different colours.

On the other hand, for deep-sky observing, the motto is: "Let there be light!" So how does a filter help? Light from deep-sky objects is usually accompanied by ambient light from sky glow and light pollution. Deep-sky filters block the unwanted wavelengths and admit those from deep-sky objects, improving the contrast between the "signal" (the target object) and the "noise" (the background).

■ FILTER FEATURES

Most filters are mounted in cells that screw into the base of eyepiece barrels. They are available for 0.965-, 1¼- and 2-inch eyepieces. Some filter models are mounted in cells that allow them to be inserted into camera adapters, and some are made to be screwed onto the front of camera lenses. All name-brand filters consist of optical glass with plane-parallel surfaces. Unlike photographic applications, there are no gelatin filters for astronomy. Many current types also have the same antireflection coatings that lenses have. With the exception of the Vernonscope Brandon models, all eyepieces use a standard filter thread, so any brand of filter may be used on any eyepiece. The Brandon eyepieces, however, require either Vernonscope or Questar filters. Some filters have threads on both sides, allowing them to be "stacked," although combining two filters usually

does not produce a more beneficial colour than that achieved with a single filter.

■ PLANETARY FILTERS

Beginners are attracted to planetary filters because they are inexpensive (about $15 each) and come in every colour of the rainbow. As with eyepieces, the temptation is to collect the whole set. You do not need them all. Planetary filters are labelled with the same Kodak Wratten numbers used in photography. A No. 80A blue filter for planetary observing is the same colour as the photographer's No. 80A.

Of all the shades available, the most useful are No. 12 yellow, No. 23A light red, No. 58 green and No. 80A blue. These constitute a good basic set for planetary viewing. A No. 8 light yellow can be substituted for the No. 12, and a No. 21 orange or No. 25 deep red for the No. 23A.

Yellow and red filters increase the contrast between dark and light areas to reveal surface markings on Mars. Green and blue filters do the opposite; they bring out the Martian clouds and haze layers. For Jupiter, a green or blue filter enhances

reddish features such as the Great Red Spot and the dark cloud bands. Observation of the planet Venus can be significantly improved with a blue or violet filter, which reduces its dazzling glare.

However, be warned: the improvement that planetary filters provide is subtle. The contrast between light and dark areas is enhanced only slightly. First, it is necessary to ignore the overall tint the filter imparts and to become accustomed to concentrating on the planetary shadings. If the Great Red

■ PLANETARY FILTERS: A Summary Comparison

Wratten No.	Colour	Object	Comments
1A	skylight	–	Haze penetration; mostly for photography.
8	light yellow	moon	Cancels blue chromatic aberration from refractors; reduces glare.
11	yellow-green	moon	Same as No. 8 but deeper colour.
12 or 15	deep yellow	moon	Increases contrast; reduces glare.
21	orange	Mars	Lightens reddish areas and accentuates dark surface markings; penetrates atmosphere.
		Saturn	May be helpful for revealing cloud bands.
23A	light red	Mars	Same as No. 21 but deeper colour.
25	deep red	Mars	For surface details; a very dark filter.
		Venus	Reduces glare; may reveal cloud markings.
30	magenta	Mars	Transmits both red and violet; blocks green.
38	blue-green	Mars	For clouds and haze layers.
47	deep violet	Venus	Reduces glare; may help reveal cloud markings; very deep colour.
56	light green	Jupiter	Accentuates reddish bands and Red Spot.
58	green	Mars	Accentuates details around polar caps.
		Jupiter	Same as No. 56 but deeper colour.
80A	light blue	Mars	Accentuates high clouds, particularly near limb.
		Jupiter	Accentuates details in belts and white ovals.
82A	very light blue	Mars	For Martian clouds and hazes.
		Jupiter	Similar to No. 80A but a very light tint.
85	salmon	Mars	Similar to orange filter; for surface details.
96	neutral density	moon & Venus	Reduces glare without adding colour tint.
–	polarizer	moon	Darkens sky background in daytime observations of quarter moon.

■ Planetary filters are available for both 0.965-inch and 1¼-inch eyepieces. They are threaded to screw into the base of the eyepiece.

Spot is not visible without a filter, it will not snap into prominence when one is added.

LUNAR FILTERS

The moon can sometimes be too bright as well. A yellow or a neutral-density filter ($15) can cut glare and ease eyestrain. The green "moon filters" supplied with department-store instruments are all right, but one rarely has to worry about collecting too much light in a 60mm refractor. It is in larger telescopes (6-inch and bigger) that lunar brilliance can be annoying. For refractors, a No. 8 light yellow or No. 11 yellow-green filter is also helpful in cancelling the chromatic aberration—a bluish fringe most noticeable on the moon, Jupiter and Venus—present in all but the finest models.

Polarizing filters are useful as simple neutral-density filters for viewing the moon. Their ability to block light waves that vibrate in a particular direction makes them good for sunglasses but has a limited benefit in astronomy. Their main application is to observe the first or last quarter moon in daylight or twilight. Light is most polarized in the region of the sky 90 degrees from the sun where the quarter moon is found. With a polarizing filter (make sure it is rotated for the best effect), the sky background can be darkened, and the moon will be easier to see in the daytime. Some manufacturers offer double polarizers containing two filters that can be rotated separately to create a variable neutral-density filter. Crossed at right angles, the two filters admit only 5 percent of the light. The variable density means that the moon can be dimmed to a pleasing level no matter what its phase.

SKYLIGHT FILTERS FOR SCHMIDT-CASSEGRAINS

A skylight filter cuts through haze by blocking ultraviolet and some blue wavelengths. It has an application in astrophotography but not in visual astronomy. Both Meade and Celestron have a skylight filter that screws onto the back of their Schmidt-Cassegrains, where it serves to seal the tube and prevent dust from collecting on the main optics. Do not bother with this accessory; instead, keep the rear end of the telescope capped when not in use.

DEEP-SKY OR NEBULA FILTERS

Nebula filters, or light-pollution-reduction (LPR) filters, have been called the biggest advance in amateur-astronomy equipment in the past two decades. Viewed by early skeptics as gimmicks, the silvery filters were introduced to backyard astronomy in the mid-1970s and are now considered to be an essential accessory for the avid deep-sky observer.

Much more than pieces of coloured glass, nebula filters are, consequently, more expensive than lu-

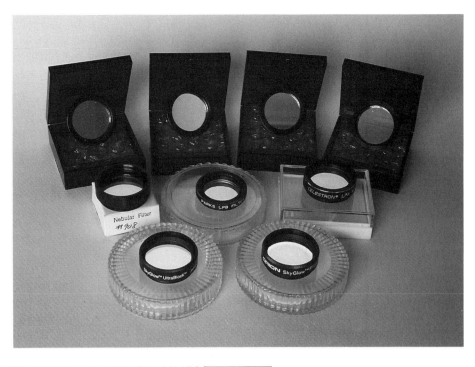

NEBULA EMISSION LINES

Nebulas are bright in these wavelengths.

Emission	Colour	Wavelength
Nitrogen-II	red	658nm
H-alpha	red	656nm
Oxygen-III	green	501nm & 496nm
H-beta	green-blue	486nm

nar and planetary filters; prices start at around $60. The high-tech filters capitalize on the fact that nebulas emit light only at specific wavelengths—unlike stars, which emit across a broad spectrum of colours. Using multiple-layer interference coatings, nebula filters selectively cancel unwanted wavelengths of light, effectively blocking them while letting through the nebular light.

Nebular light results mostly from hydrogen and oxygen atoms. Single gases have very well defined emission lines, as do the gases contained in streetlights. Mercury-vapour and sodium light, which contribute heavily to the light pollution above and around cities, emit only in the yellow and blue ends of the spectrum. Since nebulas emit mostly in the red and green parts of the spectrum, one type of light can be blocked without interrupting the other. That is what nebula filters do.

Three kinds of deep-sky objects benefit from the use of a nebula filter: diffuse-emission nebulas,

■ *An array of nebula filters from various manufacturers. These filters are available in a 1¼-inch format for $60 to $100 or 2-inch sizes for twice as much. Schmidt-Cassegrain owners can obtain filters mounted in a cell that screws onto the back of the telescope. Filters can be purchased in paired sets for use on large binoculars. All are designed to block light except for the wavelengths emitted by atoms in certain types of gaseous nebulas. The result for the viewer is that the sky background is darkened and the nebula appears enhanced in contrast.*

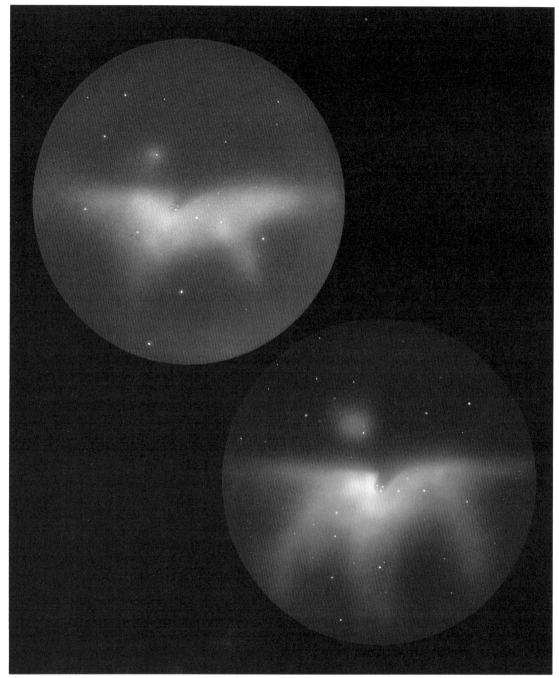

■ *Two views of the Orion Nebula with an 80mm refractor show the difference between light-polluted suburban skies (top) and dark country skies. A similar enhancement occurs with the application of a nebula filter. Although no more stars are seen with a nebula filter, the sky background is darkened, which effectively enhances the nebula's detail. The nebula itself does not become brighter, but it appears that way to the observer. Nebula filters are effective in both light-polluted city skies and dark rural sites. (Orion Nebula's orientation here is different from that seen in photographs because a star diagonal was used.) Illustrations by John Bianchi.*

planetary nebulas and supernova remnants. All emit their own type of light. Some nebulas (those seen as blue in long-exposure photographs) shine only by reflected starlight and do not benefit from nebula filters. Nor do nebula filters help when viewing galaxies or star clusters. Filters will just make these objects and the sky dimmer.

Nebula filters transform a poor, light-polluted sky into a moderately good location (at least for observing emission nebulas) and a good observing location into a great one. Contrary to popular belief, the filters are not just for city dwellers. In fact, their effect is most dramatic under dark skies, because even at the best sites, there is always some sky glow caused by ever present but very weak auroral and air-glow activity that the filter can attack.

■ TYPES OF NEBULA FILTERS

Nebula filters differ in the wavelengths they transmit. Some types let through a broad band of light in the all-important green portion of the spectrum. (The human eye is most sensitive to green, and the majority of nebulas have very strong green emission lines.) Another variety has a much narrower bandpass that blocks unwanted light more effectively at the cost of making some objects appear dimmer.

There are also filters that use bandpasses adjusted specifically for certain objects.

Lumicon manufactures the most extensive line of nebula filters, and its products have become a standard by which others are measured. Competitive models from Celestron, Meade and Parks have bandpasses whose width falls somewhere between Lumicon's broadband Deep-Sky filter and its narrowband UHC filter. On the other hand, Orion's broadband SkyGlow filter is a mild filter similar to Lumicon's Deep-Sky, while Orion's UltraBlock filter is nearly identical to Lumicon's UHC.

Although some manufacturers emphasize how much light their filters transmit at the desired wavelengths, the critical specification is the bandpass. A narrow bandpass will provide higher contrast between nebula and sky, producing a more dramatic improvement than broadband filters.

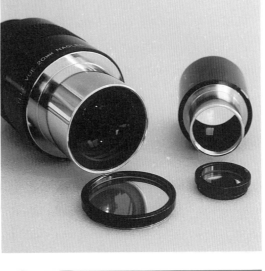

■ NEBULA FILTERS: A Summary Comparison

Nebula filters have become virtually essential equipment for backyard astronomy because they improve the view of some of the best deep-sky objects regardless of light-pollution conditions. All these filters also have a major transmission area in the red portion of the spectrum (around the H-alpha emission line at 656nm). Their main difference is their transmission of wavelengths in the green band (around 500nm).

Type	Bandpass*	Comments
broadband	90nm: 442nm to 532nm	Widest bandwidth and brightest image but least amount of blocking of light pollution. Good for photography. Can be used to some degree on non-nebula deep-sky objects. Examples: Lumicon Deep-Sky and Orion SkyGlow. Good for slow- focal-ratio telescopes.
narrowband	24nm: 482nm to 506nm	Narrow bandpass in green visual spectrum. Darkens sky further with more dramatic contrast between sky and nebula. For more limited range of objects than broadband filter, but a good general-purpose filter for emission nebulas. Suitable for urban locations. Examples: Lumicon UHC and Orion UltraBlock; many filters sold by other manufacturers are similar in transmission characteristics.
O-III	11nm including 496nm & 501nm	A line filter: very narrow bandpass centred on green doubly ionized oxygen emission lines. Highest contrast and maximum blocking of light pollution. Good for planetary nebulas and supernova remnants. Best on fast- focal-ratio telescopes. Sold exclusively by Lumicon.
H-beta	9nm centred on 486nm	A line filter: very narrow bandpass centred on blue-green H-beta emission line. Useful for some nebulas like Horsehead and California. Sold exclusively by Lumicon.
comet	24nm: 494nm to 518nm	Bandpass centred around emission lines of cyanogen gas peculiar to comets. Helps enhance some comets. Sold exclusively by Lumicon.

*Measured in nanometres. One nanometre = 10 angstroms = one-millionth of a millimetre.

■ *Eyepiece filters are threaded to screw into the base of either 1¼- or 2-inch-format eyepieces. Narrowband nebula filters are especially useful in the 2-inch size, where low power and wide field are often desirable.*

Accessories and Observing Aids

In the late 1950s, around the time when the first Sputniks were flying and the world was thrust into the space age, a major toy manufacturer introduced a unique "Luminous Star Locater." The product was a series of clear plastic discs with constellations etched in them. Each disc could be placed in a holder shaped like a small tennis racquet. Batteries and a flashlight bulb in the handle provided power to illuminate the constellation etchings. Outside at night, the observer would hold the device up, look through the disc at the sky and use the illuminated constellation to identify the real stars. It seemed like a good idea.

In reality, it was useless. Unlike the real sky, the illuminated stars were all about the same brightness. Some of the discs showed such a large area of the sky that they had to be held about two inches from the observer's nose. The Luminous Star Locater was, like so many other hobby accessory gadgets, a potentially good idea that was poorly executed.

Some more serious accessories for backyard astronomers are in the same category as the Luminous Star Locater. However, there are many fine products, such as the Telrad zero-power finderscope that adds versatility to virtually every telescope. Here is a guide to some of the more useful items.

■ FINDERSCOPES

One of the frustrations (or challenges) of observing, for both novices and veterans, is finding celestial objects. The better the instrument's finderscope, the easier this will be. With finderscopes, better usually means bigger.

A finderscope is a low-power telescope attached to the main telescope. It makes aiming the main telescope accurately much easier than simply sighting down the tube. Without a finderscope, locating even the moon can be a hit-or-miss operation. Inability to target objects due to a poor finderscope is one of the chief reasons that many people give up on their first telescope and eventually lose interest in observational astronomy. Manufacturers continue to supply inadequate finderscopes because most first-time buyers do not realize why a finderscope is necessary until they use the telescope.

Low-cost department-store telescopes often have atrocious finderscopes. Sometimes, they are no more than hollow tubes with cross hairs. In Chapter 3, we warned about another design that has become common in beginner's telescopes: a flip-up mirror system that uses the main lens or mirror as a finderscope. It sounds good in theory, but in practice, the design fails miserably. It is nearly impossible to see anything. Avoid such telescopes, or at least be prepared to add a proper finderscope.

What is a proper finderscope? Inexpensive telescopes often have a 5 x 24 finderscope. Most are junk. Many have aperture stops inside the tube, cutting the supposed 24mm aperture down to 10mm or 15mm. The reason for this deceptive design is

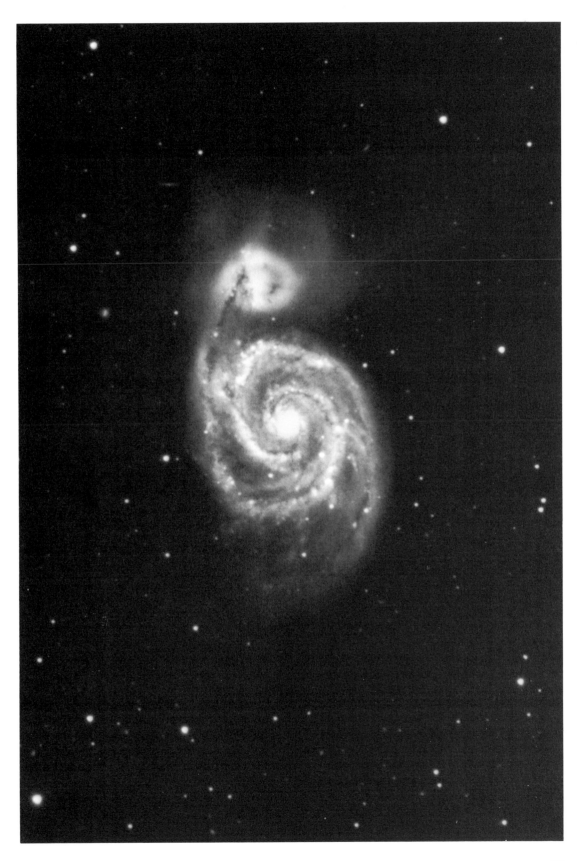

■ *The magnificent Whirlpool Galaxy, M51, is a favourite target for amateur astronomers' telescopes. The companion galaxy, seemingly attached to a spiral arm but actually a separate object, was severely disrupted by a close encounter with the larger galaxy a few hundred million years ago. Photograph by Jim Riffle, using a 12-inch Astromak.*

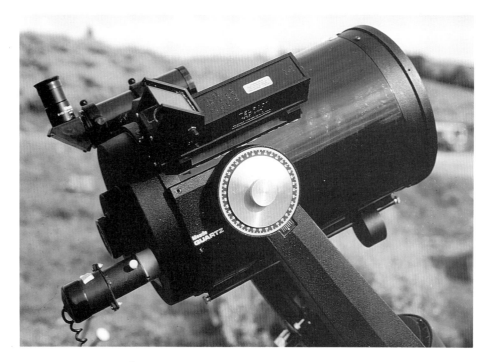

■ *Top: This 8-inch Meade Schmidt-Cassegrain is outfitted with several practical accessories. The 50mm finderscope is augmented with a Telrad zero-power sighting device. Tube counterweights serve to balance the instrument when accessories are added or removed. The manual focuser has been fitted with a motorized focuser.*

■ *Above: The largest telescope accessory is an observatory. This home-built rotating dome observatory housed a 4-inch f/15 refractor in the 1960s. Photograph courtesy Ray Thompson.*

that the finderscope lens is so bad, it cannot be operated at its full aperture of 24mm. If it were, the images would be completely fuzzy. Needless to say, with such a small aperture, it is difficult to see anything dimmer than the moon.

Some of the more expensive telescopes (smaller reflectors and Schmidt-Cassegrains) often have only 6 x 30 finderscopes. These are *just* adequate. They are sufficient for locating bright targets but are limited when you are searching for deep-sky objects. A finderscope with a true 50mm aperture and 7x to 8x is a far better choice.

If a finderscope is to be of any value, it has to be aimed to exactly the same place in the sky as the main instrument. This adjustment is done with the setscrews that hold the finderscope in its bracket. The brackets of inexpensive finderscopes have only three setscrews midway down the finderscope. Trying to aim a finderscope mounted like this is an exercise in frustration. There should be two sets of adjustment screws, front and back, and they should have locknuts to hold the alignment in place.

Another "feature" offered with many finderscopes, even larger ones, is a right-angle prism. It is much easier to look through a right-angle finderscope when viewing objects high in the sky, but the images are mirror images. They do not match the real sky or printed star charts. It can be very confusing to look for identifiable star patterns with a right-angle finderscope, since all the constellation patterns appear flipped left to right. To match a star chart, the chart must be turned over and viewed from the back by shining a flashlight through the paper—not the height of convenience.

In addition, a right-angle finderscope can be awkward because the observer does not look in the same direction as the telescope. With a straight-through finderscope, the real sky can be observed with one eye while the other takes in the finderscope view. Even though a straight-through finderscope is neck-straining near the zenith, we recommend that you stick with it when upgrading. Some finderscopes can switch between either right-angle or straight-through.

If you find that the eyepiece position of a right-angle finderscope is more convenient to use with your telescope, then get one with an Amici prism. This clever bit of optics produces an image that is right side up and correct left to right. The view in the finderscope eyepiece matches what is seen in the sky and in the star chart. Amici prism finderscopes are becoming more common, and it is worth the effort to track one down.

An 8 x 50 finderscope with good optics is adequate for most purposes, even on large telescopes. It can show ninth-magnitude stars but still has a comfortable six-degree field. A 50mm or 60mm finderscope costs $75 to $175, depending on extras such as right-angle prisms and illuminated reticles. An 11 x 80 finderscope costs about $200 to $350.

Too many finderscopes use inexpensive, narrow-field 0.965-inch eyepieces, and better-quality 1¼-inch eyepieces cannot be used on them. It is worth the extra cost for a 1¼-inch model.

All finderscopes come with eyepieces that have cross hairs. A few have a special reticle that indicates where the true north celestial pole is in relation to Polaris. While a polar-alignment reticle does not hurt, precise polar alignment is not essential unless you are doing astrophotography.

Some finderscopes have illuminated reticles, using a battery-operated light on the side of the eyepiece. Most of the models we have seen are not dimmable, limiting their usefulness. Moreover, the tiny camera batteries are expensive, and we have found it too easy to forget to turn off the light at the end of the observing session.

An innovative and very popular finderscope is the Telrad. It is a no-power finderscope without a lens or eyepiece. Instead, it has a simple but ingenious optical system that projects a set of illuminated red circles onto the sky. You sight through a small window and see a naked-eye view of the sky with red bull's-eye circles superimposed on it. The telescope can be aimed very precisely with this system. It beats grovelling in the dirt trying to sight along the telescope tube. The Telrad is manufactured by Steve Kufeld of California and is sold for about $50 by virtually every telescope dealer. Because so little battery power is required for the bull's-eye, the two AA batteries last for many observing sessions.

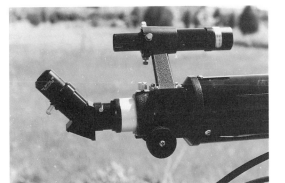

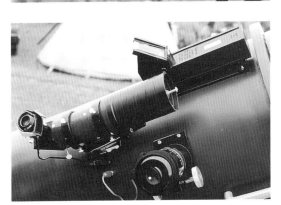

The Telrad is excellent for Dobsonians and is a fine complement to a good 8 x 50 or larger finderscope. Made of plastic, the Telrad is lightweight and does not create much of a balance problem on most telescopes. For locating just the planets and the brightest deep-sky objects, it may be all you need.

■ ANTI-DEW DEVICES

Countless observing sessions are forced to a premature conclusion by dew. It is the vampire of astronomy, silently sucking the life out of a telescope late at night. Every backyard astronomer has cursed the plague of dew-glazed optics that terminated a planet watch during an evening of excellent seeing or fogged an astrophoto.

Even at the driest desert locations, dew is occasionally encountered. As the temperature falls during the night, moisture condenses out of the air onto the optics. A wet lens can cut short an otherwise ideal observing session. Owners of standard Newtonians usually do not worry about dew, since the optics are at the bottom of a long tube that keeps dew from forming, except on the most dewy nights. But for Schmidt-Cassegrains, Schmidt-Newtonians, Maksutovs and refractors, dew can be a drawback the salesperson never mentioned.

The first line of defence is a dew cap, a tube that extends beyond the front lens or corrector plate. Refractors usually come with a built-in dew cap. Schmidt-Cassegrain owners can buy one as an accessory. Or a simple device can be made out of cardboard, foam or plastic. Either way, a dew cap is required for the susceptible telescopes. A dew cap that slides or folds back down the telescope tube for compact storage is the best. Ideally, the length of the dew cap, when fully extended, should be three times the diameter of the main mirror or lens, although a practical limit is often much less.

Dew caps function by maintaining a pocket of air in front of the objective or corrector lens that is slightly warmer than the outside air. This works as long as the temperature is falling and the telescope itself is above ambient temperature. Once equilibrium is reached, dew soon forms on the telescope.

The dew cap usually keeps moisture off the lens for about an hour longer than would be the case without the cap; but if dew is forming elsewhere, it will cover all exposed optical surfaces sooner or later.

The first attack of dew can be eradicated with a hand-held hair dryer. Warm, not hot, air is blown on the affected lens. If the observing site has AC power, a low-wattage hair dryer can be very handy. A hair dryer is good for "zapping" finderscope lenses and eyepieces as well. If you are running on 12 volts DC, use a heater gun sold in automotive stores for melting frost off windshields. It plugs into the cigarette-lighter socket. Some accessory companies, such as Orion Telescope Center, in California, sell this type of heater on the astronomy market.

Handy as it is, the hair dryer is only a stopgap measure. The optics always fog up again. On very humid nights, this method is just not enough. Every 10

■ *Top left: The authors highly recommend the Telrad finderscope, a simple but elegant device that makes any telescope easier to use. It projects a red bull's-eye onto the angled glass plate. The observer looks through the glass at the sky and moves the telescope to align the bull's-eye with the target object.*
■ *Top right: A good basic finderscope has a minimum aperture of 30mm and six fine-adjustment screws to allow a firm alignment in parallel with the main telescope. Three screws and a pressure-fit arrangement, centre, are acceptable but usually less rigid.*
■ *Centre: A 45-degree erecting prism provides upright images for daytime land viewing and low-power astronomical observing. At higher power, the prism introduces undesirable split images. Some smaller refractors have 45-degree erecting prisms, rather than astronomical diagonals, as standard equipment.*
■ *Bottom: Homemade low-voltage heaters keep dew and frost off the finderscope and eyepieces of this Newtonian. Note internal wiring and plugs.*

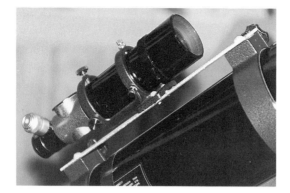

minutes, the procedure must be repeated—then every 5 minutes, then 3, then fold up the tripod and call it a night. Once the telescope has donated all its heat to the air and the air temperature is stable, dew forms very quickly and the hair-dryer method ceases to be effective. In any case, heat from a hair dryer affects the optics and is detrimental to any observing for which good seeing is important. Furthermore, a lens surface seems to accumulate sticky, hard-to-remove dust more quickly when warm air is forced over it from a dryer. This is probably due to tiny particles of wet dirt being heat-dried.

But dew does not have to be the curse that most backyard astronomers think it is. You can observe all night without being sent packing by moisture. The trick: a low-voltage heater. The telescope can be dripping with dew, and the optics stay dry. Orion Telescope Center offers low-voltage heaters for heating the corrector plate of 8-inch Schmidt-Cassegrains, but apart from that, there has been no interest in making this product available for other telescopes. The reason may be that most telescope-accessory suppliers are based in California, where dew is a minor nuisance rather than the scourge it is in the eastern half of North America.

A few companies sell wraparound low-voltage coils, both for main optics and for eyepieces, that plug into AC or DC sources. These contain resis-

tance wires that get warm under current. The extra warmth around the optics keeps dew from forming. But a telescope properly equipped with heaters can entangle the observer in cables.

Do heaters affect the telescopic image? We use heaters regularly on all exposed optical surfaces and find that the critical surface area is the objective or corrector-plate heater. If there is too much heat, seeing is degraded; too little, and dew encroaches. But once a happy medium has been achieved, there are no ill effects. A $3,000 telescope can be heater-equipped front to back, including eyepiece, finder-scope and/or Telrad, for about $150.

Not only is dew a nuisance, but it can damage the coatings on mirrors and lenses. Our industrial civilization has, in many parts of the world, changed some dew into acid dew, a cousin to acid rain. This stuff attacks coatings on lenses and mirrors and is especially brutal to enhanced silvered mirrors on Newtonians. Such silver coatings have become common since backyard astronomers have discovered the advantages of high light throughput. (A high-quality enhanced silver surface with proper overcoatings reflects 95 to 98 percent of the incoming light, compared with 88 percent for aluminum coatings, the standard for many years.)

Protective overcoatings on mirrors are similar to coatings on lenses, and all are equally susceptible to acid dew. The difference with silver is that once the protective coating has been damaged, the enhanced silver layer underneath is extremely vulnerable to tarnishing from acid dew. Lenses and aluminized mirrors stand up much better. In northeastern North America, where acid rain and acid dew are common, enhanced silver coatings are not recommended for Newtonians, in which the optics are exposed to the air. Owners of Schmidt-Cassegrains or Maksutovs with enhanced silver coatings should ensure that the tube is always closed to outside air, either with an eyepiece in place or a plug to prevent air exchange.

Heaters on Schmidt-Cassegrain corrector plates, refractor objectives and eyepieces are the best way to prevent dew formation in the first place and thus

avoid the problem altogether. Sometimes, a heavy dew will unavoidably condense on optical surfaces, but the less this happens, the better. Telescopes in observatories are far less likely to be plagued by dew. The threat of acid dew is a major reason to consider a shelter for your telescope.

■ POLAR-ALIGNMENT AIDS

Equatorial mounts must be polar-aligned. Very precise alignment is required only for astrophotography or when using traditional setting circles—two things we do not recommend for beginners. But when accurate polar alignment does become necessary, a few accessories help.

No matter what technique is used for polar alignment, you still need some way of aiming the mount precisely. This means a fine horizontal, or azimuth, motion and a vertical, or altitude, motion. Recent deluxe-model Schmidt-Cassegrains have these adjustments as standard equipment. Many older telescopes and economy mounts do not—a definite deficiency. Most of the new, better-quality German equatorial mounts have fine-alignment controls as well. (Do not confuse these with the slow-motion controls for moving the telescope across the sky. The polar-alignment adjustments are located at the base of the mount where it attaches to the tripod.)

For Schmidt-Cassegrains that lack the fine-adjustment feature, it might be possible to add an accessory kit to the wedge assembly which will allow the wedge to be tilted up and down with the turn of a threaded shaft. Or the old nonadjustable wedge can be replaced with a newer model that has controls for both azimuth and altitude adjustments. Such controls are much better than kicking the tripod or finding bits of wood to prop up a leg. For older-model German equatorial mounts (such as those on Newtonians), there are no retrofit accessory kits, so make sure you have lots of bits of wood.

Some of the newer German-style equatorial mounts imported from Japan and sold with U.S.-brand telescopes have the option of a small polar-alignment finderscope, which is located not on the telescope but right in the mount, aimed up the polar axis. It comes equipped with a reticle (sometimes illuminated) that makes it easier to find the true north celestial pole. This can be tricky to learn to use, although once mastered, it does work. For visual observing, simply getting Polaris close to the centre of the polar finderscope's field of view—within one degree of true celestial north—is good enough.

■ INVERTORS/DRIVE CORRECTORS

These electronic "black boxes" are becoming a thing of the past. A growing number of telescopes are now sold with DC stepper motors for clock drives. They run directly from batteries. If you have one of these

telescopes (such as the Celestron Powerstar or Super Polaris or the Meade Premier series), you can ignore this section. However, a telescope with an AC synchronous motor drive (like Celestron's Classic 8) presents a problem: Where can it be plugged in out in the field? The solution is an invertor.

An invertor converts 12 volts DC into 110 volts AC, allowing a telescope's AC clock-drive motor to be run with a car battery. Invertors can be purchased at recreational-vehicle sales outlets (they are used to run appliances with vehicle batteries). However, most telescope dealers sell models manufactured specifically for the low-wattage requirements of telescopes. Invertors are also simple drive correctors in that they include push-button controls to vary the speed of the motor. The controls are only for photography, though, and are of no use when slewing the telescope around the sky, since the speed adjustment is very slight.

A low-priced invertor/economy drive corrector costs about $75. More elaborate drive correctors, with quartz-locked control and dual-axis output, are overkill for visual observing. Such sophistication is needed only for astrophotography. When purchasing an invertor, make sure it comes with the cable necessary to plug it into the cigarette-lighter socket. The cable should be long enough to allow the telescope to be set up at least six metres from the car.

■ POWER PACKS

If the mount is driven by DC motors, it probably came with a small battery pack that uses several penlight batteries. These are not long-lived. D-cell batteries are really the practical minimum for drives. They usually last through several long observing sessions. But the best plan is to get the appropriate cable to plug the drive into the car battery. Or purchase a larger-capacity rechargeable pack that will be good for several nights' use before it needs to be recharged. The separate heavy-duty battery pack allows the telescope to be set up anywhere; it need not be tied to the car.

■ RED FLASHLIGHT

You don't realize how essential this accessory is until you forget it one night. There you are, far from home, with no flashlight. How do you read star charts? If you cannot read star charts, how do you find anything? Equipped with thousands of dollars' worth of instruments, you are lost in the stars for want of a $5 flashlight.

You can buy an "astronomer's flashlight," but any pocket flashlight will do. Better yet, buy two. Paint the bulb red using nail polish, or cover it with red cellophane, red paper (or even brown wrapping paper) or a red gel available from art-supply stores. A red LED light is even better. It should not be bright;

■ Accessories from Roger W. Tuthill, Inc. on an 8-inch Schmidt-Cassegrain include an 80mm finderscope, Solar Skreen full-aperture solar filter and a binocular viewer. The latter permits viewing with two eyes. It works well on the moon and Jupiter, but deep-sky objects seem brighter and more contrasty without it.

■ *Above: Where an observatory might not be practical, a protective shed may be the answer for a bulky telescope such as this Celestron 14-inch Schmidt-Cassegrain. Backyard astronomer Don Primi keeps the telescope ready for action and rolls it out on tracks for a two-minute setup.*

■ *Top left: Homemade chart tables are wonderful observing aids. Depending on the type of charts you prefer, the table can be illuminated from above or below.*

■ *Top right: A custom-made eyepiece-and-accessory box has positions for 10 eyepieces and Barlows as well as miscellaneous gear. The box is internally illuminated and wired for low-voltage heaters powered by household current. On a chilly evening, it is a pleasure to reach in for toasty eyepieces.*

■ *Bottom left: The most important inexpensive observing accessory is the red flashlight. You should have several, including a very deep red one for maintaining good dark adaptation. Although red nail polish or cellophane will work to filter the light, red gel and red paper are the preferred materials to get the light a deep red.*

■ *Bottom right: Many telescopes benefit from vibration dampeners that significantly reduce instrument vibration when placed under tripod legs.*

ideally, it should be dimmable. Buy a flashlight small enough to hold in your mouth so that both hands are free. The light should be made of plastic, because metal flashlights often become too cold to touch in winter. Flashlights with dual red and white lights are handy; a bright white light is good for setting up and dismantling equipment.

■ MANUAL SLOW MOTIONS

If the telescope has no slow-motion controls, it will have to be nudged every few seconds. Try moving the telescope a fraction of a degree to centre an object. It depends on the mount, but chances are, it will be difficult. To eliminate the inconvenience, quality mounts should include slow-motion controls as standard features (the exception is a well-made Dobsonian mount—it does not need them). A few older German equatorial mounts (the Meade research-grade Newtonians, for example) offered manual slow-motion controls as an option. It is an option worth having. A local dealer may be able to retrofit a telescope with slow-motion controls (at least in the declination axis, the one that moves the telescope north and south).

■ VIBRATION DAMPENERS

In 1989, a new telescope accessory appeared on the market, one that is sure to become a necessity for many amateurs: vibration suppression pads. These small pads are placed under the legs of a telescope tripod. A ring of rubber set in high-density metal ab-

sorbs vibrations and prevents them from being transmitted up the tripod leg. Tripods and mounts should ideally be massive enough not to require such dampening aids, but that is rarely the case. At $60 for a set of three, these pads are a useful addition that reduces image shake in portable mounts.

■ OBSERVING CHAIRS

Treat yourself to a place to sit while observing. If possible, lower the telescope so that the eyepiece is at eye height when you are seated. The increase in comfort is sheer luxury. The best observing chair is a stool with adjustable height. It should also fold up for easy storage. The stools sold in music stores for drummers are very comfortable, although not tall enough for some telescopes. Large instruments such as 17.5-inch Dobsonians, however, require an observing ladder. A small kitchen stepladder may be just the thing for reaching the eyepiece when aiming at the zenith.

■ CARRYING CASES FOR ACCESSORIES

When you have collected a number of accessories, you will need a proper case to carry them all. A cardboard box will last only so long. For eyepieces, filters and other small items, check the local camera stores. They offer all kinds of camera cases. Avoid those which have several layers of compartments; the briefcase style is the best. Some have compartments with movable dividers; others have

foam that can be cut out as needed; many have foam with precut squares that can be removed. (The latter type tends to fall apart with use.) The foam interiors provide the best cushioning, although they make it more difficult to change layouts if additional accessories are acquired.

■ OBSERVING TABLE

Many observers have found it convenient to take a small folding table to the observing site to hold star charts, books and paraphernalia. Without one, observers are forced to work off truck tailgates or out of car trunks. Some do-it-yourselfers have designed ingenious illuminated work stations, with every observing need at hand. Certainly, anything that reduces fumbling around in the dark is a welcome convenience, as long as it does not require an inordinate effort to set up in the first place.

■ TOOL KIT

A kit containing all the screwdrivers or wrenches your telescope may require can be an essential item. After a jostling road trip, parts come loose, optics need collimating and bolts require tightening. A packet of lens-cleaning tissue should also be in every camera- and telescope-accessory case. Throw in some tape as well—it is amazing what a roll of tape can fix. Don't forget the insect repellent. Mosquitoes love astronomers. But that insect repellent can be a nuisance, too, when it greases up the telescope's knobs and buttons. Worse, it can eat into optical coatings and some of the simulated leather material on binocular bodies and cases.

■ OBSERVATORIES AND
TELESCOPE STORAGE

Telescopes are pretty rugged instruments and, if handled with reasonable care, can last a lifetime. However, some telescopes are more maintenance-free than others. There are three basic storage situations for telescopes: portable telescopes usually kept in the home; portable but bulky instruments stored in a garage; and permanently mounted equipment in an unheated observatory.

The key to effective storage is avoiding moisture. Moisture attacks the surfaces of mirrors in reflector telescopes, the coatings on lenses in refractors and eyepieces and the metal parts and fittings of telescope mounts. If the observatory is located in a dry climate, such as the U.S. Southwest, the problem encountered more often than moisture is dust. Elsewhere on the continent, prolonged periods of dampness are inevitable.

Small observatories seem to be more prone to dampness than larger ones, and wood structures are usually less damp than concrete or brick, because the wood itself absorbs moisture on damp days and

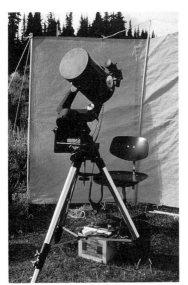

releases it in dry weather. One precaution is to have an enclosure that is as airtight as possible—it will keep dust, snow and other material from blowing in. A modest amount of electric heating from time to time, just to have the inside temperature slightly warmer than the outside, can greatly reduce moisture problems. An alternative to heating the whole building is to install permanent low-voltage heaters near the optical elements.

Storage for portable telescopes should be inside the house, but not in a basement location prone to moisture problems, condensation or mildew. Because of space limitations, a garage or shed is often a necessary storage facility. One advantage of unheated garages and sheds is that the telescope remains close to outside temperature, reducing the wait for the optics to reach the temperature stability required for optimum performance.

■ *Top left: One of the most functional and economical observatories is the split-roof roll-off design. It avoids the costly construction of a dome, yet the roof can be opened only partially to afford protection from wind and stray light. Photograph by James Rouse.*
■ *Above: Wind protection is sometimes essential. Equally important is the observer's chair—an observing aid too often ignored.*
■ *Centre: A unique portable observatory, designed by amateur astronomer Doug Clapp, fits into a car trunk when disassembled. Once at the observing site, it can be set up in minutes, bottom, to provide a dry, windproof protective environment.*

Nine Myths About Telescopes and Observing

You hear them and read them so often that you think they must be true. But they are not. These are what we call the "telescope myths" — general statements widely accepted as truths and passed down from experienced amateur astronomers to beginners in a cycle that has been going on for generations. Some of the myths are half-truths, some are vaguely based on facts, and others are just bunk. Here they are:

■ TELESCOPE MYTH #1: SPLITTING CLOSE DOUBLES IS A TEST FOR GOOD OPTICS

The first thing many telescope owners do to "test" their latest acquisition is select from a double-star list a very close pair at the resolving limit of the instrument, known as Dawes' limit. If the telescope splits the two stars, the optics are proclaimed good.

Many experienced amateurs do not realize that the double-star test is not conclusive. Just the opposite is true. Sometimes, inferior optics can split a double star that a superb telescope shows as barely double. The explanation is found in the Airy disc.

At high power, a telescope shows a fairly bright star not as a point but as a tiny disc (the Airy disc). This is due to the physics of optics. We need go no further here (for details, see Appendix) except to say that a good telescope puts as much light as possible into the Airy disc. Perfect optics will put 84 percent of the light into the disc; the other 16 percent goes into the surrounding diffraction rings. In a good tele-

scope at high power, a star looks like a miniature, faintly ringed bull's-eye. Poor optics put more light into the rings and less into the Airy disc.

For example, 1/4-wave optics, considered reasonably good for backyard astronomy, concentrate 68 percent of the light onto the Airy disc and 32 percent onto the rings. The result? The Airy disc decreases in size, and the rings brighten. This is not good for overall resolution of detail in extended objects, but it can help split double stars, especially pairs of equal magnitude. Good optics should certainly be able to split close doubles, but it is not a test. The fine details on Mars, Jupiter and Saturn are the real test objects.

■ TELESCOPE MYTH #2: HIGH POWERS ARE FOR PLANETARY VIEWING; LOW POWERS ARE FOR DEEP SKY

The standard rule was always: Deep-sky objects (being faint and extended) are best seen at low power, while high magnification is reserved for looking at the moon and the planets. Well, the latter is mostly true. The moon and the planets usually do require high power to bring out fine detail. Even so, experienced observers often keep magnification below 30x per inch of aperture and learn to pick out detail in the smaller, higher-contrast image. Even under excellent conditions, the contrast and image sharpness on the moon and the planets are best

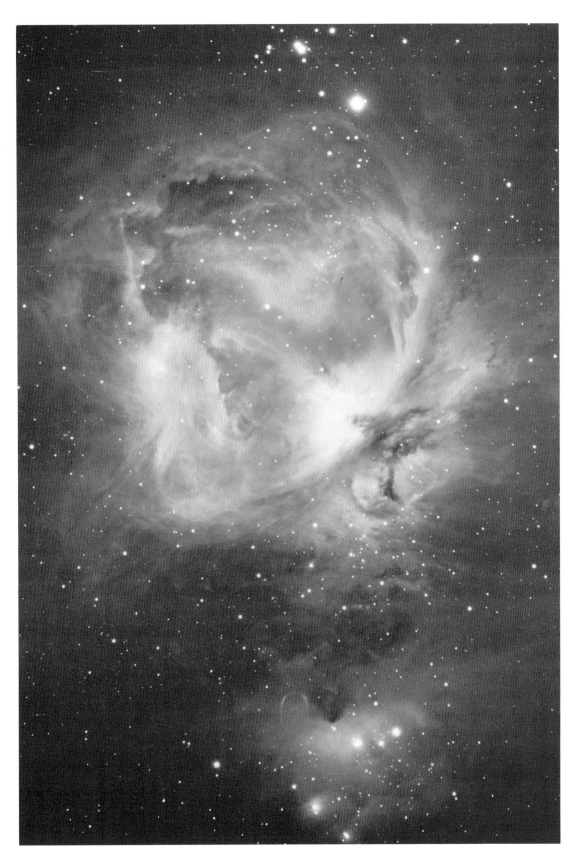

■ Intricate overlays of delicate tendrils of gas make the Orion Nebula one of the most observed and photographed celestial objects. The nebula is about 25 light-years wide and 1,500 light-years from Earth. This remarkably detailed photograph was taken by Mike Sisk with a 24.5-inch Astro Works Schmidt-Cassegrain.

91

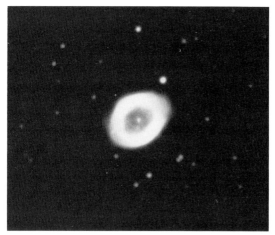

at moderate powers—in the range of 25x to 40x per inch for smaller telescopes and 15x to 30x for larger ones (8-inch or more).

For deep-sky objects, an even greater range is useful. True, some deep-sky objects look best at the telescope's lowest power, but many improve with magnification. High power, similar to that used for viewing planets, can enhance contrast in deep-sky observing. It darkens the sky background and enlarges the object enough that details are easier to see—sometimes. The best plan is to experiment. However, here are a few guidelines.

High power works best on small deep-sky objects such as planetary nebulas and galaxies. It may not do anything for large, diffuse nebulas. This is one type of observing in which there is a clear advantage offered by premium wide-angle eyepieces like the Tele Vue Naglers and Meade Ultra Wides. They provide relatively high power without sacrificing too much field of view.

■ TELESCOPE MYTH #3: IMAGES APPEAR BRIGHTER IN FAST TELESCOPES

This is a common myth, even among longtime amateur astronomers. Many people mistakenly believe that short-focal-ratio, or "fast," telescopes (f/4 to f/6) provide brighter eyepiece images than long-focal-ratio (f/8 to f/15) telescopes, making the "slow" ones unsuitable for deep-sky viewing. This myth is reinforced in advertisements which claim that f/6 telescopes have "images, both visually and photographically, that are two times brighter than with an f/10 system." This is wrong, at least as far as the visual performance is concerned.

To demonstrate, take two 6-inch telescopes of the same type. It does not matter whether they are refractors, Schmidt-Cassegrains or Newtonians. One could be an f/5 short-focal-ratio instrument, the other an f/10 long-focal-ratio telescope. Put an eyepiece in each that will give the same magnifi-

cation, say, 75x. Now, aim both at a faint galaxy. Does the image look dimmer in the f/10 instrument? No. The images will be exactly the same brightness and size. The reason is simple. They are both 6-inch telescopes, collecting the same quantity of light and magnifying the image by an equal amount. The only real difference in our comparison is that to achieve 75x with the f/10 telescope, we had to use a 20mm eyepiece. In the f/5 telescope, a 10mm eyepiece was needed.

The confusion arises because the statement "images appear brighter in fast telescopes" is true for astrophotography; fast telescopes do provide brighter prime-focus images on film, permitting shorter exposures. But for visual work, in which the magnification (and hence the brightness of the image) can be varied by changing the eyepiece, the faster-is-brighter statement is meaningless.

Therefore, contrary to popular belief, long-focus telescopes can be used for deep-sky viewing, especially when equipped with a low-power eyepiece (such as one with a 40mm-to-55mm focal length). The drawback is that it is difficult to reach extremely low powers and very wide fields with f/10 to f/16 telescopes, which hampers views of deep-sky objects that extend over a large area. This is the real reason that deep-sky fans are advised to stick with fast-focal-ratio instruments.

■ TELESCOPE MYTH #4: LONG-FOCAL-RATIO TELESCOPES ARE BEST FOR PLANETS

This statement was true when the only telescopes used by backyard astronomers were Newtonians and achromatic refractors. Crisp planetary images require superior optics. Since short-focal-ratio mirrors and lenses are more difficult to manufacture than long-focal-ratio optics, it follows that long-focal-ratio telescopes would be the instruments with the best optics and would therefore provide the best planetary images.

But today, the situation is more complex. New-generation f/5 to f/9 apochromatic refractors equal or exceed the performance of the older f/15 models. In theory, and usually in practice, an 8-inch f/8 Newtonian, because of its smaller central obstruction (the diagonal mirror), is superior to an 8-inch f/10 Schmidt-Cassegrain for planetary observation.

Some purists maintain that a short-focal-ratio telescope—say, a 6-inch f/6—cannot be used conveniently at the high power required for planets because eyepieces as short as 4mm are needed to reach appropriate magnifications. For some reason, such proponents shun the use of a Barlow lens in front of the eyepiece, which would at least double the eyepiece's magnification. But today's top-grade multicoated Barlows do not degrade optical perfor-

■ Above: A myth perpetuated by erroneous telescope advertising in the 1980s suggests that short-focal-ratio telescopes, often called "fast" telescopes, like this f/5 Newtonian, produce brighter images than equivalent-aperture telescopes of long focal ratio. See Myth #3. Photograph by Alan Dyer.
■ Right: Many deep-sky objects, such as the Ring Nebula, have subtle detail that requires not only aperture but also good optics for detection, as noted in Myth #5. Photograph by Brian Tkachyk.

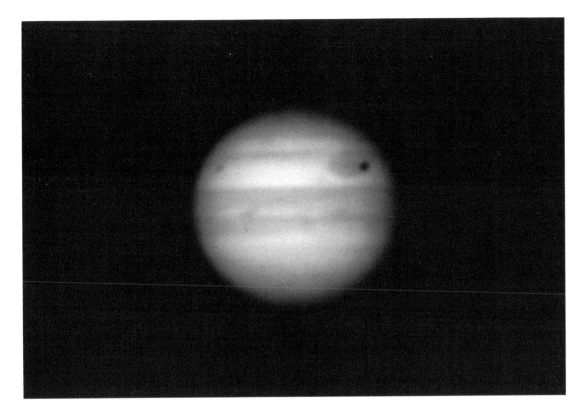

mance. Indeed, they are indispensable for planetary observing with modern instruments.

Fundamentally, it is optical quality rather than telescope type that determines performance, especially when the goal is discerning detail on the delicate faces of our neighbour worlds.

And here is one more myth on focal ratios related to performance. Long-focus telescopes are supposed to yield higher contrast and darker sky backgrounds than short-focus models. Again, given equal-quality optics and proper baffling to reduce scattered light, there is no difference between various focal-ratio telescopes of the same type. For instance, we compared a 5-inch f/12 apochromatic refractor with a similar f/7 instrument at the same magnification. In views of several galaxies, we detected no difference in contrast or resolution.

The above myth arose because it is more difficult to baffle a short-focal-ratio telescope of any type than a long-focal-ratio instrument, and in general, it is tougher to make high-quality short-focal-ratio telescopes. These were, and still are, the sources of inferior performance, not the fast focal ratio itself.

■ TELESCOPE MYTH #5: GOOD OPTICS ARE NOT NEEDED FOR DEEP-SKY VIEWING

"If I'm only going to be looking at fuzzy objects anyway, then surely, I don't need the best and sharpest optics. I can get away with lower-quality [and, therefore, less expensive] optics."

So goes the reasoning, and that argument is presented a lot. And, yes, you can use less expensive optics for deep-sky observing. But a better-quality lens or mirror always reveals more deep-sky detail. Those fuzzy objects will be a little less fuzzy. Elements of structure will become apparent where before there was only a grey patch of light.

The difference is contrast. Brute-force brightness from a large-aperture telescope is not enough. To see deep-sky objects, you also need contrast— between the object and the surrounding sky and between the subtle shadings within the galaxy or nebula. Better-quality optics also improve star images so that stars are not bloated fuzzballs but pinpoint specks. Under dark skies with steady seeing, clusters of stars look like fine dust on black velvet. Fainter stars are visible as well. Good optics improve views of all kinds of celestial objects, even fuzzy ones.

■ TELESCOPE MYTH #6: TELESCOPE TUBES SHOULD BE WHITE

Not long ago, telescopes were always white. It is a tradition still followed by some manufacturers. White is "clean" and "sterile." It is the colour of laboratory equipment and of other scientific apparatus. Companies wanted to give their telescopes the image of serious, professional equipment.

White also reflects heat, which is important because if the air inside a telescope becomes too warm, it can blur the image. So white seemed to be

■ *Few sights in astronomy provide minute-by-minute changes, but one night in 1974, Jupiter's moon Ganymede (left dot) crossed in front of the planet along with its shadow. For about 20 minutes, the shadow fell directly on the famous Great Red Spot. The rare scene was captured by James Rouse with an 8-inch f/7 Newtonian on a hazy night that did not look promising until he actually viewed the steady image of Jupiter (see Myth #9).*

a good colour for a telescope tube. But what colour are today's telescopes? Not only white, but yellow, orange, red, blue, purple and even black.

What happened? The "any colour as long as it's white" mentality has gone, partly as the result of marketing. A brightly coloured instrument attracts attention, whether it is in the store or in a glossy magazine advertisement. When Celestron introduced its production-line Schmidt-Cassegrains in the early 1970s, the tubes were orange. A Schmidt-Cassegrain at a star party stood out from all the rest. People noticed it; that is good marketing.

But what about the reasons for a white tube? It turns out that they were wrong.

The best colour for a telescope is black or some other dark colour. Keeping the tube from absorbing heat is not the main concern. The telescope is taken from a warm house or car out into the cool night air; to perform at its best, the instrument and the air inside it must be very close in temperature to that of the surrounding air. A warm telescope has to *lose* heat. The best colour to promote this heat loss is black. True, black absorbs heat more readily, but it also radiates heat more rapidly. Thus the telescope settles down more quickly.

With Newtonian models, a dark tube also helps maintain the observer's night vision. As you approach the eyepiece or stare into it, you are not forced to look at a bright tube with the other eye. So now you can have any colour of telescope you want as long as it is black.

■ TELESCOPE MYTH #7:
CLOSED TUBES ARE BETTER

Introductory books on telescopes often list the advantages and disadvantages of each type of instrument. We did so in Chapter 3. One advantage often attributed to the refractor design is the "closed tube": the lens at one end and the eyepiece at the other effectively seal the tube. Schmidt-Cassegrains and Maksutovs also have closed tubes — they have

a corrector lens at the front. Newtonians, on the other hand, have open tubes. Outside air can circulate down the tube and reach the main mirror.

A closed tube sounds like a better idea. Makers of Schmidt-Cassegrains and Maksutovs usually use it as a selling point for their models, because a closed tube protects the optics. Unfortunately, it also has an unadvertised detrimental effect: a closed tube seals in warm air.

Recall the myth about telescope colour. For the sharpest images, the air inside a telescope must be the same temperature as the outside air. It is important, therefore, that the optics, their mounting cells and the tube walls be cool; otherwise, they will radiate heat into the light path. If the light passes through layers of air of different temperatures, the image is blurred. The layers act like bad lenses. A sealed-tube telescope can take a long time to cool down — anywhere from 30 minutes to all night — because warm air cannot get out and cool air cannot get in.

Large-aperture Schmidt-Cassegrains and Maksutovs often suffer the most. When they are first taken into cold night air, heat radiating off the secondary mirrors and cells can render them useless for an hour or more. Refractors have the same problem but, in practice, are not as disturbed by it, since the light in a refractor immediately bends away from the offending tube walls after passing through the main lens. Moreover, light in a refractor has to travel down the tube only once; the multiple passes inside a Cassegrain-style reflector increase the opportunity for distortion by waves of heat. Thus it is not the closed tube of the refractor but the nature of its light path that gives it the freedom from tube currents which led to this myth.

■ TELESCOPE MYTH #8:
A TELESCOPE MOUNT MUST
BE LEVEL

The levelling of a tripod is often drilled into backyard astronomers as an essential ritual of setting up a telescope. Manufacturers even supply bubble levels on mounts to help the meticulous observer get everything just right. But it is all bunk.

To polar-align an equatorial mount accurately, even to the precision necessary for photography, simply requires that the polar axis be aimed directly at the celestial pole. The tripod does not need to be level as a prerequisite. Although levelling adjustments are not imperative, they can help aim the polar axis correctly.

■ TELESCOPE MYTH #9:
THE CLEAREST NIGHTS ARE THE
ONES WITH THE BEST "SEEING"

A common misconception among beginners, rather than a myth perpetuated by veteran observers,

■ Several persistent myths about telescopes are exemplified in this long-focus refractor: the myth that a closed tube improves seeing (#7); that telescope tubes should be white (#6); and that long-focus telescopes are best for planets (#4). Photograph by Alan Dyer.

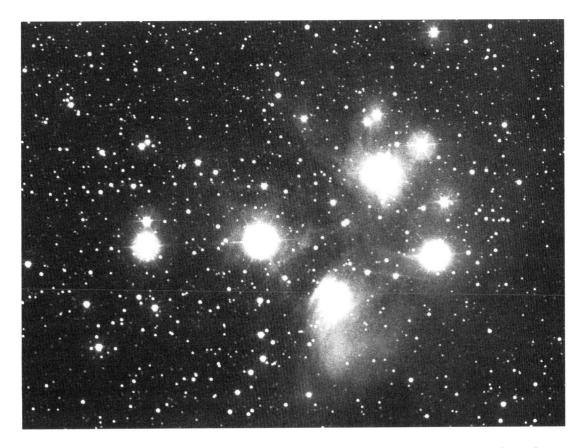

stems from a misunderstanding of what the term "seeing" means in astronomy. Seeing refers to the steadiness of a telescopic image, not to the clarity of the air. Turbulence is always present in the Earth's atmosphere, but its intensity varies enormously. A view of the moon or of Jupiter can be so hopelessly shimmering and boiling that nothing beyond the telescope's lowest power will improve it. That is poor seeing. It can occur on the clearest nights. Conversely, good seeing—a steady image—can, and often does, occur on hazy evenings.

Seeing can be rated on a scale from 0 to 10. A "10" night, with perfectly sharp, unwavering images, is rare and long-remembered. Alternatively, the terms perfect, excellent, good, moderate, fair, poor and hopeless are sufficient to distinguish the varying degrees of seeing. The effects of poor seeing are most obvious in views of the planets, but the condition degrades all types of observing.

As a general rule, the stars twinkle vigorously on nights with fair or worse seeing. Wind is usually accompanied by agitated atmospheric currents and poor seeing. Invariably, the seeing is worse toward the horizon and better near overhead due to the quantity of the Earth's atmosphere that the celestial light must penetrate before reaching the telescope. Different types of turbulence can occur at the same time. Most frequently, good seeing pops out periodically during overall moderate conditions. Some-

times, there are moments of perfect clarity during a night of good seeing, and so forth. The turbulence that causes the variance comes in two forms: fast and slow. Slow seeing is a gentle undulation or waviness in the image. Fast seeing is rapid waves or blurring or defocusing.

On an otherwise wonderful, clear night, the deep-sky observer can be plagued by rotten seeing that bloats star images and smears galaxies. The effect is more difficult to detect than the obvious rippling or erratic defocusing of a planet's disc, but the result is a loss of detail and a cutback of as much as a magnitude in the faintest stars visible. The faintest deep-sky objects can be seen only when skies are clear *and* seeing is good.

The clarity of the air is called "transparency." It is classified by the faintest naked-eye star visible in the vicinity of Polaris in the northern hemisphere or of Octans in the southern hemisphere. Outstanding transparency will yield stars in the range of 6.2 to 6.8 magnitude. Of course, it depends on the observing site and on the acuity of the observer's eyes. From a suburban location, magnitude 4.4 Delta Ursae Minoris, the star next to Polaris in the Little Dipper's handle, may be a tough sighting. At any particular site, a record of the faintest star visible in the celestial polar region will give a good comparative gauge of conditions at that site and allow fairly direct correlation between sites.

■ *The Pleiades star cluster is embedded in a pale veil of nebulosity that reflects the light from the cluster's brightest members. The nebulosity is a difficult visual sighting that requires dark skies and good, high-contrast optics (see Myth #5). Photograph by Rick Dilsizian, using an 8-inch Schmidt camera.*

95

The Sky Without a Telescope

Anyone involved in recreational astronomy soon becomes keenly aware of sky conditions, both daytime and nighttime. You automatically look up whenever you step outside. If the sky is cloudy during the day, the types of clouds give an indication of the prospects for clear skies that night. Such habitual sky surveying exposes you to a multitude of natural phenomena overhead. Many of them are visible to the unaided eyes or, at most, with binoculars. The key is knowing what to look for.

■ PHENOMENA OF THE DAY SKY ■■■■

It is natural to think of recreational astronomy as a nocturnal pursuit. But if you watch the skies carefully during the day, you will see some fascinating atmospheric effects that are due to the interaction of light with ice crystals and water droplets. Sometimes, the sky is filled with prisms and mirrors that transform the atmosphere into a complex set of optics. The most familiar result is a rainbow.

■ RAINBOWS

A sunbeam shining through a raindrop is usually reflected once and heads back in approximately the same direction it entered. In the process, the beam of light is split into its component colours by the prismlike qualities of the raindrop. When this effect is multiplied by millions of raindrops in the sky, the result is a curving swath of colour arching around the point in space directly opposite the sun. To be precise, the rainbow is always at a radius of 42 degrees from the anti-solar point. To find the anti-solar point, stand with your back to the sun and imagine a line extended from the sun through your head toward the ground in front of you.

A rainbow is never seen as a complete circle from ground level because the anti-solar point is below the horizon; just the top arc of the full rainbow circle, the part projected onto the sky, is seen. The closer the sun is to the horizon, the more rainbow is visible. If the sun is just above the horizon, you will see a semicircular arc with a diameter of more than 80 degrees. From an aircraft or a mountain peak, it is sometimes possible to see rainbows as full circles. On the other hand, when the sun is high overhead, you will not see rainbows. In fact, for a rainbow to be visible in the sky, the sun cannot be more than 42 degrees above the horizon; rainbows are usually an afternoon or a morning phenomenon.

Double rainbows occur when the sunlight is particularly strong and the sky is saturated with raindrops, perhaps when the sun breaks through after a heavy downpour late in the afternoon. A second rainbow appears as a result of light bouncing

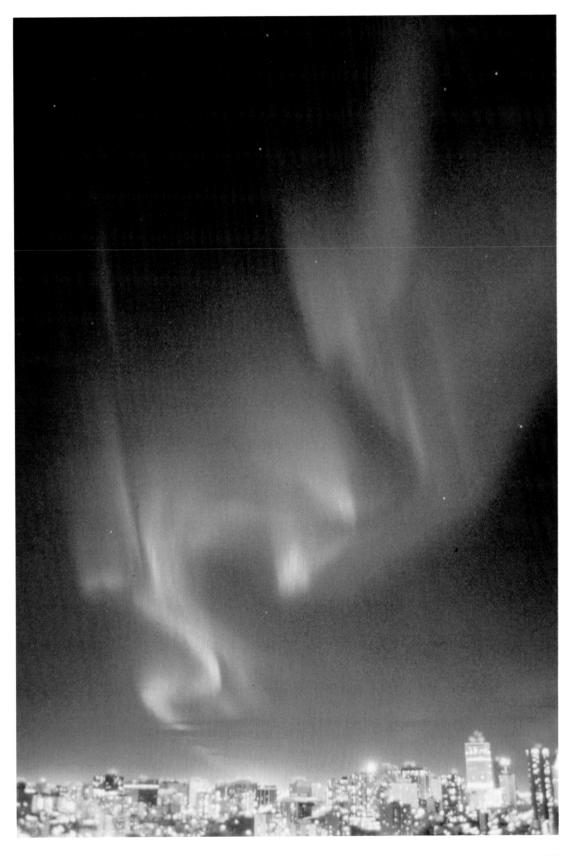

■ The lights of Edmonton, Alberta, a city of more than half a million inhabitants, came close to being over-powered by this awesome aurora borealis display on September 25, 1987. Shimmering auroral curtains are a naked-eye sky phenomenon which, at their best, blanket the sky, creating the impression that the observer is standing inside a kaleidoscope powered by purely natural forces. Photograph by Russ Sampson.

■ *Top: A double rainbow usually occurs when the main bow is especially bright. At these times, you will notice that the sky inside the main bow is brighter than the sky outside the bow because of direct reflection from raindrops. Photograph by Terence Dickinson.*

■ *Centre left: An aircraft sails in front of the setting sun, which displays an oval shape because of atmospheric refraction. Photograph by Brian Tkachyk.*

■ *Centre right: A coronal aurora, seen near overhead when auroral light fills most of the sky, can appear in bizarre shapes because we are looking at the wavering curtains from directly below. We have dubbed this one, from the Great Aurora of March 12-13, 1989, "the warp-speed cosmic biker." Photograph by Terence Dickinson.*

■ *Bottom left: Noctilucent clouds are extremely high-altitude clouds occasionally seen at night between latitudes 45 and 60 degrees. Photograph by Alan Dyer.*

■ *Bottom right: Brilliant auroras illuminate a Canadian winter landscape. Photograph by Alan Dyer.*

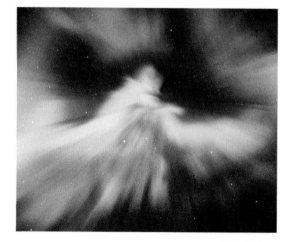

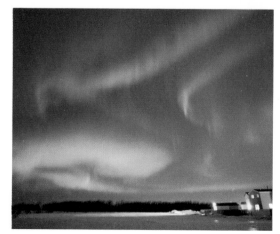

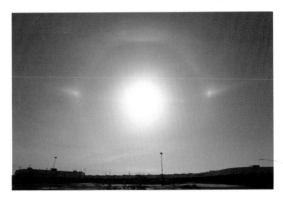

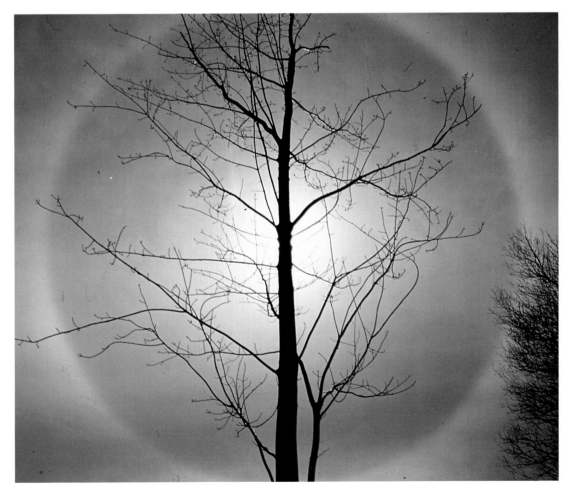

■ *Above: Crepuscular rays, a common atmospheric phenomenon, are simply an impressive interplay of sunlight and shadow—in this case, shadows cast across the sky by distant mountains. Photograph by Alan Dyer.*

■ *Top left: Sundogs are colourful patches seen 22 degrees to the right or left of the sun, usually when the sun is low in the sky. They are caused by refraction through tiny crystals in cirrus clouds and are surprisingly common. Photograph by Terence Dickinson.*

■ *Centre: Although solar haloes are fairly routine in many parts of North America, the appendages on the halo shown here are less familiar. Photograph by Alan Dyer.*

■ *Left: Solar halo seen under perfect conditions from rural Quebec. Photograph by Réal Manseau.*

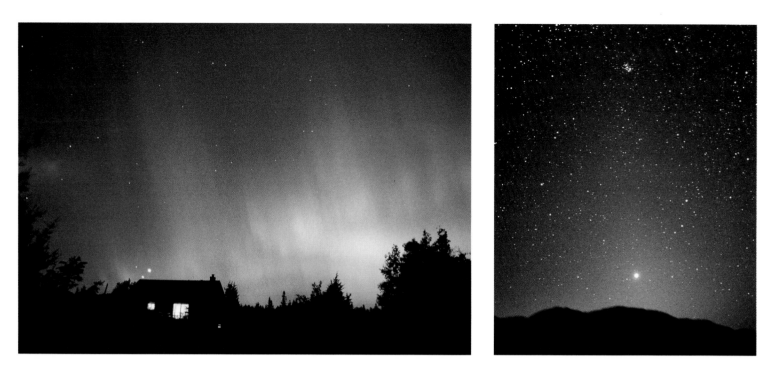

through two reflections inside raindrops; the fainter second bow shows up outside the primary bow at a radius some 51 degrees from the anti-solar point. The colours of the secondary bow are reversed, with red on the inside of the arc rather than the outside, where it appears in the main rainbow.

Other rainbow-related effects to watch for are the brightening of the sky inside the main bow and the occasional appearance of what are known as supernumerary arcs, purple and green bands on the inside edge of the main bow. They are created by interference effects between the various beams of light entering the raindrops at slightly different angles. They usually appear only when the main rainbow is especially intense.

A faint rainbow is sometimes created by the full moon at night. It is very rare and generally appears colourless, because moonlight is not bright enough to trigger the colour receptors in your eye. A long-exposure photograph would reveal all the colours of a moonbow as if it were a rainbow.

■ HALOES

Planetariums and observatories often receive calls from people reporting unusual rings of light around the sun or the moon. Solar and lunar haloes are as common as rainbows but are not nearly as well known. They are caused by light passing through hexagon-shaped ice crystals. Unlike rainbows, most halo phenomena are centred around the sun or the moon, although a few rare examples of ice-crystal refraction manifest themselves opposite the sun. Haloes are usually a cold-weather phenomenon but can occur anytime the sky is covered with high-altitude cirrus clouds or icy haze. The most common halo is a ring of light 22 degrees from the sun or the moon. A much larger and fainter circle can sometimes be seen 46 degrees from the sun.

Sundogs (formally called parhelia) appear as bright spots, sometimes coloured, on either side of the sun. (At night, look for the rare moondogs.) When the sun is low, sundogs are 22 degrees from the sun and show up as intense areas on the inner halo. When the sun is higher in the sky, sundogs are located just outside the inner halo.

The next most common halo phenomenon is the circumzenithal arc, a rainbowlike arc high in the sky curving away from the sun. It is part of a circle centred on the zenith. It often appears tangent to the large 46-degree halo. When the sun is high in the sky, a horizontal arc can sometimes be seen crossing the sun and running parallel to the horizon all the way around the sky. A complex halo display contains all these variations and more. Other arcs can sometimes be seen tangent to the sides, bottoms or tops of the inner or outer haloes; bright spots can appear on this horizontal arc at 90 degrees to the sun, 120 degrees to the sun or even directly opposite the sun. It all depends on the way the light refracts through the various combinations of facets on the six-sided ice crystals. If you see any sort of halo, be sure to scan the sky; there may be other rare and subtle effects of refraction shimmering nearby.

Light can also reflect or bounce off flat ice crystals, creating a pillar of light that rises up from the low sun. On very cold, calm nights, light pillars may form above bright streetlights. It looks as if the sky is filled with searchlights, a weird effect that is one of the few attractions of frigid winter weather.

■ GLORIES AND CORONAS

Glories and coronas are coloured rings formed when light is diffracted by water droplets or ice crystals.

The corona is a circular glow immediately around the sun or the moon, usually with a diameter of no more than 10 degrees. It is often plain white but at times can be a series of coloured rings—diffraction rings—much like those found around star images in a telescope. In order for a corona to form, the sun or the moon must be embedded in a light haze; when there are distinct clouds nearby, the clouds are sometimes fringed with iridescent colours—these are part of the corona.

The glory, a similar effect, occurs around the point opposite the sun. Your best chance of seeing a glory is from an aircraft. Sit on the side of the plane away from the sun. As you break through the nearby clouds, look for the plane's shadow on the more distant clouds below. The shadow may be surrounded by coloured rings. A form of glory known by its German name, *Heiligenschein*, can sometimes be seen as a glow of light around the shadow of your own head when it is projected onto a dewy lawn or low-lying fog in the morning.

■ PHENOMENA OF THE SETTING SUN

You have driven out to a hilltop site, anxious for a night under the stars. The sun is going down, and you are busy setting up your telescope gear. But wait. Take a moment to watch the sunset. It is one of nature's best sky shows, and close inspection will reveal some beautiful atmospheric effects

beyond the familiar red undersides of clouds that everyone notices.

■ THE GREEN FLASH

As the sun sets, its disc usually dims and reddens enough that it can be safely observed with binocu-

■ Top left: On June 17, 1991, a celestial coincidence combined an aurora with a rare three-planet conjunction (the tight triangle over the house). The planets, in order of brightness, are: Venus, Jupiter and Mars. Photograph by Terence Dickinson (28mm f/2; 20 seconds with ISO 1600).
■ Top right: The zodiacal light is a pyramid-shaped glow that can remain in the sky for about half an hour after evening twilight ends. In the northern hemisphere, it is best seen in the western sky during February and March from latitudes of less than 40 degrees. It can also be seen in the predawn eastern sky during September and October. In this photograph, taken from southern California in March 1991, the zodiacal light extends from near Venus up to the Pleiades star cluster. Photograph by Terence Dickinson (28mm f/2; 45 seconds driven, ISO 1600).
■ Bottom: Any unobstructed eastern horizon is the direction to watch for the Earth's shadow after sunset. In this photograph, the shadow's edge is the pink horizontal band. The darkness below the band is the shadow projected onto the atmosphere. Photograph by Alan Dyer.

The Soviet space station Mir produced a bright streak during a 20-second time exposure. Mir often appears as luminous as the brightest stars as it cruises across the sky in about two minutes. It has become a familiar sight to stargazers around the world. Photograph by Frank Dempsey.

lars or a telescope. *Usually.* Exercise caution. If you have to squint when looking at the sun or your eyes water, then it is too bright.

But on most occasions, as the sun sinks below the horizon, its disc will become very red and very flattened and distorted. Watch its edge—you will likely see it rimmed with yellow, blue or, most commonly, green. In the last moments, just before the sun disappears, a vivid green blob of light may appear at the top of the disc and perhaps break off. It will last only a second or two. This is the green flash.

The green flash is caused by a prismlike dispersion of sunlight by our atmosphere. The bottom of the setting sun's disc becomes red, while the top becomes yellow-green. The short-wavelength blue light becomes so scattered, there is little indication of blue in the setting sun. The same effect can be seen at sunrise just as the sun peeks above the horizon. To see the green flash, you must have a clear view of the true flat, distant horizon, over either land or water (a water horizon is best).

■ CREPUSCULAR RAYS

When the sun sets or rises from behind distant hills or clouds, another effect can appear: crepuscular rays. The rays are usually seen as shafts of sunlight beaming down through holes in a cloud deck. They are especially evident when rays from the setting or rising sun are interrupted by mountains or clouds. They then appear as shafts that spread out from the sunset or sunrise point and arc across the sky. They may converge opposite the sun. The diverging and converging effect is due to perspective.

■ TWILIGHTS AND THE EARTH'S SHADOW

Once the sun has set, watch the changing colour of the sky. If the atmosphere is very clear, you will see the western sky painted with the entire spectrum, from reds and yellows near the horizon through green-blues a few degrees up to deep blue-purples at 10 to 20 degrees. If the atmosphere is filled with high-altitude dust or smoke from forest fires or distant volcanic eruptions, the post-sunset sky will be redder than usual. Now, face the eastern sky. Look for a dark blue arc rising along the horizon. This is the Earth's shadow cast out across the atmosphere and into space, the same shadow that intersects the moon's orbit and creates a lunar eclipse when the moon passes through it.

As the sun sets farther below the horizon, the Earth's shadow climbs higher in the east. It is easiest to see when the sun is about five degrees below the horizon. As the sky darkens, the boundary of the Earth's shadow becomes invisible, but it is still there, evidenced by its effect on orbiting satellites.

■ SATELLITES

Take anyone out under a truly dark sky, and the thing which impresses that person most, after the sheer number of stars, is the fact that things are

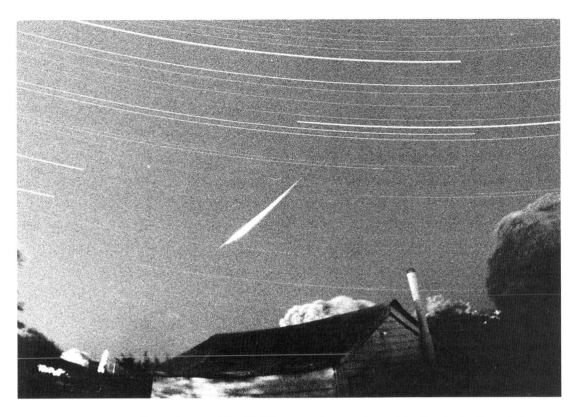

moving up there. Apart from aircraft—identifiable by engine noise, flashing lights, multiple lights or low trajectory—some silent, steadily glowing, star-like objects cruise across the sky: satellites.

There are literally thousands of satellites, spent boosters and chunks of debris circling Earth. (By the late 1980s, the number of orbiting artificial objects bigger than 10 centimetres exceeded 7,000.) Spend any time looking through a telescope, and you will see them zipping across the field of view. Even through a telescope, satellites resemble stars. That is how they appear to the unaided eye too.

Satellites in low Earth orbit (160 to 1,600 kilometres up) often appear as bright as first- or second-magnitude stars. The U.S. and Soviet space shuttles, some American reconnaissance satellites and the Soviet Mir space station are very large and can become as bright as magnitude −1 or −2. The U.S. shuttle is usually flown in an orbit at an inclination of no more than 30 degrees or so; if you live at a latitude of more than 40 degrees North, it will not come far enough north to pass over your location. A few types of shuttle missions, such as military or Earth-observation, require a high-inclination orbit that allows the spacecraft to be seen from most of the planet.

Satellites are best observed between one and two hours after sunset or before sunrise. The sun is then below the horizon for earthbound observers, but at the satellite's great altitude, the sun is still shining. The satellite reflects the sunlight, making it visible against the dark night sky. At the time of the summer solstice, people living at northern latitudes can see satellites crisscrossing the sky all night long.

How quickly a satellite crosses the sky depends on its altitude—the higher the altitude, the slower it moves. A satellite can often take two minutes or more to traverse the sky. Such objects usually travel from west to east, but polar-orbiting satellites (or high-inclination spacecraft like spy satellites) can move from north to south or south to north.

There are some interesting satellite phenomena to watch for. Objects that are tumbling often pulse in brightness. Sometimes, they flash briefly as the sunlight flares off some reflective surface. Now and then, two or more objects can be seen travelling together. Satellites frequently fade out halfway down the sky—this is caused by the object entering the Earth's shadow; it has orbited into the planet's nightside and has just experienced a sunset. Very rarely, you might be the serendipitous witness of a satellite reentering the atmosphere as a blazing fireball. This happens somewhere on Earth almost every day, but if you see one reentry in your lifetime, consider yourself lucky. However, most brief night fireworks displays are due to pieces of natural debris burning up in the atmosphere—meteors.

■ METEORS

Someone once estimated that about 1,000 tonnes of dust and rock enter the Earth's atmosphere every day. A particle about the size of a sand grain will pro-

■ A fireball (brilliant meteor) slashing the sky over Australia was captured during a lengthy time exposure with a wide-angle lens. Some astrophotographers who have taken thousands of pictures have never caught a bright meteor. Similarly, unlucky observers always seem to be looking the wrong way and see their shadow instead of the fireball at its best. Photograph by Gordon Garradd.

duce a typical meteor (a falling, or shooting, star to nonastronomers) as it penetrates the atmosphere and incinerates. A dazzlingly bright, shadow-casting meteor slashing across the starry dome might be as large as a baseball, but these are rare. You will be lucky to see more than one or two in a lifetime of recreational astronomy.

Most meteoric material comes from old comets spreading a trail of dusty debris around the solar system. When a comet approaches the sun to within the orbit of Mars, its icy surface begins to vaporize

from solar radiation. Dust and debris encased in the ice for five billion years since the formation of the solar system are released to drift into space, and some eventually plunge into the Earth's atmosphere as meteors. A few rare large meteors come from the asteroid belt between Mars and Jupiter. These are literally chips off the large rocky objects that orbit in this zone by the thousands.

During a prolonged watch on any given night, you will inevitably see a handful of meteors appear randomly across the sky. Astronomers call them

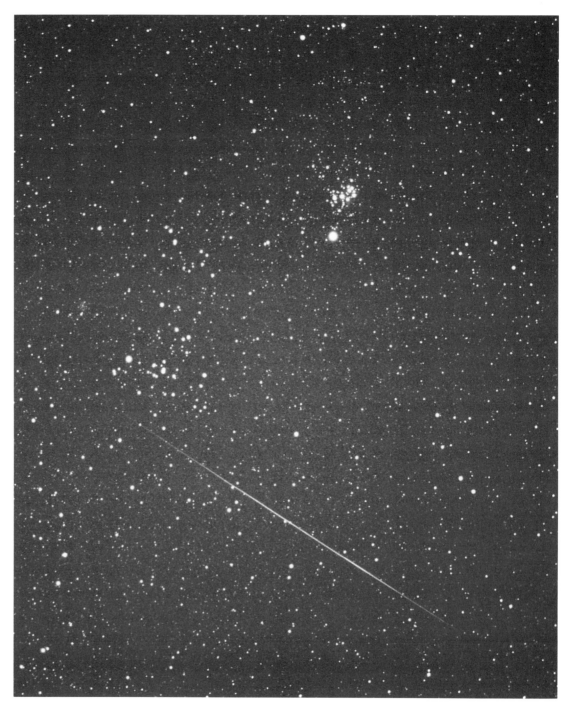

■ *During the excellent Geminid meteor shower on December 13-14, 1990, more than 200 meteors were visible from Terence Dickinson's observing site in eastern Ontario. One of them was caught passing near the Pleiades and Hyades star clusters. Mars is the bright object near the Pleiades (35mm f/2; 2 minutes driven, ISO 1600).*

sporadics. The typical meteor, magnitude 1 to 4, is a brief streak of light lasting only a second or two, the classic "falling star." A bright meteor, at magnitude − 1, might travel more slowly over a longer path and be visible for two or three seconds. Such a meteor often leaves an ionized trail that glows long after the meteor itself has burned up and faded. Any meteor brighter than − 4, the brightness of Venus, is called a fireball.

■ METEOR SHOWERS

Next to eclipses and bright comets, the celestial events that receive the most publicity are meteor showers. These are predictable annual events during which, for one or two nights, the normal sparse count of meteors jumps to around 20 to 80 meteors per hour. There are about 10 major meteor showers each year. The best known by far are the Perseids (August 11-12) and the Geminids (December 13-14). They produce the highest number of meteors and some of the brightest.

During a meteor shower, Earth is crossing the orbit of a comet, passing through the dust left in the wake of the comet's previous trips around the sun. The Perseids are thought to be the flotsam left behind by a comet last seen in 1862. The Geminids were recently identified as debris strewn along the orbit of an object called Phaethon. It is classed as an asteroid but is probably a tailless, fizzled-out comet.

Meteor showers tend to be a disappointment for many first-time viewers, especially if the news media publicize one that occurs when the moon is visible. A good shower like the Perseids or Geminids will produce only one meteor per minute. Of course, meteors never appear on a precise one-per-minute schedule. Even at the peak of a shower, several minutes may go by without any meteor; but all of a sudden, there will be a flurry of six or seven within a minute or two, then nothing again for 5 or 10 minutes. Some showers can try one's patience. In the late 1980s, the Perseids put on wonderful shows, but their intensity varies from year to year depending on the moon's phase and on whether the shower's peak occurs during dark hours.

For any shower to be seen at its best, the site must be dark with no moon in the sky. The observing equipment is simple: a lawn chair and perhaps some favourite music. Just sit back and watch the skies. If you are with longtime amateurs, you will hear "TIME!" yelled out with every meteor spotted; it becomes an automatic reaction—a useful habit for sessions when someone is recording the time of each meteor seen by a team of observers.

The first thing you will notice about shower meteors is that their trails point back to the same spot in the sky. For the Perseids, this radiant point is in the constellation Perseus, hence the name. For the

Geminids, it is in Gemini. But constellation buffs might wonder about another shower called the Quadrantids, named for the defunct constellation Quadrans, the Mural, a pattern once located in the Draco-Bootes area.

The converging of meteor trails is due to perspective; Earth is actually passing through a parallel stream of meteors, but their paths in the sky can be more than 160 kilometres long. Since a meteor's end point is closer to the Earth's surface than its beginning point, we observe the same effect as that formed by railroad tracks or any other parallel lines seen stretching off into the distance. Shower meteors can appear anywhere in the sky. Meteors seen near the radiant are often short and slow; meteors far away from the radiant are faster and leave lengthier trails. A meteor that appears head-on right at the radiant looks like a brief starlike flash.

A common practice of veteran meteor watchers is to wait until after midnight (1 a.m. daylight saving time). More meteors, both shower and sporadic, grace the skies of the post-midnight hours. At that time, the side of Earth we are on is turned in the direction of our planet's orbital motion around the sun. We face "into the wind." Any meteoric debris we run into hits the atmosphere with greater speed and produces a brighter, hotter trail.

A night spent watching a meteor shower inevitably prompts the question: Do these meteors ever hit Earth? The answer is a qualified no. No meteor shower debris has ever been known to strike the Earth's surface. Since shower meteors are made of fine, crumbly comet dust, they probably all burn up high in the atmosphere at altitudes of 60 to 120 kilometres. Of course, everyone has heard of meteorites, the correct name for objects that do hit Earth. These rocky chunks have a different origin than most meteors; they are the fragments of asteroids that have collided somewhere between the orbits of Mars and Jupiter.

If you see a bolide—a meteor that becomes so bright it lights up the ground like daylight, lasts several seconds and seems to break into pieces as it travels—it is possible that parts of it could survive to the surface. Report it to your local planetarium, observatory or college astronomy department. Note the meteor's direction of travel, height in degrees and the directions of the start and end points. Bolides, or exploding meteors, are rare, and while many do not produce meteorites, your report could help pin down an important find. But how do you distinguish a natural bolide from a reentering artificial satellite? Experienced observers have found that satellites burn up more slowly; they last longer (at least 30 seconds) and traverse a greater angle (100 degrees or more) than do bolides. Even very bright bolides have a quick burnout.

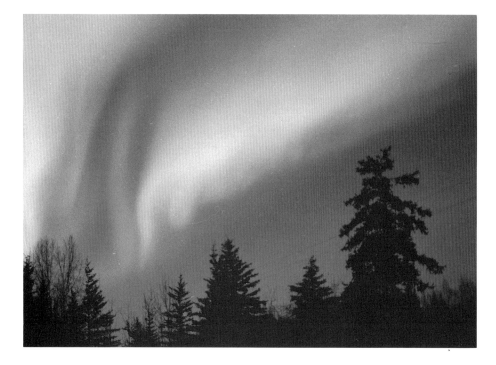

"counterglow" in German.) It comes from sunlight scattering off meteoric dust beyond the Earth's orbit. Late March to early April and early October are the best times for detecting it, since it is then projected onto star-poor regions. Seeing the gegenschein is a naked-eye observing challenge. Even more difficult is the zodiacal band, a stream of light connecting the eastern and western zodiacal pyramids to the gegenschein. Needless to say, if you cannot see either, you will not see the zodiacal band.

■ AURORAS

Northern observers are often treated to (some say plagued by) the northern lights, or aurora borealis. Auroras can be the most entertaining of all the naked-eye celestial phenomena, providing light shows that rival the best laser-show effects. Auroras usually appear first as greenish bands of light low along the northern horizon. During a spectacular display, the aurora climbs high into the sky, filling the heavens with ripply curtains and streamers. An aurora can reach up to the zenith, forming a coronal burst that looks like the tunnel effect at the end of the classic science fiction movie *2001: A Space Odyssey*. Sometimes, the aurora turns into patches of light pulsing on and off over the sky. The predominant green colour, at a wavelength of 557.7 nanometres, is the result of glowing oxygen atoms; very energetic auroras exhibit red tints that come from a much fainter emission line of atomic oxygen, at 630.0 nanometres. Ionized nitrogen can also add reds, violets and blues.

Auroras are a common sight in Alaska, in Canada's northern territories and Prairie Provinces and in northern Ontario and Quebec, where up to 200 displays a year are visible. In Europe, extreme northern Norway and Sweden record similar numbers. In the northern United States and southern Canada, the skies shimmer with auroras a few dozen times a year. The east and west coasts of North America and the southern United States have auroras 5 to 10 times a year. A rare super-aurora can extend as far south as Mexico and the Caribbean, but this occurs only once every 5 to 10 years.

In the populated parts of Europe, despite the relatively high geographic latitude, auroras are rarely seen compared with the equivalent latitudes in North America. Canada and the northern United States are much closer to the magnetic north pole, located in the Canadian high-Arctic islands. Auroras form in an oval-shaped zone with a radius of roughly 2,400 kilometres centred on the magnetic north pole. Oddly enough, the Earth's true geographic North Pole gets no more auroras than do the northern Prairie Provinces. The same situation exists in the southern hemisphere, where the aurora australis forms around the south magnetic pole, in Antarc-

If meteor watching appeals to you, then with any luck, you will be in for an experience of a lifetime on November 18, 1999. On that night, a meteor storm—one of astronomy's rarest events—may occur. Roughly every 33 years, the normally unexciting Leonids peak. In 1833, 1866 and 1966, there were spectacular super-showers featuring several dozen meteors per second. If the Leonids perform as they did in those years, they will provide a fitting celestial show to end the 20th century.

■ ZODIACAL LIGHT

A much more subtle effect of interplanetary dust can be seen in the evening skies of spring and the morning skies of fall in both hemispheres. On a moonless night, wait until the bright glow of twilight has left the western sky. If your site is dark, look for a faint pyramid-shaped glow stretching 20 to 30 degrees above the horizon. It is fainter than the brightest parts of the Milky Way and is often taken for the last vestiges of atmospheric twilight. But the glow is from sunlight reflecting off interplanetary dust in solar orbit around the inner parts of the solar system. It is known as the zodiacal light, so called because it appears along the zodiac, or the ecliptic. The closer you are to the equator, the better your chance of seeing the light pyramids, although on clear nights, sharp-eyed observers as far north as 60 degrees can pick them out.

Much tougher to see are the other zodiacal light effects: the zodiacal band and the gegenschein. The latter appears as a very large (about 10 degrees wide) and very subtle brightening of the sky at the point directly opposite the sun. (Gegenschein means

■ *A bright aurora is a common sight in Yellowknife, in the Northwest Territories. In fact, the celestial light shows are so frequent that Japanese and European tourists are now travelling to Canada specifically to view them. Photograph by Ralph Cross.*

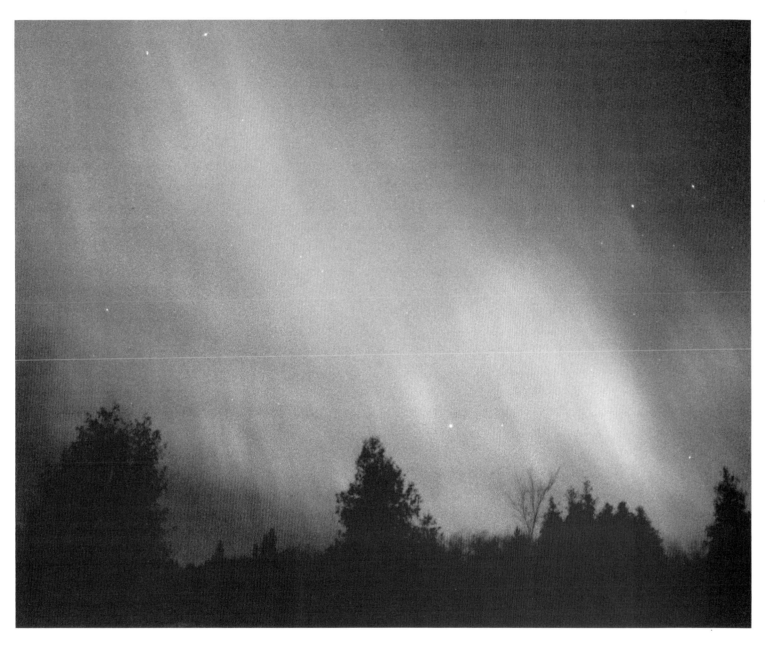

tica. But there are few populated landmasses underneath the southern auroral zone, making the southern lights a celestial event infrequently observed, except by research scientists and penguins.

Auroras are commonly thought to occur most often in winter. However, statistically, March, April, September and October host the best auroral displays. Brilliant auroras can also appear in the summer skies. The trigger is a bombardment of the upper reaches of the atmosphere by electrons and protons that originate in flares on the sun. When a solar flare explodes, it can eject into space streams of charged particles that saturate the complex radiation belts surrounding our planet. The exact process is only now becoming understood, but it seems that the radiation belts can act as particle accelera-

tors, beaming intense currents of energy onto the Earth's rarefied atmosphere at altitudes of 150 to 500 kilometres. The atmosphere acts as a television screen, glowing when it is hit by the electron beams.

A typical aurora requires an energy input of about 1,000 billion watts, hundreds of times greater than the output of the largest hydroelectric power plants. During an intense display, up to one million amperes of current flow along an aurora, enough to set up fluctuating magnetic fields on Earth. This in turn produces currents flowing along extended electrical conductors such as Arctic pipelines and power-grid networks, tripping breakers and causing all manner of havoc. In March 1989, an intense super-aurora knocked out Quebec's entire power grid.

For many years, people have sworn that they have

■ *The Great Aurora of March 12-13, 1989, was so dazzling when it reached its climax that the camera settings used to take this picture were visible without a flashlight. Photograph by Terence Dickinson.*

heard auroras. They tell of swishing and crackling sounds that change as the aurora moves. No sound waves can possibly be generated in the near vacuum 150 kilometres up. Also, no audio device has ever recorded this mysterious sound. If it exists at all, the best explanation seems to be that the surface-induced magnetic fields are detected as sound by natural dipole radio receivers acting like the old crystal radio sets. Even people's tooth fillings have been implicated as possible detectors.

■ NOCTILUCENT CLOUDS

Observers living north of 45 degrees latitude have some major astronomical disadvantages: the rich star fields of the southern Milky Way are low in the sky, if not out of sight; the summer planets always skim the southern horizon and are affected by bad seeing; and the cold winters, followed all too rapidly by the short, twilight-plagued nights of summer, cut down the prime observing seasons. But observers in Canada also have a few pluses, notably the vari-ous sky-glow phenomena that extend from the Arctic. While auroras can occasionally invade southern climates, the northern phenomenon of noctilucent clouds cannot. They are usually confined to latitudes between 45 and 60 degrees North.

As the name suggests, noctilucent clouds are seen at night. They look like silvery, bluish white bands across the northern horizon, with an opalescent glow unlike any other clouds. The strange apparitions appear only around summer solstice, when the sun is a mere 6 to 16 degrees below the horizon, even at midnight. Noctilucent clouds occur at an altitude of 80 kilometres, five times higher than 99 percent of our planet's weather systems. This amazing height puts them well above the stratosphere, at the very fringes of the Earth's atmosphere.

These are not normal clouds. They may be made of ice crystals precipitated around dust from incoming meteors or around charged atomic particles in the ionosphere itself. But so far, satellite and rocket data have failed to provide an answer. If you are at

■ RECORDING YOUR OBSERVATIONS

□ By Russ Sampson

On June 3, 1989, I was walking in a park near my home when I happened to glance skyward and saw an elaborate and peculiar solar halo. The sky was full of colourful circles and arcs. I made a quick sketch in a small notebook I carry and later produced a finished drawing. One of the arcs was an extremely rare and mysterious eight-degree halo. Trying to describe, let alone accurately remember, this event from memory would have been difficult at best.

There are many reasons why amateur astronomers record sky phenomena, but the main one is simply as a personal reminder of what was seen when. Drawings, data tabulations and written notes have the added benefit of sharpening an observer's skills. Whether I am sketching the planet Jupiter or jotting down a series of variable-star estimates, I keep my records in a small coil-bound artist's sketch pad. The thick paper withstands the effects of dewing better than ordinary notepaper. A small paper clip prevents the pages from flapping in the wind. On cold winter nights, a pencil inserted through a piece of one-inch wooden dowelling provides a better grip with gloves on.

Preparation before going outside may be necessary. If you plan to observe a planet, draw its outline. For deep-sky observing, draw a circle to mark your eyepiece's field of view. Dividing this circle or planetary outline into quadrants helps when positioning features or objects. Once outside, record the date, time, observing conditions and the instrument used. Write things down as you see them; try not to rely too much on your memory. Instead of finishing your sketch on the spot, draw outlines of features and use a numerical scale for brightness. For planetary detail, try a scale of one to five, where five is the darkest. The same method can be used for deep-sky drawings.

When drawing large-sky phenomena, such as a solar halo or an aurora, use an extended fist to estimate angular size or separation. A bare fist, viewed at arm's length, is between 8 and 11 degrees from little finger to thumb. For some observers, these quick field notes are enough. I recopy and finish my drawings onto the pages of a bound artist's sketchbook as soon after the observation as possible.

For finished planetary sketches, try a soft pencil, a white drafting eraser (the pencil-shaped erasers are the best) and a blending stump. As its name suggests, a blending stump is used to smear or blend graphite onto paper. It costs less than a dollar and is sold in art-supply stores.

One of the most difficult aspects of planetary sketching is making a realistic outline of the planet. Saturn's complex system of rings, Jupiter's equatorial bulge and the phases of the inner planets are very difficult to render in a lifelike manner. A technique used by modern graphic

a high northern latitude near the end of June or early July, be sure to look north at midnight. Amid the lingering glow of twilight, you may see the pearly white streamers of noctilucent clouds.

■ OTHER NAKED-EYE PHENOMENA

The sky glows and sights described so far can only be seen with the unaided eye. There are many other celestial sights for which binoculars or telescopes may be used but are not essential. Here is a quick checklist:

☐ Planet Positions: Simply following the changing positions of the naked-eye planets can be rewarding. The crescent moon near Venus or a grouping of bright planets in the twilight is one of the sky's best nocturnal shows.

☐ Mercury and Uranus: Seeing Mercury or Uranus without optical aid requires a careful search at the right place and at the right time. A surprising number of amateur astronomers have never seen either planet, with or without optical aid.

☐ Daylight Planets: Venus is easily visible in full daylight if you know exactly where to look. Much more difficult, but not impossible, daytime targets are Mercury and Jupiter.

☐ Naked-Eye Sunspots: When the sun is dimmed at sunset or with the help of a No. 14 welders' filter, you might be able to pick out the occasional giant sunspot group. The Chinese did it thousands of years ago.

☐ Occultations: The disappearance of bright planets and stars behind the moon is a rare form of eclipse.

☐ Novas: One nova flared up to second magnitude in 1975, adding an extra star to Cygnus. Learn the constellations, and one day, you may observe a star that does not belong.

To this list, we could add eclipses, comets, naked-eye variable stars such as Algol, the Milky Way itself and a host of clusters and nebulas large and bright enough to show up to the unaided but observant eye. Not owning a telescope should not prevent anyone from enjoying astronomy.

designers can be adapted to make a planet outline. First, find an image of the planet in its proper phase or orientation, such as the line drawings of planet discs that appear in every issue of the *Astronomical Calendar*. Then photocopy selected images, and cover the back side of the photocopy with a thick layer of pencil graphite. Carefully tape the photocopy onto your sketchbook, and trace over the image with a pen or pencil. The graphite is transferred onto the page in the form of an outline. The photocopies can be used over and over again.

Dark planetary or lunar features are added with the pencil and blending stump. Black areas, such as the background sky or shadows on the moon, can be applied using an opaque watercolour called gouache. You will need at least two brush sizes—a very fine brush to

outline the planet and a wider brush to fill in the background.

Colour drawings can be done using pencil crayons, since they are both inexpensive and easy to use. The best and most widely available are Prismacolor Crayons by Berol. The choice of paper is important. Smooth papers, like looseleaf, are not abrasive enough to take the pigment off the crayon.

The shape of the crayon tip is also critical to keep the colours diffuse and uniform. With a sharp knife, sculpt the tip of the crayon into a broad, slightly rounded stump. For large colour fields like the background sky, use a gentle circular motion, keeping the broad face of the crayon flat on the paper. If you apply only gentle pressure, the crayon will produce a soft airbrushlike quality. To colour small markings or features with sharp edges, angle the crayon tip off its broad face to its edge. For deep-sky objects, try a white pencil crayon on black construction paper.

Keep your ambitions and plans in perspective. Attempting to draw the entire face of the moon as seen through a telescope is unrealistic. Try sketching one interesting lunar feature at a time. The satisfaction of having a "hard copy" of your observation will be a reward in itself.

Russ Sampson is an astronomy educator and longtime amateur astronomer living in Edmonton, Alberta.

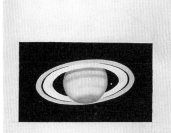

Observing Conditions: Your Site and Light Pollution

When our grandparents were children, the splendour of a dark night sky thronged with stars and wrapped with the silky ribbon of the Milky Way was as close as the back door. From almost any backyard anywhere, whether city or country, the majesty of the starry night sky was visible.

Not anymore. Giant domes of bilious yellow light cover every city in North America. At night, major metropolises such as Los Angeles, Chicago, Dallas and Toronto are visible 150 kilometres away as glows on the horizon. From 60 kilometres, they wreck most of the sky. Any closer, and the night is no longer dark.

We are not suggesting that night lighting is not needed. Yet waste lighting is all around us. Parking lots with no cars in them are floodlit all night, security lights pour into neighbours' windows rather than over the target area, and most streetlights are so inefficient that as much as 30 percent of their output spreads horizontally, reaching only the eyes of distant drivers and the air above our heads.

At the request of astronomers and environmentalists, a few cities, notably Tucson, Arizona, and San Diego, California, have passed special ordinances that require all outdoor lighting to be efficient and task-oriented. Light fixtures are designed to aim down to bathe the street, sidewalk, parking stalls or other targets and not the sky. For this purpose, every light is shielded. Drivers in Tucson and San Diego see the road instead of interfering glare

from road lighting, as is often the case in other cities. Such fixtures are also installed near all major airports. Pilots say that roadway and building lights beaming into their eyes are annoying and potentially hazardous during landings.

■ MORE THAN ASTRONOMY AT STAKE

If stargazing were the exclusive casualty of the growth in night lighting, a call for action might be considered trivial. But astronomy is just part of it. In Canada and the United States, poorly designed or badly installed outdoor lighting wastes electricity worth more than $1 billion annually by producing light that streams into the sky, illuminating nothing but airborne dust and water vapour.

Municipal authorities, like most bureaucrats, resist change. Unshielded streetlamps are mass-produced and cheap, and they do the job. Why change? People are accustomed to glaring streetlights because that is all they have ever seen. "Nobody's complaining to me about too much light," one township engineer told us. "People want more light, not less." This attitude will change only when people are presented with alternatives and a reason for change. Shielded lights are more efficient and, if used with low-pressure sodium lamps, are far less expensive to operate in the long run. They are the environmentally friendly alternative.

"Yes, all that may be true," said the township en-

■ *Night lighting over eastern North America has rendered huge sectors of the region unsuitable for many types of backyard astronomy. This 1979 image from a U.S. Air Force satellite shows that streetlights and other artificial lighting from towns as small as 1,000 population are visible from an altitude of 200 kilometres. (New York City and Washington, D.C., are at centre right; Detroit is at left edge.) To be largely free of a city's light pollution, you should be three times farther away than the diameter of the city's image shown here. In many cases, there is no easy escape.*

gineer, "but they cost more, they look dimmer, and low-pressure sodium is ugly yellow. People don't like it." San Diego and Tucson residents readily accepted the new lights once they understood the reasons for the change. They developed a high level of awareness of wasteful lighting as the result of an advertising campaign conducted a few years ago by both the city and environmental groups.

There are signs of a slow but definite change in attitudes toward lighting. Sales of full-cutoff fixtures that redirect horizontal or higher beams to road level are growing every month. While researching this chapter, we spoke with several major outdoor-lighting suppliers. Most are convinced that shielded equipment will eventually take precedence in roadway lighting and assured us that there is a slowly growing commitment to eliminating the glare produced by the old fixtures.

Professional astronomers urge municipalities near their observatories to use low-pressure sodium lamps because the light's narrow spectrum can be filtered out at the telescope more easily than other light sources. However, for what backyard astronomers enjoy doing, filters frequently are not appropriate. Containing the overall brightness of the sky and eliminating the direct interference from specific lights are the main issues. In that regard, shielding is more important than the type of light.

The inspiration of a dazzling starry night is unknown to most children today and is a dim memory to seniors who saw the spectacle from the front porch in their youth. We cannot go back to the "good old days," but as with any other aspect of our planet's natural heritage, we should save at least some of the night sky for future generations.

■ THE ERODING SKY

There is no way to reveal again the stars over the city as our grandparents once saw them. But now, the situation is deteriorating deep in the country too. A single dusk-to-dawn pole-mounted mercury-vapour lamp dims the starscape for hundreds of metres in every direction. One of these lamps eight kilometres away is as bright as Sirius, the brightest star in the night sky.

Inefficient and wasteful outdoor lighting—light pollution—is an environmental issue whose time has come. Something must be done soon, primarily for energy efficiency but also to restrict light trespass and to preserve what little dark sky remains in areas reasonably close to populated centres.

What can an individual do? Take a good look at the outdoor lighting at your home or business. If it involves dusk-to-dawn security lights, calculate their yearly operating cost. Electricity is not inexpensive anymore. Can the job be done with less? Are the fixtures shielded? For security, consider floodlights with an infrared motion-detector switch. Infrared systems use negligible electricity and, compared with all-night lighting, pay for themselves in a year or two. If the lighting is primarily decorative rather than functional, put in smaller-wattage lamps. Does your outdoor light spill into your neighbours' yards or windows? They may not appreciate it. Does a streetlight or other powerful light reduce your quality of life or prevent you from sleeping? Complain. All bad lights can be shielded. Unwanted light is in the same nuisance category as a blaring stereo in the neighbourhood. Several annoyed citizens have won such cases in small-claims court.

Above all, share your telescope and the wonders of the universe with as many people as possible. In an outdoor situation at night, gently point out the reality of light pollution. Nearly everyone is open to learning more about environmental issues. Do not preach; simply inform. Most people are receptive. They may even turn off their lights for you.

For more information on light pollution, contact the International Dark Sky Association, a nonprofit organization established to advance awareness of the problem, at 3545 N. Stewart Avenue, Tucson, AZ 85716.

■ This typical parking-lot light is a glaring example of light pollution. At least half of the light output never illuminates the intended target; instead, it floods horizontally and skyward. Apart from annoying the neighbours, this is purely wasted energy that amounts to hundreds or thousands of dollars over the life of the installation. Photograph by Tom Campbell.

■ YOUR OBSERVING SITE

Astronomy can be conducted from just about anywhere. A view of the sky, however restricted or veiled by lights and haze, still shows something. Occasionally, astonishing results emerge under even the most adverse conditions. English comet and nova hunter George Alcock proved this in 1983 when he took a break during an outdoor observing session to have a cup of tea in his kitchen. Sitting at the table, he picked up his binoculars and began scanning through a closed window a familiar field of stars in the constellation Draco. Resting his elbows on the back of a chair to steady his 15 x 80 binoculars, he spied a fuzzy patch he knew did not belong. It was a comet, his fifth discovery.

Alcock's comet-hunting prowess suggests that ideal weather is not a prerequisite either. The British Isles are notorious for cloudy conditions. Perseverance lies behind Alcock's success.

Ideally, of course, all backyard astronomers would like to live on a mountain where the sky is clear more than 200 nights a year. Realistically, however, even if the sky were perfectly clear that often, few of us would be able to make full use of it. The frustration arises when nature's schedule and

the observer's do not harmonize. Take a cue from Alcock: accept the local weather, and make the best of it. Think of how the professional astronomer must feel when, after booking time a year in advance on one of the world's largest telescopes and travelling thousands of kilometres to use it, the site is clouded out. It happens to everybody.

In any case, the chief drawback is usually not the number of clear nights; it is local observing conditions. Most of us live in or near urban areas where light intensity grows worse every year. In the centre of a large city, the light pollution can be so intense that only the moon, Venus, Jupiter and a few first-magnitude stars poke through. Yet even heavy light interference can be circumvented to a degree.

■ OBSERVING FROM THE CITY

Amateur astronomer Ted Molczan lives in a 33-storey apartment a few blocks from the heart of Toronto. From the roof of the building, with the city lights blazing upward, Molczan has seen fifth-magnitude stars in the overhead region and even a vague hint of the Milky Way in Cygnus at the zenith. Using 11 x 80 binoculars, he has no trouble seeing ninth-magnitude stars. Most people

in a similar situation would have given up without even trying. By making the best of what is at hand, Molczan has conducted a programme of artificial-satellite observations that has led to the recovery of several "lost" satellites as well as to the refinement of the orbits of others.

Some apartment and condominium dwellers may even be limited to observing through a window. This is still better than nothing, although the window glass always introduces some distortion and/or multiple imaging to binocular and telescopic viewing.

Observers in suburban situations can position their telescopes in a part of their yard that is shielded from direct interference from surrounding porch and street illumination, where their eyes have an opportunity to adapt to the semidarkness. Typically, fourth-magnitude stars can be seen from the suburbs of a large city, and fifth-magnitude stars can be seen from the outer reaches of a smaller metropolis. Of course, it depends on local conditions, but once a spot is found that is protected from direct glare or action is taken to block such light (by erecting a temporary or permanent fence or planting a row of dense evergreen trees), the result may be surprising.

Suppose, for example, that the local observing site

■ *Lights from the city of Tucson, Arizona, produced a modest glow in 1959 when the top photograph was taken from Kitt Peak National Observatory, 80 kilometres away. By 1980, it had become a menacing source of light pollution, bottom. But astronomers were already working with city and state officials. In recent years, strict controls on light pollution have been successful in preventing further deterioration of the sky. National Optical Observatories photograph.*

113

shows 4.5-magnitude stars at the zenith, third magnitude at 40 degrees altitude and nothing much below 25 degrees. What does this offer? Lots. The moon, Mars, Jupiter and Saturn are bright and largely unaffected by light pollution. An atmospheric inversion layer induced by big-city pollution sometimes steadies the air so that seeing is occasionally better than in the country. Metropolitan telescopic views of Jupiter or Mars often show as much detail as those at a dark location and make wonderful showpiece objects for visitors to your telescope.

Other kinds of observing, such as looking at lunar occultations and bright variable stars, examining the brighter star clusters and tracking the paths of asteroids, are affected by urban conditions to some extent but are generally possible from moderately light-polluted environments. The toll exacted by urban glow is a brightening of the sky background; the telescope's resolution is not affected. For example, an 8-inch telescope under suburban fourth-magnitude skies will be limited to roughly

the same deep-sky targets as a 3-inch telescope under black sixth-magnitude skies. But the resolution of the 8-inch instrument is unchanged, so what is seen can be studied in greater detail. However, such comparisons should not be carried too far. Much depends on the specific object being observed. The use of light-pollution filters changes the equation too, but only by a limited amount. Light-pollution filters make nebulas easier to see but cannot transform urban skies into rural dark-site skies.

■ EVALUATING THE OBSERVING SITE

When you are considering a telescope purchase, the proposed observing site is of paramount importance. Unless there is absolutely no alternative, do not rely exclusively on an ideal but remote site. Carefully evaluate the types of observing that can be done from a site near home as well as the convenience of the site. Consider the following:
□ Is the local site limited to binoculars, or can a telescope be used also?

■ *From the San Gabriel Mountains north of Los Angeles, the lights of the huge metropolis throw up a vast light-pollution dome that thwarts thousands of amateur astronomers and wastes millions of dollars a year in electricity. If the city lights were properly shielded, they would not be visible as point sources from such a distance. Photograph by Leo Henzl.*

☐ If a telescope is useful at the local site, how far will it have to be carried?

☐ How many pieces must the instrument be broken into for setup at the local observing site versus the remote site?

☐ Will the telescope or its largest component fit into the vehicle that will be used?

☐ How many trips will have to be made back and forth to the car or house during a typical telescope setup?

☐ Can the equipment safely be left unattended while the telescope is assembled and disassembled? (If not, can everything be carried at once?)

☐ Is power available for the clock drive (if applicable)?

☐ Considering the above, is one telescope suited to both the local and the remote site?

A telescope that can be carried outside without being taken apart will be used more frequently than one requiring a several-step assembly and disassembly. At first, it might seem like a minor point, but the process of setting up and breaking down the instrument looms as a bigger factor once the initial euphoria of the new telescope has worn off. The "paraphernalia effect" makes the pieces seem to grow larger and more awkward each time the telescope is transported to the observing site—local or remote. Frequently, the solution is two telescopes: one suited for the less-than-ideal local site and another for use at a remote dark site.

■ THE REMOTE OBSERVING SITE

Few people live where sixth-magnitude stars are visible from their backyards. Most amateur astronomers have to hunt for such a site, and reaching it can be an expedition if you live in or near a city of more than a million people. Travelling for two hours simply to get a reasonable view of the Milky Way is, unfortunately, a commonplace experience.

Well outside the city, there are still obstacles. More and more homeowners have installed dusk-to-dawn security lights that pump light horizontally into the corner of a sky observer's eye perhaps a kilometre away. But beyond the aggravation of rural farm and home lighting is the question of where to observe from once you are in the country.

Stopping on an infrequently travelled country road is fine for binocular gazing, but it is far from ideal for setting up equipment that cannot be retrieved and put in the car in a matter of seconds. There is a slight but very real danger of being mistaken for a trespasser or some form of lawbreaker. Amateur astronomers tell horror stories about being routed by suspicious landowners (who can blame them?) or, worse, by a carload of troublemakers.

Heading out on your own and driving country roads in search of a good dark site from which to ob-

serve an aurora, meteor shower or bright comet is always a gamble. But sometimes, it is the only way—especially in the case of a comet near the horizon or some other specialized quarry that needs specific viewing geometry. In general, though, a predetermined safe and dark site, free of intruders, should be a long-term goal. Begin with enquiries at the local astronomy club, or if there is no club, ask other amateur astronomers in the area. Find out where they go for dark skies. They may have a private observatory in an ideal location, or they may have found a public park or a campsite that has an area perfect for stargazing.

What constitutes an ideal observing site? The Milky Way should be distinctly visible. Under the very best conditions, the Milky Way has a textured appearance, with many levels of intensity and obvious rifts from dark nebulas. Second- and third-magnitude stars should be visible less than five degrees from the horizon, and binoculars should reveal stars right down to the true horizon. It is almost impossible not to have at least one dome of light somewhere on the horizon from a nearby town or a more distant city, but if the largest such dome is in the northern sector of the sky (southern in the southern hemisphere), it will be least annoying. Objects in that direction will be visible near overhead two seasons later.

The specific terrain of the observing site can influence sky conditions as well. Snow cover is the worst situation, not just because it is cold but because it reflects light. Even if there is little light pollution, the starry sky itself illuminates the ground. When that light is reflected back toward its source,

■ Top: Despite the lights of suburban Brisbane, Australia, veteran amateur astronomer Gregg Thompson built this observing deck as an addition to his home to take advantage of the site's convenience. Photograph by Terence Dickinson.

■ Above: The standard cobra-head streetlight, which uselessly spills up to 30 percent of its light horizontally, is a product of the 1960s, before the emergence of environmental awareness. New, full-cutoff fixtures that efficiently direct all of their light to the ground around them are available, but few municipalities buy them.

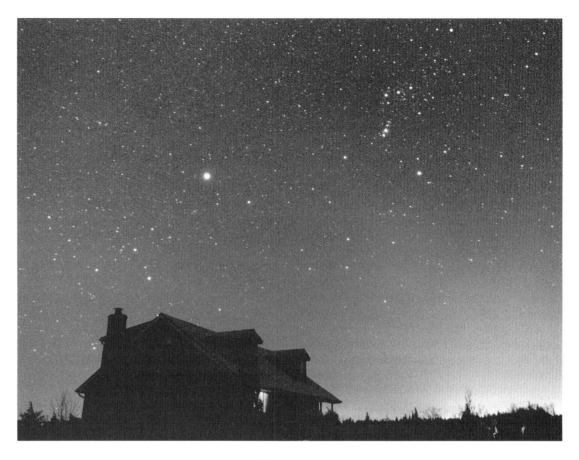

■ RATING YOUR OBSERVING SITE ■

How can you evaluate an observing site? Experience is the best guide, but here is a checklist that will help you rate your site. If you use more than one site, each should be assessed separately.

☐ Convenience: If you can observe in comfort from your own yard, take 5 points; 3 points for a short walk; 2 for a short drive; 0 for an hour or longer drive.

☐ Ground Level: If your site is outside a ground-level entrance where your equipment is stored, take 5 points. Take 3 points if car loading is required but no full flights of stairs are involved.

☐ Privacy: No possibility of surprise interruptions by people, animals or unwanted car lights is worth another 5 points. Score 0 if you sometimes feel nervous at the site.

☐ General Light Pollution: Score 10 if, on a good night, you can see magnitude 6.5 overhead, the Milky Way is obvious and the dome of light from the nearest city bulges less than 10 degrees above the horizon. Score 0 if you cannot see the Milky Way at all or a star fainter than magnitude 5.0. Estimate values for intermediate conditions.

☐ Local Light Pollution: A crucial factor. Zero points if you cannot avoid a local light as bright as the moon. Score 4 points for a site that requires moving around to remain protected from light while observing. For a full 10 points, the brightest unobscured light should be fainter than Venus.

☐ Horizon: A clear, flat horizon to the south earns 5 points. South obstructions higher than 30 degrees rate just 2 points. Similar obstructions in all directions score 0.

☐ Insects: Mosquitoes are the enemy. Subtract up to 5 points if they are predictably annoying for more than one month each year.

☐ Snow: Snow cover has no redeeming value in astronomy. Apart from the cold weather that accompanies it, snow reflects light and increases overall light pollution. Subtract 1 point for each month of likely snow cover at the site.

Maximum possible score (for a site next to your home, at a perfectly dark location, with little chance of snow or mosquitoes) is 40 points. Any score over 20 should be considered perfectly acceptable for regular use.

it illuminates the dust and moisture particles in the atmosphere from below. Under a blanket of snow, observing sites rate at least half a magnitude worse due to the reflected-skylight effect. Cold, crisp nights may look good on first inspection, but the overall brilliance of starry winter nights is partly an illusion caused by the brightness of Orion and its star-rich neighbour constellations.

The ideal dark site is an isolated, elevated clearing in an area with fairly heavy vegetation, either dense grass, scrub shrubbery or trees or a combination of these. Coniferous vegetation is preferable to leafy trees because the former releases less moisture into the atmosphere. A further advantage is the skylight-absorbing qualities of dark vegetation. A thick ground cover also acts as an insulating blanket, slowly releasing the ground's heat at night and protecting it during the day from soaking up as much heat as would bare ground.

Deserts may seem to be an ideal place from which to observe, and in some respects, they are (lots of dry, dew-free, clear nights), but the pale desert soil has undesirable skylight-reflecting qualities, and the large day-to-night temperature oscillations in desert areas work against a stable atmosphere. The sky may be clear, but layers of convection turbulence can affect the stability of high-resolution planetary images and the sharpness of stars.

■ CONVENTIONS AT DARK-SKY SITES

One significant sign that recreational astronomy has come of age is the explosive growth in observing conventions at good dark-sky sites. The agenda is to have fun observing and interacting with fellow amateur astronomers. As recently as the mid-1970s, there was only one main convention, Stellafane, in southern Vermont, but now there are four major conventions and a dozen smaller ones. One of them should be within driving distance of your home.

Stellafane is North America's largest meeting of amateur astronomers. Each summer, several thousand enthusiasts gather for a weekend atop a granite knoll named Stellafane, shrine to the stars. It is the Mount Olympus of amateur astronomy, impressive enough to overwhelm the first-time visitor. It begins with the drive up Breezy Hill Road—up and up, until the pavement ends and the gravel begins; then the gravel gives way to dirt, and it is no longer a road but a tunnel through the woods. Eventually, the visitor emerges from the poplar, pine and birch onto a sloping meadow, the Stellafane campground, mobbed with campers, automobiles and tents. The focus of the convention is a crowded field of telescopes around the pink clubhouse.

The convention has grown from a tiny gathering of 20 enthusiasts at its first meeting in 1926 to crowds of up to 4,000 people in recent years, who swarm over the rocks, bulge out of the lecture tent and devour thousands of hamburgers and hot dogs while examining the display telescopes with gem inspectors' eyes and, undoubtedly, a certain amount of envy. Telescopes are set up to be judged for optical and mechanical performance. Other telescopes are assembled for viewing purposes alone during a meeting that runs from Friday evening until early Sunday morning. At one time, Stellafane was a magnificent dark site, but as is happening almost everywhere, encroaching urbanization is be-

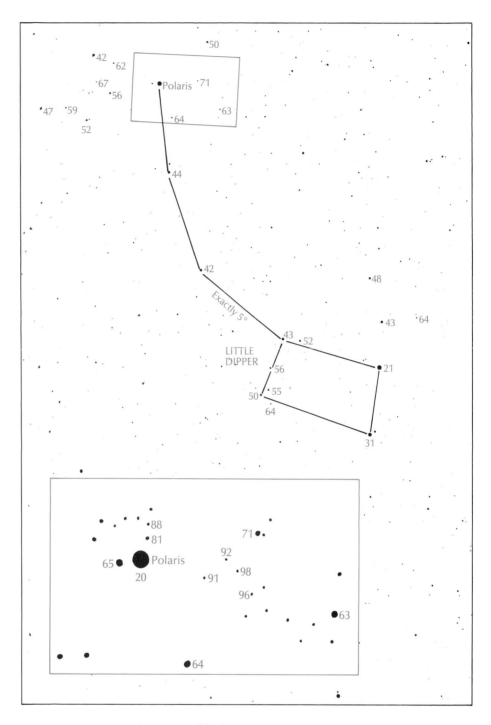

■ Using this chart, which shows stars to 10th magnitude in the vicinity of Polaris, you can rate your local sky conditions with binoculars or unaided eyes. Magnitudes are given in tenths, with decimal points omitted (thus 54 = 5.4).

■ THE MAGNITUDE SCALE ■

The brightness of a star—its magnitude—is rated on a scale that runs backward to what might be expected —the brighter the star, the lower its magnitude number. Each jump of one on the scale represents a difference in brightness of 2.5 times; five magnitude steps is equal to a brightness difference of 100 times.

Magnitudes	Celestial Objects
-27	sun
-13	moon
-4.2	Venus at its brightest
-2.9	Jupiter at its brightest
-1.4	Sirius (brightest star)
0 to +1	the 15 brightest stars
+1 to +6	the 8,500 naked-eye stars
+6 to +8	deep-sky objects for binoculars
+6 to +11	bright deep-sky objects for amateur telescopes
+12 to +14	faint deep-sky objects for amateur telescopes
+15 to +17	objects visible in large amateur telescopes
+18 to +22	objects visible in large professional telescopes
+24 to +26	faintest objects imaged by largest ground-based telescopes

■ LIMITING MAGNITUDE ■

The larger the aperture, the more light a telescope will gather and the fainter the object you can see. Here is what to expect, given excellent sky conditions and good optics. A well-trained eye can sometimes add up to 0.8 magnitude to these values.

Aperture (inches)	Aperture (mm)	Faintest Magnitude Visible
2	50	11.2
2.4	60	11.6
3.1	80	12.2
4	100	12.7
5	125	13.2
6	150	13.6
8	200	14.2
10	250	14.7
12.5	320	15.2
14	355	15.4
16	400	15.7
17.5	445	15.9
20	500	16.2

ginning to take its toll on the once pristine skies. However, it still rates a B+.

Unlike Stellafane, most amateur-astronomy conventions at favourable observing sites are of recent vintage. Some trace their roots to the tireless efforts of a single enthusiastic individual, such as Cliff Holmes, the driving force behind the Riverside convention held each May near Big Bear Lake, northeast of Los Angeles. Officially called the Riverside Telescope Makers Conference, the meeting focuses on telescope making, but not exclusively. Prominent amateur astronomers give talks on observing techniques, astrophotography and the use of equipment, as well as nuts-and-bolts telescope-making presentations.

An important drawing card for the Riverside meeting is the commercial sales area in which all major telescope manufacturers are represented, many with discount offerings. (Commercial exhibits are prohibited at Stellafane.) Riverside is probably the best place to see the complete range of astronomical equipment currently available, along with cutting-edge innovations in optics, mounts and accessories. Crowds for the two-day convention number in the thousands. The night skies are excellent. However, since it is always held on the Memorial Day weekend, the moon interferes some years.

The third big summer astronomy meeting is the Texas Star Party, held since the late 1970s in May at the Prude Ranch in southwest Texas near Fort Davis. The longest and most remote meeting, it requires the greatest commitment. It lasts for one week and is a 2½-hour drive from Midland or El Paso, the nearest good air services, but it is the meeting with the greatest potential rewards for dark-sky-hungry backyard astronomers.

The southern latitude (31 degrees North) and extreme isolation of the site from major urban areas provide some of the best skies in North America. Accommodation is a combination of campsite, ranch bunkhouses and on-site motel rooms. The bunkhouses and motel rooms are usually reserved well in advance of the convention. The Prude Ranch is, in fact, a dude ranch, but it caters exclusively to amateur astronomers for that one week in May each year. Numerous talks are scheduled for the afternoons. If the sky is clear, the Texas Star Party is nirvana for amateur astronomers.

Astrofest, held each September in central Illinois, is another major convention at a campsite with good observing conditions. A weekend meeting that has become the largest amateur-astronomy convention in the Midwest, it always has an excellent range of astronomical equipment displayed by both amateurs and commercial exhibitors.

Other meetings at fine dark sites that are beginning to draw large crowds are the Winter Star Party

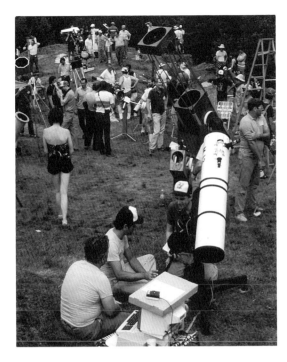

in the Florida Keys (February); Starfest, near Mount Forest, Ontario (August); and the Mount Kobau Star Party in south-central British Columbia (August). Dates, locations and addresses for further informa-

tion on these and other meetings can be found three to six months in advance in *Sky & Telescope* and *Astronomy* magazines. There is no better place than a star party for sharing enthusiasm for astronomy.

■ LIMITING-MAGNITUDE FACTORS ■

How faint are the dimmest stars visible through a telescope? It depends on much more than the instrument's aperture. Factors include seeing, the transparency of the atmosphere at the observing site, the quality of the telescope's optics, their cleanliness, the type of telescope, its magnification, the observer's experience and use of averted vision and the type of object being viewed.

Many amateur-astronomy guidebooks deal with limiting magnitude in one or two short paragraphs and a table. The table lists a telescope aperture and a corresponding limiting magnitude, not taking into account many of the factors mentioned above or not clarifying which factors are considered. A table is offered here as well. The magnitudes listed are determined for good-quality optics, transparent dark skies and a reasonably experienced observer looking at a stellar object at high magnification, 30x to 50x per inch of aperture. If any of the conditions are not met, expect to see less for the reasons mentioned below.

An experienced observer can generally see a magnitude fainter than can a novice. Hundreds of hours of observing through a telescope train the eye to detect threshold detail, whether it is definition of features on a planet or the subtle wisps of a nebula. Of

all factors, experience is the most important. Visual acuity varies from person to person, but the difference seldom amounts to more than half a magnitude.

Young people generally have slightly more sensitivity to objects at the threshold of vision, but veteran observers who are in their fifties or older can usually come within two-tenths of a magnitude of eyes 30 years younger. The ability of a youthful observer's eyes to dilate to 7mm or 8mm, compared with 6mm or less for more senior eyes, has no bearing on the equation—higher magnification, which reveals fainter objects by darkening the sky background, is achieved by smaller exit pupils.

One of the many long-standing assumptions of backyard astronomers is that faint deep-sky objects are best seen at low magnification operating at maximum exit pupil. While this does apply to some large, diffuse nebulous objects such as the Helix Nebula, it is completely untrue with regard to viewing faint stars.

Even on the darkest nights, the sky background is not black but grey. At low power, more sky is included in the view, so the overall brightness of the background sky actually increases as magnification decreases. Conversely, the sky background can be darkened by increased magnification—up to a

■ Left: In recent years, more than 2,000 people have regularly attended Stellafane, near Springfield, Vermont, the oldest and largest annual amateur-astronomy convention.
■ Right: Some amateur astronomers plan their vacations around travel to a remote observing site, such as this 3,000-metre-altitude campsite parking lot in New Mexico. Intentionally selecting weeknights in the off-season, they set up and enjoy several nights of uninterrupted viewing under optimum conditions.

power, and their light is spread out rather than concentrated into as small a point as possible, as it is with good seeing. Faint stars at the threshold of vision are significantly easier to detect in perfectly steady air than under turbulent, poor-seeing conditions. Bad seeing can remove a full magnitude from the penetration limit on a steady-air night.

Do different types of telescopes have different magnitude-penetration limits? Yes, but there is not much variation. It depends on quality of optics more than on the type of telescope. High-quality optics yield pinpoint star images instead of the tiny puffballs that never quite come into focus in mediocre telescopes. The more a star's light is concentrated into a point, the easier the point is to see; the star's per-unit surface-area brightness is higher than when its light is spread out by poor-quality optical systems or improperly collimated optics.

Finally, what about the unaided eye? The standard naked-eye limit for most people is sixth magnitude. In rare instances, people with abnormally good vision can see to 7.0 and even 7.4 under superb skies. Typically, the limit is 6.5, but it depends on the specific sky conditions. Binoculars are more limited than telescopes of the same aperture because of their fixed low power. It is an achievement to reach magnitude 9.8 with 50mm binoculars and 10.8 with 80mm glasses.

■ AVERTED VISION

Averted vision allows the observer to pick up fainter objects than can be seen by looking at them directly. The technique is simple. Look away from the object under study while continuing to concentrate on it. Averted vision is most effective if the observer looks at a point halfway from the centre to the edge of the field of view (the object in question is presumably at the centre). The technique works especially well for diffuse objects such as comets, nebulas and galaxies, but it helps reveal fainter stars too.

It is a good practice to use the averted-vision technique from a variety of angles because the highly effective dim-light sensors in the peripheral areas of the eye have different sensitivities. The overall gain achieved with averted vision can amount to more than half a magnitude. However, most backyard astronomers do not consider a sighting to be definite unless it is seen with direct vision. A notebook may read: "Glimpsed with averted vision but uncertain with direct vision." Such an observation is usually regarded as "probable." Definite sightings of faint objects need to be at least "apparent with averted vision and glimpsed directly."

The chief advantage of averted vision is to gain initial awareness of the existence of a threshold object. Then, once the target is detected, vision can be concentrated on it to attempt a direct confirmation.

point, of course. Magnification beyond 50x per inch seldom produces any further advantage.

Simply stated, the advantage of high magnification is that the sky background is darkened while the apparent size of the star image stays the same or is only marginally increased. A point source on a blacker background is easier to detect. Visual acuity is enhanced at higher magnification as well. Above 25x per inch, the exit pupil is down to 1mm or less, so the light cone, if centred on the eye, is passing through the most optically perfect part of the human vision system.

Everyone who has looked through a telescope is familiar with the effects of poor seeing, manifested as twinkling stars, ripples on the moon or undulations distorting the face of a planet. Stars and deep-sky objects are affected by seeing as well. Tiny stellar point sources are fuzzy and distorted at high

■ *Conventions at dark-sky sites have become the most popular forum for recreational astronomers, above. Most conventions include swap tables, right, where enthusiasts buy and sell used equipment and homemade gadgets, often at very attractive prices.*

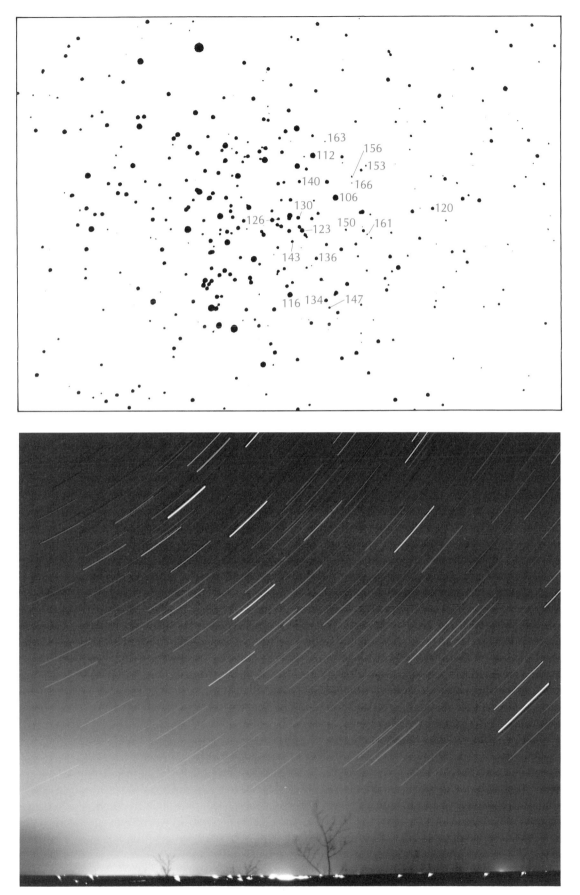

■ Top: The limiting magnitude of your telescope can be determined using this chart of the open star cluster M67. Magnitudes are given in tenths, with the decimal points omitted. North is up. Photograph by Martin Germano.
■ Left: Star trails merge with the glow of big-city light pollution. Photograph by Alan Dyer.

Observing the Moon, Sun and Comets

The moon and the sun were probably the first objects that Galileo looked at with his telescope nearly four centuries ago. Even in the crude 32x instrument, crippled by nearly every aberration known to optics, he still saw features never before observed— craters on the moon and spots on the sun. So it is today. Sunspots or lunar craters are usually the first details brought to the focus of a new telescope.

■ LUNAR OBSERVING

The excitement that Galileo must have felt as he gazed at the moon's rumpled face for the first time is part of the legacy of the telescope. Anyone's first look at the moon through even the simplest of optical instruments is instantly rewarded by a wonderfully detailed image of our nearest cosmic neighbour. The eye and mind are overwhelmed by detail—wrinkled plains, rugged fields of craters jumbled together, mountain ranges, valleys—all in stark relief undistorted by even a wisp of haze, fog or mist (on the moon, that is). The satellite is so close, its features so easily visible and the detail so abundant that regardless of the effects of poor seeing, there is always something to examine.

Today, telescopic observation of the moon is limited almost exclusively to introductory observing and to showing off the wonders of the universe to people who rarely have an opportunity to look through a telescope. Along with Saturn, the moon is the number-one showpiece object—near, yet clearly alien. Without an atmosphere to protect it, the moon has been bombarded for billions of years by meteorites, comets and asteroids—debris left over from the formation of the solar system. Its cratered face shows this. On a smaller scale, the powdery material kicked up by the Apollo astronauts is the result of micrometeorites that grind down the surface into fragments as fine as dust.

As recently as the early 1960s, the lunar surface still had secrets to divulge to backyard astronomers. By the late 1930s, much of the Earth-facing side of the moon had been photographed to a resolution of two kilometres, and a few exceptional pictures showed features near the shadow line, or terminator, to a resolution of a few hundred metres. But unlike time exposures of deep-sky objects, which reveal far more detail than the eye can see through the same telescope, lunar and planetary photographs always show less. Exposures of 1 or 2 seconds, typical of high-resolution lunar photography, are somewhat degraded by atmospheric turbulence.

Even today, lunar photography from Earth can never quite equal what the eye can discern through the same telescope. Only under rare instances of

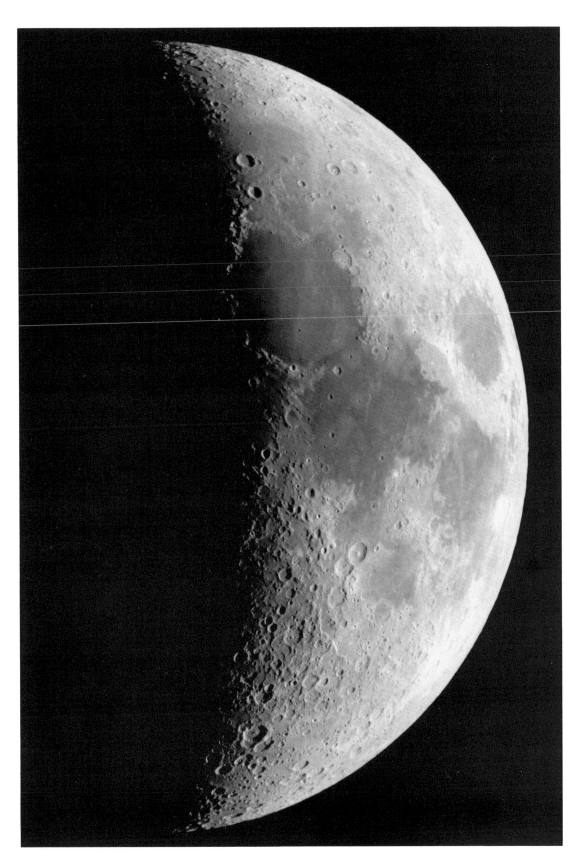

■ *Small telescopes reveal an overwhelming amount of detail on the moon, even more than is visible in this excellent photograph made with a 6-inch f/6 Newtonian. The three prominent adjacent craters just below centre are, from upper to lower, Theophilus, Cyrillus and Catharina. The stark relief along the terminator (the shadow line) makes features just a few hundred metres high stand out boldly. Photograph by Brian Tkachyk.*

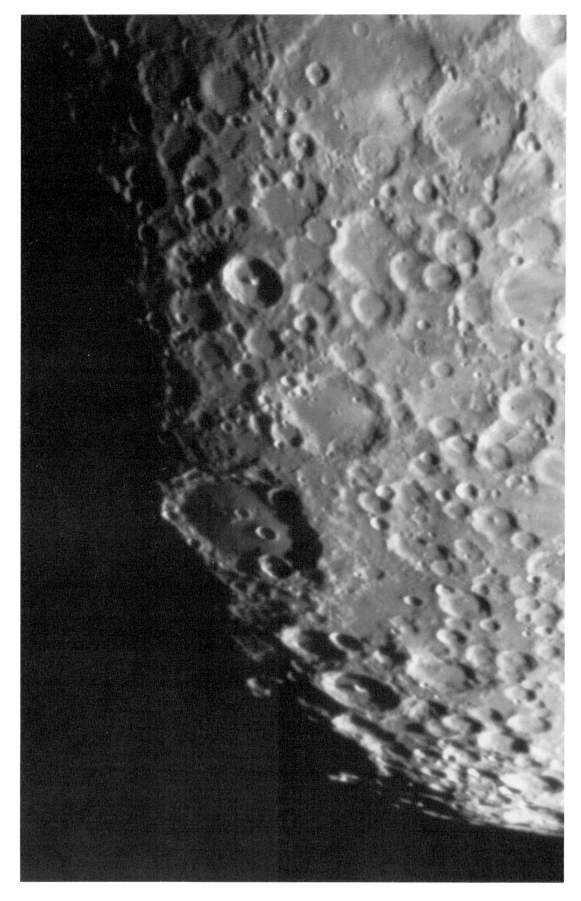

■ *With the proper attention to detail, a small telescope can yield great lunar photographs. This one was taken with an 80mm refractor. The huge crater at centre, with several smaller craters nestled inside, is Clavius, 230 kilometres wide. Photograph by Garry Woodcock, using a 10.5mm eyepiece for projection and Tech Pan 2415 film.*

perfect seeing does photography begin to come close. The experienced observer can watch for the momentary flashes of perfect seeing that occur during typical observing situations. At such times, resolution of better than two kilometres is commonplace in 6-inch telescopes, and occasionally, amazing amounts of fine detail almost magically emerge. But you have to wait for it.

THE RUSH TO MAP THE MOON

Not until about 1960 did it become clear that humans would explore the moon within a generation. To select a landing site, scientists needed highly detailed lunar maps. But because of the limitations of earthbound lunar photography, few large professional telescopes were used for such purposes. Also, in 1960, no professional astronomers in the United States and few in the world had experience plotting the moon's geography—visually or photographically. The U.S. Air Force was given the project of making an accurate high-resolution topographic map of the moon. Air Force officials recruited the Lowell Observatory's 24-inch refractor and several highly skilled amateur astronomers who were assigned the task of using their visual skills to increase the accuracy of existing lunar maps.

The resulting moon maps were wonderful to look at, exquisitely detailed and, in general, very accurate. At that time, coauthor Terence Dickinson, using a 3-inch f/16 refractor, was participating in a lunar-observing programme run by a few members of the Royal Astronomical Society of Canada. The project involved looking for low-elevation lunar features visible for only a few hours as the terminator passed over them. At such times, a very small elevation casts an enormous shadow easily visible from Earth. For example, a 10-storey building would throw a shadow several kilometres long.

In the right grazing lighting, amazingly small details stand out. The 3-inch refractor picked up features that were on no existing lunar maps, even the new Air Force effort. One structure—a wall, or scarp, near the crater Cauchy—was shown on the map as a rille, a shallow ditchlike feature. Looking at it through the refractor, Dickinson had no doubt that it was a scarp, not a rille. When the terminator passed over the region at sunrise, the scarp cast a shadow; whereas at sunset, it was brightly illuminated and had no shadow, a phenomenon that could be due only to a scarplike drop in elevation.

Such was the state of lunar cartography in 1961: detail visible from Earth in a 3-inch refractor had not been portrayed correctly on any lunar map. Although the cartography was not generally inaccurate, little attention had been paid to the project of properly recording the moon's features; that task had been left to individuals, mostly amateurs,

since about 1900. Finally, during the mid-1960s, the robotic lunar orbiters mapped most of the moon in much higher resolution than is achievable from Earth. The transition—the result of huge amounts of cash being pumped into the Apollo programme—took lunar discoveries largely out of the amateurs' domain. The sense of pioneering that had accompanied serious lunar observing for centuries was finally eliminated.

IS THERE ANYTHING LEFT TO DISCOVER?

The perception that nothing is left to learn about the moon has discouraged nearly all backyard astronomers from observing our satellite. The moon is regarded as a nuisance, since its light spoils views of dimmer objects. We are amazed at how seldom telescopes are turned toward the moon. Too many amateur astronomers have been duped by the silly notion that if there is nothing new to discover, there is no point looking. The moon is a wonderland of alien landscapes; to see them, the observer needs to know *how* to look more than what to look for.

A high-resolution photograph of the moon gives only an inkling of the truly impressive views that are possible with even moderate-aperture telescopes. Indeed, lunar observing is probably the one case in which aperture almost works in reverse—less is sometimes better than more. The moon's image is so bright that even small apertures used at very high powers provide enough light to show the displayed

■ *Mare Serenitatis, one of the lunar "seas," is the lava-flooded floor of a giant four-billion-year-old crater. Meandering across Serenitatis is the Serpentine Ridge, a feature just a few hundred metres high that is visible only when sunlight grazes it, as seen here. Photograph by Jody Metcalfe, using a Celestron 8-inch Schmidt-Cassegrain.*

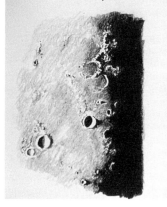

■ *Right: The full moon is the worst phase for observing lunar detail because of the lack of shadows and the overwhelming brightness. Photograph by Brian Tkachyk, using a Celestron C8.*
■ *Top: A traditional test of good optics and steady seeing is to examine the floor of the crater Plato for craterlets when the moon is one or two days past first quarter. Several craterlets are clearly shown in this 1965 Lunar Orbiter image. The two largest, about three kilometres wide, have been detected with a 4-inch refractor. NASA photograph.*
■ *Above: Sketching the moon was a popular backyard-astronomy activity prior to the space age, but few observers today even attempt it. Sketch by Matthew Sinacola.*

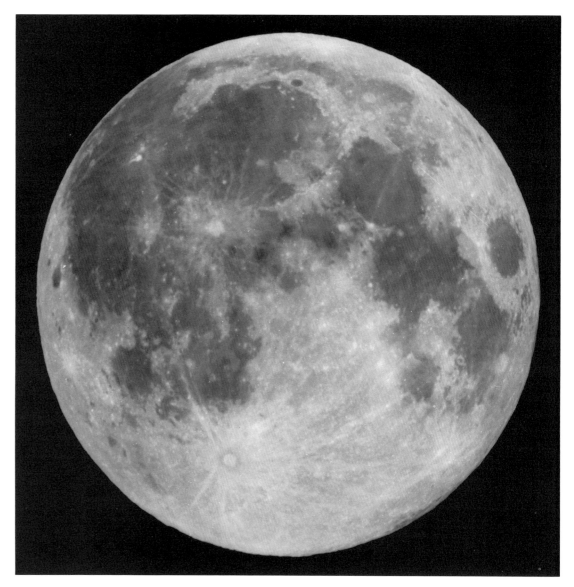

features clearly; when using apertures greater than 6 inches, what can be seen is limited not by the telescope but by the steadiness of the atmosphere. Of course, at exorbitantly high powers—more than 60x per inch of aperture—the image often becomes fuzzy because of the limits of resolution of the optical system. As a general rule, however, the moon can be viewed with higher magnifications than any other celestial object.

For instance, we have used a 5-inch apochromatic refractor for lunar observation at up to 450x, although we usually employ less. However, the most common lunar-observation magnification used with that telescope is 220x, and the images are sharp and detailed—the equivalent of looking out the porthole of a spacecraft orbiting the moon at an altitude of 1,600 kilometres. With such a telescope on a solid, accurately driven equatorial mount, our satellite becomes a fascinating world to explore. The

crawling terminator alters the appearance of the features in deep shadow within minutes, and in fine seeing, it is possible to distinguish every feature shown in the best pictures taken from Earth.

What will keep drawing you back to the moon, though, is the exquisite beauty and the barren alien nature of the lunar surface that constantly changes with the monthly sweep of the terminator.

■ EQUIPMENT FOR LUNAR OBSERVING

At first glance, the telescopic image of the moon is often overwhelmingly bright. But the glare is so simple to control, it is amazing that not every observer takes steps to do so. The only accessory required is a lunar filter (about $15) which screws into the base of a 1¼-inch eyepiece in the same way that deep-sky and colour filters do. The neutral-density filter absorbs 90 percent of the light passing through it yet

affects the image in no other way. The low-tech accessory reduces lunar glare to a comfortable level.

Another way to reduce brightness is to add twin polarized filters (about $30), sold as either two separate 1¼-inch filters or, better, two filters in a housing that fits in front of the eyepiece. An adjusting lever varies the amount of polarization between the dual filters, regulating the quantity of light entering the eyepiece from 50 percent to less than 1 percent. It works well for casual scanning, but the critical observer will notice a slight loss in resolution that does not occur with a single neutral-density filter. However, for casual lunar observing, the variable polarizer is an easy way—sometimes the only way besides extreme magnification—to reduce the moon's brilliance to a satisfactory level.

A more serious glare-reduction device, advantageous with 10-inch and larger Newtonians and Schmidt-Cassegrains, is an off-axis diaphragm. It is a simple cardboard mask placed over the front of the instrument that has a one-third-aperture hole—precisely circular and smooth-edged—located toward the edge where it will not be obstructed by the secondary mirror or its support vanes.

Off-axis diaphragms reduce the amount of light going through a telescope to about 13 percent of the full-aperture value, similar to the reduction obtained when using a standard neutral-density filter. Because the aperture is now unobstructed, contrast is enhanced, a definite bonus for lunar viewing.

Some lunar observers prefer colour filters; the favourites are green, deep yellow and orange. As noted in Chapter 4, with achromatic refractors, inexpensive colour filters have the advantage of dimming the moon while greatly reducing chromatic aberration and thereby sharpening the view. The overall colour cast is soon easy to ignore. Colour filters have no advantage over a neutral-density filter in other types of telescopes.

■ PROBING LUNAR VISTAS

Anyone who has offered views of the moon to the general public at stargazing events or to friends has heard the question, "Can we see where the astronauts landed?" The answer is yes and no. The location can be pinned down by using a lunar map, but the person usually wants to know whether it is possible to see the footprints, lunar lander and other paraphernalia left on the surface. The best way to answer such a query is to point out that the smallest crater visible in a large telescope is about the size of the largest sports stadium in the world, whereas the biggest piece of hardware left by the Apollo astronauts is smaller than a two-car garage.

The likelihood of seeing any changes on the moon—for instance, a meteorite hitting the surface or possible volcanic activity—is very small. A meteorite large enough to produce a cloud of ejecta visible from Earth would strike the moon no more than once or twice per century. There is no unequivocal proof that one has ever been observed. A few enthusiasts maintain that searches for so-called transient lunar phenomena, which could arise from the release of gases from the moon's interior, are viable programmes for backyard astronomers. It is always fun to look, but there are other observing programmes with more immediate results.

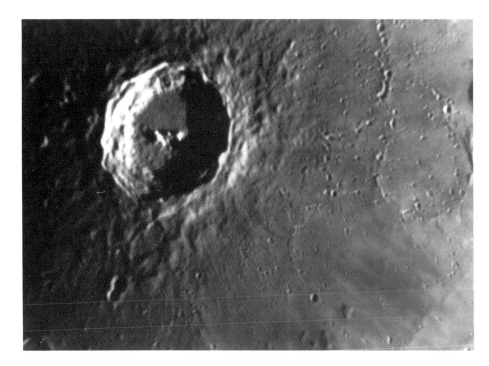

■ SOLAR OBSERVING

Examining the intensely brilliant surface of the sun is possible only with proper filtration. *Never* look at the sun through any optical device unless you are sure that it is safely filtered and that you know what a safe filter is. A very dense filter is necessary. Not only must it reduce all visible wavelengths to a safe level, but it must also block infrared and ultraviolet light. These invisible wavelengths can damage the retina of the eye, causing complete or partial blindness. *Do not take chances.* Astronomy is a benign hobby with few opportunities for personal injury. Read the following carefully.

Over the years, especially around solar-eclipse events, many materials have been recommended as solar filters. Most are unsafe. Do *not* use smoked glass, sunglasses, layers of colour or black-and-

■ *The seeing is good when you can distinguish the rows of craterlets beside the mighty Copernicus crater. Copernicus itself, 100 kilometres across, is not the largest lunar crater, but many observers say that it is the most impressive. This part of the moon is near the terminator 9 or 10 days after new moon. Photograph by Don Parker.*

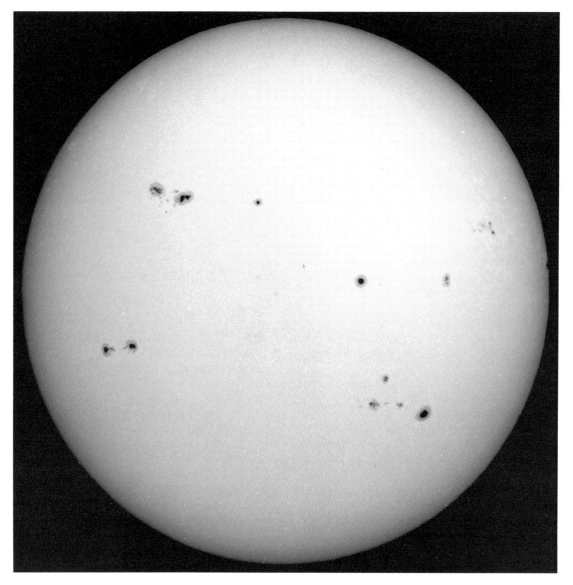

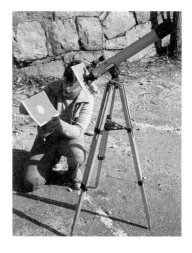

■ *Above: The simplest way to observe the sun's surface is by projection, using a small refractor. Because of internal heat buildup, catadioptric telescopes should never be used for solar projection, and any telescope with an aperture of more than 60mm should be stopped down with a 40mm-to-60mm mask in front of the instrument. Photograph by Glenn F. Chaple.*

■ *Right: When you observe the sun by projecting its image or with proper filters for direct viewing, the surface almost always displays a few sunspots. The spots often appear in pairs. Overall, they align roughly in two belts 20 to 30 degrees on either side of the solar equator. Photograph by Brian Tkachyk, using a Celestron C8.*

white film (no matter how dense), photographic neutral-density filters or polarizing filters. People have even been known to look through the bottoms of beer bottles. This seems laughable, yet many novice amateur astronomers use a type of solar filter that is far more dangerous than anything listed above.

The filter in question, which comes with many small department-store telescopes, is a piece of dark green glass that screws into the bottom of an eyepiece. Such "sun filters" are unsafe because they sit at the focus of the telescope where all the light and heat are concentrated. When the instrument is aimed at the sun, the temperature near the filter can reach hundreds of degrees, cracking it and letting through a blinding wash of sunlight. Eyepiece solar filters should be banned, but they are still included as an accessory with many small telescopes given to children for Christmas.

The simplest, safest and most readily available

filters for gazing at the sun with unaided eyes are No. 14 welders' filters. They are sold in two-by-four-inch rectangles for about $2 at well-stocked welding-supply outlets. Because the filters are made to exact specifications for the welding trade, they are reliable and have the right density to be completely safe. Only the No. 14 grade is appropriate; the more common No. 12 filter is too light.

To observe the sun with a No. 14 welders' filter, place the filter in front of your eyes *before* you gaze up at the sun. Individuals with 20/20 vision or better will see sunspots that are Earth-sized or larger. People with exceptional vision, 20/12 or better, can see spots almost daily with no optical aid other than the welders' filter.

A pair of seldom-used binoculars can become a permanent sunspot device if two welders' filters are securely taped over the front of the main lenses. Spots the size of Asia can be seen. However, for de-

tail on the spots, a telescope is needed. A 60mm-to-80mm refractor is ideal and, if properly filtered or used for projection, reveals a wealth of fine structures in and around sunspots.

■ SOLAR VIEWING BY PROJECTION

Solar projection is the filterless way of observing the sun. Aim the telescope at the sun by watching the instrument's shadow, not by gazing up the tube at the sun and especially not by peeking into the finderscope. Always cover the front of the finderscope during any solar observing. When the shadow becomes circular, the telescope is aimed approximately sunward. Hold a white card a foot behind the eyepiece to catch the sun's image. Using an eyepiece yielding about 30x, focus the projected image. This method is ideal for group observing and is particularly effective if the white card is mounted on an easel or tripod and shaded from direct sunlight to increase contrast. However, the detail visible in direct filtered viewing cannot be equalled.

Even so, projection is preferred for making full-disc drawings of sunspot positions and their relative sizes. For orientation consistency, determine the celestial east-west axis for each drawing by watching the solar disc drift into or out of the undriven field of view. The centreline of the drift motion is celestial east-west. A few months' worth of drawings reveal fluctuations in the numbers of spots. Small spots may last several days or grow into large spot groups and stay on the solar face for weeks. Because of the 3½-week solar rotation period, the scene changes a little every day and a great deal in a week.

For projection, the telescope's aperture should be limited to 60mm or less to avoid damage to the eyepiece. Small refractors are ideal; larger telescopes *must* be covered with a diaphragm. A hole in a piece of cardboard covering the aperture is fine for refractors or Newtonians, but never practise solar projection with a catadioptric. Heat can quickly build up inside the instrument and cause damage before you are aware of a problem.

Sunspots wax and wane in an 11-year cycle. The last maximum was in late 1989, and the next is due in 2000 or 2001. Solar activity continues throughout the cycle, and there are usually a few spots no matter when you look. A surprising amount of detail is visible around a large sunspot and is best seen by direct viewing with the appropriate filter.

■ SOLAR FILTERS FOR TELESCOPES

The recommended solar filter fits snugly over the front of the telescope, where it safely reduces light and heat before they enter the tube. Known as full-aperture filters, or prefilters, the best and most durable are made with optical plane-parallel glass coated with a nickel-chromium alloy called Inconel. Thou-

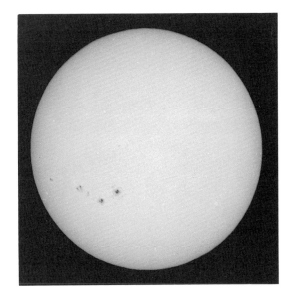

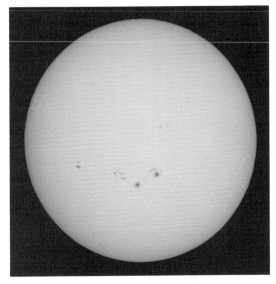

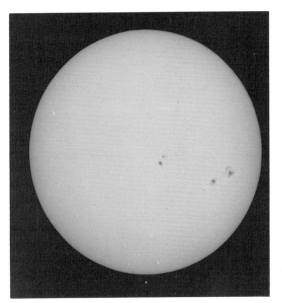

■ *Being a gaseous sphere, the sun rotates at different rates, from 25 to 35 days, depending on surface latitude. In the zones where sunspots appear most frequently, the rate is about 27 days. Thus spots seem to march across the sun's face in less than two weeks. These three photographs were taken on December 14, 17 and 19, 1990, by Greg Saxon, using a Celestron C8.*

129

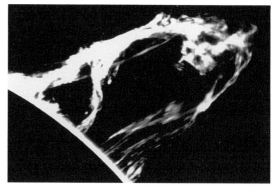

sand Oaks Optical is a major supplier of Inconel filters for any size telescope. Prices range from $50 for a 60mm refractor to $150 for a 14-inch Celestron Schmidt-Cassegrain.

Metal-coated Mylar, a durable plastic material, is an alternative to the glass filter. Two layers of Mylar in a cell press fit over the front of the telescope. Roger W. Tuthill, Inc. specializes in the manufacture of such a filter, called Solar Skreen. Celestron uses Solar Skreen material to make optional solar filters for its telescopes. Some observers report that Mylar filters equal or exceed the optical quality of glass filters; others dispute this. In any case, they cost slightly less than the glass models. The chief difference is that the sun appears as an unnatural blue through Mylar filters, a characteristic correctable with a No. 23A eyepiece filter, commonly used for Mars observations. Most metal-on-glass types present a more natural-looking yellow sun.

Another word of caution: not just any Mylar will do. Do not run down to the local hardware or automotive-supply store to buy sheets of Mylar for homemade filters. Most metallized Mylar sold for use on van and camper windows and incorporated into materials like "space blankets" is unsafe for solar viewing. It is not dense enough and does not necessarily block harmful infrared and ultraviolet light. Use only filters sold specifically for astronomical

applications by telescope manufacturers and well-known firms such as Tuthill and Thousand Oaks. With them, you and your friends and family can watch sunspots for hours in complete safety.

All the solar filters discussed so far show the sun in white light; that is, they reduce the amount of light across the entire spectrum. A very specialized type of solar filter works a little differently. It eliminates all light from the sun except the single wavelength emitted by hydrogen atoms—656 nanometres. This filter has an extremely narrow bandpass of only 0.1 nanometre, or 1 angstrom.

When the sun is viewed in the light of hydrogen atoms, features such as solar prominences, filaments and flares appear. Normally, prominences can be seen only during a total solar eclipse. With an H-alpha filter, they are visible on any sunny day. H-alpha filters add a new dimension to the hobby of astronomy, but they are expensive, costing between $700 and $2,500 depending on the bandwidth. The narrower the bandwidth, the more solar-surface details you see and the more money you spend. The most expensive of the filters require AC power to heat some of the internal elements. All require a special broadband filter over the front of the telescope for prefiltering the light before it enters the main H-alpha filter mounted at the focus. Solar-observing expert John Hicks gives details at right.

■ *Left: A full-aperture Inconel-coated glass filter by Thousand Oaks Optical fits snugly over the front of the telescope for safe direct viewing of solar features. Mylar filters work in the same way.*

■ *Right: Solar prominences are seen in remarkable detail using an H-alpha filter and a coronagraph, a specialized device that blocks the solar disc to permit more detailed viewing of the prominences. Photograph by Wolfgang Lille, using a 7-inch Astro-Physics refractor.*

■ COMETS

Comets are chunks of ice impregnated with dust. They are about the size of a small city and orbit the sun as the planets do, but in more exaggerated, elongated paths. Most comet orbits are entirely beyond the path of Neptune. Some astronomers regard Pluto—a tiny, icy world—as the biggest comet rather than the smallest planet.

The largest officially recognized comet is Chiron, a 250-kilometre-wide body with an elliptical orbit between the orbits of Saturn and Uranus. Despite its size, Chiron is invisible in amateur-astronomy equipment. Smaller comets that venture closer to

the sun, within the orbit of Mars, are the quarry of the backyard astronomer. At this distance, sunlight vaporizes the comet's icy surface, releasing gas and dust that are swept into a tail by the solar wind and the pressure of sunlight in the vacuum of space.

Apart from a few historical exceptions, comets are named for their discoverers. Comet Skorichenko-George, for example, was spotted on the same night in December 1989 by amateur astronomers Boris Skorichenko of the Soviet Union and Douglas George of Canada.

Comets that boast tails easily visible to the un-

□ By John Hicks

The surface of the sun viewed in hydrogen light is an astonishing glimpse of a giant controlled fusion furnace. Large, black, sinuous filaments arch against the sun's ruby-red surface, and intense white flares often burst out of entangled magnetic fields. The magnetic storm lines are easily seen writhing around sunspots. About the limb, silhouetted against the jet-black of deep space, dramatic prominences are evident in myriad shapes. The whole image is one of energy in its most elemental form.

For viewing and photographing the sun, a 0.7-angstrom filter provides the best disc contrast and retains reasonably bright prominences. Narrower filters produce high resolution of active surface regions but offer dimmer prominence details, and their price increases with decreasing bandwidth. The popular 0.8-angstrom ATM model by Daystar (about $1,800) is a good all-round choice for the serious amateur astronomer. It transmits light from the solar spectrum at 656.3 nanometres through a series of multiple-deposited parallel lenses that are heated by a tiny internal oven. Varying the temperature with a rheostat permits precise tuning to 656.3. New models can be fine-tuned simply by tilting the interference filters. They eliminate the necessity of a 110-volt power source but are for visual observing only. (Tele Vue's Solaris telescope uses this type of filter.)

To use H-alpha filters, the telescope must be stopped down to a focal ratio of f/30. Most H-alpha filters come with an additional energy-rejection filter (ERF) that fits over the objective end of the telescope and reduces it effectively to f/30. The ERF screens out infrared energy and filter-damaging ultraviolet light, while the reduced aperture produces the nearly parallel light beams required for optimum filter performance. My 8-inch Schmidt-Cassegrain has a 65mm ERF, which I use with 30mm or longer eyepieces. The image is too dim for higher power. The observer should have dark-adapted vision and wear a dark hood.

Photographing the H-alpha sun presents special challenges. The wispy, faint prominences around the sun's limb pose no problems for most colour-transparency films of modest speed because they are silhouetted against the blackness of deep space. However, the solar-disc features usually escape the grasp of colour films. For disc photography, I recommend Kodak

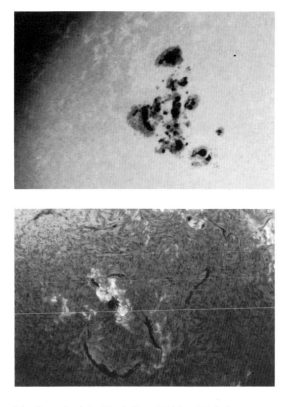

black-and-white Tech Pan 2415, which has very fine grain and extended red sensitivity. It can be push-processed and still retain its fine grain and high level of contrast. The resulting negatives can be made into slides by copying them back onto 2415.

For an 8-inch telescope stopped down to f/30, Tech Pan 2415 should be exposed 2 seconds for prominence photography and 1/15 second for disc photography. The black-hat method should be used for the 2-second exposures (see Chapter 15). Use an air-bulb release cable to soften mechanical vibration at higher speeds, or use the camera's self-timer release if it has one. I am amazed at the extremely narrow latitude permitted by disc photography; very slight changes in exposure will produce either acceptable or unacceptable negatives.

The sun's secrets are so readily unveiled with the H-alpha filter that it is easy to become immersed in the challenge of perfecting the technique. One never knows when the next giant prominence or flare will make persistent hours at the eyepiece worthwhile.

John Hicks is a landscape architect who can be found many days examining the sun from his observatory near Keswick, Ontario.

■ *Top: The sun photographed in white light (standard filtration) reveals sunspot detail and faculae—bright feather-shaped structures that are visible around sunspots and at the solar limb (edge). John Hicks ganged a pair of 2x Barlows on his Celestron C8 for this photograph using Tech Pan 2415.*
■ *Bottom: A photograph taken in hydrogen alpha shows the superior ability of this technique to expose solar detail, including fine surface granulation and flares. Photograph by John Hicks.*

aided eye are relatively rare, averaging one per decade. Of course, that is just an average. Two such comets were seen six months apart in 1957. Another clumping of bright comets occurred in 1910-11.

In January 1910, four months before Halley's Comet reached its greatest 20th-century brilliance, a spectacular comet that could be seen in broad daylight appeared and, toward the end of January, moved into the evening sky, where its tail could be detected even in moonlight. When the moon was out of the sky, a 30-degree-long tail was visible.

Halley's Comet made its appearance in April 1910, reached first magnitude and was watched by millions. Then, in October 1911, Comet Brooks reached second magnitude and was described as having a beautiful, feathery tail.

In the past half-century, eight comets have attained third magnitude or brighter when positioned in a reasonably dark sky for northern-hemisphere observers. A brief description of each follows, and a few famous — and infamous — pretenders are mentioned as well.

■ BRIGHT COMETS: 1940-90

On August 24, 1940, Leland Cunningham of Harvard College Observatory, in Cambridge, Massachusetts, took a routine photograph of the constellation Cygnus and picked up a 13th-magnitude comet. During the next three months, the comet brightened rapidly as it approached the sun, suggesting that it was going to be a spectacular object when it passed closer to the sun toward the end of the year. However, the brightening slowed abruptly in mid-November, and as the comet entered its prime observing position in early January 1941, it barely reached third magnitude, four magnitudes fainter than had been predicted. Comet Cunningham was a 1940s version of the Comet Kohoutek fiasco that involved the same media buildup and the same disappointment in the early 1970s.

The Southern Comet that graced the Earth's skies in December 1947 was visible throughout the southern hemisphere near magnitude 0 and had a 20-degree tail stretching from the horizon. When it became visible in the northern hemisphere, it was seen at about third magnitude and had a distinct tail.

In 1957, two bright naked-eye comets made an appearance. The first was Comet Arend-Roland, which became a brilliant first-magnitude object with a 15-degree tail during the last week of April. It rapidly faded to sixth magnitude by the middle of May as it receded from both the sun and Earth. The comet was notable for its luminous antitail, a dust tail that, because of perspective, appeared extended from the nucleus toward the sun.

The second 1957 comet was Comet Mrkos, a first-magnitude object discovered in twilight on July 29.

During the initial week of August, the comet was well placed in the evening sky, had an overall magnitude near 1 and a tail five degrees long. By the middle of August, the comet was third magnitude in darker skies and had a straight 10-degree tail.

Comet Seki-Lines of 1962 was a respectable entry that briefly reached third magnitude in the April evening sky and had a tail more than 10 degrees long when viewed through binoculars.

The brightest comet of the 20th century was Comet Ikeya-Seki of 1965, a member of a rare class of "sun grazers" that swoop to within one or two solar diameters of our star's surface. The explosive vaporization of the comet's ices during its rapid hairpin turn around the sun generated a dense coma and a huge tail that made Ikeya-Seki visible to the unaided eye in broad daylight if the sun was blocked from view. When only two degrees from the sun, the comet was estimated at an astounding magnitude −10 and had a two-degree tail.

As Ikeya-Seki swung into the morning sky during the last few days of October, an amazing 45-degree tail extended from a small but brilliant nucleus. However, the comet was poorly seen north of 40 degrees latitude because the tail was angled low toward the horizon. It remained a naked-eye object for only a week, rapidly fading as it pulled away from the sun. Nevertheless, most experts regard it as the finest comet of the 20th century.

Comet Bennett was discovered on December 28, 1969, by John C. Bennett of South Africa during a deliberate comet search. Throughout April 1970, Comet Bennett was a conspicuous object in the evening sky in the northern hemisphere, shining second magnitude overall with a 20-degree-long tail. It was one of the most widely observed comets of the century and the first to be photographed extensively in colour by backyard astronomers.

Three years later, Comet Kohoutek arrived. It was not a great comet but is so well known that it deserves to be dealt with in more detail.

■ THE COMET KOHOUTEK SAGA

On March 18, 1973, Lubos Kohoutek of Hamburg Observatory discovered a tiny 16th-magnitude smudge on a photograph he had taken two weeks earlier during a routine asteroid search. But the comet discovery was not routine. Orbit calculations showed that the comet was nearly five times the Earth's distance from the sun and would not reach perihelion until December 28, 1973, when it would pass within the orbit of Mercury. In early January 1974, Comet Kohoutek would emerge into the evening sky near Venus and Jupiter.

How bright would it be? In September 1973, NASA published a guide to Comet Kohoutek that was widely circulated to teachers and reporters. It

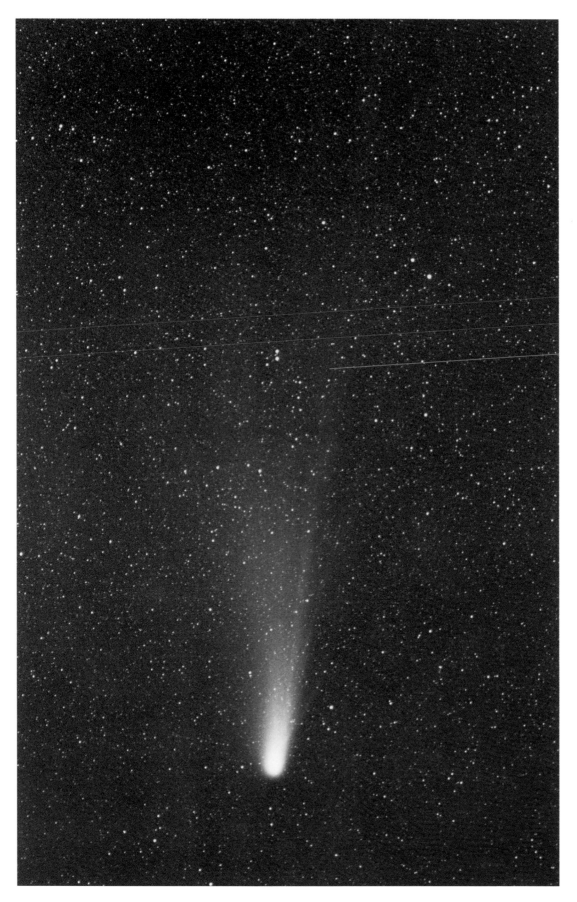

■ Although Halley's Comet was three times farther away in 1986 than it was on its previous visit in 1910, it still put on a decent display. This image by Jim Riffle, using a 400mm f/4 telephoto lens, shows the comet's yellow dust tail and blue gas tail.

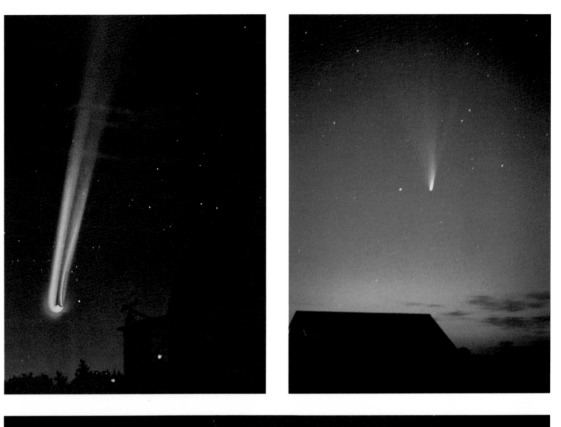

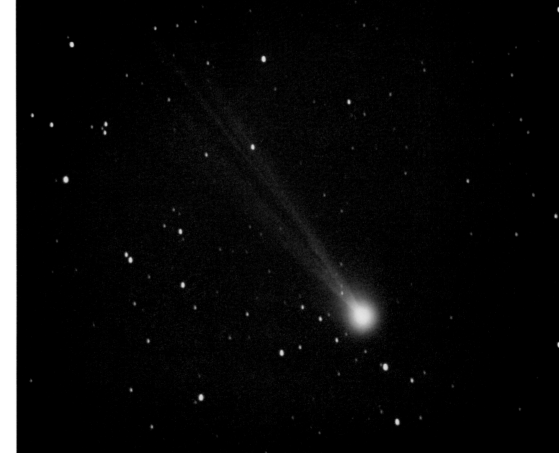

■ Top left: Painting of the Great Comet of 1882 gives the impression that it must have been awesome. To achieve the effect, the artist superimposed a telescopic view over a pastoral observatory scene. In the same vein, accounts of "brilliant" or "dazzling" comets of previous centuries are often overblown. The brightest comet ever seen in a dark sky in the last 2,000 years was likely Halley's in the year 837, when its overall brightness equalled that of Venus.

■ Top right: Comet West put on a great show in early March 1976. Photograph by Rolf Meier.

■ Right: Comet Brorsen-Metcalfe, visible for several months in 1989, was captured on film by Craig McCaw, using a 17.5-inch Newtonian.

134

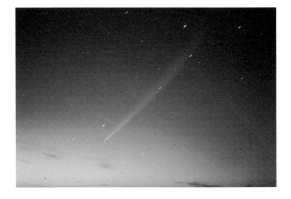

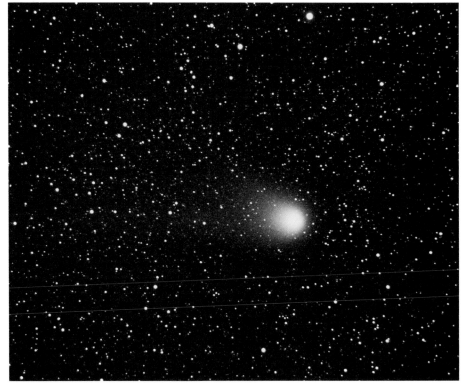

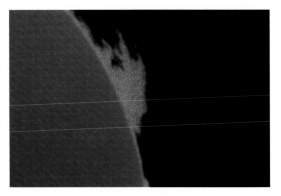

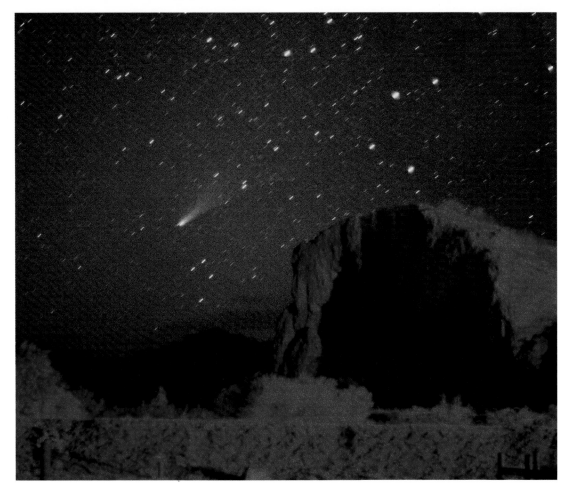

■ *Top left: Comet Ikeya-Seki had the longest tail of any comet in the 20th century. Richard Keen photographed it on November 1, 1965, using a 55mm lens.*

■ *Above: Comet Levy delighted observers through-out the northern hemisphere in the summer of 1990. It reached magnitude 3.5 while remaining conveniently in the evening sky. Photograph by Terence Dickinson.*

■ *Left: Sometimes, circum-stances combine for a memorable celestial photo-graph—if you have your camera with you. While staying at a campsite in Arizona, Alan Dyer stepped outside to take a picture of Halley's Comet. A nearby streetlight lit up the foreground, and the comet completed the scene.*

■ *Centre: A composite photo-graph of the sun, made by John Hicks using an H-alpha filter, shows surface detail as well as prominences.*

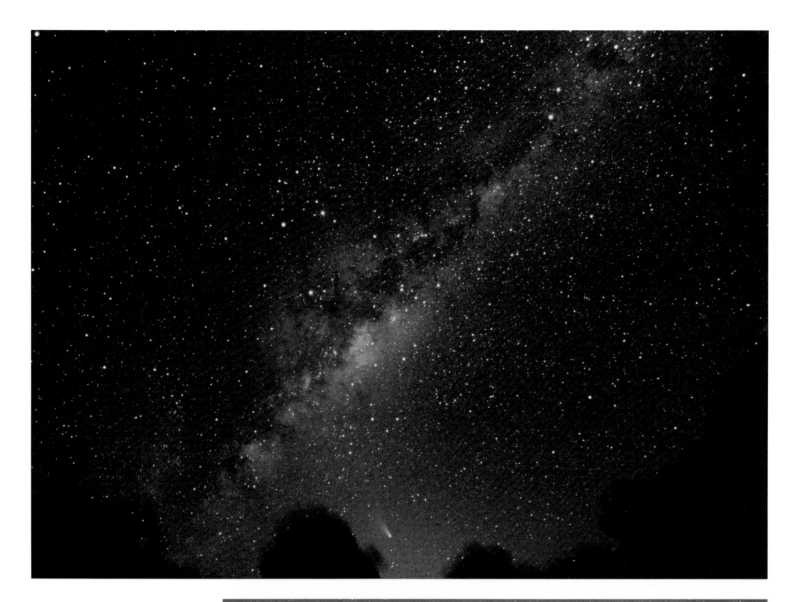

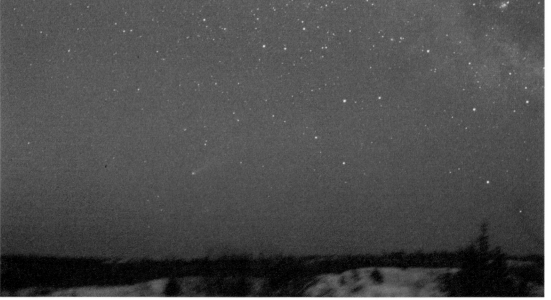

■ *Above: One of the great portraits of Halley's Comet was shot from Australia on March 10, 1986. The central bulge of our galaxy, the Milky Way, angles above the comet's image near the horizon. Photograph by Rob McNaught, using a 24mm f/1.4 lens and gas-hypered Fujichrome 400 film.*
■ *Right: From Canada and the northern United States, Halley's Comet was very close to the horizon when it was at its best, just a dim smudge over this northern Ontario landscape. Photograph by Steve Dodson.*

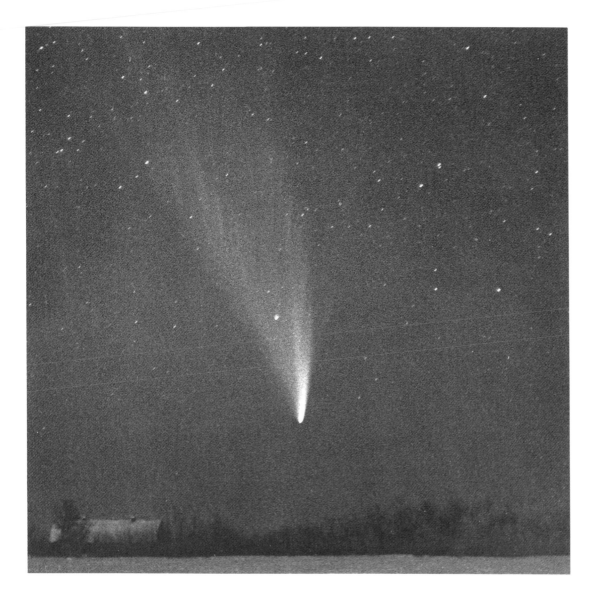

predicted that the comet would be magnitude -4 in early January—equal to Venus, which would be beside it in deep twilight. Astronomy enthusiasts were eager with anticipation, because a comet that bright had not appeared since the 1880s.

Even the most conservative estimates made in the summer and early fall of 1973 suggested that the comet would be at least magnitude 0. By December, though, something was clearly wrong. Kohoutek at its best was fourth magnitude, the same brightness as Halley in 1985-86, and was a tremendous disappointment to the thousands of backyard astronomers out in force to greet it in early January. The public, primed for a "blazing spectacle" or a "cosmic searchlight," saw nothing.

A major contributor to the inflated predictions was the fact that Kohoutek was a comet on its initial visit to the inner solar system from the Oort cloud, the comet reservoir beyond Neptune. It was a pristine chunk of cosmic flotsam that had never been exposed to solar heating before. Readily vaporized materials such as methane, hydrogen cyanide and methyl cyanide formed a cloud around the frozen comet nucleus at huge distances from the sun, giving the false impression that the activity would continue unabated closer to our star. Once these materials were dissipated, however, the rate of brightening declined sharply.

Comet Kohoutek still ranks among the top 25 comets of the century, but it will always be remembered as the comet that fizzled.

■ COMET WEST

The story of Comet West is the Kohoutek saga in reverse. It was discovered in November 1975 as a small smudge on survey plates taken at the European Southern Observatory, in Chile, two months earlier. However, as it approached the sun, it was dimmer than Kohoutek was at distances beyond Mars, so it attracted comparatively little attention.

■ *William Krosney captured more than Comet West in this fine celestial portrait taken on March 5, 1976, from Manitoba. You can feel the stillness and cold of the night and share in the exquisite beauty of a rare phenomenon—a bright comet passing through our sector of the solar system.*

But as fate would have it, in January 1976, on its way to perihelion inside the orbit of Mercury, Comet West brightened much faster than predicted. Ten hours past perihelion, the comet was visible to the naked eye 10 minutes before sunset at an estimated magnitude of -3, making it an extremely rare daylight comet. But because this was both unexpected and unpredictable, few astronomers—professional or amateur—witnessed it.

In early March, the cosmic visitor moved into the morning sky and dimmed only slightly to magnitude -1. On March 7, one of the most beautiful comets of all time adorned the heavens in every part of the northern hemisphere that had reasonably dark, cloudless skies. Comet West had a yellow main dust tail 30 degrees long that hung like a ghostly feather above the horizon just before dawn.

By March 13, the show was over, unobserved by the general population. With the Kohoutek fiasco still fresh in their minds, news editors ignored Comet West, so few people beyond the amateur-astronomy community knew of it. Others (including the authors) missed Comet West because of bad weather.

■ OBSERVING COMETS

□ By David H. Levy

The old expression "When you've seen one, you've seen them all" does not apply to comets. More than 20 comets are found or recovered every year, and each is observationally unique.

First, a comet's combination of gas and dust produces different sizes of coma, the bright comet head, as well as different strengths of gas-and-dust tails. Second, the more closely a comet approaches the sun, the more solar wind and solar radiation affect the gas and dust, causing longer, brighter tails. Third, because of the sun-Earth-comet geometry, a comet appears to change as it is observed from different angles. Included in this aspect is the chance that Earth will cross the orbit plane of the comet and the dust particles which are behind it will then become visible as an antitail. And finally, a comet's appearance is especially sensitive to the size of telescope turned toward it: binoculars reveal large-scale structures in the tail that an observer using an 8-inch telescope might miss.

Because comets can change so much in unpredictable ways, they are always interesting. Early in 1987, for instance, a new comet called Terasako was close enough to the sun that I had to find it in evening twilight. With the comet setting rapidly, I used a star atlas to locate the field. The newly discovered comet did not yet have a known orbit, so a search through two or three degrees was necessary before I finally distinguished a telltale elongated blob of light. But something was wrong. Either I was standing on my head or the comet's tail was pointing toward the sun. Upon closer examination, I realized that I was looking at the narrow antitail and that the comet also had a fan-shaped normal tail pointing away from the sun.

Like variable stars, comets fluctuate in brightness, so a comet observation includes a magnitude estimate. But unlike variable stars, comets change in other ways as well. The size, structure and concentration of the coma vary, as do the shape, length and position of the tail.

The important first step in observing any comet is to study its ephemeris, or list of predicted positions, carefully. Too many observers look only at the comet's predicted magnitude before deciding whether it is worth watching. Equally important is the comet's elongation, which represents its angular distance from the sun expressed in degrees. Suppose the "comet of the year" is predicted to be third magnitude but the elongation is just 14 degrees: the comet will be very low in the sky and visible only in bright twilight. Chances are that the comet will not be seen at all under those conditions.

A quick once-over is the first step in a comet observation. Become familiar with a comet's appearance. How large is the coma? Which direction is the tail pointing? Such basic information is essential for what is to follow.

Determining the brightness of the coma is the next step. When you have seen as much coma as there is, you are ready. Do not estimate a comet's magnitude by comparing it to some deep-sky object such as a nebula or a galaxy. Estimate a comet's magnitude by measuring it against a star. True, a star is not a comet either, but it acts as a source of light that can be effectively compared with the comet's light.

Using The AAVSO Variable Star Atlas, establish the magnitude of a few nearby stars similar in brightness to the comet. Put the stars out of focus until they are the same diffuseness as the coma. Now, compare the relative brightnesses. The comet's magnitude can be estimated by comparing it to the two stars nearest in brightness. (If you do not have The

For the comet to become 50 times brighter than initial predictions (by about the same factor that Kohoutek was dimmer than predictions), something unusual must have occurred. Around the time of perihelion, three huge chunks broke away from the nucleus—one of them almost as big as the nucleus itself—releasing far greater amounts of gas and dust than would be expected of an intact comet.

The key is the dust. Tiny particles like those which typically float in the air (illuminated in a room by shafts of sunlight) are wonderful reflectors of light. Comet dust is pushed away from the nucleus into the sweeping tail by the pressure of sunlight. Lots of dust results in a bright tail.

■ RECENT COMETS

No great comets have been seen since Comet West. From the northern hemisphere, Halley's Comet of 1985-86 never exceeded third magnitude. Although it was a nice binocular sight in mid-January, mid-March and late April of 1986, it remained unimpressive to the unaided eye. The publicity surrounding Halley's return sold many telescopes and astronomy books, but the predictions, for the northern hemisphere at any rate, were quite accurate.

Southern-hemisphere observers were disappointed by the comet's diffuse, stubby tail in early April, the time that several astronomers had predicted it would be at its best. In retrospect, this was a genuine mistake. We were looking at the comet almost head-on, and even if there had been a long, bright tail, it would not have been evident.

A year and a half after Halley's return, Comet Bradfield was well positioned in the evening sky and rivalled Halley's northern-hemisphere appearance in overall magnitude and length of tail (both comets had five-degree tails visible in binoculars). William Bradfield of Adelaide, Australia, the comet's discoverer, is the 20th-century world-record holder for visual comet finds, with 14.

A Comet Kohoutek/Cunningham clone, discovered by Rodney Austin of New Zealand, appeared in December 1989. Mindful of the Kohoutek disaster, astronomers were prepared, and estimates of Austin's potential as a zero-magnitude comet were laden with disclaimers such as "predictions of the brightness of comets are notoriously uncertain." Sure enough, Austin proved to be a comet on its first visit to the inner solar system and made an even more lacklustre showing than Comet Kohoutek, never exceeding magnitude 4.5.

The sixth discovery of North American comet sleuth David Levy reached naked-eye level, magnitude 3.5, in the August 1990 evening sky. Because it was 1.3 AU from the sun at the time, its tail was never more than a faint fan, but it was observed and enjoyed by amateur astronomers throughout the northern hemisphere.

The great comet of the late 20th century has yet to appear. It could arrive at any time, but the news media may not announce its coming. Newspapers, television and radio sometimes mention new comets, but seldom is there sufficient information to aid in locating them. *Sky & Telescope* and *Astronomy* magazines and local astronomy clubs are good sources for such details. A first-magnitude or brighter comet is a once-in-a-lifetime phenomenon, and third-magnitude or brighter comets are so rare that every effort should be made to view them.

AAVSO Variable Star Atlas, the magnitudes of all stars 8.0 or brighter are listed in *Sky Catalog 2000.0*, Volume 1.)

Estimates of coma magnitudes are notoriously difficult. You may assume that the coma is rather small and estimate its total brightness at magnitude 9.6. Another observer with a better sky, a larger telescope or a keener eye might see a larger coma and record magnitude 8.7 for the same object.

A good way to determine the diameter of the coma is to draw the comet and its surrounding stars. By comparing the drawing with a detailed star atlas like *Uranometria 2000.0*, the diameter of the coma can be measured in arc minutes.

Estimate the coma's degree of condensation on a scale of 0 to 9, where 0 denotes a completely diffuse coma with absolutely no condensation near the centre. A 3 means a diffuse coma with slight condensation, while a 6 means that the coma has a definite peak of intensity at the centre. A 9 refers to a starlike point of concentration.

Finally, describe the tail. Is it linear or curved? Is there a straight fainter tail (usually a gas tail) as well as a more curved dust tail? Determine the angular length in the same manner as you measured the size of the coma. Also indicate the direction in which the tail is pointing. This position angle is noted in degrees, where 0 points to celestial north (Polaris), 90 is east, and so on.

David Levy is North America's leading visual comet discoverer. From his home near Tucson, Arizona, he found seven comets between 1984 and 1991 using 8- and 16-inch telescopes. He is also the codiscoverer of five comets found photographically. He is the author of several books, including The Sky: A User's Guide *and* Observing Variable Stars.

■ CHAPTER TEN ■

Observing the Planets

Tens of thousands of years ago, prehistory's first Galileo noticed that a few of the very brightest stars appear to move among the rest of the stellar background. This early planetary astronomer was probably also the first astrologer, because the natural question arises, Why does a small, select group of bright stars move while the others remain fixed?

Astrological ruminations aside, planet watching remains a major element of today's recreational astronomy. On most nights of the year, at least one of the five naked-eye planets is visible. Quite often, it is the brightest object in the sky. When two or more planets happen to group together, the sight can be so striking that it turns the heads of people who normally do not look skyward. When the crescent moon joins the scene, the result is one of nature's most alluring spectacles—a silvery sickle adorned by one or more jewels.

Regularly check the *Observer's Handbook* or Guy Ottewell's *Astronomical Calendar* for interesting conjunctions or close approaches of planets to each other or to the crescent moon. A simplified diagrammatic presentation of this information is the monthly sky calendar published by the Abrams Planetarium. Planet positions are also provided in each issue of *Sky & Telescope* and *Astronomy*.

Each planet has a characteristic appearance, whether it is viewed with the unaided eye, with binoculars or with a telescope, and will be discussed individually in the sections that follow.

■ MERCURY ■

Of all the planets, Mercury is the most familiar to astronomers. This is not because it has historically been easy to observe or because it has been studied more than other worlds in the solar system. It is because Mercury happens to be very similar to our next-door world, the moon.

Mercury is only 1.4 times the moon's diameter, although it is a denser world that has more than four times the mass of our satellite. Even so, these differences are minor compared with the similarities. Like the moon, Mercury is virtually airless and is plastered with craters. Its surface material has approximately the same reflectivity and colour, and future explorers will undoubtedly find the landscapes of both worlds to be almost identical.

Most of our knowledge of Mercury's physical characteristics is a result of the Mariner 10 close flybys of the planet in 1974, which provided excellent high-resolution photographs of one hemisphere. It takes an expert to distinguish some of the close-up images of Mercury from high-resolution Earth-based-telescope photographs of the moon.

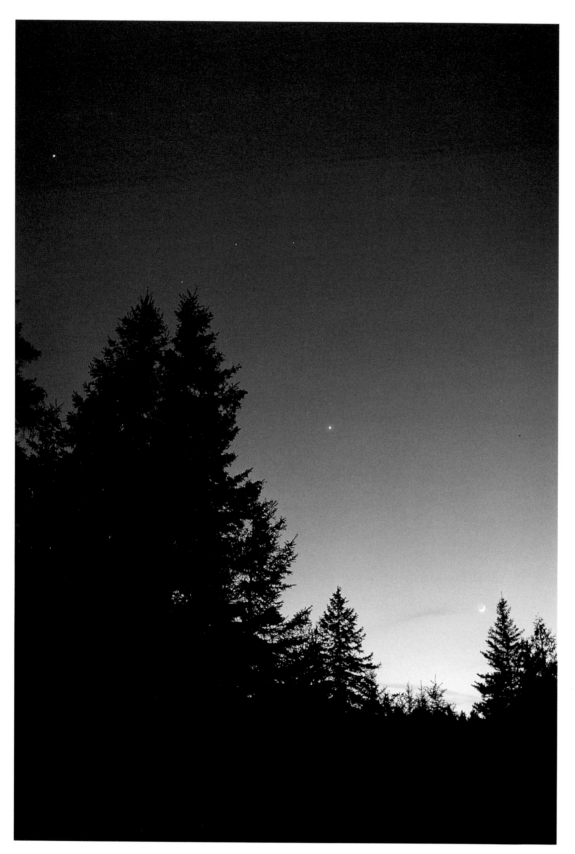

■ Shortly after sunset on May 15, 1991, the moon and three planets decorated the darkening sky. Left of the crescent moon, near centre, is Venus, the brightest planet. Jupiter is at upper left, and Mars, much dimmer, is just above the tree midway between Venus and Jupiter. These four solar system bodies strung in a line clearly define the plane of the solar system, called the ecliptic. In spring, in the northern hemisphere, the ecliptic is angled high in the evening sky, as seen here. In fall, the ecliptic lies much closer to the horizon. Photograph by Terence Dickinson.

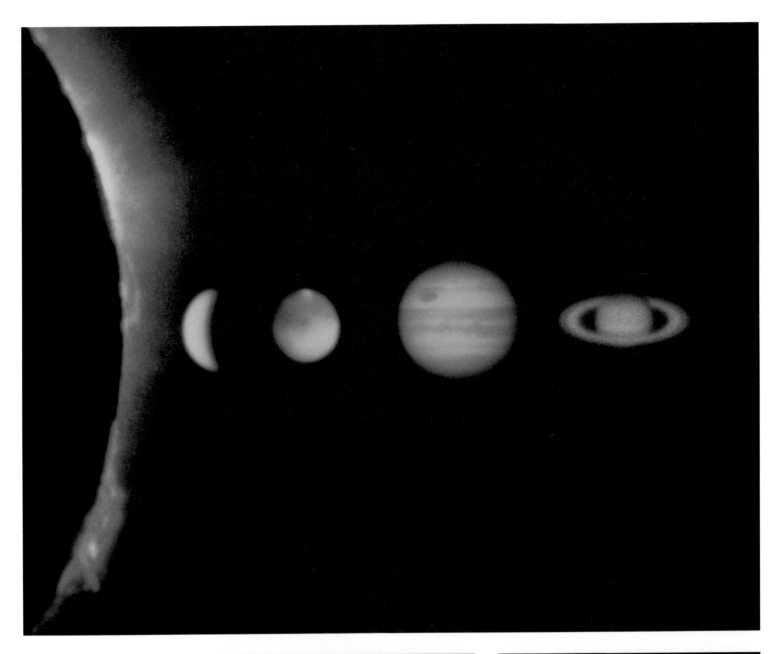

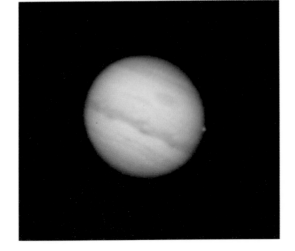

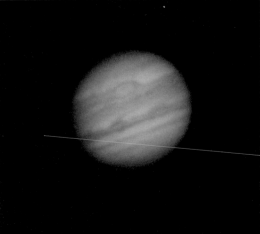

■ Above: This solar system montage, showing the eclipsed sun, Venus, Mars, Jupiter and Saturn, was compiled by backyard astronomer James Rouse using five of his own photographs taken with 8-inch and smaller telescopes.

■ Right: Jupiter, in February 1990, missing its south equatorial belt. By December of that same year, far right, the belt had returned. Photographs by Don Parker.

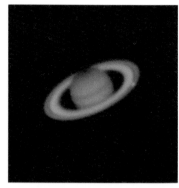

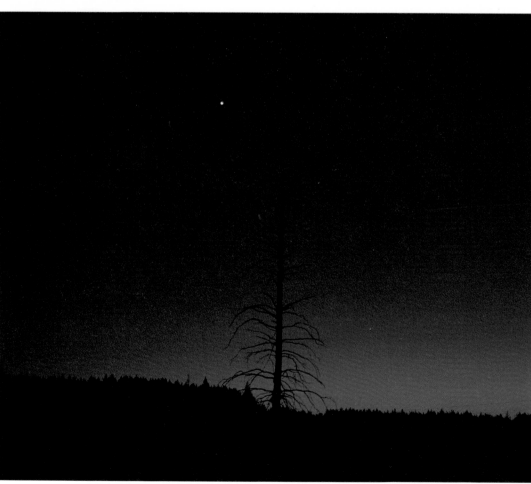

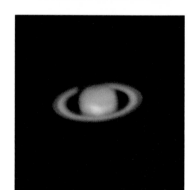

■ Top left: Jupiter and Mars, both near opposition, were close to the full moon on March 1, 1980. Photograph by Phil Mozel. Left: Venus and Mercury, May 13, 1988. Photograph by Michael Watson. Top right: Telescope view of Venus at inferior conjunction. Photograph by Richard Keen, using a 12-inch Newtonian. Centre: Extremely rare passage of Saturn in front of a bright star, July 3, 1988. Above: Saturn's white spot in 1990. Saturn photographs by Don Parker.

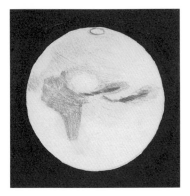

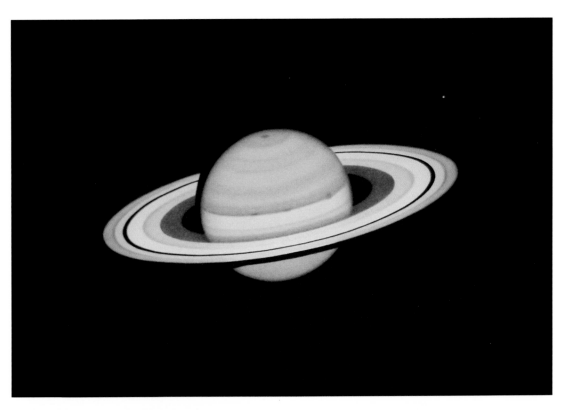

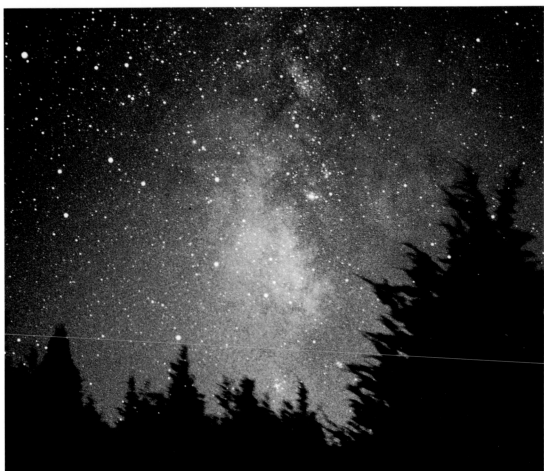

■ Above: The photograph and drawing of Mars—coincidentally made within minutes of each other on September 26, 1988—show the dark wedge-shaped feature Syrtis Major, the most prominent permanent dark zone on the planet. Sketch by Michael Maroney, using a 4-inch Celestron achromatic refractor. Photograph by Klaus Brasch, using a Celestron 14-inch Schmidt-Cassegrain.

■ Top right: Superb illustration of Saturn by English amateur astronomer Paul Doherty is based on observations with his 16-inch Newtonian in exceptionally steady seeing.

■ Right: Saturn is the bright object at upper left corner in this September 1990 wide-angle photograph of the constellation Sagittarius. Uranus and Neptune appear as tiny background stars to the right of Saturn. (Photograph's limiting magnitude is about 9.) Photograph by Terence Dickinson.

Prior to Mariner 10, the finest Mercury observations were made by Eugène Antoniadi, a Greek-born French astronomer who became one of the greatest planetary observers of all time. Antoniadi did his best work during the 1920s with refractors ranging from 12 to 33 inches in aperture. He studied Mercury almost exclusively during the day, noting dusky patches and light regions on the planet's creamy grey surface. Eventually, he was able to produce a map showing a rotation period of 88 days—the same time it takes Mercury to orbit the sun. Antoniadi concluded that one hemisphere must constantly face the sun.

Through a quirk of celestial mechanics, Antoniadi was partly right. Mercury's rotation is locked to the nearby star, but not in the way he had thought. The planet actually makes half a rotation during one orbit around the sun, so the same face returns to a sunward position after two orbits. It is a complex bit of celestial clockwork largely irrelevant to backyard astronomers, because seeing anything at all on Mercury is one of the toughest assignments in amateur astronomy. But the problem illustrates how difficult telescopic observation of Mercury is, regardless of the equipment used.

■ IDENTIFYING MERCURY

As the solar system's innermost planet, orbiting the sun at about one-third of the Earth's distance, Mercury never appears more than 28 degrees from the sun. From the northern hemisphere, Mercury is only seen in a dark sky for a few spring evenings and fall mornings each year. Even at such times, it is just a few degrees above the horizon, mired in the absorption and distortions induced by the Earth's thick layer of atmosphere at low celestial altitudes.

Binoculars are an essential aid, allowing the planet to be spotted in a darkening blue sky about half an hour after sunset, 15 to 20 minutes before it is visible to the unaided eye. There is usually little confusion; Mercury outshines all but the brightest stars found near the ecliptic—such as Aldebaran, Betelgeuse, Procyon, Regulus, Spica and Antares—and is occasionally a full magnitude brighter. If a star is available for comparison, the change in Mercury's brightness is noticeable over a few days; similarly, its position shifts from one night to the next.

■ OBSERVING MERCURY

Backyard astronomers typically make Mercury identifications in the evening sky. This is fine for naked-eye or binocular observing, but telescopically, conditions could hardly be worse. Once Mercury is finally located, it is usually less than 15 degrees from the horizon and swimming in hopelessly bad seeing. At such times, the planet looks yellow or ochre. In reality, it is a pale cream colour, but

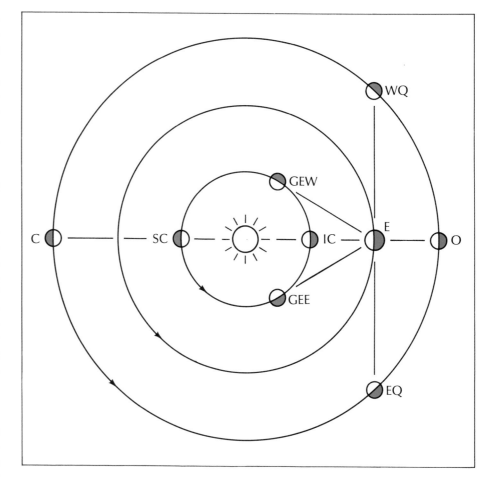

at the low altitudes where Mercury is most frequently sighted, the Earth's atmosphere absorbs and disperses light from the blue end of the spectrum, imparting the colour shift.

Observers with telescopes who hope to duplicate Antoniadi's feat of drawing planetary features will surely be disappointed when they look at the tiny, remote world. All that can be seen is Mercury's phase, which, during a typical two-week evening observing window, changes from nearly full to a slender crescent similar to a three-day-old moon.

■ OBSERVING MERCURY BY DAY

For a good telescopic view of Mercury, we must do what Antoniadi did—observe during the day. (The same applies to Venus, which can also be observed using the following technique.) The challenge is to find the planet in a bright blue sky. Here is how to do it.

The preferred method, and the easier, is dawn observing. Select a date when Mercury is a morning "star" and locate it in twilight with the unaided eye or binoculars. In the northern hemisphere, August, September, October and November are the best months because of the higher angle of the ecliptic relative to the horizon, which brings Mercury to its

■ *Astronomical jargon can be fairly dense when it comes to describing certain relationships and positions of the planets as they orbit the sun. This diagram, based on a similar illustration in the* Observer's Handbook, *should simplify it. The Earth's orbit is the middle one of the three shown. Planets that orbit the sun inside the Earth's orbit have four special configurations known as inferior conjunction (IC), greatest elongation west (GEW), superior conjunction (SC) and greatest elongation east (GEE). Planets outside the Earth's orbit have different special configurations: opposition (O), western quadrature (WQ), conjunction (C) and eastern quadrature (EQ).*

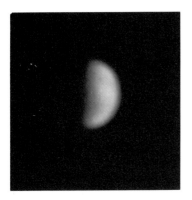

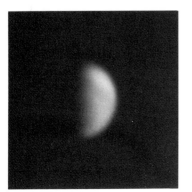

highest altitude. The actual observing window will be just two to three weeks once or twice during the four-month span.

Using a telescope with a polar-aligned, motor-driven equatorial mount, begin observing the planet, ensuring that the telescope is tracking properly as Mercury climbs from the twilight sky into full daylight. Ninety minutes after sunrise, Mercury will be 30 or 40 degrees above the eastern horizon, high enough to allow a sharp view if the seeing is good. Daytime-sky seeing is usually best around sunrise, before the sun has warmed the air and the ground and produced the convection currents that have long plagued solar astronomers. Because the sun heats the telescope as well, convection currents build up both outside and inside the instrument, and seeing inevitably deteriorates toward noon. Finding Mercury after sunrise is possible only when using telescopes equipped with reasonably accurate setting circles. (See Chapter 11).

■ DAYTIME PLANETARY OBSERVING PROTECTION

An important accessory for daytime planetary observing is an extended dew cap made of black construction paper. The paper is wrapped around the tube to extend the front of the telescope, covering at least the sunward half of the tube a foot or more beyond the normal dew cap's length. This prevents sunlight from falling on a refractor's lens, a Schmidt-Cassegrain's corrector plate or a Newtonian's secondary mirror. Some observers erect a makeshift shade for the entire telescope once they have locked onto Mercury. Windy days are out, because the makeshift shade can be blown over or the extended dew cap ripped off. In any case, seeing is usually worsened under windy conditions. Wind also transports dust. One blustery day a few years ago, we set up two telescopes, a Schmidt-Cassegrain and a refractor, to observe Mercury and Venus. After only a few hours, the front of the refractor's objective and the Schmidt-Cassegrain's corrector plate were covered with more dust than the instruments had collected in a year's worth of evening sessions.

Under the best conditions of daytime or early-twilight viewing, Mercury will be a sharply defined disc with hints of dark and light splotches just at the threshold of vision. During conditions of perfect seeing, however, the planet takes on a unique guise. Paler than Venus, its creamy surface has an appearance of being vaguely textured, like fine sandpaper. It is questionable whether observers are actually seeing evidence of craters on Mercury, but the planet is certainly different from Venus.

■ VENUS

Venus holds a preeminent position among celestial objects. It is the brightest luminary in the night sky after the moon. Venus is so dominant when it is in the sky that there is no mistaking it. Nothing approaching it in brightness is seen in the west at dusk or in the east just before dawn. The planet's brightness is due to two factors: Venus comes closer to Earth than any other planet and is often the nearest celestial object in the sky beyond the moon; and the haze at the highest levels in Venus's atmosphere, the "surface" that we see from Earth, is extremely reflective. Sixty-five percent of the sunlight that falls on Venus is reflected back into space, the highest percentage of any planet in the solar system. And because Venus is closer to the sun than any planet except Mercury, it is receiving a high dose of sunlight per unit-surface area. Thus the observer is presented with a dazzling disc.

Although unrivalled in splendour when viewed with the unaided eye, Venus is generally a disappointment up close. Seen through a telescope, the planet is as featureless as a cue ball. But it passes through phases, as does Mercury, and for the same reason. Its orbit is interior to the Earth's, but Venus is twice Mercury's distance from the sun. Venus consequently takes longer to orbit the sun and appears, at best, twice as far away from the sun in our sky. The results are longer viewing cycles and more favourable sky positions than Mercury ever attains.

The thick layer of cloud and haze blanketing Venus is extremely uniform. Yet sometimes, when the planet is viewed through a telescope, there are dusky patches and lighter poles at the limit of visibility. Cloud features and circulation motion do exist but become obvious only in ultraviolet light—wavelengths that are invisible to humans. Nonetheless, for more than a century, visual observers have reported these features, and occasionally, their drawings have coincided with markings in ultraviolet photographs taken with Earth-based telescopes. Although elusive, the dark patches were drawn long before they were photographed.

■ OBSERVING VENUS

When Venus is examined telescopically against the blackness of deep twilight, the contrast between the planet and the sky is so enormous that what little detail might be seen is lost. As well, a number of telescope aberrations that are commonly suppressed below detectable levels loom into view. The slightest amount of chromatic aberration in a refractor will produce a blue or purple halo around Venus. The

secondary-mirror supports in a Newtonian generate spikes extending from the image. Both of these effects impair resolution of detail and detract from the aesthetic appearance of the planet's pure white hue and symmetric phase.

However, the worst aberration does not occur in the telescope but, rather, in the Earth's atmosphere. It is dispersion associated with atmospheric refraction. When celestial objects are within about 20 degrees of the horizon, the planet's atmosphere acts like a weak lens, causing objects to appear displaced to higher altitudes. (The same phenomenon causes the sun to linger in the sky at sunset although it is geometrically below the horizon.) Alone, that would not be a problem, but it is wavelength-dependent, producing a red fringe on the lower side of the planet and a green or blue fringe on the upper side. When Venus is within 15 degrees of the horizon, the effect is often rainbowlike and totally destructive to the image.

The combination of ultrahigh contrast, annoying optical effects and atmospheric dispersion means that the least desirable condition for observing Venus is in a dark sky at low altitudes. As with Mercury, daytime viewing is the preferred mode, and conditions are optimum during an autumn-morning appearance, shortly before or after sunrise. However, because Venus is much brighter and roams farther from the sun than its smaller neighbour, conditions for seeing it reasonably well are less restrictive.

At its brightest, Venus can be located with the unaided eye in a clear, deep blue sky any time after 3 p.m. (near eastern elongation) or before 10 a.m. (near western elongation). Even at hours when the planet cannot be found in full daylight with the unaided eye, binoculars will readily reveal it.

■ TELESCOPIC APPEARANCE

When observed by telescope in a rich blue daytime sky, Venus is a beautiful suspended pearl, its phase instantly evident and its sunward edge dazzling and distinct. Gone are the overwhelming contrast and the optical effects that come into play when it is lower in the sky on a dark background.

The lower-contrast daytime observation of Venus reveals the surface's gradation in brightness—the difference between the sunward edge, called the limb, and the day/night line, called the terminator. Because the terminator receives only grazing sunlight compared with the direct rays on the areas of the planet turned toward the sun, it is more subdued than the dazzling limb.

The visible terminator is actually inside the geometric, or true, terminator, which is 90 degrees from the point on Venus's disc that lies directly beneath the sun. Thus when the planet is half illuminated according to references such as the *Observer's*

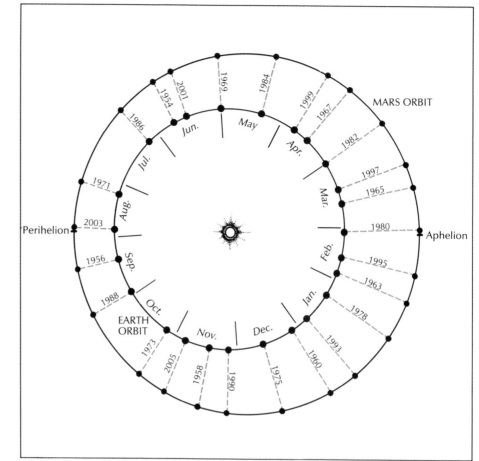

Handbook—a phase called dichotomy—it usually appears less than half illuminated in a telescope.

Because Venus passes from full phase toward crescent phase during its seven-month cycle through the evening sky, visual dichotomy occurs a few days prior to geometric dichotomy. The reverse happens when Venus is seen in the morning sky passing from crescent to full phase. For decades, backyard observers have recorded these variances. Curiously, the morning-apparition figures do not match the evening ones. The difference between visual and geometric dichotomy is 4 to 6 days in the evening sky and 8 to 12 days in the morning sky. No reasonable explanation has ever been proposed, yet the discrepancy seems to be real. Begin watching for dichotomy a couple of weeks before the date given in the *Observer's Handbook* (listed as "Venus at greatest elongation east" for evening sky or "Venus at greatest elongation west" for morning sky).

■ INFERIOR CONJUNCTION

The celestial clockwork brings Venus to inferior conjunction (page 145) every 19½ months. The most interesting time to observe Venus is the two months either side of inferior conjunction, when it is nearest Earth and less than 40 percent illuminated.

■ *Mars' elliptical orbit means that the closest approach of Mars to Earth (opposition) can range from 0.37 AU to 0.68 AU. Mars observers try not to miss an opportunity to examine the red planet during the three months centred on opposition. This illustration shows oppositions during the last half of the 20th century and the early years of the 21st. The best oppositions occur in August or September, the least favourable in February and March.*

When Venus is near inferior conjunction, its slender crescent can reach 60 arc seconds as the planet glides a few degrees above or below the sun in the Earth's sky.

The days leading up to and following inferior conjunction are the prime observing periods. No other celestial object except the moon is seen at such thin phase angles. When viewing the thin crescent of Venus, the prime objective is a sighting of an extension of the cusps (the points of the crescent) into the planet's night hemisphere. This is not an illusion but sunlight illuminating Venus's upper atmosphere. Occasionally, the extension is seen as a complete ring; the extremely thin crescent and a very tenuous and ghostlike extension of the cusps make a full sphere. Conditions must be exceptional for such an observation, but it is far from impossible and does not require a large telescope.

Perhaps the most elusive Venusian feature is the planet's ashen light, a vague illumination of Venus's nighttime side when it is seen as a thin crescent. The light is fainter than, but otherwise similar to, Earthshine on the moon. However, there is no satellite to illuminate Venus's night side, and Earth is too far away to do the job. We have never observed the ashen light, and there is some controversy over whether it is a physical feature or a contrast effect. If it is a real occurrence, some mechanism for lighting the nighttime side of Venus must be proposed. There are several theories—continuous lightning and auroras are two favourites—but the phenomenon remains unexplained.

■ MARS

Mars is the only object in the universe, apart from the moon, whose solid surface is seen in reasonable detail through Earth-based telescopes. Yet it is just far enough away from Earth that its features are difficult to observe with clarity. Mars tantalizes.

Once Mars has been viewed through a telescope with fine optics when the planet is fairly close, it is impossible not to be impressed by the feeling that it is a real world, a globe with obvious similarities to Earth: the polar caps, the dark continents in the

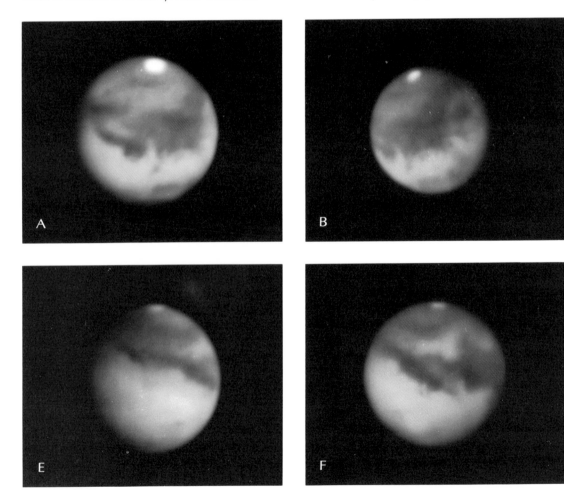

global oceans of pinkish desert, the occasional cloud and the dust storms—all have their terrestrial counterparts. What is missing on Mars, of course, are the oceans of water that characterize most of the surface of our planet. Nevertheless, nowhere else can so many comparable features be seen, including a 24.6-hour rotation period and an axis tilt only two degrees different from the Earth's. All of these together make Mars the most Earthlike planet in the solar system. When the atmosphere is steady, the seeing is good and the telescope's optics are equal to the task, it is easy to understand why some turn-of-the-century observers were convinced that they were gazing at a habitable world.

The pale, pinkish orange desert world suspended in the black void of space is an enchanting and unforgettable sight. But memorable views of Mars are not common. For only two to four months every two years, when the planet is within 0.8 AU (one AU, astronomical unit, is the Earth-sun distance), is the disc large enough to reveal rich detail. Even then, Mars is a supreme challenge for both eye and telescope.

Large telescopes are limited by turbulence in the atmosphere of our own planet, which only rarely permits detection of features below 0.3 arc second (sometimes stated as 0.3 second of arc, or 0.3"). This is a tiny angle, equal to 80-kilometre resolution on Mars when the planet is at its closest. Nevertheless, it can be reached by comparatively small telescopes. The normal good-seeing limit is 0.5 arc second, while 1.0 arc second is typical of many nights of the year at most sites. One arc second is the resolution of a 4-inch telescope; half an arc second is the theoretical capability of an 8-inch telescope. Therefore, a huge telescope is not required to see detail on Mars. What is needed is superb optics. Any deviation from top optical quality will degrade the image, eliminating that threshold detail.

■ OBSERVING MARS

Any good-quality telescope with more than a 70mm aperture should reveal surface features on Mars during the weeks around the biennial closest approaches, including changes in the outlines of Martian dark zones from one opposition to the next. Once thought to be evidence of tracts of vegetation changing with the seasons, the alterations are due to severe winds of up to 400 kilometres per hour that transport vast quantities of dark and light dust across

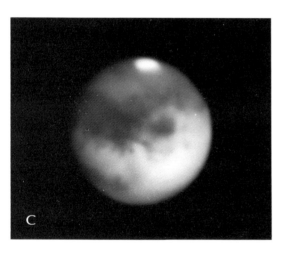

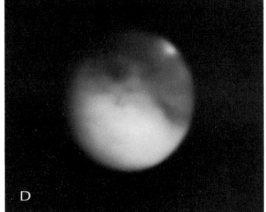

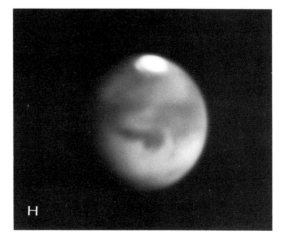

■ *In the fall of 1988, when Mars made its closest approach to Earth in a generation, expert planetary photographer Don Parker took hundreds of portraits of our neighbour world. The eight shown on these two pages track the planet over one complete rotation and serve as a guide to the position and appearance of the planet's features. Following long-standing tradition, south is up in these and other planet photographs in this book. For each photograph, the central meridian and name of the most prominent feature is given. (A) 4° Meridiani Sinus; (B) 50° Erythraeum; (C) 62° Solis Lacus; (D) 107° Solis Lacus and Amazonis desert; (E) 169° Sirenum; (F) 233° Cimmerium and Tyrrhenum; (G) 286° Tyrrhenum and Syrtis Major; (H) 344° Sabaeus Sinus.*

149

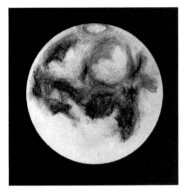

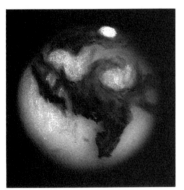

the desert planet. Mapping the changes is therefore a study in Martian meteorology and geography. It is a challenging but exceptionally rewarding area of planetary observation.

The clarity of Mars' surface features — white polar caps and dark, irregular patches on a peach-coloured sphere — depends to a great extent on the transparency of the Martian atmosphere. Dust storms can lower contrast across large sectors of the disc within days of a storm's onset. The planet may remain partly or completely shrouded for many weeks thereafter. Experienced observers can detect emerging storms when familiar desert areas of the planet brighten and encroach on nearby dark features. Global dust storms are both rare and unpredictable. Only five are well documented: one in 1956, one in 1971, one in 1973 and two in 1977.

The Martian south pole is tipped Earthward at oppositions favourable for northern-hemisphere observers. The brilliant white polar cap shrinks during the prime observing window (90 days centred on opposition), sometimes revealing detached patches or notches in the main cap. Summer is then beginning in the Martian southern hemisphere. When the southern polar cap is reduced to a tiny white button, part of the larger northern polar cap may be in view. A bluish white atmospheric haze known as the North Polar Hood often masks the northern cap itself. Both polar caps have a residual water-ice core that never disappears, but the rapid changes seen in the more extensive caps are due to the seasonal sublimation (gas to ice or vice versa) of atmospheric carbon dioxide. In winter, the polar regions are a brutal minus 140 degrees Celsius.

Inexpensive colour filters (about $15 each) that screw into the bottom of 1¼-inch eyepieces often improve the visibility of Martian surface features by reducing the effects of chromatic aberration in refractors and increasing contrast in all types of telescopes. A blue filter (Wratten No. 80A) reveals the few nondust clouds that float in the atmosphere of Mars. But the really effective filters are the orange (No. 21) or red (No. 23A) ones that enhance the con-

trast of the dark areas. The red filter may be a bit dark for instruments with apertures smaller than 6 inches, but try both to get the most out of observing Mars. Larger telescopes also benefit from the filters' reduction of the Martian disc's brilliance. In addition, a red filter improves seeing by cutting out the shorter wavelengths that are most affected by atmospheric turbulence. For telescopes greater than 8 inches in aperture, also try the deep red No. 25 filter. Generally, telescopes with more than 5 inches of aperture respond better to colour filters than do smaller instruments. For aesthetic appeal, however, nothing matches an unfiltered view of the coral deserts, pure white poles and grey-green dark regions.

The best magnification for Mars is about 35x per inch of aperture up to 7 inches and 25x to 30x for larger telescopes. This yields a pleasing image while avoiding the effects of irradiation, a contrast phenomenon that originates in the eye and causes brighter areas to encroach on darker adjacent areas. In the case of Mars, irradiation produces the apparent enlargement of the polar caps and the apparent loss of fine, darker details next to the desert areas. The effect is most troublesome at magnifications below 25x per inch of aperture. Filters are essential in large telescopes used below 25x per inch.

Regardless of the instrumentation, experience is the key to detecting the wealth of detail that Mars can present to backyard observers. At first glance, the planet appears so small that you may wonder how anyone sees anything on it. The trick is to start observing Mars at least two months before opposition to train your eye to detect the ever-so-subtle features that abound on our neighbour world. Then, around opposition, when the best views are available, you will be ready to squeeze the most out of eye and telescope, rather than discovering at the time of optimum conditions how challenging it is to observe Mars.

Articles containing detailed information on observing Mars appeared in the October 1987, December 1987, April 1988, April 1989 and August 1990 issues of *Sky & Telescope*.

■ *Veteran Mars observer Klaus Brasch has combined photography with visual inspection of the planet. On October 1, 1988, he made the sketch, top, and took the photograph, centre, within minutes of each other using a 14-inch Celestron Schmidt-Cassegrain. On a print of the photograph, he added features seen visually to produce the composite image, bottom.*

■ JUPITER

Unlike Mars, which requires superb optics and relatively high magnifications before much detail is seen, Jupiter has a number of features that are easily revealed by a 3-inch refractor at about 100x: its main belts, the Red Spot (unless it is particularly faded) and the shadows of the four Galilean satellites. Jupiter's disc ranges from 4 to 100 times larger in area than the face of Mars, depending on Mars' distance from Earth. Major disturbances on the equatorial belts and the dark "barges" in the tropi-

cal and temperate belts of Jupiter are also detectable in a 3-inch refractor at 100x to 130x.

Every increase in telescope size reveals more, but telescope aperture is definitely secondary to the instrument's optical quality. Jupiter is a bright object; there is plenty of light. Focusing that light into a sharp, high-resolution image of the disc is the key. In fairly good seeing, 25x to 35x per inch of aperture should be adequate for observing Jupiter. The image should remain sharp-edged and well defined.

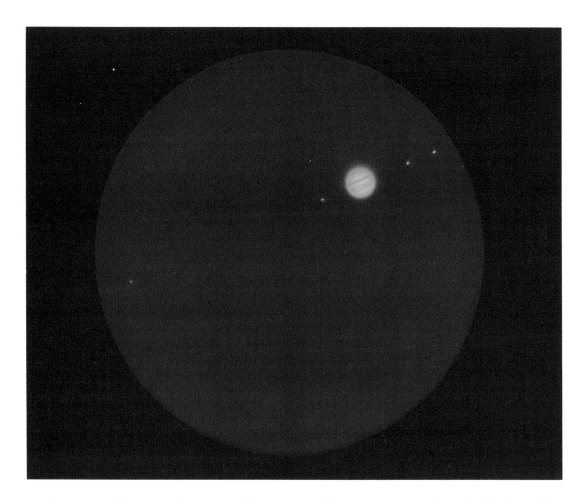

Selecting something typical as an example, say, a 4-inch refractor or an 8-inch Schmidt-Cassegrain, what can an observer expect to see? Because of Jupiter's constantly changing, cloud-covered surface, the amount of detail varies from one observing season to the next. However, three or four dark belts are always visible and sometimes as many as 10, depending on how the wind circulation is divvying up the clouds. Bumps, projections, loops and general turbulence should be evident along the edges of the dark belts. Even if the Great Red Spot has faded, its home, called the Red Spot Hollow, should be visible as an indentation in the south equatorial belt. In late 1989, the south equatorial belt itself disappeared over a period of just a few weeks, and the Red Spot, after years of near invisibility, regained some prominence. In 1990, the Red Spot faded again as the belt returned.

In good seeing, several large, white ovals, one-quarter to one-third the size of the Great Red Spot, roam in the next belt south from that occupied by the Red Spot. The Red Spot is a swirling maelstrom of cloud pumped up from a vortex that penetrates a lower level in the planet. Its coral or pinkish colour (it rarely appears red) is usually quite distinct from the hue of any other feature on the planet, indicat-

ing that its source material is probably deeper than that of other features. The Red Spot completes a counterclockwise rotation once every six days, but the anticyclonic motion is not detectable in amateur equipment. What can be seen is vague texture within the Red Spot and variations in the colour. When the south equatorial belt moves past the Red Spot and is disturbed by it, the Red Spot leaves a churning swath of clouds in its wake (the region behind it in terms of the planet's rotation).

In the early 1960s, the two equatorial belts almost merged, and the activity between them was extraordinary, with thick, twisting bridges of dark material crossing the lighter equatorial zone. Such activity is simply cloud and circulation phenomena. The light zones are at a higher altitude than the dark belts and consist mostly of ammonia haze; the dark belts are chiefly ammonium hydrosulphide. Incursions of one belt into another are constantly appearing and disappearing as the belts and zones slip by one another. The equatorial zone and the adjoining parts of the equatorial belts are known as System I, while the rest of the planet (except the polar regions) is System II. The polar regions are referred to as System III, but for amateur-observation purposes, only Systems I and II are of interest.

■ Jupiter's four largest moons are visible in binoculars and are easily seen in a small telescope, such as the 80mm refractor used for this illustration. From night to night, the satellites appear to shuttle from one side of Jupiter to the other, like beads on a wire, because we see the Jovian satellite orbits nearly edge-on. The four major moons have orbital periods ranging from 1.8 to 17 days. Illustration by John Bianchi.

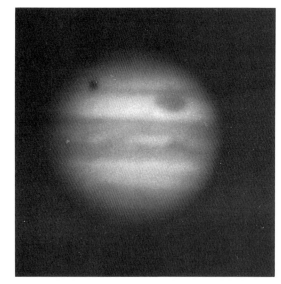

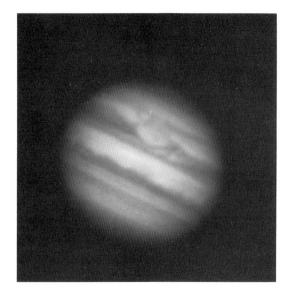

■ *Above: In the mid-1980s, members of the Hamilton Centre of the Royal Astronomical Society of Canada combined sketches of Jupiter into strip maps that show the features over many degrees of Jovian longitude. They eventually mapped the entire planet and were able to track changes in individual cloud features as well as motions of the cloud belts with respect to each other. Courtesy Derek Baker.*

■ *Right: Two photographs of Jupiter show how the intensity of the Great Red Spot varies over the years, from being the most obvious feature on the planet to just an oval hollow in the south equatorial belt. The spot has not been prominent since the late 1970s. Photographs by James Rouse (top) and Don Parker.*

System I rotates in approximately 9 hours 50 minutes; System II has a general rotation speed about five minutes longer. The two systems continually slip by each other inside the equatorial belts, making them the most active areas of the visible surface of Jupiter. System II contains the Great Red Spot. Using tables and a calculation method outlined in the *Observer's Handbook*, you can determine the System II longitude. *Sky & Telescope* usually lists the Red Spot's longitude when Jupiter is well placed for viewing. If the System II longitude is within 50 degrees of the Red Spot, it should be visible. During the 1980s, the Red Spot stayed fairly constant with respect to System II, not straying too far from 10 to 20 degrees longitude. However, in 1990, it began to move more erratically. In times past, the Red Spot has been known to shift by up to 30 degrees in a single year, so it is impossible to predict where it will be. Once seen, though, it will be visible in the same spot two days and one hour later (five Jupiter rotations).

Overall, Jupiter's disc is creamy white, bright and distinct. Yet there is an aspect to it called limb darkening — the edge of Jupiter's disc is about one-tenth as bright as its centre — that becomes apparent only when sought out. It is not obvious to the eye because the disc edge abuts the blackness of the sky. Limb darkening is caused by solar illumination that is absorbed by a thin haze in Jupiter's upper atmosphere, above the highly reflective clouds. The limb-darkening phenomenon subdues the visibility of the cloud features near the disc's edge. The Great Red Spot, for example, is not visible at the edge of the disc. Rather, it is seen clearly only when it has rotated one-quarter of the way around. The same is true of all the features, which are seldom visible for more than 2½ hours before they rotate out of view.

If you have any inclination to draw what you see, Jupiter is probably the best planet on which to try it. Beautiful strip charts of Jupiter, sketched over a few hours as the planet rotates, have been made by absolute beginners with only a few nights' training at the telescope. "The more you look, the more you'll see" is an axiom that is never more appropriate than in the case of Jupiter.

■ TRACKING THE FOUR MOONS

Among the most dramatic sights in astronomy is the transit of one of Jupiter's moons across the planet's cloudy face. As it appears to touch the Jovian disc, one of the four large satellites is transformed from a dazzling spot against the dark sky into a tiny, fragile disc etched in the limb. Each moon has its own characteristic appearance as it crosses the planet.

Io, the innermost of the four big moons, has a light pinkish hue and high surface brightness. When it

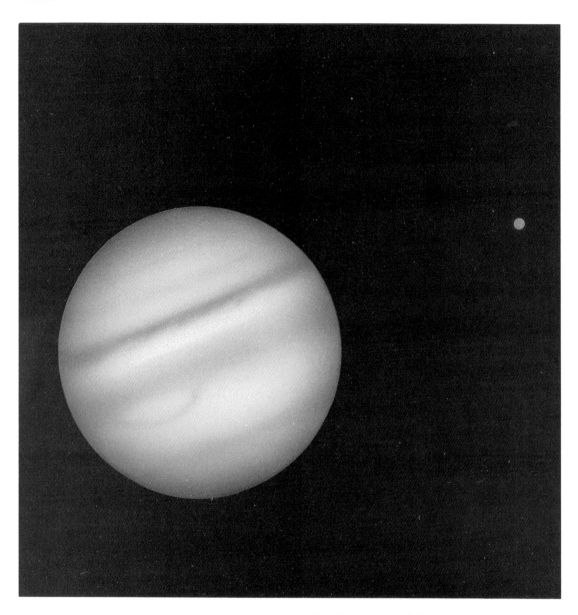

enters the disc, Io is always a bright dot on the darker limb. As it begins its transit, Io can become lost in the white zones, which have similar reflectivity. When in front of the darker belts, the moon is usually a minute but distinct bright spot.

Europa is the smallest of Jupiter's four major moons but has the most reflective surface. It is intensely white, especially as it enters the limb—a tiny white dot against the edge of the cloud-strewn giant. As Europa marches in front of the globe, it usually encounters the white clouds of the zones and disappears from view. On the rare occasion when it tracks across a dark belt, it may be observed for its entire journey. Europa is probably the most difficult moon to see throughout a complete transit.

Ganymede, the largest satellite, is easier to follow across Jupiter's face because of its size and because its colour is duller than the white clouds and brighter

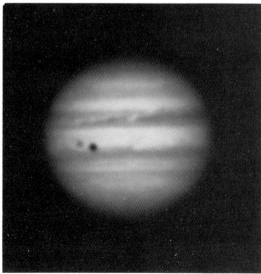

■ Top: What should a beginner expect to see on Jupiter using a small telescope for the first time? We asked professional illustrator John Bianchi, a novice backyard astronomer, to turn his new 80mm refractor to Jupiter and draw what he could see. His Jupiter sketch from May 1991, using 120x, shows the Red Spot Hollow, the pale south equatorial belt and the darker north equatorial belt. (North is up because a star diagonal was used.) A satellite is shown as a small disc to represent a steady point of light.

■ Left: Ganymede, Jupiter's largest moon, is seen as a grey spot beside the intense blackness of the shadow it casts on the giant planet. This clearly shows why the transit of a moon's shadow across Jupiter is easier to see than the moon itself, which is closer in hue to that of the planet's cloudy surface. Photograph by Don Parker.

Satellites	Diameter (km)	Visual Magnitude	Orbital Period (days)	Average Maximum Distance From Planet Centre (arc sec.)	Apparent Diameter (arc sec.)	Shadow Diameter (arc sec.)	Effective Shadow Diameter* (arc sec.)
Io	3,630	5.0	1.77	138	1.2	0.9	1.0
Europa	3,140	5.3	3.55	220	1.0	0.6	0.8
Ganymede	5,260	4.6	7.16	351	1.7	1.1	1.4
Callisto	4,800	5.6	16.69	618	1.6	0.5	0.9

*Includes darker part of penumbral shadow.

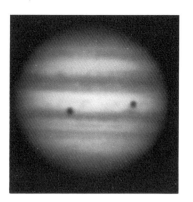

than the dark ones. When transiting a white zone, Ganymede is light brown in colour and resembles a washed-out satellite shadow. Superimposed on the limb, the reverse is the case—the limb is darker than Ganymede, and it appears as a bright dot on the darker background. As with Io, there is a transition zone in which Ganymede almost always disappears as its intensity matches the background between the limb and the more brightly illuminated central part of the disc.

Callisto is probably the easiest moon to follow because its dull surface material makes it darker than almost anything it encounters, except at the very edge of the disc when it enters or exits its transit. Callisto's crossings are by far the rarest of the four Galilean moons': it orbits Jupiter only once in 17 days, compared with 7 days for Ganymede, 3½ days for Europa and just 42 hours for Io. Also, for more than half of Jupiter's 12-year solar orbit, the planet's satellite system is angled so that Callisto passes above or below Jupiter as seen from Earth and misses transiting the disc altogether.

The shadows of Jupiter's moons are much easier to observe than a transit because they are black dots, far darker than any of the planet's surface features. But the shadows vary in size, with Ganymede's the largest, Io's the next largest and Europa's and Callisto's the smallest. Ganymede's shadow is visible in a 60mm refractor; the others usually require a 3-inch refractor for a definite sighting.

■ To see two satellite shadows trekking across the Jovian cloudscape is unusual, although not so rare that you will never witness it. There are always several such events during an observing season. The times of all Jovian satellite phenomena—shadow and satellite transits and Jovian disc and shadow disappearances and reappearances—are listed in the Observer's Handbook. *Photograph by Don Parker.*

■ SATURN ■

No photograph or description can adequately duplicate the astonishing beauty of the ringed planet Saturn floating against the black-velvet backdrop of the sky. Of all celestial sights available through backyard telescopes, only Saturn and the moon are sure to elicit exclamations of delight from first-time observers. Saturn casts its magic spell: beginners and veteran amateur astronomers alike never tire of the planet.

Almost any telescope will reveal Saturn's ring structure. A 60mm refractor at 30x to 60x clearly shows it. The view is outstanding in 4-inch or bigger telescopes. Such instruments also show several of Saturn's large family of 18 satellites, which appear as tiny stars beside, above and below the planet.

Although spacecraft have discovered hundreds of identifiable rings, only three components can be distinguished visually through Earth-based telescopes. They are known simply as rings A, B and C. Rings A and B are bright and easily visible in any telescope. They are separated by Cassini's division, a gap about as wide as the United States. Cassini's division looks as black as the sky around Saturn but is actually a region of less densely packed particles rather than a true blank space. The division is due largely to the gravitational perturbations of Saturn's moon Mimas. Ring particles orbiting in the gap are in resonance with Mimas and, over time, are gravitationally nudged into different orbits, thus largely clearing out the section. The other gaps that produce the many rings seen by the Voyager spacecraft are probably generated in the same way but involve much more complex interactions with other moons and large ring particles.

Ring A is less than half the width of ring B and is not as bright, although the difference between the two is subtle rather than striking. Ring C, the innermost ring, is so dim that an experienced eye and at least a 6-inch telescope are needed to distinguish it. Also known as the crêpe ring, C is a phantomlike structure extending about halfway toward the planet from the inner edge of B.

One other division besides Cassini's is visible in Earth-based equipment. Properly called the Keeler gap but incorrectly known as the Encke division, it is located near the outer edge of ring A and is extremely difficult to detect. The first person to see a gap in that position was James Edward Keeler, who was using the Lick Observatory's 36-inch refractor. The Encke division is not a true division but a shaded area in the middle of ring A that has been seen with telescopes as small as 6-inch refractors. Sometimes, it is invisible in much larger instruments, suggesting some variation in intensity over time.

■ OBSERVING SATURN

When observing conditions permit, you can spend hours at the eyepiece looking at Saturn, and the planet certainly deserves attention on nights of good seeing when it is well placed—especially on nights when the moon is in the sky and other types of observing are less profitably pursued. Here is what to look for, in order of increasing difficulty:

☐ The rings themselves. It usually takes only 30x to see them clearly and 60x to show that they really are like a washer surrounding a marble.

☐ The shadow cast by the planet on the rings. It can be quite small around opposition but rapidly increases when the planet moves away from opposition.

☐ Cassini's division. A 3-inch telescope will reveal it, but a good 5-inch instrument is required to detect it all the way around.

☐ The dusky, brownish equatorial belt of Saturn that separates the creamy yellow equatorial division from the beige temperate zone.

☐ The shadow of the rings on the planet is usually narrow but is not that difficult to see if specifically looked for. Depending on the geometry between the Earth, the sun and Saturn, the shadow can appear on the disc either above or below the rings as they pass in front of the planet.

☐ At a much higher level of difficulty are the gentle cloud features in the planet's atmosphere. Saturn seems to have a high-level haze of ammonia ice crystals that is largely absent on Jupiter, and this tends to subdue the contrast of surface features. Very rarely, a white spot will erupt to disturb the scene. It happened in 1933, 1960 and 1990. At maximum intensity, the white spots were visible in 4-inch telescopes.

☐ Finally, the Keeler gap, the most difficult Saturnian feature. The gap is so thin—a meagre 320 kilometres across—that it is detectable only by experienced observers using excellent equipment, probably 8-inch or larger refractors. Neither of the authors has ever seen it with certainty, even on one excellent night with the 26-inch U.S. Naval Observatory refractor when, at 330x, the planet appeared

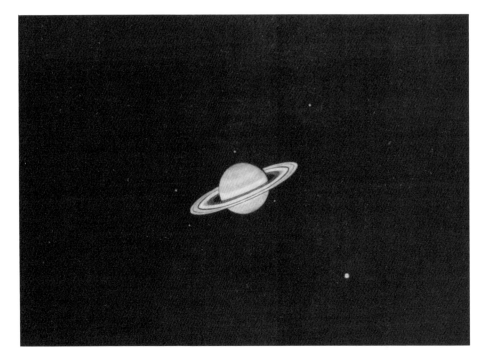

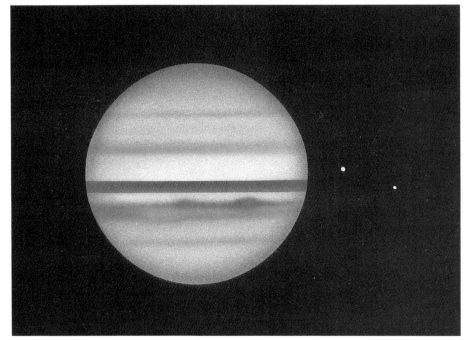

perfectly steady, like a Voyager picture taken from a few million kilometres away.

■ SATURN'S SATELLITE FAMILY

Seven of Saturn's moons are visible in 8-inch telescopes. Although their number surpasses the four big moons of Jupiter, the Saturn family is much more difficult to observe.

Titan—an eighth-magnitude object orbiting Saturn in approximately 16 days—is by far the largest of Saturn's moons and is easily seen in any tele-

■ Top: Saturn and its satellites, as seen in a 12-inch telescope. Illustration from Richard Proctor's Saturn and Its System, published in 1865.
■ Above: In 1966, Saturn's rings were edge-on to Earth and invisible for months. Only the ring shadow (thick black zone) remained. Terence Dickinson; 7-inch refractor.

Satellites	Diameter (km)	Visual Magnitude	Orbital Period (days)	Average Maximum Distance From Planet Centre (arc sec.)	Apparent Diameter (arc sec.)	Shadow Diameter* (arc sec.)
Titan	5,150	8.4	15.95	197	0.85	0.7
Rhea	1,530	9.7	4.52	85	0.25	0.2
Dione	1,120	10.4	2.74	61	0.17	0.15
Tethys	1,060	10.3	1.89	48	0.16	0.15

*Titan's shadow has rarely been seen from Earth, and there are no reliable reports of other satellite shadows.

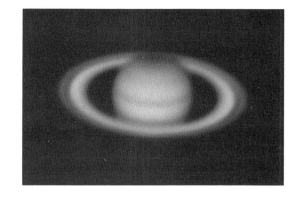

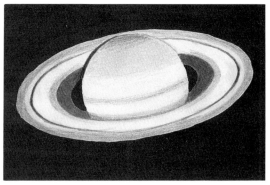

■ *The image of Saturn seen "live" in a good telescope is one of the great sights in nature. Repeated viewing never seems to diminish its elegance and symmetry— especially the haunting three-dimensional quality of the ringed planet as it floats in the blackness of space. Saturn's ring structure is divided into three distinct rings that are visible in amateur telescopes. Ring A is the outside sector, separated by Cassini's division from the wide, bright ring B. Ring C is the faint inner zone. Photograph, left, by Don Parker with a 16-inch Newtonian captures the planet's 1989 appearance. Sketch by Michael Maroney with a 4-inch Celestron achromatic refractor at 212x was made August 5, 1989.*

scope. When at its maximum distance from the planet, it appears to be five ring diameters from Saturn's centre. Titan is the only satellite in the solar system known to have a substantial atmosphere.

Instruments of more than 60mm aperture should reveal Saturn's 10th-magnitude moon Rhea less than two ring diameters from the planet. Iapetus is next on the list of visibility, but only when it is in one part of its orbit. It has the peculiar property of being five times brighter when it is to the west of Saturn than when it is to the east. Iapetus ranges in brightness from 10th to 12th magnitude. One side of the

moon has the reflectivity of snow, while the other resembles dark rock. When at its brightest, Iapetus is located about 12 ring diameters west of its parent planet; because stars may appear at a similar distance from Saturn, several observations are necessary for a confirmed sighting.

The next two moons inward from Rhea—Dione and Tethys—are about half a magnitude fainter and are visible in 6-inch or larger telescopes. Inward from Dione and speeding around the edge of the rings are Enceladus and Mimas, both a magnitude dimmer and significantly more difficult to detect.

■ URANUS ▬▬▬▬▬▬▬▬

Uranus was discovered in 1781 by William Herschel, probably the greatest observational astronomer of all time. In the course of a systematic programme to examine every object visible in his 6¼-inch Newtonian, Herschel observed a sixth-magnitude "star" that did not look like a point of light. Herschel was in the habit of using high magnification to study celestial objects, and when he came across Uranus, he was using 227x.

In his report of the discovery, published in *Philosophical Transactions* in 1781, Herschel

stated: "From experience, I knew that the diameters of the fixed stars are not proportionally magnified with higher powers, as the planets are. Therefore, I now put on powers of 460 and 932 and found the diameter of the comet increased in proportion to the power, while the diameters of the stars to which I compared it were not increased in the same ratio."

Herschel thought he had discovered a comet, but it soon became clear that his find was a planet orbiting the sun beyond Saturn. It had been seen before and had even been plotted in a star atlas. At

■ *Using corkscrew diagrams
like these for the current
month, you can identify the
four brightest satellites of
Jupiter, left, and Saturn, right.
The horizontal lines represent
0 hours Universal time on the
date indicated (0 hours UT =
7 p.m. EST the previous day).
The two straight vertical lines
in the Jupiter diagram repre-
sent the disc of the planet. The
wavy lines are the orbiting
moons' positions at any time.
The four vertical straight lines
in the Saturn diagram are
Saturn's disc (inner two) and
the rings. The four satellites
shown for Saturn are, in order
outward, Tethys, Dione, Rhea
and Titan. Saturn satellite
charts for the current year are
published in the* Observer's
Handbook. *Jupiter charts are
published in the* Observer's
Handbook *and the* Astro-
nomical Calendar. *Both
publications are essential
references for planet watchers.
Courtesy U.S. Naval Observa-
tory (Jupiter) and Larry Bogan
(Saturn).*

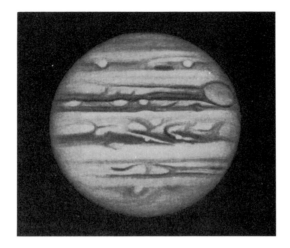

magnitude 5.7, Uranus is barely visible to the un-aided eye; however, it takes about 100x before the 3.9 arc second disc of Uranus ceases to resemble a star. Apparently, prior to Herschel, nobody had looked at it with enough magnification.

A modern telescope similar in size to Herschel's easily reveals Uranus's pale bluish green disc, but that is all. No surface features were ever clearly seen on the planet prior to the Voyager spacecraft's encounter with Uranus in 1986. And Voyager showed that there is nothing there to be seen anyway, just featureless, aquamarine haze—the top layer of the planet's thick atmosphere.

Five of Uranus's moons were known before the Voyager flyby, and ten more were discovered by the spacecraft, but the brightest are only 14th magnitude. Uranus is simply too far away to be of much interest to the backyard astronomer beyond mere identification.

If you refer to the charts published in the *Observer's Handbook* or the *Astronomical Calendar*, the planet is easy to find with binoculars or a finder-scope. Look for conjunctions that bring a planet within one degree of Uranus. This allows Uranus and another solar system body to be visible at 50x and clearly shows how dimly lit the face of Uranus is in comparison with the nearer naked-eye planets. Because of its remoteness, Uranus receives only one-quarter of the intensity of sunlight that falls on a similar surface area of Saturn.

■ NEPTUNE

In some ways, Neptune offers more interest than Uranus for the backyard astronomer—certainly, more challenge. For the beginning observer, Neptune is a much more demanding target in binoculars, although moderately experienced observers should have no trouble picking it out among the stars of eastern Sagittarius, where it will be until 1997. In most standard references, such as the *Observer's Handbook*, charts of Neptune's position include stars down to eighth magnitude; Neptune is magnitude 7.7. Uranus passes Neptune in 1993, and both planets will be in the same binocular field of view from 1992 to 1994.

Although 100x will show Neptune as a disc, only powers close to 200 unmistakably reveal it as one. Its 2.5 arc second disc is definitely blue in 6-inch or larger telescopes. In smaller instruments, the planet generally looks pale grey. Neptune has one large and seven small satellites. All but one of the small ones were discovered by Voyager 2 when it encountered the planet in August 1989. The biggest moon, Triton, is 13th magnitude.

■ PLUTO

Large aperture is not necessary for most planetary viewing. Good optics, good seeing and experienced eyes are the crucial ingredients, as this remarkable drawing of Jupiter by T. Mayazaki of Japan attests. He was using an 8-inch Newtonian. Mayazaki, who has been sketching the planets for more than four decades, has astonished several generations of planetary observers with his skill.

A tiny world, smaller than the Earth's moon, floating on the rim of the solar system offers a challenging target for owners of 6-inch or larger telescopes. The challenge is simply to see it.

Pluto looks identical to a 13.7-magnitude star. It has been seen in 6-inch telescopes, but it is a tough assignment; 8-inch or bigger telescopes are recommended. Not only does Pluto have to be identified using the charts published in the *Observer's Handbook*, *Astronomical Calendar*, *Sky & Telescope* or *Astronomy*, but it has to be identified on two nights within a few days of each other so that its motion among the stars can be plotted and the identification confirmed. A single sighting is usually not good enough because, much of the time, at least one faint star with a magnitude similar to Pluto's is nearby. During the 1990s, Pluto is located on the border between the constellations Libra and Ophiuchus, well positioned in the evening sky in late spring and early summer.

For a definite Pluto sighting, plot the stars of the immediate vicinity in a notebook, and be as precise as possible in the positioning of the planet. Return to the eyepiece a few nights later, check the same field, and see whether the object identified as Pluto has moved to another position. The 1990s are the best time to look—Pluto was at perihelion in 1989 and is slowly retreating from both the sun and Earth. It will lose about one-tenth of a magnitude per decade during the next century.

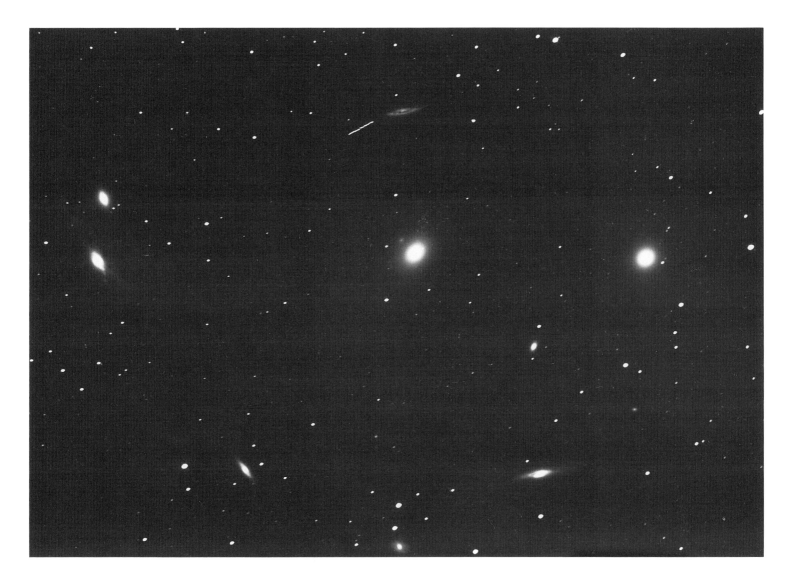

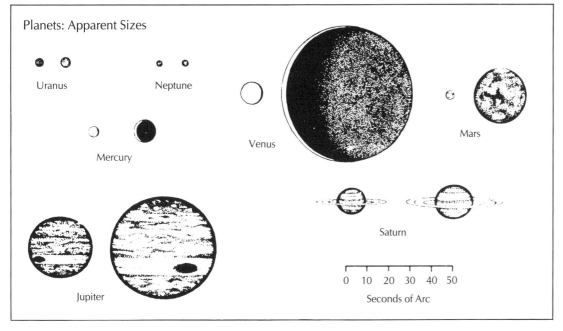

Planets: Apparent Sizes

Uranus

Neptune

Mercury

Venus

Mars

Saturn

Jupiter

0 10 20 30 40 50

Seconds of Arc

■ Above: Thousands of asteroids orbit the sun along with the planets. Astrophotographer Tom Dey caught one as a short streak during a time exposure of the Virgo galaxy cluster.

■ Left: Illustration of the apparent maximum and minimum observable sizes of the planets shows what to expect in a telescope in terms of relative sizes. Venus and Mars, the planets closest to Earth, vary enormously in size depending on their distance from us, while Jupiter and Saturn remain fairly constant.

How to Find Your Way Around the Sky

Familiarity with the night sky's geography and its overall motions is as integral to amateur astronomy as knowing how to focus a telescope. It is gained through the experience of observing the stars and understanding what you see. Without such knowledge, the most expensive telescope will add little to the hobby. Equipment alone is not enough for navigating the celestial seas.

We have seen this advice ignored many times. People buy telescopes that have fancy-looking mounts with setting circles (numbered dials on the mount) or computer-aided devices that are said to point automatically to thousands of objects. Yet the new owner knows not a single constellation. Without a proper understanding of what the instrument is supposed to do, or why, the observer will spend a few frustrating nights outside, then neglect it.

■ AN OBSERVING PHILOSOPHY

The point of backyard astronomy is not just to peek into a telescope eyepiece; rather, it is the total experience of a personal exploration of the cosmos, an incremental process that begins with the first identification of the Big Dipper and the bright planets. Recognition of the less obvious constellations follows and, from this framework, a growing appreciation of the sky's motion due to the Earth's rotation. The quest can then extend thousands or millions of light-years via binocular sightings of the brighter star clusters, nebulas and a galaxy or two.

As the months pass, the gradual shift of the celestial panorama elicits a sense of cyclical change within a timeless chamber of immense proportions. You see and understand the visible universe.

Before this stage, a telescope tends to be a distraction rather than an aid, diverting attention from the big picture. If you spend a few months stargazing with binoculars, you will know what a telescope is designed to do before you buy it. That is why we recommend binoculars for initial observing. They also acquaint you with the capabilities of simple optics and help you cross-reference all-sky naked-eye star charts to more detailed charts that include a full range of binocular targets.

The next step is to learn to use charts to find telescopic objects. Even if you plan to use a computer-aided telescope or setting circles, you still need sky charts. They are the atlases of the night sky.

■ NIGHT-SKY GEOGRAPHY

Right ascension (R.A.) and declination (Dec.) are the sky's equivalents of longitude and latitude on Earth. Just like latitude, celestial declination is 0 degrees directly above the Earth's equator and 90 degrees above the poles. Right ascension is measured in 24 one-hour segments, rather than degrees, and each hour is subdivided into minutes and seconds. The system is used because the Earth's 24-hour rotation causes the sky to parade in review at the rate of approximately one hour of right ascension in one hour

■ *In 1600, this was a state-of-the-art celestial atlas. Of undeniably high artistic merit, these charts by Willem Blaeu of Amsterdam also have reasonably accurate star positions. Until the 20th century, it was common practice to show the stars as part of a globe—the celestial sphere—and to depict the constellations as they would appear from the "outside"; hence the mirror reversal of their positions compared with a true sky view. Although visible to the unaided eye, nonstellar objects such as the Andromeda Galaxy are simply portrayed as stars. Courtesy Harvard University.*

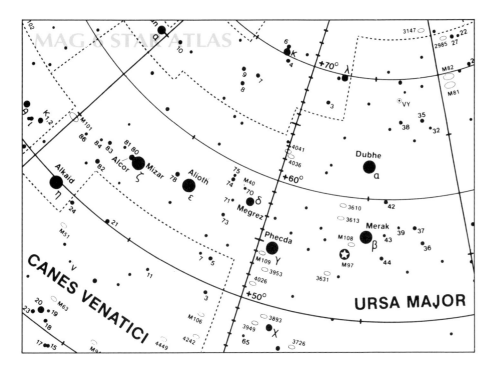

CANES VENATICI

URSA MAJOR

address, so does every sky location. R.A. 16h 42m Dec. +36° 28′ is the location of M13, the Hercules cluster. Look on any star chart detailed enough to show right-ascension and declination coordinates, and M13 can be found by these numbers alone. Older astronomy books and star atlases have epoch 1950 coordinates, while more recent charts give epoch 2000 coordinates. This reflects a slow shift in the entire coordinate system that is due to precession, a ponderous wobbling of the Earth's axis. Ignore it, at least initially. A 50-year epoch difference is not a consideration in the beginning stages when binoculars or low-power telescopes should be used. Eventually, try to use charts and tables that offer *either* epoch 1950 or epoch 2000 coordinates, but not both.

Once armed with the coordinates, how can you find an object in the sky? The traditional—and best —method is to plot the position on a star chart or star atlas, note the location relative to nearby fifth- and sixth-magnitude stars, point the telescope at that spot, and locate the object in the finderscope or the telescope's low-power field. It is simple, it works, and the sky can be learned at the same time.

The alternative—employing the telescope's setting circles—is more complicated than just dialling up the numbers. For simplicity, the star-chart point-and-look route is strongly recommended.

of clock time. However, the association between right ascension and time is a secondary issue. The important point is that the right-ascension and declination coordinates are fixed to the sky.

Just as every location on Earth has its coordinate

■ STAR ATLASES

■ *Small sections around the Big Dipper from the three most widely used sixth-magnitude star atlases are shown above and on facing page. All are reproduced the same size as the atlases themselves. Apart from the slightly different symbols used, the main variations are the number of deep-sky objects plotted and the overall clarity and legibility of the charts. The Edmund Mag 6 Star Atlas has a 6.2-magnitude limit, while the Bright Star Atlas and Norton's 2000.0 penetrate to 6.5. All three atlases have extensive tables of data on deep-sky objects. Charts (clockwise from upper left) are copyright Edmund Scientific, Willmann-Bell Inc. and Longman Scientific. Reproduced with permission.*

A star atlas is as essential to the backyard astronomer as a road atlas is to a traveller. And like the traveller, the astronomer can be inconvenienced or become lost by not selecting the right atlas for the situation.

Planning a cross-country trip requires, first, a national map for an overview, then state or provincial maps for more detail and, finally, regional or city maps for information about congested areas or sites of special interest. A similar procedure is followed when planning a night of observing under the stars with binoculars or a telescope.

For the initial overview, the entire sky must be on one map. One such reference is the monthly circular all-sky charts in each issue of *Sky & Telescope* and *Astronomy*. They are well-crafted maps, but we prefer the convenience of rotating sky charts that show what is above the horizon at a specific time for any night of the year. Our favourite chart of this type is "The Night Sky," designed by David Chandler and available from Sky Publishing for about $6. It comes in several versions, each suitable for a different latitude range.

Rotating star charts or monthly all-sky charts usually plot stars down to magnitude 4.5. Only a few prominent deep-sky objects are shown, so the use-

fulness of the charts as actual guides to specific targets is limited. They are good overviews that reveal at a glance the interrelationships of the constellations and their positions relative to the horizon.

Unless you are doing solely unaided-eye viewing, you need more than a single all-sky chart. Star-atlas charts subdivide the sky into smaller areas that are enlarged to provide greater detail. They are categorized by their limiting magnitudes. Each increase of one magnitude more than doubles the number of stars and other celestial objects shown and therefore produces a substantially bulkier atlas. More detail corresponds with the need for a higher level of observer experience to use the atlas.

■ FIFTH-MAGNITUDE STAR ATLASES

For those just beginning their tour of the night sky, several introductory books provide excellent fifth-magnitude star atlases along with plenty of support material. These include *NightWatch* by Terence Dickinson (Camden House), *The Edmund Sky Guide* by Terence Dickinson and Sam Brown (Edmund Scientific), the *Mag 5 Star Atlas* by Sam Brown (Edmund Scientific), *The Monthly Sky Guide* by Ian Ridpath and Wil Tirion (Cambridge) and the

Universe Guide to Stars and Planets by Ian Ridpath and Wil Tirion (Universe Books). Each of these books costs $25 or less and contains charts showing all stars down to magnitude 5.0 or 5.5. They include extensive introductory material aimed at the beginning observer as well as lists of hundreds of the brightest and easiest-to-find deep-sky objects.

■ SIXTH-MAGNITUDE STAR ATLASES

Every backyard astronomer needs a sixth-magnitude star atlas. Our first choice—and there is obviously some bias to be admitted here—is the *Mag 6 Star Atlas* by Terence Dickinson, Glenn F. Chaple and Victor Costanzo (Edmund Scientific, $20). The first half of the book provides introductory reference material on telescopes and observing techniques. The second half is an atlas of the sky to magnitude 6.2, divided among 12 charts reproduced on large, 12-inch-square pages. Three additional charts are blowups of congested areas. Facing each chart is a list, with descriptive notes, of nebulas, clusters, galaxies, double stars and variable stars to be found on that chart.

Another favourite is Wil Tirion's *Bright Star Atlas* (Willmann-Bell), a beautiful sixth-magnitude star atlas arranged in similar fashion to the chart section of the *Mag 6 Star Atlas*. All stars to magnitude 6.5, all open and globular clusters to 7.0 and all galaxies to 10.0 are shown. Double stars and nebulas are limited to those visible in small telescopes. The data tables are intended for observers with binoculars or modest telescopes. It is a bargain at $10.

The *Bright Star Atlas* is actually the atlas section from another wonderful book with the unusual title *Men, Monsters and the Modern Universe* by George Lovi and Wil Tirion (Willmann-Bell). Lovi and Tirion probably know more about star charts than any other two people on the planet. Their book is slightly different from the others in this category because its text concerns the constellations and their origins, mythology and importance. For such information, no better source exists than this fine hardcover reference book, reasonably priced at $25.

The world's best-known sixth-magnitude star atlas is *Norton's Star Atlas*, first published in 1910. The most recent edition (1989) of the durable work is so heavily revised that its name has been changed to *Norton's 2000.0* (Wiley, $35). All the maps have been completely redone, the tables have been reworked, and the description section has been rewritten under the supervision of English astronomy writer and editor Ian Ridpath. The charts, by Wil Tirion, are superb, perhaps the best sixth-magnitude atlas charts yet available. There are eight main maps to magnitude 6.5, each a two-page 11-by-17-inch spread, with reference tables on the previous two pages. Unfortunately, the tables emulate too closely

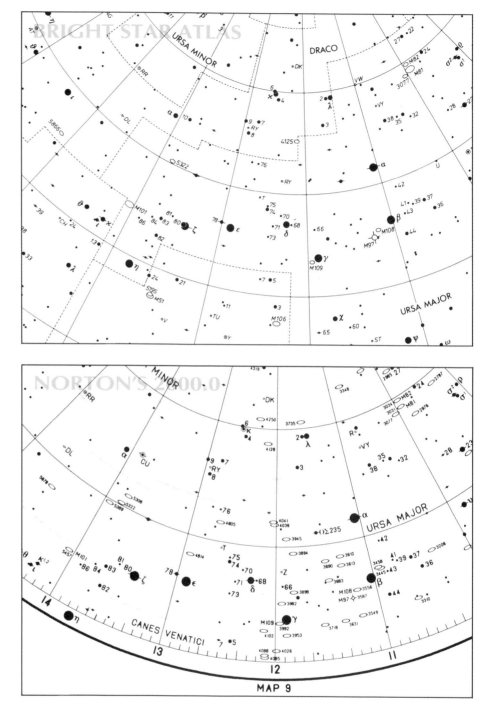

the style established by the original author, Arthur P. Norton, which reflects the observing tastes in vogue early in this century. Variable stars and double stars constitute 80 percent of the objects listed, while clusters, nebulas and galaxies are relegated to the remaining 20 percent. A better balance would have been 50-50. The chart section is followed by 150 pages of concise reference material that will be of lasting value to the more experienced observer.

Finally, in the sixth-magnitude category, is the book with the weakest charts and the best descrip-

163

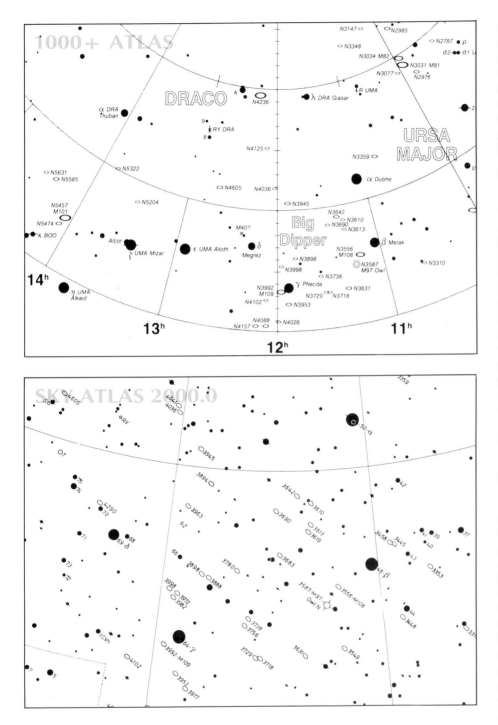

peared through his 8-inch Schmidt-Cassegrain, although the descriptions are useful for most telescopes. In addition, there is a large text section in which Lorenzin dispenses much practical advice on observing techniques and equipment. The atlas charts are competently drawn, but we have found them to be the least useful of any of the sixth-magnitude atlases mentioned here. Nevertheless, it is a highly recommended reference.

■ SEVENTH-MAGNITUDE STAR ATLAS

Only one volume falls into the seventh-magnitude category: *A Field Guide to the Stars and Planets* by Donald H. Menzel and Jay M. Pasachoff, with monthly sky maps and atlas charts by Wil Tirion (Houghton Mifflin). It is one of the venerable and highly successful books in the Peterson Field Guide Series, pocket-sized volumes intended for field use by naturalists. Although the format may work for bird watchers, it fails in this instance. Tirion's beautiful seventh-magnitude star atlas is divided into 52 charts, but each is only four by five inches—far too small for the detail they contain. The small page format is all wrong for a book this comprehensive, which is unfortunate, because there is much useful information here, packed into 450 pages of small type. Priced at less than $20, though, it is an excellent value for the amount of information it offers.

■ EIGHTH-MAGNITUDE STAR ATLASES

Astrocartographic genius Wil Tirion produced the definitive eighth-magnitude atlas with his *Sky Atlas 2000.0* (Sky Publishing and Cambridge). The 26 charts are each 12 by 18 inches. This is a big atlas, but it works. Swatches of the sky, roughly 40 by 60 degrees, are presented. If they were smaller, they would not include enough of any individual constellation to provide a feel for the portion of the sky being examined. The atlas is available in three formats: a deluxe bound edition with colour-coded charts; individual charts in a desk edition, with black stars on a white background; and the so-called field edition, with white stars on a black background. At approximately $20, the desk and field editions are real bargains. The deluxe edition costs about $40. *Sky Atlas 2000.0* is the obvious step up from a sixth-magnitude atlas.

■ NINTH-MAGNITUDE STAR ATLASES

Compiling an atlas of stars down to magnitude 9.5 was a monumental undertaking. To accommodate the observing agendas of serious amateur astronomers, more than 300,000 stars had to be plotted, along with thousands of deep-sky objects to 14th

tive catalogue, *1000 + : The Amateur Astronomer's Field Guide to Deep Sky Observing* by Tom Lorenzin (privately published; available through Sky Publishing and *Astronomy*, $40). The "1000 +" in the book's title refers to the extensive reference section of approximately 1,100 deep-sky objects—double stars, variable stars, clusters, nebulas and galaxies. The vast majority of the listed objects are nebulas, clusters and galaxies, in keeping with the tastes of the modern backyard astronomer. Lorenzin looked at every one of the objects listed, noting how it ap-

magnitude. The task was finally completed in the late 1980s with the publication of *Uranometria 2000.0* by Wil Tirion, Barry Rappaport and George Lovi (Willmann-Bell). The scale of detail necessary meant that for entire constellations to be shown on one chart, the charts would have to be the size of a tablecloth. Obviously, that was impractical, so instead, the sky was divided into 472 sections, and the book was printed in two bound volumes on 9-by-12-inch pages. The result is a tour de force, uncluttered yet offering fantastic detail. Priced at $100 for the set, *Uranometria 2000.0* has filled the last void in the star-atlas repertoire for backyard astronomers.

Some atlases show fainter stars, but they are simply reproductions of photographs of the sky, and very few of the objects are named. Their value to the average backyard astronomer is limited because the most frequent use of an atlas is to look up the location of a known galaxy or nebula. In this regard, *Uranometria 2000.0* is unrivalled. Virtually every deep-sky object you might want to observe is shown and identified.

■ ASTRO CARDS

Each three-by-five-inch Astro Card features one main deep-sky object and often several nearby objects of interest. A wide-angle chart indicates where to look in the constellation, and a naked-eye star is given as a jumping-off point for star hopping. It also has a chart containing a three-to-four-degree-wide finderscope field with the key star marked. Homing in on an object becomes a relatively straightforward

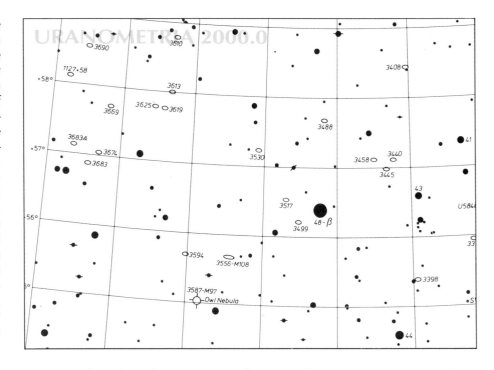

task of matching the finderscope view to the starfield drawing. The cards are easy to handle at the eyepiece and can be flipped over to match a right-angle finderscope (shine a flashlight through them). There is a set for the Messier objects, two sets of NGC-object cards, a set for large-telescope targets and a set for binary stars. The price is $7.50 per set of 100 cards. They can be ordered from Astro Cards, Box 35, Natrona Heights, PA 15065.

■ SETTING CIRCLES

Amateur astronomy is a friendly hobby; however, a few topics provoke debate. One issue that never seems to go away concerns setting circles: Are they a crutch or a contribution?

If you spend any time with a group of amateur astronomers, you will hear: "Don't use setting circles. Learn to find objects by using star charts and hopping from star to star. You'll never learn the sky otherwise." Then another voice will quickly counter: "Don't listen to him. I use setting circles all the time. I can zero right in on the object I want, and I don't have to waste time hunting for it."

Actually, both views are right. Setting circles can be a great aid to finding deep-sky objects, but the people who use them effectively understand celestial coordinates and sidereal time and know the constellations and the general positions of their targets. They are skilled observers who can recognize the objects they are looking for and, if forced to, could just as easily star-hop across the sky to find them.

Very few amateur astronomers who have yet to

become familiar with celestial coordinates and the proper alignment of their telescopes succeed at managing setting circles effectively. With luck, they may get close to a target, but not close enough. A series of near misses may cause the hapless observer to give up in frustration. Furthermore, unfamiliarity with an object's appearance can cause it to be missed even though it is in the viewing field.

Setting circles do work, but we recommend that beginners not rely on them. Instead, learn the constellations first. Find the best deep-sky objects and double stars by following star patterns. If your goal is to see all the Messier objects, track your quarry with care and precision—star-hop.

Star hopping may require more effort than using setting circles on a properly aligned telescope, but the end result is a working knowledge of the star fields. The sky becomes a friendly place. Star-hopping routes are soon as familiar as finding your way through the backstreets of your hometown. With practice, you will be able to centre the tele-

■ Facing page, top: a fourth sixth-magnitude star atlas from the book 1000+ : The Amateur Astronomer's Field Guide to Deep Sky Observing *lacks constellation boundaries and is less detailed than the atlases shown on pages 162-63. However, the descriptive tables that accompany it are excellent. Chart copyright 1000+; reproduced with permission.*
■ Facing page, bottom: The next step up from a good sixth-magnitude atlas is Sky Atlas 2000.0, *which plots stars to magnitude 8.0 and shows many more deep-sky objects. Because of the increased scale of this atlas, only the bowl of the Big Dipper is shown here. Chart copyright Sky Publishing; reproduced with permission.*
■ Above: The ultimate atlas for detail and comprehensiveness is Uranometria 2000.0. *Now, so much is shown in such detail that only Beta Ursae Majoris and its immediate surroundings fit in an area that contains the entire Big Dipper in the sixth-magnitude atlases. Chart copyright Willmann-Bell Inc.; reproduced with permission.*

scope on any number of objects with no more than a couple of quick glances through the finderscope.

So why have setting circles? They are very useful for tracking down objects in star-poor regions, finding planets in the daytime, locating comets and observing in bright city skies. This is true if, and only if, the mount is accurately polar-aligned. There are two applications of accurate polar alignment: setting circles and astrophotography. If you do not do serious celestial photography and do not use setting circles, you *never* need more than rough polar alignment, despite what the telescope instruction manual might say. Rough polar alignment is accomplished in about one minute. Accurate polar alignment requires anywhere from 5 to 45 minutes.

■ SETTING-CIRCLE BASICS

To be accurate, setting circles should be at least four inches in diameter and permanently engraved. On inexpensive equatorial mounts, the circles are small and are often marked with printed stick-on scales, making them decorations rather than tools for the observer. The pointers should also be durable and difficult to move as well as positioned close enough to the main dial to allow accurate readings. Even on expensive telescopes like Celestrons and Meades, the pointer markers are sometimes just glued on. A declination circle must be solidly fixed to the declination axis. If properly calibrated, the circle should not have to be adjusted. (Instructions for making the onetime adjustment are in the Appendix.)

The right-ascension circle, on the other hand, is designed to slip, but only when it is supposed to. Since the sky moves from east to west, the circle must be calibrated to the current aim point of the telescope each time it is used. Some right-ascension circles are "driven"; once they are set at the beginning of the night, the clock drive moves them to keep up with the rotation of the sky regardless of where the telescope is aimed. This is the best type.

■ LOCATING OBJECTS WITH A CLOCK-DRIVEN RIGHT-ASCENSION SETTING CIRCLE

The procedure for finding objects is as follows:
☐ Be sure that the declination circle is properly calibrated.
☐ Polar-align to within half a degree or better of the true celestial pole.
☐ Aim the telescope at a known star, and slip the right-ascension circle around so that it reads the star's right ascension. This calibrates the circle for the night. If the telescope has been polar-aligned, the declination circle should now automatically show the star's declination.
☐ Move the telescope to the coordinates of the target. If the object is not visible in the lowest-power

eyepiece, scan around the area within approximately one degree.
☐ Keep dialling in objects throughout the night. Do not turn off the clock drive, or the right-ascension circle will lose time. You can use coordinates from either epoch 2000 or epoch 1950, but for accuracy, do not mix the two. If stalking a comet, use tonight's coordinates; comets can move very quickly in a day or even in a few hours. Also, setting-circle inaccuracies due to imprecise polar alignment will show up more on objects near the celestial poles.

Some references or manuals instruct the user to set the right-ascension circle for the current sidereal time, to work out an object's hour angle and, finally, to dial in the hour angle. Ignore such information, as it is needlessly complicated. People who hate setting circles were probably taught this tedious technique. If the right-ascension circle is not clock-

■ *Top: Astro Cards offer deep-sky enthusiasts a handy way of planning an evening's observing. Individual cards are selected beforehand, then used at the eyepiece. Each card shows the location of a deep-sky object as well as objects of interest nearby.*
■ *Centre: A telescope's right-ascension circle is calibrated in hours and minutes that correspond to hours and minutes of right ascension in the sky (not to clock time). To initialize the reading, the circle must be set to the right ascension of a known star while the telescope is pointed at that star.*
■ *Bottom: A telescope's declination circle can be used in conjunction with the right-ascension circle to "dial up" any celestial object. That is the theory. In practice, the setting circles on many commercial telescopes are not accurate enough to do the job. They are seldom used by backyard astronomers.*

driven, as is the case on many older German equatorial mounts, the procedure is a little less convenient because before moving to a new target, the right-ascension circle must be recalibrated on either a known star or the previous object.

■ SETTING CIRCLES IN THE DAYTIME

To find Mercury, Venus, Jupiter or even bright stars in the daytime, use the following technique:

☐ Polar-align the night before. If the telescope cannot be set up and left, mark the ground to indicate where the mount should be placed the next day.

☐ Align finderscope with the main optics.

☐ Aim the telescope at the sun, being careful not to burn the finderscope, the main optics or your eyes. Use your lowest-power eyepiece and a proper full-aperture solar filter to focus the eyepiece. If you do not have a solar filter, the eyepiece must be focused on a star the night before.

☐ Check the sun's current position in an ephemeris or a handbook such as the *Observer's Handbook*. If its position is not given for today's date, then calculate its location using earlier and later dates. Calibrate the right-ascension circle to the estimated current sun position.

☐ Look up the target's coordinates, and dial in the position. If the object is not there, carefully scan in the near vicinity. If Venus is the target, it will be visible in the finderscope. Always ensure that you do not accidentally scan back over the sun.

■ ALTAZIMUTH SETTING CIRCLES

Amateur astronomers with a leaning toward mathematics have tried to adapt setting circles to telescopes that are not designed to include them. The old rule was that setting circles worked only on equatorially mounted and polar-aligned telescopes. But some altazimuth Dobson-mounted instruments have setting circles on their axes. How is this possible? Computerization.

A computer program is loaded into a programmable hand-held calculator that converts an object's permanent right-ascension and declination coordinates into an altitude and azimuth reading. The program requires initialization with the observer's position and the current time, and the readout is good for only that one moment in time, but if the observer quickly dials in the altitude and azimuth reading, it works. The Dobsonian mount has to be level, and of course, the axes must be equipped with graduated circles.

Mathematics fans and computer buffs like this technique because it allows them to apply their high-tech skills to tracking objects with low-cost, low-tech telescopes. They argue very persuasively that a calculator is much less expensive and is more portable than an equatorial mount. Generic calcu-

lator programs were published in the July 1988 *Astronomy* and the February 1989 *Sky & Telescope*.

■ LET THE COMPUTER DO THE POINTING

A new generation of computer-assisted devices combines digital setting circles, which display the telescope's celestial coordinates in LED numbers, with a technique for finding objects using coordinates stored in the data base. The observer aims the telescope at two known stars, tells the computer which ones they are and enters the target's name or coordinates, and the device shows which way the telescope should be moved to centre the object. The telescope does not have to be polar-aligned, nor does it need an equatorial mount; the computer calculates the offset correction automatically. These fascinating gadgets—the most popular are Jim's Mobile Industries' NGC-Max, Lumicon's Sky Vector, Meade's CAT and Celestron's Astromaster—are all similar and are priced in the $400 to $1,000 range.

To do their work, the devices receive input from encoders that the owner installs on the telescope mount's two axes and combine it with powerful built-in software. In theory, once the required hardware is correctly installed, digital circles are easy to use, accurate and reliable. However, a smoothly operating telescope equipped with a Telrad and a good finderscope usually takes a reasonably experienced observer no more time to aim than looking at a readout of glowing lights and numbers. We think seeking the target, and the understanding of celestial geography that the process provides, is an integral part of backyard astronomy.

■ *Dobsonian setting circles? Until the computer age, setting circles were possible only on equatorial mounts. Dobsonian telescopes have altazimuth mounts. But with the aid of a powerful calculator, above, to convert right ascension and declination to altitude (up-down) and azimuth (left-right), the Dobsonian circles are just as effective; and because of their larger size, they are often more accurate than the smaller setting circles on commercial equatorial mounts. Even so, most owners of Dobsonian telescopes do not feel that setting circles are a necessary accessory.*

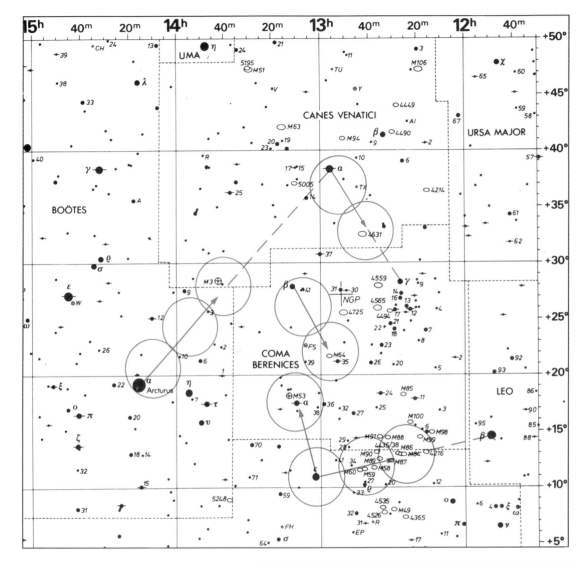

How to star-hop your way to deep-sky objects with a finder-scope: First, select an appropriate chart from a sixth-magnitude star atlas. Here, we have used part of Chart 6 from Wil Tirion's Bright Star Atlas. From various references, we selected five objects suitable for small telescopes: globular clusters M3 and M53, galaxies M64 and NGC 4631 and the central part of the Virgo galaxy cluster. Then we chose nearby but easily identified guide stars for these objects. Arcturus is the obvious one for M3. Three finderscope fields (shown as five-degree circles) toward Alpha Canes Venatici will put M3 in the field of view, where it appears as a fuzzy sixth-magnitude star. Similarly, M64, the Black Eye Galaxy, is two finderscope fields from Beta Comae Berenices. But since M64 is too faint to be visible in most finderscopes, an examination with low power on the main telescope would be necessary to identify it. Using this system of working from naked-eye stars and hopping one to three finderscope fields, hundreds of deep-sky objects can be identified. Base chart copyright Willmann-Bell Inc.; reproduced with permission.

■ WHAT'S IN THE SKY TONIGHT?

The night sky's brightest objects—the moon, Venus, Jupiter, Mars and Saturn—are always on the move. Their orbital motion, combined with that of Earth, means that they constantly shift position among the constellations of the zodiac, the celestial pathway of the planets. Observing this motion and the occasional close passes (conjunctions) among these nearby worlds is always a treat for beginners and veteran stargazers alike.

Astronomy and *Sky & Telescope* are excellent sources of information (detailed tables, charts and descriptive data) on changing celestial phenomena. We also recommend the monthly *Sky Calendar* charts that include a daily listing of visible celestial phenomena, suitable for use throughout the United States and southern Canada. Available for about $6 per year from Sky Calendar, Abrams Planetarium, Michigan State University, East Lansing, MI 48824.

For more detail, try the *Astronomical Calendar* by Guy Ottewell, about $15, from Astronomical Workshop, Furman University, Greenville, SC 29613. This extraordinary annual publication, with its fine array of charts and diagrams, is indispensable for recreational astronomers.

Another outstanding annual astronomical guide is the *Observer's Handbook*, about $14, published by the Royal Astronomical Society of Canada, 136 Dupont Street, Toronto, Ontario M5R 1V2. Its 200-plus pages are crammed with tables, maps and descriptions useful to anyone in North America interested in astronomy. The amount of information it contains is staggering.

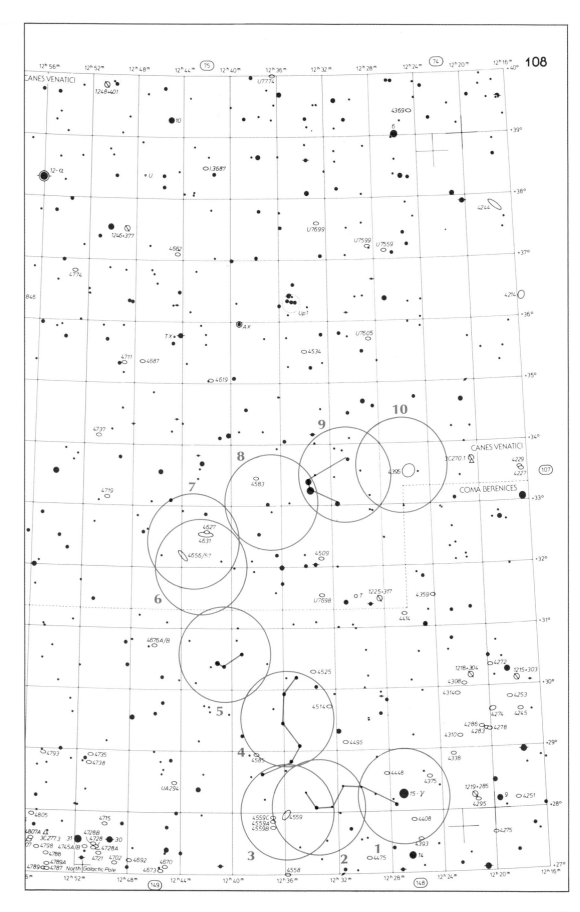

A typical telescope star-hop pattern is shown here on a section of Chart 108 from Uranometria 2000.0. This is a close-up of the region between Alpha Canes Venatici and Gamma Comae Berenices, shown on facing page. An average low-power telescope field 1½ degrees across is represented by the circles. Objects for scrutiny on this star-hop tour are the galaxies NGC 4559, 4631, 4656 and 4395. Starting from Gamma, 10.5-magnitude 4559 is a soft glow 1½ fields to the east. The marked chain of 9th-magnitude stars tells the observer which way to go in an inverted or flopped telescope view. Similarly, the distinctive stellar asterisms to the north will guide the viewer to 4631 (9th magnitude) and 4656 (10th), two outstanding edge-on galaxies in the same field (see colour photograph on page 187). The trip to 11th-magnitude 4395 is made easy by the convenient position of the bright pair of stars near the halfway point. Equatorial mounts can be used for less direct but often more accurate star hopping (2½ fields due north, then 1½ fields due east, and so on), because only one axis of the telescope moves at a time and the lines of right ascension and declination on star charts act as guides. Base chart copyright Willmann-Bell Inc.; reproduced with permission.

Exploring the Deep Sky

Seeing the subtle light from distant galaxies—and from all the other marvels of deep space—"live" through an eyepiece is very much the domain of the amateur astronomer. Professional astronomers rarely, if ever, look through their telescopes. The instruments they use are, in effect, giant cameras. Not so long ago, though, deep-sky observers were a relative minority, even among die-hard skygazers. Today, with the popularity of inexpensive large-aperture telescopes, the legion of deep-sky explorers has grown. For $500, it is possible to buy or to make a simple Newtonian large enough to reveal remote clusters of galaxies.

Granted, a galaxy cluster might appear as a field of fuzzy blobs, but each of those indistinct objects is another Milky Way, filled with stars, planets and, perhaps, curious minds like ours. It is difficult to look at any deep-sky object—especially something as remote and vast as a galaxy cluster—without stopping to reflect that here you are, alone under a starry sky, and a simple telescope is opening your eyes to billions of stars and unknown worlds in each puff of celestial mist. Whatever your personal philosophies, deep-sky observing will certainly bring them out. This kind of astronomy is done as much with the mind as it is with the eye.

■ INVENTORIES OF THE SKY ■

The deep-sky realm officially starts at the edge of the solar system and extends out to the galaxy clusters and the enigmatic quasars. Taken literally, it encompasses everything in the universe except our sun and its satellites. But in normal amateur-astronomy usage, the term "deep sky" is more selective. It refers to nebulas, star clusters and galaxies.

Today, tens of thousands of deep-sky objects bright enough for backyard telescopes have been discovered, the result of 200 years of meticulous observation. The early explorers of the sky did not know what all the newfound objects were, but they hunted them down nevertheless, carefully charting and cataloguing everything within their reach, much as the botanists and natural philosophers of the 18th and 19th centuries did with the many forms of life on Earth. The result of such pioneering observations of the sky was a series of celestial catalogues still very much in use.

■ THE MESSIER CATALOGUE

When you enter the world of deep-sky observing, you enter a world of strange codelike labels. It is easy to become intimidated by discussions of M-this, NGC-that and IC-something-or-other. What does it all mean?

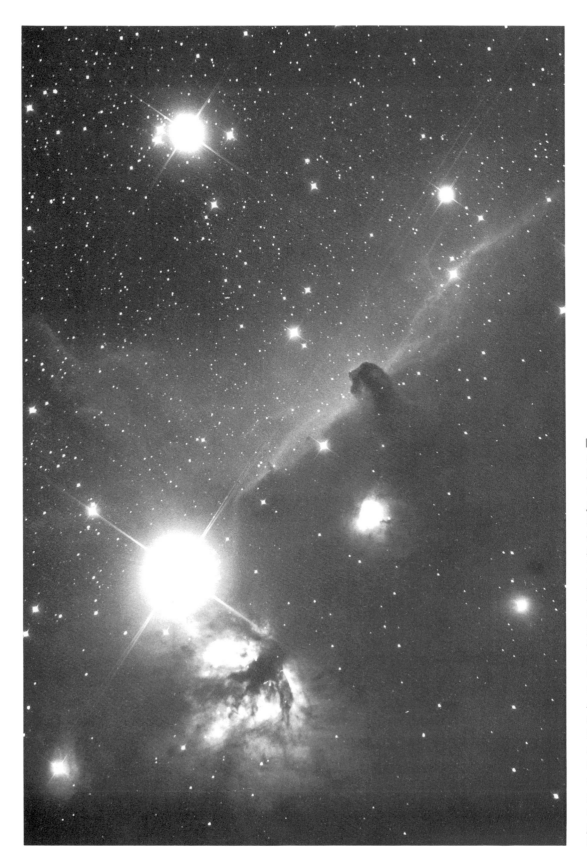

■ The region around Zeta Orionis that includes the Horsehead Nebula is one of the night sky's most photogenic areas. Zeta Orionis, the large, overexposed object left of centre, is a bright naked-eye star in Orion's three-star belt. The Horsehead itself is a light-year-wide dark cloud superimposed on a bright emission nebula, both about 1,500 light-years away. Despite its bright appearance in photographs, the Horsehead is notoriously difficult to see. A nebula filter can make all the difference. Although it has been seen with apertures as small as 5 inches, the Horsehead usually requires a 10-inch or larger telescope. Photograph by Leo Henzl, using an 8-inch f/5 Newtonian. (The Newtonian's secondary-mirror supports produced the prominent spikes from the bright stars.)

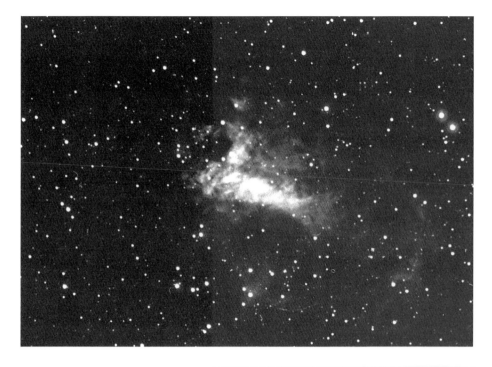

■ *Above: The Swan Nebula, M17, an emission nebula about 3,000 light-years distant, is an excellent nebula-filter target. Many of the faint loops and tendrils seen here leap out of invisibility with the application of a filter—even with a small telescope. Photograph by Leo Henzl, using an 8-inch f/5 Newtonian.*

■ *Right: For a clear view of the dark lane that gives the Black Eye Galaxy, M64, its name, dark skies and a large-aperture telescope are required. Overall, though, the eighth-magnitude galaxy itself is an easy object for small telescopes. Photograph by Jack Newton, using a 20-inch Newtonian.*

to the sky's collection of Messier objects—the clusters, nebulas and galaxies that Messier encountered as he scanned the sky for comets.

The Messier numbers follow a haphazard sequence across the sky because they are numbered in the order in which Messier located them or learned of them. Although he intended to, he never published a list with entries renumbered in order of right ascension. Illness, old age and the French Revolution intervened.

The identity of several Messier objects has often been questioned. Some writers believe that M91 and M102 are mistaken observations of M58 and M101, respectively. The objects M104 to M109 were discovered by an associate, Pierre Méchain, and reported to Messier, but they were never included in a published version of his catalogue. These M objects, therefore, are really "Méchain objects." NGC 205, one of M31's companion galaxies, was apparently found by Messier, who, for some reason, did not list it in his catalogue. Modern-day observers have dubbed this object M110. Finally, two Messier objects are not deep-sky objects at all: M40 is a pair of ninth-magnitude stars, and M73 is a random grouping of four stars. Purists sometimes reduce the Messier list to 99 or 100 objects. A recent version compiled by coauthor Dyer for the *Observer's Handbook* lists a full 110 entries, including two faint galaxies that some astronomers suggest as candidates for M91 and M102.

From a rural site, all the Messier objects can be seen with a 3-inch telescope and many with only 7 x 50 binoculars. Tracking down the Messiers over the course of a year or two is a rewarding endeavour. In the process, you will become familiar with the sky, learn how to see faint objects through the telescope and, in general, gain enough credits to graduate to the level of an experienced observer.

■ THE NGC

Most deep-sky enthusiasts complete the Messier list. But then what? The next goal is the collection of NGC objects.

NGC stands for New General Catalogue, although this "new" catalogue is more than 100 years old. It was originally compiled by Danish astronomer J.L.E. Dreyer under the aegis of the Royal Astronomical Society in England. Published in 1888, Dreyer's *New General Catalogue of Nebulae and Clusters of Stars* compiled observations of 7,840 objects from dozens of observers and replaced all previous lists and catalogues; in particular, the older *General Catalogue* of William and John Herschel. It was believed that the NGC contained every nebula and cluster known in 1888. The fact that many of the "nebulas" were actually galaxies was unknown at the time; anything that

First, the M (Messier) objects, a catalogue of deep-sky objects compiled by Charles Messier, a French astronomer of the 1700s. Among the best-known Messier objects are M45, the Pleiades star cluster; M31, the Andromeda Galaxy; M13, the globular cluster in Hercules; and M42, the Orion Nebula. Altogether, there are 110 objects in Messier's catalogue, which provides a selection of the finest deep-sky objects for northern-hemisphere observers.

Messier did not set out to find deep-sky targets. To him, they were nuisance objects that he kept bumping into during his searches for comets. He published lists of the fuzzy noncomets so that he and his comet-hunting colleagues would not be fooled by them. But today, his comet discoveries (he found 15) are largely forgotten. It is Messier's list of nuisance objects that is remembered. Modern amateur and professional astronomers the world over refer

could not be resolved into stars was called a nebula. Even today, the Andromeda Galaxy is sometimes called the Andromeda Nebula, a holdover from turn-of-the-century usage.

Unlike the listings in the Messier catalogue, the NGC objects are all ordered by right ascension. The lowest-numbered NGCs are around 0 hours right ascension, and the numbers increase as you proceed eastward across the sky. However, successively numbered NGC objects can be separated by many degrees north or south in declination.

Soon after the NGC was published, it required revision. Supplementary Index Catalogues were published in 1895 and 1908. Objects labelled IC are from one of those listings. The first IC contains 1,529 objects discovered visually between 1888 and 1894. The second IC offers another 3,856 entries, many found between 1895 and 1907 through the newly applied technique of photography. Most IC objects are very small or extremely faint and, in many cases, impossible to detect visually.

The brightest NGCs are easily seen in a 3-inch telescope. But a 5-to-8-inch telescope is a minimum to explore the NGC list thoroughly. To see all of the thousands of NGC entries, a 16-to-20-inch telescope is needed, although to our knowledge, no amateur astronomer has ever completed this task.

■ BEYOND THE NGC

With several thousand NGC objects from which to choose, it may be difficult to believe that back-

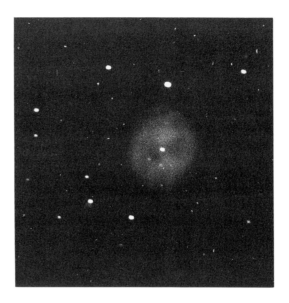

yard astronomers would seek out even more targets. One might assume that anything not in the NGC must be beyond the reach of amateur telescopes. This was certainly the attitude among amateur astronomers for decades. During the past few years, however, amateur astronomers have challenged many such assumptions. First, the Messier and NGC lists ignore one very interesting type of object: the dark nebula.

William Herschel commented on several dark "starless spots" he encountered as he swept the skies in the late 1700s, but it was left to American

■ KINDS OF DEEP-SKY OBJECTS

Object	Magnitude	Sizes	Number[1]	Min. Aperture[4]
Within the Milky Way				
globular star clusters	6 to 11	1' to 30'	100+	4 in. to 6 in.
open star clusters	3 to 10	5' to 60'	700+	2 in. to 3 in.
emission nebulas[2]	no mag.[3]	3' to 3°	100+	3 in. to 4 in.
reflection nebulas	no mag.[3]	3' to 2°	50+	6 in. to 8 in.
dark nebulas	no mag.[3]	5' to 3°	100+	3 in. to 4 in.
planetary nebulas[2]	9 to 14	2" to 15'	500+	3 in. to 4 in.
supernova remnants[2]	8 (Crab)	5' to 2°	5 or 6	4 in. to 6 in.
Beyond the Milky Way				
galaxies	8 to 16	1' to 3°	4,000+	4 in. to 6 in.
galaxy clusters	12 to 16	1° to 2°	10 to 12	10 in. to 12 in.

[1]Approximate number of these objects within reach of amateur telescopes (under 20-inch aperture).
[2]Types of objects that respond well to nebula filters. Some dark nebulas may also be enhanced if they are seen against the backdrop of an emission nebula.
[3]Magnitudes are usually not given for nebulas, but

most of the best nebulas have a brightness equivalent to 4th to 10th magnitude. Dark nebulas, by definition, can have no magnitude.
[4]Because the brightest members of each class of objects listed are detectable in binoculars, minimum aperture in this table refers to the smallest telescope that will reveal some detail or structure in the object.

■ *The Owl Nebula, M97, a 10th-magnitude planetary nebula, is easy to find near Beta Ursae Majoris, one of the Big Dipper's pointer stars. (Several of the charts in Chapter 11 show the location of M97.) The Owl's "eyes," so evident here, are only vaguely apparent in a telescope. This is another object that benefits from a nebula filter. Photograph by Bryce Heartwell, using a 10-inch Newtonian.*

amateur-turned-professional astronomer Edward Barnard to compile the first catalogue of these regions, or B objects as they are called. Included in his 1927 classic work *A Photographic Atlas of Selected Regions of the Milky Way* is "Barnard's Catalogue of 349 Dark Objects in the Sky."

In the class of emission nebulas, advanced amateur astronomers pursue elusive objects with prefixes such as Ced (from S. Cederblad's 1946 list), Sh2 (Sharpless), vdB (van den Bergh), Mi (Minkowski, not to be confused with Messier) and Gum (from Colin Gum's 1955 nebula survey). Most of the non-NGC nebulas are very small or very large; all are extremely faint. Only the brightest can be detected in the eyepiece.

Planetary nebulas constitute a category in which many recent discoveries of new objects have been made. With the advent of nebula filters, some of the non-NGC planetaries once thought to be invisible are being picked off by experienced amateur astronomers. Many come from Perek and Kohoutek's 1967 *Catalogue of Galactic Planetary Nebulae*, thus the PK designations. Most are 13th to 16th magnitude, and many are plotted on the *Uranometria 2000.0* charts. There are also Abell planetaries, from George Abell's listing of some 100 large, faint plan-

■ *The Eagle Nebula, M16, in the constellation Serpens, is another good candidate for observation with a nebula filter. Without the filter, it is almost invisible, but with a filter in place, the nebula is a delicate mist embedded in a star cluster. Photograph by Tony Hallas and Daphne Mount.*

174

etary nebulas, which he discovered by examining survey photographs taken in the 1950s with the Palomar 48-inch Schmidt photographic telescope.

Open clusters are plotted in atlases like the *Uranometria 2000.0* with such prefixes as Be (Berkeley), Cr (Collinder), Do (Dolidze), H (Harvard), K (King), Mel (Melotte), Ru (Ruprecht), St (Stock) and Tr (Trumpler). Many of the non-NGC open clusters are sparse and were missed by previous surveys because they simply do not stand out from the background star field. There are a few exceptions. One is Cr 399, variously called Brocchi's cluster or the Coat Hanger cluster, a bright and distinctive gathering of stars visible in binoculars near Beta Cygni. (It *does* look like a coat hanger.)

Over the past few decades, galaxies have been the targets of many specialized surveys at research observatories designed to catalogue and label thousands of items missed by the compilers of the NGC. *A Revised Shapley-Ames Catalog of Bright Galaxies* (1981), the *Atlas and Catalog of Nearby Galaxies* (1981), the *Second Reference Catalogue of Bright Galaxies* (1976), the *Uppsala General Catalogue of Galaxies* (the UGC, 1973) and the *Morphological Catalogue of Galaxies* (1962-68) are some of the main professional reference works used by galaxy researchers. Most amateur astronomers have little need for these lists, although the *Uranometria 2000.0* plots some of the brighter members from the UGC. For the most part, any galaxy without an NGC or IC number is fainter than 14th magnitude. Past that threshold, the number of galaxies is virtually limitless. Caltech astronomer Fritz Zwicky surveyed nearly 15 million galaxies when he compiled the six-volume *Catalogue of Galaxies and of Clusters of Galaxies*. At least 20 billion could be detected over the entire sky using a 150-inch telescope and state-of-the-art CCD imagery.

One area that amateur astronomers have moved into since the 1970s is the observation of galaxy clusters. The main catalogue used here was compiled by George Abell in the 1950s. The brighter Abell clusters are well within reach of owners of large-aperture telescopes. The amateur's main source of information about these remote objects is the *Webb Society Deep-Sky Observer's Handbook,* Volume 5.

Beyond the Messier catalogue and the NGC is an exclusive realm of objects that have rarely been glimpsed by human eyes. These faint and remote targets provide an experience of exploring the unknown unlike that found in any other aspect of backyard astronomy.

■ WITHIN THE MILKY WAY

The most varied hunting ground for backyard astronomers is our own Milky Way Galaxy. Targets range from sparkling star clusters best seen in binoculars to wisps of nebulosity at the limits of large telescopes.

■ EXPLORING PLACES WHERE STARS ARE BORN

The Orion Nebula, M42, is probably the first deep-sky object every amateur astronomer looks at, and it is the object all observers return to time after time. M42 is an example of an emission nebula, which glows with its own unique light. There are hundreds of emission nebulas in the sky. Many are too faint to be seen in amateur telescopes and show up only on photographs. Likewise, only a time exposure can

reveal the full extent of the brighter nebulas. Despite this, a 6-to-12-inch telescope can show an amazing wealth of detail in the brightest of this class of objects, producing views that look almost like photographs. In fact, some nebulas look better in real life than they do in an astrophoto. The eye can capture the full range of detail from bright to dim along with stars embedded deep within the nebula, something that film emulsions cannot do.

However, for any nebula to be seen well, the sky must be dark; a light-polluted sky washes out a nebula's delicate features. To combat this problem, many amateur astronomers use a nebula filter, which blocks all wavelengths of light except those emitted by the nebula.

■ *At magnitude 8.3, the Sombrero Galaxy, M104, is among the sky's top 30 in brightness. A massive spiral galaxy seen almost edge-on, with a strong dust lane—the sombrero's brim—this object is impressive in any telescope. It is about 30 million light-years distant. Photograph by John Leader, using a 12.5-inch Newtonian.*

The majority of the galaxies are in the diagram showing the Local Group with distance circles at 1,000,000 LY and 2,000,000 LY. Labeled objects include M31, NGC 205, M32, And I, And II, And III, M33, NGC 147, NGC 185, IC 1613, Draco, Ursa Minor, Leo II, Milky Way Galaxy, Sculptor, LMC, SMC, Fornax, Leo I, and NGC 6822.

oxygen is called O-III. The fact that nebulas emit light at these discrete wavelengths makes nebula filters possible — they allow the select wavelengths to pass through while rejecting all others, especially those from artificial-light sources. A filtered view of an emission nebula can show a significant improvement in contrast between object and sky.

The Eagle Nebula, M16, in southern Serpens, is a good example. Spotting this nebula without a filter is often difficult even in a dark sky. Viewed with a filter, it is revealed clearly as a field of greyish haze surrounding a cluster of stars. Other, fainter NGC nebulas, such as the Rosette Nebula, in Monoceros, and nameless nebulas such as NGC 2359, in Canis Major, and NGC 281, in Cassiopeia, are normally barely visible even in a dark sky but stand out dramatically when seen through a filter.

■ REFLECTION NEBULAS

Most nebula filters do little to enhance the view of reflection nebulas. A member of this class of deep-sky objects does not emit its own light. Rather, it shines because the light of nearby stars scatters off the nebula's clouds of minute dust particles. "Dust" is a catchall term for any particulate interstellar matter larger than molecules. The dust inside nebulas is thought to be made up of particles about 0.0002 millimetre across, probably graphite coated with ice. When starlight hits fields of dust particles, the light is simply reflected. The spectrum of a dusty reflection nebula is essentially the same as the broad continuous spectrum found in stars. Since newly formed stars in nebulous regions are usually bluish, reflection nebulas are also blue.

Reflection nebulas are less common than emission types. Most are also much fainter and more difficult to see, since they are often washed out by the glare of the source star. For example, the only reflection nebula in the Messier catalogue is M78, in Orion. M20, the Trifid Nebula, in Sagittarius, has some reflection components, which show as blue areas in photographs of the Trifid.

One hazard in seeking reflection nebulas is that dew or a film of dirt on the eyepiece or the main optics can produce pale glows around bright stars. To be able to see the nebulosity surrounding the Pleiades, for example, requires clean optics. A humid atmosphere also creates hazy star images, thus the need for a dry-climate site or a night with particularly transparent skies.

■ DARK NEBULAS

Deep-sky enthusiasts are just beginning to observe the class of objects known as dark nebulas. Although composed of the same mixture of gas and dust as other emission and reflection nebulas, dark nebulas lack any embedded or nearby stars that il-

■ *The majority of the galaxies in what astronomers call the Local Group (our neighbour galaxies out to three million light-years) are dwarfs invisible or inconspicuous in typical backyard astronomers' telescopes. But the six brightest are easily seen. Heading the list are the Large and Small Magellanic Clouds (LMC and SMC), two satellite galaxies of the Milky Way that are both naked-eye objects visible from the southern hemisphere. Next is M31, the Andromeda Galaxy, followed by M33, the Triangulum Galaxy. M32 and M110 (NGC 205) are companions to Andromeda.*

Embedded within every emission nebula is a very hot blue star (more often, a group of them, such as the four Trapezium stars at the heart of M42) newly formed out of the surrounding cloud. The star emits prodigious amounts of ultraviolet light in the heart of the nebula. The neutral hydrogen atoms in the nebula absorb the ultraviolet radiation and are "pumped up" by this shot of energy. As a result, the atoms are torn apart into a sea of free electrons and protons, a process called ionization. Ionization turns the neutral hydrogen into singly ionized hydrogen atoms called H-II. Thus emission nebulas are often dubbed H-II regions.

The electrons and protons eventually recombine to form neutral hydrogen, but as the wayward electrons are recaptured, they give up their excess energy as visible light in a series of well-defined wavelengths.

In photographs, emission nebulas look red, the result of red hydrogen-alpha light emitted at a wavelength of 656.3 nanometres. In the eyepiece, however, emission nebulas, if they show any colour at all, appear greenish. M42 is a case in point. Its green colour is produced in part from the hydrogen-beta line at 486.1 nanometres, but it arises primarily from a pair of emission lines at 500.7 and 495.9 nanometres. These two lines come from oxygen that has lost two of its eight electrons. Doubly ionized

■ Globular clusters are swarms of up to one million stars 30 to 100 light-years wide. They are satellites of the Milky Way Galaxy, plying huge, looping orbits well outside the spiral arms. The brightest of the 140 known globulars are showpiece objects. A telescopic view of one can be breathtaking. Globulars are one class of celestial object that often looks more impressive in the eyepiece than in photographs. Only the eye can resolve a cluster to the core and, at the same time, detect the faint outlying stars. And only the eye can see the cluster stars for what they are—infinitely small, discrete specks of light. The globular clusters shown here are M13, left, the best example visible from midnorthern latitudes, and M15, top. Photographs by John Leader, using a 12.5-inch Newtonian.

■ Top: Some celestial objects are far more impressive in photographs than they are "live" in the telescope. The Triangulum Galaxy, M33, is certainly one such object. Its spiral arms, so evident here, are dim and diffuse, even in 16-inch or larger instruments. But that is just the type of threshold observation which challenges backyard astronomers. The pink blobs embedded in the spiral arms are emission nebulas, similar to, but larger than, the Orion Nebula. This exceptional photograph is a three-hour exposure by Neyle Sollee, using a 24.5-inch Astro Works Schmidt-Cassegrain.

■ Right: The open cluster M11, about 5,500 light-years from Earth, is so star-rich that it can be mistaken for a globular cluster when seen in a small telescope. But unlike a globular, this cluster resolves completely into stars, leaving no central stellar mist. The name "open" derives from this difference. Many observers rank M11 as the finest of all open clusters. Photograph by John Leader, using a 12.5-inch f/6 Newtonian.

■ *Top left: Northern-hemisphere observers do not realize what they are missing until they see for themselves some of the great sights of the far southern skies. Top among them is the Eta Carinae Nebula, larger and brighter than the Orion Nebula—an awesome object with or without a nebula filter. Beside it is the naked-eye cluster IC 2602, another jewel that is well seen only from the southern hemisphere. Photograph by Kenneth Jones, using a 200mm f/2.8 telephoto.*

■ *Top right: The open cluster M35 in Gemini, 2,300 light-years away, happens to lie in the same direction as NGC 2158, an even richer cluster about seven times more remote. M35 is an easy binocular target, one of a chain of four beautiful open clusters strung from Gemini into Auriga. Photograph by John Mirtle, using a 16-inch f/4.5 Newtonian.*

■ *Left: Almost half the diameter of the moon and seventh magnitude, the Helix Nebula, in Aquarius, should be easy to see in binoculars—until you consider that the brightness is spread over a huge object. This is a tough binocular target. The per-unit surface-area brightness is very low. Use a nebula filter and low power for the best view. Photograph by Barry Sobel.*

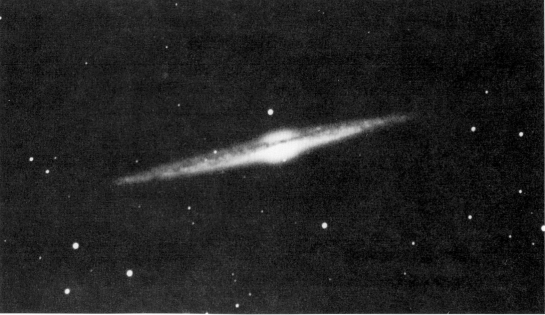

Above: The Double Cluster in Perseus, a pair of fifth-magnitude open clusters, is visible to the unaided eye as a hazy patch in the Milky Way. Individual stars are seen in binoculars, but the scene is especially captivating with a telescope at 25x to 40x, which reveals all the faint stars at the core of each cluster. NGC 884 is the cluster at left; the other is NGC 869. Photograph by Jim Riffle, using a 12-inch Astromak.

luminate them. They appear as nearly starless voids, dark patches obscuring whatever lies behind them.

Some dark nebulas can be spotted with the unaided eye. In fact, the dark rifts and lanes that split the Milky Way in Cygnus are all dust clouds lining the arms of our galaxy and are about 4,000 to 5,000 light-years away.

Not all dark nebulas are so large. Many fit nicely into the low-power field of a telescope. Just as Messier was the first person to catalogue the best and brightest deep-sky objects, Edward Barnard did the same for the obscure dark nebulas in the 1920s. For a unique observing sport, try tracking down some of the best B objects. How does one observe something that gives off no light? The trick is to use a wide field (one degree or more) in order to see the dark area framed by the surrounding bright star field. A large telescope is not needed; a fast-focal-ratio 3- or 4-inch refractor will do. So will giant 10 x 70 or 11 x 80 binoculars.

Once you find dark nebulas, how do you identify them? Most star atlases either do not plot dark nebulas or do not label them. An exception is the *Uranometria 2000.0.* With it, you can locate such dark nebulas as B86 and B92, in Sagittarius, both small, opaque patches nestled in the Milky Way. A good binocular object is B168, a three-degree-long filamentary streak running from M39, a star cluster in northern Cygnus, to the faint Cocoon Nebula.

A very dark sky is imperative for observing dark nebulas. Unless the Milky Way is a shining river of light, forget hunting for this elusive class of objects. Even then, a nebula filter often helps by reducing natural sky glow and allowing dark nebulas to stand out more clearly.

■ EXPLORING PLACES WHERE STARS DIE

Mention an exploding star, and people immediately think "supernova." During that violent event, 90 percent of a star's mass is blasted into space, while the remaining core collapses into a superdense neutron star or, perhaps, a black hole. In the process, the star gives off as much energy as an entire galaxy—a spectacular finale to a star's life, but a very rare one. Only a few of the most massive stars are supernova candidates. A bright naked-eye supernova in our section of the Milky Way is long overdue.

Until then, we must be content to observe the remains of a handful of ancient supernovas that litter the sky. The best example is the Veil Nebula (also known as the Cirrus Nebula), in Cygnus. Viewed with a nebula filter through a large telescope, the Veil Nebula is an intricate lacework. Without a filter, the Veil is barely visible, even in a dark sky.

IC 443, a similar supernova remnant, appears as a crescent-shaped arc near the star Eta Geminorum.

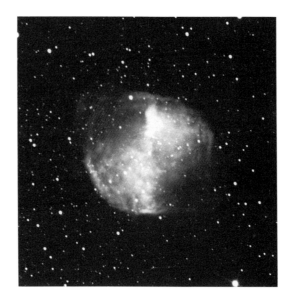

It is extremely faint and is a challenge even for an experienced observer using a filter-equipped 12-inch telescope.

One supernova remnant that is bright and fairly easy to spot is the Crab Nebula, M1, the remains of a supernova that exploded in 1054 A.D. Because of its youth, the Crab Nebula has not yet expanded into an open shell or into arcs of material like the Veil. (By comparison, the Veil is thought to be about 30,000 years old.) Visually, the Crab is a disappointment to many observers. In small-to-moderate apertures, it resembles an amorphous blur. The wispy filaments that gave it its name can be seen only in large apertures. William Parsons (Lord Rosse) first observed them in 1844 with his 36-inch reflector. Curiously, in 1848, using his 72-inch reflector, Parsons reported seeing no filaments, just an oval glow with little structure. Nebula filters make little difference with this object, since the brightest part of the nebula shines with a continuous spectrum generated by the 16th-magnitude pulsar at its centre.

■ OBSERVING PLANETARY NEBULAS

In spite of their name, planetary nebulas have nothing to do with the early stages of the life of stars and their attendant systems of planets. Instead, they are shells of gas expelled by ageing stars during an unstable period in their life histories. Many of them appear as small bluish discs through a telescope, reminding pioneering observers of Uranus and Neptune. Uranus's discoverer, William Herschel, was the nomenclature culprit. Ignorant of the role these objects played in the life cycles of stars and for want of a better name, he called them planetary nebulas. The name stuck.

Planetary nebulas are caused by a continuous stellar wind that, over the course of thousands of years, gradually expels as much as one-quarter

■ Above: The Dumbbell Nebula, M27, can be seen even in 7 x 50 binoculars or a moderate-power finderscope. It is among the sky's finest deep-sky wonders, one you will return to night after night. This is another object that looks as good in a large-aperture telescope as in a long-exposure photograph. Narrow-band nebula filters enhance the view in any telescope. Photograph by John Leader.
■ Facing page, bottom: The edge-on galaxy NGC 4565 probably resembles our own galaxy as it would appear from the side. We, of course, view the universe from inside such a system. The dust lane along the middle of NGC 4565 is the same dark stuff that pervades the Milky Way as seen, for example, on the cover of this book and in the first photograph of the introduction. NGC 4565 is located near the open star cluster Mel 111, also known as Coma Berenices. In a telescope, it is a ghostly cigar-shaped glow, the best edge-on galaxy. Photograph by Barry Sobel, using a 14-inch Celestron Schmidt-Cassegrain at f/7.

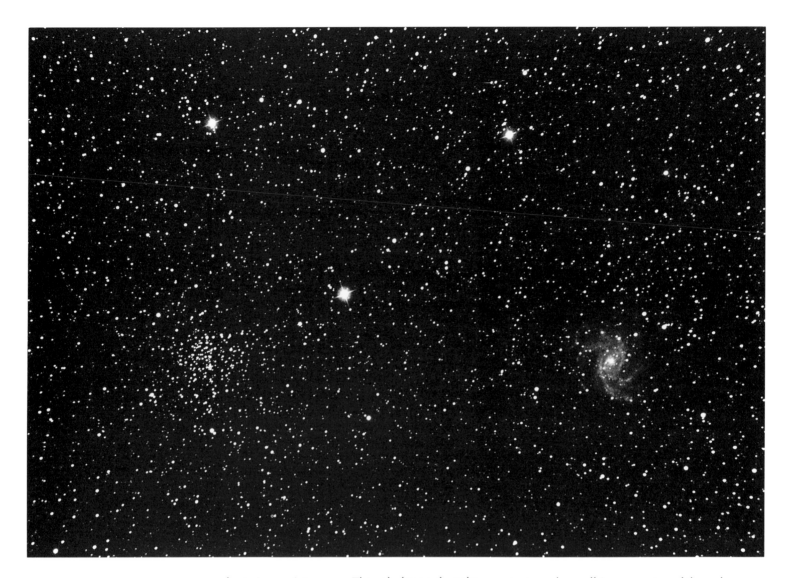

of a star's mass into space. The nebulas are thought to be a by-product of the final stages in the life cycles of stars one to six times the sun's mass. The formation of a planetary nebula is one way for an ageing star to lose weight. After this bit of stellar dieting, the star shrinks to a white dwarf, an object perhaps only 10,000 kilometres across but with an extremely high surface temperature of 100,000 degrees Celsius. On its way to the white-dwarf stage, the hot, shrinking star bathes the expanding shell of gas in ultraviolet light that causes it to glow—a planetary nebula.

There are about 1,500 known planetary nebulas in our section of the galaxy. Since it is thought that they last only 100,000 years or so, planetaries must be constantly forming. Indeed, a number of strange objects are now classified as proto-planetaries, stars in the early stages of casting off a nebulous shroud. The older, well-formed planetary nebulas visible through amateur telescopes typically range from about one-quarter of a light-year to one light-year

across and are all in our sector of the galaxy, no more than a few thousand light-years away.

For the deep-sky observer, planetary nebulas fall into one of three broad categories: large and bright; bright but starlike; and large and faint. The differences are partly intrinsic and partly due to distance.

As an example of a large, bright planetary, the Ring Nebula, M57, is the classic choice. At ninth magnitude and 70 arc seconds across, it has a very high surface brightness for a planetary nebula. Its smoke-ring form is easily seen in a 3-inch telescope in a dark sky. It is also one of the simplest deep-sky objects to find because of its convenient location between the two bright stars that mark the bottom of the constellation Lyra. However, one feature of the Ring Nebula is far from easy—the 15th-magnitude central star. We have seen it with a 14-inch Schmidt-Cassegrain under superb desert skies, but usually, it is rendered invisible by the surrounding nebula no matter what size backyard telescope is applied.

Unfortunately, such large, bright showpiece

■ *Often overlooked even by fairly experienced backyard astronomers is this unusual pairing of an open cluster, NGC 6939, and a galaxy, NGC 6946, less than one degree apart, near the star Eta Cephei. A nice viewing combination is a telescope of about 1,000mm focal length with a 13mm, 14mm or 16mm Nagler-type eyepiece. The open cluster is eighth magnitude; the galaxy, ninth. Photograph by John Mirtle, using an 8-inch f/6 Newtonian.*

planetaries are the exception. The majority fall into the category of "bright but starlike," often difficult to distinguish from stars, especially at low power. Most have diameters of well under 20 arc seconds, making them smaller than the disc of Saturn. A few of these tiny planetaries are well worth the search.

A couple of our favourites are the Blue Snowball (NGC 7662), in northern Andromeda, and the Eskimo Nebula (NGC 2392), in Gemini. They are bright enough—magnitudes 9 and 8, respectively—to accommodate fairly high magnification. With a diameter of 30 arc seconds, the Blinking Planetary (NGC 6826), in Cygnus, is fairly large by planetary-nebula standards. Its notable feature is a bright 10th-magnitude central star. Stare directly at the star, and the nebula seems to disappear; look to one side with averted vision, and the nebula pops back into view. The eighth-magnitude Saturn Nebula (NGC 7009), in Aquarius, has two extensions on either side of the disc and resembles a fuzzy image of Saturn.

Planetaries with diameters of less than 10 arc seconds are tough to find no matter how bright they are. Even at high power, they can look like blue-green stars. One technique that helps is to hold a nebula filter between your eye and the eyepiece and move it in and out of the light path. While the stars and background sky will dim with the filter in place, the planetary will remain the same brightness and stand out. Try this on two tiny but bright (ninth magnitude) blue planetaries: NGC 6210 and NGC 6572, in Hercules and Ophiuchus, respectively.

■ THRESHOLD PLANETARIES: A NEW FRONTIER

At the opposite end of the planetary-nebula scale are large (more than 60 arc seconds) but exceedingly dim objects. Two good examples are NGC 6781, in Aquila, and NGC 246, in Cetus. Faint, diffuse planetaries such as these are often difficult to see, if not invisible, without a nebula filter. When viewed with a filter under dark skies, they can become showpiece objects in telescopes larger than 10 inches in aperture.

At the extreme end of visibility are planetaries that, as recently as the late 1970s, were assumed to be strictly photographic objects. These large but faint planetaries from Abell's list or Perek and Kohoutek's *Catalogue of Galactic Planetary Nebulae* now fall prey to deep-sky hunters armed with "light-bucket" telescopes and hungry for new targets. One of the best Abell planetaries is PK 205 + 14.1, the Medusa Nebula. Its disc is more than 11 arc minutes across—huge for a planetary (the moon is 30 arc minutes). However, this is a rough estimate, since there is no official measurement of the size of the object. It can be found on Chart No. 184 in Volume 1 of the *Uranometria 2000.0*, where it is erroneously plotted as having a disc less than 30 arc seconds across.

Deep Sky, a quarterly magazine, frequently publishes lists of other threshold planetaries. When tracking down planetary nebulas from such lists, you will soon learn that the official magnitude figures for most of the objects are not reliable indicators of the actual brightness. Large, diffuse planetaries often carry ratings of eighth or ninth magnitude, which would lead you to believe that they are as easy to see as the Ring Nebula. But these magnitude figures are measures of the total integrated light output of the object; a large, faint planetary could have the same magnitude rating as a small, bright one. Also, most magnitudes are measured using a standard set of photometric filters whose passbands do not coincide with the green part of the spectrum, where planetaries emit the majority of their light. Therefore, small planetaries officially listed as 12th to 14th magnitude often appear much brighter than, say, a galaxy of the same magnitude. This is especially true if you are using a filter.

Planetary-nebula hunting is one area of observing in which you should ignore all presuppositions of what should and should not be visible through your telescope. Approach the sky with an open mind. While you may encounter some disappointments, you will certainly be guaranteed a few exciting surprises.

■ SAVOURING THE OPEN STAR CLUSTERS

Astrophotographers can make a good case that the full glory of a nebula or a galaxy can be seen only on film, but they lose the argument when it comes to star clusters. Few astrophotos have ever captured a cluster's visual quality of glittering diamond dust.

Open star clusters are congregations of stars bound together by their mutual gravity. Individual stars in an open cluster were all born about the same time from a collapsing nebula such as the Orion or Lagoon nebulas. The word "open" used to describe these clusters refers to their resolvability—all the stars in them can be seen individually in contrast to the haze at the centre of globular clusters. There are about 1,200 known open star clusters, most of them confined to the Milky Way band. Even if your observing is confined to city limits or to a small-aperture telescope, there are many satisfying open star clusters available. They range from objects that fill the eyepiece with brilliant star fields to clusters that appear as faint, barely resolvable smudges.

How well a cluster shows up in the eyepiece depends on several factors. Of course, one is size. Large clusters (more than 30 arc minutes in apparent diameter) require very low power and a wide field. For example, the Pleiades and the Beehive

■ RATING OPEN CLUSTERS ■

Open clusters range from beautiful stellar jewel boxes easily seen in binoculars to scatterings of dim stars barely perceptible by telescope. To categorize the appearance of open clusters, astronomers use the "Trumpler system" ratings (e.g., II-3-r). These ratings are often listed in deep-sky catalogues. Here is how to decode them:

Concentration of Stars

I	well separated with a strong concentration to the centre
II	well separated with little concentration to the centre
III	well separated with no concentration to the centre
IV	not well separated from the surrounding star field

Range in Brightness of Stars

1	small range in brightness
2	moderate range in brightness
3	large range in brightness

Richness of Cluster

p	poor, less than 50 stars
m	moderate, 50 to 100 stars
r	rich, more than 100 stars

clusters often look better in a finderscope than they do in a telescope. To appreciate a cluster fully, you need a field of view twice the size of the cluster itself so that the cluster will appear distinct from its background. Conversely, small clusters (less than five arc minutes) require very high power to resolve.

Magnitudes of open star clusters range from 1.5 for the Pleiades to fainter than 12 for the dimmest ones. You would think that the brighter the cluster, the better it would look; however, that is not necessarily the case. The cluster's magnitude is just a measure of the total brightness of all its member stars. If there is merely a handful of bright stars, the cluster's appearance may be disappointing despite a high magnitude rating. Where you had hoped to see an eyepiece filled with scintillating points, only a sparse collection is visible. What makes a cluster interesting is its richness (the number of member stars) and the contrast between it and the surrounding star field. The best clusters usually contain 100 or more member stars, earning them the official designation of "rich," as opposed to "moderate" (50 to 100 stars) or "poor" (less than 50).

Gorgeous NGC 7789, in Cassiopeia, is one of the least known of the rich-cluster cream of the crop, while M11, in Scutum, is one of the best known and one of the finest clusters in the sky. Not all clusters are winners; some are duds—no more than scattered groupings of stars that look much like the surrounding field. A few otherwise poor clusters are intriguing because of some unusual trait. NGC 2175, in Orion, is immersed in nebulosity. Nearby in Orion, NGC 2169 has a pattern of stars that resembles the number 37 or an XY, depending on how your mind interprets this celestial Rorschach test.

In the end, despite the vast catalogues of published data that exist, the only way to know whether a deep-sky object like an open cluster is worth looking at is to look at it.

■ THE GLORIOUS GLOBULAR CLUSTERS

A second type of star cluster populates the Milky Way: the globular cluster. Approximately 140 have been found associated with our galaxy. Globulars are like miniature spherical galaxies; they contain hundreds of thousands of stars packed into a space about 25 to 250 light-years wide. Globular clusters formed 10 billion to 15 billion years ago as byproducts of the creation of the galaxy itself.

To see globulars in all their glory requires sharp, well-collimated optics as well as aperture. A good 4-to-6-inch telescope will begin to resolve the best globulars, such as M13 and M92, in Hercules; M3, in Canes Venatici; M5, in Serpens; M22, in Sagittarius; or the legendary Omega Centauri. But with a 10-to-12-inch instrument, the view is spectacular.

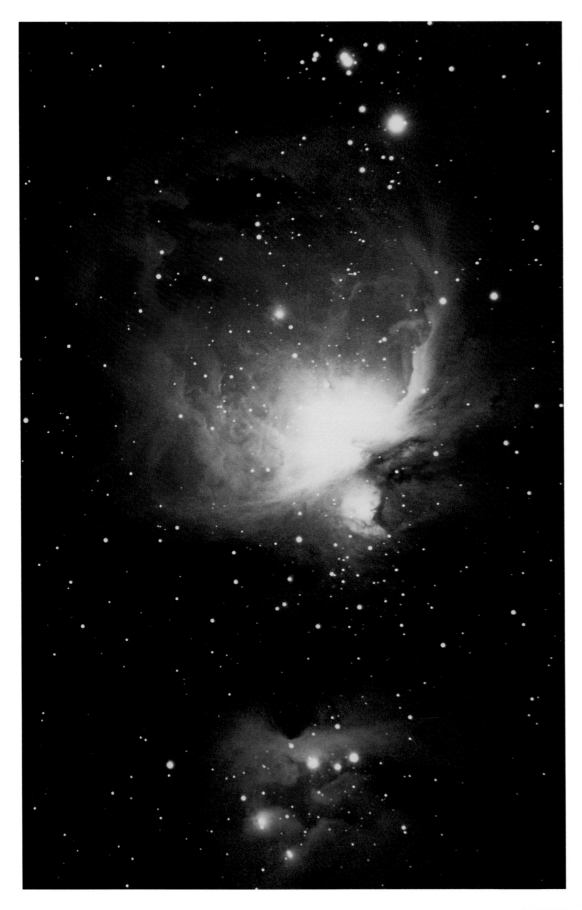

■ *Above: Planetary nebula NGC 6781, in Aquila, appears telescopically as a dimmer version of the Owl Nebula, M97. But even at 12th magnitude, it is easy with an 8-inch telescope and a narrowband nebula filter. Photograph by Jack Newton, using a 20-inch Newtonian.*

■ *Left: Probably the sky's most-photographed object, the Orion Nebula, M42, is one of the great deep-sky showpieces. Visually, the detail is subtle but intricate even in small telescopes. Because the human eye is relatively insensitive to wavelengths that produce the nebula's red glow, the observer instead sees a pale green hue in the telescope. Photograph by Tony Hallas and Daphne Mount.*

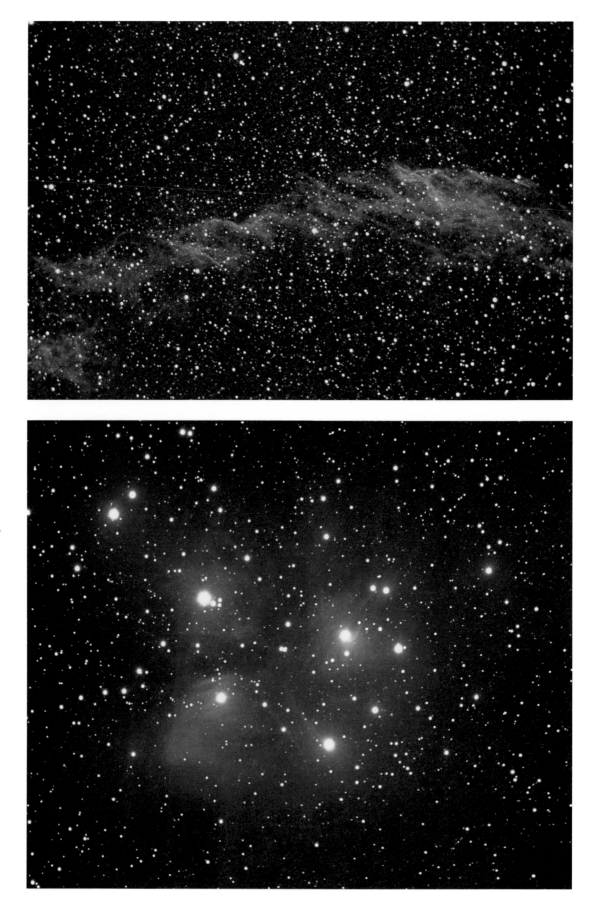

■ Top: The tattered remnants of a once mighty star that exploded as a supernova 30,000 years ago are seen today as the Veil Nebula, NGC 6992. Seeing this large, faint object requires very low power and a narrowband nebula filter. Photograph by Mike Mayerchak.

■ Right: Celestial jewellery. The Pleiades, the sky's best-known open star cluster, is a group of at least 400 stars 450 light-years away. The brightest member stars illuminate a thin gas that pervades the cluster. Under ideal conditions, this elusive nebulosity shows as a misty fog around the brighter stars. We have seen this nebula in a 5-inch in good skies, but it is subtle at the best of times and invisible at any other time. Photograph by Tony Hallas and Daphne Mount.

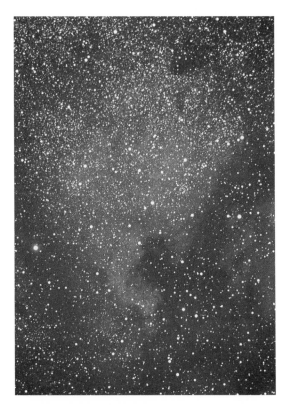

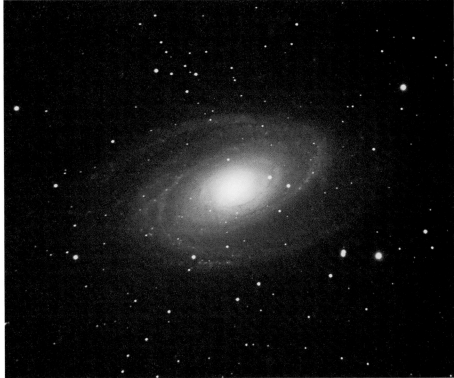

■ Top left: The North America Nebula, NGC 7000, located beside the star Deneb, is one of the few deep-sky objects that is too big for the average backyard astronomer's telescope. It requires a four-degree field. The best bet is 10 x 70 or 11 x 80 binoculars and a black night sky. No colour is evident in binoculars, but the basic shape is there. Photograph by Terence Dickinson.

■ Above: The seventh-magnitude galaxy M81 is 10 million light-years away and similar to our own Milky Way. Even at that distance, it is plainly visible in 50mm or larger binoculars as an oval smudge. Photograph by Tony Hallas and Daphne Mount.

■ Left: One of the best examples of a pair of edge-on galaxies is the duo of NGC 4631 (larger galaxy) and NGC 4656, 9th and 10th magnitudes, respectively. The detailed star-hop guide chart in Chapter 11 shows their location. Photograph by Evered Kreimer.

■ *Above: Seen only from the southern United States or farther south (because of its southerly location in the sky), the globular cluster Omega Centauri is a magnificent celestial showpiece—a swarm of a million suns—the largest and brightest globular cluster. Photograph by Craig McCaw.*

■ *Top right: A group of 12th- and 13th-magnitude galaxies in Leo, led by NGC 3190, is the type of target favoured by deep-sky observers who have tracked down all the Messier objects and the brighter NGCs. Photograph by Tony Hallas and Daphne Mount.*

■ *Right: Open cluster M46 is an easy binocular object, but it requires at least a 3-inch telescope to reveal the tiny doughnut of a planetary nebula that lies in the same direction as the cluster. Photograph by Craig McCaw.*

Yet the reality is that not all globulars are as dazzling as those showpiece objects. Globulars vary in appearance because of their apparent size and actual concentration.

The size range for globular clusters is from 1 to 20 arc minutes. The best are the largest ones. Small globulars tend to be more difficult to resolve, appearing as fuzzy-edged spheres. But how well even large globulars can be resolved depends on their concentration. Some are so highly compressed that they are impossible to resolve.

At the other end of the scale are a few globular clusters which are so loosely concentrated that they take on the appearance of very rich, finely resolved open star clusters. NGC 288, in Sculptor, NGC 5466, in Bootes, and NGC 5897, in Libra, are good examples of this type. All are best seen in large apertures; smaller telescopes at low power show them only as circular glows. One oddball globular in this class that is well worth a look is the bright M71, in Sagitta; for many years, it was considered to be an open star cluster. On the other hand, the open star cluster NGC 2477, in Puppis, is so rich that it borders on being a globular.

As might be expected, the most distant Milky Way globulars (more than 150,000 light-years away) appear small (one to two arc minutes across) and faint and are difficult to resolve in all but the largest amateur telescopes. For intergalactic wanderers such as NGC 2419, in Lynx, and NGC 7006, in Delphinus, the reward is simply seeing them. If reaching out to greater distances appeals to you, you need not stop at the boundaries of our galaxy. If you live below latitude 40 degrees North, try NGC 1049, an 11th-magnitude blur only 0.6 arc minute across. Its claim to fame is that it belongs to another galaxy, a dwarf elliptical called the Fornax System. The sur-

■ RATING GLOBULAR CLUSTERS ■■■

As with open clusters, there is a classification system for rating the appearance of globular clusters. This one deals strictly with the cluster's "concentration." Devised by Harlow Shapley, the globular-cluster rating system goes from Roman numeral I through XII.

I	very highly concentrated; very difficult to resolve
II thru XI	decreasing degree of concentration
XII	least concentrated; very loose globular; easily resolved, but not as richly spectacular

The finest globulars fall in the middle of the range, about Class V to VII, which is the best compromise between richness and resolvability. Class I and II globulars seem star-poor, while Class XI and XII globulars are so loose that they resemble rich open clusters.

face brightness of the galaxy itself is so low that the galaxy is too faint for most amateur telescopes, but this one globular stands out. The distance to NGC 1049 is roughly 400,000 light-years.

But NGC 1049 is not the distance champ. Since the 1970s, owners of large instruments have observed globular clusters 2.3 million light-years away surrounding the Andromeda Galaxy. About 300 such globulars have been catalogued. The brightest can just be seen in a 12-inch or larger telescope. The clusters look entirely stellar and, at about magnitude 15, are impossible to distinguish from faint foreground stars in our own galaxy.

■ BEYOND THE MILKY WAY ■■■■■

Galaxies are by far the most numerous class of deep-sky objects. In fact, the stars we think of as countless are really just a scant foreground clutter between us and the real universe—a space tangled with galaxies. Several thousand galaxies are brighter than 13th magnitude, the effective dividing line between moderately bright galaxies and those that show as barely perceptible blurs.

However, as with other deep-sky objects, do not put too much stock in published magnitude figures. Most galaxy magnitudes are photographic, which means that they were measured in the blue part of the spectrum. These values are generally fainter than visual magnitudes (yellow-green). For example, a galaxy with a photographic magnitude of 12.5 might have a visual magnitude of 11.8. Where only

a photographic magnitude is given, the galaxy will usually appear brighter than that. How much brighter depends on the galaxy's relative abundance of young blue stars versus old yellow stars.

Although small telescopes easily show the brightest galaxies, the best recipe for galaxy hunting is to combine a dark sky with a large-aperture telescope. To see galaxies as more than fuzzy blobs, use at least a 6-inch instrument. Galaxy aficionados will want a 12-inch or larger telescope. Pursuing galaxies into the depths of space is one of the prime motivations of those who select bigger and bigger reflectors.

But galaxies are not just for the big-telescope user. Binoculars will show a handful of the best galaxies, while many more can be seen even in modest 80mm telescopes, quite remarkable when you con-

■ *The Pinwheel Galaxy, M101, is easy to locate near Mizar and Alkaid, the two end stars in the Big Dipper's handle. Binoculars show it as a pale smudge. A 10-inch telescope will reveal the curving spiral arms. M101 is nearly double the size of our Milky Way Galaxy. Photograph by Tony Hallas and Daphne Mount.*

sider that the closest major galaxy, the Andromeda Galaxy, is a colossal 2.3 million light-years away.

■ THE ANDROMEDA GALAXY

Andromeda, M31, is usually the first galaxy anyone looks at. Beginners are often disappointed with that initial glimpse. Expecting an eyepiece image that looks like a two-hour time-exposure photograph, they see instead a featureless smear. The best way to be introduced to Andromeda is with binoculars. With a width of more than four degrees, Andromeda stretches across most of the field of even 7 x 35s.

To see the Andromeda Galaxy as more than a diffuse patch, use a wide-field 6-inch or larger telescope and look for two dark bands crossing the glow of the central core. These are the dust lanes that separate Andromeda's spiral arms. They are not difficult to see, but many people miss them because they are unaware of what to look for.

As viewing the Andromeda Galaxy demonstrates, small telescopes may not reveal much detail in a galaxy, but they do show its overall shape, a characteristic that depends on the galaxy's morphological type and on its orientation to our line of sight.

■ THE GALAXY ZOO

Elliptical galaxies such as M32 and M110, Andromeda's two nearby companions, are the most common type in the universe; they are also the least interesting to observe. Most have no internal structure. However, depending on the degree of ellipticity, such galaxies can vary from circular cometlike glows to elongated patches. (Ellipticals are rated from type E0 to E7; E0 and E1 galaxies are circular, E4s are football-shaped, and E6s and E7s are very flattened.) In the Messier catalogue, many of the brightest members of the Virgo swarm of galaxies—namely, M59, M60, M84, M85, M86 and M87—are ellipticals. M87 is a giant elliptical that is probably the most massive galaxy within 75 million light-years of Earth.

The type of object people think of when they hear the word galaxy is the spiral, its graceful curving arms the epitome of deep-sky grandeur. As luck would have it, the majority of bright nearby galaxies are spirals. Not all reveal their classic pinwheel structure; it depends in part on whether the galaxy is tilted edge-on to us or face-on (the best orientation for seeing the spiral arms) or somewhere in between (as is usually the case).

The finest spiral galaxy is M51, the Whirlpool Galaxy. Exactly how small a telescope will reveal its face-on spiral arms is debatable. Most people are so familiar with what this object is supposed to look like that they often imagine a blatant spiral structure where there is only a hint of a circular glow. But it is safe to say that even novices perceive the sug-

gestion of spiral arms through an 8-inch telescope. With anything larger, there is no question.

Edge-on galaxies are the favourite targets of many observers. Because their discs are tilted at such an extreme angle, edge-on galaxies appear as thin streaks. Most are spirals, but some elongated ellipticals (such as the Spindle Galaxy, NGC 3115, in Sextans) and some members of a transition type called S0 spirals also produce fine edge-ons.

For the best view of an edge-on galaxy, search out the 10th-magnitude NGC 4565, in Coma Berenices. It may be difficult to find at first because of the lack of prominent stars for star hopping, but the view is worth it. Even an 80mm refractor will show it clearly as a faint sliver of light. It is 16 arc minutes long, very large by galactic standards.

■ SKETCHING AT THE EYEPIECE ■

□ By Gregg Thompson

A drawing of a celestial object records much more detail and subtlety than can be expressed in words. "But I can't draw," some people exclaim. Drawing astronomical objects does not require the talents of Michelangelo. Typical drawings are records of simple shapes with various degrees of shading.

The equipment is ordinary untextured white bond paper and a soft 2B or 4B lead pencil. Use the tip of the pencil for stars and other well-defined objects and the side of the pencil for nebulous objects. Lead pencil on paper provides the easiest medium for the soft smudging needed to give a natural look to deep-sky objects. Smudging is best done with an inexpensive artist's blending stump.

Of course, using pencil on paper means that you are making a drawing with black stars on a white background, much like a photographic negative, but this is of little consequence. It is far more practical than trying to use pieces of chalk or white crayon on black paper.

After more than 20 years of experimenting with astronomical drawings, I strongly recommend two things:
1. Make the circle representing the eyepiece's field of view six to eight inches across. Most observers draw a circle half this size, and it is too small.
2. Apply the highest magnification that permits you to see the object at its best. Contrary to advice in older books, most deep-sky objects reveal much more at high power than at low power because of their increased size and enhanced contrast against a darker background.

Other top-ranked edge-ons are NGC 5907, in Draco, and NGC 2683, in Lynx. A fine southern-sky edge-on is NGC 55, in Sculptor; it has no dust lane but has a mottled appearance. NGC 4762, on the outer limits of the Virgo galaxy cluster, has the distinction of being the flattest galaxy known.

The list of superb edge-on galaxies is long. Because their light is concentrated into a compact shape, all are very distinct and therefore good targets for owners of small telescopes. When selecting candidates for a night's observing, look for galaxies whose catalogued dimensions are asymmetrical; for example, 10 arc minutes long by 1 arc minute wide. This is an indication of an edge-on galaxy that is sure to be an interesting sight.

A few galaxies—irregulars—do not fall into any neat category. This class of galaxies is a minority group whose members are often oddly shaped or contain such chaotic details as patches of nebulosity, mottled dark lanes or straggling appendages. The best example of an irregular galaxy is M82, in Ursa Major, thought to be exploding because of some unknown internal process. Another irregular object that doubles as a radio source is the southern-sky galaxy NGC 5128, or Centaurus A. It looks like a bright elliptical with a dark band crossing its disc and is theorized to be two galaxies colliding.

Some galaxies are regular spirals that have peculiar characteristics which distinguish them from the galactic crowd. For example, M77, in Cetus, is a spiral with a very starlike nucleus. It is the brightest example of a Seyfert galaxy, a type that has a very

Use most of the area of a page, keeping the bottom for notes about the factors that affect your drawing. Such notes become a valuable reference and encourage consistency. Record the name of the object, the image orientation (mark north and east by watching the drift of the image across the undriven field), the telescope's aperture and magnification, the type of eyepiece, the type of filter (if one was used), the object's elevation in degrees above the horizon, the steadiness of the air (seeing), the darkness of the sky (transparency), the observing site and whether you have made a detailed drawing or merely a rough sketch.

Start by drawing simple telescopic objects such as the Ring Nebula, M57. Other good beginning subjects are naked-eye or binocular drawings of star clusters such as Coma Berenices, the Beehive, the Pleiades or the Hyades. Gradually progress to fainter and more detailed objects.

Always begin by positioning the main features relative to each other—some bright stars or the general shape of a galaxy, for instance. Once you are happy with the overall proportions, fill in the detail. Do not be reluctant to draw brighter stars larger or to give them spikes or diffraction rings to indicate the relative brightness.

A proficient observer must learn how to see. Let your eyes adapt to the darker field. Novice observers simply glance at an object in the eyepiece for a few seconds and believe that they have seen it. Always inspect the object carefully.

When you make the effort to draw what you see, a wonderful thing happens: you will see far more than you ever imagined you could.

Drawing the view in the eyepiece forces you to look for subtle shadings and structure. Scrutinizing a celestial object for 10 to 20 minutes often rewards observers with inspiring detail that is invisible to those who merely take a cursory look. The proof is in the doing.
Gregg Thompson, an expert deep-sky observer and coauthor of The Supernova Search Charts and Handbook *(Cambridge; 1989), lives in Brisbane, Australia.*

■ *Eyepiece sketch of the eighth-magnitude globular cluster M30 shows the detail seen by experienced deep-sky observer Gregg Thompson, using a 12.5-inch Newtonian. Thompson developed this observing form and had copies printed on 8½-by-11-inch paper so that he could record his observations with some degree of consistency.*

energetic nucleus. Seyferts are thought to be one step away from being quasars. (Quasars are vastly remote galaxies with energetic nuclei.)

Most people have heard of quasars, but not all amateur astronomers realize that they can see a quasar. At about 13th magnitude (the brightness varies), the quasar 3C 273 in Virgo is the brightest member of this unusual and controversial class of objects. (The next brightest quasars are roughly 14th to 16th magnitude.) All that can be seen, however, is a faint star. But at an estimated three billion light-years, 3C 273 is probably the most distant object visible in an amateur telescope.

■ GALAXY GROUPS

Our Milky Way Galaxy belongs to a cluster of galaxies called the Local Group, whose two largest members are M31 and the Milky Way. A third prominent member, M33, in Triangulum, just below M31, is rated as a small spiral. There are other similar families of galaxies visible which are not populous enough to be called clusters but which provide interesting fields containing two or more members.

One of the best is the "Leo trio": M65 and M66, in Leo, are two bright spirals that form a triangle with a large, faint edge-on galaxy called NGC 3628. A much fainter target is the NGC 5353 group located seven degrees southeast of the Whirlpool Galaxy. Owners of 10-to-12-inch telescopes will find a high-power field containing five 12th-to-14th-magnitude galaxies. These are only two of countless such fields around the sky. Volume 5 of the *Webb Society Deep-Sky Observer's Handbook* series, *Clusters of Galaxies*, will lead you to many more, and star charts such as *Uranometria 2000.0* offer good candidate targets.

For southern observers, the field surrounding NGC 1399, in Fornax, contains no fewer than nine galaxies within a one-degree circle. All the members of this group are between 11th and 12th magnitude, making them suitable for 4-to-6-inch telescopes. This is the best collection of galaxies

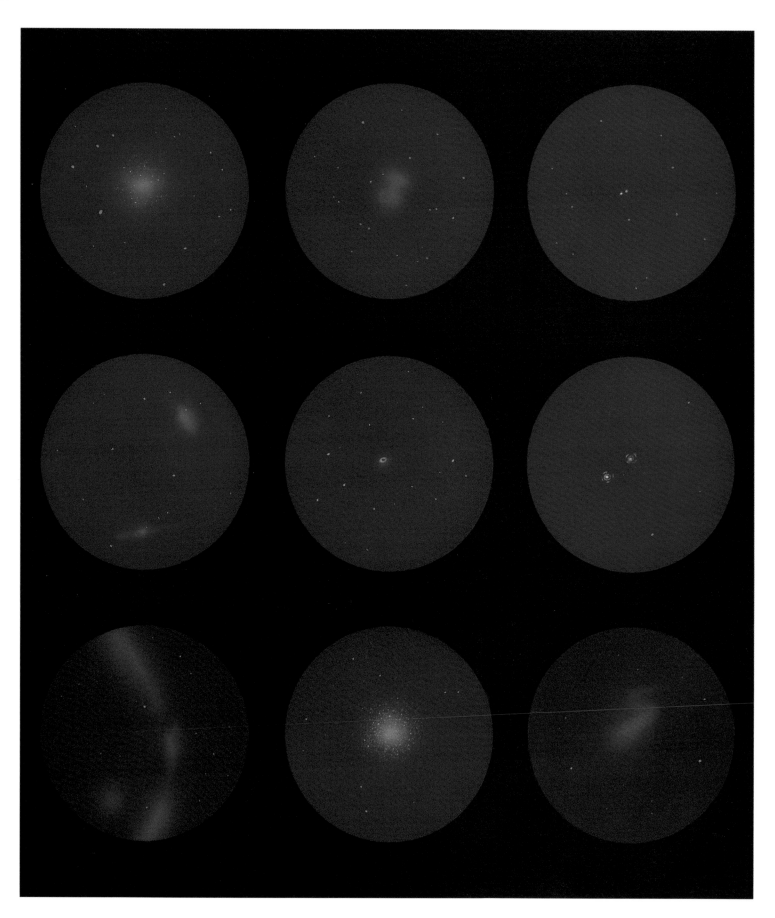

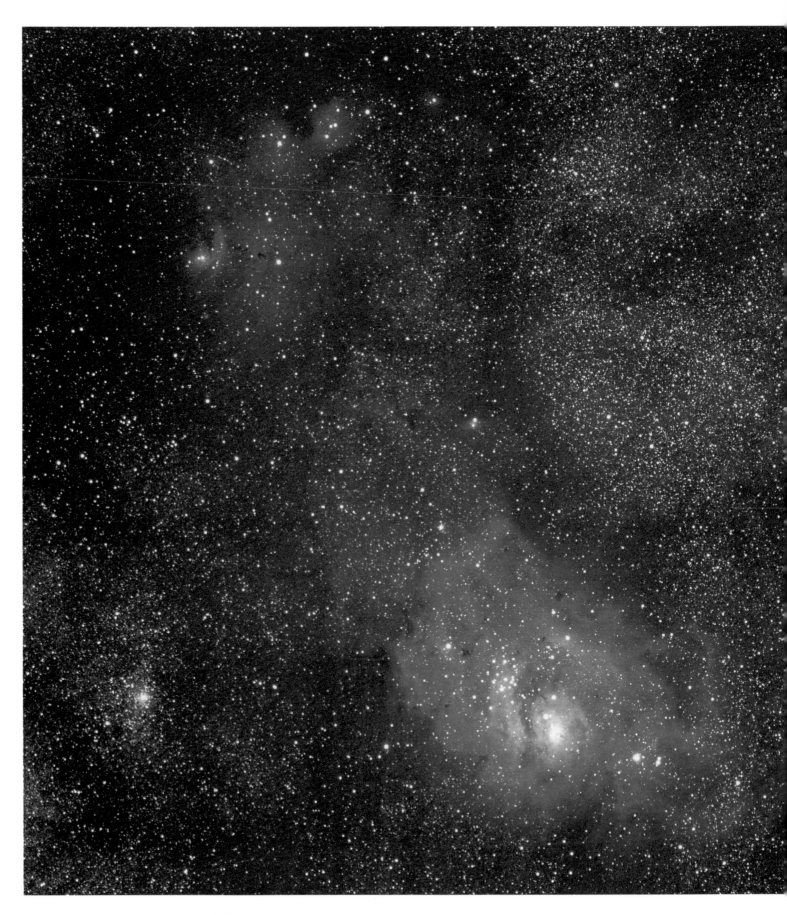

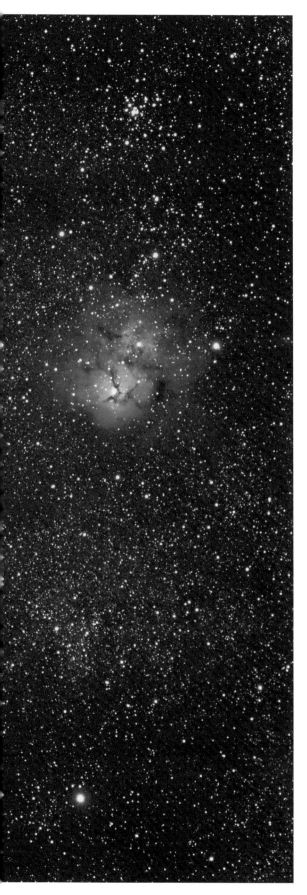

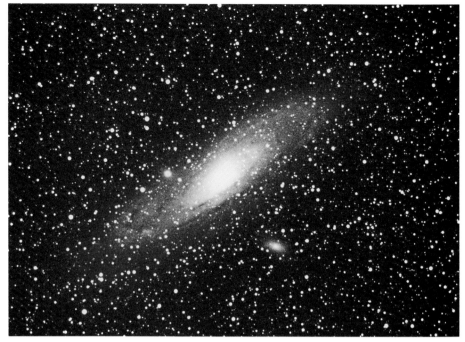

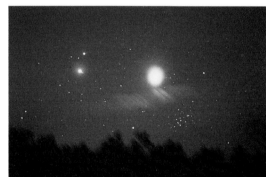

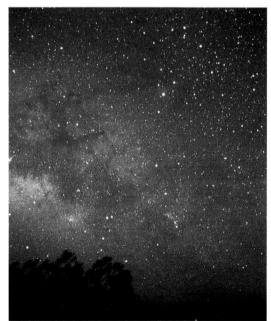

■ *Far left: A window on the Sagittarius Milky Way reveals one of the richest sectors of our galaxy. The larger emission nebula is the Lagoon, M8; the smaller one is the Trifid, M20. They are about 4,000 light-years away but easily visible in binoculars. Photograph by Tony Hallas and Daphne Mount, using a 5-inch f/8 Astro-Physics refractor.*

■ *Above: The Andromeda Galaxy, M31, has two small elliptical companion galaxies, M32 (above M31) and M110, that a skilled observer can see using 50mm binoculars. Photograph by Terence Dickinson, using a 4-inch f/6.5 Astro-Physics refractor at f/4.3.*

■ *Centre: A celestial traffic jam in June 1991 featured the Beehive open cluster and, in order of brightness, Venus, Jupiter and Mars. Photograph by Terence Dickinson.*

■ *Left: A desert location was ideal for capturing the entire constellation Scorpius and a portion of the Milky Way rising in the southeast. Photograph by Terence Dickinson, using a 35mm lens at f/2.8.*

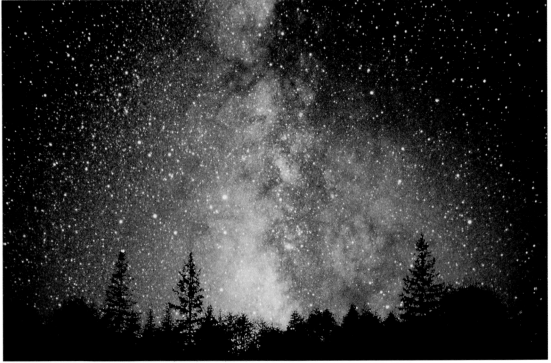

■ Above: Through a 12-inch or larger telescope, the tendrils of gas extending out to either side of M42, the Orion Nebula, sometimes have a very slight reddish tinge. Film picks up red light much better than does the eye. Conversely, photographic film overexposes M42's central region, but here, the eye sees tremendous detail around the central four stars, called the Trapezium. Photograph by Jack Newton, using a 20-inch Newtonian.

■ Right: A wall of starlight marks the centre of the Milky Way Galaxy. When viewed from the darkest locations on Earth, this sector of the Milky Way is bright enough to cast shadows. Composite photograph by Terence Dickinson, using a 35mm f/2.8.

in the southern sky, an area otherwise sparsely populated with galaxy clusters.

THE VIRGO GALAXY CLUSTER

When we face Cetus, Sculptor and Fornax, we are looking down through the plane of our galaxy toward its South Galactic Pole. This area has many widely scattered galaxies but lacks the great swarms and clusters found in the north polar area. In part, this is because the view south is not as clear; we have to peer through a greater thickness of the Milky Way disc because our solar system lies about 30 light-years north of the Milky Way's equator. But another reason we do not see as many galaxy clusters in this region of the Milky Way is that there are not as many to be seen.

In the direction of the constellations of Ursa Major, Canes Venatici, Coma Berenices, Leo and Virgo, we look straight up out of the disc of our galaxy toward its North Galactic Pole, which lies in Coma Berenices. That sight line passes through the least amount of galactic dust, allowing us to see clearly into the many gatherings of distant galaxies.

The crowd of galaxies in the Coma-Virgo area is a galaxy cluster, the nearest such grand-scale gathering. Its presence in the northern spring sky gives that area of the heavens a definite statistical edge in galaxy numbers. The centre of this galaxy cluster is about 60 million light-years distant, only a stone's throw away on the galactic scale. In fact, member galaxies of the Coma-Virgo cluster, because of its proximity and size (about seven million light-years across), are scattered over a huge swath of sky.

The problem with exploring spring-sky galaxies is that because there are so many galaxies and so few bright guide stars, it is easy to become lost in a field of anonymous fuzzy spots. Still, if you want to check off all the Messiers, you will have to enter the galactic labyrinth of Coma-Virgo one night, since about a dozen Messier objects reside there. To help you in this galaxy quest, see charts in Appendix.

To begin a night of galaxy hunting, first find second-magnitude Denebola (Beta Leonis) at the end of Leo's tail. Then slew about 6.5 degrees due east to the fifth-magnitude star 6 Comae Berenices (it is bright enough to be a naked-eye star at a dark site). That is the jumping-off point for the Virgo galaxy cluster. Within one degree of 6 Comae are M98 and M99. From there, work north to M100 and on up to M85 (near the star 11 Comae). Then backtrack to 6 Comae and work south to NGC 4216 (a neat edge-on galaxy) and east to M84 and M86. These two ellipticals are in the same field and are the brightest members of a remarkable string of galaxies of different sizes and shapes called Markarian's Chain, which is the core of the Virgo galaxy cluster, one of the greatest deep-sky wonders.

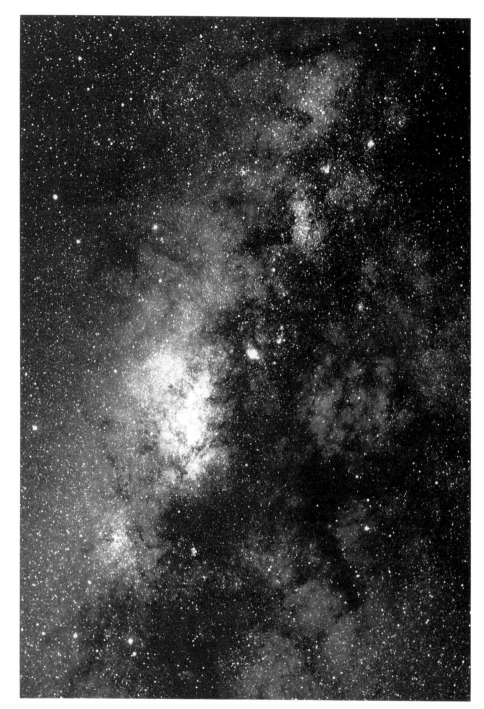

There is something here for every size of telescope. One night, we examined Markarian's Chain with a 4-inch f/6.5 refractor using a 16mm Nagler eyepiece that gave 41x and a two-degree field. Ten galaxies floated like tiny, pale snowflakes in the star field. The view included the entire chain and the giant elliptical galaxy M87 to the southeast, the true gravitational centre of the Virgo galaxy cluster.

From M87, move farther east to M89 and the trio of M58, M59 and M60. Two degrees east of M60 is the edge-on spiral NGC 4762. This excursion will

■ *This is a more detailed view of the same section of the Milky Way shown on the facing page. The rich webbing of star fields and dark nebulosity makes this region endlessly fascinating at low power. Can you see the dark horse with the ghostly rider in the sky? Photograph by Mike Mayerchak.*

197

■ A SAMPLING OF GALAXY CLUSTERS ■

Cluster	R.A. (2000)	Dec.	Remarks
Abell 347	2h 23.3m	+41° 57′	15th-magnitude galaxies ½° SE of NGC 891
Abell 426	3h 19.8m	+41° 31′	chain of galaxies west of NGC 1275
Abell 1367	11h 44.0m	+19° 57′	rich collection of faint galaxies in Leo
Abell 1656	12h 59.6m	+27° 58′	Coma Berenices cluster; very rich
Abell 2065	15h 23.0m	+27° 45′	Corona Borealis cluster; extremely faint
Abell 2151	16h 04.4m	+17° 45′	Hercules cluster (brightest member mag. 14.5)

■ RECOMMENDED WIDE-FIELD INSTRUMENTS ■

Instrument	Eyepiece	Power	Exit Pupil	Actual Field
11 x 80 binoculars	Kellner	11x	7mm	5°
15 x 100 binoculars	Kellner	15x	7mm	3.3°
4-inch f/5 refractor	32mm Erfle	15x	6.6mm	4.3°
5-inch f/8 refractor	40mm Erfle	25x	5mm	2.6°
6-inch f/4 reflector	20mm Nagler	30x	5mm	2.7°
8-inch f/5 reflector	32mm Erfle	30x	6.6mm	2.1°

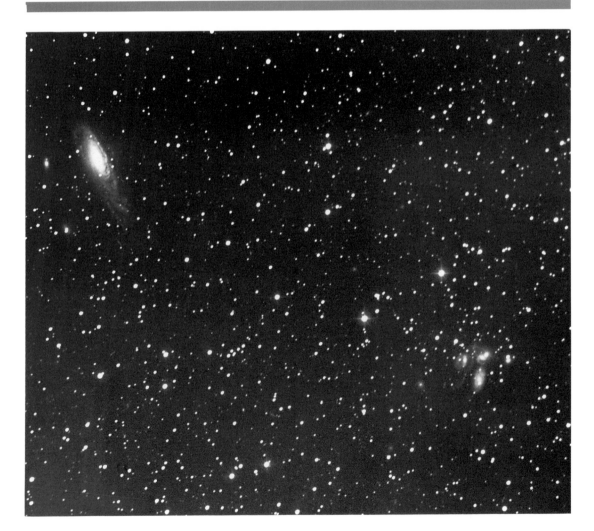

■ *A quintuple galaxy, NGC 7317-20 in Pegasus (lower right), popularly called Stephan's Quintet, has long been a centre of astronomical controversy, because one of the quintuplets has a very different redshift than the other four. The Quintet is located just an eyepiece field (half a degree) southwest of NGC 7331 (upper left), a fine 9.5-magnitude spiral. With magnitudes of 13 to 15, Stephan's Quintet can be seen as a smudge in a 6-inch, but a 12-inch is usually considered minimum to distinguish the individuals properly. Through an eyepiece, only four galaxies are obvious, since two of them are so close together they appear as one. This photograph by Tom Dey may have set a record for amateur astro-photography—it is a five-hour exposure. Dey used gas-hypered Tech Pan 2415 on his 12.5-inch Newtonian.*

introduce you to the richest portion of the Virgo galaxy cluster and perhaps inspire you to extend your explorations farther afield to the straggling cluster members north and south of the core area. In this section of the sky, there are galaxies enough to occupy many evenings of deep-space observing.

■ DISTANT CLUSTERS

If you enjoy observing the Virgo galaxy cluster, you may wish to attempt other rich but much fainter galaxy clusters. These objects are at the top of the cosmic hierarchy and are among the most challenging of deep-sky targets. Because of their great distance, each is contained within an area only one to two degrees wide at most, instead of being spread across 30 degrees as is the Virgo galaxy cluster. Often, the entire cluster can be seen in one field as a collection of faint, ill-defined smudges. Galaxy clusters usually require a lot of aperture, preferably 14 to 20 inches.

The *Uranometria 2000.0* is a must for observing distant galaxy clusters. Its clear, well-labelled charts have a limiting magnitude of about 15 for galaxies, a couple of magnitudes fainter than most other star atlases. A skim through Volume 1 (northern sky) will reveal numerous swarms of galaxies packed within a square degree or so.

A starter cluster in this challenging category is Abell 1656, the Coma Berenices galaxy cluster. (Most galaxy clusters have an Abell number, from George Abell's 1950s catalogue of some 2,700 rich galaxy clusters.) The brightest members of Abell 1656 are a pair of 12th-magnitude galaxies, NGC 4874 and NGC 4889, 400 million light-years away. We have seen them in a 5-inch telescope. Surrounding these two giant ellipticals are about 50 very faint 13th-to-16th-magnitude galaxies that require at least a 12-inch instrument.

Nearby, in Leo, is Abell 1367, centred around the 13th-magnitude elliptical NGC 3842. Five dozen galaxies brighter than 16th magnitude make up this cluster. An autumn-sky favourite is Abell 426, just two degrees east of Algol, the eclipsing binary star in Perseus. This cluster is composed of a chain of 14th-to-15th-magnitude galaxies, with the exploding galaxy NGC 1275 at its heart.

The distance record holder for galaxy clusters is Abell 2065, the Corona Borealis galaxy cluster. It is included in Tirion's *Sky Atlas 2000.0* and *Urano-*

metria 2000.0, but it is not a target for the casual skygazer. With a 14-inch telescope under pristine skies, sharp-eyed amateur astronomers have observed this cluster as a greyish mottling of the sky, just bright enough to indicate its presence. Abell 2065 is 1.5 billion light-years away, nearly 1,000 times farther than the Andromeda Galaxy. Except for a few of the brightest quasars, Abell 2065 marks the edge of the amateur astronomer's universe.

■ *The lure of the deep sky can take observers to such outposts as the Hercules galaxy cluster (Abell 2151), one degree northwest of Xi Herculis. In a single-eyepiece field with a 10-inch or larger telescope, more than a dozen galaxies float within a volume of space tens of millions of light-years wide, 600 million light-years from Earth. Photograph by Tom Dey, using a 12.5-inch Newtonian.*

■ DEEP-SKY STRATEGIES

There is so much to explore in the deep-sky realm— several classes of nebulas, open star clusters, globulars and galaxies—that it can be difficult to know where to start. Here are a few suggestions for making the most of deep-sky excursions:

☐ Plan each night's targets, and make a list of a dozen or so deep-sky objects. Avoid beginning without any idea of what you want to look at.
☐ Have a long-term goal. We recommend tracking down all the Messiers. Or pick a constellation and

attempt to locate every deep-sky object within its boundaries. This is called "constellation mopping."

□ Organize a work station for accessories, atlases and notebooks. Whatever makes life in the field more convenient will also make observing more enjoyable.

□ Find some observing friends. The hunt is all the more satisfying when you share the prize. Also, other observers may introduce you to deep-sky objects you have never seen before.

□ Do not give up on city observing. The brighter Messier objects are visible even through the murk of urban sky glow. As long as there are no lights glaring into your eyes, with a little patience, you should be able to locate double stars, variables, open star clusters and the brighter nebulas and globulars. Ur-

ban observing is a situation in which setting circles can be put to good use, especially the new style of easy-to-calibrate digital circles.

□ Do not underestimate the capabilities of your small telescope. Every Messier object can be tracked down with no more than a 3-inch instrument. Under a dark sky, a small telescope can reveal an amazing amount of detail. You can thoroughly explore the Virgo galaxy cluster, including picking out 11th- and 12th-magnitude NGC galaxies. An extra 30 minutes' drive to a dark site sometimes more than compensates for a modest aperture.

□ Subscribe to astronomy magazines. *Astronomy* has frequent deep-sky articles of interest, but real enthusiasts read its companion quarterly, *Deep Sky*, in which some of the world's finest deep-sky ob-

■ DEEP-SKY OBSERVING AT THE LIMIT

□ By Alister Ling

Among the great pleasures of deep-sky observing is the challenge of detecting the subtle wonders of the universe by pushing both your instrument and your skill as an observer to the limit. Seeing wispy streamers from explosive stellar shock waves, dust lanes and nebular complexes in galaxies or delicate puffballs of ionized gas does not necessarily require brute-force aperture. I have found that by refining techniques, attitudes and equipment, it is always possible to see more with the telescope you already own.

■ IMPROVING YOUR VISION

The most important tool in astronomy is the eye. Its sensitivity depends on its level of dark adaptation. I cannot overstate how jealously you must guard dark adaptation. A highly dark-adapted eye is vastly more effective than a larger telescope.

Studies have shown that even the particular shade of red of a flashlight can affect how quickly the eye readapts after exposure to the light. The deeper the red (the longer the wavelength), the better. Red light should also be dim. An intensity sufficient to locate dropped objects or to read star charts at arm's length can retard your maximum sensitivity by up to 15 minutes.

Even at relatively dark sites, I shield my eye while observing. Any ambient light is too much. A black cloth hood draped over my head keeps me in the dark quite nicely. A hood also alleviates the stress of keeping the nonobserving eye closed. However, a heater coil around the eyepiece may be required to prevent the

observer's body moisture from condensing onto the lens. The cost of a heater is small compared with that of any eyepiece; one can even be made from old toaster wire.

Experienced observers constantly use averted vision. Glancing to one side of an object aligns it with the more sensitive receptor cells around the periphery of the retina. Seeing an elusive deep-sky object by *not* staring straight at it may sound contrary, but it works. Another trick is to jiggle the telescope, which can reveal the presence of dim targets that might go unnoticed otherwise.

In addition, I have found that fatigue can cause the view to "grey out" as I strain to detect a faint object. I lie down for 15 minutes to rest, then have a hot drink (but not alcohol; it does not warm you, and it hinders dark adaptation).

■ IMPROVING CONTRAST

To see faint deep-sky objects, the solution is not necessarily brighter images (a larger telescope) but images with more contrast between the sky background and the target object. If stray light—even that of the Milky Way—leaks into the eyepiece, it can scatter across the eyepiece field and degrade contrast. I recommend that owners of open-tube Newtonians cover the tube's framework with a dark cloth. Next, an extension tube at the front end ensures that stray light cannot infiltrate the focuser. If your instrument is a solid-tube Newtonian, line the telescope tube, especially the section opposite the focuser, with black velveteen or corduroy. This will absorb light bouncing off the tube walls.

As a further measure, keep the optics clean; dust scatters a lot of light in the wrong directions.

■ *In small telescopes, the Crab Nebula, M1, looks like a tiny, dim cloud located between the horns of the traditional depiction of the constellation Taurus. Charles Messier saw it in 1758 during his comet sweeps and, after deciding that it was not a comet, started to compile his list of bogus comets, which proved to be his enduring legacy. Why, then, did Messier include obvious naked-eye objects such as the Beehive, M44, and Pleiades, M45, clusters? Astronomy historian Owen Gingerich has suggested that Messier added M44 and M45 simply to bring the number of entries in the initial instalment of his list up to 45. Photograph by Neyle Sollee, using a 24.5-inch Astro Works Schmidt-Cassegrain.*

servers share their experiences and expertise. Another publication of merit is *The Observer's Guide*, a bimonthly published by George Kepple.

☐ Collect a library of deep-sky references. No deep-sky observer should be without a copy of *Burnham's Celestial Handbook*. The three-volume set contains a gold mine of information about thousands of objects. It is wonderful cloudy-night reading. Other recommended references are listed in the Appendix.

☐ Change telescopes. If you feel that you have exhausted all that is visible with a particular telescope, a new telescope will often rekindle your observing interest. Usually, this involves moving to a larger aperture. Using an 8-inch telescope after being accustomed to a 3-inch is like rediscovering the sky. Another possibility is a wide-field instrument such as a short-focus refractor or giant binoculars, which, in a dark sky, can give stunning views of Milky Way fields and large deep-sky objects.

☐ Change latitudes. If you live at midnorthern latitudes, a whole new sky awaits you in the south. You do not have to go to Australia; even a trip 1,000 kilometres farther south will bring hundreds of new objects above the horizon.

Endless satisfaction can be found exploring the deep-sky realm. From objects so large that they can be seen only with the naked eye to objects so small and faint that they require a 24-inch giant telescope, the universe has much to offer. While deep-sky objects may appear merely as faint puffs of light briefly glimpsed in the eyepiece, they will long be etched in your memory.

Finally, faint stars and small galaxies can only be seen with aligned optics. Always ensure that the telescope is collimated so as not to defeat yourself at the outset.

■ USING NEBULA FILTERS

Nebula filters boost image contrast. In my opinion, at least one nebula filter is basic equipment, not a luxury. Broadband filters, such as Lumicon's Deep-Sky and Orion Telescope Center's SkyGlow models ($60 to $120), are useful in heavily or moderately light-polluted areas. As well as enhancing emission nebulas such as M42, broadband filters improve galaxies, comets and reflection nebulas under less-than-ideal conditions. But in darker skies, a broadband filter has a limited effect.

While narrowband filters, such as Lumicon's UHC and Orion's UltraBlock ($80 to $200), do nothing for galaxies, comets and reflection nebulas, they work wonders on emission and planetary nebulas.

The third type of filter, the line filter, is a specialty item. This category includes Lumicon's Oxygen-III and H-beta filters ($100 to $200), which provide extreme contrast, blocking starlight by almost three magnitudes. Compared with the narrowband filter, the Oxygen-III filter offers a distinct improvement in the visibility of planetary nebulas, at least at low power. The H-beta filter enhances some faint extended nebulosities and is especially effective on the Horsehead Nebula, the California Nebula and NGC 40. A line filter is most efficient at low power (5mm-to-7mm exit pupil). At higher powers, the sky is already completely black

through the narrowband filter, so it cannot be made any blacker.

I have found that filters work best in combination with an observing hood. Without a hood, stray light can reflect off your eyeball, travel through the eyepiece, reflect off the filter and bounce back to interfere with the view. I have seen this effect discourage observers who did not shield their eyes.

Through the application of such simple techniques, my well-used instrument continues to provide me with one of the most rewarding experiences in amateur astronomy—observing the delicate details in the web of our universe. *Alister Ling has written many articles on deep-sky observing for* Astronomy *and* Deep Sky. *He lives in Edmonton, Alberta.*

■ *A typical entry in Alister Ling's observing log has this drawing and the following notes: "The Medusa Nebula (planetary), PK 205 + 14.1 = Abell 21 = Sharpless 2-274; 744" x 670". Seeing 2"; limiting mag. 6.2; 12.5-inch, 65x, 40' field, O-III filter. Very bright in O-III, huge! Has a dark E-W lane through half. Hints of a complete circle, but I can't be sure. Better skies would help. H-beta filter shows just the northern brighter-limb 'blob.' Cannot see anything without the filter."*

Capturing the Sky on Film

Backyard astronomers are captivated by sky shooting for the same reason that people are motivated to take pictures of any scenic attraction—it provides a permanent memento that can be viewed with pleasure again and again. Everything we see in the sky, and many things we cannot see, can be captured on film. Here is a guide to selecting the best equipment to do it.

■ SELECTING THE RIGHT EQUIPMENT ■

For the professional astronomer, photography is a technique for collecting data. For the rest of us, it is a means of producing beautiful images that we can look upon with pride. Some astrophotographs, like constellation portraits, star trails and planetary conjunctions, are surprisingly easy to take. Others, such as planet, galaxy and nebula shots through a telescope, require practice and proper equipment. Astrophotography is a hobby within a hobby that can grow to addictive levels. ("If only it would clear up tonight so I could try that shot of M101 again.") We have both spent many nights outside staring into a viewfinder or guiding eyepiece hoping to bag a memorable shot. Much can go wrong—too much, it seems. But astrophoto addicts keep trying. Their achievements are displayed throughout this book.

Astronomical work pushes photographic technology to the limit, and that alone provides a sense of accomplishment for those who love to make the most of what cameras and film can do. For decades, amateur astrophotographers could not compete with the output from professional observatories. But times have changed. Today, virtually every professional telescope used for taking photographs is fitted with charge-coupled device (CCD) cameras. These electronic marvels produce images that are wonderful for research purposes and for computerized data reduction but often look unimpressive or indecipherable to the nonresearcher. Only the classic methods of photography can produce the stunning wide-field, star-filled pictures people associate with fine astronomical photography.

Producing images on film, especially colour film, is a realm now left almost exclusively to the amateur. This is rather fitting, because amateur scientists, some of them astronomers, invented photography in the 1830s. Since then, photography and astronomy have progressed hand in hand, innovations in one field prompting advances in the other.

Professional astronomers' recent penchant for CCD chips over photographic film comes, interestingly, at a time when the technology of photographic emulsions is improving greatly. Super-fine-grained films such as Kodak Tech Pan 2415 along

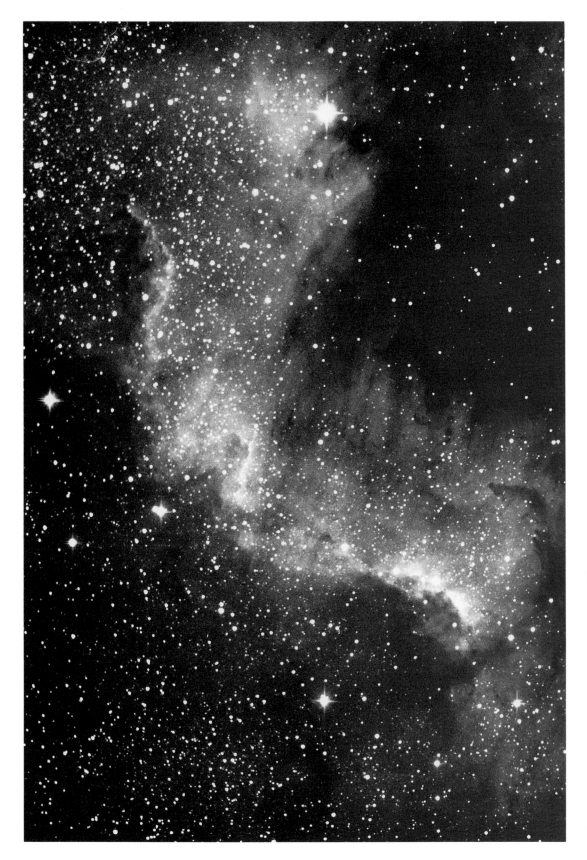

■ *The Central America Nebula, a section of the North America Nebula, is seen here in remarkable clarity. Yet the instrument used for the 70-minute exposure was an 8-inch f/6 Newtonian, a modest instrument by today's standards. Apart from the attention to detail on the part of photographer John Mirtle, the secret to great black-and-white astrophotography is Kodak Tech Pan 2415 film. When gas-hypered, this film is in a class by itself. All serious astrophotographers use it (unless they shoot colour only).*

with gas-hypering techniques to increase the film's sensitivity now enable the dedicated amateur to produce astronomical photographs that rival those taken with the world's largest telescopes. This is another source of inspiration spurring many backyard astronomers on to greater levels of achievement.

■ SELECTING THE RIGHT CAMERA ■

Any camera, from a pocket model to a 4 x 5 Linhof, can be used to take pictures of the night sky. The main requirement is a B (bulb) setting on the shutter that permits time exposures. But for taking pictures through a telescope or for exploring the full range of astronomical photography, one type of camera is best: the 35mm single lens reflex, or SLR.

If it is a recent model with automatic functions, however, it may have some major drawbacks for night-sky photography. Not only is all the high-tech electronic wizardry for auto-exposure, auto-wind and auto-focus unnecessary for astrophotography, but it can be a real disadvantage.

Some cameras are so automatic that they have no manual override of aperture and shutter speeds. Such cameras are essentially useless for astrophotography. Other types allow manual settings but rely on battery power to maintain them—battery power is required to keep a shutter open on a B setting, for example. A cold night coupled with a 30-minute exposure is guaranteed to kill the batteries, reducing the camera to a high-tech counterweight rather than a functioning piece of equipment. When purchasing a camera that may be used for astrophotography, remove the battery in the store and determine what shutter speeds still function. Unfortunately, most 35mm cameras now on the market are unsuitable for astrophotography.

Only a handful of fully manual non-battery-dependent cameras remain available in the 1990s. The Nikon FM2 is relatively inexpensive (about $400) but lacks interchangeable prisms, and neither of the two optional focusing screens available for it is suitable for astrophotography. The Pentax K1000 is a low-cost, no-frills manual camera ($150) with many desirable attributes. Among the feature-laden high-end models, the Pentax LX has an excellent array of viewfinders and screens and a shutter that works from 1/75 to 1/2,000 second and at B, even if the batteries fail. The Olympus OM-4T and Contax RTS III both have interchangeable screens as well as shutters that work without batteries at 1/60 second and at B (the Olympus) or just at B (the Contax). However, the Contax has a built-in motor winder that only adds weight and complexity for our purposes. The Leica R6 is a fully manual, nonelectronic camera with interchangeable screens, but its cost—$2,500—may raise eyebrows.

Of all current camera models, the Canon F-1 is probably closest to ideal. It has a mechanical shut-

ter for the B setting and for speeds from 1/2,000 to 1/125 second, an excellent array of focusing screens and a superior 6x viewscreen magnifier—every feature an astrophotography camera should have except, surprisingly, mirror lockup. The competitive Nikon F3 has an electronic shutter that works without batteries at 1/60 second and at B. (The newer Nikon F4 is burdened with an unnecessary motor drive; we do not recommend it.) Overall, Canon and Nikon cameras stand out in this select group because of their superb array of lenses, which are considered by many to be the best on the market.

■ USED CAMERAS

Since the selection of current cameras that can be used for astrophotography is limited, we recommend seeking out a used model traded in by someone upgrading to fully automatic equipment. All that is really needed is a camera body in good condition. The lenses can be purchased either used or new. However, find out whether new accessories such as lenses, screens and viewfinders will fit the older model or whether suitable older-model accessories are available.

■ *Top: Two important features in an astrophotography camera are the ability to remove both the pentaprism and the interchangeable focusing screens. Pentaprism removal allows insertion of a viewfinder magnifier. Shown here are 2x and 6x magnifiers. The best focusing screens for through-the-telescope photography have plain, extremely fine-ground-glass surfaces with no Fresnel lens pattern and preferably a clear central spot with etched cross hairs. An independent brand of fine-ground-glass focusing screens by Beattie, called Intenscreens (available for some cameras), works very well.*

■ *Bottom: Available only on the used-equipment market (for about $150), the Olympus OM-1 is the camera of choice for many astrophotographers. It is lightweight, fully manual, reliable and far less expensive than a new manual camera suitable for celestial photography, such as the Canon F-1.*

Among secondhand models, Nikon F and F2 cameras are unbeatable. The original Canon F-1 is in the same high-class league and has mirror lockup. But the camera of choice for many astrophotographers was, and remains, the Olympus OM-1. It is a lightweight manual camera with mirror lockup, interchangeable screens and a selection of good, although not great, lenses. Our best recommendation for a reasonably priced astrophotography unit is a used OM-1. (The OM-2 and OM-3 are also good choices.) But act quickly; they may not be available on the used market for much longer.

■ SELECTING A LENS

Most lenses do a creditable job on terrestrial subjects. Even the least expensive 35mm camera lenses are reasonably sharp at f/11, the typical snapshot setting. But capturing a field of stars with the aperture set wide open is another matter—it is the ultimate test of a lens. The smallest deviations from lens perfection will become glaringly apparent as distortions in the star images. For astrophotography, fast lenses are preferred—f/2.8 to f/1.2. These are difficult to make and can exhibit the greatest optical aberrations, one reason we prefer top-quality brand names such as Nikon and Canon.

Unfortunately, the most common SLR lenses today are zoom lenses, the least desirable for astrophotography. Zoom lenses are typically f/4, too slow for many types of celestial shooting. Fixed-focal-length lenses are usually f/2.8 or faster. A basic set of lenses for astrophotography would be a wide-

■ CAMERA FEATURES YOU NEED ■■■

Presented in decreasing order of importance.
☐ High-quality interchangeable lenses
☐ All shutter speeds (or at least B setting) operational without battery power
☐ User-interchangeable focusing screens
☐ Availability of clear-spot astrophoto screen
☐ Interchangeable prisms or right-angle magnifier finder accessory
☐ Independent mirror lockup

angle (24mm or 28mm), a normal lens (50mm or 55mm) and a short telephoto (85mm to 135mm). Resist being tempted by compact 300mm-to-500mm f/8 mirror or so-called reflex telephotos. They are far too slow for anything but the brightest subjects.

■ SELECTING THE RIGHT FILM ■■■

The most common astrophotography question is, What film do I use? Since the night sky is a very dim subject, the first impulse is to use the fastest film: the faster the film, the shorter the exposures. Certainly, shorter exposures are desirable; during long exposures, all sorts of gremlins can creep in to blur the picture. On the other hand, fast films are grainier than slow films. Slow, fine-grained films record sharper detail than fast, coarse-grained films. In all cases, use the finest-grained (which usually means the slowest) film that the subject will allow.

Film speeds are indicated by ISO numbers; the higher the ISO number, the faster the film. The slowest, finest-grained films currently available are ISO 16, and the fastest films are ISO 3200. ISO numbers are the same as the old ASA speeds. Therefore, ASA 400 is ISO 400.

As might be expected, there is no one "best" film. The selection of film depends primarily on the brightness of the object. In astrophotography, the entire range of film speeds, from ISO 16 to

ISO 3200, is used at one time or another. Indeed, experimenting with new films is part of the fun.

■ COLOUR FILMS

We recommend using colour film right from the start. The idea that black-and-white film is less expensive to learn with is ancient history. Considering the time required to develop and print, not to mention the cost of darkroom supplies, black-and-white film is far from inexpensive.

There are two types of colour film: one that yields slides and one that produces negatives from which prints can be made. Prints have the disadvantage of requiring an extra processing step. Unless you do your own printing, you will have to rely on someone else (usually involving an automated operation) to prepare the photographs. The results can range anywhere from perfect to terrible.

The main advantage of print film is the availability of very fast medium-grained emulsions, such as Kodak Ektar 1000, Fujicolor Super HG 1600

■ The best lenses for piggyback astrophotography are fixed focal length (that is, nonzoom). They should be f/2.8 or faster. A good set would include a wide-angle lens (24mm or 28mm), a normal lens (50mm) and a short telephoto (85mm to 135mm). These sizes are widely available on the used-equipment market.

and the remarkable Konica SR-G 3200. These films are so good that many astrophotographers use them exclusively, despite the extra work and expense involved in achieving a final positive image. In medium-speed colour print films, Fujicolor Super HG 400 has gained a reputation for fine grain and superb colour.

The alternative to the fuss of colour negatives is transparency, or slide, film. The advantage of slide film is that it requires no further treatment for finished images. It is generally less expensive than print film and produces good results for the least amount of effort and cost without imposing the vagaries of the print process. Beginners are well advised to use slide film. As of early 1991, Agfachrome 1000 and Scotch Chrome 1000 are the fastest slide films currently available, although they are quite grainy. Other high-speed emulsions, such as Fujichrome 1600D, Ektachrome 800/1600 and Scotch Chrome 800/3200 (known in the United States as Scotch Chrome 400), are actually 400-speed slide films packaged for "push-processing." All of them can be shot at ISO 400, 800, 1600 or 3200, marked for push-processing and sent to a film laboratory, where technicians will leave them in the developer longer than normal to boost the films' speeds. There is usually a surcharge of $2 or $3 for this process.

Any slide emulsion can be push-processed, but the 400-speed films gain the most for astrophotography. Push-processing them to ISO 800 creates relatively little increase in grain yet produces doubled speed, cutting exposure times in half. When pushed to 1600, 400-speed films become substantially grainier, similar to Agfachrome 1000, but the speed gain is often a good trade-off. Push-processing to ISO 3200 offers spectacular sensitivity, but most astrophotographers feel that the cost in increased graininess is too great.

■ RECOMMENDED 35mm FILMS ■

Astrophoto Subject	Colour Slide	Colour Print	B&W
day-sky phenomena	Kodachrome 25	Ektar 25	–
sunsets and twilights	Kodachrome 64	Ektar 125	–
constellations (fixed camera)	Agfachrome 1000 or Scotch Chrome 400	Ektar 1000 or Konica SR-G 3200	T-Max 400 or T-Max P3200
star trails	Kodachrome 200 or Fujichrome 400	Ektar 125 or Fuji HG 400	T-Max 400
auroras	Fujichrome 400 or Scotch Chrome 400	Fuji HG 400 or Ektar 1000	–
moon (telephoto and prime focus of scope)	Kodachrome 25 or 64	Ektar 25	T-Max 100 or Tech Pan 2415
lunar close-ups (high magnification through scope)	Kodachrome 200 or Fujichrome 400	Fuji HG 400 or Ektar 125	T-Max 400 or Tech Pan 2415
sun (white-light filter)	Kodachrome 25 or 64	Ektar 25	Tech Pan 2415
sun (H-alpha filter)	–	–	Tech Pan 2415[1]
planetary (high magnification through scope)	Kodachrome 200 or Fujichrome 400	Fuji HG 400 or Ektar 1000	T-Max 400 or Tech Pan 2415
lunar eclipse (telephoto or prime focus of scope)	Kodachrome 64 and Fujichrome RD400[2]	Ektar 125 and Ektar 1000[2]	–
solar eclipse	Kodachrome 25 or 64	Ektar 125	T-Max 100
deep-sky (piggyback)	Kodachrome 200 or Scotch Chrome 400	Fuji HG 400	Tech Pan 2415 or T-Max 400
deep-sky (prime focus)	Scotch Chrome 400 (pushed to 1600)	Ektar 1000 or Konica SR-G 3200	Tech Pan 2415
comets (fixed camera)	Agfachrome 1000 or Scotch Chrome 400	Ektar 1000 or Konica SR-G 3200	T-Max P3200
comets (guided)	Fujichrome 400 or Scotch Chrome 400[3]	Fuji HG400 or Ektar 1000	T-Max 400 or Tech Pan 2415

[1]Tech Pan film was designed for this type of photography.
[2]Slower film for partial phases of lunar eclipse; faster film for totality.
[3]Speed of film depends in part on brightness of comet.

■ Facing page: Another example of modern amateur astrophotography reaching levels of excellence previously attained only at professional observatories is this portrait of the Rosette Nebula. The smallest dark globules silhouetted against the bright backdrop of nebulosity are about one-tenth of a light-year wide. The Rosette is roughly 3,000 light-years away. Tom Dey used gas-hypered Tech Pan 2415 for this three-hour guided prime-focus shot with a 12.5-inch Newtonian.

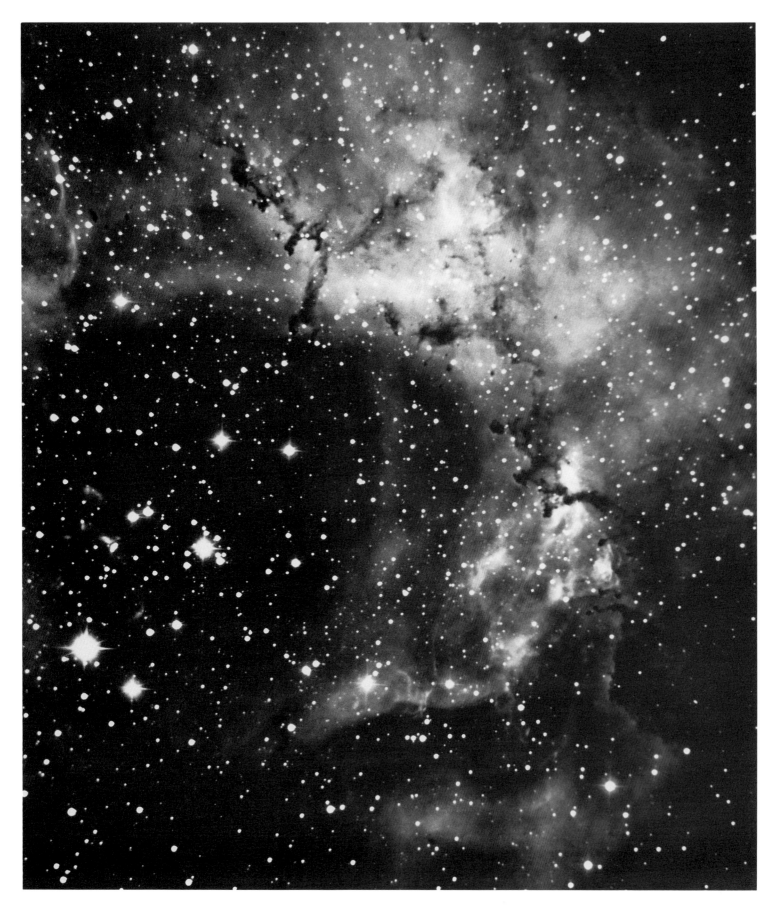

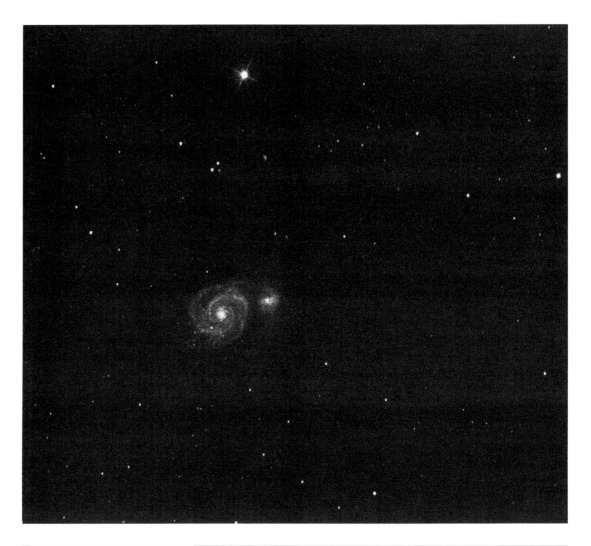

■ *Although gas-hypered Tech Pan 2415 is king of the black-and-white films, Kodak T-Max P3200 is easier for beginners. It can be push-processed to ISO 25,000 for results like this, unhypered. The film grain is much more evident, but exposure times are short and the film can be used right out of the box. Photograph by Andreas Gada, using a 6-inch f/6 Newtonian; 10-minute exposure.*

■ THE ULTRAFAST FILMS

During the past few years, manufacturers have introduced myriad high-speed colour films: Fujicolor Super HG 1600, Ektar 1000, Agfachrome 1000, Scotch Chrome 1000 and Konica SR-G 3200, the most popular film among amateur astronomers. The ultrafast films can pick faint nebulas and Milky Way star clouds out of the sky better than any film before them, all in exposures of less than 1 minute at f/2. For example, with Konica SR-G 3200 or Ektar 1000 and a tripod-mounted camera, a 30-second untracked photograph can capture almost as much faint deep-sky detail as a 5-minute tracked and guided piggyback exposure on ISO 400 film. Ultrafast films are ideal for:
□ beginners or dabblers who want satisfying results from the simplest equipment
□ travellers who cannot pack elaborate clock-driven mounts
□ photographers who do not have access to f/2.8 or faster lenses
□ taking the maximum possible number of quality pictures during one observing session
□ photographing bright comets and auroras
□ prime-focus deep-sky work at f/6 to f/10

If the high-speed films are so laudable for deep-sky photography, why use anything else? The answer is film grain. A Konica SR-G 3200 negative will not stand tremendous enlargement. For most purposes, this will not matter, even if the exposure is published in a magazine, unless it is enlarged to the size of a two-page spread. But if the goal is to have 11-by-14-inch or 16-by-20-inch framed prints or the sharpest originals possible, then medium-speed film (ISO 200 to 400), top-quality fast optics and longer guided exposures are the only alternative. The finest results always come at a price.

Astrophotographers need an ISO 3200 colour slide emulsion with reasonable grain. Major manufacturers have tested such films but have yet to place them on the market. Apparently, the demand is still too small to justify perfecting them.

Because of the lack of a good ultrafast slide emulsion, acknowledgment must be given to Konica SR-G 3200 print film. Introduced in 1987 (as SR-V 3200), this amazing product is by far the most sensitive colour emulsion available (as of early 1991). For pure speed, it is in a class by itself. The typical exposure times of other films are cut in half by Konica 3200, making it a backyard-astronomy favourite.

■ THE BEST BLACK-AND-WHITE FILMS

While selecting a colour film might involve difficult choices and, ultimately, compromise, there *is* one black-and-white film that stands out as the best: Kodak Tech Pan 2415. It is a high-contrast, medium-speed, very fine-grained emulsion for scientific applications that evolved from a film designed for solar photography. With extended red sensitivity, incredible resolution and a normal ISO speed of 125, Tech Pan 2415 has been described as an almost perfect astrophotography film. It is available in 36-exposure cassettes from photography dealers that cater to professionals. Tech Pan 2415 can be used right out of the box for solar, lunar and planetary photography. However, for deep-sky work, it must be gas-hypered to boost its sensitivity over long exposures. (More about this in Chapter 15.)

For decades, the most common black-and-white emulsion was Kodak Tri-X. However, its day is past. In the mid-1980s, Kodak introduced its T-Max black-and-white film, with much finer grain, in 100, 400 and 3200 speeds. T-Max 100 and 400 can be pushed one f-stop with very little increase in grain, while T-Max P3200 can easily be pushed to ISO 6400 or 12,500. Tests show that it can withstand pushing to 25,000 or even 50,000.

■ SELECTING THE RIGHT TELESCOPE ■

If you are still in the process of selecting a telescope and suspect that astrophotography is one of your ambitions, keep in mind that the crucial feature in an astrophotography telescope—more important than the optics—is a very solid mount. A beefy equatorial mount with a clock drive is essential. However, in most cases, portability is also a prerequisite. Despite the marvels of current films and filters, most deep-sky photography, like deep-sky observing, has to be done from dark locations. This involves transporting the telescope into the country, so while the instrument must be sturdy, it should also be compact, easy to set up and capable of carrying piggyback cameras with large lenses.

Another feature to look for is a telescope drive with a worm-and-wheel gearing mechanism. This type of drive is usually better than spur gears. It provides a smoother, more accurate drive motion that reduces the trailed star images produced by any inaccuracies. The larger the wheel-gear diameter, the more precise the drive. When stated at all, drive-error ratings are usually given in arc seconds. An error of less than 10 arc seconds, generally stated as plus or minus five arc seconds, is excellent.

Celestron and Meade have introduced periodic error correction (PEC) circuits that electronically memorize, and compensate for, the regular speed variations introduced by gear errors. These PEC circuits can reduce tracking error to below five arc seconds. However, even with the finest drives and PEC circuits, random tracking errors creep in from motors, gears and bearings. Manual guiding is al-

ways required for through-the-telescope photography. To allow instantaneous variation of the drive rate for overcoming such errors, telescopes with a battery-powered DC stepper or pulse motors usually have standard push-button speed controls. AC motors require a separate electronic drive corrector.

■ TELESCOPE OPTICS FOR ASTROPHOTOGRAPHY

Aperture is important for only one type of astrophotographic subject—planets. To photograph our neighbour worlds requires a great deal of magnification and therefore as much light as possible to keep exposures short. A 4-inch telescope is the absolute minimum for planetary photography. Lunar photography is not so demanding. Small instruments (less than 4 inches) fare well in this area. However, a telescope with a focal length of 1,500mm to 2,200mm is best for good pictures

■ *A top priority for successful astrophotography is a rock-solid, accurate equatorial mount such as this Astro-Physics Model 600. The best plan is to get an oversize mount for the telescope you plan to use. A mount that will hold a 10-inch telescope for casual viewing should be used with a 5-inch telescope for astrophotography.*

of the moon, since at these focal lengths, the moon fills a 35mm frame nicely.

For photographs of deep-sky objects, aperture is not as important as focal ratio. Fast f/4 to f/6 telescopes of any aperture are far easier to use for faint-object portraits than f/7 to f/10 instruments. Anything slower than f/10 makes the exposures torturously long, even with the fastest film available. In this respect, deep-sky photography is not like deep-sky observing. For observing, the biggest transportable telescope is usually preferred. However, for astrophotography, a larger-aperture instrument will not produce shorter exposures. Rather, deep-sky exposures are determined by focal ratio: the faster the telescope, the shorter the exposure.

Why use a large-aperture model at all? A big tele-

scope (10 to 20 inches) has a small field of view, often less than a degree when coupled with 35mm film. This makes large telescopes superior for detailed pictures of small deep-sky objects, such as planetary nebulas, globulars and many galaxies. However, some deep-sky objects are so huge (M31, the North America Nebula and the Veil Nebula, for example) that they will not fit into the frame when using a large telescope. Small 4-to-6-inch f/4 to f/6 telescopes excel with oversize targets. With their shorter focal lengths, smaller instruments have a wider field of view; they are certainly more portable. As with visual observing, there is no perfect telescope for every type of astrophotography.

■ RECOMMENDED TELESCOPES

What telescope has most of the right features? With some reservations, we recommend Schmidt-Cassegrains as the best all-round, commercially made instruments for astrophotography. An 8-inch Schmidt-Cassegrain has adequate aperture for planetary photography, and the 2,000mm focal length of the f/10 models is ideal for shots of the moon. For piggyback photography, cameras readily attach to the top of the tube, where it is a snap to aim and frame the star field. A fork-mounted Schmidt-Cassegrain with sliding tube weights is easy to balance and relatively easy to set up and align, and the controls are right at your fingertips.

■ DEVELOPING YOUR ASTROPHOTOGRAPHIC SKILLS

We want to encourage backyard astronomers to take up astrophotography as a rewarding part of the hobby, but at the same time, we offer this counsel: astrophotography can be a mine field of aggravations and technical problems. To avoid unnecessary anguish, you need to know:
□ how to operate a manual camera for regular photography (or how to operate a fully automated camera in manual mode)
□ what f-stops, film speed and film grain mean
□ how to find things in the sky
□ how to polar-align a telescope
But you do *not* have to know about film

developing, darkroom techniques or film sensitometry curves to achieve good results. The secret of success in astrophotography is to start simple. Here is the sequence we recommend for developing your astrophotographic skills:
□ constellations with a camera on a fixed tripod
□ the moon through a telescope
□ tracked exposures with a camera piggybacked on a telescope
□ eyepiece-projection shots of the moon
□ eyepiece-projection shots of the planets
□ guided deep-sky exposures through a telescope

■ ESSENTIAL FEATURES IN AN ASTROPHOTO TELESCOPE

■ *Wheel-and-worm gears, such as those used to drive Celestron's 8-inch Ultima, are preferred for astrophotography over the spur gears on earlier models of Schmidt-Cassegrains. We regard the Ultima as the best off-the-shelf Schmidt-Cassegrain for astrophotography.*

□ *Very* solid mount
□ Fine polar-alignment adjustments
□ Declination slow-motion control, either manual or electric
□ An accurate worm-gear drive
□ Speed controls in right ascension
□ Car-battery adapter

□ Ability to attach piggybacked cameras or guidescopes
□ Fast optics, preferably f/6 or faster for broadest choice of targets
□ Ability to fill 35mm film frame
□ Smooth focuser (preferably 2-inch diameter) with lock

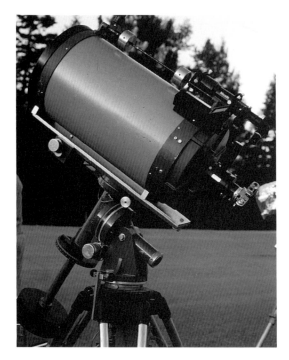

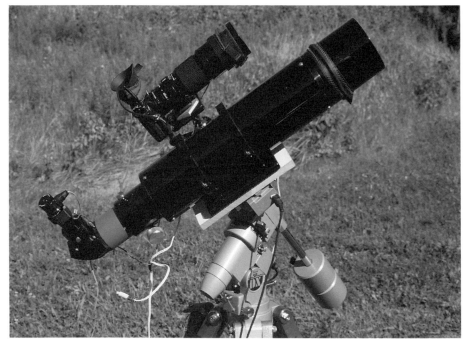

However, a flaw of many Schmidt-Cassegrains is that their lightweight fork mounts shake with the slightest touch or breeze. Long exposures are possible but require far more care and a calm night.

Another disadvantage of most Schmidt-Cassegrains manufactured throughout the 1970s and 1980s is their focal ratio. It is difficult to record faint deep-sky objects at f/10, even over long exposures. An optical accessory called a telecompressor will convert an f/10 telescope into an f/5 or f/6. The first telecompressors that appeared on the market were of mediocre quality and produced a loss of resolution and vignetting at the edge of the frame. But Celestron's newest model, the f/6.3 reducer/corrector, turns an f/10 Schmidt-Cassegrain into an f/6.3 unit and also compensates for the curvature of field that is inherent in all Schmidt-Cassegrains. This handy accessory lens yields sharp star images across an entire 35mm frame while increasing the effective photographic speed of a standard f/10.

As an alternative, Meade offers Schmidt-Cassegrains that produce an f/6.3 speed without additional accessory lenses. First introduced in 1988, these fast Schmidt-Cassegrains are a good choice for someone looking specifically for a deep-sky instrument. However, the mounts, especially for the 10-inch models, are a little shaky.

What about other types of commercial telescopes? For deep-sky photography, it is difficult to beat good 6- or 8-inch f/4 to f/6 Newtonians *if* they are on solid mounts and have excellent drives — features most commercially available Newtonians lack. Avid astrophotographers often have to replace the standard drives on Newtonians with highly

accurate custom units from companies such as E.R. Byers or Thomas Mathis.

Another problem with some commercial Newtonians is a focuser that will not rack in far enough to allow the camera to reach focus. There are two solutions: move the main mirror up one or two inches, or switch to a low-profile focuser.

The 6- and 8-inch MTS Schmidt-Newtonians from Meade have excellent speed (f/4 to f/5). However, as of early 1991, the fork mounts are still too shaky and lack precise polar-alignment adjusters. Improvement in these models would make them excellent for deep-sky astrophotography.

If money is no object, the $8,000 NGT-16 or $9,000 NGT-18 reflectors from Jim's Mobile Industries are superb outfits for detailed deep-sky pictures. Remarkably portable for their giant 16- and 18-inch apertures, these telescopes can travel well to dark sites. But as with any large unit, they work best in the hands of experienced photographers.

Among refractors, 3-to-4-inch short-focus apochromatic models, such as Vernonscope's 94mm f/7, Tele Vue's Genesis 4-inch f/5 and Takahashi's 3- and 4-inch fluorites, are excellent for wide-field deep-sky photography and for lunar work, but not for planets. The larger medium-focus (f/6 to f/9) 5-to-7-inch apochromatic refractors are great for all-round work, but they are either moderately expensive (Astro-Physics) or very expensive (Takahashi). The mounts produced by both of these companies are excellent and include all the features an astrophotographer would want.

Specialized astrophotography telescopes from Japanese firms (for example, Takahashi's hyper-

■ *Left: Serious astrophotography with a big telescope such as the Celestron C14 requires a better mount than the fork version provided with the telescope. The owner of this instrument replaced the mount with a massive German equatorial. Manufacturers of specialty mounts for photographic applications are listed in the Appendix.*

■ *Above: For less ambitious astrophotographers, mounts such as Vixen's Super Polaris DX (shown here) or Tele Vue's Systems Mount are good choices. If accurately polar-aligned using the built-in polar-axis finderscope, these mounts track very accurately at focal lengths in the 200mm-to-600mm range, and virtually no guiding corrections are required.*

bolic astrographs) are extremely well made. Due to dollar-yen exchange-rate differences, such high-end Japanese products are expensive for North American buyers, although the hard-core astrophotography addict may feel that they are worth the cost. In the same price league are the American-made Questars, which offer first-class optics and mounts. At f/16, they are too slow for practical deep-sky photography, and their astrophotography accessories are very pricey. The 7-inch Questar is superb for planetary work, and both the 3.5- and 7-inch models are good for lunar and piggyback photography. However, the 3.5-inch model is too small to carry heavy cameras and large lenses.

In spite of slow speed and a mount that is just passable, an 8-inch fork-mounted Schmidt-Cassegrain (either a standard f/10 or a faster f/6.3) is still the best choice for a general-purpose, portable astrophotography outfit at the best price. For deep-sky photography, a fast 4-to-5-inch apochromatic refractor is a good choice. In the hands of a veteran, it can produce astonishing celestial portraits.

To sum up, a low-cost beginner's telescope that serves for casual viewing simply will not do the job for someone who wants to get into astrophotography seriously. For a portable outfit, be prepared to spend $1,500 to $3,000 for the telescope and a few hundred dollars for accessories.

■ SELECTING THE RIGHT ACCESSORIES ■

There are many kinds of earthbound photography —portrait work, landscapes, still lifes, photojournalism—and each requires a special set of photographic equipment and accessories. The same is true of astrophotography. The moon calls for different techniques and equipment than the planets. A faint galaxy requires another set of accessories. However, to attach the camera to the telescope, you need one essential accessory: a camera adapter.

There are two types of basic camera adapters. One slides into the focuser just as an eyepiece does. These are available for 2-inch, 1¼-inch and 0.965-inch focusers and should be used on Newtonian reflectors and refractors. The other type is for Schmidt-Cassegrains. They screw onto the back of the instrument in place of the usual eyepiece holder, or visual back. At the camera end of both of these kinds of adapters are so-called T-mount threads, which were once used by camera manufacturers when screw-in lenses were common. To attach a camera body to the threads, a T-ring is needed to fit the brand of camera. T-rings are sold in most camera stores and by many telescope dealers.

With a basic camera adapter and a T-ring, a camera body can be attached so that it looks through the telescope. This is called prime-focus photography. There is no eyepiece on the telescope and no lens on the camera. The telescope becomes the lens, a setup useful for photographs of the whole disc of the moon or the sun.

The first prerequisite is an equatorial mount with a clock drive. Another necessity is an eyepiece-projection adapter—an eyepiece inserted into the light path acts as a projector lens, throwing a magnified image directly onto the film. As with prime-focus photography, there is no lens on the camera. On a Schmidt-Cassegrain, eyepiece projection is accomplished with a tube that screws onto threads on the normal visual back. This accessory, called a tele-extender by both Meade and Celestron, also has standard T-threads on the camera end.

The other kind of camera adapter, the type that slides into the focuser, comes with extension tubes which allow the insertion of an eyepiece. But be sure that the eyepieces will fit into the projection adapter. Some eyepieces are too big.

■ PIGGYBACK PHOTOGRAPHY: THE STARS AND THE MILKY WAY

A normal camera lens can capture spectacular pictures of star fields and nebulous regions of the sky, provided that the camera tracks the stars. An equatorially mounted telescope makes an ideal camera platform. To attach a camera so that it rides along with the telescope requires a piggyback bracket affixed to the tube or mount of the telescope.

■ EYEPIECE PROJECTION: LUNAR CLOSE-UPS AND THE PLANETS

With prime-focus photography, a 2,000mm-focal-length telescope becomes a 2,000mm telephoto lens. By normal standards, this is an enormous focal length. But in astronomy, it is only the beginning. Close-ups of small regions of the moon and detailed exposures of the planets require more power.

■ *Any single lens reflex (SLR) camera can be attached to a telescope using a T-ring and a 1¼-inch or 2-inch camera adapter. T-rings for SLR cameras are available from any photography store. All telescope dealers carry telescope adapters. Then comes the hard part: taking a celestial photograph through the telescope. Start with the moon.*

■ FIXED-CAMERA EQUIPMENT

Astrophoto Accessories	Telescope Requirements	Camera Requirements
☐ solid tripod ☐ locking cable release	☐ no telescope needed	☐ B shutter setting (nonbattery B setting preferred) ☐ 50mm f/2 or faster lens (wide-angle or telephoto lenses optional)

■ PRIME-FOCUS EQUIPMENT

Astrophoto Accessories	Telescope Requirements	Camera Requirements
☐ basic camera adapter ☐ T-ring ☐ extra counterweights (optional)	☐ equatorial mount with clock drive preferred ☐ any focal ratio okay for the moon ☐ 2,000mm focal length best	☐ right-angle magnifier viewer (for S-C and refractors) ☐ fine-matte ground-glass screen (i.e., no microprism spot) ☐ mirror lockup ☐ self-timer on camera (use instead of cable release)

■ EYEPIECE-PROJECTION EQUIPMENT

Astrophoto Accessories	Telescope Requirements	Camera Requirements
☐ tele-extender or eyepiece-projection extension tube ☐ T-ring ☐ extra counterweights (optional) ☐ eyepieces (25mm to 6mm)	☐ equatorial mount with clock drive ☐ 5-inch telescope minimum ☐ f/10 to f/15 best	☐ right-angle magnifier viewer (for S-C or refractors) ☐ OR straight magnifier viewer ☐ clear centre spot focusing screen (very important) ☐ cable release

Another piggyback accessory is an illuminated-reticle eyepiece. It allows the observer to position a set of lit cross hairs on a star. Ideally, the telescope's drive should automatically keep the star centred on the cross hairs, ensuring pinpoint images on the film. However, because of drive errors and misaligned mounts, the star may appear to wander off. Using the right-ascension or declination slow-motion controls, the trick is to centre the star again carefully to avoid trailed images. The illuminated cross hairs make it easier to see where the centre is. When photographing with 28mm-to-135mm lenses, such guiding is not essential.

■ GUIDED PRIME FOCUS: DEEP-SKY OBJECTS

This is the most demanding area of astrophotography and therefore requires the most elaborate setup.

During the 10-to-60-minute exposures needed for prime-focus deep-sky pictures, the telescope cannot be left to track on its own. Minor speed variations in the drive would produce trailed stars, an aesthetic and technical flaw that is the bane of deep-sky photographers. To avoid this problem, manual guiding is required during the exposure. To do this, it is necessary to monitor the movements of a star near the object being photographed.

☐ Off-Axis Guiders

How do you look through a telescope when a camera is attached to the telescope's focus? The usual solution is an off-axis guider, which contains a small prism that deflects a star image from the edge of the field and sends it to an eyepiece. Celestron and Meade have off-axis guiders; Lumicon, Spectra Astro Systems and Versacorp make off-axis guiders for all brands of telescopes.

213

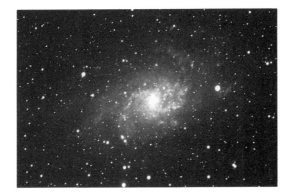

An alternative is a second, smaller telescope, a guidescope, piggybacked to the main unit with an adjustable bracket that allows it to be positioned independently. It is easier to find a bright guide star with this method than with the off-axis guider. The disadvantage is possible flexure between the guidescope and the main optics, producing false guide-star motions. When the guidescope moves in its housing, the astrophotographer mistakenly corrects the position of the main telescope, and trailed stars result.

Compared with a guidescope, an off-axis guider is much more convenient to set up and is more accurate. It is usually less expensive as well. In short, an off-axis guider is the preferred method despite the difficulty of finding a bright guide star near the object in question.

□ Drive Correctors/Speed Controls

The actual guiding can be done with a manual slow-motion control in declination, although an electronic slow-motion control is usually smoother. But in right ascension, where most of the corrections are needed, manual slow-motion controls are too crude. The tiny corrections must be done electronically. With AC synchronous motors, a drive corrector is required. This black box puts out 110 volts at 60 cycles AC for its normal speed. The fast button increases the output to 110 volts at 70 cycles, speeding up the motor, while the slow button produces a 50-cycle output and slows down the motor.

DC pulse motors do not require separate drive correctors. Most include a control paddle and the necessary electronics to vary the stepping pulse rate. Two to eight times the normal speed range is common. Two times the normal speed rate is best for performing the slight corrections needed during deep-sky photography; the high-speed rates are for fast slewing of the telescope around areas of the sky.

□ Guiding Eyepieces

All the guiding eyepieces have illuminated reticles. There are several options. Some are powered by separate battery packs. Others use small batteries placed in a compartment attached to the side of the

eyepiece. Cordless types are less prone to tangled cables, but the batteries can die in the cold, and replacements can be difficult to find. The best design employs a cable that plugs into a designated low-voltage jack on the telescope's control panel or drive corrector. Celestron has an interesting unit that projects an illuminated reticle into the field of any eyepiece and allows movement of the cross hairs to help select a guide star. It is heavier and bulkier than normal guiding eyepieces, but it works well.

Reticle patterns also vary. The best type defines the centre with dual cross hairs or a small circle so that when the star is accurately centred, it is not hidden behind the intersection of the cross hairs. A 12mm or 9mm focal length is adequate. For higher guiding power, a Barlow lens can be added.

□ Telecompressors

An optional deep-sky photography accessory is the telecompressor, commonly used with Schmidt-Cassegrains, although companies such as Astro-Physics have models for their refractors as well. A telecompressor is an achromatic lens that functions in a manner opposite that of a Barlow. It reduces the telescope's effective focal length, usually by a factor of 0.7 to 0.6, turning a standard f/10 Schmidt-Cassegrain into a fast f/7 to f/6 telescope. The result is smaller but brighter images and much shorter exposures. Meade, Celestron and Lumicon all market telecompressors.

□ Coma Correctors and Field Flatteners

Astrophotographers who use fast Newtonians for deep-sky pictures must contend with coma at the edge of the field—with an f/4 system, stars beyond the central 12 millimetres of the frame elongate into comet-shaped blobs. At f/5, the coma-free zone is a circle about 20 millimetres across. At f/6, only stars at the very corners of the frame are distorted. Coma-corrector lenses marketed by Celestron, Tele Vue and Lumicon greatly reduce coma in f/4 to f/6 Newtonians; they are expensive, but they work.

Schmidt-Cassegrains also have an off-axis aberration—a curvature of field that throws stars at the corners slightly out of focus. This problem is not as intrusive as the Newtonians' coma, but with f/6.3 Schmidt-Cassegrains, the field curvature is more noticeable. Celestron and Meade both have field flatteners for their telescopes.

A similar field flattener is sold by Astro-Physics for use with the Starfire line of apochromatic refractors. The lens corrects for field curvature beyond the normal 35mm frame, which allows the use of medium-format 120-film cameras such as a Pentax 6 x 7. This combination provides a sharp field three to four degrees wide while retaining the focal length necessary to resolve smaller deep-sky targets. Some of the most impressive photographs in this book were taken using such a setup.

■ *A portrait like this, showing a galaxy in far more detail than can be discerned visually, is a significant achievement—especially if you took the picture. Photograph by Rajiv Gupta.*

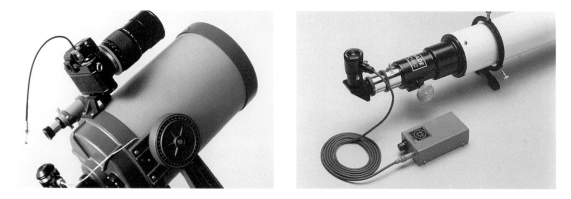

■ PIGGYBACK EQUIPMENT

Astrophoto Accessories

☐ piggyback mount/bracket
☐ illuminated reticle eyepiece (optional)
☐ drive corrector (for AC motors only)

Telescope Requirements

☐ solid equatorial mount with clock drive
☐ slow motions (manual okay)
☐ any optics will do

Camera Requirements

☐ nonbattery B setting
☐ high-quality fast lenses
☐ locking cable release

■ GUIDED PRIME-FOCUS EQUIPMENT

Astrophoto Accessories

☐ illuminated reticle eyepiece (essential here)
☐ drive corrector (AC motors)
☐ off-axis guider or separate guidescope
☐ T-ring for off-axis guider
☐ extra counterweights (optional)
☐ telecompressor (optional)
☐ coma corrector (optional); for Newtonians only

Telescope Requirements

☐ equatorial mount with worm-and-wheel clock drive
☐ slow motions (fine manual okay on Dec.; electric better)
☐ fast f/4 to f/6 telescope best
☐ any aperture okay (larger telescopes give bigger images)

Camera Requirements

☐ nonbattery B setting
☐ right-angle viewer (for S-C and refractors)
☐ fine matte or clear centre spot focusing screen
☐ locking cable release

■ *Left: A powerful, portable piggyback setup—a camera with a 180mm f/2.8 telephoto atop an 8-inch Schmidt-Cassegrain. Note the wire that provides current for the illuminated-reticle eyepiece. If the selected guide star stays in the telescope's cross hairs (reticle), the exposure will have nice round stars. Before trying through-the-telescope shooting, we recommend piggyback astrophotography. Most of the wide-field photographs in this book were taken using this surprisingly effective technique. Many manufacturers offer piggyback adapters for their telescopes.*

■ *Right: One option for guiding when shooting through the main telescope is to use a separate guidescope, as shown here, firmly mounted on the main telescope. Courtesy Meade Instruments.*

■ PHOTOGRAPHIC LIMITING MAGNITUDE

Focal Length	Faintest Stars Possible (magnitude)
24mm	9.5
28mm	10
35mm	10.5
50mm	11.5
85mm	12.5
135mm	13.5
180mm	14
300mm	15
500mm	16
1,000mm	17

Unlike visual limiting magnitude, which is aperture-dependent, the limiting magnitude of a photographic system is dependent on focal length, not aperture or focal ratio. For a given focal length, once the exposure is sufficient to reach the limiting magnitude, lengthening the exposure just increases the background sky glow. Focal ratio is a factor in determining the length of the exposure. Faster focal ratio means shorter exposures to reach limiting magnitude. Sky conditions, film resolution and optical quality are important too. Limiting magnitudes given in the table are for ideal conditions, good optics and optimum exposure.

The Essential Techniques

Astrophotography can be simple or complex. You are the arbiter. For some enthusiasts, celestial photography is a consuming passion, a hobby within a hobby. There is no limit to the depth of this aspect of backyard astronomy. For beginners, though, taking things step-by-step is crucial. Start simple. Basic tripod-and-camera techniques can produce startlingly beautiful results.

■ TRIPOD AND CAMERA ▋

Anything visible with the unaided eye can be captured on film with no telescope at all, just a camera on a tripod. Photographs that depict the sky virtually as the eye sees it can be taken with exposures of less than 60 seconds. Longer exposures produce results that border on the abstract.

■ SHORT EXPOSURES: CONSTELLATIONS

Pictures of the major constellations are a good starting point in astrophotography. The technique is simple, making it ideal for a first attempt at celestial portraiture. First, load a camera with Konica SR-G 3200, Kodak Ektar 1000, Fujichrome 1600D or some other ISO 1000 to 3200 colour film. Use a 50mm normal lens. Attach the camera to a tripod, and set the lens to f/2 and the shutter to B. Frame the constellation, and open the shutter for . . . ?

After "What film do I use?" the second most common astrophotography question is "How long should the exposure be?" For constellations, about 15 seconds. In exposures longer than that, the stars

move enough to become trails, rather than pinpoints. Shorter exposures may not show them at all.

With today's superfast films, it is amazing what can be recorded using this simple technique, provided that you shoot from a dark-sky location. An f/2 lens will reveal stars of at least eighth magnitude, much fainter than the naked-eye limit. The brightest sections of the Milky Way are within easy reach, yet with the slower films available a few years ago, they required lengthy guided exposures. Many deep-sky objects can be picked up in wonderful colours. Where your eye sees only white stars, the film will record the reds, yellows and blues that are hovering below the colour-perception threshold of human vision.

As the accompanying photographs show, the same technique can also be used to capture bright comets, planetary configurations and auroras.

■ LONG EXPOSURES: STAR TRAILS

Despite the chart showing maximum exposure times for photographs of the constellations, some

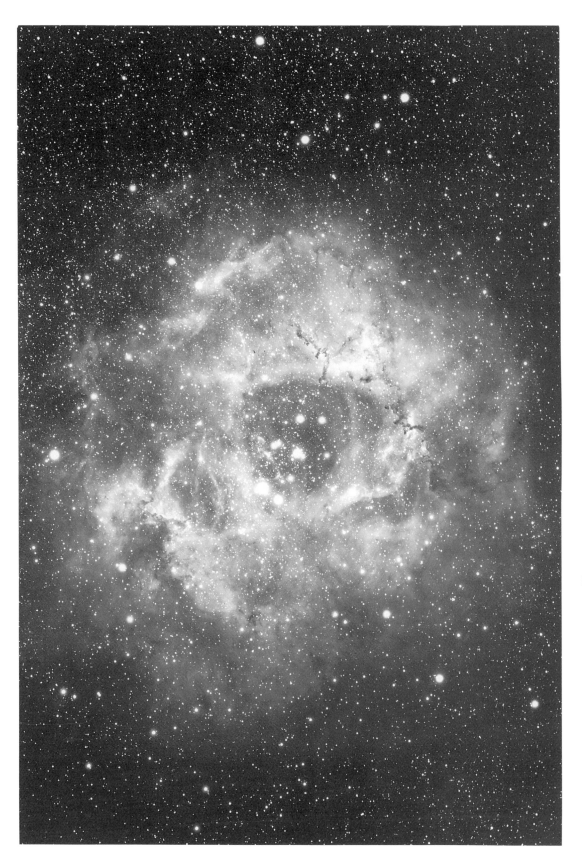

■ *The vast majority of astrophotographers take celestial portraits because their pictures reveal another universe, one of beauty and wonderment that is largely invisible to the human eye. This shot by Jim Riffle of the Rosette Nebula, in the constellation Monoceros, is a perfect example. In binoculars, the Rosette is a pale, ghostly haze around a small star cluster. Yet here, it is a magnificent, starstudded gaseous wreath; 90-minute exposure on Tech Pan 2415 with a 12-inch f/5 Astromak Maksutov-Cassegrain.*

The maximum exposure that can be used before trailing becomes noticeable depends on the focal length of the lens *and* on where in the sky the camera is pointed. During a given amount of time, stars near the celestial equator (Dec. 0°) move over a larger arc than do stars near the pole (Dec. 90°). Exposures for the Big Dipper can be longer than exposures for Orion before trailing begins.

Lens	Near Celestial Equator	Dec. of 45°N or S	Near Celestial Poles
28mm	25 sec.	40 sec.	90 sec.
50mm	12 sec.	20 sec.	50 sec.
105mm	6 sec.	10 sec.	25 sec.
200mm	3 sec.	5 sec.	12 sec.

■ FIXED CAMERA: Exposure Summary ■

Subject	Lens	Film	Focal Ratio	Duration
constellations	50mm	ISO 400 to 3200	f/1.4 to f/2	10 to 20 sec.
planets in dark sky	50mm to 135mm	ISO 400 to 3200	f/2 to f/2.8	4 to 20 sec.
planets in twilight	50mm to 135mm	ISO 64 to 200	f/2 to f/4	2 to 6 sec.
lunar haloes	35mm	ISO 100 to 400	f/2.8 to f/4	2 to 10 sec.
auroras	8mm to 50mm	ISO 400 to 3200	f/1.4 to f/2.8	4 to 20 sec.
zodiacal light	8mm to 28mm	ISO 400 to 3200	f/2 to f/2.8	1 min. +
star trails	28mm to 50mm	ISO 400	f/2.8 to f/4	5 to 60 min.
meteors	28mm to 50mm	ISO 400	f/2 to f/2.8	5 to 20 min.

of the most creative results arise from breaking the exposure rules. If the shutter is left open for more than a minute during a star shot, the stars will trail noticeably due to the Earth's rotation. It can produce a dramatic photograph. At a dark site, try exposures of 10 to 60 minutes. In this case, avoid using superfast films and lens apertures, as they will produce only washed-out skies. Instead, use standard ISO 100 to 400 film with the lens set at f/2.8 to f/4. Anything from a 24mm to a 50mm lens works well. Try aiming at the celestial pole (north or south, depending on your hemisphere). The result: an amazing set of concentric star trails circling Polaris or Sigma Octantis.

■ SHOOTING THE MOON ■

While the moon is certainly bright enough to be photographed with a short exposure, it is smaller than it looks—half a degree in diameter. Thus its image will be very tiny on the frame with standard camera lenses. To capture an image of the moon large enough to show features such as craters and mountains, use a 500mm or longer telephoto lens or a telescope. To determine the lunar image size with a particular lens or telescope, divide the focal length (in millimetres) by 110 to arrive at the lunar diameter (in millimetres) on the film.

What exposure should you use? Because of the moon's brightness, it is possible, although not ideal, to photograph it with long focal lengths without a drive or an equatorial mount. How long an exposure can be used before the motion of the sky blurs the image depends on the focal length of the lens. As with fixed-camera constellation shots, the longer the lens, the shorter the exposure must be to avoid blurring.

Any specific lunar-exposure recommendations we offer are based on our experience, but they are easy to calculate yourself. The key is to realize that the moon is simply a sunlit grey rock. If you are photographing a sunlit rock or scene on Earth, the rule of thumb is: at f/16, set the shutter speed at the reciprocal of the ISO speed of the film. For example, ISO 64 film at f/16 under full sunlight would be correctly exposed at 1/60 second. ISO 400 film would require 1/500 second (the closest setting to 1/400). The same rule applies to the full moon, even though it is 380,000 kilometres away. In practice,

Lens	Image Size on Film	Maximum Exposure to Avoid Trailing	
		Undriven	Driven at Sidereal Rate
50mm	0.45mm	12 sec.	4 min.
100mm	0.9mm	6 sec.	2 min.
200mm	1.8mm	3 sec.	1 min.
500mm	4.5mm	1 sec.	20 sec.
1,000mm	9mm	½ sec.	10 sec.
1,500mm	13.5mm	¼ sec.	7 sec.
2,000mm	18mm	⅛ sec.	5 sec.
2,500mm	23mm	$\frac{1}{15}$ sec.	3 sec.

■ EXPOSURE GUIDE FOR LUNAR PHOTOGRAPHY: Nominally f/16* ■

ISO Film Speed	Full Moon	Gibbous	First Quarter	Thick Crescent	Thin Crescent	Earthshine
3200	$\frac{1}{2,000}$	$\frac{1}{1,000}$	$\frac{1}{500}$	$\frac{1}{250}$	$\frac{1}{125}$	2 to 5 sec.
1600	$\frac{1}{1,000}$	$\frac{1}{500}$	$\frac{1}{250}$	$\frac{1}{125}$	$\frac{1}{60}$	5 to 10 sec.
800	$\frac{1}{500}$	$\frac{1}{250}$	$\frac{1}{125}$	$\frac{1}{60}$	$\frac{1}{30}$	10 to 20 sec.
400	$\frac{1}{250}$	$\frac{1}{125}$	$\frac{1}{60}$	$\frac{1}{30}$	$\frac{1}{15}$	20 to 40 sec.
200	$\frac{1}{125}$	$\frac{1}{60}$	$\frac{1}{30}$	$\frac{1}{15}$	⅛	40 to 80 sec.
100	$\frac{1}{60}$	$\frac{1}{30}$	$\frac{1}{15}$	⅛	¼	N/A
50	$\frac{1}{30}$	$\frac{1}{15}$	⅛	¼	½	N/A
25	$\frac{1}{15}$	⅛	¼	½	1	N/A

*Use one shutter speed faster around f/11 and two faster around f/8, and so on. As a general rule, though, always bracket exposures one or two shutter speeds either side of values given to account for atmospheric absorption and other vagaries. Use a lunar-rate drive for longer Earthshine photographs.

some light absorption by our atmosphere usually means increasing the exposure by about one f-stop or one shutter-speed increment. Therefore, the correct exposure for the full moon at f/16 with ISO 400 film is 1/250 second, not 1/500.

What happens if another focal ratio is used? Suppose you have an f/10 telescope, which is one full f-stop faster than an f/16. (Recall that the photographic f-stops run f/22, f/16, f/11, f/8, f/5.6, et cetera.) A gain of one f-stop means the shutter speed will be twice as fast. For the full moon, the exposure becomes 1/500 second instead of 1/250. With an f/8 instrument (two f-stops faster than an f/16), the exposure would be 1/1,000 second. The relationship between f-stop and shutter speed is reciprocal: as the aperture is increased, the exposure is decreased, and vice versa. In short, a change of one f-stop requires a change of one shutter-speed increment to give the same exposure.

What happens when using a film with a speed other than ISO 400? The relationship is again reciprocal. Decreasing the ISO speed by half (in this case, going to ISO 200 film) requires twice the exposure; doubling the speed requires half the exposure.

■ WHAT ABOUT PHASES OTHER THAN THE FULL MOON?

The most interesting lunar features are revealed along the terminator, which is best seen near first quarter and last quarter phases. A general rule is that a decrease of one lunar phase requires a doubling of exposure. However, no astrophotography-exposure calculation is guaranteed. Variations in film sensitivity and atmospheric absorption are only two of the unpredictable factors. It is always a good practice to take shots one to two shutter-speed increments either side of the recommended exposure. (Taking extra shots to ensure that at least one is properly exposed is a technique applicable to all aspects of astrophotography. Even veteran astrophotographers do it.)

Because the moon is so bright and offers so much

fine detail to record, the best images are captured on fine-grained film. This applies to those taken at prime focus through a telescope or through a long telephoto lens. Faster films are needed only for high-magnification close-up photographs using eyepiece projection. Kodachrome 25 and 64 are preferred colour-slide films. Kodak Ektar 125 is regarded as one of the best print films for the moon. For black-and-white work, Panatomic-X and Ilford Pan-F (both about ISO 32) are excellent, as is Kodak T-Max 100. Tech Pan 2415 (developed for low contrast) is another ultra-fine-grained black-and-white film.

■ THE SUN AT PRIME FOCUS

Nearly everything we have said about photographing the moon applies to the sun at prime focus or with a long telephoto lens. The sun has the same apparent size as the moon, making its image on film as small as the moon's. To pick out sunspots requires a focal length of at least 750mm.

What about the filter? The information about safe filters and solar-observing techniques in Chapter 9 applies to photography. *Never* attempt solar photography without a filter. You could easily damage your eyes and melt the inside of the camera.

A slow, fine-grained film is optimal for photographing the sun—Kodachrome 25 and Fuji-chrome Velvia are excellent colour-slide films. Among black-and-white films, Tech Pan 2415, developed for medium to high contrast (in either D-19 or HC-110 Dilution D), is the best choice, giving an effective ISO speed of 100.

Exposure depends on the density of the filter used. Both Mylar and metal-on-glass filters vary several f-stops in density from filter to filter, even while staying within the range of safety. In general, a good starting assumption is that the filtered sun is the same brightness as the full moon. One or two test rolls should narrow down the correct exposure for your own telescope, filter and film.

■ LUNAR AND SOLAR CLOSE-UPS

The disc of the moon or the sun will fill the frame at a focal length of 2,000mm, but for close-ups of selected areas, at least 4,000mm—sometimes more than 10,000mm—is needed. Few amateur telescopes have focal lengths that large, so how are they achieved? There are two techniques: negative projection and positive projection. The former uses a Barlow lens or camera teleconverter, while the latter uses a regular eyepiece. With both techniques, there is no lens on the camera itself.

Barlow lenses and teleconverters consist of con-cave, or negative, lenses. They project an enlarged image onto the film. Placing a 2x Barlow in the light path doubles the effective focal length of a telescope, but at a loss of two f-stops. This is probably the best application for 2-inch Barlows, which have limited use in visual astronomy.

An alternative to a Barlow is a 2x photographic teleconverter. Click the teleconverter onto the T-ring of the camera adapter, then attach the camera body to the teleconverter. The result is a sturdier hookup than can be achieved with most Barlows.

Negative projection is fine for a small increase in focal length, but for more power, switch to positive, or eyepiece, projection. Using an eyepiece inside a suitable extension tube on the camera adapter will yield focal lengths of up to 40,000mm and focal ratios of f/45 to f/200 or more.

■ EXPOSURES AND FILMS FOR CLOSE-UPS

To close in on a small sector of the moon or sun, you will need a focal length of about 10,000mm. Positive projection with an eyepiece of 25mm to 12mm is usually required. To calculate the approximate increase in focal length created by an eyepiece-projection setup, measure the distance in milli-metres from the eyepiece's eye lens to the camera's film plane. Divide this figure by the eyepiece focal length. This amplification factor (usually between 4x and 10x) is how many times your telescope's fo-

■ The Earth's turbulent atmosphere is the main barrier to capturing fine detail on the sun's surface. For this sunspot-group photograph on Tech Pan 2415 at 1/500 second, Brian Tkachyk used a Celestron C8 with f/50 eyepiece projection and a photographic solar filter, which is several f-stops faster than a visual filter.

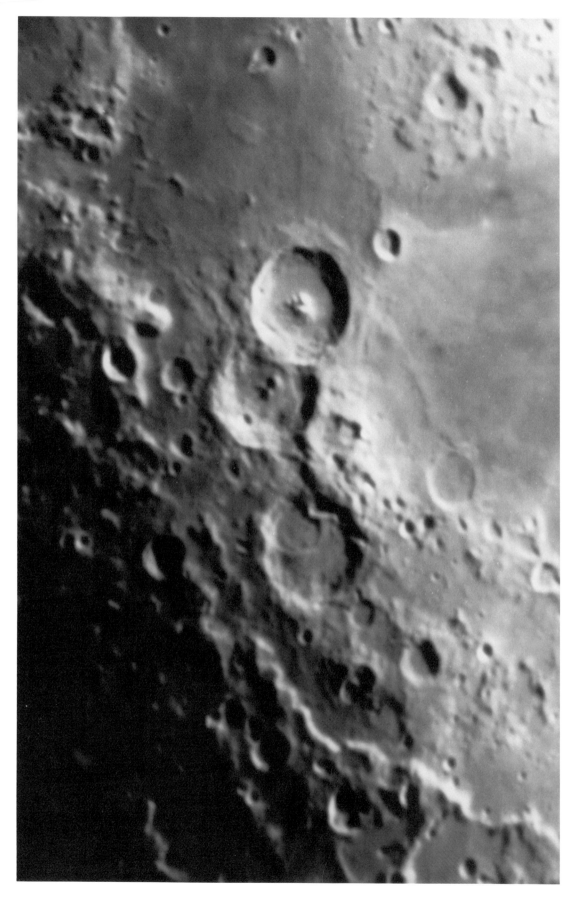

■ *Lunar close-up using eye-piece projection shows the region around the three giant craters Theophilus, Cyrillus and Catharina. Photograph by James Rouse, using a 4-inch Celestron fluorite refractor and Tech Pan 2415.*

cal length and focal ratio are increased. For example, 5x amplification on an 8-inch f/10 Schmidt-Cassegrain (2,000mm focal length) yields 10,000mm focal length and an effective focal ratio of 50.

Around f/50, exposure times for sunspots will be about ¼ second with ISO 200 film. The lunar terminator, regardless of the moon's phase, will require about 1 second with ISO 200 film.

■ PLANETARY PORTRAITS

Eyepiece projection is the only good technique for photographing the planets. There is no other way to make the planets appear large enough on film, since they are so small that with any focal length shorter than 10,000mm, they are submillimetre dots composed of a few lumps of film grain.

Check the "Image Sizes on Film" table for a breakdown of how big an image can be expected from each planet, although "big" is perhaps the wrong word. While focal lengths longer than the 30,000mm upper limit of the table would produce larger images, too high a power spreads the image into a faint, fuzzy disc. It is better to keep it sharper and brighter, between 2mm and 4mm across.

More than any other type of celestial photography, planetary work is a compromise between two conflicting requirements: the need for a large image to combat film grain and the need for a short exposure to compensate for seeing and drive errors. Even large telescopes at professional observatories have never overcome these problems. Planetary photography is tough. We recommend it as one of the last types of astrophotography to be attempted.

■ EXPOSURES AND FILMS FOR THE PLANETS

To capture detail on the planets, there would seem to be a choice: slow film and a short focal length, giving a small, bright image on a fine-grained emulsion; or fast film and a long focal length, yield-

■ THE PLANETS: Image Sizes on Film

Planet	Actual Size	Apparent Size With Various Focal Lengths				
		5,000mm	10,000mm	20,000mm	25,000mm	30,000mm
Mercury	9″	0.2mm	0.45mm	0.9mm	1.1mm	1.3mm
Venus						
full phase	10″	0.25mm	0.5mm	1.0mm	1.2mm	1.5mm
quarter phase	35″	0.85mm	1.7mm	3.4mm	4.2mm	5.1mm
crescent phase	60″	1.5mm	2.9mm	5.8mm	7.3mm	8.7mm
Mars						
smallest size	4″	0.1mm	0.2mm	0.4mm	0.5mm	0.6mm
average size	12″	0.3mm	0.6mm	1.2mm	1.5mm	1.7mm
largest size	24″	0.6mm	1.2mm	2.4mm	3.0mm	3.6mm
Jupiter						
smallest size	30″	0.7mm	1.5mm	2.9mm	3.6mm	4.4mm
near opposition	45″	1.1mm	2.2mm	4.4mm	5.5mm	6.5mm
Saturn						
planet diameter	16″	0.4mm	0.8mm	1.6mm	1.9mm	2.3mm
across rings	45″	1.1mm	2.2mm	4.4mm	5.5mm	6.5mm
Uranus	4″	0.1mm	0.2mm	0.4mm	0.5mm	0.6mm
Neptune	2″	0.05mm	0.1mm	0.2mm	0.25mm	0.3mm

Notes:

The "actual" size of a planet is its angular diameter measured in arc seconds. This size will vary depending on the distance of the planet from Earth. The apparent size on the film is measured in millimetres. Any image less than 2mm across is too small to be of much value. These sizes were calculated using the formula:

$$\text{SIZE ON FILM} = \frac{\text{Angular Size x Focal Length}}{206,265}$$

ing a larger, fainter image on a coarse emulsion. Exposure times could be the same in both cases. However, experienced astrophotographers have found that combining a medium-speed film with a focal ratio of about 100 produces the best compromise of a reasonably short exposure (to avoid the effects of poor seeing) and an image large enough to overcome the limitations of the film's resolving power and grain. With an 8-inch f/10 Schmidt-Cassegrain, the standard Meade or Celestron tele-extender adapter plus a 16mm eyepiece will yield an effective focal length of 18,000mm at f/96, which is close enough.

The best choice in colour film at this focal ratio is medium speed, such as Kodachrome 200, Ektachrome 200, Fujichrome 400, Kodak Gold 400 or Fujicolor Super HG 400. Higher-speed films are too grainy. In black-and-white films, we recommend the remarkable Tech Pan 2415, which when developed for high contrast produces a speed of about ISO 125. A shorter focal length and faster focal ratio (f/64 or so) are acceptable with this high-resolution film. All the black-and-white photographs in this chapter were taken with Tech Pan 2415 (unhypered).

Venus is the brightest planet; Jupiter, with its lower surface brightness, is three to four f-stops fainter; and Saturn is one to two f-stops fainter still. Mars at opposition is usually the brightness of Jupiter. Ballpark exposures at f/100 with the recom-

mended colour films are: less than 1 second for Venus, 1 to 4 seconds for Jupiter and Mars and 2 to 10 seconds for Saturn. To minimize atmospheric blurring, exposures should be less than 5 seconds.

Planetary photography is not easy—especially with small telescopes. For example, a 3-inch telescope at the suggested focal ratio of f/100 yields a focal length of only 8,000mm. Even with a super-fine-grained film such as Tech Pan 2415 (at ISO 125), the images are too small and the exposures are too long. Venus's brightness and size make it the only planet accessible to a 3-inch telescope. For the other planets, a 4-inch is minimum and a 6- or 8-inch aperture is far better.

■ DEEP-SKY PIGGYBACK PHOTOGRAPHY ■

Lunar and planetary astrophotographers strive to record all the detail visible through the eyepiece. In deep-sky astrophotography, the camera's long exposures capture details and objects the eyes cannot see, revealing an otherwise invisible universe.

All aspiring deep-sky astrophotographers should first go through the school of piggyback astrophotography. Only when you have mastered sharp, nontrailed piggyback exposures should you venture into the arduous world of prime-focus deep-sky work—the through-the-telescope shots. But piggyback astrophotography is not just a stepping-stone to higher accomplishments. Far from it. It is a powerful technique that can produce stunning results. In fact, piggyback work may give you all the photographs you need to satisfy the urge to capture glowing deep-sky objects in star-filled frames.

The big task is guiding, which becomes more demanding in proportion to the focal length of the lens being used. With wide-angle and normal lenses (20mm to 50mm), guiding is easy, and if the telescope is aligned within half a degree of the celestial pole, no guiding should be necessary.

With a 200mm lens, a well-aligned telescope requires only occasional adjustments. However, when shooting through a 2,000mm-focal-length telescope, guiding is a physical and mental strain.

Why is guiding necessary? After all, telescopes have clock drives to take care of that, don't they? They do, up to a point. But to expect a mount and drive to keep stars centred to an accuracy of a few arc seconds for more than half an hour is expecting too much even of modern machining and electronics. Besides, there are other factors such as atmospheric refraction that will also slightly shift the image during a long exposure. However, the major source of image drift with portable setups is that the telescope is not precisely polar-aligned. The real solution is more accurate alignment, but exact polar alignment can be time-consuming and difficult with portable equipment. The only method to compensate for all of these factors is manual guiding.

■ GUIDING TOLERANCES

To determine how far the guide star can drift before the photograph becomes spoiled by trailed stars, put

■ *This is the setup James Rouse used to take the photograph on page 221 and several other shots in this book. With a motorized focuser and a bulb shutter release, he avoids jiggling the telescope. The extension tubes house an eyepiece used for image projection to the camera. This effectively increases the 4-inch fluorite refractor's f/9 focal ratio to anywhere from f/30 to f/90.*

■ To track the sky without an equatorial mount, you can build a "barn-door" platform for a few dollars that will keep your camera aimed at the stars for up to 10 minutes. Coupled with today's ultrafast films, the photographs obtained with this simple setup will rival the best piggyback shots. The secret is to use a lens no longer than about 135mm. The actual tracker is made of two hinged pieces of wood. One piece is fixed to a camera tripod; the other has the camera on it, mounted on a ball-and-socket tripod head that allows the camera to face any region of the sky. The platform itself is aimed so that the hinge points at the celestial pole. A sighting tube or inexpensive finderscope attached to the top board near the hinge serves as a pole finder. As the top board turns around this hinge, it and the camera it carries are essentially rotating around a polar axis. The two boards have a threaded rod running between them that gradually separates the two halves as it turns. The rotation can be supplied by hand or with an electric motor. In manual models, as shown here, the distance from the hinge point to the ¼-20 threaded rod must be 11 $7/16$ inches. If the rod is turned $1/60$ of a turn every second, then the camera will track the stars. For more information, see the October and November 1985 issues of Sky & Telescope.

the reticle eyepiece in the guidescope and locate a star fairly close to the celestial equator. Now, turn off the drive for the following interval, depending on the focal length of your telescope or telephoto lens: 50mm, 12 seconds; 100mm, 6 seconds; 200mm, 3 seconds; 400mm, 1½ seconds; 800 mm, ¾ second. The star might move only the width of a cross hair. That distance is the allowable guiding tolerance. If, during the exposure, the guide star moves any farther than that in any direction, the stars will be trailed. Clearly, for focal lengths longer than 800mm, the tolerances are tight. Some quick excursions can be tolerated, especially at the end of an exposure, when the film has lost much of its sensitivity. But if the guide star spends any time away from its "correct" position, start again.

The advantage of photographing with shorter focal lengths is clear: the star can move around much more before the photograph is ruined. The advantage of high power for the guiding eyepiece is also apparent. Small movements of the guide star are easier to detect. However, at higher power, the guide star is fainter and more difficult to see. In general, guiding requires a magnification of at least 100x. For critical work at focal lengths of 1,500mm or more, 200x to 400x is often used by veteran astrophotographers. Start with short-focal-length lenses, then work up.

■ EXPOSURES AND FILMS FOR PIGGYBACK SHOTS

The immediate inclination with deep-sky work is to use as fast a film as possible. Certainly, ISO 1000 to 3200 film will record faint objects very quickly, often in less than 5 minutes, making guiding frequently unnecessary with lenses shorter than 135mm. The new films are remarkably fine-grained

(measurements are for 35mm-format cameras)

Focal Length	Field of View
18mm	67° x 90°
24mm	53° x 74°
28mm	46° x 65°
35mm	38° x 54°
50mm	27° x 40°
85mm	16° x 24°
105mm	13° x 20°
135mm	10° x 15°
200mm	7.0° x 10°
300mm	5.0° x 7.0°
400mm	3.5° x 5.0°
500mm	2.75° x 4.0°
600mm	2.5° x 3.5°
800mm	1.75° x 2.5°
1,000mm	1.4° x 2.0°
1,500mm	1.0° x 1.3°
2,000mm	0.7° x 1.0°

for their speeds, but they are still grainy. In piggyback astrophotography, we are usually dealing with lots of small-scale detail. As with lunar and planetary work, the trick is to use as slow a film as possible.

In general, the best piggyback results are produced with a medium-speed film and longer guided exposures (5 to 30 minutes at f/2 to f/2.8), rather than the shoot-and-run technique involving superfast film. A few years ago, Fujichrome 400 was a favourite for piggyback work. Then Fuji changed the 400's emulsion formula, reducing the red sensitivity important for picking up emission nebulas. Kodachrome 200 has outstanding fine grain and red sensitivity, but it tends to turn magenta during long exposures. Our favourite slide film is Scotch Chrome 400. It has nearly as fine a grain structure as Fujichrome 400, has better overall sensitivity and retains its speed well throughout long exposures. Unfortunately, Scotch Chrome 400 is not as widely available as more familiar brands, but it is worth tracking down, especially for piggyback work. On the other hand, the more readily available Kodak Ektachromes produce greenish skies and lose speed rapidly during extended shots. Although some astrophotographers have had success with the Ektachromes, we do not recommend them for piggyback shots.

In colour print films, the medium-speed Fujicolor Super HG 400, Kodak Gold 400 and Konica 400 are all highly rated because of their fine grain and medium speed, but custom printing is usually re-

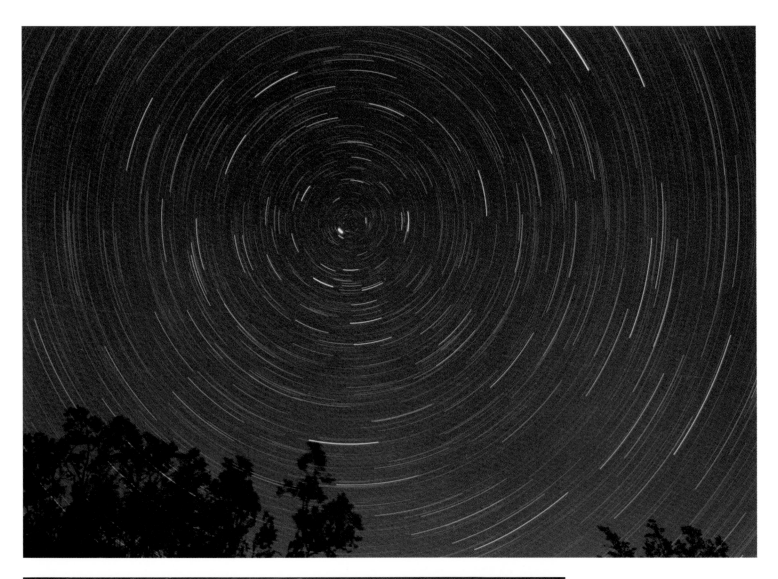

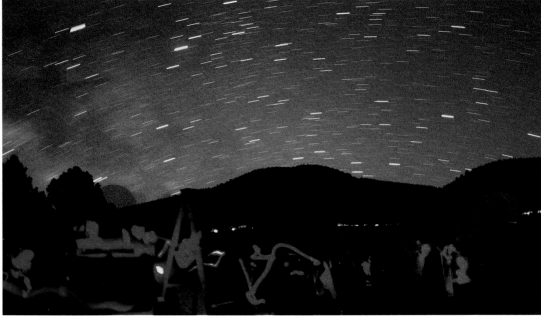

■ Above: Of all types of celestial photography, star trails are the simplest to take. This is one of the few ways a standard zoom lens can be used in astronomy. Photograph by Terence Dickinson; 90 minutes with 35mm lens at f/3.5 on Fujicolor 200.

■ Left: Star parties where no one dares brandish a white-light flashlight are ideal settings for star-trail photographs such as this one from the Riverside Telescope Makers Conference. Alan Dyer used a 28mm f/2 lens and Fujichrome 400 for the 20-minute exposure.

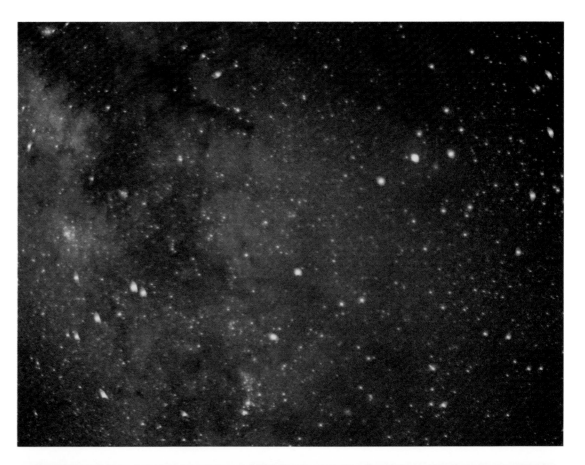

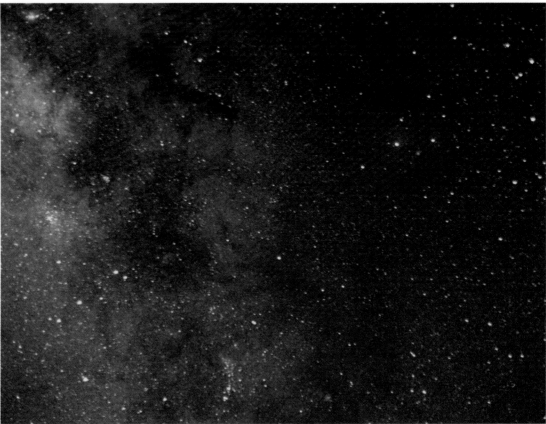

■ Almost all camera lenses shorter than 90mm focal length cannot be used "wide open" for astrophotography. Even the best lenses do not correct all aberrations at very fast focal ratios like f/2 or f/1.4. These two photographs by Alan Dyer demonstrate the problem and its solution. Both are 30-second exposures of Scorpius with the same Nikon 50mm f/1.4 lens on Konica SR-G 3200 print film. The top photograph used the lens wide open at f/1.4. At right, the lens was stopped down one full f-stop to f/2. Not only are the stars much sharper in the f/2 image, but there are just as many if not more stars shown. Lenses of lesser quality may require a retreat of 1½ or 2 f-stops to produce sharp star images across most of the field. Good-quality telephoto lenses 90mm or longer can be used wide open.

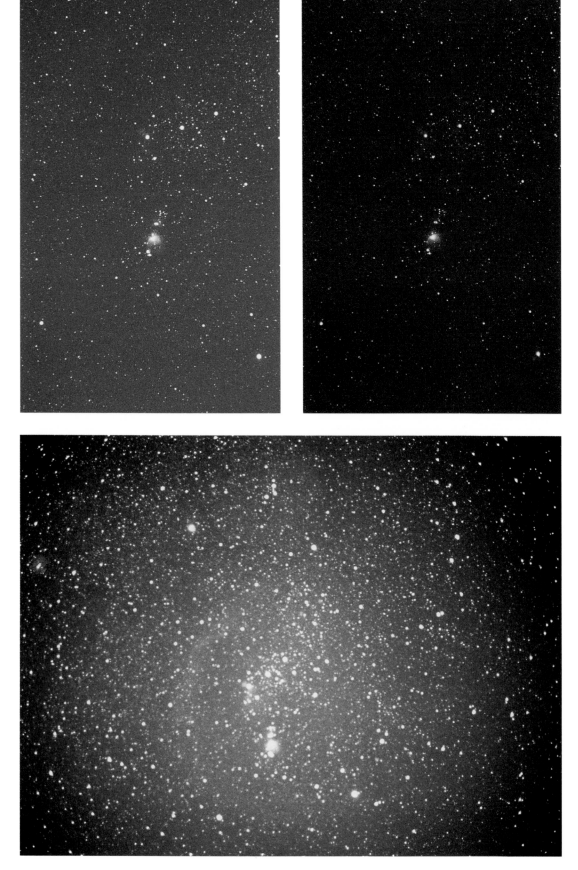

■ Top: Two photographs taken the same night with the same 85mm f/2 lens show the effects of Lumicon's Deep-Sky filter. Two-minute exposure at left (no filter) is overexposed and washed out from light pollution. At right, the filter dramatically cuts light pollution and sky glow but lets the stars, and particularly the Orion Nebula, shine through. Exposure was increased to 5 minutes to account for the filter. Fujichrome 400 was used, which responds well to this filter's characteristics. Photographs by Terence Dickinson.

■ Left: Even the best standard camera lenses 50mm or shorter produce vignetted fields (the centre is brighter than the edges). This is a property of short-focal-length, fast-focal-ratio optics, but it seldom reveals itself in standard photography. However, in astrophotography, a smooth, dark background is desired. Stopping down the lens helps, but vignetting cannot be eliminated entirely. Photograph by Mark Kaye.

227

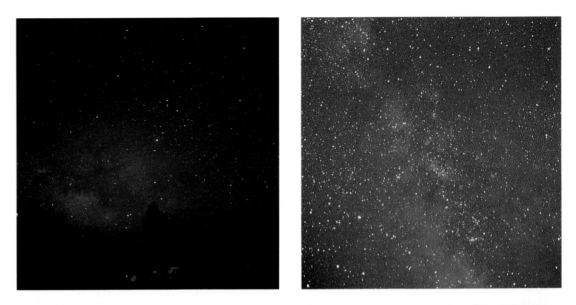

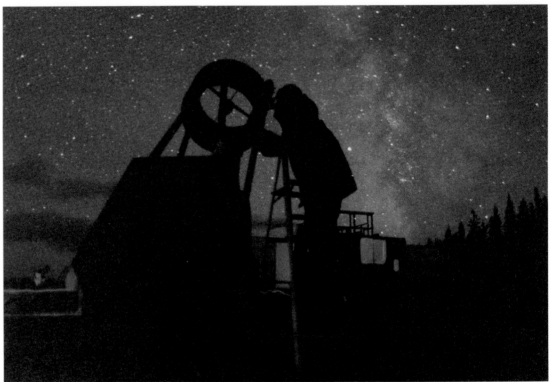

quired to realize their potential. Among black-and-white films, T-Max 400 and T-Max P3200 have excellent grain for their speeds. Tech Pan 2415 is better still, but only if it is hypersensitized.

RECIPROCITY FAILURE

Most piggyback exposures are best if kept at less than 30 minutes. Even if you could tolerate guiding for longer than that, the result might not be any better than with a 30-minute shot. The reason is a film flaw called reciprocity failure. In standard photography, exposures shorter than a few seconds have

a straightforward relationship: if the shutter is open twice as long, the film records twice as much light. However, beyond a few seconds, the relationship breaks down. A 60-minute exposure does not record twice as much light as a 30-minute one, and a two-hour shot may not pick up any additional information at all. The new incoming light simply does not trigger the film's atoms into doing anything, meaning much more effort for much less output.

An ISO 400 film can drop to an effective speed of ISO 25 after 20 minutes. Reciprocity failure varies from film to film. Two of the best are Konica SR-G

Filter	Film	Cuts Out These Wavelengths	Increase Exposure	Cost (approx.)
Colour or B&W				
No. 1A Skylight	colour or B&W	shorter than 480nm	0x	$15
Minus Violet	colour or B&W	shorter than 440nm	1.1x	$50
Lumicon Deep-Sky	colour or B&W	shorter than 440nm & from 540nm to 620nm	3x	$120
B&W				
No. 25 Red	B&W 2415	shorter than 580nm	1.5x	$15
No. 29 Red	B&W 2415	shorter than 600nm	1.5x	$15
No. 92 Red	B&W 2415	shorter than 620nm	2x	$15
H-Alpha Pass	B&W 2415	shorter than 630nm	3x	$50

The skylight and Minus Violet filters let through all colours except ultraviolet and deep violet light. The Lumicon Deep-Sky filter also cuts out the yellow-green band but lets through blue, blue-green and deep red. The various red filters and the H-alpha filter block all colours except varying amounts of red.

3200 and Scotch Chrome 400; both continue soaking up light during extended exposures. In some cases, slower films are as good as fast ones for deep-sky work. As in the story of the tortoise and the hare, the fast films leap ahead initially but are eventually passed by the slower films that hold out over the exposure. Because films are reformulated every few years, trial and error is often the only guide.

Colour films have another problem—the reciprocity failure does not occur equally in each colour-sensitive emulsion layer. This creates a colour shift during long exposures, often resulting in magenta, green or brown background skies. Hypersensitizing film, discussed in the next chapter, is a technique that greatly reduces reciprocity failure.

■ FILTERS FOR PIGGYBACK WORK

For piggyback astrophotography in colour, there is a limited selection of useful filters. A No. 1A skylight filter or an ultraviolet filter helps cut down sky fog a modest amount, although both serve best as lens protectors. Lumicon markets an interesting variation called the Minus Violet filter. Like the ultraviolet and skylight filters, it also eliminates ultraviolet and violet light but has a deeper cutoff point that pushes slightly into the visible part of the spectrum. It filters out the shorter wavelengths that contribute most to chromatic aberration. This yields sharper star images, especially with telephoto lenses.

Most nebula and light-pollution filters on the market are not suitable for colour photography. Lumicon's Deep-Sky filter is an exception, since its bandpass is broad enough to be effective with colour films. It dramatically cuts sky fog (sky background illumination from natural and artificial sources), but exposure times must be tripled to accommodate it. In typical dark but not black skies, a 45-minute exposure at f/2.8 on ISO 400 film would be hopelessly fogged without the Deep-Sky filter, but with it, the result is a dark sky with good red nebulosity. The filter imparts a pinkish cast to colour film, but since many films have a tendency toward greenish sky backgrounds in long exposures, the Deep-Sky filter helps rebalance the colour. We have found this filter is especially effective with Fujichrome 400 film. Most other light-pollution filters not specifically intended for astrophotography cut out so much of the spectrum that photographs taken through them have a very strong colour cast.

The best filter for black-and-white film is another marvel from Lumicon, the H-alpha filter. Not to be confused with the expensive H-alpha filters used for solar observing, the deep-sky H-alpha filters resemble ordinary camera filters that screw onto the front of the lens. They cut out all colours except the extreme red end of the spectrum that includes the H-alpha line (where many nebulas emit much of their light). This filter must be used with hypered Tech Pan 2415. No other readily available black-and-white film has enough sensitivity in the red end of the spectrum. With hypered Tech Pan 2415 and an H-alpha filter, a large amount of nebulosity can be photographed even from suburban locations.

However, the disadvantage of H-alpha filters is their extreme darkness, which makes it difficult to see through them in order to focus and frame the photograph. For piggyback astrophotography, the image can be framed with the filter off, but focusing is still a problem. It may be necessary to move the focus closer to the infrared mark on the lens

barrel. The exact setting for any particular lens will require a series of test exposures.

Since H-alpha filters cut out so much light, exposures through them on hypered Tech Pan 2415 may have to extend for 30 to 60 minutes even at f/2. H-alpha photography is effective only for emission nebulas. Do not expect the filter to enhance photographs of galaxies, blue-reflection nebulas or bright comets. Most of the green-coded objects plotted in the deluxe edition of the *Sky Atlas 2000.0* are emission nebulas.

A less expensive but still effective method of cutting through sky glow is to use a plain No. 25 red filter, stocked by any camera store. With a broader bandpass than an H-alpha, a No. 25 lets through more light and has a less drastic effect on exposures. At f/2.8, try 30 minutes. (No. 29 or No. 92 filters are a little deeper than a No. 25, but not as severe as an H-alpha.)

While red-light photography is generally considered to be specific to black-and-white film, it can also be applied to colour emulsions: place a No. 25 filter over the lens for half of the allotted time, and complete the exposure without a filter. Some astrophotographers have found that this method works well for enhancing red-emission nebulas.

■ It is amazing what a standard lens can do. Here, Brian Tkachyk stopped down a 55mm lens to f/2.8 to obtain pinpoint star images. He used the finest-grained film, gas-hypered Tech Pan 2415 and a deep red filter for the 45-minute piggyback exposure. The result: a plethora of nebulas in the Orion region. The Rosette is at upper left; Barnard's Loop is the large arc on the left side of Orion.

■ PRIME-FOCUS DEEP-SKY PHOTOGRAPHY ■

Prime-focus deep-sky work is the point at which many aspiring astrophotographers start their hobby; unfortunately, all too often, it is where many find their enthusiasm coming to an abrupt end. All they have to show for their efforts are some blurry photographs, a depleted bank account and an advertisement in the astronomy-magazine classifieds for a "complete astrophotography outfit, seldom used, mint condition, best offer." We strongly recommend that beginners go slowly and first master the less demanding requirements of piggyback work.

Many of the objects that show up well on piggyback exposures through lenses under 500mm focal length are too large for prime-focus work, which typically operates at focal lengths between 750mm and 2,500mm and with fields of view of one degree or less. The targets for prime-focus shooting are small and preferably bright deep-sky objects.

230

The two best objects for cutting your teeth on prime-focus work are the Ring Nebula, visible April through November, and the Orion Nebula, visible October through April. Both are bright enough to show up well on a 5-to-10-minute exposure, even at f/10. Initial photographs of these objects may be trailed, underexposed or a little out of focus, but enough will show up so that you will know you are on the right track. Analyze your less-than-perfect Ring Nebula or Orion Nebula pictures, figure out what went wrong, then try again. Galaxies are too faint for beginning targets. Also avoid open clusters and globular clusters; they are bright, but a star-filled field makes the slightest trailing stand out.

■ EXPOSURES AND FILMS FOR DEEP-SKY PHOTOGRAPHY

At telescopic apertures, it is easy to reach stars as faint as magnitude 15 or 16 photographically. However, extended objects fainter than eighth or ninth magnitude require fast film and/or fast focal ratios. For the brighter objects, a 400-speed film should work fine. Fujicolor Super HG 400 is a favourite. But most prime-focus subjects will benefit from the use of faster films. The standouts in this category are Konica SR-G 3200 and Ektar 1000 (for prints) and Scotch Chrome 400 pushed to 1600 (for slides). Exposures with these superfast films can be as brief as 3 minutes for the brightest objects, but endurance sessions of 15 to 90 minutes are more common, especially with systems slower than f/6. Again, for black-and-white film, hypered Tech Pan 2415 has vanquished all contenders.

■ FILTERS AT PRIME FOCUS

The same array of filters useful in piggyback astrophotography can be employed in prime-focus work. For colour pictures, many astrophotographers have found a Lumicon Deep-Sky filter worthwhile for less-than-perfect skies. The Minus Violet filter is not needed with reflector telescopes, since there is no chromatic aberration to worry about, and Schmidt-Cassegrains have their own Minus Violet filter, the corrector plate. For hypered Tech Pan 2415 film, a No. 25, No. 29 or No. 92 red or an H-alpha filter is generally preferred to a nebula filter for reducing sky glow and enhancing emission nebulas. However, using any filter for prime-focus photography introduces additional complications.

First, the filter must be placed in the light path. Meade and Celestron Schmidt-Cassegrains accept special drop-in filters in their rear cells. The off-axis guider screws onto the cell and holds the filter in place. Meade and Celestron also offer nebula filters that screw onto this cell; the guider/camera adapter then screws onto the filter. The disadvantage of both methods is that the light going to the

guiding eyepiece is also filtered, making it difficult to see the guide star. Lumicon guiders accept any 48mm-diameter filter in a position after the pick-off prism, so light going to the guiding eyepiece is unfiltered—the preferred arrangement.

Second, no matter where the filter is in the system, its use shifts the focus point considerably. You must therefore refocus with the filter in place. When the filter is as dark as an H-alpha, this can be a problem, since it is difficult to see anything through it. One trick is to insert a less dense filter, focus and frame the object, then switch back to the H-alpha. For this to work, the dummy filter must be the same thickness as the H-alpha.

■ FINDING A GUIDE STAR

The most important task in setting up an astrophoto is finding a bright guide star close to the target object. With a separate guidescope, it is not too difficult, although the pointing adjustments may need to be fiddled with to get everything lined up. To avoid field rotation, always use a guide star within three degrees of the subject.

Using an off-axis guider is more limiting because of the small field of view. Suppose, as frequently happens, not a single guide star is available. To bring one to the centre of the cross hairs, you must move the telescope in right ascension and declination. But doing that will move the target object, cutting it off at the edge of the frame. After 10 or 15 minutes of fussing, you settle for a fainter guide star, in order to keep the target object well framed. To use this star, however, puts the guiding eyepiece at a neck-straining angle. You tolerate the position; about 10 minutes into the exposure, the guide star begins to fade. Where is it? Then you catch sight of it again, far off centre, and hurriedly recentre it. And so it goes for perhaps another 30 minutes.

The longer you stare at a guide star, the fainter it gets. It is almost as if your eye and brain have a reciprocity failure of their own; after several minutes of constant staring into an eyepiece, it becomes more difficult to see faint stars and even the cross hairs. Gusts of wind blowing across your face that make your eyes water or a careless breath on the eyepiece that causes it to fog up contributes to the discomfort. Keep repeating to yourself, "This will be a great shot, this will be a great shot . . ."

If the process sounds tedious (and it is), start saving for one of the new CCD auto-guiders. For $800, these ingenious devices take all the work out of guiding. Once properly aligned, the light-sensitive CCD chip senses any motion of the guide star away from its original position and pulses the drive motors to compensate, automatically ensuring a guiding accuracy of one arc second. During the exposure, you can enjoy the stars.

■ The late Alfred Lilge, an outstanding astrophotographer, used a 12-inch telescope equipped with all the accessories for sky shooting. Here, he is seen using an off-axis guider, the most common method of guiding long-exposure prime-focus photographs.

Eclipses, Gremlins and Advanced Techniques

Learning the basic techniques of astrophotography is just the beginning. True mastery of the art comes only after making lots of mistakes and learning from them. Later in this chapter, we will review some of the things that can go wrong. First, though, the essentials of eclipse photography, the one category of astrophotography that almost all backyard astronomers attempt sooner or later.

■ LUNAR ECLIPSES ■

An eclipsed moon glowing deep red against a background of faint stars is an irresistible target. Striking photographs can be taken without resorting to elaborate equipment.

■ LUNAR-ECLIPSE PHOTOGRAPHY WITHOUT A TELESCOPE

The simplest technique for recording a lunar eclipse is the same method used to photograph untrailed constellation patterns. With a 50mm lens and fast film (ISO 400 to 3200), expose up to 15 seconds at f/2 to f/2.8. Use exposures for the normal full moon until the shadow is halfway, then descend in steps until you reach 15 seconds for full totality.

Since the moon's image on film will be very small when a standard 50mm lens is used, most people use their longest telephoto and 2x teleconverter. Such a setup works well during the partial phases when the moon is bright, but not during totality.

With a stationary tripod-mounted camera and a long telephoto lens, the moon's motion will blur its own image if exposures are more than 1 second or so (2 seconds for 300mm; 1 second for 500mm). During totality, use ISO 1000 to 3200 film. For a very dark eclipse, even fast film may not be sensitive enough to keep exposures under 2 seconds.

The eclipse-streak photograph is an interesting and easy alternative. Lock the shutter open, and let the moon move across the frame for the duration of the eclipse. The result is an unusual light streak the width of the moon that gradually fades from white to red and back to white again. A normal 50mm lens for a 35mm single lens reflex (SLR) camera has a field of view wide enough to record the continuous motion of the moon across the sky for 2½ hours, more than long enough to last from the start to the finish of totality.

To avoid excessive light buildup from sky glow and city lights during the eclipse-streak exposure, stop the lens down to f/16. Use a slow film like Kodachrome 64. At the beginning or the end of the exposure, you might also try a double exposure of an extra 2 to 4 seconds at f/2.8 to add foreground landscape details.

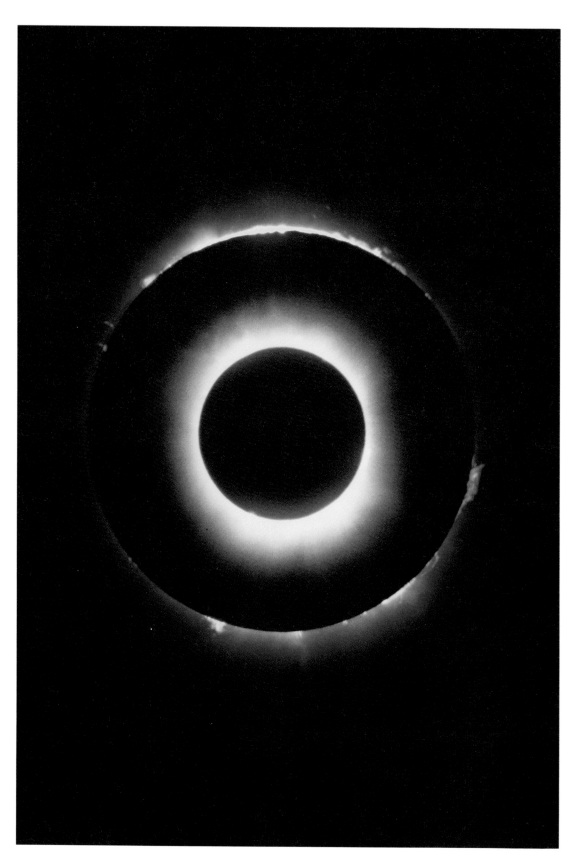

■ *James Rouse's imaginative composite of three total-eclipse exposures shows the sun's corona inside a complete ring of prominences. Prominence ring is two photographs taken on Ektachrome 200 through a 5-inch Schmidt-Cassegrain. Corona was shot on Kodachrome 64 with a 400mm f/6.3 telephoto.*

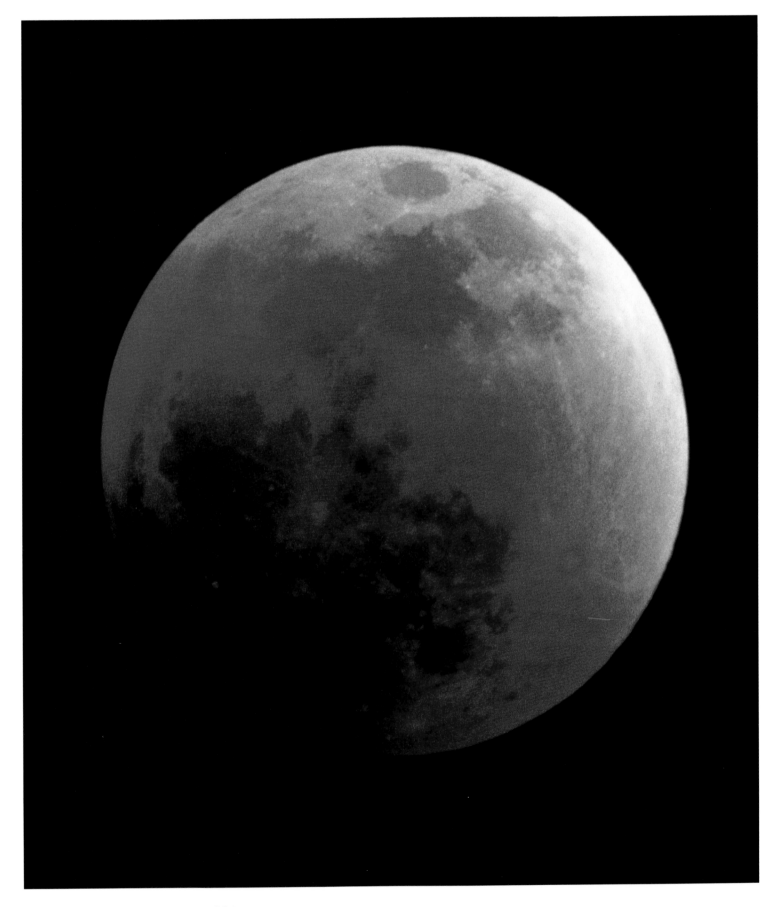

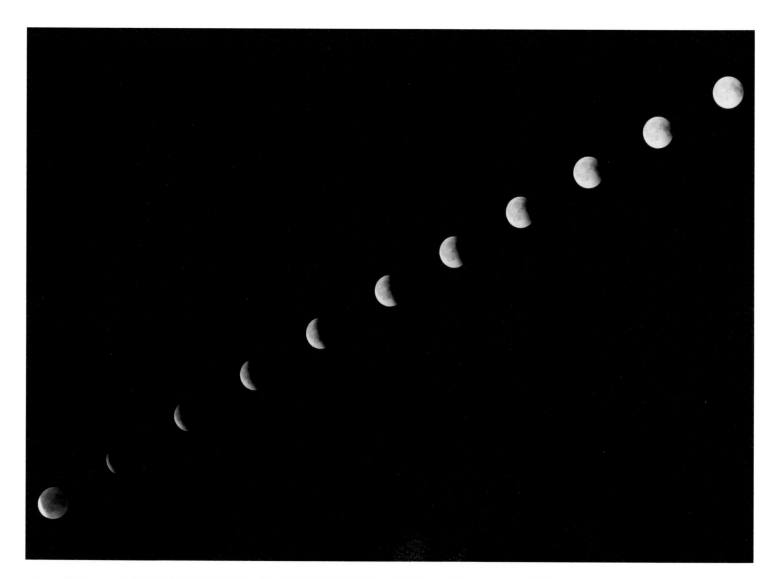

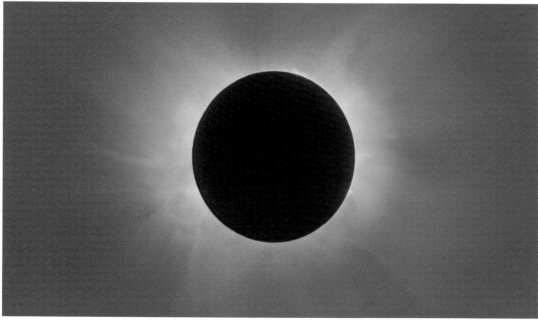

■ Above: By photographing the partially eclipsed moon every 10 minutes on the same frame of film, William Sterne captured the moon's exit from the Earth's shadow.

■ Left: Delicate loops and filaments in the solar corona, which are very difficult to capture on film, are well seen in this shot of the February 26, 1979, total solar eclipse. Photograph by William Sterne, using a 3-inch f/12 refractor.

■ Facing page: The total lunar eclipse of August 16, 1989, was one of the most widely observed celestial events in history. Photograph by Terence Dickinson, using a 5-inch refractor; Kodachrome 200.

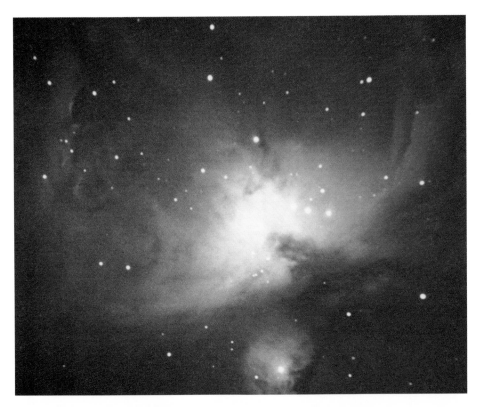

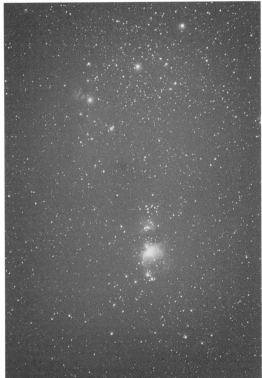

■ Above: Visible for just a few seconds at the beginning and end of a total solar eclipse, the spectacular diamond ring is one of the greatest sights in nature. Photograph by Robert May, using a 5-inch f/8 refractor; Kodachrome 64, 1/250.

■ Right: At the midpoint of the August 16, 1989, total lunar eclipse, the full moon was transformed into a rust-hued globe by the Earth's shadow. Photograph by Terence Dickinson.

A variation of the streak photograph uses the same equipment, but instead of taking a single long exposure, many short exposures are taken on the same frame at regular intervals. The result is a photograph with multiple moons in the sky, each recording a different stage of the eclipse. You will need a camera capable of making multiple exposures on one frame. There is no opportunity for bracketing such a photograph, so the exposure estimates must be correct. Exposures should be made every 5 to 10 minutes. The motion of the sky carries the moon its own diameter in about two minutes; exposures made more frequently than this would create overlapping images.

For an especially creative challenge, combine the streak method with multiple exposures — have the moon streak into position, appear singly or in a series of images, then streak off the frame. Hang that photograph on your wall, and it is a guaranteed conversation piece for years.

■ LUNAR-ECLIPSE PHOTOGRAPHY WITH AN EQUATORIAL MOUNT

A camera riding piggyback on an equatorially mounted telescope opens up possibilities not available to standard tripod setups. Use a 50mm-to-500mm lens to take exposures up to 10 minutes during totality. With ISO 400 film, the eclipsed moon may be overexposed, but the idea is to record the background stars as they frame the dimmed full moon. Of course, a dark site is a prerequisite. Manual guiding on a star should not be strictly necessary, provided that the mount is properly polar-aligned

and the drive is tracking. Use the normal sidereal rate rather than the lunar rate.

For frame-filling photographs of a blood-red moon, shoot through a telescope. During the partial phases, exposures for the sunlit part are in the same range as exposures for the normal full moon, although the exposure times increase as the eclipse progresses. Just before the beginning of totality, the exposure for what is left of the bright area of the moon will be three or four f-stops greater than at the beginning of the partial umbral phase. Exposures for the shadowed half of the moon are from 1 to 20 seconds with ISO 400 film — the same range required to record Earthshine. Exposing for the darkened sector will greatly overexpose the sunlit side. This is all right just before and after totality, but in the early and later stages of the partial eclipse, it is best to expose for the bright half and let the dark part disappear.

Bracket over and under by at least two shutter-speed increments at every stage of the eclipse. Even veteran astrophotographers use ample bracketing and, typically, three or four rolls of film for a total lunar eclipse. There is plenty of time to change rolls. A slower film (ISO 64 to 100) could be used for the partial phases.

During totality, switch to a faster ISO 400 film, but have a roll of ISO 1600 film handy in case it is a rare "black" eclipse. For darker eclipses, exposures can extend up to 80 seconds, even at f/5. The mount has to be precisely polar-aligned, and the drive must be running at a slower lunar rate (about 4 percent slower than the sidereal rate).

■ SOLAR ECLIPSES

There is no more dramatic astrophoto than one depicting a total eclipse of the sun. It seems that everyone who makes the effort to see an eclipse wants a photograph of it. Fortunately, total eclipses are among the easiest astronomical subjects to capture on film. The problem is to contain your excitement enough to shoot the event properly.

■ SIMPLE SOLAR-ECLIPSE PHOTOGRAPHY

The first thought is to use a long telephoto lens. But many photographers have produced outstanding results with normal, wide-angle and even fish-eye lenses. Try to include foreground objects — a dramatic landscape, a city skyline, a well-known landmark — to set the scene. The hole-in-the-sky impression created by a total eclipse turns even the most mundane terrestrial setting into a surrealistic image. The eerie twilight glow on the horizon can also be recorded with a wide-angle lens.

Use a slow, fine-grained film, 50mm or shorter lenses and exposures of 1/2 to 8 seconds at f/2.8 to f/4. This may overexpose the solar corona but will record dimly lit landscape details and bright planets near the sun.

As with lunar eclipses, the entire sequence of a solar eclipse — whether partial or total — can be captured on one frame. During the partial phases, keep the filter on for every shot. Remove it only for a single image of the totally eclipsed sun. Make precisely spaced exposures once every 5 minutes (if you want lots of suns) or once every 10 minutes. A 50mm lens should frame the entire sequence, since the sun and the moon will move about 30 degrees across the sky during a typical two-hour eclipse. If it is a partial or an annular eclipse, the sequence could be ended with an unfiltered exposure of the whole scene, placing the multiple suns in a daylit sky. Wait until the sun moves out of the frame before adding this final touch.

■ *Facing page, top left: Although several photographs of the Orion Nebula appear in this book, each was taken with a different film and a different telescope. This portrait was taken from a moderately light-polluted suburban location with a 10-inch f/11 Schmidt-Cassegrain. Shooting with such a long focal length keeps the sky background dark but requires the use of fast film — in this case, Konica SR 1600, the predecessor to Konica's new-generation 3200 films. More details on city and suburban astrophotography on pages 244-45. Photograph by Klaus Brasch.*
■ *Top right: The blue haloes around the bright stars in this photograph are caused by chromatic aberration, a flaw common in inexpensive telephoto lenses, such as this 200mm f/3.5 lens that cost less than $150. In telephoto lenses that use glass designated ED, UD or low dispersion, this defect is largely corrected. Photograph by Terence Dickinson.*

For images of just the eclipsed sun, use as long a telephoto lens as possible. During totality, use ISO 25 to 100 film. The Kodachromes are recommended, although many photographers prefer print film due to its wide exposure latitude for recording both bright and dim parts of the pearly corona.

There is no single correct exposure. Shorter exposures reveal only the brilliant red prominences; successively longer exposures show more of the corona. The best plan: At the onset of totality, start at the fast end of the shutter range to capture Baily's beads and the diamond-ring effect (1/1,000 to 1/30 second), and work down to the slow exposures (1 to 2 seconds), then step back up to the fast speeds for the end of totality.

■ SOLAR-ECLIPSE PHOTOGRAPHY WITH AN EQUATORIAL TELESCOPE

For spectacular shots of the corona and for details of the prominences, focal lengths of 1,000mm to 2,000mm are needed. This requires shooting at the prime focus of a telescope and focusing the image carefully once totality arrives. While an equatorial mount and clock drive are not essential, they keep the sun's image centred during the eclipse.

Exposures for telescope shots are about 1/500 second for the diamond ring, 1/125 for the prominences, 1/15 for the inner corona and 1/4 to 1 second for the outer corona, assuming f/8 with ISO 64 film. Fast film is not necessary; the delicate details of the corona and prominences call for fine grain.

■ FILTER ADVICE FOR PARTIAL AND ANNULAR ECLIPSES

All the techniques for total eclipses apply to partial and annular eclipses as well, except that the filter is never removed from the lens or telescope.

For telephoto-lens photography up to 400mm, a simple, inexpensive filter is a No. 10 to No. 14 welders' filter. Never use anything lighter than a No. 10 for photography, and never look at the sun for extended periods with a filter lighter than a No. 14. Welders' filters are not optically flat but will provide acceptable images when securely taped over the front of the lens. They produce a green sun, so you might want to use black-and-white film.

Never use photographic neutral-density filters, crossed polarizers or homemade devices. Only approved astronomical solar filters or welding filters block all the harmful infrared and ultraviolet light that can damage the retina, even through a camera viewfinder. Exposures for the partially eclipsed sun or for an annular eclipse depend on the filter but will probably fall into the range of 1/60 second at f/8 with ISO 64 film. Since the sun's surface is the same brightness whether it is being eclipsed or not, take test shots well in advance of eclipse day to determine film and exposure times.

The secret of a good eclipse photograph is to select one technique, then plan and rehearse the steps over and over again. The limited time available during the big event is not the time to be learning how to do astrophotography, although it inevitably happens. Minutes before totality, a cry goes out: "Hey, what exposures do I use?" or "Can someone help me? I can't get my camera to focus." For want of a little preparation and practice, the hapless photographer misses the chance of a lifetime.

As a final bit of advice: Do not forget to look at the eclipse. A binocular view of a totally eclipsed sun will imprint in your memory with more lasting value than any photograph.

■ KEEPING THE GREMLINS AT BAY

■ Why is it necessary to guide a clock-driven equatorial mount manually? The reason is demonstrated in this unguided shot with the mount's polar axis purposely off the pole so that the stars drift slightly. As they do, tracking errors in the drive cause wiggles that would show up as blurring in a properly aligned shot. Photograph by John Mirtle.

In *Twilight Zone—The Movie*, John Lithgow portrayed a man with a fear of flying. The poor fellow kept seeing a terrifying gremlin on the wing tearing apart the engines. No one else could see the creature. There comes a time in every astrophotographer's life when he or she feels a little like Lithgow's character. The gremlins are attacking, but only you are aware of them. Everyone else seems to be doing just fine.

You see all the great photographs other people are taking and wonder, Why are the gremlins picking on me? Relax. There is no escape. They pick on everyone, even on the people with the multi-thousand-dollar astrophotography setups. Nobody displays failed attempts, yet everybody has them. It is not your equipment that makes the difference; it is your patience.

So what can go wrong? Lots. Here are some of the more common gremlins.

■ PROBLEMS WITH FUZZY PHOTOGRAPHS

Probably the number-one nemesis of astrophotographers is fuzzy, out-of-focus pictures. Tracking down the cause depends on the specific problem.

□ Out-of-Focus Images

Solution: Replacing the camera's focusing screen with a fine-grain matte focusing screen on the camera is sometimes enough. However, the best method is to use a focusing screen that has a ground-glass area surrounding a clear central spot. The central spot should have cross hairs. Position the image in the central spot, and focus as well as you can. Then, move your head back and forth. Note

whether the image moves with respect to the cross hairs. If it does, it is still out of focus. This technique is called aerial-image parallax focusing. Another trick is to offset to a bright star and focus on it, then return to your subject.

Some deep-sky photographers use a method called "knife-edge focusing." A special viewer is inserted at the focus in place of the camera body. The photographer looks for a certain pattern of dark and bright areas in the disc of light from a bright star, a pattern that appears only when the viewer's knife-edge or grating cuts across the precise focus. Commercially available knife-edge focusers, such as Spectra Astro Systems' SureSharp ($150), can be valuable items for deep-sky photography.

□ Blurring From Wind or Vibration

Solution: Ensuring that all the fittings on the mount are tight can reduce vibration. Keeping the tripod low and wide can also help, as can placing it on a set of vibration-dampening pads.

For lunar and planetary exposures longer than 1/2 second, a common technique is the "black-hat method." Hold a black card over the front of the lens or telescope (nobody really uses hats), and open the shutter to B. Wait a few seconds for the vibrations to die down. Quickly flip the card away for the duration of the exposure. With the card back in front of the lens, close the shutter.

□ Blurred Images From Poor Seeing

Solution: There is none; just wait for a night of better seeing. On nights of bad seeing but good transparency, do piggyback photography. In all cases, photograph objects when they are as high as possible in the sky.

□ Fuzzy Stars on Part of the Frame

Solution: This occurs when the film buckles in the film plane. If the film has been in the camera for a few weeks, advance it two frames before a shooting session. Fuzzy stars on part of the frame can also occur if the camera was mounted crookedly.

■ PROBLEMS WITH TRAILED-STAR IMAGES

In deep-sky photographs, stars can be sharply focused and still appear misshapen because of trailing in one or both directions.

□ Trailing in Right Ascension Due to Drive Errors

Solution: If the guide star takes off suddenly at regular intervals, the clock drive has periodic errors; that is, one of the gears (usually the worm wheel) was inaccurately manufactured. Barring an outright mechanical failure in the drive (such as a loose or broken gear), the only solution to periodic errors is to replace the entire motor-and-gear drive mechanism with a unit of greater precision. If the star keeps drifting out slowly in the same direction, the elec-

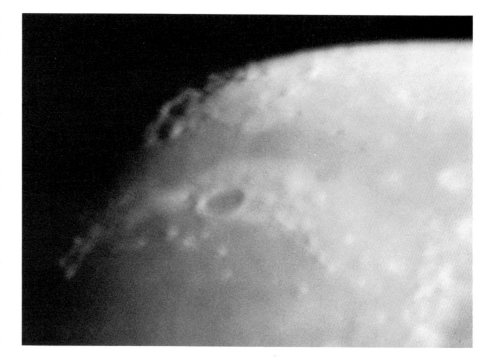

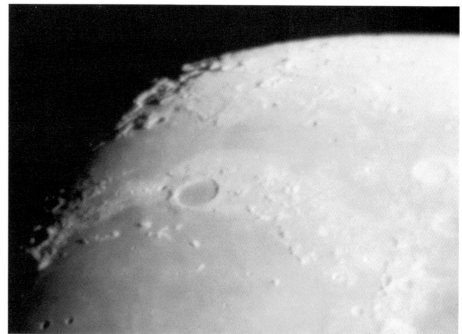

tronics may be emitting a signal that makes the motor run too slowly or too quickly. Try running the unit from a different power source or on another mount.

□ Rotation Around the Guide Star

Solution: Do stars in your guided photographs appear to be trailed in arcs? If so, the telescope has not been accurately polar-aligned, and stars are drifting out in declination during the exposure. Correcting in the usual way for such drift ensures that the guide star is untrailed, but the rest of the frame gradually turns about the guide star. The problem shows up

■ *Vibration introduced by mirror slap in an SLR camera can ruin any celestial photograph in the 1/30-to-1/2-second exposure range. The lower photograph was taken with the mirror locked up, a feature not all SLR cameras have. Photographs by Alan Dyer.*

239

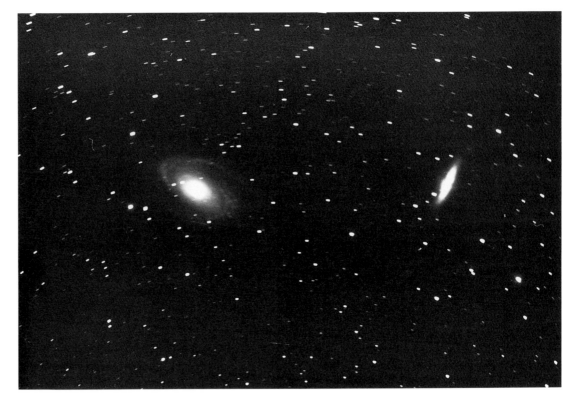

Above: Murphy's Law at work. In the middle of this exposure, the batteries died, and of course, the camera ceased to track the target.

Right: Accurate polar alignment is not necessary for visual observation, but it is for astrophotography. Even when the telescope is manually guided, as it was here, if the alignment is off by just a few arc minutes, field rotation results—star trails around the guide star. The longer the exposure, the more field rotation occurs. This was a 90-minute exposure. Photograph by John Mirtle.

more frequently when you are shooting near the celestial poles. Accurate polar alignment is not just convenient—it is essential in astrophotography.

☐ Trailing for No Apparent Reason

Solution: If you are using a separate guidescope, it could be shifting with respect to the main telescope. In piggyback photography, the camera can slip on its mooring as it changes orientation during the exposure. With Schmidt-Cassegrains, the primary mirror itself can shift as the telescope moves from one side of the sky to the other.

Sometimes, too low a power is being applied when guiding. A rule many photographers follow is to use a guiding magnification equal to 2½ to 5 times the focal length of the telescope (measured in inches). Thus an 8-inch f/10 Schmidt-Cassegrain requires a guide power of 200x to 400x.

PROBLEMS WITH UNWANTED IMAGES

Once you succeed in recording a sharp, untrailed image, unwanted extras sometimes appear. Several "comets" and "novas" have been reported by astrophotographers misinterpreting these rogue images.

☐ UFOs on the Deep-Sky Shots

Solution: Any location near airport glide paths is a bad place for piggyback astrophotography. If you see an aircraft coming, cap the lens until the airplane moves clear of the frame. Restart the exposure after you have made sure the guide star is still centred.

Strange ghost images can sometimes come from

bright stars just outside the frame. Their light reflects off optical elements or internal parts of the telescope and reaches the film.

☐ Fogged Deep-Sky Shots

Solution: Sky fog will always be worse when you are photographing close to the horizon or in the direction of a city. To shoot Orion when it is in the eastern sky, travel east of a city, thus putting the urban glow behind you. Red filters and black-and-white Tech Pan 2415 film can cut through a lot of sky glow, but the best solution is to find a darker site. Astrophotographers often plan their vacations around the new moon. Indeed, a week or two at a dark site in, say, the desert in the American Southwest can produce finer results than any number of extra accessories, filters or exotic films. Many of the best astrophotos are shot at a dark site with no filters.

PROBLEMS FROM OPERATOR ERROR

If you think you can blame all the bad pictures on equipment or on viewing conditions, think again. It helps to have a sense of humour, because once the setup is perfected, there is still human error.

☐ Nothing Is Visible on the Exposure

Solution: After making a beautifully guided half-hour exposure, you release the shutter cable. Rather than hearing a satisfying click, you hear nothing. Immediately, you realize that the shutter was set at 1/500 second. It is a mistake everyone makes—once. Always double-check camera settings. Also,

check for tension on the rewind knob to ensure that the film is loaded properly. You do not want a whole night's photography exposed onto a single frame.

☐ You Cannot Find the Target

Solution: A clear spot-focusing screen or an extreme fine-grain matte screen, like the Beattie Intenscreen, can help you to see deep-sky objects through the camera finder. But some objects are so faint that it is necessary to employ a detailed star chart or a photograph of the target to show the star pattern around the area.

☐ Every Star Looks Double

Solution: Commonly called "nose and foot binaries," such images are created by bumping the tripod with your foot or by nudging the guiding eyepiece with your nose sometime during the exposure, usually as you nod off to sleep.

■ PROBLEMS WITH MISCELLANEOUS GREMLINS

A horde of other gremlins can creep in that do not fit into any neat categories. They are just annoying.

☐ Dew Coats the Main or Corrector Lens

Solution: The result will be a bluish haze around the bright stars, a loss of faint detail and a sky that is not very black. Dew caps, dew guns and heater coils are the answer.

☐ Vignetted Lunar Shots

Solution: The problem is insufficient eyepiece projection distance; the projected image is not sufficiently large to fill the frame. Either increase the projection distance by adding another extension tube or use an eyepiece with a shorter focal length.

☐ Cold-Weather Gremlins

Solution: Unless the film is advanced and rewound slowly in cold, dry weather, static electricity can be created that shows up in the photograph as unwanted lightning strokes across the sky. Cold film also becomes brittle and can break at the sprockets with a sharp stroke of the advance lever. Go easy.

As another cold-weather precaution, always wrap the camera in an airtight plastic bag before bringing it into the warmth from subfreezing temperatures.

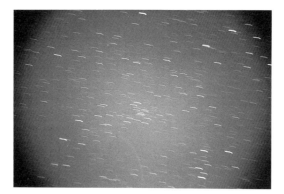

Let it warm up inside the bag; otherwise, moisture can condense on the intricate workings inside the camera and on the film.

☐ Images Sliced in Half

Solution: Photographic laboratory technicians can have a tough time locating the edge of frames in astrophotos. Make it easy for them. Expose frames at the beginning and end of a roll with nonastronomical shots; even aiming the camera into a flashlight for a second or two will do. For added insurance, instruct the laboratory to return the film uncut and unmounted, then mount the frames yourself.

☐ Processor Flaws

Solution: Seek recommendations on good professional photographic laboratories. Such outfits are accustomed to satisfying the demanding professional photographers whose livelihoods depend on reliable service.

If the film has scratches, check the camera first. Scratches can come from the camera back, from film guides or from dirt in the mouth of the film cassette itself. One way to beat the odds is to shoot two of everything.

The gremlins get the best of many backyard astronomers, causing them to throw up their hands in frustration, perhaps quitting astronomy altogether. The gremlins can be beaten. It takes time and patience. Getting good results is challenging but rewarding. The key to great astrophotos lies in your ability to learn from mistakes and in your willingness to stick with it. Indeed, the learning never ends.

■ ADVANCED TECHNIQUES

If astrophotography appeals to you, you will soon want to graduate to more advanced techniques to improve your craft. Here is a quick summary of some of the methods that amateurs are now using to achieve the best possible results.

■ HYPERSENSITIZED FILM

Broadly defined, hypersensitizing, or hypering, is any film treatment that reduces reciprocity failure.

More specific to the amateur world, the most common hypering process involves: (1) Sealing the film in an airtight container (with the film preferably spooled out of its cassette onto a developing reel), then pumping out all the air. (2) Filling the chamber with a mixture of 92 percent nitrogen and 8 percent hydrogen for several days prior to exposure and development. This nonflammable, nonexplosive gas mixture is called forming gas and is commonly

■ The darkened edges in this photograph were caused by a 1¼-inch camera adapter. The 1¼-inch size is too small for the full 35mm frame. Photograph by John Mirtle.

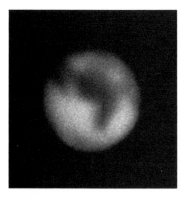

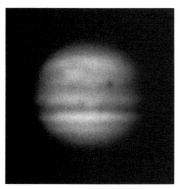

used in welding shops. (3) Heating the container and its contents to 30 to 50 degrees Celsius for the duration. The combination of "soaking" in forming gas and baking in warm temperatures desiccates the film and removes the oxygen from the emulsion.

Dry, oxygen-free film is more sensitive, although the reason is not fully understood. Gas hypering seems to be part alchemy and part black magic. The best techniques have been determined strictly by trial and error. Even so, after recommended times and temperatures have been followed, films may not hyper consistently for peak results. What works on one day may not work on another. Some films and some emulsion batches hyper better than others.

A few amateur astrophotographers have built their own hypering chambers. Others have purchased them from Lumicon, the sole supplier of this equipment. Still others prefer not to get involved with handling high-pressure gases and simply buy prehypered film. The problem with buying gas-hypered film via mail order is that once treated, the film should be stored in a freezer until use. Several days' exposure to normal humid air during shipping could negate all the hypering benefits.

Clearly, hypering is a lot of work. Is it worth it? To obtain maximum deep-sky detail or the faintest objects, the answer is yes. Thirty-minute exposures that show barely any nebulosity with stock film produce knockout results with hypered film—at least with Tech Pan 2415. Gas hypering is *de rigueur* for deep-sky work with this remarkable film, which is nearly 10 times as sensitive when hypersensitized. Gas hypering can be applied to colour films as well. Amateurs often treat Konica, Fuji and Ektachrome emulsions, but there have been few objective comparison tests to determine which film works best.

For more information on hypering, contact Lumicon. Also see Brad D. Wallis and Robert W. Provin's informative book *A Manual of Advanced Celestial Photography*.

■ SLIDE DUPLICATING

When considering ways to enhance a photograph once it has been taken, many astrophotographers think first of darkroom techniques that involve expensive enlargers and of printmaking skills that rival those of Ansel Adams. But few people have the space or the resources to set up an elaborate darkroom, let alone put it to good use. However, if the originals are slides, home duplicating can work wonders. Slide duplicators for SLR cameras range from $70 to more than $2,000.

Be prepared to use rolls and rolls of film to establish the correct colour balance and exposures. The most important preliminary is matching the light source to the type of film being used. Standard daylight colour film requires either daylight or an appropriate electronic flash or floodlights. In all cases, use a slow, fine-grained film to duplicate onto. Each type of film will require different filtration, so a few rolls of testing are needed initially to determine the correct filter pack.

Duplicating is a powerful tool for bringing out de-

■ *Two fine planet shots by James Rouse using a Celestron 4-inch fluorite refractor demonstrate what is possible when good optics, good seeing, experience and persistence come together in astrophotography. (Mars, November 21, 1990; Jupiter, April 1, 1991.)*

■ SLIDE-DUPING SUMMARY

Copy From	Copy To	Result
colour slide	Kodak 5071 dupe film	positive colour slide as close to the original as possible (no contrast change)
colour slide	Kodachrome 25	positive colour slide with slight increase in contrast
colour negative	Kodak Vericolor 5072	positive colour slide with slight increase in contrast
E-6 slide film developed as a negative in C-41 chemistry	Kodak Vericolor 5072	positive colour slide with increase in contrast
Tech Pan 2415 negative	Tech Pan 2415 developed in D-19	positive B&W slide with good contrast
two colour negatives sandwiched together	two Vericolor 5072 positives sandwiched and duped onto Kodak Internegative 4117 film; two internegs sandwiched and duped onto 5072 or printed	positive colour slide or print with major increase in contrast and some decrease in grain (technique developed by Tony Hallas and Daphne Mount)

tails from an underexposed original, increasing contrast and colour saturation, cropping in to magnify a subject and correcting off-colour skies. We do not recommend the special duplicating films provided by major film manufacturers. Generally, astronomical subjects benefit from contrast enhancement, which occurs naturally when a slide is duplicated onto standard transparency film. In most astrophotography, contrast snaps up the image and brings out faint detail, improving upon the original. Colour-print-film negatives can be turned into positives by duplicating them onto a film designed for this purpose: Kodak Vericolor 5072.

The above techniques and the ones summarized in the table are only a few of the most popular. Inventive photographers will no doubt find other combinations of films that will wring every last bit of detail from their originals.

■ SPECIAL CAMERAS

Up to this point, we have concentrated on photography with standard 35mm SLR cameras. However, by skimming through the pages of *Astronomy* and *Sky & Telescope* magazines, you can find photographs attributed to cold cameras or Schmidt cameras. What are these?

First, cold cameras. They can be purchased from specialty suppliers such as Northern Lites. They are simple camera bodies with chambers for holding crushed dry ice—maintained at a temperature of about minus 80 degrees Celsius—which freezes the film. Cooling the emulsion during exposures is another hypering technique. It, too, eliminates reciprocity failure. For many years, cold cameras were the preferred method among advanced deep-sky photographers. Now, gas hypering has largely taken over, and only a tiny minority of astrophotographers still prefer cooling.

Schmidt cameras are special telescopelike units that sound like an astrophotographer's dream come true: incredible resolution and speed (f/1.5) plus pinpoint images across a wide field. But there is a catch. They are expensive and have a fussy film-loading technique. Schmidt cameras are less commonly used than they once were, especially with the excellent high-speed films now available that have almost eliminated the need for the f/1.5 speed.

■ DIGITAL ASTROPHOTOGRAPHY

According to professional astronomers, film is on the way out. Charge-coupled devices (CCDs) produce digital images that can be enhanced and number-crunched far better than any photograph, without the fuss of changing film and guiding the telescope for hours. But is this relevant to backyard astronomy? Until recently, the answer was no. In the 1990s, however, CCDs will likely

■ DETERMINING FILTER PACKS ■

If Dupe Is Too	Subtract	Or Add
red	yellow and magenta	cyan
green	cyan and yellow	magenta
blue	cyan and magenta	yellow
cyan	cyan	yellow and magenta
magenta	magenta	cyan and yellow
yellow	yellow	cyan and magenta

■ A peek into the future of astrophotography. These views of images obtained by CCDs available on the amateur-astronomy market are just the vanguard of what will become a major revolution in the hobby before the turn of the century. Top: Mare Imbrium images by SpectraSource Instruments' Lynxx. Centre: M51 by Patterson Electronics' CCD. Bottom: Ring Nebula, a composite of four 2-minute exposures with a Celestron C11 and the Santa Barbara Instrument Group's CCD.

■ *Above: Photographing the Horsehead Nebula from the suburbs is a challenge, but it is possible. Klaus Brasch used a Deep-Sky filter on a 500mm f/6 lens piggybacked on a 10-inch telescope for this 18-minute exposure with gas-hypered Tech Pan 2415.*

■ *Far right: The Ring Nebula was captured on gas-hypered Tech Pan 2415 from a suburban location using a 10-inch f/13.5 telescope and a long exposure—40 minutes. Filters and longer focal ratios are almost mandatory for deep-sky photography in less-than-good conditions. Photograph by Klaus Brasch.*

□ By Klaus R. Brasch

If you live in the suburbs of a fairly large city as I do, there are probably streetlights on both sides of your house and an infernal "security" light shining day and night in your neighbour's yard. In short, it is less than ideal for backyard astronomy and seems hopeless for deep-sky photography. You really should drive 80 kilometres out of town for reasonably dark skies. But how often will you do that—twice, maybe three times a year?

However, the situation is not all that bleak. Thanks to modern developments in films and filters, many of the brighter Messier objects can be shot from urban settings, often with astonishing results. Here are some hands-on pointers to get started.

Select the darkest or most light-shielded areas on the property. Trees, tall fences and garages can be great assets here. I do 90 percent of my backyard astrophotography between adjacent houses, which provides a usable sector of sky about 60 degrees wide. Fortunately, the celestial panorama changes seasonally, and I have learned to be patient.

The easiest way to begin urban deep-sky photography is to use the camera piggyback fashion on the main telescope. Half a dozen exposures can be obtained quickly during one session. More important, though, this provides a

record of the sky-fog limits, appropriate focal ratios and film and filter combinations for your location. For example, try shooting the Orion region with a 50mm lens (closed down a stop or two) and a medium-speed slide film. Most of the constellation will be captured on the frame as well as M42, the Horsehead region and Barnard's Loop. Try 2-, 4- and 8-minute exposures, then 4-, 8- and 15-minute shots with a light-pollution filter (Lumicon's Deep-Sky filter or a generic broadband filter). After that, try the same sequence with a good telephoto lens for comparison.

Although suitable for deep-sky photography with the usual array of camera lenses, the super-fast colour emulsions (ISO 1000+) are not ideal for this from urban locations. They are simply too fast and will quickly fog, even with light-pollution filters. It is better to use medium-speed (ISO 200 to 400) finer-grained films under typical urban conditions, permitting longer exposures and providing better contrast and resolution.

When you finally "graduate" to prime-focus photography through the main telescope, use one of the super-fast colour emulsions like Konica SR-G 3200 or Scotch Chrome 400 pushed to ISO 1600. These films are exceptionally good with instruments of long focal length and slow effective focal ratios. Most Schmidt-Cassegrain and Maksutov-type telescopes fall into this class, as do many refractors. Such combinations have several distinct advantages in moderately light-polluted backyard conditions.

First, longer focal lengths translate into large image sizes and consequently less trouble with the relatively coarse-grained structure of the superfast films. Second, slower focal ratios yield darker backgrounds and better image contrast, since film fogging is sharply reduced. Exposure times are still reasonably short (10 to 30 minutes) with brighter Messier objects because the films are so sensitive.

For black-and-white work with all optical combinations, there is only one choice for astronomical objects: Kodak Tech Pan 2415. This film must be hypersensitized for deep-sky objects, as it is too slow otherwise. Its extended red sensitivity makes it possible to use deep-red filters such as a Wratten No. 25, No. 29 or No. 92. This effectively blocks most light pollution while admitting light from emission nebulas like M8, M17, M20 and M42.

Unfortunately, similarly efficient filtration is

not possible for most galaxies and other faint objects that are not strongly red-light-emitting. Nonetheless, in any attempt at galaxy photography from urban settings, light-pollution filters are essential. With the aid of such filters, I have captured pleasing images of brighter, compact galaxies such as the Blackeye (M64) and the Sombrero (M104) in about 20 minutes using Konica SR-G 3200 or hypered Tech Pan 2415 at f/6 to f/8. Without such a filter, the films would be hopelessly fogged under the same conditions.

With open and globular star clusters, shooting at relatively slow focal ratios, even up to f/15, is possible. The best option is to try photographing such objects without telecompressors or light-pollution filters. At f/10, bright clusters such as M2, M11, M13 and M22 can be nicely recorded in 20 to 30 minutes with hypered Tech Pan 2415 and unhypered Konica SR-G 3200 colour negative film.

Overall, light pollution and sky glow will noticeably diminish around midnight in most locations, when the normal world goes to sleep. Whenever possible, aim away from the city centre, and wait for the target to reach its highest point in the sky. Always use a dew shield with Schmidt-Cassegrains, refractors and telephoto lenses to prevent condensation on the front element and to protect it from stray light from airplanes, cars and other unexpected sources. *Klaus R. Brasch, an active amateur astronomer since the late 1950s, is a biology professor at California State University, San Bernardino.*

change the way we approach astrophotography.

CCDs are currently found in two kinds of cameras: the home camcorder (for movies) and scientific imaging cameras (for still frames). Today's home video cameras are remarkably sharp and sensitive. A camera with a low-light sensitivity of about two lux can easily record images of the moon and planets through a telescope. The best cameras for this technique are those with a removable lens. Most home cameras do not have this feature, but it is possible to obtain remarkably detailed solar, lunar and planetary images simply by aiming a video camera with lens attached straight into a telescope eyepiece. Then use the camera's zoom lens to vary the size of the image, and your video tour of the solar system can be recorded on tape.

However, the maximum exposure time available with a home video camera is 1/30 second, too short to record deep-sky objects or faint stars. That requires a CCD imaging camera capable of building up an exposure over extended intervals. Such cameras are beginning to appear in the marketplace.

For about $1,000, a simple-to-use CCD astrophotography system can be purchased from suppliers like Santa Barbara Instrument Group and SpectraSource Instruments, both of California. With exposures of only 30 seconds, the CCD imagers produce prime-focus deep-sky images with almost as much detail as 30-minute film shots. The single-frame output of a CCD chip can be displayed in real time on a television monitor or stored on a computer disc. A personal computer and some remarkable image-processing software can then be used to manipulate the pictures with far greater ease and precision than is possible in a darkroom with film.

But even such state-of-the-art cameras have drawbacks. First, a lot of equipment is needed at the telescope—not only the CCD camera but also a controller box, a computer and a monitor. Much of it requires standard household power. Another problem is that affordable CCD chips are small, just a few millimetres across. On a telescope, they provide a field of view of merely a few arc minutes; when attached to a telephoto lens, their field is only a degree or so. Such a narrow field is fine for compact deep-sky objects, but astrophotography requiring a wide field is likely to be the domain of film well into the next century, especially for ultrahigh resolution.

Nevertheless, CCDs are going to take over several areas of amateur astrophotography—prime-focus deep-sky and planetary photography in particular—making many of the techniques we have outlined in the last three chapters obsolete. The new digital technology linked with computer processing is beginning to offer backyard astronomers powerful new ways to capture the sky.

The Universe Awaits

Every August, a small band of dedicated sky-watchers navigates the tortuous 20-kilometre road up Mount Kobau, in southern British Columbia, in search of perfect skies. Sometimes, they are rewarded: the weather cooperates, and the black canvas of the sky is painted with the delicate brush strokes of the Milky Way. But other years, the normally dry summer weather turns foul. Isolated at the top of a 1,500-metre mountain, the troop of observers is forced to wait out a thunderstorm's torrential rains, hoping that the next night, or perhaps the next hour, will reveal the stars.

And yet, even when the weather turns cold and wet, everyone leaves the Mount Kobau Star Party saying, "See you next year." They know they will be back. And so it goes at virtually every star party and amateur-astronomy gathering. The great thing about backyard astronomy is that it can extend much farther than your backyard. There is a vast community of thousands of like-minded lovers of the sky. Perhaps, as you pursue your interest in the stars, you will find yourself becoming a part of that community. You, too, may discover a place such as Kobau or Stellafane or any of the many other dark-sky observing meccas for amateur astronomers that are emerging across the continent.

On the other hand, your personal mecca may always be as close as your backyard and your community of fellow skywatchers no larger than your family and friends. But no matter. Wherever you observe, it is the same limitless sky overhead, a sky we hope this book helps you to explore.

Throughout *The Backyard Astronomer's Guide*, we have tried to emphasize topics that have been largely neglected by other guidebooks to astronomy. For example, we have talked a great deal about equipment. We have done this because we find that most of the enquiries we receive from beginners are variations on a single question: What should I buy? Our emphasis on hardware may lead to the impression that amateur astronomy is nothing more than collecting equipment. For some, that is the case. But those people rarely sustain their enthusiasm for the hobby, which brings us to the concluding topic that is seldom discussed in amateur-astronomy literature: why people lose interest in astronomy.

As we said in Chapter 1, you cannot buy your way into astronomy; but some newcomers try. They purchase the best and most prestigious equipment on the market but never get around to investing the time to learn how to make proper use of it. Are they backyard astronomers? Not in our view. Real backyard astronomers learn how to use the instruments and how to appreciate what they can reveal. Most important of all is developing the skills to find things in the sky, something no book can teach people unless they spend time under the stars with star maps in hand and with curious minds.

The primary reason people lose interest in as-

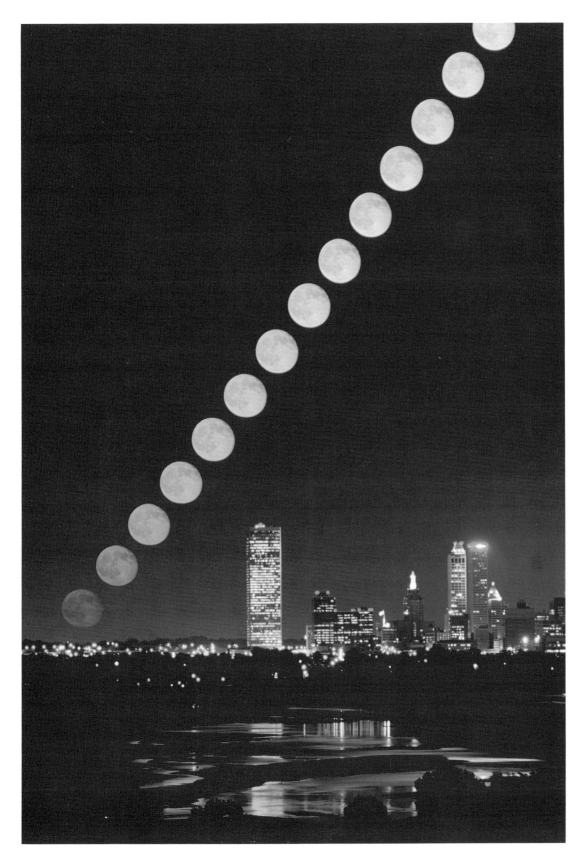

■ *Moonrise: Multiple exposures reveal the moon climbing above the eastern horizon due to the Earth's rotation. The silvery orb may add lustre to a night scene like this one, but for astronomy enthusiasts, full moonlight obscures many of the sky's more subtle treasures. Photograph by William Sterne.*

248

tronomy is that the equipment absorbs their attention and they neglect the stars. The sky never becomes a friendly place: the star patterns are anonymous, and the locations of the sky's attractions remain hidden. What could have been a lifelong interest becomes a passing phase. Instruments that are too complex make setting up the gear an onerous chore. We have seen this problem many times, and that is why we recommend binoculars, rather than a telescope, to most first-time buyers.

There are other reasons people lose interest in astronomy. Some leap into astrophotography too quickly. Three chapters of this book deal with photography techniques, because many beginning amateurs express an interest in taking astrophotos. But do not think that astrophotography is something you must do. If you wish to try it, start with some simple constellation shots or photographs of the moon taken through the telescope. Ease into the more complex subjects slowly. The equipment—filters, special lenses, gas-hypering tanks, CCD auto-guiders —can be seductive. But a lot of dedicated time is required to learn how to use it all properly. Both of us began our astronomical careers as avid astrophotographers, and we both gave it up. We reached our limits of tolerance in terms of effort and dollars expended for the photographic results, and so we returned to visual astronomy. But there is something undeniably satisfying about seeing a great astrophoto that *you* took, and so, with the improvement in high-speed films in the past few years, we have both cautiously inched back into astrophotography. From experience, we advise others to go slowly.

Developing stargazing skills takes time. Some people find they simply never have enough time. Weeknights are filled with work, courses, health-club sessions and meetings. Weekends are busy with trips, family outings, errands, social engagements and more obligations than we care to think about. It seems the more leisure time we have, the more we fill it with demanding activities that are far from leisurely. We certainly cannot pose as experts on time management, but we feel that finding time to be under the stars is more a matter of attitude than of organization. For us, the time spent pursuing this hobby is a quiet respite from life in the fast lane. And backyard astronomy does not have to be a solitary pursuit. Involving the family will make your moments under the stars all the more valuable.

After the initial novelty wears off, some amateurs drift away from the hobby for lack of a purpose, a common malaise we have both experienced from time to time. To rekindle the interest, take on a project and work toward a goal, such as observing all the Messier objects, sketching the planets or photographing the constellations. There are many possibilities. The astronomy magazines offer new ideas

and timely information on special events in the sky. Keeping abreast of celestial happenings is essential to maintaining your interest and sustaining the feeling that you are a true naturalist of the night.

Every now and then, we all need a shot of inspiration to recharge our batteries. Sometimes, a casual observation of a planetary conjunction or an exceptionally clear night is enough to remind us of how endlessly fascinating the sky is and how much we have been missing by not paying closer attention. Other times, it takes a "group therapy" session, such as a star party, a motivating lecture at a club meeting or just touching bases with skywatching friends.

Like every other leisure pursuit, you can take astronomy seriously or casually. It is entirely up to you. Our task has been to provide advice on the tools and an introduction to the techniques of sky observing. We leave the rest to you. Welcome to the universe of backyard astronomy.

■ *Above: Sometimes, a sky observer's line of sight intersects terrestrial as well as celestial objects. This image of a DC-10 zipping across the moon was discovered only after the film was developed. Courtesy John Stull.*
■ *Facing page: Barnard's "E" Nebula is one of many dark nebulas that web the Milky Way, imparting a textured appearance to our galaxy's midsection. Photograph by John Mirtle, using a 6-inch f/4.5 Newtonian.*

■ RECOMMENDED BOOKS AND MAGAZINES ■

(For information on star atlases and annual astronomical almanacs, see Chapter 11.)

■ INTRODUCTORY GUIDEBOOKS

Starlight Nights by Leslie C. Peltier (Sky Publishing; Cambridge, Massachusetts; 1980). A compelling and ultimately profound book chronicling one man's odyssey in backyard astronomy. Written by one of the 20th century's most gifted amateur astronomers.

The Universe from Your Backyard by David J. Eicher (Cambridge; New York; 1988). A nice constellation-by-constellation guide for small-telescope users.

The Guide to Amateur Astronomy by Jack Newton and Philip Teece (Cambridge; New York; 1989). A well-balanced treatment of observing, telescope making and astrophotography.

The Sky: A User's Guide by David H. Levy (Cambridge; New York; 1991). Well-written introduction to amateur astronomy.

NightWatch by Terence Dickinson (Camden House; Camden East, Ontario; revised edition, 1989). Comprehensive guide for the beginner. Full-colour charts; lavishly illustrated. *The Backyard Astronomer's Guide* was developed as a sequel to *NightWatch*. There is intentionally little overlap between the two.

Wonders of the Sky by Fred Schaaf (Dover; New York; 1983). Weakly illustrated but otherwise excellent guide to naked-eye phenomena of the night and day skies.

The Amateur Astronomer's Handbook by James Muirden (Harper & Row; New York; several editions). The best of at least a dozen similar books from Britain that take a traditional approach to amateur astronomy and seem to repeat the same information from one author to the next.

Touring the Universe Through Binoculars by Philip S. Harrington (Wiley; New York; 1990). The biggest and best guide to binocular observing. Comprehensive tables and descriptions but no charts. Must be used with a sixth-magnitude star atlas.

Turn Left at Orion by Guy Consolmagno and Dan M. Davis (Cambridge; New York; 1989). A practical guide to the night sky's showpiece objects for beginners with small telescopes (under 4-inch aperture). Much better charts and diagrams than most books of this type.

■ OBSERVING REFERENCES

Burnham's Celestial Handbook by Robert Burnham, Jr. (Dover; New York; 1978). A classic. Wonderful descriptions and data for thousands of deep-sky objects visible in amateur telescopes. In three volumes.

Messier's Nebulae & Star Clusters by Kenneth Glyn Jones (Cambridge; New York; second edition, 1991). A welcome new edition of a fine reference long out of print.

Observing Handbook and Catalogue of Deep-Sky Objects by Christian B. Luginbuhl and Brian A. Skiff (Cambridge; New York; 1990). Eyepiece descriptions of more than 2,000 galaxies, nebulas and star clusters visible in amateur astronomers' telescopes. An important work for advanced observers.

Sky Catalogue 2000.0 edited by Alan Hirshfeld and Roger W. Sinnott (Sky Publishing; Cambridge, Massachusetts; 1985). Volume 1 of this two-volume set contains data on every star to magnitude 8.0. Volume 2 lists information on tens of thousands of deep-sky objects.

Observing Variable Stars by David H. Levy (Cambridge; New York; 1989). The best introduction to the subject, written by a veteran variable-star observer.

The Supernova Search Charts and Handbook by Gregg Thompson and James Bryan (Cambridge; New York; 1989). A magnificent set of 236 charts drawn by Gregg Thompson, each showing the appearance of a galaxy visible in backyard telescopes along with magnitudes of the stars in the same field. Intended as a guide for seeking supernovas in other galaxies, the charts also serve as a reference for casual observers of galaxies. A 134-page descriptive handbook is included.

Webb Society Deep-Sky Observer's Handbook, edited by Kenneth Glyn Jones (Enslow; Short Hills, New Jersey; 1979). Despite a crude printing job and weak illustrations, this eight-volume series from England's Webb Society contains a wealth of information on double stars, nebulas, clusters and galaxies. We have found Volume 4 (*Galaxies*) and Volume 5 (*Clusters of Galaxies*) especially useful. Available individually from Sky Publishing.

Observe Meteors by David H. Levy and Stephen J. Edberg (The Astronomical League; Washington, D.C.; 1986). Two experts offer everything you need to know about meteor observing in a concise form. Also from the same authors: *Observe Comets*. Order both from The Astronomical League listed under North American Organizations.

The Under-Standing of Eclipses by Guy Ottewell (Astronomical Workshop; Greenville, South Carolina; 1991). Written by the same person who prepares the indispensable *Astronomical Calendar*, this 90-page book uses clear text and excellent illustrations to explain why eclipses occur and the cycles that lie behind them. Address: Astronomical Workshop, Furman University, Greenville, SC 29613.

The Astronomical Companion by Guy Ottewell (Astronomical Workshop; Greenville, South Carolina; 1979). Another outstanding book from the multitalented Ottewell. Clear diagrams and text show where we are in the galaxy and the universe. Lots of useful information not easily found elsewhere. Address above.

■ ASTROPHOTOGRAPHY

Astrophotography for the Amateur by Michael Covington (Cambridge; New York; 1985). Good introduction to astrophotography.

Astrophotography by Barry Gordon (Willmann-Bell; Richmond, Virginia; second edition, 1985). Lots of practical tips for astrophotographers.

A Manual of Advanced Celestial Photography by Brad D. Wallis and Robert W. Provin (Cambridge; New York; 1988). Much useful information for more serious astrophotographers.

Introduction to Astronomical Image Processing by Richard Berry (Willmann-Bell; Richmond, Virginia; 1991). An easy-to-follow introduction to the new art of computer processing and enhancement of digital CCD images. Includes image-processing software.

■ PLANETARY OBSERVING

Introduction to Observing and Photographing the Solar System by Thomas A. Dobbins, Donald C. Parker and Charles F. Capen (Willmann-Bell; Richmond, Virginia; 1988). A comprehensive guide to planetary observing and photography by three experts. Many of the planetary photographs in Chapter 10 were taken by Parker.

Astronomical Tables of the Sun, Moon, and Planets by Jean Meeus (Willmann-Bell; Richmond, Virginia; 1983). Tables of oppositions, conjunctions, distances and much more. A handy reference.

Planets & Perception by William Sheehan (University of Arizona Press; Tucson; 1988). Well-written investigation into why the great planetary observers (Schiaparelli, Lowell and others) so frequently misinterpreted what they saw — or thought they saw.

■ TELESCOPES

Telescope Optics by Harrie G.J. Rutten and Martin A.M. van Venrooij (Willmann-Bell; Richmond, Virginia; 1988). The most detailed book of its type suitable for amateur astronomers.

All About Telescopes by Sam Brown (Edmund; Barrington, New Jersey; 1967). Badly out of date but still a classic with unique illustrations and plenty of solid information.

The History of the Telescope by H.C. King (Dover; New York; reprint). Every step in the development of the telescope from Galileo to Mount Palomar is between the covers of this definitive work.

■ TELESCOPE MAKING

Build Your Own Telescope by Richard Berry (Scribner's; New York; 1985). Without question the best guide for anyone who wants to build his or her first telescope.

How to Build Your Own Observatory, edited by Richard Berry (Kalmbach; Waukesha, Wisconsin; several editions). A compilation of more than a dozen articles from *Telescope Making* magazine — ideas for anyone contemplating building an observatory.

Amateur Telescope Making, edited by Albert G. Ingalls (Scientific American; New York; 1935, and many subsequent editions). The "bible" for generations of telescope makers. In three volumes.

How to Make a Telescope by Jean Texereau (Willmann-Bell; Richmond, Virginia; second edition, 1984). Much useful information for do-it-yourself fans.

■ THE DAY SKY

Exploring the Sky by Day by Terence Dickinson (Camden House; Camden East, Ontario; 1988). Concise guide to day-sky phenomena.

The Nature of Light and Colour in the Open Air by M. Minnaert (Dover; New York; reprint). This all-time classic daytime-sky-phenomena reference will never be surpassed.

Sunsets, Twilights and Evening Skies by Aden and Marjorie Meinel (Cambridge; New York; 1983). A fine summary of twilight atmospheric phenomena.

Rainbows, Halos, and Glories by Robert Greenler (Cambridge; New York; 1980). Thorough but very readable guide to the day-sky phenomena mentioned in the title. Greenler is a world authority on this subject.

■ MAGAZINES

Astronomy enthusiasts have two outstanding monthly magazines—*Astronomy* and *Sky & Telescope*—brimming with news items, charts of current sky events, product reviews and lots of advertisements for everything from astronomy books to observatory telescopes. One or the other of the two publications is essential reading for any backyard astronomer. Many enthusiasts subscribe to both. *Astronomy*, Box 1612, Waukesha, WI 53187 (414-796-8776); *Sky & Telescope*, Box 9111, Belmont, MA 02178 (617-864-6117).

Kalmbach, the publisher of *Astronomy*, also produces *Deep Sky*, a quarterly magazine for more serious observers and astrophotographers, and *Telescope Making*, another quarterly, for the devotees of home-built telescopes. Both are available from the *Astronomy* address above.

Quality bimonthly publications include *Mercury*, The Journal of the Astronomical Society of the Pacific (390 Ashton Avenue, San Francisco, CA 94112), *Star Date* from the McDonald Observatory (RLM 15.308, University of Texas at Austin, Austin, TX 78712) and *The Observer's Guide* from Astro Cards (Box 35, Natrona Heights, PA 15065).

■ NORTH AMERICAN ORGANIZATIONS ■

Amateur Satellite Observers, HCR 65, Box 261-B, Kingston, AZ 72742.

American Association of Variable Star Observers, 25 Birch Street, Cambridge, MA 02138 (617-354-0484). Variable-star charts available.

American Meteor Society, Department of Physics-Astronomy, SUNY–Geneseo, Geneseo, NY 14454 (716-245-5282).

Association of Lunar and Planetary Observers, Box 143, Heber Springs, AZ 72543 (501-362-7264). Journal with membership.

The Astronomical League, Science Service Building, 1719 N Street NW, Washington, DC 20036.

Astronomical Society of the Pacific, 390 Ashton Avenue, San Francisco, CA 94112 (415-337-1100).

Astronomy Book Club, Riverside, NJ 08370. Offers four or five new astronomy books each month at discount prices. Convenient and reliable, especially for those in rural areas, but after shipping and handling, savings over bookstore prices are modest. Write for membership brochure. Unlike other entries in this section, this is a business, not a nonprofit club.

Astronomy Day Headquarters, Chaffee Planetarium, 54 Jefferson SE, Grand Rapids, MI 49503 (616-784-9518; 616-456-3987). International Astronomy Day resource materials available.

Group 70/Large Amateur Telescope Project, 2331 American Avenue, Hayward, CA 94545 (415-969-6869).

International Amateur-Professional Photoelectric Photometry, Dyer Observatory, Vanderbilt University, Nashville, TN 37235.

International Dark-Sky Association, 3545 North Stewart, Tucson, AZ 85716. Promotes awareness of light pollution. Quarterly newsletter.

International Occultation Timing Association, Box 7488, Silver Spring, MD 20901 (301-495-9062).

The Meteoritical Society, Department of Geological Sciences, University of Tennessee, Knoxville, TN 37996.

National Deep Sky Observers Society, 1607 Washington Boulevard, Louisville, KY 40242 (502-426-4399; 502-561-6103).

National Space Society, 922 Pennsylvania Avenue SE, Washington, DC 20003 (202-543-1900).

The Planetary Society, 65 North Catalina Avenue, Pasadena, CA 91106 (818-793-5100). Excellent magazine, *Planetary Report*, with membership.

Problicom Sky Survey and Nova Patrol, 1940 Cotner Avenue, Los Angeles, CA 90025 (213-478-2526). Free quarterly newsletter; send four self-addressed stamped envelopes.

Royal Astronomical Society of Canada, 136 Dupont Street, Toronto, Ontario M5R 1V2 (416-924-7973). Local centres across Canada. *Observer's Handbook* and other publications with membership.

Small Scope Observers Association, 4 Kingfisher Place, Audubon Park, NJ 08106 (609-547-9487).

Society of Amateur Radio Astronomers, 247 North Linden Street, Massapequa, NY 11758 (516-798-8459).

Webb Society (North America), 1440 S. Marmora Avenue, Tucson, AZ 85713-1015 (602-628-1077).

Western Amateur Astronomers, 163 Starlight Crest Drive, La Canada, CA 91011.

World Space Foundation, Box Y, South Pasadena, CA 91031-1000 (818-357-2878).

■ASTRONOMY PRODUCT SOURCES

Each company listed is the primary source for at least one unique product. Some of the companies offer their products through telescope dealers; others only sell direct. Write or call for information on complete product lines and availability of items through local dealers.

■ COMPLETE TELESCOPES

Some of these companies offer optics and mounts separately to those who wish to assemble their own telescopes. Many also sell accessories and eyepieces.

Astro-Physics, 11250 Forest Hills Road, Rockford, IL 61111 (815-282-1513).
Apochromatic refractors, lenses, equatorial mounts.

Celestron International, 2835 Columbia Street, Torrance, CA 90503 (213-328-9560).
Schmidt-Cassegrains, equatorial Newtonians and small refractors, plus eyepieces and other accessories. Importer of Vixen telescopes. Extensive catalogue.

Cheshire Instrument, 38 Geraldine Drive, Smyrna, GA 30082 (404-438-9200).
Achromatic refractors, lenses.

Chicago Optical and Supply, Box 1361, Morton Grove, IL 60053 (312-827-4846).
Rich-field Newtonians, accessories.

Coulter Optical, Box K, Idyllwild, CA 92349 (714-659-4621).
Economical Dobsonian reflectors, mirrors.

D&G Optical, 6490 Lemon Street, East Petersburg, PA 17520 (717-560-1519).
Large achromatic refractors, lenses.

Dobbins Instrument Co., 5168 Lynd Avenue, Lyndhurst, OH 44124 (216-449-5730).
Large achromatic refractors and Cassegrains.

Edmund Scientific, 100 East Gloucester Pike, Barrington, NJ 08007 (609-547-3488).
Small refractors, small- and medium-aperture reflectors, eyepieces, accessories, optics, telescope-making supplies. Extensive catalogue.

Great Lakes Instruments, Box 610, 1971 Haslett Road, Haslett, MI 48840 (517-339-1151).
Newtonian telescope kits.

Jason Empire, Inc., 9200 Cody, Box 14930, Overland Park, KS 66214 (913-888-0220).
Small imported refractors and reflectors.

Jim's Mobile Industries, 1960 County Road 23, Evergreen, CO 80439 (303-277-0304).
Large-aperture equatorial Newtonians, electric focus and declination motors, digital setting circles. Extensive catalogue.

Jupiter Telescope Company, 815 S. U.S. Hwy. 1, Suite 4-237, Jupiter, FL 33477 (407-694-1154).
Premium Dobsonian reflectors, equatorial platforms.

Land, Sea, and Sky/Texas Nautical Repair, 3110 S. Shepherd, Houston, TX 77098 (713-529-3551).
Importer of Takahashi Newtonians, Cassegrains and apochromatic refractors, accessories for same.

Lorraine Precision Optics, 1319 Libby Lane, New Richmond, OH 45157 (513-553-4999).
Tilted-component reflectors.

Meade Instruments Corporation, 1675 Toronto Way, Costa Mesa, CA 92626 (714-556-2291).
Schmidt-Cassegrains, equatorial Newtonians and small refractors, plus eyepieces and other accessories. Extensive catalogue.

Obsession Telescopes, 923 Stony Road, Lake Mills, WI 53551 (414-648-2327 mornings, 414-648-8284 afternoons).
Premium Dobsonian reflectors.

Optical Guidance Systems, 2450 Huntingdon Pike, Huntingdon Valley, PA 19006 (215-947-5571).
Ritchey-Chrétien Cassegrain telescopes, plus equatorial mounts.

Optical Research Corporation, 3009 East Forest Street, Appleton, WI 54915 (414-734-5006).
Newtonians with unique three-axis fixed-eyepiece mount.

Orion Telescope Center, 2450 17th Avenue, Box 1158, Santa Cruz, CA 95061 (408-464-0465).
Small imported refractors and reflectors, plus unique eyepieces, filters and accessories. Extensive catalogue.

Parks Optical, 270 Easy Street, Simi Valley, CA 93065 (805-522-6722).
Medium- and large-aperture equatorial reflectors, small imported refractors, plus mirrors and accessories. Extensive catalogue.

Photon Instrument, Ltd., 1325 Brummel Street, Evanston, IL 60202 (708-864-6675).
Small- and medium-aperture refractors, plus telescope repair and restoration.

Questar Corporation, Route 202, Box 59, New Hope, PA 18938 (215-862-5277).
Premium Maksutov-Cassegrains, accessories for same.

R.V.R. Optical, Box 62, Eastchester, NY 10709 (914-337-4085).
Premium large-aperture imported telescopes.

Safari Telescopes, 110 Pascask Road, Pearl River, NY 10965 (212-621-9199).
Premium Dobsonian reflectors.

Sky Designs, 4100 Felps, Suite C, Colleyville, TX 76034 (817-581-9878).
Premium Dobsonian reflectors.

Sky Instruments, Box 3164, Vancouver, BC V6B 3X6 (604-270-2813).
Small refractors and reflectors.

Star-Liner Company, 1106 S. Columbus Boulevard, Tucson, AZ 85711 (602-795-3361).
Equatorial Newtonians and Cassegrains, plus mounts.

Swift Instruments, Inc., 952 Dorchester Avenue, Boston, MA 02125 (617-436-2960).
Small imported refractors, reflectors and catadioptrics.

Tasco, 7600 NW 26th Street, Miami, FL 33122 (305-591-3670).
Small refractors, reflectors and catadioptrics.

Tectron Telescopes, 2111 Whitfield Park Avenue, Sarasota, FL 34243 (813-758-9890).
Premium Dobsonian reflectors, focusers, collimation tools.

Tele Vue Optics, Inc., 20 Dexter Plaza, Pearl River, NY 10965 (914-735-4044).
Apochromatic refractors, plus mounts, premium eyepieces and other accessories.

T.R. Inc., Box 65, Mooers, NY 12958 (514-672-5697).
Importer of small high-quality reflectors and refractors.

Unitron, 170 Wilbur Place, Box 469, Bohemia, NY 11716 (516-589-6666).
Achromatic refractors.

Vernonscope, 5 Ithaca Road, Candor, NY 13743 (607-659-7000).
Apochromatic refractors, plus mounts, premium eyepieces, filters and other accessories.

■ OPTICS FOR TELESCOPE MAKERS

These companies specialize in premium optics for use in homemade reflecting telescopes.

E&W Optical Inc., 2420 E. Hennepin Avenue, Minneapolis, MN 55413 (612-331-1187).
Secondary mirrors for Newtonians.

Enterprise Optics, Box 413, Placentia, CA 92670 (714-524-7520).

Galaxy Optics, Box 2045, Buena Vista, CO 81211 (719-395-8242).

Palomar Optical Supply, Box 1310, Wildomar, CA 92395 (714-678-5393).
Mirror- and lens-making kits.

Star Instruments, Box 597, Flagstaff, AZ 86002 (602-774-9177).

■ MOUNTS FOR TELESCOPE MAKERS AND ASTROPHOTOGRAPHERS

These companies specialize in premium, heavy-duty mounts and drive systems.

Astro-Track Engineering, 9811 Brentwood Drive, Santa Ana, CA 92705 (714-289-0402).

Edward R. Byers Company, 29001 W. Hwy. 58, Barstow, CA 92311 (619-256-2377).

Epoch Instruments, 2331 American Avenue, Hayward, CA 94545 (415-784-0391).
Also sells Schmidt cameras.

Hollywood General Machining, Inc., 1033 N. Sycamore Avenue, Los Angeles, CA 90038 (213-462-2855).
Also makes extensive line of mounting accessories and adapters.

Optic-Craft Machining, 33918 Macomb, Farmington, MI 48024 (313-476-5893).

Thomas Mathis Co., 830 Williams Street, San Leandro, CA 94577 (415-483-3090).

■ ACCESSORIES AND TELESCOPE PARTS

These companies specialize in accessories for all types of telescopes plus telescope parts for use in homemade telescopes.

AstroSystems, Inc., 1536 Meeker Drive, Box 1183, Longmont, CO 80501 (303-678-5339).
Focusers and other accessories.

DayStar Filter Corporation, Box 1290, Pomona, CA 91769 (714-591-4673).
H-alpha solar filters, nebula filters.

Electrim Corp., Box 2074, Princeton, NJ 08543 (609-799-7248).
CCD imaging cameras.

Equatorial Platforms, 11065 Peaceful Valley Road, Nevada City, CA 95959 (916-265-3183).
Tracking platforms for Dobsonian reflectors.

Kenneth F. Novak & Co., Box 69, Ladysmith, WI 54848 (715-532-5102).
Primary mirror cells, secondary mirror supports, focusers, other telescope-making supplies.

Lumicon, 2111 Research Drive, #5, Livermore, CA 94550 (415-447-9570).
Nebula filters, astrophoto accessories, film-hypering kits, digital setting circles. Extensive catalogue.

Northern Lites, 640 Cains Way, R.R. 1, Sooke, BC V0S 1N0.
Cold cameras, guiders, other astrophoto accessories.

Optica b/c Company, 4100 MacArthur Boulevard, Oakland, CA 94619 (415-530-1234).
Astrophoto accessories, telescope-making supplies.

Opto-Data, 600 Mariners Island Boulevard, Suite 36, San Mateo, CA 94404 (415-377-0211).
Digital setting-circle and LED star-atlas display unit.

Photometrics Ltd., Suite 100, 3440 E. Britannia Drive, Tucson, AZ 85706 (602-889-9933).
Premium CCD cameras.

Roger W. Tuthill, Inc., Box 1086, Mountainside, NJ 07092 (908-232-1786).
Mylar solar filters and other accessories.

S.B. Kufeld, 7092 Betty Drive, Huntington Beach, CA 92647 (714-847-8903).
Telrad finderscope.

Santa Barbara Instrument Group, 1482 East Valley Road, #601, Santa Barbara, CA 93108 (805-969-1852).
CCD auto-guiders, imaging cameras, software.

SpectraSource Instruments, 2220 Careful Avenue, Agoura, CA 91301 (818-707-2655).
CCD imaging cameras.

Spectra Astro Systems, 6631 Wilbur Avenue, Suite 30, Reseda, CA 91335 (818-343-1352).
Astrophoto and other accessories. Extensive catalogue.

Thousand Oaks Optical, Box 248098, Farmington, MI 48332 (313-353-6825).
Mylar and glass solar filters.

University Optics, Inc., Box 1205, Ann Arbor, MI 48106 (313-665-3575).
Unique eyepieces and accessories, telescope-making supplies.

Versacorp, Box 7, Sun City, AZ 85372 (602-876-8344).
Astrophoto accessories.

Vista Instrument Co., 307 E. Tunnell Street, Santa Maria, CA 93454 (805-925-1240).
Astrophoto accessories, cantilever binocular mounts, camera trackers.

Vogel Enterprises, 38W150 Hickory Court, Batavia, IL 60510 (708-879-8725).
Drive correctors and other accessories.

■ BINOCULARS

These companies offer binoculars suitable for astronomy. Their products are usually available through telescope and camera stores, plus sporting, marine and outfitting shops. Contact the company for dealer names and product literature.

aus Jena (Zeiss), c/o Europtik, Ltd., Box 319, Dunsmore, PA 18512 (717-347-6049).

Bushnell/Bausch & Lomb, 300 N. Lone Hill Avenue, San Dimas, CA 91773 (714-592-8072).

Carton Optics, Tad International, 1037 Enderby Road West, Sunnyvale, CA 94087 (408-245-4818).

Celestron International, 2835 Columbia Street, Torrance, CA 90503 (213-328-9560).

Fujinon Inc., 10 High Point Drive, Wayne, NJ 07470 (201-633-5600).

Jason Empire, Inc., 9200 Cody, Box 14930, Overland Park, KS 66214 (913-888-0220).

Kowa Optimed, Inc., 20001 S. Vermont Avenue, Torrance, CA 90502 (213-327-1913).

Leica Camera, Inc., 156 Ludlow Avenue, Northvale, NJ 07647 (201-767-7500).

Meade Instruments Corporation, 1675 Toronto Way, Costa Mesa, CA 92626 (714-556-2291).

Minolta Corporation, 101 Williams Drive, Ramsey, NJ 07446 (201-825-4000).

Mirador Optical Corporation, Box 11614, Marina del Rey, CA 90295 (213-821-5587).

Nikon Inc., 1300 Walt Whitman Road, Melville, NY 11747 (516-547-4200).

Optolyth USA, 18805 NE Melvista Lane, Hillsboro, OR 97123 (503-628-0246).

Orion Telescope Center, 2450 17th Avenue, Box 1158, Santa Cruz, CA 95061 (408-464-0465).

Parks Optical, 270 Easy Street, Simi Valley, CA 93065 (805-522-6722).

Pentax Corp., 35 Inverness Drive East, Box 6509, Englewood, CO 80155-6509 (303-799-8000).

Pioneer Marketing and Research, Steiner Binoculars, 216 Haddon Avenue, Suite 522, Westmont, NJ 08108 (609-854-2424).

Selsi Company, Inc., 40 Veterans Boulevard, Carlstadt, NJ 07072 (201-935-0388).

Simmons Outdoor Corporation, 14530 SW 119 Avenue, Miami, FL 33186 (305-252-0477).

Swarovski Optik North America Limited, One Wholesale Way, Cranston, RI 02920 (401-942-3380).

Swift Instruments, Inc., 952 Dorchester Avenue, Boston, MA 02125 (617-436-2960).

Tasco, 7600 NW 26th Street, Miami, FL 33122 (305-591-3670).

(Carl) Zeiss Optical, Inc., 1015 Commerce Street, Petersburg, VA 23803 (804-861-0033).

■ STAR CHARTS, POSTERS, SLIDES AND SPECIALIZED PUBLICATIONS

Astro Cards, Box 35, Natrona Heights, PA 15065 (412-295-4128).
Index-card finder charts, bimonthly *The Observer's Guide* magazine.

Astronomical Society of the Pacific, 390 Ashton Avenue, San Francisco, CA 94112 (415-337-1100).
Posters, slide sets, videos.

Astronomical Workshop, Furman University, Greenville, SC 29613.
Guy Ottewell's annual *Astronomical Calendar*.

Edmund Scientific, 100 East Gloucester Pike, Barrington, NJ 08007 (609-547-3488).
Introductory star atlases and how-to books.

Hansen Planetarium Publications, 1098 S. 200 West, Salt Lake City, UT 84101 (801-538-2242).
Posters and slide sets from major observatories.

Kalmbach Publishing, 21027 Crossroads Circle, Box 1612, Waukesha, WI 53187 (414-796-8776).
Astronomical books. Publisher of *Astronomy, Deep Sky* and *Telescope Making* magazines.

Royal Astronomical Society of Canada, 136 Dupont Street, Toronto, Ontario M5R 1V2 (416-924-7973).
Annual *Observer's Handbook*.

Sky Publishing Corp., Box 9111, Belmont, MA 02178 (617-864-7360).
Star atlases and astronomical books. Publisher of *Sky & Telescope* magazine.

Willmann-Bell, Inc., Box 35025, Richmond, VA 23235 (804-320-7016).
Star atlases and astronomical books.

■ ASTRONOMY SOFTWARE

These are the main general-purpose programs available as of mid-1991. Hundreds of other specialized

programs are available, many from small single-product companies or as "shareware." See *Astronomy* and *Sky & Telescope* magazines for reviews and product notices.

☐ Amiga
Distant Suns (formerly *Galileo*), Virtual Reality Laboratories, 2341 Ganador Court, San Luis Obispo, CA 93401 (805-545-8515).

☐ Apple II
Sky Travel, Deltron Ltd., 155 Deer Hill Road, Lebanon, NJ 08833 (201-236-2928).
The Observatory, Lightspeed Software, 2124 Kittredge Street, Suite 185, Berkeley, CA 94704 (415-540-0671).

☐ Atari
Atari Planetarium, Atari Corp., 1196 Borregas Avenue, Sunnyvale, CA 94088 (408-745-2000).
Skyplot, Robtek Ltd., 1983 San Luis Avenue, Suite 24, Mountain View, CA 94043 (415-968-1345).

☐ IBM-PC and compatibles
Dance of the Planets, A.R.C. Software, Box 1974S, Loveland, CO 80539 (303-663-3223).
EZCosmos, Future Trends Software, Box 3927, Austin, TX 78764 (512-443-6564).
Genesis Project, Lewis-Michaels Engineering, 48 Delemere Boulevard, Fairport, NY 14450 (716-425-3470).
Hypersky, Willmann-Bell, Inc., Box 35025, Richmond, VA 23235 (804-320-7016).
Lodestar, Zephyr Services, 1900 Murray Avenue, Pittsburgh, PA 15217 (412-422-6600).
Superstar, Picoscience, 41512 Chadbourne Drive, Fremont, CA 94539 (415-498-1095).
The Sky, Software Bisque, 912 12th Street, Golden, CO 80401 (303-278-4478).
Visible Universe, Parsec Software, 1949 Blair Loop Road, Danville, VA 24541 (804-822-1179).

☐ Macintosh
Voyager, Carina Software, 830 Williams Street, San Leandro, CA 94577 (415-352-7328).

■ POLAR ALIGNMENT

If a telescope has an equatorial mount but its polar axis is aimed toward the wrong part of the sky, its tracking function is nullified. The equatorial mount becomes an impediment to comfortable viewing, rather than an asset. When a first-time purchaser of an equatorially mounted telescope reports that "the clock drive doesn't work, and nothing stays centred," the trouble probably lies not in the drive but in the user's skill at setting up the telescope.

Equatorial mounts with clock drives have the advantage of hands-off tracking of celestial objects, while setting circles provide a method of finding objects. For both to work as promised, the mount must be aligned to the celestial pole.

As Earth rotates, the heavens appear to rotate in the opposite direction. The sky's pivot point (in the northern hemisphere) is an imaginary spot called the north celestial pole, directly above the North Pole. If a telescope is to track properly, it, too, must rotate around an axis aimed at this location.

■ THE EASY WAY

Rigorous, time-consuming methods of precision polar alignment are necessary only for advanced astrophotography—either extended and guided deep-sky shots or high-magnification f/200 planetary photographs. For general observing, pictures of the moon or wide-angle piggyback exposures, an alignment within one or two degrees of the celestial pole will be adequate. This is accomplished in a few seconds by aiming the polar axis toward Polaris, the North Star, as closely as possible.

Schmidt-Cassegrains can be aimed up one of the fork tines and raised or lowered on adjustable tripod legs to achieve approximate alignment. Precise levelling is a waste of time for casual point-and-look viewing. The polar axis of German equatorial mounts can simply be eyeballed toward Polaris.

■ MORE ACCURATE POLAR ALIGNMENT

For more demanding applications, the telescope's polar axis should be within five arc minutes of the true celestial pole.

The north celestial pole is conveniently near Polaris, the end star in the handle of the Little Dipper. To be exact, the true pole lies 0.9 degrees from Polaris in the direction of Alkaid, the end star in the handle of the Big Dipper.

For observers in the southern hemisphere, locating the south celestial pole is a little more difficult. It lies one degree from a 5.4-magnitude star in Octans called Sigma Octantis, which is not a shining beacon in the southern skies.

The finder charts included here should help you zero in on the celestial pole. Now that you know where the celestial pole for your hemisphere is, the next step is to aim the telescope's polar axis at it.

■ POLAR-ALIGNING FORK-MOUNTED TELESCOPES

Which one is the polar axis? In fork-mounted telescopes such as Schmidt-Cassegrains, the polar axis (also known as the right-ascension axis) is the one around which the forks revolve. The other motion, which swings the tube up and down through the fork arms, is the declination axis. To be polar-aligned, the polar axis, and therefore the two fork tines, must be aimed at the celestial pole. Here is what to do:

1. First, adjust the altitude, or latitude, setting on the wedge (or top of the pier). From a latitude of 40 degrees North, set the angle on the latitude scale to 40 degrees. This can be done at any time, even indoors before setting up.

2. At the observing site, place the telescope so that its forks are aimed northward. Roughly level the telescope if you wish, but precise levelling is not necessary.

3. Swing the tube so that it reads 90 degrees declination on the circles on the side of the tube, and lock it there. This should put the tube parallel to the forks.

4. Move the telescope left to right to centre the pole in the finderscope. Do this by moving the whole tripod or by using the fine azimuth adjustments on the wedge assembly. Do not alter the telescope tube's declination or right ascension.

5. Move the telescope up and down to centre the pole in the finderscope. This may mean raising or lowering a tripod leg (it is usually best to have a tripod leg pointing south for this) or using fine altitude adjustments on the wedge.

6. It may be necessary to adjust the azimuth and altitude a few times to refine the aim point. With practice, it takes only 5 to 10 minutes. Remember, to aim at the north celestial pole, move the entire telescope so that the finderscope cross hairs are 0.9 degrees from Polaris along a line toward the end star in the Big Dipper's handle. If that star is not visible, use a line joining Polaris and Epsilon Cassiopeia, the first star in the distinctive W shape, but still offset toward the Big Dipper's handle.

The main problem with this method is that it can be difficult to find the correct pole location, since it lies in a blank area of sky. Moreover, it is too easy to move off the pole star by the required amount in the wrong direction. In straight-through finderscopes, the sky appears upside down; in right-angle

finderscopes, the sky is right side up but flipped left to right. With most 6x and 8x finderscopes, the field of view is about four degrees wide, which means that when the true celestial pole is in the centre, the pole star (Polaris or Sigma Octantis) is about halfway from the centre to the edge of the field.

■ POLAR-ALIGNING GERMAN EQUATORIAL MOUNTS

The finderscope method described above can be applied to all telescopes on German equatorial mounts. The declination axis on such mounts has the telescope on one end and the counterweight on the other. The polar axis—the one the clock drive turns—has the declination axis attached to it and is the part of the mount that must be aimed at the pole.

First, set the angle of the polar axis to your present latitude with the adjustment at the base of the mount—usually a large bolt with a graduated dial showing 0 to 90 degrees. Extra care should be taken when it is loosened, though, since the whole mount could flop down. If the telescope has a graduated dial, set the latitude and tighten the bolt. The latitude adjustment should be made only once, when the instrument is purchased, unless the telescope is transported north or south to a new latitude (travelling east or west makes no difference). If the equatorial mount does not have a graduated circle for a local latitude setting, follow the steps in the next paragraph; otherwise, skip ahead.

Latitude adjustment: At the observing site, place the telescope so that the polar axis aims as close to Polaris as possible using the eyeball method. Adjust the tripod legs to level the base of the mount. (This is one case when you *do* have to level the mount. Some mounts have bubble levels for this purpose.) Swing the tube in declination so that it is at 90 degrees as read on the declination circle—the circle nearest the tube or the counterweight. The tube is then parallel to the polar axis and is pointed in the same direction. Lock both axes. Carefully loosen the bolt that clamps the tilt of the polar axis, and adjust it until Polaris is seen in the finderscope midway between the top and bottom of the field (not necessarily centred, just midway). Now, tighten the bolt, and that should set the latitude angle. This procedure is necessary only once.

When the latitude adjustment is made and the telescope is levelled, the polar axis will be at the correct angle if it is aimed toward Polaris. On subsequent setups, with the tube at 90 degrees declination, use the fine altitude and azimuth adjustments on the mount to move the telescope left and right and up and down to centre the pole area in the finderscope. If your telescope has no fine adjustments, alter the height of the south-pointing tripod leg and nudge the tripod left or right.

If the mount has a polar-alignment telescope built into the polar axis, accurate polar alignment is relatively easy. The small instruments have reticles that show how far to offset from Polaris in order to centre on the true celestial pole. Since polar-axis telescopes invert the image, the true pole offset appears to be toward Cassiopeia from the pole star. Many finderscopes offer almost the same convenience as polar-axis telescopes if they have an offset ring or a small off-centre circle for Polaris. For this to work, the finderscope must be prealigned to the main telescope.

In addition, the declination setting-circle reading must be accurate. In other words, when the telescope is set at 90 degrees declination, the tube must be aimed at the same spot that the polar axis is. Declination circles can slip, so a setting of 90 degrees may not in fact be 90 degrees.

■ CALIBRATING THE DECLINATION CIRCLE

Swing a fork-mounted telescope in declination so that it parallels the forks as closely as the eye can judge. For German mounts, move the instrument to bring its tube parallel to the polar axis. Look into the eyepiece of the main telescope at low power, and watch the stars (any stars) as the telescope is rotated around the polar axis. Do the stars circle the centre of the field? (If the telescope is truly set to 90 degrees declination, they will.) If not, move the telescope slightly in declination to see whether the situation improves. Keep adjusting the declination until the stars move in concentric circles when the instrument is rotated in right ascension.

Now, loosen the declination circle(s), and set it (them) to show 90 degrees. Most declination circles on fork-mounted telescopes have a central bolt that can be loosened for this. Once tightened, the declination circle(s) should not need readjusting.

■ MORE PRECISE METHODS

Serious astrophotographers prefer stars to stay within a few arc seconds of their intended spot for an hour or more. This requires high-precision polar-alignment techniques.

□ The Single-Star Method
This technique was described by Dennis di Cicco in the December 1986 *Sky & Telescope*. It is a favourite of many amateurs, since with practice, it takes only 10 minutes. First, follow the steps in the previous section to align the mount with the celestial pole. Then aim the telescope at a bright star near the celestial equator whose right ascension is known, preferably in coordinates for the current year.

With the star centred in the eyepiece, rotate the right-ascension setting circle so that it displays the star's right ascension. Now, swing the telescope

■ Six-degree finderscope views show the stars in the vicinity of the north celestial pole (NCP) and the south celestial pole (SCP). Delta Ursae Minoris is the closest star to Polaris in the handle of the Little Dipper. Many telescope finders and polar-axis finderscopes have offset reticles for positioning Polaris relative to the NCP. Stars to eighth magnitude are plotted near the SCP to aid in direct aligning with polar-axis finderscopes. Fifth-magnitude Sigma Octantis is also shown on the Sky Region Chart on page 287. NCP and SCP positions are for the year 2000, but at this scale, these diagrams will be useful throughout the two decades from 1990 to 2010.

Star	Name	R.A.	(1990)	Dec.
α Andromedae	Alpheratz	0h 08m		+29° 02′
α Arietis	Hamal	2h 07m		+23° 25′
α Tauri	Aldebaran	4h 35m		+16° 29′
α Canis Minoris	Procyon	7h 39m		+05° 15′
α Leonis	Regulus	10h 08m		+12° 01′
α Bootis	Arcturus	14h 15m		+19° 14′
α Aquilae	Altair	19h 50m		+08° 51′

back until the circles show Polaris's coordinates (1990: R.A. 2h 22m Dec. +89° 13′). Move right ascension first, then declination. When swinging the mount in declination, be sure to stop at the first 89-degree setting. Do not go past the 90-degree mark to the 89-degree mark on the other side. Lock the mount in right ascension and declination. Do not worry if Polaris is not in the field.

Using the mount's fine altitude and azimuth adjustments, move it until Polaris is in the centre of the field of a medium-power eyepiece. Do not move the declination or right-ascension motions. Once Polaris is in the centre, unlock the telescope and swing it back to the calibration star. Adjust the right-ascension circle again if necessary. Repeat the procedure. Each repetition should require fewer and fewer adjustments. If the starting position was fairly close, only a couple of iterations should be needed to zero in on the pole. As di Cicco points out, the method also works in the southern hemisphere with Sigma Octantis and its coordinates (1990: R.A. 21h 00m Dec. −89° 00′).

If this technique is used often, keep the pertinent coordinates handy in a logbook or gadget case. Or if the telescope is set up in the same spot every night, mark the ground so that the tripod is always returned to the same orientation. This saves having to polar-align at every session.

☐ The Two-Star Method

This procedure is more time-consuming, but for perfectionists, it is the method of choice. When setting up a permanent site or a backyard observatory, it is also the best way to achieve the final alignment of the mount.

Again, use the simpler method to polar-align. Then aim the telescope at a star on the celestial equator due south. If possible, put an illuminated-reticle eyepiece in the telescope, and align the cross hairs so that they run parallel to the lines of right-ascension and declination motion. Ensure that the drive is running. Now, watch the star carefully. Ignore any drift it makes east or west in right ascension, but watch for a drift in declination, that is, north or south. It may take a few minutes to show up.

If the star drifts north, the polar axis is aimed too far west (it is to the left of the actual pole for northern-hemisphere astronomers). If the star drifts south, the polar axis is aimed too far east (to the right of the pole). Be careful. Make sure you know which way north is in the eyepiece. Move the mount in azimuth in the appropriate direction, then go back to the star, and watch again. Has the drift improved? Eventually, no drift should appear even after 20 minutes.

Once this stage is satisfactory, point the telescope at another star on the celestial equator, but one that is rising in the east. Observe it for a while, again ignoring any drift in right ascension. If it drifts north, the polar axis is aimed too high (it is above the actual pole). If the star drifts south, the polar axis is aimed too low (it is below the pole). Adjust the altitude of the polar axis accordingly. As long as the initial setup was good, only a small adjustment should be required. Now, go back to the east star, and watch again. The drift should have improved. Finally, repeat all the steps. If this is done in the southern hemisphere, substitute south everywhere we have said north, and vice versa. Clearly, such a tedious procedure is best reserved for permanent setups or for astrophotographic situations in which only perfection will do.

There is very little to wear out on a telescope, and it should literally last a lifetime, but not without some basic maintenance. The constant jostling and exposure to the elements is bound to take its toll, requiring that you clean and collimate the optics.

∎ COLLIMATION

For a telescope to deliver the best image possible, precise collimation of the optics is essential. This means all the mirrors and lenses should be centred and angled properly so that light rays hitting the main mirror or lens on-axis form an image in the exact centre of the eyepiece. If the optics are not collimated, stars in the centre of the field will be distorted comets flared to one side, rather than symmetrical pinpoints. In severe cases, nothing will focus properly. Before blaming the quality of your telescope's optics for poor images, check the collimation.

The test for poor collimation is simple: slowly rack a bright star out of focus. If the resulting expanding round disc is not symmetrical, there is a problem. On reflectors, the test is especially easy because the central dark shadow cast by the secondary mirror should be dead centre in the out-of-focus blur circle.

Commercially made refractors or Maksutovs are collimated at the factory and generally offer no user-adjustable settings. In the event that their optics do require collimation, it usually means a trip back to the manufacturer. Some refractors have three sets of screws in the lens cell for home collimation, but that is rarely needed.

However, if you have a Newtonian or a Schmidt-Cassegrain, collimation is something you should be aware of. Although it takes a major bump to knock mirrors out of collimation, it can happen (sometimes during shipping from the factory). Or the accumulation of small shocks and temperature changes over time can eventually degrade the alignment of mirrors. In either case, an adjustment of their collimation is required.

☐ Collimating Schmidt-Cassegrains

These are the simplest telescopes to collimate. The adjustments are done strictly with the three small screws on the secondary mirror cell. (On some models, the screws are hidden behind a protective plastic cover.) The idea is to use these screws to adjust the tilt of the secondary mirror so that it projects the light beam straight down the centre of the telescope. On most Schmidt-Cassegrains, the secondary mirror magnifies the focal length by a factor of five; its collimation is therefore extremely critical. Even a slight maladjustment can degrade performance. Always approach collimation with a light

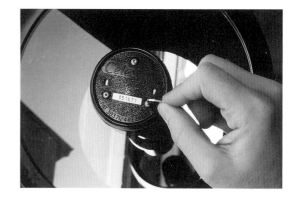

hand — a mere fraction of a turn may be all that is required — and check your progress to be sure you are on the right track.

With the typical Meade and Celestron Schmidt-Cassegrains, there are two other precautions: (1) Never loosen the central screw on the secondary mirror cell. It holds the mirror in place. (2) Be careful not to overtighten the three collimation screws. If they push on the secondary with too much force, the mirror surface will distort, creating astigmatic star images.

☐ Collimation Procedure

1. On a night with fairly steady star images, set up the telescope, and let it cool to outside air temperature. This may take an hour.

2. Aim the telescope at a second-magnitude star more than 45 degrees above the horizon. Use a medium-power eyepiece, but do not use a star diagonal, because it can introduce collimation problems of its own.

3. Place the star dead centre, then crank it out of focus until it is a sizable blob. If the telescope is out of collimation, the secondary-mirror shadow will appear off-centre.

4. Now use the slow motions to move the telescope so that the star image is displaced from the centre of the field. Select a displacement direction that makes the central shadow appear better-centred.

5. Using a tiny Allen wrench, turn the collimation screw that makes the out-of-focus star image move back toward the centre of the field. This takes careful trial and error. Remember to make very small adjustments.

6. If the image is still asymmetrical, then repeat Steps 4 and 5. Turning one screw may not be sufficient. A combination of two may be required. If one screw gets too tight, loosen the other two to perform the same move. At the end of the whole procedure, all three screws should be finger-tight.

7. Once you have done this at medium power, switch to high power (200x to 300x). Any residual

∎ *The three collimation screws for a Schmidt-Cassegrain are located on the secondary mirror cell. Small adjustments to these screws are often all that is required if collimation becomes necessary.*

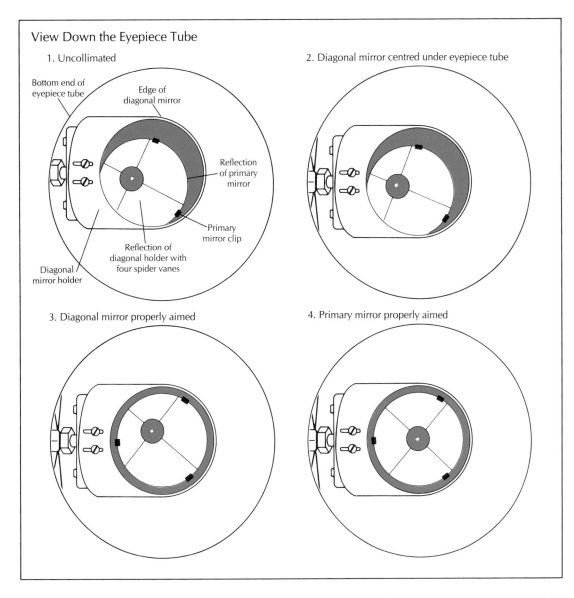

View Down the Eyepiece Tube

1. Uncollimated

Bottom end of eyepiece tube

Edge of diagonal mirror

Reflection of primary mirror

Primary mirror clip

Reflection of diagonal holder with four spider vanes

Diagonal mirror holder

2. Diagonal mirror centred under eyepiece tube

3. Diagonal mirror properly aimed

4. Primary mirror properly aimed

collimation error that remains after Step 6 will show up now, especially if you rack the star just slightly out of focus. Perform Steps 4 and 5 again, making even finer adjustments.

You can do this procedure to a fair degree of accuracy during the day. Sight a distant power-pole insulator or piece of polished chrome trim. Look for a specular glint of sunlight—it can serve as an artificial star. For the final adjustment, use a star at night.

☐ Collimating Newtonians

Both mirrors in a Newtonian are subject to adjustment, which slightly complicates the process. But you can bring Newtonian mirrors into close collimation in the comfort of your home simply by examining the appearance of the various reflections while looking down the focuser. To do this, you

need to make a "collimating eyepiece." Cut off the bottom of a plastic 35mm film canister, then drill or punch a small pinhole in the exact centre of the lid (where the moulding dimple is). This makeshift device will keep your eye in the centre of the focuser tube for the line-up tests. Insert the film-can eyepiece into the focuser in place of a regular eyepiece.

☐ Rough Collimation Procedure

1. The first step is to centre the secondary or diagonal mirror. It should be in the centre of the tube and directly underneath the focuser. To get it in the centre of the tube, adjust the spider vanes so that they are of equal length. It is that simple.

2. To get the mirror directly under the focuser, turn the threaded rod that the secondary-mirror holder sits on. This moves the secondary up and down the

■ *These four diagrams, adapted from* Perspectives on Collimation—*a booklet from* Tectron Telescopes—*represent the view down the eyepiece holder during the main phases of collimation.*

263

length of the tube. Look into the focuser through your collimation eyepiece to see whether the secondary mirror is centred on the focuser hole. Do not worry about any off-centre reflections in the diagonal mirror; just get the mirror itself positioned.

3. Rotate the diagonal holder until the top of the holder is directly under the focuser (so that the diagonal is not turned away from the focuser tube). It is fairly easy to eyeball this. (On most new commercial telescopes, Steps 1 to 3 should rarely, if ever, be necessary. However, homemade or used telescopes can have many collimation ills.)

4. Adjust the tilt of the secondary mirror. This is where most Newtonian owners will need to start. To do this, adjust the three collimation screws on the diagonal holder so that the reflection of the main mirror is precisely centred in the diagonal mirror. For this step, ignore the reflection of the spider and secondary mirrors; just concentrate on getting the perimeter of the main mirror nicely lined up with the outline of the secondary mirror. Up to now, you have not touched the main mirror at all. That is next.

5. At this point, the main mirror's reflection of the spider and diagonal holder probably looks off-centre. To bring them in line, adjust the three collimation screws on the main (primary) mirror cell. The dark diagonal-mirror silhouette should end up in the centre of the reflection of the primary mirror, which itself is centred in the secondary mirror.

6. Once the coarse mechanical adjustments are made, take the telescope out at night and check the out-of-focus star images to see whether they are symmetrical. Wait for the telescope to cool down, then follow the same procedure outlined under Schmidt-Cassegrains, but with a difference: use the three collimation screws on the primary mirror cell to do the final fine-tuning. Do not adjust the secondary mirror.

On some Newtonians, the secondary mirror is on a single-stalk spider with no provisions for adjustments. Should adjustments be necessary, the stalk must be bent to achieve Steps 1 to 4.

Any Dobsonian telescope in which the mirror is removed each night may require collimation touch-ups each time the telescope is used. To assist you in collimating Newtonians, more sophisticated accessories such as the Cheshire eyepiece are available. Tectron Telescopes in Florida makes a series of collimation aids that come with detailed instruction manuals. For more information on collimating telescopes, see the March and April 1988 issues of *Sky & Telescope*.

■ CLEANING TELESCOPE OPTICS

Never use cleaning solutions or special cloths sold for eyeglasses. These contain ingredients that may smear, leaving a chemical film on the lenses. Commercially available lens cleaners work fine for the small surface area of camera lenses and eyepieces but may be too high in detergent content for the larger areas of telescope objectives and corrector plates. Often, the result is smearing, unless the larger optic is polished to excess following the application of fluid.

The best plan is to mix your own lens cleaner suitable for optics both large and small with inexpensive supplies available at a drugstore. Mix distilled water and isopropyl (rubbing) alcohol of the cheapest and least aromatic variety in a ratio of 50-50. Then add a few drops of dishwashing liquid (*not* dishwasher), just enough to undo the surface tension that causes beading of the water-alcohol mixture on polished glass. The resultant brew is a potent cleaning agent that is safe for virtually any antireflection coating and dries clean with a minimum of polishing.

You can use lint-free commercial lens tissue, but we have found white facial tissue to be equally satisfactory. It may leave lint, but that is what a can of compressed air is for. Avoid the perfumed tissues, because they may contain oily aromatic substances.

However, the chief ingredient of care is the prevention of dust in the first place, so keep the optics covered when not in use. When dust does accumulate on the surface, you can defer a major cleaning job by removing it promptly while it is still dust, before a night of heavy dew transforms it into mud.

☐ Cleaning Eyepieces and Lenses

Of all optical components, eyepieces require the most cleaning. The eye lenses pick up grease and oil from eyelashes and from misplaced fingers fumbling in the dark. In refractors and catadioptrics, the front lens or corrector plate can gather dust. If dew is allowed to form on these surfaces often, a filmy residue can accumulate.

1. First, blow loose dust and dirt off the exterior lens surfaces with a bulb-blower brush or a can of compressed air. (Be careful with the canned air: if you tilt the can, some of the propellant may spew out, spotting the optics with chemical gunk.)

2. Next, use a soft camel-hair brush and very light strokes to remove loose specks. Any that remain could scratch the surface when you perform the following step.

3. Moisten some tissue with a few drops of the cleaning fluid mentioned above. Do not apply the fluid directly onto the lens; it can seep into lens cells and into the interior of eyepiece barrels.

4. Gently wipe the lens with the moistened tissue. Do not press hard. If the stain is stubborn, use new pieces of tissue. Sometimes, gently breathing on the lens can help remove stains.

5. Use a dry tissue for a final cleaning of moist areas,

plus some more air puffs to blow off the bits of tissue that inevitably remain.

Never take an eyepiece apart, at least to the extent that the eyepiece lenses are removed from their mountings. The inner surfaces were assembled in a dust-free environment. Also, in attempting to reassemble an eyepiece, it is all too easy to get the tiny lenses in the wrong order or flipped around back to front.

In some refractors, it is possible to remove the front lens assembly, cell and all. This may be necessary to get at the rear surface, where a filmy residue can sometimes appear. But never take doublet or triplet refractor lenses apart or remove the assembly from the cell.

The front corrector plate, complete with the secondary mirror attached, can be removed from the front of most Schmidt-Cassegrains. But use extreme care; Schmidt-Cassegrain corrector plates are very thin. Getting at the inside surface of the corrector or at the secondary mirror may be required if the interior of the telescope has become contaminated with dust or moisture. Important: The corrector plate/secondary mirror assembly must be put back in the same orientation as you found them.

For objective lenses, correctors and other large refractor surfaces, clean in a number of relatively small pie-shaped sections. If you attempt to clean a large optic in a single fell swoop, the portion wetted will almost certainly dry to smears while you attempt to get the first part dry. Discard the tissues used on prior sections, and use fresh ones, in case some grit was picked up along the way. There may be a few smears remaining, but a final polish with a fresh tissue and light condensation from your own breath will restore the pristine appearance.

□ Cleaning Mirrors

For most of the lifetime of a Newtonian, the primary and secondary mirrors should require only the occasional blast of canned air and a few strokes of a camel-hair brush. Aluminized surfaces can scratch easily, and a mirror full of microscopic scratches is far worse than a mirror with a few isolated specks of dust on it. However, for that rare cleaning, follow these steps:

1. Remove the mirror from its cell—a task sometimes made tricky by poorly designed clips.
2. Once the mirror is free from the cell and safely on a table, use a blower and brush to remove as much loose dust as possible.
3. Now, place the mirror on edge in a sink on top of a folded towel to prevent it from slipping around.
4. Run cold water over the front of the mirror to wash off more of the dirt. Do not worry; this will not remove the aluminum coating.
5. Then fill the sink with warm water and a few drops of a gentle liquid soap.

6. Lay the mirror flat in the sink; there should be about half an inch of water covering the surface. Use sterile cotton balls or gobs of cotton to swab the mirror gently. Always brush in straight lines across the surface, using the weight of the wet cotton as the sole source of pressure on the mirror's face. Never rub or use circular motions. Repeat if necessary with fresh cotton balls and moving in a direction perpendicular to the first procedure.
7. Drain the sink; then rinse the mirror with cool water.
8. Perform a final rinse with bottled distilled water (to remove mineral substances from the tap water).
9. Let the mirror dry by standing it on edge. Once cleaned in this fashion, the mirror should not have to be subjected to this treatment again for many years, if ever. Final caveats: Be very careful when handling the wet mirror. Remove any rings from your fingers so that the mirror does not get scratched. And do not use any chemical solvents or cleansers.

■ COLD-WEATHER PRECAUTIONS

Moving a telescope from a warm house to the cold night air, even if it is minus 30 degrees, should not have any ill effect on the optics. Parts will contract, but we have never heard of a telescope mirror or lens shattering from the cold. However, mechanical parts become difficult to move because of the grease stiffening. Focusers and clock drives become very balky. If your telescope mount seems to seize up under extremely cold conditions, never force it. Forcing a frozen component can cause it to break or strip gears. To solve this, observers who frequently use their telescopes under cold winter conditions often replace the standard grease with a special low-temperature silicone lubricant.

When bringing a frosted or dew-covered telescope in from the cold, always cap the main optics and pack the telescope and eyepieces in their cases first. Then carry the protected optics inside, and allow them to warm up gradually. This will help prevent condensation from forming on them. Once the equipment has warmed close to room temperature, it can be uncovered. If optics have not dried off, exposure to warm household air will soon clear them.

A little moisture on the optics now and then will do no harm, but if it happens regularly, corrector plates and lenses can collect a filmy residue, sometimes on both the outside and inside surfaces, forcing more frequent cleaning, which is not good. If the telescope is being used night after night in cold weather, store it in a cold but dry place, such as an unheated garage with a dry concrete floor. This will avoid all the condensation problems, not to mention the long wait for perfect star images while the telescope settles down to ambient temperatures.

■ A GLOSSARY OF OPTICAL JARGON ■

□ By Peter Ceravolo

Here is a glossary of terms to help decode the jargon often encountered in product reviews and telescope advertising. In reviewing the definitions of terms, you will detect a bias toward high-quality, high-contrast telescopes. Although this might suggest refractors as the only instruments of choice, Newtonian and Cassegrain-type reflectors can, in fact, achieve a high degree of optical perfection when made correctly. Also addressed are a few imperfections in the way amateur-astronomy optics are described and marketed. Words in italics are defined elsewhere in the glossary.

■ ABERRATIONS

Aberrations are the result of the defects and/or design compromises inherent in even the finest optics. On-axis aberrations, such as *spherical aberration* and *chromatic aberration,* cause a loss of sharpness and *contrast* to images in the centre of the field. Off-axis aberrations, such as *coma* and curvature of field, affect images at the edge of the field. Depending on the source of the aberration, *astigmatism* can affect images in either part of the field.

■ ACHROMATIC REFRACTOR

A refractor that uses a two-lens *objective* made of conventional crown and flint glasses will reduce *chromatic aberration* to low levels, bringing two colours to a common focus. Such a lens system is called "achromatic," meaning mostly colour-free.

■ AIR-SPACED LENS

Small doublet lenses (less than 4 inches) are often cemented together. In larger lenses, this is impractical. Larger doublets and many triplet lenses are air-spaced, a design that gives lens makers greater freedom to produce an *objective* which reduces *aberrations* to a minimum and which cools down more quickly than would a massive lens with all elements in contact.

■ AIRY DISC

The wave nature of light prevents even the most optically perfect telescope from showing stars as pinpoints. Instead, in the ideal telescope system at high power, a star looks like a tiny disc—the Airy disc—surrounded by a series of rings (diffraction rings) of decreasing brightness. In fine-quality, unobstructed optical systems, 84 percent of the light is concentrated into the central Airy disc, and 16 percent is distributed among the rings. As the optics or design of the telescope system deviates from perfection, more light is spilled out of the Airy disc and into the diffraction rings, lowering *contrast*. To understand this, think of the Airy disc as the telescopic equivalent of the dots that make up a television image. In extended targets, such as planets and deep-sky objects, light that spills into the rings washes over the adjacent picture dots, diffusing the difference in brightness between adjacent dots. The Airy disc's size is 280 divided by the aperture of the telescope in millimetres.

■ APOCHROMATIC REFRACTOR

Apochromatic is sometimes used to mean any high-contrast colour-suppressed refractor system. To be precise, an apochromatic lens will bring three wavelengths to a common focus and will achieve *spherical aberration* correction in two wavelengths. In order that no extraneous colour is seen even on the brightest celestial objects, a lens must bring all the visible colours together to within 0.01 percent of the system's focal length. Modern apochromatic telescopes can have two-, three- or four-element *objectives* in focal ratios as fast as f/5. A telescope that has extra lens elements beyond the two standard in an *achromatic refractor* is not necessarily apochromatic; it must be carefully designed that way.

■ ASPHERIC SURFACES

Any optical surface that employs a figure which is not a simple surface of a sphere is called aspheric. Spherical surfaces are the simplest optical systems to manufacture and are therefore more likely to approach perfection. Examples include the classic long-focus refractor. However, some refractor systems and most reflector and *catadioptric* systems require optics that are aspheric. Examples are the *parabolic* surface used on all quality Newtonian primary mirrors.

■ ASTIGMATISM

One of the principal optical *aberrations*, astigmatism spreads the star image out into an ellipse or line. In main optics, astigmatism can be caused by poorly mounted optics that bend the lens or mirror along one axis. It can also be caused by improperly manufactured optics. Astigmatism is often present in even the finest eyepieces, where it distorts stars at the edge of the field into elongated sea gulls. Eyepiece astigmatism effects are frequently and erroneously called *coma* by amateur astronomers.

■ BAFFLING

Ideally, only light passing directly through the telescope's optics from the object under scrutiny should reach the focus, but this is seldom the case. Light

from other areas of the sky can sometimes enter the field of view, either directly or after bouncing off tube components. The result is reduced *contrast*. Eliminating the scattered light is the job of well-placed baffles. In a refractor, baffles take the form of several discs with holes of varying diameters positioned along the inside of the tube. In a *Cassegrain telescope*, baffle tubes usually extend from the main mirror's central hole and from the secondary mirror mount. Newtonian reflectors are difficult to baffle. If the focuser is mounted too close to the end of the tube or if there is a gap between the primary mirror cell and the tube, then stray light can reach the focus directly from both top and bottom.

■ CASSEGRAIN TELESCOPE

Cassegrain is the family name for any type of reflecting telescope that has a concave primary mirror (like a Newtonian) but whose secondary is a convex (dome-shaped) mirror. This mirror amplifies the primary's focal length and reflects the light beam back down to the bottom of the tube, where it passes through a hole in the primary mirror. A Cassegrain system allows long focal length in a short tube.

■ CATADIOPTRIC TELESCOPE

Catadioptric is the family name for any type of telescope that uses a combination of reflecting mirror and refractive lens (usually in the form of a full-aperture corrector lens). Schmidt-Cassegrains and Maksutovs are both catadioptrics. The corrector lens corrects *aberrations* introduced by the main spherical mirror, making a compact closed-tube system.

■ CENTRAL OBSTRUCTION

Any telescope with a secondary mirror in the light path (such as a Newtonian or *Cassegrain telescope*) has a central obstruction. The amount of the obstruction can range from 15 to 25 percent of the main mirror's diameter for Newtonians and from 30 to 50 percent for Cassegrains. A few manufacturers state this specification as a fraction not of the diameter but of the area. This makes the obstruction sound smaller. The loss in light from an obstruction is not as important as the increase in diffraction. Calculations show that a 30 percent (by diameter) central obstruction has roughly the same effect on image contrast as a 1/4-wave *wavefront error*. For example, the 70mm secondary mirror in an 8-inch Schmidt-Cassegrain blocks about 35 percent of the diameter of the main mirror. This obstruction produces an *Airy disc* that contains 63 percent of the light, with the remaining 37 percent spread into the diffraction rings. In instruments with large central

obstructions (30 percent or more), a planetary image, even under excellent seeing, has a gauzy appearance, as if it is being observed through a very fine ground-glass screen. However, the deterioration in contrast is often noticeable only to experienced observers or in a side-by-side comparison with an *unobstructed telescope* of similar aperture.

■ CERTIFIED OPTICS

Manufacturers sometimes use this term to indicate quality. But optics certified by whom and to what standard? Few manufacturers supply documentation to prove their so-called certification. "Certified optics" is a meaningless advertising term.

■ CHROMATIC ABERRATION

This optical *aberration*, characteristic of refractors, occurs when all the colours are not brought to the same focus. The result is a halo of unfocused colour around bright objects. Refractors with fast focal ratios suffer the most from this defect.

■ COMA

Coma is an off-axis *aberration* that affects only images away from the centre of the field of view. Coma causes stars to appear flared, like tiny comets pointing inward from the edge of the field. It is a characteristic of fast-focal-ratio Newtonians and some *Cassegrain telescopes*.

■ CONTRAST

The difference in brightness over the surface of an object or the difference in brightness of an object compared with the sky is the contrast. Since a great deal of the detail on planets and within deep-sky objects is inherently low in contrast to begin with, any *aberration*, stray light or turbulence that lowers contrast will also obscure detail.

■ CONTRAST EFFICIENCY

In effect, contrast efficiency is the capability of a telescope to form as ideal a diffraction pattern as possible with the least amount of scattered light. Only high-quality optics in a well-designed tube assembly will offer high-contrast efficiency. A high-contrast image of an object in a small telescope can show the same detail as seen in a less efficient system with a significantly larger aperture. Overall, the image may be fainter, but the same details are visible.

■ DAWES' LIMIT

Nineteenth-century observer William R. Dawes found that a telescope could resolve double stars

which were separated by 4.56 arc seconds divided by the aperture of the telescope (in inches). The rule of thumb applies only to yellow stars of equal magnitude. However, manufacturers often state that a telescope will resolve better than Dawes' limit as a claim of its optical quality.

■ DIFFRACTION LIMITED

Commercial telescopes are often advertised as diffraction limited. This means 1/4-wave performance—good enough for many recreational-astronomy applications but a little lax for high-finesse imaging.

■ ENHANCED COATINGS

Ideally, a mirror should reflect 100 percent of the light that strikes it. However, the aluminum coating standard on most telescope mirrors reflects 88 percent of the incident light. Since there are at least two mirrors in any reflective system, only 88 percent of 88 percent (78 percent) of the incident light gets to the focus. In a *Cassegrain telescope*, the star diagonal, whether it is a mirror- or prism-type, causes a further loss of light.

The efficiency of reflective telescopes can be improved by using silvered rather than aluminized surfaces. Silver has about 95 percent reflectivity, but it tarnishes easily unless overcoated for protection. Because of problems with silvered optics, manufacturers turned to aluminum enhanced with multi-layered overcoatings. Reflectivities as high as 98 percent can be achieved, although in practice, enhanced aluminum coatings are usually limited to about 95 percent reflective efficiency—a significant improvement in image brightness that makes enhanced coatings an excellent option.

■ FLUORITE LENS

Most two-lens (doublet) *apochromatic refractors* have one element made of either calcium fluoride or fluoro-phosphate crystal and are known respectively as fluorite or ED apochromats. These materials are expensive, more thermally sensitive and more difficult to work with than conventional glass. However, fluorites and ED lenses can achieve superb colour correction.

■ FULL-THICKNESS MIRRORS

Mirrors with a width-to-thickness ratio of 6:1 are called full-thickness mirrors. Theoretically, they will hold their figure better than will a thin *lightweight mirror*. However, their large mass can take a long time to cool down.

■ HAND-FIGURED OPTICS

Manufacturers often say that their optics are hand-figured, implying a greater degree of precision or care in the manufacture. In practice, all telescope optics must receive some degree of hand-figuring. The quality that results depends on how well the optics are hand-figured.

■ LIGHTWEIGHT MIRROR

Thin mirrors (with a width-to-thickness ratio of from 10:1 to 15:1) are often priced at a fraction of the amount of *full-thickness mirrors* and are much lighter. Yet it takes just as much time, if not more, to figure a thin mirror accurately as it does a full-thickness one. If any mirror is not supported properly, gravity will deform it. This problem becomes worse with thin mirrors. As an alternative to thin mirrors, mirrors can also be made lightweight by moulding them using a ribbed egg-crate structure.

■ MAGNESIUM-FLUORIDE COATINGS

In a refractor, some of the light (approximately 1 percent per 25mm of thickness) is absorbed by the thick glass lenses. If the lens surface is uncoated, about 4 percent of the light is also lost to reflection at each air-to-glass surface. For the average uncoated air-spaced doublet, only 81 percent of the incident light reaches the focus. To increase light transmission, lenses can be treated with a single layer of magnesium-fluoride coating. This reduces the light loss to less than 1.5 percent per surface, and the overall transmission of an air-spaced doublet increases to about 95 percent.

■ MULTICOATED OPTICS

To increase light transmission further, lenses and corrector plates can be coated with multiple layers of antireflection material. This reduces light loss to less than 1 percent per surface. Modern eyepieces, with up to 10 or more air-to-glass interfaces, benefit the most from multilayered coatings.

■ NULL FIGURED

A type of test used during fabrication of telescope optics. Does not necessarily imply high quality. (The Hubble Space Telescope's primary mirror was Null figured.)

■ OBJECTIVE

The main lens or mirror in a telescope is often called the objective.

■ PARABOLIC MIRROR

To focus all incoming light rays to the same point, Newtonian primary mirrors must be aspheric or parabolic in shape. This is achieved by altering the spherical surface of the mirror during polishing. Accurate parabolizing is essential to achieving optimum performance (except in the case of 6-inch

or smaller Newtonians f/10 or longer, where a spherical primary will suffice).

■ RESOLUTION

Resolution is a telescope's ability to reveal fine detail, especially low-contrast detail such as Jovian cloud belts. The traditional test for resolution is to examine equal-magnitude double stars close to the instrument's theoretical resolution limit, or *Dawes' limit*. However, an optical system that splits equal-brightness double stars will not necessarily reveal subtle lunar and planetary details. (See Chapter 6.)

■ RITCHEY-CHRÉTIEN CASSEGRAIN

This system uses primary and secondary mirrors, each of which has a hyperbolic surface. Its off-axis *aberrations* are low, making it suitable for wide-field photography, but it does have some *astigmatism* and curvature of field. The Hubble Space Telescope is a Ritchey-Chrétien.

■ SATISFACTION GUARANTEED

Many manufacturers of amateur-astronomy optics lack the costly test equipment necessary to guarantee a specific surface accuracy or *wavefront error*. Rather than misrepresent their products, they simply guarantee satisfaction. Should you be unhappy with your purchase, most companies will readily exchange or fix your telescope. However, the problem some buyers have encountered is that the new or repaired instrument is no better than the original, making such a guarantee rather hollow.

■ SECONDARY SPECTRUM

The unfocused light, usually blue or violet, around bright objects in refractors with *chromatic aberrations* is called the secondary spectrum.

■ SPHERICAL ABERRATION

The defect that plagues the Hubble Space Telescope. Rays from the perimeter of the *objective* do not focus at the same point as rays from the centre. The result is overly bright diffraction rings, loss of detail and haloes of unfocused light around planets. If the *aberration* is acute, star images will be unfocusable blurs.

■ SPHEROCHROMATISM

The variation of *spherical aberration* with the wavelength of light is called spherochromatism. In some refractors, *spherical aberration* can be very low in the green portion of the spectrum but higher in the red and/or blue ends of the spectrum.

■ SURFACE ROUGHNESS

Although commercially made mirrors, corrector plates and lenses can have a good overall figure, they may still suffer from relatively narrow but numerous zones that add up to a "rough" surface which causes light scatter and reduced image contrast.

■ TURNED EDGE

A common figuring defect of optics is to have the area around the outside edge too flat or too steeply curved. If the zone is wide enough, this defect can seriously affect image quality by introducing *spherical aberration*.

■ UNOBSTRUCTED TELESCOPE

Any telescope that does not place a secondary mirror in the light path is called unobstructed. Telescopes without central obstructions include refractors and reflector designs such as Schiefspieglers that employ tilted mirrors.

■ 1/20-WAVE OPTICS

When reflective optics are described as 1/20-wave, the implication is that no defect on the mirror's surface causes it to deviate from the ideal shape by more than one-twentieth of a wavelength of light. But without further qualification, it could mean deviation of 1/20-wave either way from the ideal, for a total error of 1/10-wave, rather than true 1/20-wave surface error, called peak-to-valley. Then consider this: After reflection, a ray hitting the high points of the mirror will be ahead of a ray hitting the low points by twice the depth of the defect (because the low one has to traverse the distance twice). Thus peak-to-valley errors are doubled once the reflected wavefront is heading to the eyepiece. Moreover, because there are two mirrors in Newtonian optical systems and three in a Schmidt-Cassegrain with a diagonal, the *wavefront error* of each mirror is compounded.

■ WAVEFRONT ERROR

Each of the various lenses or mirrors in a telescope contributes some distortion to the light rays passing through the system. The final effect is a wavefront entering your eye with a certain degree of optical *aberration*. The amount of the wavefront error, or optical path difference (OPD), is the most critical value in determining optical quality. Yet no manufacturer (to our knowledge) supplies wavefront-error numbers. A certification of a telescope's wavefront would be a guarantee of actual performance. Someday, manufacturers will supply documentation of wavefront data. Until then, the various claims of optical-surface accuracy mean little.

Peter Ceravolo is a professional optician with the optical-design group at the National Research Council of Canada, in Ottawa. He is also associate editor of Telescope Making *magazine.*

■ HOW TO TEST YOUR TELESCOPE'S OPTICS ■

Have you ever wondered whether your telescope is delivering the image quality it is supposed to? You can find out by conducting the star test, which can be done outside at night with no special equipment yet is sensitive enough to reveal even subtle defects in a telescope's optics. It can also reveal many problems that are not the fault of the telescope, so some care is required.

■ WHAT YOU SHOULD SEE

The star test is administered by examining star images at high power, both in focus and out of focus. Surprisingly, the out-of-focus images can demonstrate a great deal about a telescope's optical quality and performance potential.

■ THE IN-FOCUS DIFFRACTION PATTERN

At high power, a star looks like a distinct spot surrounded by a series of concentric rings, with the innermost ring being the brightest and most obvious. This is called the diffraction pattern. The spot in the middle is known as the Airy disc. Any telescope that claims to be diffraction limited must create a very good likeness of that pattern.

■ AIRY DISC AND DIFFRACTION PATTERN

Your telescope may not produce as perfect a bull's-eye as is depicted in the accompanying illustration. Few telescopes do. But you can see a perfect diffraction pattern by masking your telescope down to a one-to-two-inch aperture. Then focus the telescope on a bright star well above the horizon, such as Vega or Capella, using a magnification of 50x to 100x. Doing so should provide you with a classic diffraction pattern that can then be used as a standard of comparison when star testing telescopes.

■ THE OUT-OF-FOCUS DIFFRACTION PATTERN

With the telescope stopped down, slowly rack the star out of focus. An expanding pattern of rings will emerge, like ripples spreading across a quiet pond. Defocus the instrument to the point where four to six rings show. Except for a fat outer ring, the light is spread more or less uniformly among the rings.

Now, rack through focus to the same place on the other side of focus. The pattern should look identical, with a uniform distribution of light within rings. The outer edge of the rings will be sharp; the edge should not fuzz out on either side of focus.

In an unobstructed telescope, such as a refractor, the out-of-focus pattern will be filled in. In an ob-

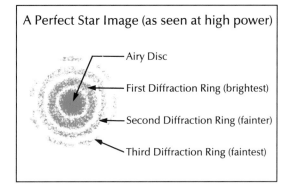

A Perfect Star Image (as seen at high power)

Airy Disc

First Diffraction Ring (brightest)

Second Diffraction Ring (fainter)

Third Diffraction Ring (faintest)

structed telescope—a reflector with a secondary mirror—the out-of-focus pattern looks more like a doughnut. Examining the appearance of an out-of-focus star image (called the extrafocal image no matter which way it is defocused) is the essence of the star test.

Now, remove the aperture stop, and test the instrument at full aperture. To do this, choose a second-magnitude star and defocus it so that four to eight rings are visible. If you defocus it too far, the test loses all sensitivity. Use about 25x to 35x per inch of aperture.

■ WHAT YOU MIGHT SEE

Many factors besides the quality of the optics themselves can ruin star images, so try to reduce these outside effects. Otherwise, you may be blaming your telescope for a defect it does not have.

■ TELESCOPE COLLIMATION

A telescope that is out of collimation is unfairly judged by the star test. The out-of-focus diffraction pattern in such a telescope looks like a striped, tilted cone as viewed from the pointy end. If your telescope gives poor images, it is probably because of poor collimation. Follow the directions in the collimation section of Appendix 3 before conducting a star test.

■ ATMOSPHERIC TURBULENCE

On nights of poor seeing, turbulent air churning above the telescope can turn the view into a boiling confusion. When this happens, don't bother testing or collimating. Because they look through a larger volume of air, large telescopes are affected more by this problem than small ones, making it difficult to find a good night to test big instruments.

■ TUBE CURRENTS

Slow-moving currents of warm air inside a telescope can introduce defects that mimic permanent errors

on the glass. Diffraction patterns look flattened or flared. These image-distorting currents occur when a telescope is taken from a warm house into the cooler night air. When star testing, always allow the telescope to cool down. It may mean a wait of an hour or more.

■ PINCHED OPTICS

Badly mounted optics create very unusual diffraction patterns. Most common for Newtonians is a triangular or six-sided spiking or flattening (depending on which side of focus you are on). This occurs if the clips holding a mirror in its cell are too tight. The solution is to loosen them. Secondary mirrors glued onto holders can also suffer from pinching.

■ OTHER SOURCES OF ERROR

To conduct a star test, use a good-quality eyepiece such as a Plössl or Orthoscopic. Do not use a Barlow—it may add some optical errors of its own. Also, do not use a star diagonal; always look straight through the telescope. And be sure to do the star test with the image centred in the field of view.

As a final precaution, if you wear glasses which have strongly curved lenses or which correct for astigmatism, leave them on. Although you may not be able to see the whole field, that does not matter for this test.

■ WHAT YOU DON'T WANT TO SEE: DEFECTS

Now, the heart of the test: determining whether there is a defect in the optics themselves. Errors on the optical surface are divided into categories. Unfortunately, the diffraction image does not always neatly conform to textbook patterns. Errors sometimes combine to mix up the patterns illustrated here. However, one error usually dominates, making the diagnosis fairly obvious.

■ UNDERCORRECTION AND OVERCORRECTION

The most common error in optical surfaces produces a distortion called spherical aberration. This often happens when a mirror or lens is undercorrected, that is, the surface has not been polished to the proper parabolic shape, making light rays from the perimeter focus closer in than rays from the centre. Inside of focus, the diffraction pattern has an overly bright outer ring; outside of focus, the outer rings are faint and ill defined.

The opposite pattern, with a fuzzball inside of focus and a doughnut outside of focus, results from overcorrection. Either error causes spherical aber-

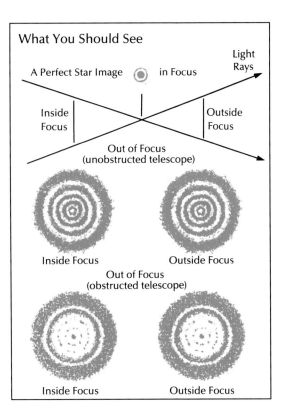

What You Should See

A Perfect Star Image · in Focus · Light Rays

Inside Focus · Outside Focus

Out of Focus (unobstructed telescope)

Inside Focus · Outside Focus

Out of Focus (obstructed telescope)

Inside Focus · Outside Focus

ration that in turn leads to fuzzy images. Stars and planets never snap into focus.

But do not confuse the secondary mirror's shadow in the ring system with a problem in your instrument's optics. At some point in defocusing, the centre of the expanding cone of light is no longer illuminated in obstructed telescopes, leading to a doughnut pattern. The important factor is that the pattern should be the same on both sides of focus.

■ ZONES

Zones are small figuring errors in the form of shallow valleys or low hills arrayed in rings on the optical surface. They often result from harsh machine-polishing methods. Most commercial optics suffer from zones to some extent. Severe cases degrade image quality noticeably. To check for zones, defocus the image more than is usual in the star test. On one side of focus or the other, you may notice that one or more of the rings looks weak.

■ TURNED-DOWN EDGE

One type of zone is the turned-down edge—a rounding off of the edge of the mirror or lens caused by unusual polishing pressure. Turned-down edges can be troublesome because the perimeter of a mirror or lens represents a large fraction of the light-collecting area.

■ *In a perfect telescope, all the light rays reach a common focus. When viewed at high power and precisely in focus, a star should appear as a tiny disc surrounded by faint rings (top). When viewed out of focus, the star image should appear as a series of concentric rings. Ideally, the pattern will be identical on either side of focus, although few telescopes exhibit the ideal textbook patterns depicted here. In an unobstructed telescope (such as a refractor), the out-of-focus pattern will be filled in (middle). In an obstructed telescope (a reflector with a secondary mirror), the out-of-focus pattern will look more like a doughnut (bottom).*

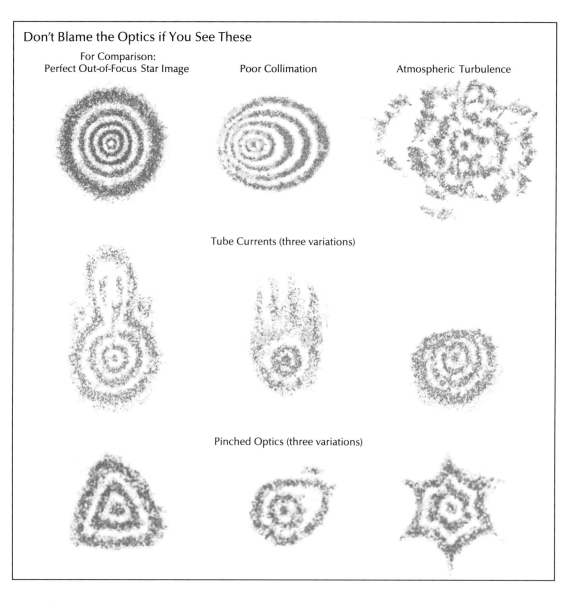

Don't Blame the Optics if You See These

For Comparison:
Perfect Out-of-Focus Star Image Poor Collimation Atmospheric Turbulence

Tube Currents (three variations)

Pinched Optics (three variations)

■ *Strange, out-of-focus star images may not be the result of poor optics. Poor collimation can produce elliptical images. Tube currents often cause a distortion on one side of the image. Turbulence in the atmosphere outside the telescope tube generates overall distortions (poor seeing). The patterns created by pinched optics are caused by the way in which the optics are mounted, not by the optics themselves. Also, a refractor or Schmidt-Cassegrain should never be tested with a star diagonal in place because defects in the diagonal's mirror or prism can contaminate the test.*

In reflectors, a turned-down edge displays its presence in the star test by a fuzzing out of the edge of the disc inside of focus. As you approach focus, the diffraction pattern looks flat; the rings are not crisp. Outside of focus, the diffraction pattern is less disturbed and is difficult to distinguish from that produced by a perfect mirror.

For refractors, the reverse is true; the disc has a fuzzy edge outside of focus. However, the edge of a refractor's objective is covered by the mounting cell, so a turned-down edge appears less often in a refractor.

■ ROUGH SURFACES

Another common problem with commercial optics is a kind of bumpiness or relief pattern caused by harsh machine polishing. Its descriptive nickname is "dog biscuit," and it is more prevalent in reflectors than in refractors. It appears in the star test as a less-

ening of contrast between the rings and the appearance of spiky appendages to the rings. Do not confuse diffraction from spider vanes with these spikes — spider diffraction is spaced regularly. Since other aberrations can often obscure the appearance of rings on one side of focus or the other, you must inspect both sides of focus for signs of roughness. A velvety smooth ring system means you do not have trouble with roughness.

■ ASTIGMATISM

If an optical surface is ground or polished on an uneven backing with an uneven stroke or if poorly annealed glass is used, the resulting cylindrical shape causes astigmatism. This in turn makes a star image look like a stubby line or an ellipse that flips over at right angles as you rack from one side of focus to the other. The best focus looks vaguely crosslike. The easiest way to detect astigmatism is to rock

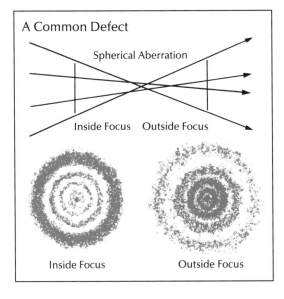

A Common Defect

Spherical Aberration

Inside Focus Outside Focus

Inside Focus Outside Focus

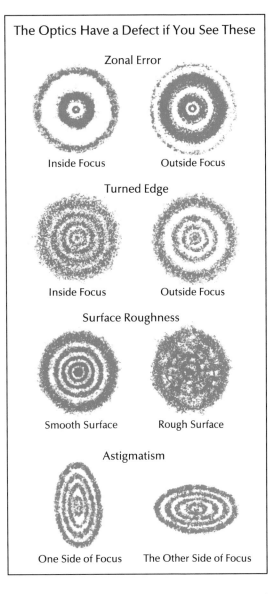

The Optics Have a Defect if You See These

Zonal Error

Inside Focus Outside Focus

Turned Edge

Inside Focus Outside Focus

Surface Roughness

Smooth Surface Rough Surface

Astigmatism

One Side of Focus The Other Side of Focus

the focuser back and forth quickly. Mild astigmatism may be evident only at three rings defocused. This problem is common in Schmidt-Cassegrains that have corrector plates poorly matched to the main mirrors or improperly oriented.

Astigmatism can also arise from an uncollimated telescope or from pinched optics. Astigmatism in Newtonians may indicate a diagonal that is not flat. To test this, rotate the main mirror 45 degrees. If the pattern does not rotate by the same amount, the diagonal is bad or poorly mounted.

■ WHAT IF YOUR TELESCOPE FAILS?

Nearly all telescopes have questionable grades on one or more of the star-test checks—not because they are bad instruments but because the star test can be astonishingly sensitive. So before dismissing any telescope, do some other checks. How does it perform on the snap test? One of the quickest star tests is to watch the image as it passes through focus. Does the focus snap into place, or does it ooze through focus? If it snaps, it is doing well.

How does it do in comparison with other instruments of similar type, size and focal length? If your telescope always performs poorly in comparison with others, you have good reason to believe the instrument is at fault. Then consider the magnitude of the defect. Severe errors on any telescope include obvious turned edge, any astigmatism that originates on the glass, easily seen correction difficulties, bad zones or severe roughness. These warrant returning the telescope.

Possible acceptable errors include small correction flaws that are not immediately obvious, mild zones (particularly those near the centre) and light roughness. You must carefully weigh the likelihood that you will get better optics at the same price. You must also consider what you bought the telescope

to do. If yours is a low-cost light bucket, be prepared to accept less-than-top-grade optics. On the other hand, if you have paid a premium price for a telescope advertised as diffraction limited, you have a right to expect high marks on the star test.

If your telescope seems to fail the star test, do not immediately confront the dealer or manufacturer. You may be wrong. Like all types of observing, proficiency at star testing takes time. Try star testing other instruments. Get a second opinion. Ask more knowledgeable members of your local amateur group to star test your telescope. If the telescope still fails, work with the dealer or manufacturer responsibly, and you will probably receive satisfaction. *This Appendix was adapted with permission from the article "Test Drive Your Telescope" by Florida amateur astronomer and telescope maker Dick Suiter. The original appeared in the May 1990 issue of Astronomy. Illustrations courtesy Astronomy.*

■ *Left: In many telescopes, the mirrors are undercorrected. In such systems, light rays from the perimeter of the mirror focus close in, while light rays from near the centre of the mirror focus farther out. This produces spherical aberration. The result is images that never snap into sharp focus.*
■ *Right: Four primary optical defects. A turned edge is a form of zonal error in which the edge of the mirror is lower than the ideal surface. Surface roughness and turned edge are more common in reflective than in refractive optics. A telescope can be afflicted with more than one defect.*

CHARTS OF SELECTED SKY REGIONS

This Appendix presents charts of selected regions of the night sky rich with interesting objects.

INTRODUCTION TO THE SKY REGIONS

As we described in Chapter 11, the backyard astronomer can choose from a complete range of star atlases for every observing situation. Rather than attempt a mini-atlas to end this book, we have selected eight sky regions that are particularly rich in celestial treasures. The format for each is a photograph accompanied by a map based on the photograph. This combination avoids cluttering a photograph with labels, permitting clear identification of individual objects. A small locater map showing at least one of the bright stars identified in the key maps on pages 22 and 23 displays the specific position of each sky region.

STAR NAMES

The worn-out expression "It's all Greek to me" actually applies when a backyard astronomer examines a star chart. Just before the invention of the telescope early in the 17th century, German astronomer Johannes Bayer assigned a Greek letter to all of the prominent naked-eye stars in each constellation: alpha for the brightest, beta for second brightest, and so on. The system is still used today. For example, Deneb, the brightest star in Cygnus, is also known as Alpha Cygni. (Following traditional rules of star naming, constellation names become genitive in this context—Cygnus to Cygni, Orion to Orionis, et cetera.)

Deneb is also known as 50 Cygni, a designation called a Flamsteed number after English astronomer John Flamsteed, who decided that a system which extended beyond the limitations of the Greek alphabet was needed. In general, the very brightest stars, such as Deneb, Altair, Rigel and about 40 others, are widely known by names handed down over the centuries. Most stars in the range of magnitude 2 to 5 have Bayer designations. Fifth- and sixth-magnitude stars are usually known by Flamsteed numbers. Fainter stars have modern catalogue numbers such as HD 105262.

OBJECT DESIGNATIONS

Clusters, galaxies and some nebulas are marked by open circles on the charts. The general shapes of larger bright nebulas are shown with a solid-line outline, dark nebulas with a dashed-line outline. Objects from the Messier and IC catalogues are given their M or IC prefixes. Using the system followed in most star atlases, we omit the NGC prefix. Thus NGC 4298 is marked as 4298.

VIRGO GALAXY CLUSTER FINDER CHART

The night sky's richest galaxy hunting ground, the Virgo galaxy cluster is given two sky regions of the eight, a detailed photograph and chart on pages 276-77 and the wide-field finder chart on the facing page. The finder-chart photograph shows stars to about ninth magnitude; the chart gives the positions of 10 galaxies, all eighth or ninth magnitude. Use the dashed line from Beta Leonis to Epsilon Virginis (17 degrees long) as a guide. At its midpoint is the core of the Virgo galaxy cluster, a congregation of galaxies known as Markarian's Chain.

THE GREEK ALPHABET

α	alpha
β	beta
γ	gamma
δ	delta
ε	epsilon
ζ	zeta
η	eta
θ	theta
ι	iota
κ	kappa
λ	lambda
μ	mu
ν	nu
ξ	xi
ο	omicron
π	pi
ρ	rho
σ	sigma
τ	tau
υ	upsilon
φ	phi
χ	chi
ψ	psi
ω	omega

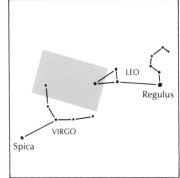

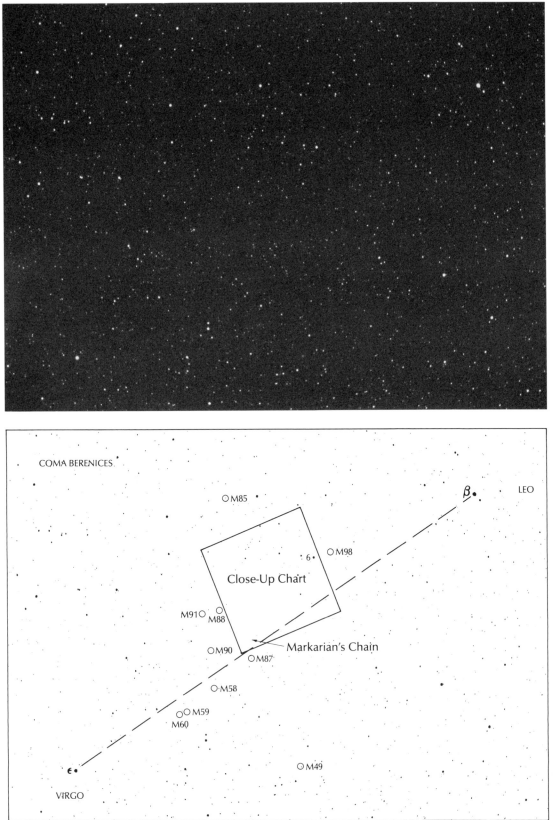

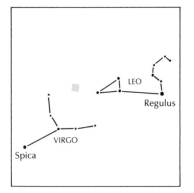

Markarian's Chain of at least a dozen galaxies is a premier target for any size telescope. The wider field of view in small instruments can include the entire archipelago of galaxies from M84 to NGC 4477 and NGC 4459. The galaxies in Markarian's Chain range from 9th-magnitude M84 and M86 to 13th magnitude.

All the galaxies marked on the chart should be visible in a 10-inch telescope, and most of them are seen in much smaller instruments. A very dark sky is far more important than aperture for galaxy hunting. Magnitudes of some of the brighter galaxies: NGC 4216, 10.0; M99, 9.9; M100, 9.4; M84, 9.3;

M86, 9.1; NGC 4438, 10.1; NGC 4459, 10.4; NGC 4473, 10.2; NGC 4477, 10.4.

Observing tip: Start exploring this region by centring on the fifth-magnitude star 6 Comae Berenices. It can be spotted with the naked eye under dark skies about seven degrees east of Beta Leonis. By easing the telescopic field away from this star, you can trace the star chains to the various galaxies. If you get lost, return to 6 Comae Berenices and start again. Base photograph by Tom Dey; 6-inch f/1.6 hybrid Schmidt-Cassegrain astrographic camera.

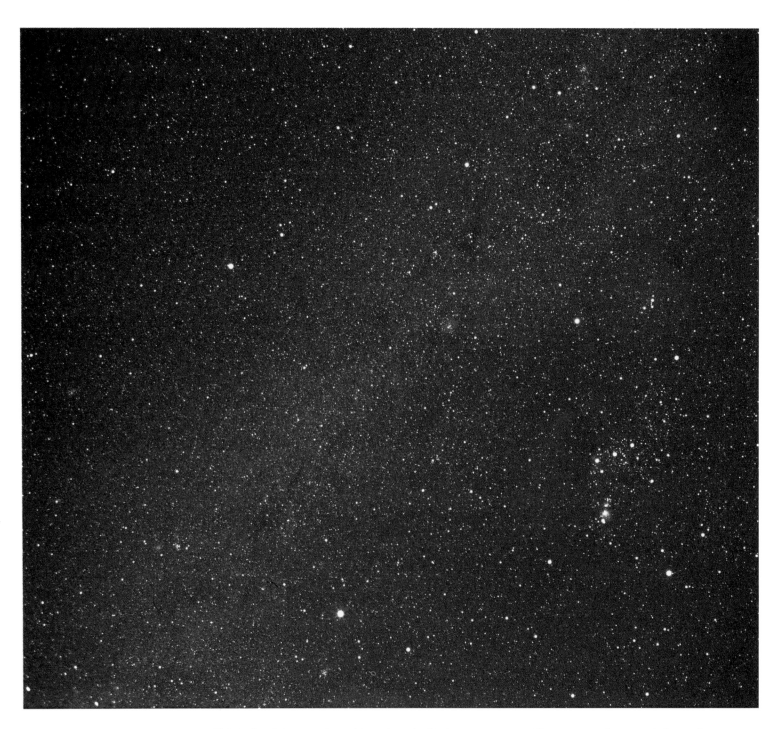

This is the richest section of the winter Milky Way visible from midnorthern latitudes, and it is appropriately flanked by the brightest of all the constellations, Orion. One of the first objects every backyard astronomer observes is the Orion Nebula. Visible as a faint smudge to the naked eye, the Orion Nebula's teacup shape becomes evident in binoculars. In dark skies, a 6-inch or larger telescope offers a magnificent view. The eye's ability to discriminate over a huge range of brightnesses offers a distinct advantage over photography. This is nowhere more evident than when viewing the Orion Nebula. Intricate detail deep within the nebula's brightest sectors, which is burned out in photographs, can be detected with the eye.

The Rosette Nebula wreathes the open cluster

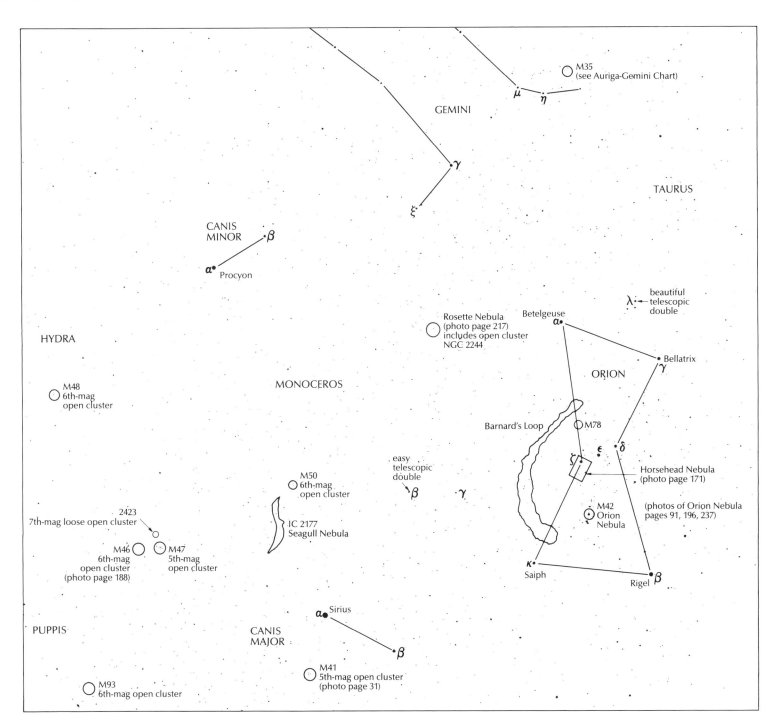

NGC 2244. The cluster is an easy binocular object, but the nebula is much fainter than the Orion Nebula, although it can be glimpsed in 7 x 50 binoculars. The view in a telescope is greatly enhanced when a nebula filter is added. The Seagull Nebula, IC 2177, is much more difficult even with a nebula filter. Use low power. The whole region harbours splendid open clusters, the finest of which are the contrasting pair M46 and M47. M46 is a rich swarm of faint stars that looks hazy in binoculars but magnificent telescopically. M47 has fewer stars, but they are brighter, making it brighter overall and resolvable in binoculars. A close rival is M41. Its location near Sirius makes it an easy target for backyard astronomers. Base photograph by Terence Dickinson; 35mm lens at f/2.8.

279

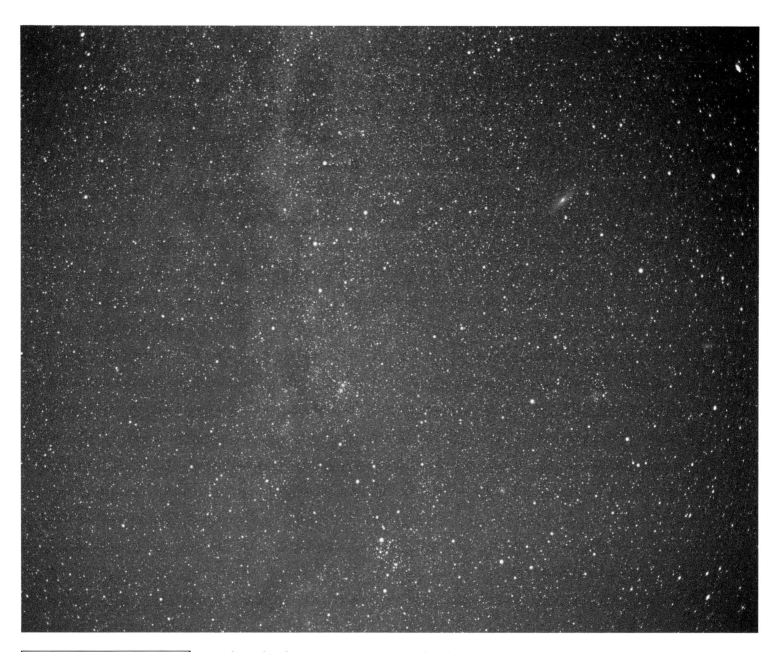

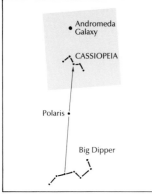

High overhead on autumn evenings in midnorthern latitudes, the distinctive W-shape of Cassiopeia is the key to this sky region, which includes two of the sky's brightest galaxies along with a fine collection of open clusters.

Despite its fourth-magnitude prominence as an easy naked-eye object, the Andromeda Galaxy has a reputation as a disappointing telescopic target. There are several reasons for this, not the least of which are the impressive photographs of it in this and many other astronomy books. Time exposures soak up light; the eye does not. What appears to dazzle in pictures can be dim or invisible in the eye-

piece. You may find that the most aesthetically pleasing view of M31 is through binoculars. Observing tip: Use low power; this is a huge object. Look for two dust lanes and the companion galaxies, M32 and M110. For a challenge, try tracking NGC 147 and NGC 185, two much smaller companions to M31.

The Triangulum Galaxy is another large, low-power subject with little detail. Spiral structure has been glimpsed with a 5-inch telescope, but it is tough to see in any backyard instrument.

Moving on to the open clusters, we encounter the reverse situation to the galaxies: they often look bet-

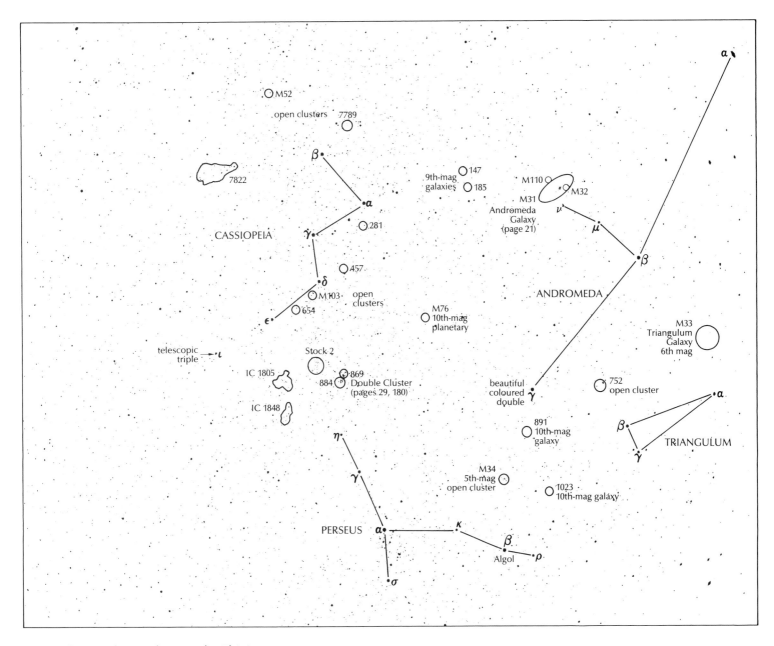

ter in a telescope than in photographs. This is especially true for the Double Cluster, in Perseus. The tiny, sparkling stars nested together in two knots lure the backyard astronomer back again and again. Much less well known is NGC 7789, one of our favourites. Its stars are dim – but there are so many of them!

The three nebulas indicated here are very difficult visual objects but are familiar to astrophotographers. Base photograph by Terence Dickinson; 35mm lens at f/2.8.

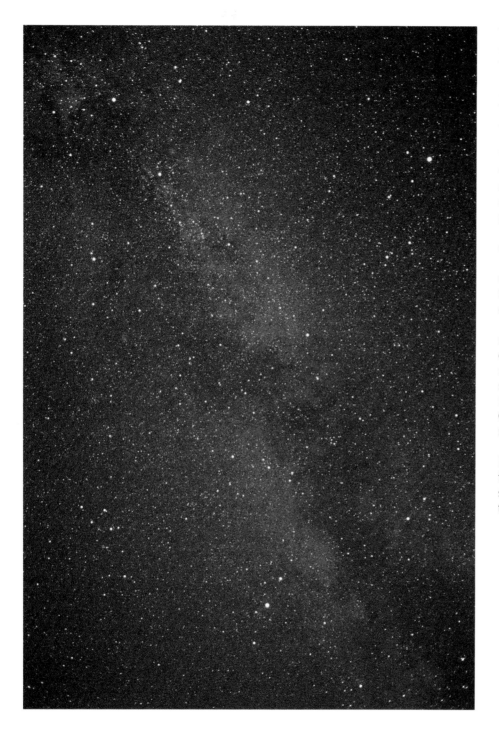

The glowing star clouds of the summer Milky Way offer an edge-on view into our own galaxy. One of the great experiences in backyard astronomy is spending a cool, dry summer evening scanning Cygnus with binoculars or a low-power telescope. The region is so thick with stars that open clusters such as M29 hardly stand out.

The top binocular targets here are the neat double stars Epsilon and Zeta Lyrae and the aptly named Coat Hanger cluster. Slightly more difficult for binoculars is the small oval glow of the Dumbbell Nebula. In a telescope, though, the Dumbbell is a bright patch of nebulous gas—the expelled matter of a dying star—that resembles an x-ray view of an apple core (photograph, page 181).

The famous Ring Nebula is in the same family of objects as the Dumbbell, but it is strictly a telescopic target. Small, but bright, it looks like a ghostly doughnut among the stars.

The Veil Nebula was once regarded as a tough visual object, regardless of the equipment used. Today's nebula filters make it easy. Even a 3-inch refractor used at low power with a nebula filter shows coils and filaments in both sections of this remnant of an ancient supernova. Nearby, the Gamma Cygni Nebula is more elusive and is primarily a target for photographers.

Low power is essential for seeing the shape of the North America Nebula (photograph, page 187). The favoured instruments are 11 x 80 binoculars or telescopes that can operate at less than 25x. Observing tip: Look for the Gulf of Mexico.

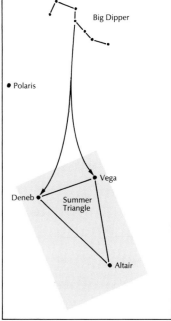

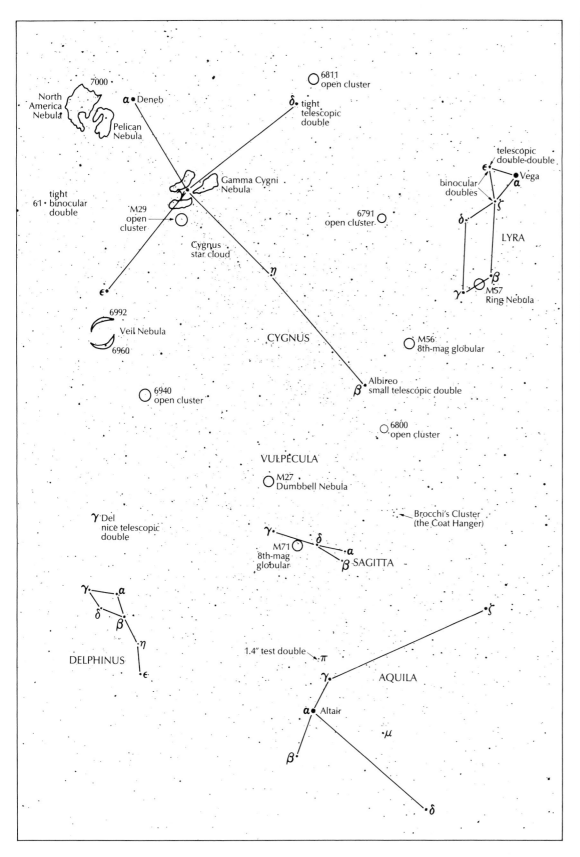

North America Nebula

7000

Pelican Nebula

α • Deneb

6811 open cluster

δ • tight telescopic double

tight 61 • binocular double

M29 open cluster

Gamma Cygni Nebula

6791 open cluster

telescopic double-double

ε • *α* • Vega

binocular doubles *ζ*

δ

LYRA

Cygnus star cloud

η

ε •

6992

Veil Nebula

6960

CYGNUS

γ *β*

M57 Ring Nebula

M56 8th-mag globular

6940 open cluster

Albireo small telescopic double

β

6800 open cluster

VULPECULA

M27 Dumbbell Nebula

Brocchi's Cluster (the Coat Hanger)

γ · Del nice telescopic double

γ · *δ*

M71 8th-mag globular

α

β · SAGITTA

γ · *α*

DELPHINUS

δ · *β*

η

ε

1.4″ test double

π

γ ·

AQUILA

ζ

α • Altair

μ

β ·

δ

283

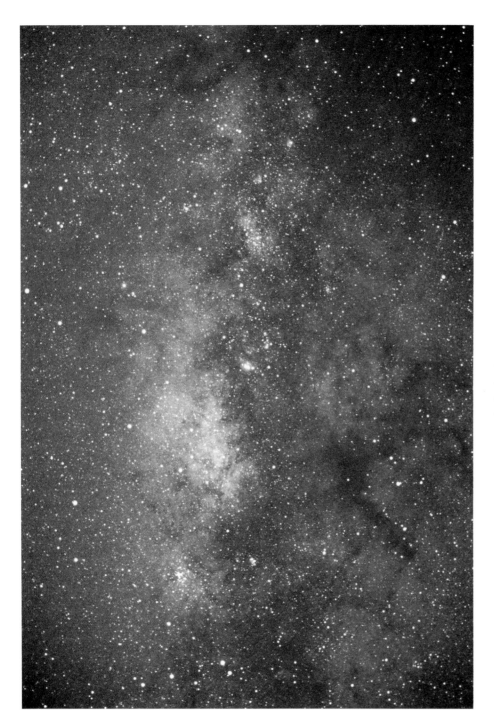

The teapot shape of the constellation Sagittarius is the guide to the centre of the Milky Way Galaxy. Most of what we see here is part of the Sagittarius arm of our galaxy, the next spiral arm inward from the Orion arm where our sun resides. Among the magnificent fields of countless stars in this section of the sky are some of the finest star clusters and nebulas.

On pages 194-95 is a detailed photograph of the region around the Lagoon and Trifid Nebulas. The Lagoon is embedded in a star cluster that is far more evident visually than in photographs. Nebula filters enhance the view of both these nebulas as well as the Swan and Eagle Nebulas farther north along the Milky Way.

Most of the open clusters are easy binocular objects. Be sure to seek out M7. It is sensational in binoculars. You can hardly miss it. In dark skies, it is an easy naked-eye blob in the Milky Way.

Just at the top of the teapot, the globular cluster M22 is a threshold naked-eye object. Binoculars reveal it as a small circular glow, and even a 3-inch telescope begins to reveal its true nature—a swarm of thousands of stars. For anyone confined to northern-hemisphere viewing, M22 rivals M13, the Hercules star cluster, as the best of its type.

Base photograph by Terence Dickinson; 50mm lens at f/2.0.

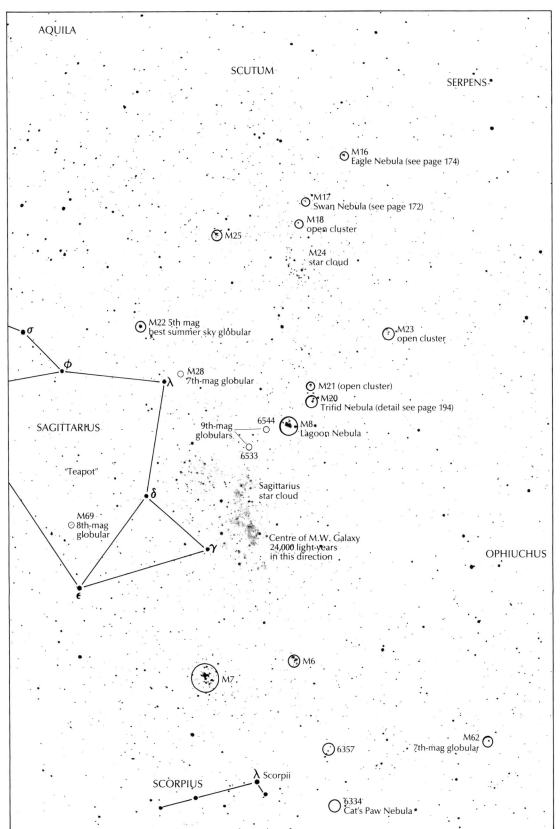

AQUILA

SCUTUM

SERPENS

M16
Eagle Nebula (see page 174)

M17
Swan Nebula (see page 172)

M18
open cluster

M25

M24
star cloud

M22 5th mag
best summer sky globular

M23
open cluster

σ

φ

λ

M28
7th-mag globular

M21 (open cluster)

M20
Trifid Nebula (detail see page 194)

9th-mag
globulars

6544

6533

M8
Lagoon Nebula

SAGITTARIUS

"Teapot"

Sagittarius
star cloud

δ

M69
8th-mag
globular

Centre of M.W. Galaxy
24,000 light-years
in this direction

OPHIUCHUS

γ

ε

M6

M7

M62
7th-mag globular

6357

SCORPIUS

λ Scorpii

6334
Cat's Paw Nebula

Altair

SAGITTARIUS

Antares

SCORPIUS

Summer Southern Horizon at about 40°N

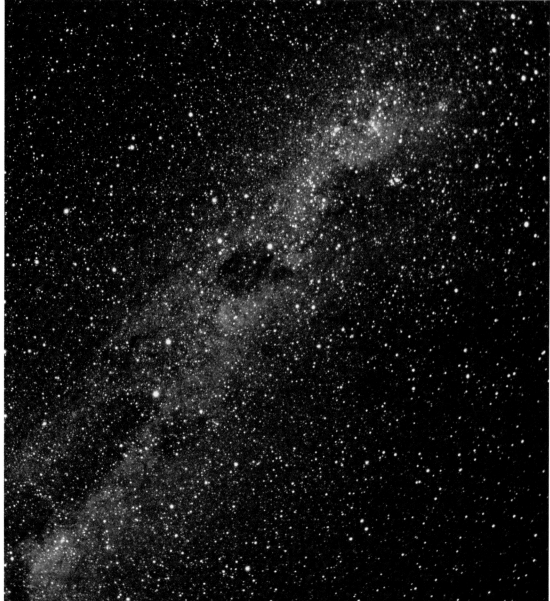

Unfortunately for northern-hemisphere backyard astronomers, the finest of all sky regions never rises above the horizon. This section of the Milky Way is properly viewed only from the southern hemisphere. It contains the brightest nebula, the brightest globular star cluster, some of the finest open clusters and the nearest star, Alpha Centauri (Rigil Kentaurus).

The Eta Carinae Nebula is plainly visible to the unaided eye as a ragged but distinct glow in the Milky Way in the constellation Carina. Binoculars show its shape — a petal-like structure — flanked by beautiful star clusters, NGC 3532 and IC 2602. Telescope viewing of the Eta Carinae Nebula is an experience worth the trip to the southern hemisphere. If that is not enough, the globular cluster Omega Centauri is about three times bigger and three times brighter than the Hercules star cluster.

Crux, the Southern Cross, is not as distinctive as its name would suggest, but it lies in a glorious part of the Milky Way. Beside Crux is the Jewel Box star cluster, NGC 4755, equal to any open cluster in the northern-hemisphere sky. Beside it is the most distinctive dark rift in the Milky Way, appropriately called the Coal Sack. Base photograph by Michael Watson; 24mm lens at f/4.

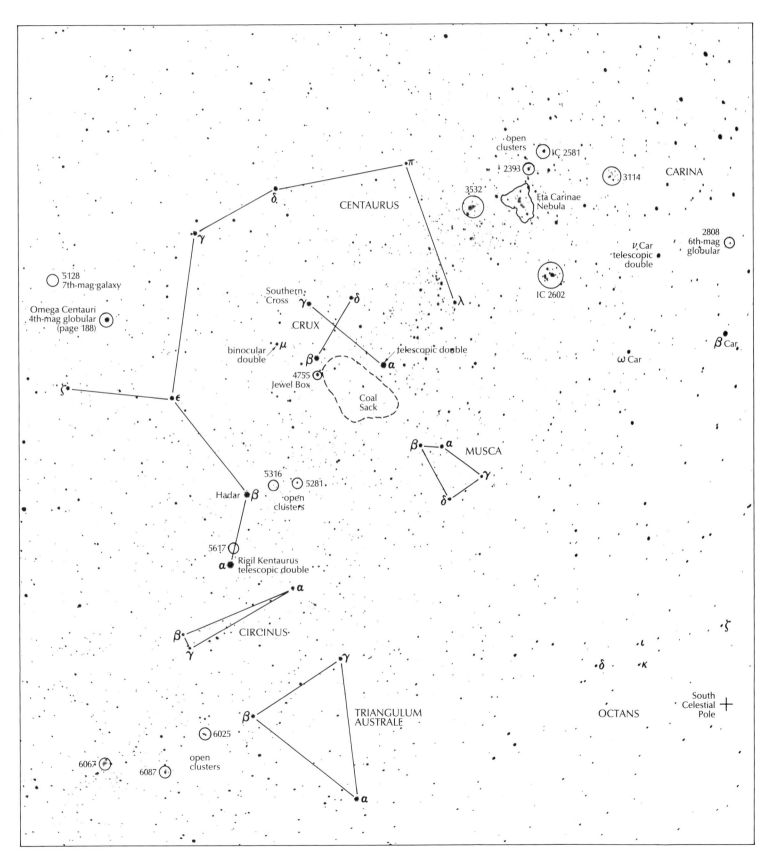

This region is highlighted by a chain of four impressive open clusters: M35, M36, M37 and M38. The best of the bunch is M35, partly because it is the brightest but also because of its coincidental alignment with NGC 2158, a star cluster even richer than M35 but five times more distant. The individual stars of M35 can be resolved with binoculars, and telescopes show interesting chains apparently radiating from within the cluster. In small telescopes, NGC 2158 is just a smudge beside M35, and it is an interesting test for both telescope and observer to try to detect individual stars. A 6-inch or larger telescope is usually required.

A close rival to M35 is M37, a rich, dense open cluster also resolvable in binoculars. Less impressive but still easy binocular targets are M36 and M38.

The famous Crab Nebula, the remnants of a supernova that was first seen in the year 1054, is a dim smudge, and a nebula filter will not bring out details. This is one subject where large apertures really make a difference.

The small nebulosities IC 405 and IC 410 are very faint visually but relatively easy to pick up photographically. Although the Milky Way is not as bright in this region of the sky as it is elsewhere, it is still a rewarding area to sweep with binoculars.

AURIGA

M38
6th-mag
open cluster

○1907

Stock 8

IC 405
AE Aurigae
Nebula

IC 410

to Capella

3rd- and 7th-mag
double 3½"
test for good seeing

θ

M36
6th-mag
open cluster

M37
5.5-mag open cluster
richest of Auriga clusters

γ

TAURUS

Crab
Nebula
M1
8th-mag
supernova remnant

Tau
ζ

two weak
open clusters

M35
5th-mag open cluster
one of the northern sky's finest
(photo page 179)

IC 2157

2158

2129

1

GEMINI

to ε Gem

η

IC 443

μ

2175
open cluster

2174
nebula

Capella

AURIGA

Castor

GEMINI

Pollux

289

■ INDEX ■

■ THE AUTHORS

■ TERENCE DICKINSON

Terence Dickinson is Canada's leading astronomy writer. He is the author of six books and the co-author of three and has received numerous national and international awards for his work. A former editor of *Astronomy* magazine, Dickinson was an instructor at several science museums and planetariums in Canada and the United States before turning to science writing full time in 1976. His articles have appeared in many magazines, including *Equinox*, *Reader's Digest*, *Omni* and *Science Digest*, and he writes a weekly astronomy column for *The Toronto Star*. Dickinson also teaches astronomy part-time at St. Lawrence College, Kingston, Ontario, and is an astronomy commentator for *Quirks and Quarks*, CBC Radio's weekly science programme.

Dickinson traces his interest in astronomy back to the age of 5 when he was fascinated by the sight of a bright meteor. At 14, he received a 60mm refractor as a Christmas present and since then has owned more than 20 different telescopes. Today, he observes under sixth-magnitude night skies near the village of Yarker in rural eastern Ontario.

■ ALAN DYER

Alan Dyer is an associate editor of *Astronomy*, the world's largest-circulation magazine for backyard astronomers. He is widely regarded as an authority on commercial telescopes, and his evaluations of equipment appear regularly in *Astronomy*. He is an experienced astrophotographer, deep-sky observer and astronomy writer and, for more than a decade, was writer/producer at the Edmonton Space and Sciences Centre.

Dyer recalls, as a child, asking his parents' permission to stay up late to watch the stars. At 15, he used money earned from delivering newspapers to buy his first telescope, a 4-inch Newtonian reflector. He has owned telescopes up to 13-inch aperture but prefers high-quality optics of more moderate size that he can use at a moment's notice from his backyard near Eagle, Wisconsin.